The Lives of Lucian Freud

THE LIVES OF
LUCIAN FREUD

The Restless Years,

1922–1968

William Feaver

ALFRED A. KNOPF NEW YORK 2019

THIS IS A BORZOI BOOK
PUBLISHED BY ALFRED A. KNOPF

Copyright © 2019 by William Feaver

All rights reserved.
Published in the United States by Alfred A. Knopf,
a division of Penguin Random House LLC, New York,
and distributed in Canada by Random House of Canada,
a division of Penguin Random House Canada Limited, Toronto.
Originally published in hardcover in Great Britain by
Bloomsbury Publishing Plc, London, in 2019.

www.aaknopf.com

Knopf, Borzoi Books, and the colophon are
registered trademarks of Penguin Random House LLC.

Grateful acknowledgement is made to the following for permission to reprint
previously published material:

David Higman: Excerpt from "Refugees," copyright © Estate of Louis MacNiece,
reprinted by permission of David Higman.

TIME USA, LLC: The extract on pages 254–5 copyright © 1947 by
TIME USA, LLC. All rights reserved. Reprinted and translated from TIME
and published with permission of TIME USA, LLC. Reproduction in any
manner in any language in whole or in part without the written
permission of TIME USA, LLC, is prohibited.

Library of Congress Cataloging-in-Publication Data

Names: Feaver, William, author.
Title: The lives of Lucian Freud / by William Feaver.
Description: First American edition. | New York : Knopf, 2019. |
"Originally published in Great Britain by Bloomsbury Publishing Plc,
London, in 2019." | Includes bibliographical references and index.
Contents: [volume 1]. The restless years, 1922–1968
Identifiers: LCCN 2019016659 | ISBN 9780525657521 (v. 1 : hardback) |
ISBN 9780525657538 (v. 1 : ebook) |
Subjects: LCSH: Freud, Lucian. | Painters—England—Biography. | BISAC:
BIOGRAPHY & AUTOBIOGRAPHY / Artists, Architects, Photographers. | ART /
Individual Artists / General. | ART / History / Contemporary (1945–).
Classification: LCC ND497.F75 F39 2019 | DDC 759.2 [B]—dc23
LC record available at https//lccn.loc.gov/2019016659

Jacket photographs © The Cecil Beaton Studio Archive at Sotheby's
Jacket design by Carol Devine Carson

Manufactured in the United States of America
First American Edition

To Andrea Rose

CONTENTS

AUTHOR'S NOTE

The day we first met, in 1973, I told Lucian that for interview purposes I just wasn't interested in his private life. All that mattered was the work.

Time passed and in later years whenever he taxed me with having been so artless my response was that what perhaps had sounded like a pledge had been a mere clearing of the throat. By then of course it had become obvious to me that the work reflected the life and embodied the life, and because the life Lucian led was spent more in the studio than anywhere else that was its commanding peculiarity. As he himself said: "Everything is biographical and everything is a self-portrait." Since his relationships tended to be compartmented and the vicissitudes that eddied around various passions so clearly affected him, it seemed to me that some sort of consolidated account of them extending beyond self-portraiture was now needed.

Initially this book was to have been a brief account of Freud the artist, but in the late 1990s, as the tapes accumulated and reminiscences flowed, we agreed that what Lucian had taken to referring to as "The First Funny Art Book" was outgrowing its prospectus, so it was shelved for the time being, Lucian half-heartedly assuring me that he would have no objection to "a novel" appearing once he was dead. Working with him on a number of exhibitions made the oeuvre ever more familiar to me and we went on talking, primarily on the phone, almost daily. The notes I took from the countless conversations ("How old am I now?" he would often ask me or, less specifically, "How goes it?") are the chief source for these two volumes of biography.

PROLOGUE

"Always wanted never to have anything known about me"

There were, as usual, several pictures on the go. The main one, on an easel directly under the skylight, was so far little more than eyes and chin, floorboards edging in, indications in charcoal of body on bed, a muzzle and smudge where Pluto the whippet would lie and a patch of white at the foot of the bed where a woman was to have stood. She had become intrusive, the painter had decided. A lesser distraction was needed. "Possibly something under the bed," he said.

While what was to become *Sunny Morning—Eight Legs* preoccupied Lucian Freud in daylight hours, others were worked on through evening sessions and into the night. Rose, one of his daughters, and her husband Mark were sitting for a double portrait, their heads distinct but as yet unrelated, the gap between them just beginning to be realised. "I've already put some air in here," was the comment. Another daughter, Ib, had been sitting with a book for a second daytime painting. The relationship of head to Proust had worked out well but more breathing space was needed and so the canvas had been extended. Proceeding as he did by accretion, form by form, Freud often found enlargement necessary. That way, ideas grew. The seams that zigzagged down all four sides of *Ib Reading* would soon be painted over, leaving scars visible only in a raking light.

Freud's working methods were demanding while unassuming throughout. Presuming nothing save the presence of whoever or

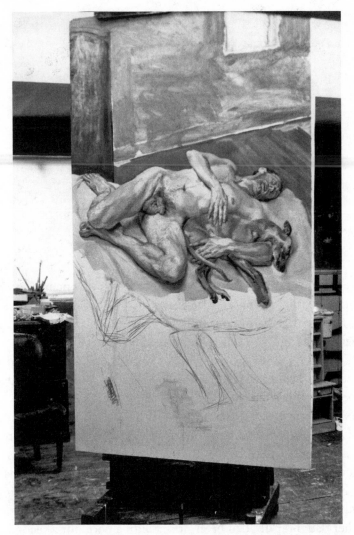

Freud's Holland Park studio: work in progress on
Sunny Morning—Eight Legs, at a six-legged stage, 1997

whatever he had felt like painting, he would go ahead with little or
no preconception beyond the glimmerings of potential. Early on, as a
beginner, there had been the buzz, the magic almost, of making imag-
ined things substantial, making them convincing somehow. "In that
way, once I got going, they led me on; I liked to have nothing there
so that I felt they came from nowhere." Later he came to depend on

engaging with what he actually saw, intuition reminding him, by the by, that a sitter's outward appearance was "to do with what's inside his head."

No other painter in modern times has more straightforwardly made so much of the particular. He used to mock me for being obliged, he said, as an art critic to maintain "eternal vigilance." Which of course was what in practice he demanded of himself. His was an intent alertness sustained hour by hour, week in week out. Painting had to be unremitting, never (in his words) "indulgent to the subject matter; I'm so conscious that *that* is a recipe for bad art." He talked about perseverance as an instinct. Ruthlessness too, he assumed, but that went without saying. "I always thought that an artist's life was the hardest life of all."

Painting absorbs whatever affects the painter. Every consideration, emotional or otherwise, Freud believed, stretches a painting's potential. "I don't think there's any kind of feeling you have to leave out." If the feeling wasn't there, then ultimately the painting failed. Yet the feeling in a painting was necessarily filtered, distanced, objectified. He stressed the need to avoid "false feeling" or gratuitous fervour. "I don't want them to be sensational, but I want them to reveal some of the results of my concentration." His concentration over the years yielded paintings, drawings and etchings that fix insistently on what we are whoever we are, on the motif whatever it may be, getting a hold on the ingrained uncertainties that spice a life.

Freud liked unpredictability, particularly at the outset. "I try and vary the way I start. What I mean is, sometimes I put down a lot of paint but sometimes—say on a single figure—I start in a different place. Often I've started round the stomach and different parts. It's to do with my horror of method, which may come of my having had such a rigorous method at the very beginning."

That method, conspicuously exhaustive, culminated in *Girl with Roses* (1947–8), considered by Freud his "first real picture" and certainly one of the first to advance on a sizeable scale the notion of close attention as the essence of a relationship. The girl's stare is subjected to that of the painter. She looks towards a window shown reflected in her eyes. Such detail may prompt metaphysical analogy (windows

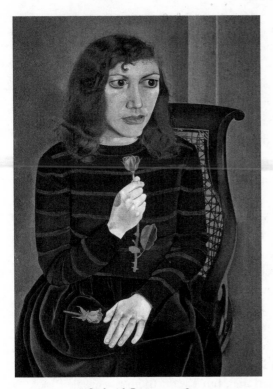

Girl with Roses, 1947–8

into the sitter's soul), but it represents more the desire of an exacting young painter to make the image alert.

The sitter was Kitty Garman, a daughter of Jacob Epstein whose bust of her done three years previously represented her as a sort of naiad with a streaming head of hair. Epstein talked of "a trembling eagerness of life" pulsing through such portrait sculpture: "Head, shoulders, body and hands, like music." His future son-in-law, "the spiv Lucian Freud," as he was to refer to him after the divorce, saw Kitty plain: wide eyes, braced shoulders, seated as rigidly as a playing-card queen. He had painted her a couple of times before, initially young and artless in a busman's jacket and then holding a tabby kitten as though proffering a decanter, the relaxed limpness of the paws indicating a kindly grip on the neck of this namesake cum attribute.

Girl with Roses exemplifies wariness. It harks back to *One Hundred Details from Pictures in the National Gallery*, a selection made by the Gallery's Director Kenneth Clark and published in 1938 in which, page after page, the black and white photogravure reproductions parade stimulating qualities: the poise of Holbein's *Christina of Denmark*, the salon aplomb of Ingres' *Madame Moitessier*, one of Freud's favourite paintings and Clark's most astute acquisition for the National Gallery in his time there. Leafing through, the detail that in sudden alacrity most vividly compares with *Girl with Roses* is the close-up of the tabby cat clinging to the chair-back in Hogarth's *The Graham Children*: eyes enormous, thorny claws bared.

Thanks to Clark who fixed it for him, Freud used to have his

paintings photographed by Mrs. Wilson in the National Gallery photographic department and as *Girl with Roses* approached completion he began wondering how it would look in black and white. "I remember being so excited when I did the green stripes on the jersey. I put black dots on the green stripes because I thought if I put them in they'd come out. Like doing etching: knowing it won't show on the plate but it will come out in the print." This peppering showed up well in the photograph. Reproduced opposite the tonal fug of a barmaid picture by Ruskin Spear, a blustery third-generation Sickert, in a 1951 Pelican book, *Contemporary British Art*, by Herbert Read (who, in a later edition, was to dub Freud "The Ingres of Existentialism" and replace the Spear with a Burra), the painting looked radiantly distinctive. To the Greek poet Nanos Valaoritis, writing in the early 1950s, Kitty here was "petrified in a corner, at bay, like a frightened animal."[1]

In keeping with the "things that are not made up" that Freud admired in ancient Egyptian art, *Girl with Roses* exalts appearance. Here are individual fingernails and individual hairs, some with split ends, living relics as fully realised as the golden tresses of a Dürer. "I did the hair architecturally and moved it and watched it and then I did that thing, through working slowly, that I've often done, which is to change *life* to suit *art*."

Daylight graces the painting, moulding the velvet skirt, glossing the lips, adding penumbra to the frizz of loose hairs around the head, streaking down the arm of the chair and silhouetting its torn cane-work. This chair, from a junk shop in a former chapel in the Harrow Road, near Delamere Terrace in Paddington where, since 1943, Freud had rented a flat, was peculiarly uncomfortable. "If you leant back the wrong way you snagged a nail. It's useful in the picture." Equally useful is the congruity of forms, as calculated as any pin-up pose: flecked curls and curvy stripes; teeth and fingernails so alike; the nostril flare of the chair-back; the petal-shaped birthmark on the hand. The rose held up like a child's buttercup thrust against the chin to test a taste for butter is halfway to being an emblem. Poetic rather than symbolic—the rose of Venus—it recalls the phrase of Rilke, "The rose of onlooking," which Freud had seen in the September 1947 number of *Poetry London*. It and the other rose on her lap nuzzling her left hand are studiedly inanimate. "I suppose they are portraits,"

Freud said, by which he meant that they are specific, having been done from life. "They are not 'let's have a rose,' they are actual ones, those cheap bunches you got where most of them died but one or two survived; you don't see them now: costermonger's flowers, yellow and red ones, wired to keep them throttled. Very often they couldn't get enough water so they just had asthma."

Over time *Girl with Roses* has eclipsed the most famous seated figure in British art of the period, a figure in Hornton stone even more complacent than Ingres' statuesque Mme Moitessier: Henry Moore's *Northampton Madonna*, unveiled in 1944 in the Church of St. Matthew, Northampton, by Kenneth Clark who remarked as he did so that it "may worry some simple people." Moore, talking of "an austerity and nobility and some touch of grandeur," had shrunk his Madonna's head a little in the interests of monumentality. Freud did the opposite. For him there was the urge to accentuate. He had to achieve the looming look of a face that, as the expression goes, is all eyes. Knowing by heart, as he did, swathes of poetry of all kinds, there were phrases that bit into the memory and came to mind as he worked. Muttered, murmured, behind *Girl with Roses*, are lines he loved, Shakespeare's pox on the rhetoric of "false compare":

> *My mistress' eyes are nothing like the sun;*
> *Coral is far more red than her lips' red:*
> *If snow be white, why then her breasts are dun;*
> *If hairs be wires, black wires grow on her head.*
> *I have seen roses damask'd, red and white,*
> *But no such roses see I in her cheeks . . .*

"The fact of your life being your subject matter doesn't in any way change the nature of art or artistic enterprise. And therefore it seems absolutely obvious, as well as convenient, to use as a subject what you are thinking and looking at all the time—the way your life goes."

Berlin, London and Devon
1922–39

I

"I love German poetry but I loathe the German language"

With a doleful shake of the head, during a platform discussion with me at the 1995 Edinburgh Festival relating to a "School of London" exhibition, the critic David Sylvester declared Lucian Freud to be, in his view, "not a born painter." Freud, he said, "had applied himself to the art of painting without ever convincing me that he was a painter."[1] Five days later in an article in the *Guardian*, written in response to a report of the discussion in *The Times*, he expanded on this notion of the inherent or incubated: "In reality he has become an outstanding painter without having been, I think, a painter by nature: he is a painter made, not born, made by a huge effort of will applied to the realisation of a highly personal and searching vision of the world."[2]

Reading this, Freud laughed. Here was cliché rounding on cliché. Certainly he liked to think of himself as self-made. "I like the anarchic idea of coming from nowhere. But I think that's probably because I had a very steady childhood." Anyone with Sigmund Freud as a grandfather could be all too readily assumed to have privileged access—by genetic imprint maybe—to a searching understanding of character and motivation, not to mention a predisposition to examine people on couches. The parallels are inviting: clinical analysis and portrait analysis, neuroses diagnosed and neuroses depicted. In reality however Lucian inherited only his grandfather's fur-collared overcoat and a part share, with the other grandchildren, in the copyrights on his published works. True, the illustrious surname awaited him at

birth. That may have provoked expectations. But the idea of anyone being born or not born an artist or indeed born a psychoanalyst was, he murmured, ridiculous. "It's jargon. A twerp's born. 'A born idiot.' No, the only thing you can be born, actually, is a baby."

Born in Berlin on 8 December 1922, the middle son of thirty-year-old Ernst Ludwig Freud, youngest son of Sigmund Freud, Lucian Michael Freud was named after his mother, Lucie Brasch, and Michael, the fighting archangel. His elder brother, Stefan Gabriel, had been born sixteen months before and the younger brother, Clemens Raphael, came sixteen months later. The 8th, number eight and multiples of eight were to become significant factors in gambling calculations throughout his life. As for the archangel names, Lucie Freud explained that they fitted in with her plan to have three children. She had been certain that she would have boys only.

Lucian considered himself isolated, outstandingly so, from the start. "My mother said that my first word was '*alleine*' which means 'alone.' 'Leave me alone': I always liked being on my own, I was always terribly anxious there should be no competition." His mother, it emerged, had a special attitude to Lux, as both he and she were familiarly referred to. He was the born favourite. "She treated me in a way as an only child from very early on; it seemed unhealthy, in a way. I always longed to have a sister."

Ernst Freud maintained an architect's office in the large family apartment—tall, panelled rooms with chandeliers—in Regentenstrasse 23 in Lützow, an imposing district of Berlin near the Tiergarten, two streets away from where Mies van der Rohe's Neue Nationalgalerie now stands. He had a partner and two assistants: "Mr. Kurtz and Mr. Augenfelt, who we called Grock ('Grockchen') as he looked like Grock the clown who I'd seen at the circus." Lucian considered his father good at jokes but a bit distant. "I thought the one time I liked my father was when he used to walk me with my feet on his feet and he'd open his mouth and be a giant and take huge steps." Professionally speaking he was easy-going, so much so that he had to be bailed out on several occasions by his mother-in-law or cousins, the Mosses, when business ventures failed. He was happy, eager even, to represent the great Viennese Professor Freud at receptions in his

honour. "My mother wasn't: she felt it was wrong to be put in the position of going somewhere for his father rather than himself.

"My father's favourite musical instrument was the one-man band: bike, drum and trumpet. Grandfather too prided himself on being unmusical. In Vienna you have to have attitude.

"He wasn't the sort of architect who'd draw houses that weren't built. Richard Neutra was an old friend of his from Vienna and Gropius he admired, and knew a little, but he was obviously not in the forefront. He did things very quietly and even though the style was quite radical he was not an *innovator* of the style, he was a user of the style." His buildings included a small cigarette factory, the Neue Villa in Dahlem, for Sigmund Freud's friend Dr. Hans Lampl, and a house overlooking a lake in Geltow near Potsdam for Dr. Frank, Director of the Berlin Discont-Gesellschaft, a novel feature of which was a window, described in the *Studio Year Book: Decorative Art 1934*[3] as "a glass wall 20 feet long sliding down into the cellar, worked by weights and easily manipulated by hand." He fitted out consulting rooms for psychoanalysts—couches calculatedly placed just so in relation to the analyst's chair—and designed furniture: heavy shelving in African rosewood for his own study, and sofas that Lucian remembered as being "most inventive in ashwood and very severe." In a Berlin of grand turn-of-the-century apartment blocks, the interiors that Ernst Freud produced were clear-cut expressions of modernity installed behind ponderous façades.

Frank Auerbach, who, many years later, was to become Freud's closest painter friend and whose father was a lawyer, remembered the type of apartment that he and Lucian grew up in as being stiflingly well appointed: "The apartment. I don't know what you'd call it. A sort of hexagonal hole with doors leading off it in various directions, my father's office being one of the doors leading off. These flats were big and there were courtyards where people would beat carpets in the centre of the court. Ours was a Wilmersdorf flat. Tiergarten was Park Lane."[4] Evidently the Freuds, thanks to Brasch family money, were one step up from the Auerbachs.

In April 1922, Sigmund Freud wrote to Ernst for his thirtieth birthday: "You possess everything a man can want at your age, a loving wife, a splendid child, work, and friends." This was more than the usual good wishes. Earlier that year there had been (as Hans Lampl

put it) "a brief period of alienation" in his youngest son's marriage about which he knew next to nothing, for disturbing news was generally kept from the Professor. However, according to his daughter Anna—a not altogether reliable source—he blamed his daughter-in-law for whatever upset or estrangement there may have been and lamented how few women know how to love their men. An admirer sarcastically referred to by Ernst Freud as "Schwäbisches Nachtigall" (the Swabian Nightingale) was said to have addressed poems to her. Seventy years later Lucian Freud confirmed this. "He wrote these poems to my mother. Sonnets. But I don't think she would have given my father any cause. She could never have had anything to hide; it wasn't her way." As it was, the couple were reconciled, Lucian was born and the marriage thrived. "I'm sure they were happily married as they would go abroad on their own to Italy or Spain or Greece."

In later life both brothers, Clement and Stephen as they became

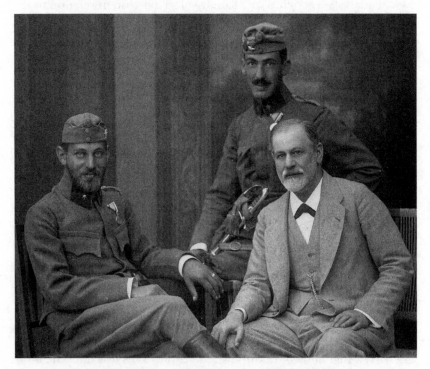

Sigmund Freud with sons Martin and Ernst (seated left), 1916

known, took to letting it be known confidentially that, their mother having died meanwhile, the time had come to disclose that the Swabian Nightingale, Ernst Heilbrun, was, quite possibly, Lucian's father. Setting aside the entertaining thought that if he didn't happen to be descended from Sigmund then he could be relieved of the irritation of it being so often said that he had inherited the genes of psychoanalytical acumen, Lucian dismissed the guess as a brotherly slur. "My grandparents adored my mother. Both loved her and were terribly pleased that my father—gentle, quiet—had married such a talented and good woman. In some ways, considering what you read about Berlin then, they led a sheltered life."

Lucian Freud's mother, Lucie Brasch, 1919

While Ernst Freud was known for easy-going optimism (though subject to migraines), Lucie Freud was admired for her seriousness, her beauty and vivacity and, moreover, for being a good housewife. "My mother's classical scholarship—University of Munich—came in useful once, when they were on a boat and there was a priest on it and the only language they had in common was Latin." Ernst, being Austrian—the Berlin police picked him up once in the twenties as a suspect foreigner—lived by Viennese conventionality. "We had lunch on Sundays with our parents. Father required two vegetables for a main dish and he made coffee after the meal as men did that in Vienna: it was one of the links between Turkey and Vienna. The famous couch was Turkish."

Home life was compartmented and secluded. First a nanny then a governess had charge of the boys. The barber came to the house, and the dentist. ("Stephen said to me, 'I forget: was it the dentist or the barber that you bit?' ") Round the corner, in Bendligstrasse—now Stauffenbergstrasse—were the Mosse cousins: Dr. Mosse, his wife

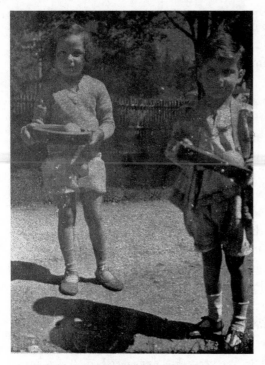

Gabriele Ullstein and Lucian Freud c. 1925

Gerda (Lucie's sister) and their children, Jo, who was a couple of years older than Lucian, Richard—"Wolf"—a year younger, and Carola. The Mosses' wealth derived from newspaper publishing, as did that of the Ullsteins, who lived next door to the Freuds. Gabriele Ullstein, a few months older than Lucian (whom she knew as Michael), was the granddaughter of Louis Ullstein, publisher of the *Berliner Morgenpost* and the *Berliner Illustrirte Zeitung* whose Ullstein Printing House, on Ullstein Strasse, was one of the finest modern industrial buildings in Berlin. Looking back, Gabriele suspected that her mother rather kept her distance from Lucie Freud, uncomfortable with having so good-looking a neighbour.

Arrangements however were made for the Freud boys to join Gabriele and others in an improvised kindergarten with use of the Ullstein sandpit.

Every afternoon, Gabriele Ullstein remembered, nannies gathered in the Tiergarten with their charges and settled into cliques. Children with Misses looking after them were hived off from those with Mademoiselles or with Fräuleins. Superior broods had English nannies and governesses; Gabriele had Rose from Ipswich, then a Miss Penfold, then a Miss Parfitt, while the Freuds had a Bavarian to look after them. Lucian did not take to her. "Fräulein Per Lindemeyer (we called her Linde): I remember thinking there was something wrong about my mother coming up to the bedroom to get an affectionate goodnight when, just before, I'd been beaten by Linde the governess. Just bashes with her huge arm." Linde's recollection of Lucian, decades later, he reported, was that he was "Very lively but not affectionate."

"When we went to Bavaria to stay in a chalet that the Ullsteins

had, on the way down on the train to Munich, in the sleeping car, she fell out of the hammock."

The Bavarian chalet had a balcony around it where every afternoon the children were made to sit on their potties. Silent concentration was the rule until one day, according to Gabriele, Lucian decided to play up, jerking himself along the landing on his potty like an eager jockey. He was, Gabriele felt, a born instigator. "Lucian had the authority of expecting to be obeyed." His memory of this went further. "I remember feeling very merry on the upstairs landing and wanting to go out looking for mushrooms and wild strawberries."[5] Let loose, they splashed around in a stream and competed to see who could get the most leeches on their legs.

Told at his first school to tie shoelaces in a particular way, he promised himself: "I'll never tie them that way again."

Misbehaviour always stimulated him. "We were walking with our nannies in the Tiergarten, with Michael and Paul, the sons of our doctor, Professor Dr. Hamburger. There were beggars around, there were lots then, and there was a beggar with a flaming red beard and eyes and we rushed to get money from our nannies to put in his bag and tiptoed, terrified, up to him. But Paul, who was the youngest of us, toddled up and took all the money and put it in his pocket and I thought it terrifically funny, this amazing feat. When I got home I told my mother and she said it was wrong. But then when my Aunt Anna bought a farmhouse, with her friend Dorothy Burlingham, at Hochrotherd, the vendor was a beggar from the streets of Vienna: a prosperous beggar with considerable property, she was told." Paul Hamburger was to become, in London, Paul Hamlyn, publisher and philanthropist.

After lunch the boys were sent to their room for a rest and when the blinds were drawn Lucian would say, "Have I gone blind?," knowing he'd get a reaction out of Stefan who couldn't see the joke, ever.

Seventy years later Clement wrote about his mother's favouritism. "When she came into the nursery she nodded to Stephen and me and sat down with Lucian and whispered. They had secrets. I did not realise for many years that this is not what good mothers do."[6] Lucian himself didn't regard being his mother's chosen one as advantageous. "It's what my brothers resented; and so did I. A violent thing, really bad, was when, during a picnic, I picked, or took, some fruit. 'Give

it to your brothers,' my mother said, and she forcibly tried to take it from me and I wouldn't let go. It was apricots, and I squashed them in my fist." He was to maintain that her reaction was inexplicably passionate, so much so that he never trusted her again.

Lucian used to say that always—or as far back as he could remember—he'd found his brothers unrewarding. "They were always together and I was always alone. On the Berlin tube Cle caught the outside of his hand in the outside of the escalator. Terrific screams. I remembered getting his hand out and thinking how odd: it was frightening but I thought just how *odd*. I was just looking at him screaming." A photograph taken in the street in 1928 shows them hand in hand. "The three of us in English clothes, tailored, and dark-suited sneering men staring at us pampered boys."

Their mother read to all three but especially, he felt, to Lucian: "Schiller and Goethe ballads, Schiller's 'Der Handschuh' [The Glove], a ballad in which the hero drops into a cage to retrieve his lady's glove, a cage with a lion, a tiger and two leopards who won't fight: they spare him and he throws the glove in her face. And one about Frederick the Great, how he rode up and down in front of his troops in the battle and shouted '*Gauner!*'—Villains (No, that's not the word. Spivs? Cheats?)—'Do you want to live for ever?' And a soldier answered, 'Fritzen: not to *betray* for sixpence a day, this is enough.'"

Lucian was stirred by the rhythms if not the sentiments of *Heimat*—homesick—songs and he loved comic poems. The conceits in Christian Morgenstern's *Galgenlieder* (Gallows Songs), printed in a heavy typeface on rough paper, appealed for their confounding logic: the notion of the gaps in a picket fence being used to build a house much to the fence's annoyance; the clock with two pairs of hands, one pair advancing, the other retreating so as to tell the time both ways and, best of all, "*Fisches Nachtgesang*" (Fish's Night Song), spelt out wordlessly in typographic waters composed of hyphens and brackets. When he was seven he was given a ballad book with illustrations that ranged from Grünewald ("marvellous") to Adolph Menzel ("thrones and lowly corners"); there were drawings he took a lifelong dislike to ("Käthe Kollwitz, I'm sorry to say") and drawings to wonder at, particularly Dürer's study of his hollow-eyed mother and *Das Grosse Rasenstuck* (The Large Piece of Turf), his miraculously vivid clump of weeds.

Equally attractive were the picture books devised by a cousin, Tom Seidmann-Freud (born Martha Gertrude, daughter of Ernst's elder sister Martha Freud), who died in 1930 aged thirty-seven, shortly after the suicide of her husband Jankel Seidmann. Her books were made to be tweaked and fingered and coloured in. "Things you could pull and things disappeared and red and blue paper where, if you passed them across the drawings, people disappeared. I loved the way they were drawn." *Das Wunderhaus* (The Wonder House) and *Die Fischreise* (The Fish Journey) were perked up with trim little outline drawings of captivated youngsters, amazing flowers, whippety rabbits and suchlike. The even more succinct *Hurra, Wir Lesen! Hurra, Wir Schreiben!* (Hurrah, We're Reading! Hurrah, We're Writing!) (1930) and *Hurra, Wir Rechnen!* (Hurrah, We're Counting!) (1931) had squirrels, storks, cats, frogs and children of all nations and races prompting first steps in reading and arithmetic.

Freud's earliest drawings, treasured by his mother, displayed similar idiosyncrasies, demonstrating what Grandfather Freud characterised as *"strahlende Intelligenz,"* the radiant intelligence of children. There were upbeat goblins, skeins of chimney smoke intertwining over rooftops and rhythmic flights of fancy: five eager-beaked birds in a five-fingered tree all straining in one direction, readied to be up and away.

Though Grandfather Freud lived in Vienna, he came to Berlin every so often for cancer treatment and to be fitted with what he described as "the very model of a neces-

DENKE DIR EINE SCHÖNE KURZE GESCHICHTE ZU DIESEM BILD AUS UND SCHREIBE SIE HIERHER.

40

Tom Seidmann-Freud: *Hurra, Wir Lesen!*

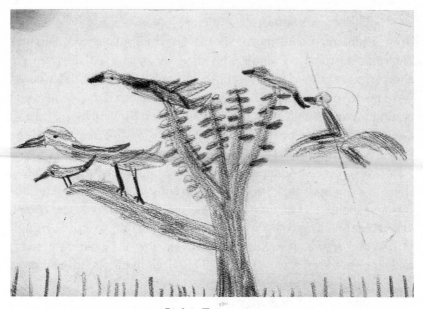

Birds in Tree, c. 1930

sary evil": a prosthetic palate to separate his ravaged oral and nasal cavities.

"My first meeting with him was when he was in Berlin, by the lake where he was having therapy or rest. When he walked he was quite bent in a way people are who sit a lot. He was frail." His grandfather, he discovered, was a mushroom hunter with biological skills (he could sex eels) and a taste for Morgenstern's catchy poetry. He also knew all about *Max und Moritz*, Wilhelm Busch's comic-strip urchins; indeed, the very first time he met him, he acted like a Busch grotesque. "He snapped his false teeth at me and my mother was upset." Also, inspiringly, he gave him reproductions of Brueghel's *Seasons* from the Kunsthistorisches Museum. Of these Lucian particularly liked *Hunters in the Snow* because of the skating, and *The Return of the Herd* with the cattle blundering down the lane. "There are no bottoms like them." Another time he brought *The Arabian Nights* illustrated by Edmund Dulac ("lovely fat books with what seemed to me pretty good watercolours. I don't know if I'd like them now") and a two-volume *Grimms' Fairy Tales*. Lucian made a set of illustrations for "Snow White" foregrounding the dwarfs: a dozen or so drawings in a concertina strip joined up with stamp hinges. This he presented to Linde.

"A child's emotional impulses are intensely and inexhaustibly deep to a degree quite other than those of an adult; only religious ecstasy can bring them back," wrote Professor Freud.[7] He once listed Kipling's *The Jungle Book* among his ten favourite works of literature. Its correlation of childish impulse and animal instinct must have appealed, and the flavour of myth. Lucian's prospects as a Mowgli of the Tiergarten were not good, but he had a golden salamander and there were cats that he used to "love and torture" and an English greyhound called Billy.

Lucian's maternal grandmother Eliza Brasch, known to them as Omi, owned an estate at Cottbus near the Polish border. "She was this rich widow and I think the reason my father and mother set up in Berlin was because my grandmother helped them economically." Lucie Freud did not get on with her mother. "She hated her. It was unreasonable. She and her sisters had had a French governess, whom all adored, and their affection went to her and so my grandmother couldn't forgive my mother for not having her affection. Here was my easy-going, bridge-playing grandmother who saw this and said she'd give the governess the sack, and my mother and her sisters—aged ten, eleven—said they would kill themselves if she did. So she kept her."

Decades later Lucian's eldest daughter Annie was impressed by her grandmother Lucie's concern for her emotional wellbeing. "She believed that a child ought always to approve of itself and that there should be no such thing as clandestine. For example, when a child began to get obsessed with pooh, shitting, words, things like that, she would work out a little system of things—rhymes for what I did so that I could get them out of my system, so that I could not as it were get infected with all this dirty talk.

"It was tyrannical but it was also fantastically secure. My hand in hers. One of the main things about being a child is your physical relationship with the people who love you or are meant to love you. And her hand was absolutely the softest and most enveloping thing and she would always hold my hand if I went out. If I had a story to tell about my toy rabbit she would take this story, there'd be no irony in the way she'd respond; if I decided my toy rabbit was going to get married she would get her dressmaker to make her a wedding dress. It was completely selfless, this enveloping love for me."[8]

Grandfather Brasch, who died before Lucian was born, had been

a grain merchant. He had acquired the Cottbus estate in lieu of debt. "He'd behaved nobly in the war. Asked by the Kaiser to supply grain he said he would, but not on a profiteering basis. I asked my mother, 'Everything you say about your father not profiteering: if so, why take the property?' She said that he didn't want to accept, but my grand-mother was so keen on it that he did."

The house, Gross Gaglow, built around 1902, was big and ugly, with high windows and a stable full of horses. The boys spent holi-days there. "We were met at the station in marvellous coaches: they had different coaches for different occasions. The stables caught fire once: nothing to do with me except that it kindled my love of fire. It was very feudal there and the village related to the house." Once, when all three were ill, children at the village school were let out so that they could come up to the house and entertain them.

"My mother hated the estate because, with her classical education and love of the ancient world, she felt it was sort of sybaritic. I loved it there. There was, for instance, an ice-bank so you could have ice any time in the summer: an ice mountain with a straw cap over it. That seemed incredibly luxurious.

"Motor cars were few; but there was a friend of my grandfather's called Lampl and I remember driving over the border with him and being so excited at going over there, probably into Czechoslovakia." Czechoslovakia (a recently created country: product of the Peace of Versailles) or wherever: countries were just names on the mixed pack-ets of postage stamps that he used to send off for on approval.

His grandmother's Berlin apartment, in Hardenbergstrasse, Charlottenburg, was impressive but off-putting. "The drawing room was formal, dark, with a huge tasselled lamp over the table, incred-ibly comfortable and luxurious. Palm trees about a lot, carpets on the tables: a sort of palm court feeling, like the Ritz." The bedroom had a polar-bear rug and ivory objects, and statuettes of Napoleon Bonaparte. "There was a great fashion for Napoleoneana. Rather like people now having things of Hitler. My mother thought my grand-mother was terribly vulgar as she had bridge parties where they drank beer."

His grandmother used to take him to the Charlottenburg muse-ums and the Neues Museum on Berlin's Museum Island. The painted bust of Nefertiti—recently made public and astonishingly immediate

with its serene authority—impressed him more than the Rembrandts, which struck him as "brown and disgusting."

The Brasch relatives were familiar to Lucian, unlike the Freuds in Vienna; they were also wealthier and, in some cases, more memorable. "My mother was one of three sisters and there was an elder brother, Erwin Brasch, whom I never met. He was in the war and was an officer and was on patrol when he suddenly realised he had been deserted in this sinister wood by his platoon. He was captured, thrown into prison and then sent to Africa. In the train he went to the loo, broke the window and tried to jump out, but they caught him by his legs. After having been the only son from a wealthy family, trained in the law, when he came back from the war he was really troubled and restless and wandered around the streets and fell in with a religious lot and married a woman from the streets who had been a whore, supposedly. The marriage was a private marriage conducted in my grandparents' flat and, not long after it, my uncle's wife cursed my grandfather and said that she wouldn't have children, or couldn't have children, because he disapproved of the marriage. He was terribly upset by this and died.

"My uncle became a Catholic missionary and went with his wife to the Mount of Olives where they built a house and he became manager of Barclay's Bank—I always say Olive Branch—and was very friendly with the Arabs and everyone liked him, and one night, coming home from having dinner with the Arabs in the hills, he was murdered by the Irgun, probably mistaking him for a Jew, which he was, but he was a passionate Christian. That was in the thirties, not long before the war.

"My mother's younger sister, Gerda, whom she adored and would do anything for, was married to a children's doctor called Carl Mosse. I had an extra toe on my small toe, which he removed when I was two or three. I said to my mother, 'How dare you,' but she said she thought I would have had such trouble later if it hadn't been taken off. Anyway, he left my aunt, went to China and lived at 101 Bubbling Well Road in Shanghai, where I used to write to him, just to be able to write the address on the envelope. He sent a backscratcher as 'a present from.' I thought of him in a friendly way but my mother didn't. 'He's awfully vulgar,' she said. A funny thing: when Uncle Carl went to China his three children turned into orientals: Jo, who I liked,

looked like a Pekinese. The elder sister married a horrible art dealer, Hans Calmann, a banker who when he came to London became an art dealer because that was his passion. He had a gallery in St. James's Place; she died in Hamburg. I used to stay with them sometimes in their very grand eighteenth-century house in Hamburg. I remember a spiral staircase with old maps, with ships on the maps."

Hanging in the Freuds' apartment, besides Lucian's Brueghel reproductions and the Dürers, was a framed watercolour of oak trees by Ernst Freud who had studied art during his architectural training in Munich and remained partial to Klimt. His few surviving drawings—which Freud turned up when he went through his mother's belongings after his father died—date from around 1913 and feature villas in diamantine Alps overlooking Italian lakes. Secessionist in spirit, carefully so, they do not suggest that he ever entertained any strong ambition to become a painter. Ernst once told his father, according to the Wolf Man, Freud's famous patient, that it would be foolish for anyone such as him, of moderate means, to take up art. He did however have in his library George Grosz's graphic portfolio *Ecce Homo*. Lucian admired the yellow bindings of his edition of Conrad and realised, later on, that he had quite a daring taste in modern literature. "A great deal of Rilke—my mother adored his work—and a first edition—the only edition then—of Kafka's *Metamorphosis*." It puzzled him rather that his father had such books. "But then, lots of people have lively moments when students."

For their entertainment, once they were old enough, a projectionist was hired to show films in the apartment. "The first film I ever saw was actually an English film [in fact American] called *Bring 'Em Back Alive*, about wild animals." Made in 1932 the film featured a baby elephant being bottle-fed and fights between python and crocodile and python and tiger. "In Germany children weren't allowed to see films with love interest—a kiss meant love interest—and the most marginal, near-dirty film some children were allowed to see was a Charlie Chaplin film, that one with the famous dance with the buns: *The Gold Rush*. It had a kiss in. That was the dirtiest film I saw. But *Felix the Cat* was all right."

Being Jewish, distinctively so, part of the Jewish 4 per cent of

Berliners, had not impinged until then. The family never went to synagogue and there was no religious observance. "I was not a practising Jew but perhaps conscious of being a little non-Austrian. Like all proper Jews I'm not interested in religion." Years later he agreed joyfully with something that Isaiah Berlin said to him, quoting Heine: "The Jewish religion is not a religion, it's a disaster." Lucie Freud did suggest once, perfunctorily, that he should try *shul*.

"Why?" he asked.

"It's to do with your ancestry."

"So I went for one lesson or maybe two but I thought the rabbi smelt, so I said that I wouldn't go any more. Mother was completely agnostic."

Ernst Freud had Zionist inclinations, and possibly a pious streak. "If it hadn't been for the agnostic tradition of my grandfather, my father would have been quite talmudic, I think, because he liked the ritual and the curious sort of scholarship. He had all his volumes of the Talmud bound in red." But Sigmund Freud's unbelief was persuasive. "His final kick at the Talmud was that book he published here in England: *Moses and Monotheism*, about Moses being an Egyptian floating down the river. An outrageous book."

The family could not but be conscious of their Jewishness, however, in that it was increasingly held against them and used against them. Sneers hardened into threats. "I used to collect cigarette cards: Abdulla cigarette cards had profiles of movie stars. Stephen and I got my brother Cle to ask people for them, to go into cafés where Nazis went and say, 'Heil Hitler, have you got cigarette cards, please?' And some would say: 'Yes, all right. So long as you don't give them to any little *Jewish* boys.'"

Art appreciation was something to be encouraged. And art as an expression of growing awareness: what better indication could one have of a child's personal development? Lucie Freud kept the drawings sent to her by the boys in their letters from Hiddensee, the island off Germany's Baltic coast where they spent summers, June to September, often while their parents stayed in Berlin or went off on their own leaving them with the governess.

"Hiddensee lay stretched out from north to south, long and narrow like a lizard lying in the sun," Elizabeth von Arnim wrote in *The Adventures of Elizabeth in Rügen*, published in 1904. The island was

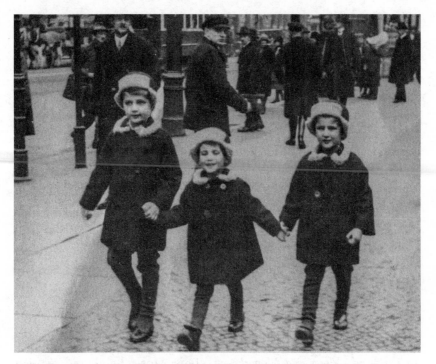

The Freud brothers hand in hand: Stefan, Clemens and Lucian (right), Berlin, 1927

the perfect playground. Anna Freud rhapsodised over it. "A combination of everything beautiful in one small patch and with air and wind and sun and freedom."[9] Sigmund Freud, who stayed there once, in 1930, in the lighthouse hotel, but left after a couple of days when his heart condition played up, said that it was a *Gesundheitsparadies* (health paradise) for the children, if not for him. The attractions— sea, sand and away from it all—were also its drawbacks. Einstein went to Hiddensee, as did Franz Kafka, Billy Wilder, Bertolt Brecht, Hans Fallada, Ernst Barlach, George Grosz, Erich Kästner, Rainer Rilke, Thomas Mann and Walter Trier, the cartoonist and illustrator, who drew carefree figures bouncing around its dunes and hills. At least one of these now celebrated cultural figures, Edgar Wind the art historian, once called on the Freuds. Little Lucian, according to his mother, said to him, "Wind: did you blow in through the window?"

"Hiddensee was between Germany and Denmark, opposite Rügen, where Isherwood and Spender went. It was a long strip of an island in the shape of a seahorse with some hills at the far end where

there were some rather grand houses, castellated places, where the Nazis had a castle, and then a narrow middle part, which you could walk across in ten minutes, with the middle village, where we had a house, with a baker's next door where Linde the governess used to take the plum cake she'd made to be baked, and then a far-off village, Neuendorf, where people practised free love." Lucian's mother tried explaining to him what they did. "These are odd people," she said.

The Freuds' cottage in the village of Vitte was steep-roofed and semi-detached; the other half belonged to a fisherman and his family called Kollwitz. "They spoke *Mundart* [dialect] Plattdeutsch. The daughter, Irma, was ten, pretty and very strong and had a huge German plait and she would sing, '*Dengst du den, dengst du den . . .* ,' a song that translated 'Do you really think, you Berlin weed, that I like you . . . ?' A large pear tree stood by the house, which I had a lot of life in." He drew himself as an elfin nipper standing between house and pear tree with an airship—the *Graf Zeppelin*—passing overhead.

Lucie Freud kept a record of the holiday summers in a series of photo albums, a dozen altogether, mostly one snapshot per page for

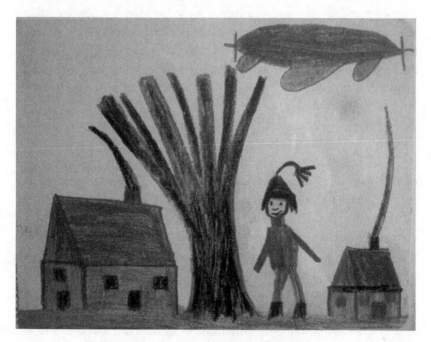

Hiddensee House with Artist, Pear Tree and Zeppelin, c. 1930

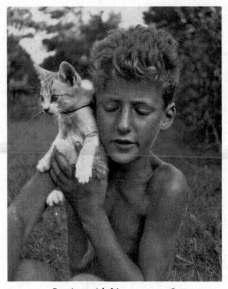

Lucian with kitten, c. 1928

the usual arrival, the walk to the house along the track between flat pastures where horses grazed, sailing expeditions, picnics behind a wicker windbreak with buckets and spades and model boats, Billy the greyhound in his muzzle, Ernst in holiday trousers, the three boys lolling on a swing seat, Lucian looking out to sea, Lucian with a retinue of admiring little girls. One summer their Mosse cousins joined them and they played diabolo, at which Lucian showed off his dexterity, and hide and seek in the pine trees, where they were thrilled to be trespassing.

Mishaps were a further stimulus. "I was cycling in the middle village on a fixed pedal cycle and obviously it couldn't brake, so I came down from higher ground to the harbour whizzing pedals at speed and threw myself off the bike, as I couldn't swim. My mother, in trousers, and her friend Tanya were standing there as I crashed on to the pebbles and covered myself in cuts and bruises." And then there was school, obligatory when the stay on Hiddensee was prolonged beyond high summer. "Huge classes of village boys. We were asked 'How long did the Thirty Years War last?' and I was the only boy who could answer. The schoolmaster was sweet on Linde."

Lucian sent drawings to his mother with covering letters in spiky German script. "This is good, take care of it," he wrote on one of them. Looking through them sixty years later, still smarting at being explained by David Sylvester, he remarked that, if not a "born artist," certainly he had been a lively beginner, drawing the lighthouse on the point and the clumsy great ferries *Swanti* and *Caprivi*, seabirds aloft and bright flowers shoved in jugs. What better subject than what they'd been enjoying, a boat trip to Denmark or jelly for tea?

One afternoon, while they were playing bowls, a cart filled with drunks came lurching down the grass strip that ran through the village. "We moved out of the way, to let it pass, and my mother was

obviously very worried when they slowed up and leered at her. One of them, a red-faced, huge young man, said—looking at Stephen, who hadn't taken in what was happening—'Mildly Jewish-looking youth, I would say,' and my mother went scarlet. I remember that: the strange atmosphere. The whole thing was very very odd.

"There used to be thunderstorms in the hills on Hiddensee. They were trapped there and couldn't get away and got stuck, people said. I liked that idea."

Unlike their Mosse cousins, the Freuds were sent to state schools. Lucian began at the Volksschule near by in the Derfflingerstrasse in 1931 when he was eight. He went on his own. Choosing a smallish street for the purpose, he tried his own version of Russian roulette, standing on the pavement, eyes closed, counting to ten and running across, eyes still shut. "To test my fate. Until finally hit. I was hit by a car and thrown up in the air and as I came down I was hit again as the car stopped. I lay there and a crowd formed and wanted to lynch the poor driver. As I went through the air I wetted myself, as you do when you're dead. The crowd said we must have your address, so I pretended to be deaf and dumb and limped away. In the bath the governess said, 'What happened?' I'd been hit on the thighs and was all blue. I was running when the car hit me and went up, perfectly relaxed I suppose. Well, I proved that I was not indestructible. Mother never found out.

"Derfflingerstrasse was very mixed, middle class and working class. I had a friend called Schucki—Schuckmeier or something, very plebeian—who was my friend, at school only. It was slightly unthinkable to bring a street boy home.

"'What do you do at Christmas?' he asked me. 'We have half Christmas and half Chanukah. What do you do?' 'My brothers and sisters, father and mother and grandparents, we eat and drink until we fall under the table,' he said. I was mad on skating and, looking for danger in the Tiergarten, I skated under a bridge, got through but, where the ice was thin, went into the water. A man, very thin and dressed in black—Berlin poor—pulled me out and he turned out to be Schucki's father. After that I was allowed to take Schucki home.

As circumstances worsened, economic disaster triggering extreme

reactions, the ten-year-old Lucian became aware gradually that politics could affect him. "There was a socially conscious teacher who was obviously very fond of my mother, and he was worried about the situation in Germany and he said in class, 'Any of the boys whose parents are unemployed, will you put your hands up?' I'd heard a lot of talk at home (my father was getting less and less work and there was less and less for him to do) so I put my hand up and the teacher gave me a strange smile and said, 'Oh, you can put your hand down.' I felt rather badly about it because there were really poor then and for us it didn't count. For us it was like not having the pudding in the restaurant."

Going down the street with his mother one day Lucian started chalking swastikas on the wall. Puzzled at her appalled reaction, he told her that it was just something all his friends did. By then he was involved with a school gang that went in for lighting fires and minor daredevilry, behaviour inspired, where Lucian was concerned, by

Lucian c. 1929

Erich Kästner's *Emil and the Detectives* (published in 1928, filmed in 1931 with a script by Kästner and Billy Wilder) in which a pack of boys from Wilmersdorf, the neighbouring working-class district, outwit a bank robber turned pickpocket. Being the keenest and smallest in the gang, Lucian was the one who volunteered to go into the shop on the way home from school to pocket Trumpf chocolate. However, he found himself excluded from the new after-school activity: Hitler Youth meetings. Unlike all but two of the others he was ineligible. His classmates told him that he wasn't missing much. "'Don't worry,' they said, 'Thursday afternoons we just sing songs and eat sausages.'

"Strange as it may sound, at that age, a great deal of my conversation with the other boys was about politics. I was aware of the excitement. I lis-

tened very much: 'Vote for Hitler or Hindenberg.' I remember these words like *Reichskanzler* [Reich Chancellor], which I'd never heard before."

In 1931 the Ullsteins moved away from Regentenstrasse because they objected to being overshadowed by a ten-storey office block erected next door to them beside the Landwehrkanal: the Shell-Haus by Emil Fahrenkamp, in the International Modern Style, later to become headquarters of the Navy High Command and one of the few buildings in the district that was to survive the war. The Freuds moved as well, though not to avoid modernism, to the nearby Matthäikirchstrasse 4, to a large early nineteenth-century apartment, more elegant than Regentenstrasse, with a garden just big enough for athletics. "I had the idea of training for the long jump. It was better doing it with someone else, especially someone who was worse; not someone that, in the ordinary way, I'd have chosen." The boy was called Goldschmidt. "He'd got that special thing, it's a kind of Jewish upbringing thing, which makes people opposite of athletic. Isaiah Berlin had it: indoor characteristics, basically unphysical. It doesn't show when older."

In November 1931 all three brothers caught scarlet fever and were kept indoors for six weeks, during which time they were sent commiserations from the school on Hiddensee. "It was to do with my governess who was courted by the schoolmaster, Dr. Heldige: a huge package of letters from Hiddensee to Berlin. One of them said, 'I'm afraid I'm new so I don't know how to write to you.'" Their mother wrote to her in-laws that, when released from their seclusion, the boys "flew and leapt down the stairs in a way that frightened and alarmed me."

The Chinese matting in the apartment corridors was good to slide on. "I slid very fast and went through a glass door. My father's horrible partner, Mr. Kurtz ('Shorty'), who was hugely tall and, like all the assistants, in love with my mother, held my wrist hard to stop me from bleeding to death. It missed the artery by millimetres, so after that I had to write with my right hand. It was neater than my present writing; because it was Gothic writing with so many loops that I could fill in with colour. The scar weakened my wrist. I was always left-handed and there was a certain amount of talk about it." His mother kept a poem for Kurtz that he wrote in his new right-handed script:

Lieber Kurz
Hertzliche gluckliche wunsche
Zum Kurzen geburtstag
Ich habe Kurzlich gehort
Das du 3 zentimeter
Kurzer geworden
Ich habe nur Kurze
Zeit und muss bald
Kurzschbuss machen
Giete grusso von
Mir
Lux

Dear Kurz
Very happy short birthday
I heard shortly
That you are 3 cms shorter
I only have a short time
And must soon
Cut this short.
Lots of love
Lux

While memory isolates incidents, photographs flatten them. Family photos, particularly, lose immediacy and become just typical; within a few years they look quaint, a little while longer and pathos obtains. The three young Freuds posed in long trousers is one of those countless photographs that, had they not left Germany, would have been seen subsequently to foreshadow fate. "Me and my two brothers, in Berlin, in tailored clothes, which I find is a bit like, 'all those lovely boys ended up in gas ovens.' Those dark looks.

"I love German poetry but I loathe the German language."

In January 1933 President von Hindenburg made Hitler Chancellor. A month later the Reichstag fire and the orchestrated commotion the next morning meant a detour for Lucian on the way to his new school on the other side of Unter den Linden: the Französisches Gymna-

sium, where Embassy children were sent and French was spoken. Not that he went much. "I was ill with all the different things as a child and I never caught on there at all." He saw Hitler once in Matthäikirch-platz. "He had huge people on either side of him and he was tiny.

"On Unter den Linden, on the side we used to walk down, there was Siegesallee [Victory Alley] and there were all the kings and emperors of Germany in marble and bronze, and one of the German kings that amused us—you know how children love fat people—was Karl the Fat. My Mosse cousins had an uncle—a relative—called Karl Selowsky who was a lawyer, quite young, and enormous and we thought he was wonderful. And then a terrible thing happened. On the way to his office (he was well-to-do and lived very well, no doubt that was why he was so enormous) he was got hold of by some Brownshirts and was badly beaten up and this news filtered through and seemed pretty terrible, but then he was OK and out again." Selowsky survived the war—in France—and became a judge in Karlsruhe.

The Mosse children's uncle, Rudolf Mosse—a German nationalist who became an officer in the war, won the Iron Cross first class and was supposed to go into the publishing business—had decided instead to take up farming, so he ran the family estate near Potsdam. According to Dick "Wolfi" Mosse, "He tangled with the local Nazis, who didn't like Jews as Prussian officers or as farmers. He was beaten up and arrested in 1933 at five in the morning and, whether he threw himself under a lorry on his way to the concentration camp or was thrown, either way, his body was delivered in a coffin." Sigmund Freud's comment was that "Jews owning land was an obscenity to them as Jews were a 'nomadic' race."[10]

In April 1933 the first boycott of Jewish shops was staged ("I didn't know there *were* Jewish shops") and the banning of Jewish lawyers and doctors and other professions began. Ernst's brother, Great-Uncle Olli, a civil engineer, left Berlin for Paris. There were meetings round the dinner table, the Freuds and friends debating what to do, whether to wait and see or leave forthwith. In May Ernst Freud, visiting his father in Vienna, mentioned Palestine as a possibility. Clement, whose turn it was to go with him, told his grandfather that he was referred to at school as "Jud Freud." Book-burnings were organised in Berlin with verbose damnations for the works of certain writers: "Against soul-disintegrating exaggeration of the instinctual life

I commit to the flames the writings of . . . Sigmund Freud" was an official line.

According to Lucie Freud, rich German Jews had taken to going to England to give birth, thereby endowing the baby with a place-name on birth certificate and passport that would serve to impress officials; she and Ernst, however, had no reason to regret their lack of foresight in this respect. When I first met him, Freud told me that his parents had planned leaving before Hitler came to power and sent money well in advance. In 1933 quitting Germany was a relatively straightforward business. Fifty thousand Jews left in the course of the year; obstructions and confiscations ("flight taxes") were not yet in place and there was little idea of any worse fate than penury and dis-qualification. For the Freuds the move, as Lucian remembered, was fairly easy. "It's not that we were well-to-do, but we were reason-ably comfortable. Lots of Jewish people in similar positions, or per-haps more wealthy people, didn't think it could happen, didn't think it would go that far, didn't believe it." Having decided to move to England Ernst went ahead to London to see if there were any pros-pects for him there and to find a suitable school for the boys. While there he attempted to strike up useful contacts: Erich Mendelsohn, who had already moved there; his one-time employer in Munich, Fritz Landauer, who also had settled in London; and he showed his work to Edwin Lutyens, the top name in British architecture at the time. Robert Lutyens his son was a possible partner, he thought. He saw the need to publicise himself. *Homes and Gardens* was to publish, in March 1934, an account of his Scherk house of 1931 in Berlin. He secured reduced fees meanwhile for the boys at Dartington School in Devon.

While he was away Lucie took Gab (Stephen) to see Mae West in *I'm No Angel*. Lucian, she said, wasn't old enough.

In July the two younger boys, together with their cousin Jo Mosse and a couple of others, went on a three-week camping trip to the lakes and rivers of Mecklenburg. This was, Lucian felt, "a kind of toughening-up treat." The *Edvige II*, a motorboat, with portholes in each side and an awning at the stern, operated as the Seeschule Racki, Racki being the skipper, "a good-looking, big, young non-Jewish type. He was rough and tough: he taught us swimming by pushing us in. We kept a log and Racki made a film with a commentary and it said

about me: 'Lucian, over-excited as always . . .'" On the bank of one of the lakes they spotted a lunatic with a bucket on his head making a speech thinking he was Hindenburg.

"We were already planning going to England so Racki taught us what he said were English swear words. 'Burrshit,' he said."

For some months there had been English lessons. "The first book I read in English was *Black Beauty*. Actually *Alice in Wonderland* was the first, but I didn't understand it fully. I remember trying to read it at Cottbus; being there, with the ice-house outside the sitting room, me being with my mother and saying the first sentence: 'Alice was beginning to get very tired of sitting by her sister on the bank, and of having nothing to do . . .' And down the rabbit hole she went, 'never once considering how in the world she was to get out again.'"

In one of the letters Lucian wrote to his father with news of his swimming and long-jumping, a haircut and new check trousers, he added as an illustrative footnote a cheerful little talking skyscraper that said, "Scrape me break me cloud then Unemployed Freud can build me again."[11]

This was optimistic. For when it came to making the break from one way of life to another with no welcome and hardly any likelihood of return, the shock of dislocation could be devastating, as their neighbours the Hamburgers found when in November 1933 they left Berlin. Michael Hamburger was sent to school the day after they arrived in Edinburgh. "I and my younger brother walked to school unaccompanied—in Berlin we always had our governess with us—because we were all under such extreme stress: Father had to pass all his exams in one year to be allowed to practise in England and mother, confronted with an extremely cold house where in the past she had had servants, could spare no time for us. My brother was weeping. We spoke no English and didn't know where we were."[12] Soon afterwards they moved from Edinburgh to Hove, then to St. John's Wood.

Bertrand Russell, writing that October in a news magazine, *Everyman*, on "Why Are Alien Groups Hated?," talked about the revival of "utterly unreasonable dislikes" in Germany in the months since the Nazis had acquired power. "Spain ruined itself by the expulsion of the Jews and Moors. In almost every white man's country, the average among Jews is higher than amongst the rest of the popula-

tion, not only in intelligence, but in public spirit, in artistic capacity, in industry, in fact in almost every valuable quality."[13] A subsequent editor of *Everyman*, Major F. Yeats-Brown, who described himself as "friendly to British Jews," was more enthusiastic than his distinguished contributor about "the active, integral, authoritarian state" that Germany was fast becoming. English tourists, he reported, came back impressed with the "spirit of business-as-usual and cheerful self-respect." So-called "Down-and-outs," he added, "are collected into Labour Camps and provided with work, clothing, food, pocket money. Youths of both sexes possess magnificent physiques . . . Hard work and serious play are the order of the day. Germany is pre-War. The Jews are ostracised as they were then. France is hated, England half-envied, half-despised."[14] Ernst Freud remarked that English people were welcoming, though when they said something nice about Hitler, thinking to be friendly, he was speechless.

Immediately before leaving Germany the Freuds went to stay in Vienna, all of them except Lucian. "We could choose and I refused and went to my Calmann cousins in Hamburg." Then they left. "It was just in time. Afterwards it became much more difficult. We weren't refugees, we were émigrés." Being émigrés they could take all they wanted with them. Money over and above the amount allowed out with them was hidden in the leg of a circular table with a red marble top, designed by Ernst, though not with concealment in mind. The household dispersed. Kurtz worked as a servant for a while in Scotland, Ernst's other assistant Augenfelt came with them, and Linde the governess too, but she returned to Germany shortly before the war and went into a nunnery. Grandmother Brasch remained in Berlin. "She stayed on and came just before the war with just the five pounds which was allowed." Forced to divest herself of Gross Gaglow, she sold it to a Zionist organisation set up to train Jews for work on the land in Israel. This was soon forfeit.

The Regentenstrasse neighbourhood became a diplomatic quarter where the embassies and legations of Axis-friendly or Axis-acquired countries accumulated, among them those of Austria, Argentina, Greece, Japan, Hungary, Romania, Spain and Yugoslavia.

"Very much a slightly artistic place"

In September 1933, Lucie Freud took the boys to England. Their English was now jingle standard:

Ring ting ting
Hear the bell ring
School has begun.

The school chosen for them was the recently founded Dartington Hall on the Dartington Estate near Totnes in Devon. The Elmhirsts, owners of the estate, were hospitable utopians, Dorothy Elmhirst being rich and Leonard Elmhirst a former agricultural adviser to the great Bengali poet and musician Rabindranath Tagore. Lucie Freud stayed with them while the boys settled in. "They patronised her a bit. My mother wasn't proud, but she was rather amused by Dorothy Elmhirst, who would say 'of course, of course,' all the time."

In November, Ernst Freud finally wound up his Berlin business affairs, dismantled the Matthäikirchstrasse apartment, sold the Hiddensee house to a Leipzig lawyer and returned to London, this time for good. He was by nature optimistic, Lucian always found, and keen to appear confident. Lucian and Clement had sent him a Mabel Lucie Attwell postcard of an extravagantly dimpled child lisping: "It's nice to have a man about the house." The apartment he took for the time being was in Clarges Street, off Piccadilly. "When I asked my mother why there, she said, 'Your father asked what's the equivalent in Lon-

don of living in the district next to the Tiergarten?' 'Mayfair,' they said, 'without question.' After a short time, when they got to know one or two people, my parents realised that there was no need to live there."

Impressive introductory address though it was, 36 Clarges Street lacked domestic staff. "Two maisonettes, sharing a butler, an ex-butler called Humble, in fact, who had charge of the property and who didn't like looking after my guinea pigs in the holidays." Lucie Freud never forgot the occasion when, exhilarated at cooking for practically the first time in her life, she went into the fish shop in Shepherd's Market and asked for cod and the fishmonger's response was: "Cod? In *Mayfair*?" Soon a maid called Jones was hired and taught to cook. Lucian himself quite liked being there. He took to fish and chips and would eat nothing else for a while, cod, cod, cod and chips, until the thought of batter nauseated him permanently. There was a cigarette machine on the ground floor, which he discovered could be fixed to cough up packets with a halfpenny change fastened to them for the investment of a halfpenny instead of the required shilling. Also, Clarges Street was near Hyde Park, celebrated for its loitering soldiers and nursemaids. There, on Rotten Row, he could admire the horses—"I felt this was a very English thing"—always hoping to find bearing reins being used so that he could then reproach the riders for the practice so fiercely condemned in *Black Beauty*. A harangue would have been an impressive exercise of his uncertain English.

School however was the England he first knew. "Deepest Devon, red soil, and you had your own room, which was nice." His grandfather had heard well of Dartington from a Dutch patient who had told him that it was the only school in England with good food. So it proved. "A line from one of the girls there was 'Starvation diet: *lobster*.'" In the *Shell Guide to Devon*, published in 1935, John Betjeman described Dartington as "a co-educational school to which modern authors and intellectuals send their sons." Given the renown of Sigmund Freud, his was a good name to have on the school roll. Accordingly, Ernst negotiated reduced school fees. Stephen, Lucian and Clement were to fit in with Bertrand and Dora Russell's John and Kate, the Huxley children and the son of G. E. Moore the philosopher. Not to mention Miranda Domvile, whose father was one of Oswald Mosley's lieutenants. ("She thought modern education was so ghastly she might

as well be educated there.") And Dani Petrov whose father, Lucian understood, "was something in the Russian Revolution."

The school, which in 1933 had been going only seven years, had recently expanded to take 150 pupils. "Boys and girls at the school can learn besides 'school' work from practical activities connected with the estate," Betjeman noted in the *Shell Guide*. The prospectus stressed self-regulation. "We set no prohibitions on things to be seen or touched, nor any bounds to the children's wanderings on or outside the Estate. The first thing the individual boy has to do is to find his feet and to learn to know something about himself, his fellows and the world around him." That suited Lucian. As far as he was concerned, "Dartington had only one rule: no pushing people into the swimming pool.

"I took three years to find my feet. The headmaster, W. B. Curry, had indiscriminate appetites; he was fat and jolly and wrote books—I looked at them once—and I did such an awful thing—not understanding anything about England, school or behaviour. Letters would arrive and be put on the desk in the front hall and I opened a letter addressed to my housemother, Marge Foss: a love-letter from Curry to her. You mustn't do that, I was told; there was real annoyance, but I didn't *know*. I realised I'd done an unsuitable thing quite soon when I read it. I didn't do it secretly though. It was like animals learn by copying: people always opened letters, so I opened the letter." He was equally insouciant with his own correspondence. "Grandfather sent me and my brothers a letter with a five-pound note each, grand and crinkling. I threw mine away because I didn't know what it was."

The school awarded neither marks nor prizes, imposed no penalties, banned competition save in team games, and classes were voluntary, at least in theory. "We exert no compulsory attendance at classes nor are we greatly worried if the first term appears wasted in wandering about," the prospectus said. Lucian took advantage of this. No educational scheme, however sympathetic, would have suited him, stranger that he was, awkward with his new right-handed writing and his broken English. When he tried out what he thought was his English swear word, "Burrshit," he got no reaction.

A birthday letter to his father, with a drawing of a horse and a goat grinning in a field under a purple crayon sky, mentions daily cricket and a feast for which provisions were already laid in, and, most

important, he wrote: "*Ich gehe jeden tag in die farm*" (I go to the farm every day).[1] The school farm, across a field from Foxhole Copse, the main buildings, offered escape. "That's where my life really was. I didn't talk to people and so, spending all the time on the farm, I had a solitary life, which I liked." Animal husbandry was part of the Dartington scheme and Lucian took full advantage. "I got up at five or six and helped Bob the farmer milk the goats and so on; after milking the goats I smelt so much I was avoided. I was quite pleased about that. When I fed the pigs early in the morning and switched on the light, rats came out of the gutter and I shut my eyes and banged them with my spade; it was terrifying, banging their backs. They felt soft and they jumped at me. I was afraid they'd get into my wellingtons."

Conventional pets were allowed so Lucian kept guinea pigs ("Ginnipigs," he wrote), not that he liked them particularly. They fought all right but were less interesting than the ferrets sent down rabbit holes and much less involving than horses. "I trained a Shetland pony to come to the gate and take me down to the farm." Children could stable their own horses on the farm. Lydia Jacobs for one. She was two years older than him. "Fat Lydia: I thought she was ridiculous, big and fat, kept a horse. I used to be pleased, as it was a horse that farted and she went on it in big breeches and it would fart." Another girl attempted, with Lucian's help, to teach her horse, called Bill, dressage. And there was Starlight.

"Starlight, a grey, partly Arab, came with a boy who knifed someone. He was oddly, extravagantly, un-English and was sent away, and I decided Starlight was mine, as the parents never sent for it. They were possibly French, anyway too wealthy to bother. I *felt* it was mine and rode it in a way that nobody else could ride it, very heavily on the left rein, so if anybody got on it, it would veer that way, unsteerable, like a car or ship with a list. I couldn't bear the idea of someone else riding it when I left. I used to ride nearly all day and got further and further behind." He used to sleep with the horses, himself and horse under one blanket, keeping watch over any one of them that was ill.

In February 1934 Lucie Freud drove down with the parents of another boy, Frank Phillips; there was a crash and she broke her leg and was taken to hospital in Yeovil. It was feared at first that she had fractured her skull and, although this proved not to be so, she took months to recover and the boys were unable to go home for the Eas-

ter holidays. For Freud this was not a hardship. "It meant I could have more horse life."

He wrote home urgently asking to be sent some of the albums of Hiddensee photos so that he could show them to Jo and to "Briget" (Bridget Edwards, his new housemother), Bob the young farmer and others. He wanted to show off an idyllic past to those who, he felt, took an interest in him. In schoolwork, meanwhile, he positioned himself as a non-starter. One of his school reports, pithy enough for him to commit to memory, read: "Lucian doesn't seem to have mastered the English language but is fast forgetting all his German. This seems to be quite a good argument against his taking up French."

In time the English proved to be no problem. He retained for the rest of his life a German tinge in his speech and residual German syntax, but treated the switch to Englishry as a pretext for veering away from being saddled with academic accomplishments. Letters home, written on Wednesdays—with the address usually typed by the housemother—were in German, though English soon began seeping in. He wrote about native customs: the Devon Show, feasts on the Dartington Estate, the pressing need for a torch ("All the other children have them"), a pair of breeches ("Briges") and the right sort of sleeping bag ("11/6 from Gamages, waterproof"). "To night I will properly sliepe outsiede in my new Sleeping beg."[2]

His new English handwriting was, and remained, unschooled, each word as boldly executed as in a note to the milkman. Having to learn to write with his right hand in a new language and a new script prompted him to feel that such discipline, being foreign to him, was not for him. This became his pattern of behaviour at boarding school and, later on, in London: wilfulness passed off as extreme individuality. He came to regard England as a place in which to be a lone operator, a resourceful Crusoe observing the natives. "I thought of Joseph Conrad, in my father's yellow-bound books. And I was really excited about the names. They seemed so exotic. A girl called Kim." That Kim Ebbels had the same first name as Kipling's boy spy may have been stimulating but no great friendship developed, though he lent her his comics.

One of the attractions of the school was that children each had their own bedroom. "I had this passion for Marjorie Brown and wanted to have the room next to her. Marjorie used to protect me. I'd

hit people and there was a rule at Dartington—'Privacy of Rooms'—which meant that you weren't allowed to be got at so I would kick someone and rush into my room but they came in anyway and got their revenge. She used to protect me and I'd give her my comics. *Hotspur, Wizard, Skipper* and *Adventure*. The lot."

Lucian's best friend, his only friend, at Dartington was a boy called Michael Schaxons, with whom he stayed during the holidays on the family farm at Ilstead in Sussex. "They had a spaniel called Sue, the first dog I ever liked." And there were horses. "We rode up to Bertrand Russell's house on Telegraph Hill, quite a long way—lost my watch—to see Kate and John, and he was there. A lively old figure, he seemed: there was a red-haired woman he was chasing round the place. It was almost the first thing of sex I'd seen. Very abandoned. They barely stopped for tea." Staying with the Schaxons gave him further insights into English behaviour. "It was fascinating, compared to my home. For example, someone would come to the house and ask, 'Where's Michael?' 'I've no idea,' his mother would say. If someone came to us, my mother would know where I was and what I was thinking: *everything*. How marvellous, I thought. How casual and generous and daring. I remembered my terrific battle to go to school alone in Berlin."

Cousin Jo, two years older than Lucian, arrived at the school. Since 1933, when Dr. Mosse left and went to Shanghai, Aunt Gerda had acquired a boyfriend ("called Möring, looked like Göring") to whom she became an embarrassment, as he wanted to get on in Nazi Germany. The Mosses came to England with just the £5 allowed to later émigrés and Ernst Freud got them a house ("Aunt Gerda could never forgive my father for keeping her") and a place at Dartington for Jo. "She went out with a boy called Peter Stone and I said, 'A rolling Stone gathers Jo Mosse.'"

In June 1934 Jo wrote to her Aunt Puzie, as she called Lucie Freud, after a school camp by the sea. "The camp was heavenly. I (all of us) came back well content, bronzed, happy and dirty." She enthused about Vic, Victor Rosenbaum ("terribly nice, isn't he?"), who played hockey for France and ran the camp. "Once Vic stayed in our girls' tent until 3 in the morning, talking to us. In fact we never went to bed punctually." As Victor Ross, Vic was to write for *Reader's Digest* and, Freud remarked, "Foreigners' Guide to England books:

jokes about mistakes made. His mother, Erna, was the psychoanalyst of Burgess and Maclean and friendly with Aunt Anna."

"Luckily and through sheer happiness," Jo wrote, "I have completely forgotten that the Nazis are there—it's terrific that they are all shooting each other now, isn't it?"[3]

At the end of the summer term Stephen left Dartington. "My mother told me he wrote a letter saying, 'Take me away from here, I'm wasting my precious youth,' and I thought, hmm, he didn't have a precious youth." Stephen was awkward, with a nervous tic and glasses, Lucian maintained. "A queer fish: he had such a bad time." Clement, who also left, went to the Hall School in Hampstead, a prep school for St. Paul's, where both he and Stephen ended up. "They were at Dartington three terms perhaps; I was there two and a half years. That makes the division more: they were always together and I was on my own. I was always athletic rather and they never were." Stephen thought of Lucian as a fine rider and good at cricket and that was about it, but Clement, needing protection, looked up to him as a champion: "Being insufficiently fluent in English to counter insults, he went for people: hit them, wrestled them to the ground, gave and got black eyes and bloody noses and I, who loved him a lot and had no other friends, stood on the perimeter of the fight crowd and cried."[4]

Stephen recalled an event that sparked the one thing all three brothers were always to have in common: a love of the turf. "An older boy gave us a tip for a horse called Cotoneaster, so we clubbed together and put our pocket money on it. It didn't matter that the horse lost. We were hooked."[5] Hooked maybe, but not united: Lucian's instinct was to edit his brothers out of his life. "I never remember anything about them. Lots of things I suppress." Certainly they featured less and less. He took to teasing them across the fraternal divide, every so often reminding Clement that he had the same birthday as Hitler.

"I beat up my brother—Cle—in Walberswick and my mother said, 'You've ruined the whole holiday.' Oh good, I thought." The Freuds began holidaying in Walberswick in 1935. A village on the Suffolk coast, it was reminiscent of Hiddensee in its relative isolation, hemmed in by river and sea. Initially they rented a beach hut, one of many lined up along the River Blyth, eventually to be washed away by the tide. Theirs was the largest. "Nicknamed Buckingham Palace as it was a long bungalow, with several rooms. It belonged to a painter

called Tom Van Oss who wore tweeds and did landscapes, portraits and satirical illustrations. I rummaged around in the huge studio: nothing that interested me. Vlaminckish slashes of palette knife sea and sky: 'Run up some brilliant seascapes,' as people would say." Walberswick became a second home to the Freuds. "My parents fell in love with Walberswick. They actually went to the pub." In 1937 they bought Peganne, a converted barn, and renamed it Hidden House. "It is typically Jewish not to renounce anything and to replace what has been lost," Ernst Freud wrote to his father. He named a guesthouse in the garden Hidden Hut.[6]

"Walberswick was very much a slightly artistic place: ladies with amber beads doing watercolours on the green and Leach pots in the crafts shop. And then there'd be R. O. Dunlop, RA, painting on the bank of the Blyth." The film-maker Humphrey Jennings, born in Walberswick, recalled his childhood there as "a time of artists and bicycles and blue and white spotty dresses";[7] Lucian remembered that and more, noticing particularly the most outré: "Peter Upcher with dyed hair—so extreme—who drove a chaise. His father was a baronet and owned a huge amount of land around Southwold, so he was sort of the Walberswick Stephen Tennant. He adopted Frank Norman, who wrote *Bang to Rights* and *Fings Ain't Wot They Used t'Be*; Frank was with him as a sort of . . . Peter Upcher had been a visitor in Borstal. How naive people were.

"And there was a famous queer, Alfred Holland, who had a hut by the river, before all the huts were swept away: a studio, which I went into, with a Max Ernst in it—one of those jungly forest things—and D. H. Lawrence paintings. It was the first time I was alive to such things: I just saw reproductions before. And I heard Cab Calloway for the first time. Alfie charmed my parents; he didn't treat them as foreigners; they didn't realise, though I did, that they were snubbed a bit. And he kept horses and had money. I was about twelve, thirteen, and I used to go racing at Newmarket in his dark-green Lagonda. We went through the card and he asked if I wanted to place bets. 'Do you want anything?' 'Yes, I'll have two shillings with you,' and I had eight pounds as a result and bought my first suit—grey flannel pinstripes—at Dunn & Co. in Tottenham Court Road. My parents were slightly worried, he taking me to the races and being attentive, but they knew how wilful I was. I was aware of his being . . . I felt I

was living. And he was a gent, tall and freckled and dressed in shoot-
ing clothes, a lively mind and laughed a lot. The Lagonda had a gear
lever with a flat rubber knob and I said I liked it and he laughed and
laughed. Afterwards I wondered about that. Zoe, a pretty girl in Wal-
berswick, was madly in love with him and dressed as a boy to appeal
to him. The fact was, everyone knew Alfie had been to jail for queer-
ness. He was friendly with people at the garage and he told me that
a Lagonda or Bentley was brought to the jail when he got out and he
was worried that he'd forgotten how to drive. But it was all right, he
just got in and drove off.

"Being horse-mad, I got up at six to exercise ponies and quieten
them for when people came to ride them during the day. And I'd ride
the carthorse that pulled the cauldron of tar making the road from
Walberswick to Southwold. Every few minutes it moved on."

Sixty years later, when we were looking at Constable's *The Leap-
ing Horse*, in which a boy on a barge horse clears a twelve-inch barrier
on a tow path, Freud turned to me exclaiming: "Oh, it's the greatest
painting in the world!"

Towards the end of the 1935 summer holidays Ernst Freud went
to visit his parents in Austria. Having refused to go two years before,
and Clement having been in 1934, it was now—"children are keen
on equality"—Lucian's turn. They took a detour to avoid Germany.
Sigmund Freud was no longer fit to travel so the grandparents were
spending some months in a villa in Grinzing, a suburb north of
Vienna, with a garden where he could sit out and in the evenings
play cards, a form of tarot called "Killing the King." Lucian's Uncle
Martin, a former soldier and by then a lawyer acting as his father's
business manager, took Lucian off to the Prato riding school to test
his boasted equestrian skills. "I went on a horse and trotted around
and made it change its legs and different things, but I couldn't make
it do very much as, very sensibly, the Prato horsemen had bridles
and saddles but no bits. And I said, 'I'm afraid I can't show you very
much about controlling this horse because it has no bit and all I could
do was control it with my legs.' At that, my uncle—a terrific figure,
dashing—went up to the man and shouted at him and practically hit
him and he cowered.

"I remember odd things about Grinzing. Being photographed
posing with a cigarette. Driving into Vienna in a car—my father didn't

drive—for something or other. A sunny morning. Sunday. Not much traffic. Wide main road, hill, and two motorcyclists going rather fast, having a race backwards." He envied such daring.

In the new school year at Dartington Lucian was more involved in set activities, particularly those that demanded physical effort. In "Agility" he learnt to somersault. "I'd dive head first over horses, and I loved that thing of jumping on to my feet from a lying position. People said I'd be really sorry later on, arthritis at least." The school library, which had what he called "a foreign department" with German books, also attracted him. "I read a rather salacious book about slum life in Berlin with whores, and a song being sung, and Vicki Baum's *Grand Hotel*. And then someone lent me *The Picture of Dorian Gray*: my mother having heard of Oscar Wilde and those plays burst into tears and confiscated it. I remember her saying it's a wicked book and me really wanting to read it, especially Lord Henry Wotton's remarks." Wildean epigrams, voiced by Lord Henry Wotton, were an incitement to flippancy: "A man can be happy with any woman so long as he does not love her." And, even more appealing to the twelve-year-old worldling: "What a fuss people make about fidelity. Why, even in love, it is all a matter of physiognomy."

The sculptor Willi Soukop, formerly of Vienna, came to teach. Lucian found him encouraging but that wasn't enough to get him to sculpt or paint. "The art master was too arty." Mark Tobey, the artist in residence, a convert to Bahá'í philosophy, was away in China and Japan most of the time Lucian was there and he was barely aware of him; Bernard Leach the potter appeared once or twice—"the old boy was like an amazing fossil"—and his son David initiated Lucian into pinch-potting and throwing and salt glazes.

As it turned out, the high spot of Lucian's spell at the school was his performance as the Young Mariner in *The Rime of the Ancient Mariner* with the Dartington Eurythmic Players. It was the most dramatic role imaginable ("Alone, alone, all, all alone . . .") and a photograph captures the moment when, stripped to the waist, Lucian resorts to prayer and his punishment ends with the albatross (a stuffed gull, absent from the photo) falling from his neck as the ship's crew, that "troop of spirits blest" gathered in front of a Cubistic iceberg, look on in fitting amazement.

Coleridge's Ancient Mariner, when young, broke a taboo; Freud

Lucian Freud (far right), as the Young Mariner in the 1934 Dartington
Eurythmic Players production of *The Rime of the Ancient Mariner*

acting innocent of convention, scored a success, his broken English
leapfrogged by his agility. But he had no future at the school. "I liked
the word 'bad-tempered' very much. They used to say that I was bad-
tempered and I suppose that was why they took me away. My parents
said I'd been kicked out. In fact they'd taken me away but, under-
standably, they didn't tell me because I don't know what I'd have done
otherwise. They didn't tell me, and I was terribly upset. I had this
absolute passion for a farmer."

The young farmer, Bob Woods, was his tutor. He had been con-
siderate and perceptive in allowing Lucian to ride every day, often all
day, thus evading timetable and academic bafflement. He wrote sym-
pathetically to the Freuds. "His letter said, 'He may well be unhappy
but I don't think he'll ever be as happy again as he is now.' Which was
sort of true. I don't mean 'My Tragic Life' but it was certainly very
true for then. It was obvious to take me away because I didn't go into
school at all. You didn't have to, but you were expected to, and I was
on the farm all the time. I was twelve when I left Dartington."

Coincidentally, and on similar grounds, the school goats were disposed of, for "breaking bounds and indiscriminate appetites," the headmaster reported.

In London the Freuds now lived at 32 St. John's Wood Terrace, "one of the century-old houses of the Eyre Estate being modernised and enlarged," as Noel Carrington described it in his magazine *Design for To-day*. A narrow house, it needed enlargement; even then Lucian had to share a bedroom with Clement. Carrington interviewed Ernst Freud who by then was, in effect, resident architect for the Estate, employed mainly on renovations and minor jobs for fellow émigrés. He was photographed for the magazine seated at a table in his newly built study extension examining a plan, behind him a *Zimmerlinde* plant and, on rosewood shelves brought from Berlin, a Tang horse and other antiques, trophies of a collecting habit derived from his father. This tableau of modern interior design transferred from Berlin to the early Victorian elegance of St. John's Wood is a display of capability and flair. Electric ceiling panels heated the rooms. Carrington asked what he thought of English open fires. "I love them. But I by no means consider them a suitable form of heating." There were large sliding windows "on noiseless tracks" looking out on to a patch of lawn and lupins galore, a Synkunit kitchen and, besides the Freud furniture, a Gordon Russell sideboard. "I myself would never design 'period furniture,'" he told Carrington, who featured in the 1938 edition of *Design and Decoration in the Home* his glass-topped coffee table with telescopic legs.

The most notable of Ernst Freud's London buildings were Belvedere Court built in 1937–8 in Lyttelton Road, Hampstead Garden Suburb, and Frognal Close in Hampstead: six "well planned and well designed" houses, as Nikolau Pevsner noted:[8] flat-top *moderne* houses that he designed in 1937 and in two of which he had "an interest." Lucian admired them: "Subtle: each house is different. He didn't think that he had problems but people jumped on hearing him. I went with him once to Frognal Close, the building site, and—being used to German workmen—he was shouting, 'Why you got workmen who don't work?' and they were looking at each other in amazed stupefaction, at him in his pork-pie hat and with the rather long hair

he had. He was trying to tell them what to do in Viennese English. I felt protective." The Freuds befriended the potter Lucie Rie when she arrived in London in 1938; Ernst Freud converted a mews house in Albion Mews into a flat and studio for her, accommodating her Ernst Plischke furniture; she told people she thought him a pig. Unlike Gropius (who spent time at Dartington before moving on to America), Ernst Freud found that England—his England extending from Regent's Park to Walberswick—suited him well enough, eventually. He added an extension of several rooms to Ernest Jones' house in Sussex (Jones was Sigmund Freud's English standard-bearer). But jobs were few and he was understandably disconcerted when people taking a friendly interest asked him, this presumed German, how Hitler was. According to Frank Auerbach, who was sent to England from Germany in 1939 at the age of eight and whose cousin Gneditch was an assistant to Ernst Freud before the war: "Ernst Freud must have picked up a lot of work, doing conversions. He was in with Mr. Hess who was a property speculator who kept buying houses. My uncle was Hess's lawyer and when Hess was my uncle's landlord in Belsize Park I think the conversion was by Lucian's father and when Hess refused to pay for something in the bathroom, my uncle said, 'Rather stupid: we'll put it on to the next bill.' Of course the war made him slightly more well off. I don't think he, Ernst Freud, was a speculator: Hess was a speculator."

The choice of school was partly up to Lucian. Abbotsholme in Staffordshire, a school with a farm and progressive credentials, was a possibility. He went there for a couple of days to see whether he would like it or suit it. "At lunch they said something scoutish like 'Any volunteers to get up at five in the morning to go to the forest beyond the wood and chop trees?' So I thought I'm not going *there*." It was decided that Bryanston, a less heartily progressive boarding school, would be more suitable; he needed however to serve time at a prep school before starting. "They thought they would de-Dartingtonise me and Bryanstonise me by insisting on prep school first."

Before that there were the holidays, at Saint Brieuc in Brittany, which Lucian remembered for the candied fruits he filched on the boat crossing the bay to Saint Malo. He had a handy phrase, *"Ma mère*

attendra plus tard," which he found got him out of paying for things if caught. "We were well dressed so got away with it; my mother didn't mind anything so long as it was legal."

During his two days at Abbotsholme he had been encouraged to take photographs of his potential new school. He took one so good, he thought—"a superb photograph into the sun into trees"—that he stuck it into an album and photography engaged him briefly. "Some artistic things of milk bottles on a stand at Walberswick" were followed by human interest. At Southwold, a mile or so up the coast, the Duke of York—soon to be George VI—arrived to preside over his annual summer camp where public schoolboys mucked in with lads from deprived districts. "He was walking along with all the campers in long shorts and I walked backwards taking my photo of him. He looked a bit nervous, and I went rushing off to the chemists in Walberswick to get it developed."

Kitted out in school uniform, "a little half-sun emblem on the cap: the evening sun going down on the equator," Lucian was sent off to Dane Court at Pyrford near Woking in Surrey, a school with a liberal ethos. There were weekly music appreciation classes and, besides, the headmaster's Danish wife (hence "Dane Court") introduced "Danish feasts and games to do with barrels and apples." Advertised in the *New Statesman* as a school of "Modern ideas. Good food. No Prep. Sensible discipline. Reasonable fees," the school boasted in its prospectus "every facility in the neighbourhood for riding, boating, bathing, and nature study," most of which appealed to Lucian. Unlike at Dartington, sport was compulsory and competitive. "I thought what an extraordinary idea and I liked it. I was in all the teams. I won the swimming cup on merit, and the boxing cup, because the three best boxers were ill in the sick bay. I was fast, but interested in fighting, not boxing. My interest is to hit and run really: street fights, wrestling a bit. I used to jump on people, get them by the neck until they couldn't breathe, then run off." Wrestling lessons taught him arm locks and as a centre forward he learnt to kick: skills that remained with him.

Lucian found that not only was he the oldest boy in the school, he was the only one to have grown a fang between his front teeth: "a tooth that only sharks have. It stuck out, and when it was taken out the dentist said it was an amazing rarity and could he have it. It made

headlines in the dental magazine." A fellow pupil, Jack Baer, regarded him as "a star in the firmament."[9] Sixty years later he still remembered, he said, how much he admired and feared him. "All other characters were half the size. I felt his age and sophistication and I was jealous of his savoir-faire. He was like an adult, dark, with a serious expression, the most inspiring, interesting, provoking figure there. He made me a sort of captive audience." Baer's parents lived near the school and he would go to see them at weekends, often accompanied by a friend or two but, he said, he never took Lucian. "He would have been my obvious choice, because of our backgrounds." (Baer's father was a German Jew who had come to England before the First World War.) "But no." Anyway, he exasperated Lucian, who resorted to bashing him. "I tried to get him to react: he was screaming, lying on the floor. Then I felt badly about it, as he was tall, weak and weedy. So what can I do? I thought. If you are to show someone that you are sorry, give them your most precious possession. I had an octagonal box covered with veneer and mother of pearl, given me by my mother; so I gave it to him—if you give something to someone it makes you like them—and he said thank you and took it and he didn't know it was precious. I was embarrassed."

Lucian became a boy scout, a member of the Kangaroo patrol, and attended church at Pyrford near by: it was compulsory, same as sport, not that he objected. The church had medieval wall paintings; these he barely noticed but he did enjoy some of the hymns they sang there: "'For Those in Peril on the Sea'—paintings go with songs." News of the civil war in Spain stirred him and he decided to do something about it. "The first political thing I was caught up in. Anti-Franco. The paper we had at school was the *Daily Express*, which was rather pro-Franco, and I wanted the *News Chronicle*, which was anti. Anyway I started a paper, which I printed on hectograph jelly in the lavatory at night. It was quite hard work. I tried to get Jack Baer, who was deputy leader of the Kangaroos, interested. He wasn't much good on the *Dane Court Chronicle*, but there was 'Big Toe's Revenge,' a cartoon by a boy called Harvey II, a bogus Red Indian cartoon. I wrote it, Harvey II drew it (for me, the Editor, to do cartoons was not right). He had a nice curvy style of drawing. I wrote the *Chronicle* and printed it—there were two or three editions—and sold it on parents'

day and sports day, which caused unease, and the money from it went to a *News Chronicle* fund: 'Milk for Spain.'[10]

"The hectograph was a primitive, messy, duplication method. You had to get a tray coated with hectograph jelly, write on it the wrong way round with hectograph ink and put paper on the jelly to print. You could get about thirty copies. They got pale pretty quickly." Adrian Heath, later the co-author of a definitive *300 Years of Industrial Design*, helped out. "I was probably layout man and printer," he said. "I remember Lucian's seriousness and enthusiasm and feeling I was engaged in a very important project with him. My clearest memory of all is the look of the thing. It was on foolscap paper and the print was a brilliant violet colour. The production was curious and very messy: it was printed on jelly!"[11]

Content was whatever caught Lucian's fancy. "We found curious things lying in the grounds, pamphlets or letters, and we made dramatic meanings out of them. One whole issue was based on a crazy letter we found lying around somewhere, to some housewife, an ordinary suburban letter, and we pretended it was a radical spy document affecting the whole future of school and country. That was the best issue."

If Dane Court achieved little academically with Lucian it did stimulate his competitive instincts and acerbic streak. Among the linocuts he made was one of a bolting horse, which was, he remembered, how he felt. He published a poem in the school magazine, emulating the trailing kerfuffle of Morgenstern's *Snail's Monologue* ("*Soll i aus meim Hause raus? . . . Rauserauserauserause . . .*"). Recited from memory seventy years later, it went:

> *Worms are creatures that vary in size,*
> *Some being silly and some being wise.*
> *They haven't got tongues so they can't tell lies,*
> *They go about naked without any ties.*
> *So if you meet a worm any day*
> *Pray do not turn your face away.*
> *And if you want a poor worm to assault,*
> *Stop and remember it isn't his fault.*
> *The moral of this story is,*
> *The poor worm should be sympathised with.*

The syntax was deemed unacceptable. "The master turned the last line round to '*Needs all your sympathies*.'"

When the time came to sit the Common Entrance examination, Lucian flunked it, or so he said. "A complete failure; I got nought in certain subjects." Nonetheless Bryanston accepted him. Once again being a Freud helped see him through. Jack Baer too was offered a place. "Lux will be there," he told his father; this was, for him, a dreadful prospect: further years of Lux lording it over him. But as it turned out he saw little more of him and went on to become, in the words of the *Daily Telegraph*, "among the most creative and imaginative Old Master dealers of his generation."[12]

Bryanston, founded ten years earlier and housed in a Queen Anne Revival country house, was less disposed than Dartington had been to let the pupil pick and choose from the timetable. The curriculum was organised according to the Dalton Plan: work was set and boys were supposed to do it largely on their own initiative; although there was opportunity for waywardness, attendance in class was expected. Short trousers were worn.

In the Backward Latin class, taught—though to little effect—by the writer Aubrey de Sélincourt, Lucian met a boy called Patrick George, a few months younger than him, who told him about the Oil Painting Club. "There was a ridiculous art room and then, Bryanston being rather independent, there was the Oil Painting Club." Learning that "it was in a sense rebellious" he decided to join. Meetings were held in the end section of an open-air dormitory on the ground floor. "Very cold and with a Valor heater giving off a pervading smell of paraffin," George remembered. To ingratiate himself and impress the membership Lucian bought a painting by a boy called "Koala" Barlow ("because he had hair like it") and wrote home for the money. They held an exhibition and prizes were awarded. George got second prize for a picture of tugs beneath a bridge; Lucian won with an underwater scene and moreover almost sold it.

The primer for students of the Modern, among whom members of the Oil Painting Club counted themselves, was Herbert Read's *Art Now*, published in 1933, a key book ("Tanguys and everything") that Freud came across at Bryanston, skipping the text and lingering over the plates. Otto Dix's Grünewald-style *Blond Girl* appeared opposite Chaïm Soutine's turbulent *Maid of Honour*, Edward Burra's spooky

fiesta figures confronted Paul Klee's *Gay Breakfast Table*. Most telling of all for Freud in later years, though not then, was the pairing of a Picasso *Baigneuse*, an arching seaside construct like a sculpted capital A, with *Crucifixion*, a wishbone figure by the then aspiring interior designer Francis Bacon.

"Pansy" Hughes, the Bryanston art master, considered these to be sheer affronts; his preference according to Patrick George was "crinolined ladies and ploughmen coming over the hill in watery water colour," though Lucian remembered him as being slightly more advanced than that: "More Gauguin's maidens riding on the beach." A taste he shared. "Even then I realised that I liked it but that it was something a bit too easy to like." Certainly the same could be said of the Tahitian nakedness of *Old Man Running*, his second oil painting. The first he remembered as "a kind of marshy grey yellow swampish" picture of a naked man bending over. *Old Man Running*, signed "Lux," was a jibe aimed at his art master, at his elders, at those avuncular and lonesome figures Edward Lear enshrined in limericks. The cross-country run—a routine punishment for Freud and one that he enjoyed—sends a Lear-like aged Uncle Arly scampering over the Dorset hills and far away.

This old man however has higher connections. Lucian enjoyed, and memorised, whole stretches of *The Poet's Tongue*, an anthology selected by W. H. Auden and John Garrett and used as a textbook at Bryanston. "Poetry is a struggle to reconcile the unwilling subject and object," they wrote. "Those, in Mr. Spender's words, who try to put poetry on a pedestal only succeed in putting it on a shelf."[13] Auden had been appointed to teach at Bryanston in 1935 only to have the offer withdrawn when, Freud understood, a letter from him to a pupil was leaked to the headmaster. "Not a question of him teaching there after that." The finale of *The Poet's Tongue* was the storm scene from *King Lear*. Lucian's old man ("such a poor, bare, forked animal as thou art") has to be "Nuncle" Lear, stripping off and breaking loose on "a naughty night to swim in."

In an essay on John Masefield's *Reynard the Fox*, Lucian wrote that the string of similes applied to the hunted fox ("Like a rocket shot . . . like a ripple of wind running swift on grass; Like a shadow on wheat when a cloud blows past") ran in the wrong order. "Each

one was slightly weaker than the last." He was proud of his perception that imagery ("Like the gannets' hurtle . . . like a kestrel chasing . . . like all things swooping") should be deployed, not merely listed. The English teacher, "Dicky" Moore, wrote "good idea, well put." Lucian took this to be a patronising tick in the margin implying, he felt, "and bollocks to you." He learnt by heart Harry Graham's *Ruthless Rhymes* and Hilaire Belloc's *Cautionary Verses*, particularly the latter, given the artless illustrations to them by "BTB," Basil Blackwood. There was, he thought, something brilliant in stringing poems and drawings together, fitting thoughts and jokes and feelings into picture phrases.

The editor of *Punch*, E. V. Knox, was more encouraging than Dicky or Pansy, initially at least. Lucian submitted a number of cartoons to him. "The first one I sent he sent back with a note saying 'good try: try again, E.V.K.' I never had another note from him." Among the *Punch* cartoonists he particularly liked Fougasse, whose line was lively and casual-looking, reminiscent of Walter Trier, the illustrator of *Emil and the Detectives*. "I might have been influenced by that tiny comma nose he always did. The one I loved of his was of a keeper haring through the zoo shouting, 'There's a moose loose!' and a man asks, 'Are you English or Scots?'"

Lucian did not contribute to the school magazine, the *Bryanston Saga*, though he saw that it was a good pigeonhole for what could have been regarded as "Dada gestures"—one boy, he remembered, stuffed all his exercise books into the *Saga* contributions box—but he produced over a dozen poems for "The Collected Freud," with which Michael Jeans, his main Bryanston friend whom he knew from Walberswick, helped. "I liked him better than he liked me. He edited it. I tore it up. But I still have the jacket: a commonplace book with a maroon cover. 'Nothing added, Nothing taken away,' it says."

Among the poems were "Ode to an English and History Lesson" and one influenced as much by Wordsworth as by Morgenstern. He remembered it beginning:

> *A constipated hedgehog wandered*
> *Slowly across the green fields*
> *Meditating . . .*

In similar vein ("Like Morgenstern except there's no hate in it") was his "Ode to a Fried Egg":

> *On a chalk white plate you lie*
> *With loathing in your yellow eye*
> *Swimming in sickly fat.*
> *Ugh.*

"My mother started worshipping it so I smashed it"

A photograph taken in the garden at Walberswick shows the young artist aged fourteen, shirt off, brushes at the ready, standing over a canvas propped on a dining-room chair while his father, seated on a stool beside him, bows his head appraisingly and cradles the cat. The work in hand was possibly, Lucian thought many years later, his third oil painting: "an idyllic idea of little fields with a horse in each field," as in the last chapter of *Black Beauty* in which the surviving horses are put out to grass. A happy ending that was all very well for horses, but he was becoming bored with family life, particularly in Walberswick, and particularly irritated by his father coming up behind him, taking his brush and correcting him. Sharing a bedroom with Clement was equally irksome; he even got tired of bullying him, he admitted. A sister would have been good to have around. "I've always wished for a sister. I'd have got on better with girls, been more natural, not frightened them so much, being so excited and nervous. It would have been a great help to my life. One thing I'd have liked to have had would have been a sister. That and a suit, which I did get."

Like the Freuds, the short-story writer A. E. Coppard had a holiday home in Walberswick, as did Coppard's *Argosy* magazine rival L. A. G. Strong. Coppard's daughter, Julia, was six months older than Lucian and considerably more confident. "She wrote me a sort of love letter, which stimulated me. I was fooling around with her in a hayrick and another boy tried to get her and he had a fit, which excited me. I was conscious that I had bow legs from all that riding and it worried

Lucian Freud with his father at
Hidden House, Walberswick, 1936

me and so I did a *Just William*
thing: had socks coming down."
(In Thomas Henry's illustra-
tions to Richmal Crompton's
books about a scapegrace Home
Counties schoolboy, socks in-
variably sagged to the ankles.)
"Nothing remotely happened
with Julia; she became a siren in
Hampstead and married twice."

At Bryanston there were
similar temptations. The Back-
ward Latin master, Aubrey de
Sélincourt, had two daughters:
"Anne, who everyone lusted
after, and Lesley: I sent notes to
her, which I left in the stables
saying she didn't look after her
horse properly. No reply. We
never spoke." Lesley went on to
marry her cousin Christopher
Robin Milne of *Winnie the Pooh*
fame. The headmaster, Thor-
old Coade, had daughters too:
"Faith, Hope and Felicity. People used to wank over the eldest. The
headmaster was going through a religious conversion. He said to
Mervyn Jones-Evans, 'The only time I ever make love to my wife is
when I want a child,' and Mervyn relayed it to the school. Faith, Hope
and Felicity meant that he did it only three times." In the throes of
adolescence Lucian became a byword for inkiness and general untidi-
ness; he was the wayward spirit, impulsively outrageous yet shy and
elusive. "I didn't go into classes so I couldn't be called absent because
I wasn't there and that meant I couldn't be given the assignments
which you did in your own time."

Art was an alibi, and an end in itself. His painting of the old man
running, described as "old gentleman at speed," was praised in a
school report. "I used to go and sculpt; I'd disappear down to the pot-
tery school." Ceramics, he found, often failed before the firing stage.

Sculpture was a better option. Having read *Jude the Obscure* he rather fancied becoming a stone carver like Jude and maybe, like him, falling in with women and seeking his fortune in the world beyond Dorset. His fish on a rock, in alabaster, was a good start and then, gratifyingly, his martyr on a rock was compared in the school magazine to a Michelangelo. His Bryanston masterpiece, however, his one sculpture known to survive, vigorous in its feel for limbs and neck and grazing lips, was a sandstone horse, nearly two feet high, three legs serving convincingly as four. This was no mere ornamental horse. "I have shod horses: filing the nails, rubbing linseed oil and blacking on to the hoofs. The thing of keeping them upright: you have to *be* the back leg, leaning against the leg as you raise it." Though pleased with the horse he came to regard sculpture as an initiation only. As he put it: "a schoolboy phase. It's unwise to pursue your first love."

Bryanston proved quite agreeable once he began to let himself be known. He almost won the school's riding cup. Michael Jeans proved an ally, though not wholly reliable. "He did me one very bad turn. We had early-morning runs before breakfast and there'd be a prefect in the bushes to see we'd done it. The head of Portman House was someone called J. F. L. Bowes and as I was going round with Michael he said, 'Ask Bowes what the F. L. stands for,' so I did and he said, 'Come to my study later and I'll tell you,' and when I came into his study he hit me on the side of the head so hard I nearly became unconscious. Not until twenty years later did I find out what 'F. L.' stood for. It either meant you knew about sex or, even more impressive, you knew what prophylactics were for. Bowes was killed in the war, I was pleased to see."

Jeans was more companionable on home ground in Walberswick. Besides he had a sister and, for that matter, a family worth knowing. "Ronald, his father, wrote plays with Noël Coward and, with J. B. Priestley, ran the Westminster Theatre; Margaret, his mother, was a novelist [*The Clown and My Fellows*] and she was amused, in a slightly bitter way, by his philandering: pretty actresses at L'Etoile. They had a private cinema at Walberswick, seated thirty, where they showed funny films or good silent films." Up in London during the holidays he and Jeans tried being young men about town. "We went to what we thought the grandest restaurant, the Carlton Grill in the Haymarket, sat down, swarming waiters—as it was only 12:30—had

soup, paid and left. Getting in there proved we were having a good time." In Walberswick they hung around. "An ordinary elderly couple at Walberswick had a lunatic son, a village idiot, about twenty, and we'd see him on the village green in a proper hat and suit, very good clothes, walking his dog, and when his dog went for another dog he'd cheer his dog on. George Orwell had been his tutor; in *Down and Out in Paris and London* he mentions that he went back to England and looked after 'a tame imbecile.' We tried to talk to him and do imitations. He was harmless, manic, only just a lunatic. I've always been fascinated by lunatics, as schoolboys are."

Stage roles attracted Lucian, this time Ibsen. "I played a girl in *The Pillars of Society*," a part "sustained by dreams and expectations" the school magazine commented. "I had to say, 'I want to make something of myself, and I don't want just to be an object to be used.' That got a round of applause." What he accomplished off stage made him notorious: diving head first out of windows, somersaulting the Dartington way so as to land safely and storming the school with a pack of hounds. "I did a really clever thing: the Portman Hounds were wandering in the park and I got them into the hall and up the stairs, all flapping around." Less cleverly, in that the school rules insisted that boys had made their beds in the mornings, he refused to do so for he never felt, then or ever, that domestic chores were any business of his. Others followed his example and the strike caught on. Patrick George—who became Head Boy and captain of rugby—saw Lucian as a leading player in "the conspicuous band of boys wearing white shirts rather than the bluish grey ones. This was some mark of wrongdoing, and a punishment, but was turned by the delinquents into high fashion."

In the summer term of 1938 any notoriety that Lucian enjoyed at school was eclipsed by the tremendous event of his grandfather's exit from Austria and arrival in England. Since the *Anschluss* in March that year more than 70,000 Jews had been arrested in Vienna and photographs had appeared showing crowds looking on as rabbis were set to scrubbing pavements. Sigmund Freud's eminence ensured his being a prominent object of Nazi concern, but his fame and international connections gave him some slight protection against this, though

Anna was arrested and detained for a while. "The Gestapo arrived at Berggasse 19, very embarrassed, with their guns and my grandmother said, 'Do put them away in the umbrella stand,' which they did. She asked the maid to bring the key to the safe and they cleared it out and left. A week or two later a high-up man came and said, 'We have had a lot of complaints that private people have been roughly handled and would you be kind enough to sign these papers saying we acted in a civil and polite manner?' My grandfather read it, smiled, said he'd sign it as it was true and said, 'I'll add "I can heartily recommend the Gestapo to everyone.""'" A senior Nazi official commandeered the villa at Grinzing.

"Two prospects keep me going in these grim times: to rejoin you all and—to die in freedom," Sigmund wrote to Ernst who, a month later, was to escort him from Paris, on the last stage of the journey to England. His choice of refuge was world news. Here came a great name, another Einstein, "the discoverer of the subconscious mind," as *Picture Post* put it, and the publication of two of his books as Pelican paperbacks endorsed the belief that his ideas were crucial to modern minds. *Psychopathology of Everyday Life*, the Pelican edition of which appeared in February 1938, "tells you something of the 'you' you may have forgotten or never known," readers were assured and by the time *Totem and Taboo* (concerning "resemblances between the psychic lives of savages and neurotics") appeared eight months later Freud the elderly refugee from modern barbarity became the symbol of civilised thought and practice. Diplomatic strings were pulled to get him to England, principally by his well-connected supporter and former patient Princess Marie Bonaparte; President Roosevelt and William C. Bullitt, US Ambassador in Paris (another former patient); and, it was rumoured, even Mussolini proved helpful. Princess Marie's privileged status protected her and her persistence paid off, for besides bribing and pressuring the authorities in the Greater Reich to release Freud she had arranged for the confiscation of his possessions to be waived and for his gold coins to be sent over in the Greek diplomatic bag.

The great man arrived at Dover on 6 June with a small entourage of supporters and dependants; on landing he was exempted from customs examination on the orders of the Lord Privy Seal, though Lun the chow was taken into quarantine. "I found the kindliest welcome

in beautiful, free, generous England," Freud wrote when, having set-
tled in, he resumed work on what was to be his last book, *Moses and
Monotheism*, in which he declared: "Here I live now, a welcome guest,
relieved from that oppression and happy that I may again speak and
write—I almost said 'think'—as I want or have to."[1]

Lucian's four great-aunts remained in Vienna provided with
enough money to see them through. Following *Kristallnacht* in Ger-
many and Austria five months later ("pogroms in Germany," Sigmund
Freud noted in his diary, significantly writing in English), there was
growing anxiety over their fate. It was hoped that arrangements could
be made for them to be moved to the Riviera but this proved imprac-
ticable. They died some time later: the youngest, Dolfi, of starvation
in Theresienstadt, Rosa in Auschwitz, Pauli and Mitzi in Treblinka.
Lucian had hardly known them. To him they were as remote as crea-
tures of legend. "Mitzi had a daughter, Lilly, who claimed to be the
inspiration of a song: her married name was Lilly Marle and the Mar-
les' lodger at one time was the man who wrote 'Lili Marlene.'"

In Britain there were pockets of professional animosity directed
against the Freuds, notably from Melanie Klein whose psychoanalyti-
cal theories focused on childhood stemmed from Freud and whose
antagonism was directed primarily at Anna Freud. A feud developed.
Although Lucian decided to detest his aunt, his sympathies were with
her over this: "Melanie Klein came to London before her (in the late
twenties) and she went to the Foreign Office and said it would be dan-
gerous if my grandfather and aunt were admitted to this country. 'It
would be in the national interest to keep them out of England.' I have
to say that when my aunt heard about it later she laughed."

"Into a large-windowed Hampstead house," *News Review* reported
in newsreel-commentary style, "moved Nazi-exiled, psycho-analytic
GOM Dr. Sigmund Freud, with one of his multitudinous chows and
his daughter, Dr. Anna."

Installed temporarily in a rented house in Primrose Hill, Pro-
fessor Freud received masses of plaudits and marks of recognition.
Letters addressed to "Dr. Freud, London" reached him, the charter
book of the Royal Society was taken to 39 Elsworthy Road for his sig-
nature, and André Breton hailed him in the English Surrealists' house
journal, the *London Bulletin*, as "he from whom so many of us derive
our finest reason for existence and action." On 19 July Salvador Dalí

called with a sketchpad. Edward James the art patron, who accompanied Dalí, said that Freud whispered to him, "That boy looks like a fanatic; small wonder that they have civil war in Spain if they look like that." Dalí was eager to make a drawing that would bear out his notion of the resemblance of Freud's head to a snail and this he did, also a more robust one on blotting paper.

Lucian was to develop a regard for Dalí's nerve, not as exercised in the showy paintings but when vented in fearless gestures. There was the occasion he threw himself downstairs at the art academy in Madrid and, even better, his response to André Breton's question as to how he saw Hitler. He liked the way his belt dug into his stomach, he replied: such lively observation. Then there was the time he went round the Louvre and said, "Any work here not signed by me is a fake."

Aware that he had little longer to live, Sigmund Freud made a will leaving the copyrights in his writings to the grandchildren and bequeathing to Anna the books, furniture and antiquities that he had been allowed to bring with him from Vienna; despite this, Lucian became convinced later on that some of the collection could have been intended for him: "Tang horses, Oceanic things, Cycladic things and one very fine Greek head, given him by Marie Bonaparte, Praxiteles or a bit later, perhaps 100 BC. He had amazing things.

"What was very lucky was that he had some money in England. This sort of cautious thing, which is quite a Jewish thing: just enough for my father to get the house ready, and so on." Ernst found a Queen Anne–style house, 20 Maresfield Gardens, Hampstead, "corresponding to our complicated demands and modest means," his father wrote: it was to be, he said, "re-erected Berggasse." More than that: it was to be the best home he ever had, so much so that he felt tempted, he said, to shout "Heil Hitler." When Lucian walked around the house with his father to see if it was suitable he was pleased to see that the previous occupant, the Mayor of Hampstead, had installed a cocktail bar in the hall. That went and improvements began.

One Saturday afternoon in June 1938 Marie Bonaparte filmed Stephen and Lucian with their grandfather at 39 Elsworthy Road, Lucian slight and deferential, conscious of the camera's clockwork whir as they walked round the garden, pausing at the goldfish pond set into a rockery. Then Lucian performs one of his running somer-

saults and makes a dash for the camera as though aiming to knock it senseless.

The move from Elsworthy Road to Maresfield Gardens took place at the end of August. By then Ernst had put in a lift, as his father couldn't manage the stairs, and recreated the Berggasse study, complete with couch and antiquities, figurines mostly, crowded into cabinets, on shelves and on his desk. Stephen was given the task of cataloguing the books.

To Lucian, his grandfather seemed "light-hearted; and he had such a humour and wisdom generally. He seemed fairly youthful really. He was extremely nice to me. Always seemed to be in a good mood. He had what people who are really intelligent have, which is not being serious or solemn." In September he went to see him after an operation. He saw him through the porthole in the door of his room. "I went to the London Clinic; I think he wanted to see me, and I looked through a hole in the glass door. You hold these things tenaciously." One Friday afternoon two months later when Lucian went to tea at Maresfield Gardens hoping not to see Mervyn Jones, son of Ernest Jones, he met Isaiah Berlin. Professor Freud mentioned maybe setting up a practice in Oxford and had an edgy conversation with the young philosopher, suspecting, correctly, that Berlin doubted the validity or efficacy of psychoanalysis but was too polite or overawed to say so. Lucian said he had been to see *Romeo and Juliet*. "I thought you were your own Romeo," his grandfather said.

In July 1938 an exhibition of *20th Century German Art* was held at the New Burlington Galleries, the catalogue for which was issued along with *Modern German Art*, a Penguin Special by "Peter Thoene" (pseudonym for the critic Oto Bihalji-Merin) and a statement "Art has its disciplines, but these originate in the mind of the artist, and cannot be imposed by the indoctrinated will of a statesman, however wise." ("In view of the political situation the organisers have refrained from consulting the artists themselves.") The exhibitors included Beckmann, Corinth, Dix and Grosz. A Franz Marc horse was reproduced on the cover wrapper. "A book with a lot of Nolde and Lehmbruck who I did like, rather." A couple of months later *Guernica* was exhibited to raise funds for Spanish Relief at the New Burlington Galleries;

Lucian saw it either there or at the Whitechapel Art Gallery where it was also shown, under the auspices of the Stepney Trades Council, in January 1939. "I remember thinking how dull the paint was. Exciting but . . . Much, much later, when I saw it in New York, I thought it looked tiny." The first Picassos he had seen were at Rosenberg & Helft in Bruton Street in 1937, among them a number of paintings of the voluptuous Marie-Thérèse Walter, most notably the fondling doubled loops of *Young Girl at a Mirror* (1932). "I was very excited but I've never been able to use things directly that excited me." Read's *Art Now* remained his atlas of Modern Art. "It's all I saw, never saw anything else."

Hans Calmann, his uncle by marriage, was the Freud family connection with the art trade. He had arrived from Hamburg with his family in March 1937 and within a year established himself in a gallery in St. James's Place. Lucian found Calmann patronising and absurd. "He said of Picasso: 'a sentimentalist turned mathematician.'" Calmann dealt almost exclusively in old masters and antiquities. Exceptions were an exhibition in November 1937 of watercolours by Chiang Yee, author of *The Silent Traveller in Lakeland*, an unexpected bestseller followed up with *The Silent Traveller in London* and ten other books illustrating an alien's experience in a strange land. And in March 1938 Calmann gave Mervyn Peake his first exhibition. "I went in there to see it. I met him; he was sweet. I was aware of the affectations: a big head to show 'Hungry.' I never liked whimsy or fancy at all. Except Odilon Redon: the eye on a parachute."

In September 1938 Alexander Freud, Sigmund's youngest brother, came to Britain from Switzerland, hoping to obtain a visa for the United States. "He was very nice, lived in a block of flats in Oxford Street, there was a feeling of good living and opulence; he took me to lunch at the Hungarian restaurant Csardas in Soho." Anna Freud established herself in Maresfield Gardens as housekeeper and guardian of the Freud cult and legacy while specialising in child therapy. For someone who had never got on with children, her nephews agreed, this was an unexpected development. Lucian developed a fixed dislike of her. "Aunt Anna was completely medieval, tremendously unapproachable and very very grand. She'd got that spinsterish thing of minding very much about *things* really, and the collection of antiques; her relaxation was reading murder stories and weaving

huge carpets on an enormous loom. It's her lack of inner life that makes me wonder. The fact that she hadn't been to the cinema or, perhaps more importantly, was a virgin: none of these things matter at all. It's that she was full of phobias and very intolerant." Not only that, she welshed on a deal with him. Shortly after he left school he gave her a painting of tulips ("like a Matisse painting of flowers") that she had admired, asking only that she paid for a frame. "I was sixteen and really pleased so I said could I have it framed? I took it to West's in Swiss Cottage and had it done for £2 10s or £3 and said to her could I have the money? 'How much? Absolutely ridiculous,' she said. 'Zat is out of ze question.'" He destroyed the painting.

In the late autumn of 1938 Peggy Guggenheim held an exhibition of children's art at Guggenheim Jeune, her gallery in Cork Street. Dora Russell's school and others contributed and at the last minute Lucie Freud, being a friend of Peggy Guggenheim's younger sister Hazel King-Farlow (she had tried to seduce Lucian, he recalled, then gave him paints instead), brought in some drawings by her talented son. This was not the first time that she had entered his work in child art exhibitions and complained when they were not returned to her; the loss of a *Landscape of Grasses*, reminiscent of Dürer's eternal tussock, was particularly resented. Looking back Peggy Guggenheim remembered a Freud painting of three naked men running upstairs, doubtless related to the old man scampering cross country, but she took it to be a portrait of grandfather Freud. Roland Penrose and E. L. T. Mesens (who had organised the New Burlington Galleries showing of *Guernica*) bought a few tasty pictures from the exhibition—to them child art was underage Surrealism—but nothing by Lucian, whose work failed to sell. Peggy Guggenheim scolded him for handling a Calder mobile in the gallery. She did not impress him. "She had a huge pockmark."

Shortly before his sixteenth birthday, and having spectacularly exhausted the school's tolerance, Lucian left Bryanston. According to Stephen Freud, the great bed revolt was the last straw: 150 boys being persuaded to object to the school wanting to save money by requiring them to make their own beds. Lucian therefore, being the most offensive, had to go. In fact, Lucian maintained, his expulsion

was more to do with bringing the school's name into disrepute in Bournemouth, the nearest seaside resort. The idea for this arose from a prank in Walberswick the previous summer. "There was a disused narrow-gauge railway bridge across the river: for trespassers the quickest way to Southwold. I made a film—actually a lot of snaps—of Jeans playing a vicar with trousers falling down and screaming on this terribly dangerous ruined, rusty bridge over the Blyth estuary." A more public sequel occurred to them, this time in "a most respectable place where parents took boys to tea and so on." One afternoon, towards the end of the autumn term, they went into Bournemouth, walked on opposite pavements along the Bath Road until, at a prearranged moment, they simultaneously dropped their Bryanston shorts and shuffled down the street like hobbled colts.

"The one who drew the biggest crowd won. Some treacherous person telephoned the school and informed on us." The headmaster, Thorold Coade, renowned for his godliness, was minded to overlook the prank and keep Freud on, if only for his name's sake, but the housemaster saw it as the opportunity to rid the school of a nuisance and in the circumstances Coade felt he couldn't overrule him. "He said, 'Since Mr. Cowley has sacked you, I won't go against it, but I'd like to say that if you change your house, your clothes, your behaviour, your friends, your subjects, everything, you can come back next term.'"

Eager to leave, Lucian packed his horse sculpture in his suitcase, abandoning most of his other possessions to make room for it, and caught the train home.

A few days later Ernst Freud wrote to the headmaster:

Dear Mr. Coade,

I have to thank you very much indeed for your letter of Dec 12th and your kind suggestion to allow Lux to return after the holiday. In the meantime we had the opportunity to think over the situation and to discuss it with him and ultimately we have decided to keep Lux at home and have him attending the Central School of Arts and Crafts. I do hope that his interest in the subject may tempt him to improve his work generally. I am very sorry that Lux carrier [sic] at Bryanston has ended so suddenly

(actually I did not call him home before Mr. Cowley asked me to do so) but I feel sure that it was his fault entirely.

Michael Jeans was not expelled. Lucian, however, almost scuttled that reprieve. "I did have the alternative of coming back but the conditions were difficult. I sent a letter to [him at] Bryanston and sealed it in the envelope with a photo of him on the railway bridge with his bottom showing and the letter was confiscated; Michael Jeans said that it was nothing to do with school, but Bryanston could not believe that there was a bottom that wasn't at Bryanston. I think that Michael Jeans tried to be consciously good." Jeans worked for the BBC at one stage and then became a vicar. "Once I said to him, 'Why is there a god?' 'Look at nature,' he said. 'Things are so varied and different there must be a god.' I said, 'I think that's one reason why there isn't one.'"

Lucian went back to Bryanston once a few years later and, understandably, the headmaster asked him why he had come. Because, he said, he wanted to stay for a couple of days so as to have the pleasure of experiencing breaking up once again. Accepting that Lucian's schooldays were over, his father took the three-legged horse to the Central School of Art ("lugged it to the Central"), where cousin Jo Mosse was already a student, and persuaded the Principal to give Lucian a place for the following term. The horse was then installed on the mantelpiece at Walberswick: the one trophy of Lucian's schooldays. "My parents, particularly my mother, admired it so much I gave it a great bash; my mother started worshipping it so I smashed it." His father, more puzzled than exasperated, introduced him to his friend the potter Lucie Rie around this time saying, "This wild animal is my son." He couldn't quite grasp how venturesome this son of his had become. Once, at a sale with Rodin drawings in it, Lucian urged him to buy one but he said, "I don't think that I want to have anything as good as that." As for Lucie Freud, she, Lucian said, was "so keen on my becoming an artist it made me feel sick. She used to make me give her drawing lessons."

Ernst Freud had once discussed with his father the idea of becoming an artist. Don't become one, he decided, if one isn't "either very rich or very poor." Lucian was to manage both. He began at the Central in January 1939. "My father compromised by making me do a

general course—metalwork, composition, pottery and painting, when I wanted to do just painting." He carved an attractive frog—"I remember polishing his back of alabaster and the markings"—considerably bigger than the fish that he had done in his last term at Bryanston. "I thought it was rather good and gave it—warm from the mallet—to my grandfather. Marie was with him and he said, 'Much as I like it I'm sure you won't mind my giving it to Princess Marie Bonaparte because, when you become an artist, she will be your first patron.' He made it a humorous ceremony."

Marie Bonaparte had come to London on this occasion with Dr. Lacassagne of the Institut Curie who was brought in to examine a new swelling in Freud's mouth. Though not much of a patron to Lucian, as it turned out, Princess Marie was a useful connection. The great-granddaughter of Bonaparte's brother Lucien, with a fortune derived on her mother's side from the founder of the Casino at Monte Carlo, she had married into the Greek royal family and, as Princess George of Greece and Denmark, was the Duchess of Kent's aunt. Having been a patient of Freud's she had become a psychoanalyst herself and they were close. Freud wrote an introduction to her book on chows, the breed that he too cherished (his Topsy and Jofi displayed, he said, "affection without ambivalence"), and she paid for the re-establishing of his International Psychoanalytical Press with the poet-publisher John Rodker which, as the imprint Imago, published in 1948 her *Myths of War*, a short book that Lucian found perhaps unexpectedly readable. "A very interesting book; she writes as if it's a thriller."

Year after year Ernst Freud had tried to secure British passports for the family. In 1939 he was told that naturalisation for people from Germany was suspended indefinitely. Again, happily, Marie Bonaparte pulled strings. "Princess Marie was having lunch with the Duke of Kent and said, 'My friend Professor Freud is so worried in this international situation about his family'; the Duke lifted the phone and that afternoon someone from Immigration came round." So they got their passports in the nick of time, receiving the papers at the end of August—30 August—and these were actually signed on Monday 4 September 1939. "The only rule bent was that the suspension was unsuspended in our case." There was no mention of how they had been favoured in this way—though having been resident in Britain for over five years they qualified for naturalisation, unlike those who

had arrived more recently—but clearly the issue of passports had come through the Palace. Had he not got a passport, Lucian thought, he probably would have been interned a year later on the Isle of Man like his uncle or despatched to Australia like his cousin Walter.

Lucian learnt however that, though one's surname could be open sesame at the Home Office, it was inadvisable to be too free with it. As his grandfather said, "Freud is not a name as rare as I would wish." It was ripe for exploitation. "I had people saying, 'Any relation to the great Frood?' 'No relation in any way,' I'd say." But there was always the temptation to flaunt it. In Regent Street once Lucian put his name to a protest in support of Republican Spain. Noticing the signature the boy behind the table asked if he was by any chance related to Professor Freud. "It would mean so much to us if you could get him to sign."

"So I went off to ask him but he said, 'I really don't believe in individuals' names being used in order to press causes; but since you've promised that you'd get this signature, here you are.' It was the nearest thing to a telling-off. Being against the idea of using people is a principle that I endorse. You know: 'We've got so and so on the petition . . . Stephen Spender . . .' Anyway, I went back to Regent Street, terribly proud. There was another person on the table by then and I said, 'Um, er, this morning they asked me to get my grandfather's signature for the cause,' and he said, 'Oh, thanks very much,' and didn't look at it. Obviously thinking everyone's got a grandfather. Bloody fool, bringing his grandfather's signature."

4

"To cut a terrific dash"

According to Lawrence Gowing, who first met him towards the end of 1938, "Lux" Freud was "already spoken of as a boy-wonder" in the pubs and cafés of Soho and Fitzrovia, making a name for himself or rather (the name being a given) a persona: "fly, perceptive, lithe, with a hint of menace."[1] Between leaving Bryanston and starting at the Central, he explored this new territory. "I felt curiously privileged and in a terrific position to experience things. I was excited about the life."

Where better to start than at the Café Royal in Regent Street? Shabbily palatial with its mirrored red and gilt and marble-topped tables, "a resort of the lonely," as the painter Matthew Smith said—he was a regular—it was where Whistler and Frank Harris had bantered, where H. G. Wells could still be sighted, where Jacob Epstein or rather his mistress Kathleen Garman scouted for portrait-bust commissions and where for many years Augustus John had looked so obviously a genius. Lucian took his Bryanston friends there because for bohemians, or fifteen-year-old would-be bohemians, it was the obvious rendezvous. "It seemed glamorous: I was a Londoner and we went to the Café Royal." It did not disappoint them, situated as it was on the frontier of Soho proper, the seedy but exotic Soho of the *Dreigroschenoper* (*Threepenny Opera*), which his mother had seen again and again in Berlin, relishing its caustic lilt. Behind the Café Royal lay enticing narrow streets.

Near them as they larked around that December evening sat a

man called Podbielski, a Polish exile not much older than them who, stuck for conversation, began surreptitiously kicking a drunk who had slumped within range until eventually the drunk got up and over-turned the table so they had to leave. "We will now go somewhere really interesting," their new acquaintance announced and hailed a hansom cab—one of the few that still operated in Piccadilly Circus—which took them to an all-night café in Flitcroft Street, an alley off the Charing Cross Road.

"This was where my life rather began. As a child I liked Van Gogh, *The Night Café* especially. The Coffee An' was busier but it too had a broody atmosphere and porno pictures on the walls. Run by a Rus-sian chess fanatic called Boris Watson: Boris served Russian tea with a slice of lemon and you could probably get a bun, crumpet or eggs, but I was never conscious of anything even vaguely commercial."

There Lucian first encountered such Soho figures as Jack Neave, "Iron Foot Jack" (said to have lost several inches off one leg railroad-ing in America), who ran an occult sect in Charlotte Street; Napier "Napper" Dean Paul, a toff-turned-dosser; Willy Acton, brother of the aesthete Harold Acton; and the painter John Banting ("very charming, self-effacing, with a syphilitic nose"), whose opening remark to Lucian was "Have you read *Decline and Fall*? It's all about people I know but Waugh got it *completely* wrong: we bright young things were *much* brighter and more amusing." Banting had spent time in Paris existing "Chattertonesquely in a garret," according to the *Daily Express*, and practising Surrealism. "He had very little money and was so easy-going it was a long time after he got syphilis that he had it seen to."

On a good night the Coffee An' was a hellhole buzzing with gossip. "A savage fight broke out at least once a night. The noise was always deafening. The air was thick with smoke," wrote Peter Noble, a showbiz columnist.[2] "The barman was rude, the waiters uncouth and the coffee undrinkable." Besides the halt and the lame (one-footed Mary Hunt and Iron Foot Jack), there were people with impressive connections, such as Isabel Delmer, later Rawsthorne. As one who had lived with Derain, sat for Giacometti and Epstein and was to marry the composers Constant Lambert and Alan Rawsthorne, she was a femme fatale to rival Alma Mahler.

Lucian took to the regulars once they took notice of him. "You

didn't have to be very grand or rich to cut a terrific dash in the Coffee An'; people talked to you." After a while he decided to treat some of the more shiftless regulars there to a show of compassion by taking them home to St. John's Wood Terrace. "I brought them back late at night, put them up on lilos in my father's office which was across the garden, and came into the house at half past four. At a quarter to eight my father was walking up and down the garden and I thought oh Christ he's going to go into the office, so I thought I'd better tell him. He was rather annoyed but not very. He said, 'If you're going to put up all the down-and-outs in London there's not room in the office.'"

Lucian's half a crown a week pocket money, when it was 9d for the cinema, wasn't enough to meet his expenses. "As a child I used to lie and steal a lot. My mother minded that I didn't mind when I confessed once to stealing a lot of things in Brittany, where we went on holiday: Hôtel de la Plage de la Mer, Saint Brieuc. Cakes I stole. I told her, as they were very good." He decided to cull his mother's gramophone records. "I took records out of symphonies and Bach which she kept in a cupboard with her Lotte Lenyas. I had two and six a week pocket money and got five shillings for records: they went to the Gramophone Society at the Central." Emboldened, he helped himself to some of the gold that his father kept in a desk drawer. "A spectacular theft. Grandfather, when we were born, put gold down for each of us in gold coins in little sacks. He was paid by foreigners in gold. I took the lot, first mine then the others' and the bags got thinner and thinner. I sold it at a pawnshop in Kensington Church Street, now an antique shop selling to Japanese. I was nervous and he gave me—obviously—a rotten deal. There was a five- or ten-dollar piece with a Red Indian head on it and father said, 'What did you get for that?' He was surely fed up but, to me, the *one* interesting thing is: did my parents tell my brothers? I think not, because otherwise it would have come up in rows."

He needed the money not so much for his immediate needs, more as a social boost. "I sort of gave it away. It made me a bit more dangerous, powerful. It wasn't a straightforward 'now I can have this,' more 'now I might do *anything* now I have money in my pocket.' And it wasn't just the money. My Aunt Anna said I stole books from my grandfather. But the only thing I had from his library was *Some Limericks*, edited by Norman Douglas, privately printed with 'Some

Limericks' in red letters, scholarly notes and a hideous yellow hessian binding. The flyleaf was inscribed 'For . . . (just two initials): Please don't show to Professor Freud' and gave the number of one of the less good ones. It was obviously given to a patient or someone staying with my grandfather. I got it out and showed it to him. 'It says, "Please don't show to Professor Freud."'

"'Well,' he said, 'in that case you'd better not. Please have it.' It was stolen from me later."

Among the verses that Lucian memorised—"schoolboys love limericks"—was one attributed to Tennyson, which began: "There was an old whore of Baroda, who kept an immoral pagoda." The one not to be shown to his grandfather—"he loved limericks"—was by Philip Heseltine (aka Peter Warlock the composer):

> *Young girls who frequent picture-palaces*
> *Have no use for this psychoanalysis*
> *And though Dr. Freud*
> *Is distinctly annoyed*
> *They cling to their long-standing fallacies.*

A more serious scrape, in that it could have landed him in trouble publicly, was when he got drunk one evening and went home on the night bus. "Rather a mad thing: I jumped off with the little tin box that the bus driver had on the bus. It was full of letters from him to his girlfriend to do with another woman; I didn't read them but my mother did and thought that I was involved in some blackmail scheme." She told him he had to go to the police. "She said, 'You must face the music and go to jail.' Not wanting to be La Speranza [i.e. Oscar Wilde's mother, "La Speranza," who had urged him to be as radical as she] but loving the idea that, 'You may be my son but you'd better be a hero,' she wanted to sacrifice me." Instead he sacrificed the box. "I threw it in the canal."

Consequently—there seemed to be no other choice—Lucian was sent to see Dr. Willi Hoffer, formerly of Vienna who had arrived in London in 1938. A warm and popular figure in Freudian circles, a great believer in clinical observation, he was to be involved in Anna Freud and Dorothy Burlingham's Hampstead War Nurseries. The sessions were put to Lucian as being friendly chats only: "No ques-

tion of an analysis but to have preliminary discussions. My father said, 'You don't deserve to be a painter,' which hadn't struck me that way before. So it affected my life. I went five times or so to Dr. Hoffer, a great friend of Aunt Anna. We chatted and he said he thought I was queer and I said, 'Why? I don't think I am.' And he said, 'Because of the shape of your father's hat.' Not being circumcised, I didn't know it could be seen as an emblem: my father had a pork-pie hat and Dr. Hoffer thought that must have made me prick-conscious. 'How interesting,' I said. 'I don't think I am.' He went on: 'Are you heterosexual? Have you ever had sex with a woman?' I always wanted to know what happens so I said, 'What do you mean?' At that time I hadn't learnt the facts of life so he started explaining it in semi-Latin terms and I said, 'Oh, in that case, I haven't.' Dr. Hoffer was nice, he was tactful, and when I left he gave me a bottle of whisky and then a few years later he bought a Scillonian picture of mine."

Lucian told his friend Frank Auerbach that he had been amazingly uninformed about sex. "He actually said something to the effect that he didn't really know the way women worked until fairly late on and he did say that he didn't know the facts of life until he was sixteen or seventeen."[3] That Dr. Hoffer had said he was gay did not surprise Auerbach. "I think there was something happening, but, then again, when Lucian made a decision he made a decision." For the time being there was, Lucian acknowledged, confusion to some degree. "At the Central, when I went there, there was a naked girl in the life room and I got Michael Hamburger and others and I said, 'Come and see this naked girl. My God, look at this.' I didn't have any girlfriends until awfully late by modern standards, though I did about a month later. David Kentish, who fell for really unsuitable people, fell in love with someone known as the Whore of Babylon, a huge man with a pitch near Piccadilly, and he sent flowers and presents to him, but he also had a girl he was in love with—he didn't really know her—called 'German Lily,' in trousers, in the Coffee An'. I took her back to my parents' house when they were away. I was in my parents' bed with her and afterwards didn't want to go on so she went down to my room, where David Brown was staying the night. David, whose father was an MP, was keen on girls and he had a go. After a bit I thought, 'That wasn't so bad,' so I thought I'd have another go, so I went downstairs. Too late."

Analysis could not compete with the escapism available on the corner of Oxford Street and Tottenham Court Road on Lucian's route to the art school. "I went to the Dominion Cinema a lot where there was a double feature and a stage show for less than a shilling if you got there by mid-day." Westerns—"anything with horses in"—pleased him best. And Mae West being suggestive or Will Hay films with staccato puns and overgrown schoolboys. Afterwards came the stage show. "It was girls from the Midlands or girls from Wales who won the Eisteddfod and were brought in to sing, and Sandy MacPherson on his organ, and comedians. Then back for a last half-hour at the Central. The beautiful Valerie Hamilton I played ping-pong with; I'd hit the ping-pong ball a vicious swipe, hit her in the stomach and she'd double up."

Free tickets to the theatre were supplied by Michael Jeans with whom, in March 1939, Lucian saw T. S. Eliot's *The Family Reunion* at the Westminster Theatre managed at the time by Michael's father. In this first production it was the Furies coming through the French windows (later to become a much exercised motif for Francis Bacon) and "the low conversation of triumphant aunts" that he particularly enjoyed. "A marvellous woman as Aunt Agatha, and Lady Monchensey saying to the doctor that she is worried about the younger son and he says 'You have trusted me a good many years, Lady Monchensey; this is *not* the time to begin to doubt me.'" Much of what was said on stage had a familiar ring to him. "Your mother's hopes are all centred on you." And "Mother never punished us but made us feel guilty." He made no connections then—"never thought of it"—for to him the play was not Freudian delving but a comedy of manners, like Saki short stories with their perverse twists.

A standard Saki tactic was to get to girls through the brother. Lucian's Bryanston friend Clemens von Schey had a sister. "I went to have lunch on the steps of the British Museum with sister Inge, big, fat, maternal. She gave me some puppets." He tried again, more amorously, with Michael Jeans' sister, Angie. "She was wonderful and I wrote to her and asked her out. I took her to anarchist meetings, crazy anarchist groups in London, which I knew of from the Central. I was longing to find out more but she snubbed me. 'When you are further from the egg,' she wrote, she might consider it. But she let me wash her hair once with foam; she was quite amused, and I tried to

do pictures of her. Angie was very attractive and pretty promiscuous. Kitty [Garman], who knew her, told me that she said to her, 'The lift men at Selfridges are awfully good.'"

Years later, when his mother fell into a depression after his father died, Freud found lots of his own letters that she had kept in a drawer. "Something I felt shocked by: going through mother's things, when she was ill, I came across all these letters I'd written to Angie. Mother, seeing her in Walberswick—she had a place there—must have wanted them."

Being his mother's object of pride and devotion, Lucian felt he had to pull away from her. He needed grounds for resentment but couldn't think of many and even those he taxed her with were slight. "For example, when we came to London, being non-English, she installed a pale-green bidet in the bathroom. I asked her what it was for and she said, 'It's a foot bath.' And she cut her hand once and washed it and left blood in the water. I'm not analytically disposed, but surely it was a thing of wanting me to see, of saying: 'I've given you so much already and now this.' No wonder I didn't go near her if I could help it until she was as good as dead. She never reproached me."

Theatre, cinema and Coffee An' were ready distractions from the Central but parts of the course were enjoyable. "It was very exciting to be out of school in another sort of school. I liked metalwork best. Mr. Bradley taught it. Working on the lathe I made a sharp metal spike in brass, which—and people rather found significance in this—I gave to my mother. I liked working on lathes and girls working on them too. I thought I was a good potter after Dartington and Bryanston, but I had to sandpaper to make the pottery look like porcelain. I never got anything fired at the Central. In Composition, Mr. Cooper, raving mad, talked about Paris and Braque and so on and draped red handkerchiefs and fruit about. A very depressing sub-academician taught painting. 'If you can't draw hands, indicate them,' he said, which even then I thought wrong."

In the painting studio, where he worked fairly regularly, he saw William Roberts, the one-time Vorticist, now a painter of rounded figures, all of a breed: deliberate, as though sandpapered into shape,

yet impressive. "He would draw something on the side of a student drawing and they would keep them. Quite exciting. But I never really talked to him. I got always a strong feeling he had a system." Roberts practically always painted from squared-up drawings. "When I was there once Bernard Meninsky came in—he was teaching drawing— and I was painting, and he said, 'You're *enjoying* yourself; why don't you come and learn drawing with me? I guarantee to teach you to draw.' I thought that was a threat which I didn't want to give in to." Though unaware then of Picasso's maxim "above all develop your faults,"[4] he realised that what he needed was not the bearing rein of formal instruction but a basic grasp. "The one thing that can be taught is the one thing that can be learnt, like riding a bicycle, which is a certain discipline relating to proportion."

The model in the sculpture room was called Joan Rhodes. She was about the same age as Lucian. "She posed and I would be flicking tiny balls of clay at her shapely form and I'd do that schoolboy thing of looking up at the ceiling to pretend it wasn't me. I knew her from the Coffee An'. She'd been kicked out by her parents in Scotland when she was twelve or thirteen and was taken up by a rough old busker. There must have been something very nice about him: nowa- days she would have been molested, but he taught her everything and she became a strong woman on the music halls."

John Skeaping, "charming, encouraging, glamorous, really," taught sculpture. He had been married to Barbara Hepworth, but by 1939 that was well in the past, she having gone on to marry Ben Nicholson. "Skeaping was a family man and quite exhibitionistic, liked admiration and it naturally came to him, on the whole. He had a job at Peter Jones as art manager. One night I was crossing Sloane Square. Quiet and empty, apart from a bullfighter with a cape being charged by girls: John Skeaping. He did have this amazing effect on girls. A frail, beautiful one ran up an eight-foot Christ in concrete or teak under his influence. He seemed very generous and lively and not phoney. He did those animal sculptures, very slick, and he did smudges-with-the-finger drawings of deer. But then there was an unfortunate *How to Draw* Studio book: how to draw horses in three lines."

In this little book, published in 1941 and much reprinted, Skeap- ing confessed to having a "point of view biased in favour of animals";

it was of course just how Lucian felt. "My one wish was to be a jockey," Skeaping wrote. "I was so obsessed with this idea that I spent most of my time pretending to be a horse or drawing them. I felt every effort in my own body and muscles. I imagined the bit in my mouth and could feel the tug of the reins in my cheeks." His exhortation to "get all the vitality possible in your work" was tastier than any Meninsky guarantee of future prowess.

Skeaping had the idea, attractive to Lucian, that "we were people who should get back to primitive things." Primitive art, like child art and some psychotic art, had a directness that suggested anyone could try it. Primitives managed without the strictures and bodybuilding courses of art-school training; their freshness looked well at Guggenheim Jeune. Primitivism was as heady as anarchism and as stimulating as Surrealism, to which, by descent, it was related.

Lucian took up with Toni del Renzio, a young designer, Russian-born, an avowed cosmopolitan and the only painter, besides John Banting, that he met in the Coffee An'. Del Renzio claimed to have an elaborate past. This was myth, Freud said, dismissing the obituaries that appeared in 2007. He had been born in the East End, father unknown, and the stories of his youth (conscripted into Mussolini's Tripolitan cavalry and posted to the war in Abyssinia; escaped across the desert disguised as a Bedouin, fought against Franco in Barcelona and Aragon and then worked as a designer in Paris) were essentially surreal, fiction. During the years Lucian knew him del Renzio was mainly homeless. Women took pity on him and in 1939 he was living in plausible poverty in a Charlotte Street attic with a model called Sally (he later married, briefly, the painter Ithell Colquhoun). Being a Surrealist with proper Parisian connections, del Renzio was good to know and indeed imposing enough to be taken home for Sunday lunch. Lucian wanted his parents to appreciate that his new friend was a bit older than him; however, they were more concerned by his smelliness and lack of socks. He was, Lucian remembered, camp with his hands, fluttering them as he talked. They decided to start a magazine, to be called *Bheuaau* (pronounced Boo), but fell out over a phrase. Del Renzio said, "Horses are thicker than water," and Lucian disagreed. "I said, 'Horses are thinner than water.'" Reconciliation proved impossible and *Bheuaau* failed to appear.

Surrealism, Lucian discovered, generally meant Dalí or Breton

rather than Picasso and that, he thought, was reason enough for not getting involved. His grandfather, who had been quite taken with Dalí when he came to tea, had remained sceptical about Surrealism's irrationale. "I may have been inclined to regard the surrealists, who have apparently adopted me as their patron saint, as complete fools (let us say 95 per cent, as with alcohol)," he wrote. Lucian learnt to avoid casual art entanglements. Even then he considered himself a painter and, despite distractions, nothing but a painter. "It always seemed understood. At the Central I didn't want to use cheap 'students' colours' because I thought I'm not a student, I'm a painter."

Although he painted quite a bit at home in St. John's Wood Terrace this was mainly to declare and demonstrate his calling. "I hadn't got into the habit of working; I was showing off all the time at the Central. I did some figures and a portrait of Cle (Stephen had his own room but I shared with Cle); I did a self-portrait on board and went out and got some white for eyes and a smock. It was the first I did. It seemed brilliant."

The trouble was that he found the course at the Central neither demanding enough nor easy-going. It was too much like school. His social life on the other hand was promising. One fellow student, Margaret Levetus, remembered him as "Lutz Freud, a rather frail-looking youth, but he proved to be a demon at ping-pong." She beat him twice only. Lucian was quick to strike up acquaintances. "I talked to people and looked at people like Honor Frost, who had the next easel to me and was friendly, and Natalie Newhouse, who had been a dental assistant, very pretty and very very funny, but she had no time for me: to do with money." Many of those he first met that term were to reappear in his life, among them Lawrence Gowing and Stephen Spender (both of whom attended the rigorously figurative Euston Road School run by William Coldstream, Claude Rogers and Victor Pasmore), V. W. (Peter) Watson, margarine heir and patron of the arts, and Denis (Smutty) Wirth-Miller, a window-dresser for Tootals at £15 a week. "No one else had any money. Denis was doing Weimar Republic paintings, like those Germans who copied Van Gogh: Schmidt-Rottluff Wirth-Millers." His friend Dicky Chopping had a rich mother and did flower paintings, "rather nice, quite fresh and very like." "They were generous and hospitable, had parties and were friendly—that I was a boy probably helped a bit—in a flat in Charlotte

Street. Better than all the little dumps there, like Toni del Renzio's attic and the terrible John Constable house, which Joan Rayner had. Very quiet and well-behaved parties, mildly naughty; the Queen's hat maker would be there."

One night at the Coffee An' Lucian met Smutty Miller's half-sister Annie Goossens, daughter of the oboist Eugene Goossens and an impressive jitterbugger. How bored he was at the Central, he told her and she said she'd heard of somewhere that might suit him. A friend of hers, Bettina Shaw-Lawrence, was at a different sort of art school not too far from London. "Annie said, 'Oh you must go and study at Cedric's, it's the only place.'" She was referring to the East Anglian School of Painting and Drawing at Dedham in Essex, an art school with few constraints. It sounded attractive, compared to the Central or for that matter the Euston Road School, concentrated as it was on life drawing and about to close down anyway. And so in the spring of 1939 he moved there. "I wasn't really looking round for an art school. I wouldn't have thought of it. It was a jump to go there, done on impulse."

Founded in 1937 by Cedric Morris and Arthur Lett-Haines, the East Anglian School was a glorified summer school ("largely for old women," Lucian discovered), offering tuition (twenty-six guineas a year, down to two guineas a week: enough to cause Ernst Freud to seek a reduction) in "Landscape, Life, Flowers, Still Life, Animals, Design" in agreeable surroundings. Stiflingly agreeable in that Dedham church tower—tall and distant in Constable's pictures of Dedham Vale—stood over the village, a reminder to students that the entire place had been consigned through art into English Heritage.

"The Constable country was rather sickening. Ghastly women went there and did watercolours of the Stour and I thought it was his fault." To leave the Central in High Holborn for the heartlands of East Anglia was to risk being sucked into seemliness. Yet for all its brick and flint and half-timbering Dedham was "on the right side of pretty," Lucian soon decided, though it was quite a while before he came to regard Constable as a great and daring artist. "It was through Francis [Bacon] I got keen on Constable, because he was so keen on *The Leaping Horse*; I think early on that I thought he was a bit soppy."

Even so he tried emulating him. "I remember plonking my easel in front of a tree at Dedham—I'd seen the Constable tree at the V&A—and thought I can't do it. I didn't know where to start. It just seemed impossible. There has to be some correlation between *me* and the picture."

According to Felicity Hellaby (later Belfield), a fellow student who was to become a friend, Lucian arrived at the school very much a juvenile. "He was sixteen. I'd never heard of the Freuds and this chap turned up and people said he's got a very famous grandfather. He and I were probably the youngest."[3] He already had friends and acquaintances there, among them David Kentish, ex-Bryanston. John Banting was often around and John Skeaping was a Dedham legend, for he had stayed at Pound Farm, where Morris and Lett-Haines lived, with Barbara Hepworth and after the break-up of their marriage he had both worked there—teaching Agatha Christie to paint, briefly—and remarried there in 1934. "His wife, Morwenna, was daughter of the vicar of Langham, the local parish, and people said he seduced her on the altar. Maybe he did: the fact that everyone knew it meant something, surely?" The whiff of scandal lingered. "Cedric said he, and Christopher Wood, who had stayed too, were smoking opium and he wouldn't have them there. There is often a puritanical side to queerness and Cedric was a Welsh nationalist. 'I really couldn't allow it,' he said; it was a school, after all, and word would have got around. Though opium was considered odd and exotic, not druggy: no one ever says, 'Do you like opium?'"

Morris was a painter known for his colourful spreads, the aesthetic of the matted rag rug blended with the sensibilities of Christopher Wood and Edward Burra, Pissarro and Utrillo. His work had a disarming quality that suited Guggenheim Jeune and the Wertheim Gallery where it fitted in with the taste for child art, "unprofessional" art and free-range Surrealism. A decade earlier he had been considered quite the leading figure; indeed in 1928 the critic T. W. Earp wrote that "the paintings of Cedric Morris are the happiest event which has occurred during the last few years in the annals of English painting," especially happy in that he had never bothered to get himself skilled in "the mechanical redundancies of the art school."[6] He and Lett-Haines had quite a past as players in the travelling avant-garde of the twenties, associated then with Jean Cocteau in Villefranche, with

the Paris crowd, the big names—Hemingway, Man Ray, Picabia—and others besides, ranging from Nancy Cunard to Nina Hamnett. They had thrown memorable parties. Morris—who was to become Sir Cedric in 1947 when he inherited a baronetcy—told Lucian that the thing to do before such parties was to "toss yourself off in the taxi to make your eyes shine." "He was so quirky and odd. But he wasn't bitter."

Morris had taken to speaking of London as "that evil place" and, exercising his social conscience, became involved in schemes to alleviate distress in his native South Wales through art, serving as trustee of an arts centre in Dowlais (where unemployment was 73 per cent) and inviting people from there to work at Dedham with the aim of enlarging their experience without subjecting them to academic routine. He advocated "sincere painting," unvarnished, unmodulated, robust. He said of his pupils that he could, "by making them peg away at it, sometimes turn their weakness into their strongest feature."[7]

Lucian liked Morris' relaxed attitude. "No teaching much, but there were models and you could work in your own room." An arc of easels would be set up on the lawn around a model in swimming trunks. Morris' love of plants and animals, louche schoolboy humour (tireless innuendo concerning Constable's Flatford Mill neighbour Willy Lott and his cottage) and even his persistent giggle were more appealing than the courses that Lucian could have tried in London, whether draughtsmanship with Bernard Meninsky or the subdued tones of the Euston Road School. He was self-taught but not naive, still less faux-naif. "His tag at the beginning was 'Cézanne from Newlyn': a bit unfortunate." His drawings, veering between suave and waspish, impressed Lucian. As did his practical tips: how to stretch and prime a canvas and how to economise with turps bought by the gallon from the oil merchant, not "pure turps" from the art shop. Not that he ever acted on these. He was never one for chores.

"Concerning Plant Painting," an article by Morris in the *Studio* for May 1942, could have been written with his restless pupil in mind. "The first reaction of the painter to the suggestion that he should write about painting is a retort that he should mind his own business and that you should look at the pictures," it began. Delving into his subject on a rising note of waspish glee, he mocked any idea of floral prettiness. "The aspect of *belles et jolies fleures*, or charming, gay,

lovely, etc., mean no more to me than such qualities do in natural reaction to life in general; it is more the attributes of grimness, ruthlessness, lust and arrogance that I find, and, above all, the absence of fear in their kingdom." This led him to pose flowers as living creatures endowed with human values and characteristics. "Be he able to express the blowzey [*sic*] fugitiveness of the poppy as could Jan van Huysum, the slightly sinister quality of fritillarias as Breughel the Elder, or the downright evil of some arums, the elegance, pride and delicacy of irises, the strident quality of delphiniums, the vulgarity of some double peonies, chrysanthemums, roses, and most dahlia . . . all this and much more the flower painter has to do."

The notion of evil in an arum lily may be questionable but the idea that portraiture covers everything, that it's the life that matters more than the likeness—a sense of life made sharper and more immediate—was an inspiration after the cautionary procedures of the Central. "I thought Cedric was a real painter. Dense and extraordinary. Terrific limitations. I remember him showing David Kentish how to do Welsh tiles on a roof with a knife and I sort of smiled to myself." He began to feel proficient and in good company, compared to the Central. "There were people working seriously. You could talk to Lett-Haines—who actually ran the place—and he'd tell you about what it was like in Paris. I liked the whole thing there. There was a very strong atmosphere." At the Marlborough Head pub, where he had a room, a fellow lodger, Ralph Banbury, a former accountant and admirer of Morris (with whom he had had an affair), would greet him every day with a "Hello, boy," telling him that what he really wanted in life was to be presented with a crisp new five-pound note every morning. "There were certain undertones. When the war started he went into the Guards almost at once and was killed."

Having settled into an agreeable routine, suddenly, on the morning of Thursday 28 July, Lucian was awakened by crackle and glare. Across the street from his bedroom window the art school was ablaze. A Chinese medical student who had been acting as a model and was the only person sleeping in the building jumped in his pyjamas from an upstairs window. The excitement was terrific, for after the Colchester Fire Brigade arrived it took an hour to get the blaze under control and another six hours to extinguish it completely. Since he and a friend, David Carr, had been smoking in the school until late

Lucian thought that he could have been responsible. "The Chief Constable of Essex came and looked and said it was a fuse, but I knew it wasn't. I just wondered."

During the damping down, Alfred Munnings the horse painter and a future President of the Royal Academy, who lived just outside the village, drove up and down the street in his Rolls-Royce braying with delight. "He shouted, 'Modern Art is burning down,' and 'Hooray: now you'll never be able to paint except out of doors.'" Munnings was famously reactionary. "Wore one black and one brown shoe. Once he was at Waldorf Astor's, drawing the horses, and Astor asked him what Brighton was like. 'Lots of Jews on the beach buggering each other,' he said. Being a grandee, with a park, he had hunters and when war broke out he shot them all as in the First War they had been called up. He was impulsive: must have felt terrible about it." By then it was rumoured locally that the Home Guard had him down as a fascist to be disposed of were invasion to occur. He decamped to Exmoor.

The fire was dramatic enough to fill a page in the *East Anglian Daily Times*. Photographs showed students searching through the debris, among them Daphne Bousfield cuddling a Buddha that she had borrowed from her father, a retired major in the village, and recovered miraculously undamaged. The *Daily Mirror* ran one of these photographs and identified the youth in linen suit and sandals holding a charred sketchbook as "Lucien [*sic*] Freud a grandson of the famous psychologist." It was a sort of debut. The cause of the fire was put down to a cigarette dropped on paint rags. Whose cigarette it could have been was not established. Morris set the smouldering wreckage as a subject for everyone, including himself, to work from. "The students," Lett-Haines told the local reporter, "propose to rebuild the school for themselves, but I don't see how they are going to do it." For the time being tuition continued in the billiard room of the pub and two miles away in the stables at Pound Farm, Higham, where Lett-Haines and Morris lived.

"Pound Farm was lovely. It had a brick paved yard, which Cedric had made himself. There weren't animals about, lots of evidence of them—cages and so on—but not even a dog. Stuffed birds he did have, which I drew." Lucian worked in the stables and on a low hillside beyond, painting a box of apples among other things, and was

1939 East Anglian Daily Times

DEDHAM: (1) The ruins of the East Anglian School of Painting and Drawing, which was completely gutted by fire on Thursday morning; (2) Students searching among the debris for their sketches; (3) A student with the Buddha, which was the only object undamaged by the fire. A full story appears on Page 9. (E.A.D.T. photos.)

The East Anglian School of Painting and Drawing
the morning after the fire, *East Anglian Daily Times*, 1939

photographed with the others in the garden relaxing in a deckchair in shorts and sandals and borrowed sombrero. He served as a model too, and was paid for it. Morris himself drew from him: "an acrobatic pose, just a minute or so though."

Around the same time he became briefly involved with his cousin

Jo Mosse. "My nice dumpy cousin. I was staying with her mother and my cousin Wolf and Michael Hamburger near Dunmow in Essex. I was impressed with her, as at the Central she had been having an affair with John Skeaping. Jo and I had hardly any sexual encounters until I sort of seduced her. Or she seduced me, actually. They were playing games downstairs with my aunt and Jo said, 'Come upstairs.' Romance it wasn't and it endeared her to me. It was just after the Central. We went on a bit and were always friendly."

By September 1939 Sigmund Freud was, he told Marie Bonaparte, "a small island of pain floating in an ocean of indifference."[8] Lucian was aware of this. "I was commuting to London some days. Grandfather was dying. He kept on having things cut away." He had already seen him a while before, through a glass panel in the door of his hospital room. "I didn't go in. There was a sort of hole in his cheek, like a brown apple: that was why there was no death mask made, I imagine. I felt upset."

After asking his doctors to administer extra morphine Freud died on 23 September. Unlike the rest of the family, Lucian did not go to the funeral at Golders Green cemetery. "I did write to my aunt that it was not out of disrespect." He could have reminded her that, opposed as he was to religious rites, Freud himself had not attended his mother's burial nine years earlier. His ashes were placed in a Greek urn presented to him some years before by Marie Bonaparte.

That autumn Lucian tinkered with illustrations for what he and Micky Nelson from Bryanston conceived as the *Black Book*, a dark reflection, they imagined, of *The Yellow Book* in that it was filled with drawings influenced by Aubrey Beardsley in his *Lysistrata* vein, all rumps and smirks and pen-and-ink stippling. "It was in a black folder. It was juvenile but lively." They also had in mind Verlaine and Rimbaud escaping to London.

In that devil-may-care spirit Lucian went to Oxford one day with Peter Watson—patron of young artists and prospective backer of a new literary review to be called *Horizon*—accompanying him on a return to old haunts. "He had been sent down because he gave a cocktail party and the street outside was blocked with so much traffic: Gerald Berners wrote a novel about him giving motorcars to every-

body. Cecil Beaton was envious of his Rolls in beautiful colours and when Peter became fed up with Beaton he gave him a Rolls and never saw him again. He liked Oxford. We'd go to Oxford for the parties of boys I'd been at Bryanston with. A flashback: I remember coming into the foyer of the Randolph Hotel with Peter when the war began and a drunk man in evening dress singing:

> "*Mademoiselle from Armentières*
> *Parlez-vous,*
> *Hasn't been fucked in twenty years . . .*"

Twenty-one years on from the Armistice and naturalised British in the nick of time, the Freuds were in no risk of being interned, but for Ernst Freud, as for most architects, prospects dwindled once the war began. He decided to rent out the house in St. John's Wood Terrace and take a flat in Maresfield Gardens, cheaper and safer once he had reinforced the ground-floor rooms against air raids. Lucian—who, with his grandfather dead and adulthood in prospect, I will refer to from now on as Freud—was more concerned with the prospects of the East Anglian School and what Morris had to teach him.

Invariably, whether painting people, landscapes, birds or flowers (he was becoming a revered cultivator of irises), Morris bunched forms and wadded patterns and colours, giving portraits especially a conspiratorial if not mildly ridiculed look. Freud appreciated this ("His Alison Debenham is pretty good; Mary Butts is amazing, and Frances Hodgkins, and I loved the one of Paul Crosse") but, being far from assured as to what he wanted to achieve, he felt his way by drawing primarily and using paint for gloss only and elaboration. Here Morris was a force for good, setting an example of sustained application. "Paint the background and the eyes and work down in one go. It was great to watch: a feeling of sureness. He used to start at the top, as if he was undoing something, with roof, sky, chimneys all along, and go down, like a tapestry maker (except that they work from the bottom up)." Morris taught him by example, encouraging him to step up production to, ideally, a picture a day. Painting excursions were arranged. "We went to Ipswich docks in Lett-Haines' car. I did a brilliant, rather big, two foot by two and a half there, using linseed oil in the paint to make it more glistening. Ugh. I learnt to work properly,

to work hard. I got the feeling of excitement working." He even sold one of them, to one of his father's friends.

Freud's 1939 paintings are naive in that they appear untouched by, indeed oblivious to, academic discipline. His self-portrait from that pre-war summer is a face flattened, as it were, behind picture glass, spread like a pelt and barely more animated than a mask. It could be his version of a funerary portrait—such as the one given to his father by Hans Calmann, or those belonging to his grandfather and displayed in the study at Maresfield Gardens—posthumously painted and set into the wrappings of an embalmed head covering the actual face. *Horses and Figure*, a brown study of masked head and horse heads thinly painted on a sheet of tin, combines menace and alarm with affectionately observed hindquarters, muzzles and necks. Similarly *Woman with Rejected Suitors* is mock psychic, with intimate touches such as the crease in the elbow and curve of a nostril: details that make her more than a figure of fun. The woman was Denise Broadley from Dedham, a student contemplating becoming a nun. "Cedric and I had a joke about her: no one would ever take her to anything and these were her rejected suitors." Jammed together like skittles the imagined lovers haunt her. In that Freud had been reading *Ulysses*, she could be a dejected Molly Bloom. "I did some huge imaginary women's heads. It was then that I realised how people change the air. It's what haloes do . . . 'He has that air about him, people say.'" An essay in character, *Woman with Rejected Suitors* struggles for air. Poor Denise Broadley, sagging in her rayon blouse, was herself a Cedric Morris reject and Freud was being knowing at her expense. Eventually she decided against the convent life and went into the Land Army.

In the mind's eye sensations could be readily exacerbated. The newspaper seller in *Memory of London* standing hand in pocket on the lookout for punters was based on a man Freud used to see at the end of St. John's Wood Terrace, here transferred to a narrower and more sinister pitch—more like Flitcroft Street—and worked up into a likely pimp. In the autumn of 1939 blackout was a novelty and moonlight, or the lack of it, became appreciable suddenly after half a century of uninterrupted street lighting. Freud's memory here is of night in the city, of the *unheimlich* or uncanny, the fear and thrill of back-alley encounters and the sound of footsteps in the dark, "Footsteps coming nearer," as the caption read to a similar scene in Bill Brandt's *A*

Night in London, published in 1938, and in his photo essay "Unchanging London," published in *Lilliput* magazine in May 1939 in which images from Gustave Doré's *London* of 1872 were aligned with his: shots of men conferring on street corners in Jack the Ripper or Mack the Knife neighbourhoods with policemen near by, waiting to nab them. Freud had been reading Henry Miller's *Black Spring*. This, he said, "is quite a bit in the picture," not least Miller's "gutters running with sperm and brandy."

"I borrowed a suit from my friend Michael Jeans that belonged to his father, dark-grey flannel, horrible pinstriped. We called it 'The Suit.' I usen't to be let into places. There was a pub in Shepherd's Market that I was turned out of; I asked the man why. 'No reason given,' he said. That's why I wore The Suit. Anyway, I took Lys Lubbock out and we were walking along Piccadilly when I saw somebody to chase, or exercise my headfirst dive on, and I dashed across the road to where the Green Park railings had been taken down for the war effort, and dived over a barbed-wire fence and the brand-new suit got torn to bits. Lys said, 'You're really mad.' Really *really* mad, she meant."

PART II

The Phoney War and the Real War
1939–45

"A private language"

At the end of October 1939 the East Anglian School closed for the winter and Freud and his Bryanston friend David Kentish decided to go off on their own and paint. They rented rooms—£3 10s a week—in an isolated cottage called Haulfryn outside Capel Curig, near Betws-y-Coed, where the Kentish family had connections. Owen Kentish was a governor of Bryanston and his sister was head-mistress of what Freud described as "an evacuated baby school" in Bangor. "So they knew about this boarding house. David laid it on. Rent was very modest, which my parents paid. Full board. Rather nice landlord: Pritchard, ex-miner. It was the first time outside art school where I worked very hard on my own. Well organised."

They spent three months at Haulfryn, fully provided for, with a shed fifty yards from the house where they could paint. *Memory of London* was done there ("in a mountain hut: nostalgia") and the apples painting, begun in the stables at Pound Farm, became *Box of Apples in Wales*, its background Snowdonia, treeless, and therefore—in terms of displaced apples—marginally surreal. Not that conscious Surreal-ism was involved, the mountains shown were as Memling, Patinir or El Greco would have featured them: alps arising wherever. The sides of the crate fitted into the setting like the angular walls in the field outside Van Gogh's cell at Saint Rémy. Pleased with what he had so swiftly accomplished, Freud wrote to Cedric Morris: "I've finished my picture of the crate of apples by putting a Welsh landscape in the background. I also painted a large monster and landscapes of more

monsters and a street at night . . . I am doing a great deal of drawing all the time. I think my painting is getting much better and the paint is more interesting than it used to be."[1]

From Wales David Kentish (characterised by Freud as "rugger playing, caught TB at school and still suffered from it, smoked a pipe and copied his father") wrote with thumping jocularity ("just a month before Christ's birthday") to Joan Warburton, nicknamed "Maudie" by Cedric Morris as she was a colonel's daughter. Kentish urged her to come and join them. "Costs a pretty penny to get here, actually about 360 or 364, work it out for yourself."[2] She didn't take his invitation seriously; however she did keep the letters that he and Freud sent her during their stay.

There was the misfortune, Kentish told her, of leaving his gramophone behind on the train. "The lost gramophone is serious, since we have masses of, hundreds of, records which we are unable to play even with the fire tongs, though we have tried hard, and dust is slowly accumulating on the tops of the cases, measuring our despondency."

Writing to Lett-Haines, Freud told him that he had done a lot of work and that "the paint is much more interesting than it used to be."[3] Then, writing to Cedric Morris, he asked if the rumour "started by Lett through David's father" was true: was he going to start a school in London after Christmas? "Or is it just Letticia up to her old tricks again?" He mentioned that they'd had visitors for the weekend: "Tony [Hyndman] and Stephen [Spender] and another man."[4] On the Sunday they had all been over to Bangor to see David's sister. By the end of November the shed became too cold to work in. Days grew shorter. The isolation got on their nerves.

They went home for Christmas, thinking of not returning as Snowdonia had become insufferably wintry, but in the New Year they did go back after all, train to Bangor, bus to Capel Curig. Freud wrote urgently to his mother in Walberswick asking her to get his father, who was at home in London, to send his skates to him. She complied, saying in her letter to Ernst that unfortunately Lux and David had gone off with a thriller, and that she feared Lux had started reading the Marquis de Sade.

For their second stint in Wales they were better equipped and more in the mood. "Christmas frolics," as Stephen Spender put it when he suggested joining them, rather to Freud's surprise. "He

said could he come, I think: slightly odd having this adult with us."
Almost twice Freud's age, Spender was a noted and busy literary fig-
ure with a taste for art, particularly for being drawn and painted. He
had sat for William Coldstream, Henry Moore, Wyndham Lewis
and, most recently, Robert Buhler whom, characteristically, he had
helped out. "Bobby's hobby was cycling to aerodromes but because
he was not properly English—his mother was Swiss—he was always
being arrested and Stephen, who was sort of in love with him, got him
out." Spender shared a weekend house with his brother Humphrey
at Lavenham and had been over to Pound Farm to see his boyfriend
Tony Hyndman, an ex-guardsman, working as a life model, which is
how Freud came to know him. "I'd quite wanted to meet him because
I liked some of his poems and there were all those jokes. By Betjeman
for example: *Friends of Stephen Spender at ease / Eating lumps of bread
and cheese.*"

That Christmas Spender had found himself rather at a loss, Inez
his wife having gone off with Charles Madge, the poet of Mass-
Observation, the sociological reportage project, a few months before,
leaving him not so much bereft as perplexed. The marriage break-
down was precipitated, partly at least, by his having gone to Spain
to pluck Tony Hyndman from jail following his desertion from the
International Brigade. William Coldstream, who had painted Inez in
1938 and Spender before that, told Freud, years later, that he never
really forgave Spender as he himself had made such an effort not to
make up to Inez when working from her. "Spender said afterwards
'Did you go with her?' in a friendly way, as if he expected it. If he'd
known what I was suffering . . ."[5] Spender was puzzling, a curious
mix of candour and disingenuity. Coldstream thought of his poems
as "full of slightly embarrassing & very strong feelings, very personal,
very big & over life size in emotion but very original and striking,"
and, as John Lehmann waspishly remarked in his *New Writing in
Europe*, a Pelican book published in 1940, "One may feel it must be
extraordinarily painful to be Stephen Spender at times . . ." Virtually
uninvited, newly divorced, he arrived at Haulfryn laden with a type-
writer and about forty books.

"Stephen was desperate to get married. He kept saying, 'Will you
introduce me to any girls that you know as I so much want to get
married again? Anyone who may be Miss Right.' I think he wanted

someone about whom people would say, 'Ahhh, Stephen was out last night with someone noticeable.' Not someone from the Coffee An' like Mary [Keene] say." A conjectural possibility was Honor Frost from the Central whom Freud had found "friendly, old-maidish" and who, despite being struck at the time by his lack of natural talent and his anxiety to overcome it, had even been prepared to illustrate Spender's poems. "I introduced Stephen to Honor Frost and he said to me the next day, 'I took her out. She was so like a goldfish I took her to a department store and got her a goldfish.'"

"Do you think we can make a comic poet of him?" W. H. Auden asked Freud, no doubt for effect, some years later. Fat chance but, Freud commented, "in a way he was right. That was where Stephen's true talent lay. Stephen could do genuine embarrassment. For example: 'My parents kept me from children who were rough . . .' And those pylons: 'bare like nude, giant girls that have no secret.' Lay off!"

Freud's first inkling of Spender had been when he read "The Pylons" in Auden's *The Poet's Tongue* anthology, a fitting poem for Capel Curig:

> *The secret of these hills was stone, and cottages*
> *Of that stone made.*

Since that October Spender had been involved with Cyril Connolly in setting up the literary magazine *Horizon*, the first number of which appeared a week before Christmas; it was, as Freud recalled, a phase when "Stephen did reviewing and wrote to Eliot." The back room of Spender's flat in Lansdowne Terrace served as the office and, as it happened, Spender had been in correspondence with Joan Warburton, one of the 200 initial subscribers and another potential Miss Right. He had also been trying his hand at painting, with Lawrence Gowing as tutor, finding respite from getting started on his first novel, he said, in "a sensuous activity with tangible material." Freud took to him. "There was something about his ridiculousness and snobbery which was somehow sympathetic; I was very fond of him, and one forgets what it was like at seventeen." Certainly he dazzled Spender. "Lucian is the most intelligent person I have met since I first knew Auden at Oxford, I think," he wrote to a friend, Mary Elliott. "He looks like Harpo Marx and is amazingly talented, and

also wise, I think."[6] By his account, he told T. S. Eliot that he was in love with Lucian and Eliot's response was "There's nothing I understand more."[7]

The skates arrived. And a thank-you note to his father, sent (or possibly not sent after all) was written: "*Lebe Pap Vielen Dank fur die schlittschuhen*. Here there is 2 feet of snow. How can one get out of the house? Working very hard Love Lux."

Spender, the size of whose daily postbag impressed Mrs. Pritchard, wrote all day, Freud painted and Kentish, who had acquired a new EMG gramophone and *Lucia di Lammermoor* spread over many records, also painted but began to fret. "We live in a sort of perpetual musical aroma," he wrote. "It is rather a nuisance because we have no electricity and have to wind it."[8] The days passed, turning to darkness by mid-afternoon. In a long letter to Joan Warburton, written one evening in front of the fire in the intervals between cranking up the gramophone, Kentish described the situation. He had just closed the curtains and tea, a tuckbox spread, was about to be cleared away. ("It was rather exciting as we had sardines and Stilton cheese with strawberry jam but it made an awful mess on the table because we were only meant to have a cup of tea so there were no plates.")[9] Having completed a page or so more of *The Backward Son* Spender was playing patience and Freud was doing "lovely drawings: I was only seventeen and I very much prided myself on my drawing," in the publisher's dummy that Spender had given him as a slightly belated birthday present. Initially Spender was the motif: reading, typing or just looking at him like a well-meaning head of house. The blank pages were being filled with mapping-pen revue: horses dancing, horses snogging their riders, figures transformed when (harking back to the graphic antics of cousin Tom Seidmann-Freud) overlapping pages were turned, drawings of skating and of Mr. and Mrs. Pritchard in bed with a stash of their guests' missing socks, cod operatic drawings provoked by the impassioned Lucia, drawings of the oil lamp and feet in front of the fire, and one or two of Kentish, who nonetheless felt cold-shouldered, seeing that Freud had drawn Spender about a dozen times by then. The situation was getting to him.

"We have just finished tea," Kentish continued and, after describing the stars outside, the dark, the cold, the frozen lakes, he got to the point:

Stephen Spender in Wales, photograph taken by Lucian Freud, January 1940

Lucian and Stephen have a sort of fantastic business relationship known as Freud & Schuster. [Schuster had been Stephen's German Jewish family name.] *This is terribly strange, it is rather difficult to describe, but I feel as if I were staying with two people who are married or living together as I suppose their minds actually are. And sometimes I must say I feel terribly alone and rather bitter, but I don't want you to get a wrong idea, because I certainly am not jealous (I don't see how I could be, or of what) and I like them both enormously, but they manage to give me (only at times) a kind of feeling of inferiority, a feeling that I cannot possibly live up to their standard and make their kind of remark, and then I try to and fail and I feel more miserable than ever. I suppose it is rather silly to tell you this but I felt I should tell someone, because I am ashamed of these feelings and am annoyed with myself.*[10]

According to Freud, Kentish was apt to wrestle on the floor with Spender when the mood took him. "He was hysterical. He used to try and strangle himself, which you just can't do successfully. Something to do with jealousy: he'd go very scarlet, tears pouring down his face, retching."

To Kentish the "Freud & Schuster" notion seemed calculatedly exclusive. To Freud it was a lark. "Our association was of the most platonic nature: like Walt Whitman's idea of camaraderie." It was, in Spender's view, a manifestation of *Freundschaft* on the German model, the business of "Freud & Schuster" being not unlike Christopher Isherwood and Edward Upward's fantasy realm of Mortmere, though less sustained—the conceit lasted so briefly—and mainly graphic, consisting as it did of doodles and teases ("Old David Kentish who has been with the firm 65 years"), most of them no more meaningful than scribbly outcomes of parlour games. The mentions, for example,

of Freud having designs on Schuster's sixteen-year-old granddaughter were parlour banter. "Stephen and I had jokes: slightly semi-German, semi-Jewish jokes."

A Freud couplet established the partnership in formal rigmarole:

> *If Freud catches the rooster*
> *Half of it belongs to Schuster.*[11]

Before giving the dummy to Freud in the first place, Spender/ Schuster had penned an apostrophic preface:

> *O Lucien Freud, if you will*
> *This red bound blank dummy fill*
> *With pictures of that dreadful IT.*
> *By which we shall be finally hit,*
> *And writings from that unknown HOUR*
> *When we're at the height of POWER,*
> *Tracing the image of MISS RIGHT*
> *As she appears shining at night,*
> *Then the book's fame will increase*
> *Though Freud and Schuster both decease.*[12]

That "dreadful IT" was world events; there was no wireless at Haulfryn so they relied on the *News Chronicle* for reports on what was being declared the Phoney War. Bottles of ink, red, green, blue, black, cluttered the parlour table as Freud filled the pages with whatever occurred to him, one notion sparking another. "The drawings are very high-spirited. Absolutely not to do with the war," he insisted. They were Audenesque: "A private language." Louis MacNeice's "Crisis" in the January issue of *Horizon*: "Cranks, hacks, poverty-stricken scholars . . . hanging like bats in a world of inverted values" prompted flights of fancy, body parts spewing out of a drainpipe ("Probably from a newspaper story. I was quite stump conscious: Iron Foot Jack"), visions of wrinkly midriffs, a big-game hunter or two and grinning fish. ("I always liked aquariums. Always keen. I had one or two: used to go to Palmer's in Parkway and buy fish. Father may have had a few too.") A man posed with hat and pipe beside grand Egyptian columns: "I had these ideas about the ridiculousness of tourism.

Ridiculous, the thing that adults do, which is to go and look at the ruins."

The Freud–Schuster Book, clothbound in dulled terracotta, was a Freud sketchbook with occasional Spender insertions such as "To a Reviewer in *The Tablet*, Martin Turnell" ("crabbed and obsolescent / You choose to call me adolescent"), to that extent a Snowdonia variation on Auden and MacNeice's *Letters from Iceland* of 1937, with its flow of doggerel and diary, skits, maps and private jokes. As the pages filled they took on something of Auden's clipped schoolmasterly manner, the matter-of-fact ragged by the ridiculous. Looking through them Freud thought back to how it had been in 1940.

"The whole climate is so odd. Audenish. The mystification in his early things appealed to me. I suppose it came from Kafka. Fears and injustice. It's so marvellous the way he leaves emotion out of it. That poem 'To a Writer on his Birthday': 'Your squat spruce body and enormous head.'[13] It's specific and full of feeling and humour and tenderness where 'Lay your sleeping head' is beautiful and a bit banal: that's the one I don't like."

There were also art references. He drew stilted versions of El Greco's *Portrait of Don Juan de Avila*, his *St. Paul* and *St. Philip* were copied from his Phaidon book on El Greco with its velvety photogravure close-ups of demonstrative hands, skulls, Byzantine eyes, looks of rapture and concentration, lambent flickers, keys, buttons, spectacles and writing desks.

"I grew up with the Phaidon *El Greco* and even made a special cover with potato cuts. I used to love the woman in a fur coat."[14] He drew Stephen Spender in El Greco foreshortening, his face a cut-out photograph, a halo above and a celestial birdman: Spender as a sainted boy scout. "Others came out of some song or revues. I went very early in the war with Michael Redgrave and Tony Hyndman to see revues by Coward done by Bea Lillie and some came out of that."

Miss Right was a theme: Honor Frost, a drawing of whom was the frontispiece. "It went on a lot about getting Miss Right; but all I knew was a lot of scrubbers in the Coffee An'."

As the inconsequentialities accumulated, the book became a trawl of Freud's mental landscape, birds cavorting over hills, female nudes, facetious archaeology, drawings sprouting from moment to moment,

each a quote or quip, some like Spender's "the pale unshaven stare of shuttered plants,"[15] some as flippant as Harry Graham's couplet:

> *When Baby's cries grew hard to bear*
> *I popped him in the Frigidaire.*

"I used to dwell on phrases rather."

Above them, as they worked on it in front of the parlour fire, was a sampler. It read:

> *Work Done by Anne Jones*
> *Jesus Wept*

Freud produced a painting ("sort of Freud–Schuster") of a man in a painting being stronger than the person depicted. "It came out of a Russian short story I read, Leninish-looking man with a beard and a red garment and grey/blue-looking people and a splendid man above. It was done on a home-made stretcher, like *Memory of London.*" A few years later he swapped this and another picture for Lugers: spoils of war. Kentish meanwhile began a double portrait of Freud and Spender but completed the Spender half only. As for Spender, he sent a postcard to Joan Warburton: "We are deep in snow ice etc. D & L skate and take photographs in the snow, we are all enjoying ourselves very much." Kentish photographed Freud: "Me hanging upside down in the snow in a strange fur coat. Quite a lot of snowballing. Nice atmosphere." Freud photographed Spender and Kentish squaring up to one another in the snow.

He too wrote to Joan Warburton,

Leering Man from the
Freud–Schuster Book, 1940

a letter done in brush and ink on a large sheet of paper, the words augmented with a figure carrying a banner and a weeping snake head.

> *Darling Moud*
> *At it again are Ye? Well, well, well. This is a "Foranzeige" (whip out the little Germans Dictionary) for a lengthy apistle. Thanks terribly for your last letter. Hey Ho Moud and let the Nordic Banners fly! Please write me a little note to 32 St. John's Wood Terrace NW8, Londinium.*

At the end he stuck a newspaper cutting of a smiling debutante: "This is my fiancee. Like her?" and an arrow: "pretty hat bought her last Saturday." "Hoping this finds you as it leaves me if it leaves me arf arf arf."[16]
Kentish then wrote to her on 25 January:

> *Lucian sends his love thank you for the pc so does Stephen . . . Do you know when the East Anglian School is reopening, and if so is it at Hadleigh as Lett said last time that I saw him? Most of the snow has gone and it has been raining the last 24 hours.*[17]

A day or two later:

> *Since my last letter I have decided to go back to London or rather my home in about a fortnight. This is because firstly I am finding it so difficult to work as it is so cold and the studio so damp and uninviting and secondly because I am terrified of being alone with Lucian again for any length of time.*
> *It is filthy outside and dark and murky . . . I have been playing a few games of patience that simply won't come out I feel more than a little dreary . . . Everything outside is encased with ice and the telegraph wires are all broken.*[18]

Spender returned to London at the end of the month. "I had a marvellous time in Wales with Lucian and David," he wrote to Joan Warburton. "They were delightful, we did a lot of work, the lakes were frozen and the mountains covered with snow. For almost a fort-

night it was exceedingly fine."[19] Before leaving he wrote verses for the
visitors' book addressed to "strangers who came after" and beginning:

> *David and Lucian and Stephen,*
> *Envy our happiness and laughter,*
> *During a war even.*[20]

Many years later Freud deleted the Spender poems, deeming
them superfluous. The Freud–Schuster Book thereupon became
his 1940 sketchbook and was exhibited and dispersed. The images
were reshuffled for publication and drawings done elsewhere, of his
mother, Cyril Connolly, Robert Buhler and his wife Eve, were added.
This, Freud then insisted, was true to the spirit of the book's incep-
tion, it being a sixteen-going-on-seventeen-year-old's effusion all the
better for being divested of Spender verbiage. Yet at the time, writing
from Benton End, Hadleigh, the new school premises, he maintained
the "F. S." (Freud–Schuster) relationship, conducting it partly in pid-
gin German. "Mein Lieber Schuster, Spionscollege" received several
enormous straggling letters on flimsy paper, letters enclosing the bills
for his stay ("which is a terrible lot"). He mentioned adding some self-
portraits plus "a picture of an undertaker taking somebody under."

Determined to dispel what he saw as "the false idea of my relation
to Stephen" he edited the volume—some time in the late fifties—to
suit his view of it. "I didn't think that anything removed was worth
keeping. The Stephen things made it into a historical sentimental
thing instead of a book of drawings. Maybe selfish and rather vain,
but I didn't want these conjectures to do with if I had a romance.
Which I did not. I was one of a number of people Stephen made amo-
rous propositions to. I was fond of and influenced by him certainly."

The months in Wales were for Freud a first experience of living
away from home and school for any length of time. That he got on
David Kentish's nerves was predictable. After Wales he hardly saw
him. "It was rather the end." In later life Kentish was a stage man-
ager for Laurence Olivier. "He modelled himself on him and talked
like him. He was odd. Very operatic. When I ran into him once he
based the whole conversation on how Olivier talked. 'I still do the odd
picture now and then. And the occasional drawing.'" Vivien Leigh,

sitting next to Freud at dinner years later, said what a pity it was that Kentish got married.

As for Spender, that they had had such a good time together was from his point of view unsurprising. Virginia Woolf referred to it in her diary (7 February 1940) as Spender "sentimentalising" with Freud, who, looking back after fifty years of intermittent friendship, quietly remarked that "it was when he had a life which he quite liked: that's the thing." Spender's final lines in the Haulfryn visitors' book went:

> Rich loved and lovely though you (may) be
> Yet you will never be like us happy and free

"Born naughty"

Freud returned to London in February with quite a few paintings, several of which (given the lack of space in St. John's Wood Terrace) he left with Spender. "I gave him what I thought were the best ones and he lost them all. He wasn't very interested in the sketchbook." Others he stored in a house in Richmond Green where Betty Shaw-Lawrence, from the East Anglian School and a girlfriend of David Kentish for a while, lived with her mother ("With this lecherous mother. 'Oh fuck, excuse my French,' she'd say"). Those went on a bonfire eventually, to her subsequent regret.

Through the late winter of 1940, waiting for Morris and Lett-Haines to reopen the School, Freud nosed around Fitzrovia and Soho. "It was very important to me to make friends or otherwise enemies. I didn't want anything neutral at all. I never minded if my friends liked me or not. And I showed off. This was pre-amorous adventures. The Café Royal played quite a part." His attendance there won him the acquaintance, friendship too in some cases, of well-connected people: Cyril Connolly, Clarissa Churchill, niece of Winston Churchill ("Horrid Clemmie made her go and work in a factory"), Lord Berners, the young writer James Pope-Hennessy and Donald Maclean of the Foreign Office and, it later emerged, the KGB. At the other extreme, in the Coffee An', he came across Harry Diamond, who worked in the Ferodo brake-block factory and complained of not being tall enough to attract girls. "I always thought he was very curious; same sort of age as me." Diamond was to become one of his key sitters, his stocky

boxer body and aggressively bewildered air stimulating yet exasperating.

The seventeen-year-old Freud on the loose in London wanted to live the life, as Baudelaire defined it, of a *flâneur* or dandy at large: "to be away from home and yet to feel oneself everywhere at home; to see the world, to be at the centre of the world, and yet to remain hidden from the world."[1] The basement of the Coffee An', he discovered, was a dive run by Cypriots, "really scruffy, violent old Cypriots, a place where people were asleep, old women, tramps, all-night drivers and some ponces. I went sometimes, but you were definitely 'English' when you went down. Once there was an attractive girl in a nightdress. She would have been a working-class girl trained by them to get her clothes off. Exciting, near-bedtime. Anyway, the stairs were really steep and I found myself suddenly at the top again: the owner had thrown me upstairs. I just felt hit by an enormous wave. I don't think I would have been quite so easy to knock about later on."

The urge to lurk yielded to the desire to win attention, some of which he resented. "Opinion was divided as to whether he would have a career comparable to that of the young Rimbaud, or whether he would turn out to be one of the doomed youths who cross the firmament of British art like rockets soon to be spent," the critic John Russell recollected. "Everything was expected of him." That March Disney's *Pinocchio* opened in London; this, the most colourful spectacle in town, was, for Freud, analogous to his own disentanglement from parental ties. "Jiminy Cricket saying, 'What's an actor want with a conscience?' It's not in the book, which I read in Germany before I was ten. My mother sort of thought I was doing good works or something; my father tried not to notice."

Rimbaud or Pinocchio? John Russell heard Freud spoken of as "the equivalent of Tadzio in Thomas Mann's *Death in Venice*, the magnetic adolescent who, to his admirer, seemed by his very presence to keep the plague at bay."[2] In war, as in plague, any diversion was alluring. One of the clubs that Freud liked was called Careless Talk; the pianist there was Francis Bacon's future lover Peter Lacy. At the Gargoyle one night he met Graham Bell, South African painter and one of the initiators of the Euston Road School, with Lawrence Gowing ("a terrific groupie") in tow. "He said, 'When I was your age I was doing everything, I was so tough.' A he-man. He got killed."

The Rockingham, where he also went a few times, was males only, though women were to be seen there occasionally. "Toby Rowe who ran it was very gentle. His club basement in Soho was done up in stripes like Covent Garden and he had this illusion that all queers were debutantes and that he was one of those ladies that gives balls. He liked being shat on and Francis [Bacon] told me that it was tragic: he had to put panes of glass over himself because he couldn't get his clothes cleaned." Another attraction was the Music Box in Leicester Square run by Muriel Belcher, a "Miss Dolly" and another woman. The pianist there was called Hugh Wade. "He made up irreverent songs about Lady Redesdale and her daughter [Unity Mitford who had a crush on Hitler]. 'Don't send your daughter to the Reich, Lady Redesdale.' I used to go in and shout and turn off the lights." Though banned from the Music Box, in March 1940 Freud was the subject of a flattering paragraph in the *Evening Standard*'s Londoner's Diary probably placed by "Napper" Dean Paul, a supplier of gossip items (and a future sitter) indicating Freud as a name to watch out for rather than already world famous. "The seventeen-year-old promises to be a remarkable painter, intelligent and imaginative, with an instinctive rather than a scientific psychological sense." Following that, six months after his grandfather's death, Freud had the greater satisfaction of seeing a self-portrait drawing—his most Düreresque Haulfryn one—published in *Horizon*. When asked, years later, what started him off as an artist Freud liked to say that he used to go around saying he was a painter and that after a time he had to do something about it. The image had to be substantiated.

With most galleries closed, art schools evacuated to safer places, internationalism suspended and patronage in abeyance, it was becoming less possible than ever for young artists to make an impact, let alone sell anything. To have one's work placed in *Horizon*, which sold 8,000 copies that month—its largest-ever circulation—was a heady boost, especially in mid-1940 when almost all the other literary magazines had closed down. There was resentment. "Subra, the Indian poet-around-Soho, got very annoyed. 'You have no culture,' he'd say. 'Is it true that *Horizon* has sold 10,000 copies?'"

Freud's success with *Horizon* was not fortuitous, for Stephen Spender's flat, where the magazine was initially housed, was one of his haunts. He had a key to the flat, enabling him to stay away

Cyril Connolly, 1940

from home more. The writer Ruthven Todd, "unemployable, persistent, rather squalid-looking,"[3] as the disobliging critic Geoffrey Grigson described him ("Poor Ruthven Todd," Freud said of him, many years later, "a kind of non-phoney Johnny Craxton"), stayed overnight there once and remembered getting up in the morning to find "Lucian still luxuriating in bed." As they got breakfast Spender ("absolutely no sense of humour") looked over at him and said, " 'Do you know, Ruthven? I'm afraid that so far as Lucian is concerned his grandfather lived in vain.' Too good a remark to be lost."[4]

Among the four or five paintings Freud gave to Spender on their return from Wales there was one that he particularly liked; it was, he said, "influenced by a poem about a room across the square and people lying in the square":

The light in the window seemed perpetual
Where you stayed in the high room for me.[5]

"That thing of people lying near each other in a square. These were two men":

Now I climb alone to the dark room
Which hangs above the square
Where among stones and roots the other
Peaceful lovers are.[6]

"Stephen never kept anything. 'What are we going to do about your work?' he would say. He never believed in my work.

"I remember when I worked at *Horizon*. Well, not *worked*: I hung

around, making a nuisance of myself. Sonia [Brownell] being a crass character, liking the loud whisper behind the hand, was incredibly generous to me. I drew quite a lot there as I wasn't set up and I hadn't got anywhere proper to work. I used to borrow the flat sometimes from Stephen because he didn't really live there; and I helped address envelopes which, unfortunately, had to be readdressed afterwards because of my handwriting."

The *Horizon* office, fussed over by Sonia Brownell and staffed by other admirers of Connolly and Watson, attracted would-be poets and writers offering their services free. Among them was Michael "Micky" Nelson from Bryanston in whose 1958 novel *A Room in Chelsea Square* the setting up of *Horizon* (there called *Eleven*) was lampooned, with Peter Watson and Cyril Connolly as the two most guyed characters.

Horizon's backer, Peter Watson (£33—and more—a month, ostensibly to subsidise the sale of 1,000 copies), had become a backer of Freud too. "He helped me very much, looked at my pictures and bought things and gave me money and books. He had pictures that I liked and learnt from, very good things. And he worked quite hard at *Horizon*. Dalí was bitchy about him. 'Peter Watson only likes Picasso because it reminds him of Pre-Raphaelites,' he said."

Watson had established himself in Paris at 44 rue du Bac, where most of his paintings (Picasso, Miró, Klee, Rouault, Poussin) were lost when he retreated to England leaving them with a Romanian friend. He had returned from Paris the week war broke out. To him, London was journey's end for a reluctant cultural evacuee. While there, *Horizon* was to be his war effort. He built up a more insular replacement collection in London and moved from a flat off Piccadilly to a Wells Coates block in Kensington's Palace Gate where his drawings by Paul Klee, a Juan Gris, a de Chirico ("one with a statue and row of houses and a girl with a hoop and a long shadow"), Picasso's *Metamorphoses*, a monograph on Altdorfer and the art magazines *Verve*, *Minotaure* and *Revue Blanche* were available to his protégés and indeed to all well-disposed callers.

"Peter Watson had an extraordinary kind of taste, amazingly free and open. One week he came back and he'd bought a Poussin, a small one, he just saw something so modern in it, but when he got jaundice he sold it because he couldn't bear anything with yellow in it. He had a marvellous kind of abandon. His queerness didn't affect me; the gay

world was more assimilated then, I mean for me: it wasn't something people made a feature of. Anyway, he wasn't a night bird. Too fragile."

Separated by the fall of France from the bulk of his collection, Watson restocked locally. In May 1940 he bought Sutherland's *Entrance to a Lane*: a transplant of de Chirico sundial shadows to the hollow lanes of Pembrokeshire. The fat root and stem in his Sutherland *Gorse on a Sea Wall* became a talismanic beckoning arm or honking tuba, diverting impressionable young painters into Neo-Romantic locales, that rhetorical consolation of English landscape art in wartime.

Watson had inherited a fortune derived from margarine. "Money was secondary to him; he was tremendously generous." He gave Freud contacts, travel opportunities and rooms to work in. His patronage was unique, not to say quixotic. "The best possible relationship with him," Stephen Spender said, "was to be taken up very intensively for a few weeks and then remain on his waiting-list."

Freud remained high on Watson's list for ten years. "Early on, when I went down to Cedric's in 1939, Peter wrote to my parents and said he would like to pay fees for my being there. My father was a bit put out and said it was very nice of your friend but . . ." Watson wrote to Freud saying he believed in his work and ending with "All my ripest and my finest for you." That was, Freud commented, "quite bold for then." But then, as Michael Wishart, a later protégé, remarked: "Peter's cure for boredom was to interest the young. No one was better at it."[7]

Tall and diffident, the heir to the Maypole Dairies margarine fortune was an open-handed self-effacing patron, supportive when opportunities for young artists were dwindling and when for many the temptation to embrace dolorous self-expression was irresistible. "He knew very poor people: boy friends that he spent time with. One evening when the doorbell rang and he was being pestered he said, 'I want to be treated as a newly married couple.' Which was sophisticated in the best possible way. He giggled a lot.

"My horrible Uncle Calmann obviously thought I was queer and he asked me and Peter Watson to lunch at his gallery and told my father I was mixing with very disreputable and dangerous people. So disgusting: I never talked to him again. The other guest was this very unlikely person, a grandee called Sir Campbell Mitchell-Cotts, a very queer baronet who played butlers in touring repertory companies and

collected old china. He was only a customer my uncle asked because he thought what other poof can I ask with my nephew and this rich dilettante?"

The East Anglian School reopened shortly after Freud and Kentish got back from Wales, initially in rooms behind the Sun Hotel in Dedham, then at Benton End, a sixteenth-century farmhouse in four acres of orchard (thereafter mostly garden) bought for Morris by Paul Crosse, the Crosse & Blackwell soups heir. "Paul Crosse had been photographed by Man Ray as a beautiful hermaphroditic; he used to come over; he had an affair with Cedric which broke up his romance with Lett and his name used to come up in rows."

The house, a few miles over the Suffolk border, above the meandering River Brett between Layham and Hadleigh, had been unoccupied for more than ten years. At first Freud was not allowed to stay in the house (why risk him smoking in bed?), so he lodged at the Shoulder of Mutton in the village. He faced the inconvenience of sharing a bed with Kentish. "I was having an affair—quite out of devilment—with his girlfriend, Betty Shaw-Lawrence, and in the night he turned over, shouted her name and felt an arm and thought I was her. And I thought he was her. It went nowhere."

Before long, and none too soon, he thought, he was given an attic room to himself and a stall in the stables beside the house to use as a studio. Hadleigh was within walking distance of Walberswick; proving this, he found once, took all night.

Freud's *Lyrebird*, paraded in a drawing done soon after the move to Benton End to serve as a cover illustration for the Indian poet Tambimuttu's magazine *Poetry London*, looks cocky enough to advertise the new establishment. Elevated to phoenix status, it flaunts itself in front of an old "Suffolk pink" colour-washed building with a smoking chimney and a necklace of spotty onlookers strung beneath it. Emblematic perhaps, certainly exotic, it is art, or the artist, come to strut in Hadleigh and facing local resentment of the arty London weekend types who flocked there, albeit in small numbers.

Freud wrote to his mother a letter mostly in English and primarily thanking her for "delicious socks" and demanding sheets, blankets and pillow cases for his Benton End bedroom ("*schnell! schnell!*

schnell!"), adding, "Please for your own sake not for *mein geh in eins von den* Charingcrossroad Bookshops." He urged her to buy:

> *the magazine POETRY (LONDON) for which I designed the drawing on the cover. I enclose a few circulars for it which would you please give to some of your richer intelligent friends Marjorie Gill etc. Who I am sure would be interested.*

Ernst Freud meanwhile responded with special pleading to a letter from Lett-Haines concerning school fees. His prospects were poor, he stressed. "I'm not doing very well as an Architect just now and unfortunately there is not much hope that things will improve soon."[8] Three months later, by which time the Battle of Britain was well under way, he wrote again:

> *We are both very glad to hear from you and from Lucian directly as well that he is working hard and with success. [Then to the nub:] I had to write to him a few days ago asking him to economise and to try and find some means of earning at least part of his living. Owing to the war my work has stopped and Lucian is only one of eight people for whom I have to provide. On the other hand I do not want him to stop with the work at your school as long as it can be avoided. I hope he will do something about it. I am enclosing a cheque for the materials [covering] 18 April and 19 July 1940.*[9]

Lax in many ways, careless over keeping curtains closed in the blackout (thereby prompting suspicions in the village of Benton End about the school being a hotbed of fifth-column activity or foreign intrigue), Morris had never really bothered to impose discipline or restraint in what his prospectus described as "an oasis of decency for artists outside the system." His knowingness comes across in the portraits of one another that he and Freud produced in the early days at Benton End. Freud's Morris looks sharp, pukka, teeth clamped on a ridiculously small pipe ("A penny pipe: I used to smoke tea in them when I was fifteen") and a well-used thumb suggestively cocked. Conversely, Morris' blue-eyed Freud looks uneasy, all too aware that a portrait could be—maybe should be—"revealing in a way that was

almost improper." He described it in a
letter to Spender: "My face is green. It
is a marvellous picture."[10] Morris was
bringing him on as a painter by force
of example and that in itself made him
uneasy. "You can't really teach paint-
ing but you can certainly encour-
age the talent, if any, that is there."[11]
Later on Freud thought the painting
"rather quick, a bit soppy, hair made a
bit much of."

"I used to watch him work. He
never said much. I got the feeling of
excitement. He worked in a very odd
way. Rolled from top to bottom as if
he was unrolling something that was
actually there. And even when he was
painting a portrait he'd do the eyes—
put the background and the eyes and

Sir Cedric Morris, 1940

then the whole thing in one go and not touch it again. Great to watch:
gave a feeling of sureness. I got quite fascinated watching him." Mor-
ris' aversion to medium and over-painting, wet on wet, impressed
him; he was to abstain similarly many years later.

Freud gave his portrait of Cedric Morris as a swap to another stu-
dent, Barbara Gilligan, who was to marry David Carr, the Peek Frean
biscuit heir, a couple of years later.

Carr lived with his mother in Walberswick. "Once he gave me a
lift in his little car to Walberswick and as we went he reached over and
started to undo my trousers. I told him to lay off.

"'Your friend Michael Jeans doesn't mind,' he said.

"'You're wasting your time.'

"'I hope you show that kind of sincerity in your paintings,' he
said. I wasn't a fragile flower: no 'leave me alone.'

"'Thanks, awfully, I can undo my own flies,' I said. I was never
queer. At school I had odd moments. A boy, Humphrey King: I used
to put out my arm as I went by—like sailors and girls—but if he'd
responded, I wouldn't have."

. . .

Usually, during the week, Freud would be at Benton End, then at weekends he would come up to London for the night life, going to clubs: the Boogey-Woogey and the Swing Out in Denman Street off Piccadilly, the Shim-Sham or Frisco's in Sackville Street. "I'd do anything to get in. I'd go to the Café Royal and some queer would take me along there and I'd disappear. There were bottle parties: cost ten shillings and your bottle to get in and the bottles were marked to show how much you had drunk. I was quite popular there among those 'waiting expensively for miracles to happen' (that Auden poem)."[12]

One weekend Freud went with Spender to stay with Rosamond Lehmann and Wogan Philipps, her estranged husband and communist peer of the realm. The visit to this "domed hall near Reading decorated by John Banting" was not a success. "Cecil Day-Lewis was Rosamond's lover, living there, and he asked me to do drawings for his translation of Virgil's *Georgics*, on agriculture, but I looked and felt I couldn't. Wogan took me to his studio (he was a keen amateur painter) and there were several hundred portraits of Rosamond and this lover. She, deeply understanding, put me in a bedroom next to Stephen and I had to put a chair under the door handle."

In a letter to Spender he surrounded an image of himself weeping huge mock tears with rollicking banter.

> *Life for me is no longer the monotony of waking up in a cold room to find myself with Clap, D.Ts, Syph or perhaps a poisoned foot or ear! No Schuster, those happy and carefree days are gone. The phrase 'Freud and Schuster' no longer calls to mind happy scenes such as two old Hebrews hand in hand in a wood or a bathroom in Athenaeum Court or pension day in the Freud–Schuster building but now the people think of Freud and Schuster in bath chairs, Freud's ear being amputated in a private nursing home and puss running out of his horn. Schuster in an epileptic fit with artificial funny bones. When I look at all my minor and major complaints and deseases [sic] I feel the disgust which I experience when I come across intimate passages in letters not written to me.*[13]

With that, he assumed, the game of pretence was ended.

Among those who came down to Hadleigh was Tony Hyndman, whom Freud drew finger in mouth in the back pages of the Freud–Schuster Book. "Tony had been Stephen's great friend; he had taken up with Michael Redgrave who was always a schoolmaster: he had 'M. Redgrave' printed in red letters on his writing paper, which we thought vulgar. Stephen used to write news poems to me. One of them went:

> *Tony's gone to Scotland*
> *In special sleeping car*
> *Michael's gone with him;*
> *You'll remember he's a star.*

At Benton End he painted Spender, awarding him a face twisty with concern and concentration. Peter Watson also visited, bringing books. "One was *Histoire de l'art contemporain* and I remember David Carr walking round declaiming the title 'Historie de l'art contemporain, Historie de l'art contemporain,' on and on. David had *circus* good looks, camp and hysterical, easily frightened, anti-foreigner, anti-Semitic. He was furious when I had my first show." (In fact Carr bought a drawing from the show but then developed a more lasting admiration for L. S. Lowry.)

The book passed on to him by Watson that most appealed to Freud was *The Lay of Maldoror* by Isidore Ducasse, alias the Comte de Lautréamont: the edition published by the Casanova Society, translated by John Rodker—who described it as "the last magnificent flare up of Byronism in Europe"[14]—and embellished with Odilon Redon images, among them the eye suspended from a parachute.

Freud liked imagining himself caught up with Maldoror in magnificent tempests and the thought of being wooed by a female shark. He plunged into the spume of words dashed luxuriantly together: "perfumed sores, the thighs of camellias, the guilt of a writer who rolls down the slope of annihilation and despises himself with joyful cries."[15] *The Lay of Maldoror* served Surrealists as the gospel of automatic writing, their very own Pentateuch. In his *Short Survey of Surrealism*, written when he was seventeen, the poet David Gascoyne hailed it as "a debauch of the imagination."[16]

Maldoror had enjoyed a happy childhood. "Afterwards he became

aware he had been born naughty," Freud said: whereupon his instinct was to seize the passing fancy—"Fleas are not capable of doing all the evil they meditate"—with disregard for inner meaning, aphorisms spitting and ricocheting like hot fat in a wetted pan. "Hatred is stronger than you think, its behaviour is inexplicable, like the shattered appearance of a stick in water." Excited by such talk, Freud added doodles to the folder of material for the *Black Book*. "Micky [Nelson] had written a lot, anarchic writing, and I did drawings, influenced by Maldoror. Things like the terrible waves and someone clambers on to a rock with one last effort and a man on the dunes picks him up." Reading *Maldoror* encouraged in him the hope that feelings ardently expressed could more than offset any lack of facility. "It was when my idea of ultimate artistic sophistication was not being too artistic: to draw a line and then do dot dot dot for what I couldn't. Most people thought then that my work was rotten."

What others may have assumed to be a disregard for accomplishment was actually Freud's literal interpretation. To him the perils of Maldoror were validation through metaphor. Things said could be things done in drawing. "The spar of flesh was washed ashore": he could draw that. Maldoror as Symbolist jetsam was salvageable, but in line rather than tone, in black and white rather than colour. Any art-school-approved "form in the mass" exercise would have been pointless and, at this stage, beyond his capability.

"I found the actual putting on of paint extremely difficult but drawing I always liked and had an idea I could do it and so didn't value it. I think my system came through an obsessive way of working. I don't know where it came from. It's a crazy way. I sort of still work like that." The sketchbooks that Freud had used in Wales still had blank pages among the many studies of skating and horses and dogs and Stephen Spender. Drawings of Cyril Connolly ("He hated it—it was very like—and didn't speak to me for six months"), of Tony Hyndman and of the painter Robert Buhler were added, also three of his mother done at different times: an unsmiling face.

By the summer of 1940 the Phoney War was over and Heinkels were overhead, en route from the Hook of Holland to targets in southern England. Few resident students remained at Benton End. Morris devoted himself to reclaiming the walled gardens and began the cultivation of irises; Lett-Haines did most of the cooking and talking. "It

was all very makeshift. We had models quite often but days revolved around meals, which were delicious. Dicky [Chopping, whose father had been Mayor of Colchester], and Denis [Wirth-Miller] were maid and cook in exchange for tuition. It didn't work out very well as Denis made some remark about old people and Cedric was very touchy. Dicky took care of the fetish side of things. An eccentric woman who ran out of happiness and marriages said to him, 'I'd like to show you my buggery.' She collected bugs, the sort of thing he drew. Dicky had this idea of 'Histoire Naturelle of Penises' and Denis wouldn't let him." Chopping in striped shirt and duffel coat sat for both Morris and Freud: same clothes, similar pose, but in Freud's painting his eyes narrowed and he lacked elegance. "The painting came quite near," Freud said, meaning that it was as close to the Cedric Morris manner as he ever went.

Visitors still came to Benton End: Algernon "Algy" Newton, painter of wooded landscapes theatrically side-lit and preternatural calm on urban stretches of the Regent's Canal, who lived in Suffolk; the textile designer Allan Walton from Shotley near the mouth of the Orwell and the Stour; and Katie Hale—Kathleen Hale, Mrs. Maclean—the author of the *Orlando the Marmalade Cat* books, who stayed for weekends occasionally. "She had a sort of affair with Lett, and Cedric was fairly sour, even though he never spoke to Lett, as he didn't like having women in the house. 'Moggy' she was known as, for obvious reasons." She put recognisable people in her drawings such as Augustus John, her first lover. Lett was Monsieur Pied-à-Terre the dancing master, and Benton End became one of her settings. Orlando (named after the Benton End cat) went camping on the riverbank below the house, and the farmyard also featured. She bought two pen drawings by Freud, one of a woman, possibly Denise Broadley: "A woman playing an instrument, rather nice; it relates to my later things. Denise was spiritual so I made her slightly like an angel. A wing-ish look. Moggy got in a fury and I had a flaming row as she asked me to sign them and I said my signature would be worth something." Freud himself did not feature in any *Orlando* book; in her memoirs, however (*A Slender Reputation*, 1994), she described him as "a strange lad, sharp as a needle and sophisticated beyond his years" and included a snapshot of him in the garden at Benton End wearing his fez. He was, she said, "like a being from another world and his

presence at the school had a galvanising effect on the other students."
Her graphic style, bold but ornate with double spreads sprawling
over quarto pages and laced with gossipy innuendo, was a cheerful
reflection of life at Benton End. And Freud's work was not entirely
excluded. The bedroom of Judge Wiggins in *Orlando the Judge* (1950)
was a parody of *The Painter's Room* (1944), Freud's prized zebra head
transformed into a rhinoceros head and his potted palm into hat-peg
antlers.

Benton End bubbled with intrigue. Cedric and Lett would com-
municate only by notes stuffed in coat pockets and when friends came
visiting relationships were endlessly speculated on and tut-tutted
over. A Welsh couple, Tom and Marion, were brought in to help
around the place. "It was awkward when Cedric had them there—job
creation—as they didn't have enough to do. Tom did many practical
things, and bullying too; he was a bit of a bastard, incredibly stimu-
lated and not knowing whether to be excited or disapproving that
there was some sex going on."

Girls featured. "A girl called Lorenza Harris there was a row
about. There were twin girls—piggish and nice—people thought
them marvellous identical twins, but I could tell them apart." A silo
tower in a field above the house became a rendezvous, handy for a bit
of privacy. Betty Shaw-Lawrence ("ugly, plum in her mouth") was up
for going there with Freud but she refused to go to London with him.
"She was quite exciting, sort of corrupt in a tiny way. Priggish. I was
eighteen and I liked the idea of glamorous older women." He did a
drawing of himself in the silo tower draped coltishly over a demure
girl in high heels, his face peppered with pen and ink stippling, her
hands touching and the hay tinted yellow. The girl was Felicity Hel-
laby and the scene was a daydream: some lines as heavy as the leading
in a stained-glass window design, others going dot dot dot for what he
couldn't be clear about. Her parents lived in the area and were friends
of the Munningses, therefore wary of Cedric Morris and his crowd.

Mary Hunt, the Coffee An' acquaintance with a metal foot and
married to a film-maker, came to model (his idea) at Benton End.
She became his first buyer—ahead of Kathleen Hale—when she paid
£5 for *Stable at Benton End* (1940), a picture of a wary girl minding a
shrunk and stretched horse ("I made up the horse") below a portrait
hanging beside the painter's jacket on the part whitewashed, pain-

stakingly detailed brickwork enclosing his loose-box studio space. Painted shortly after *Stable at Benton End* and the portrait of Cedric Morris, *The Refugees* (1941) is a set of characters straight off the boat, "(friendly) enemy aliens" as Freud put it, oddly clad with awkward hats; not arrivals as his own family had been: immigrants with possessions and opportunities and potential for assimilation. The central figure in dark glasses with a dozen hairs trained across his baldness was modelled on the Freuds' dentist in the Finchley Road. His wife and son link arms with him, steadying him and towering over the more lively youngsters. Behind them a yacht and other vessels, recalled from holidays on Hiddensee, sail by. For some reason (why, Freud couldn't remember) he rather liked implanting curious wee details in certain paintings and drawings, like the drolleries in the margins of illuminated manuscripts. "Guilty but insane," he said. There are tiny faces in the woman's skirt, scratched in like lice. As a group, laced together—hands on shoulder, arms linked, fingers crossed—they are suspicious of England but, with their backs to the sea, they have nowhere else to go. Forgetting her manners, the little girl in a pixie hood sticks her tongue out. Different expressions, direct, averted, abstracted, obscured by dark glasses, were tried. "I did a kind of joke refugees group; the composition was supposed to be like a banal photograph you line up (No, I can't see you . . . No . . .); the children in the first row and second row and so on." They resemble the people in Louis MacNeice's poem "Refugees," published in March 1941:

> *With prune-dark eyes, thick lips, jostling each other*
> *These, disinterred from Europe, throng the deck . . .*
> *Thinking . . .*
> *. . . we do not want any more to be prominent or rich*
> *Only to be ourselves . . .*

"Refugees were terrified when they came, and demoralised. So many there were, Jews in Golders Green and Hampstead, and they gathered in those terrible restaurants in Finchley Road: horrible and Germanic and only a bit better than concentration camp food. And they'd sit there. Just sit there. There was a joke. The word '*miete*' means rent and '*mieter*' is lodger. A man knocks on a door and says, 'I've come to read the meter.' 'I *am* the *mieter*,' the woman says."

. . .

Landscape with Birds, dated July 1940, was painted, with the board resting on his knees, in the ground-floor flat in 2 Maresfield Gardens where the Freuds moved—"just a Jewish panic, you know"—to be in a more substantial building come the anticipated bombing. Its tumbled bricks, artificial flowers and withered trees rendered in household paint make it a throwback to the shiny daylight of a Dulac illustration and, more immediately, Freud the cinema-goer's touchdown on the Land of Oz. "Since I remember nearly everything I've done, actually doing it, I remember doing the sky in *Landscape with Birds*, and then the birds on it. I realised that painting in house paint over house paint would be a disaster, so the birds were ordinary paint. Learning to paint is literally learning to *use* paint." For the boy launching a paper boat the setting has to be Hiddensee remembered, the Hiddensee of holiday drawings from ten years before: same flowers, same building-blocks, same quirky birds. "My idea of birds was this body, like a fishing float between two wings. I don't know where it came from."

The *Studio* magazine in June 1940 reproduced *St. Christopher*, by Konrad Witz, in which comparable birds fly over similar land and water and two months earlier the magazine carried a reproduction of the tumbler angels in Giotto's *Pietà* in the Arena Chapel in Padua. Freud admired quattrocento assurance: "I used to look with marvelling wonder at that kind of thing." Whatever their origin—possibly not Giotto but the heraldic eagles on old German banknotes—the birds have sprung into the air, alarmed by the bogey boy leaping a spit of land.

In July leaflets publicising Hitler's "last appeal to reason" were dropped over southern England as a preliminary to what was to become the Battle of Britain. That month Uncle Martin was interned as an enemy alien and his son, Walter Freud, was deported to Australia on the SS *Duneira*, as was Podbielski, Freud's Café Royal acquaintance. Anna Freud, up the road at 20 Maresfield Gardens, had her radio confiscated. "They took it away because I am an alien," she explained to a visiting American newspaper owner, Ralph Ingersoll. Freud was conscious that, had Marie Bonaparte not intervened the year before, he too might have been sent away on the *Duneira*. "It was where I would have been without the Duke of Kent."

Landscape with Birds invites assorted interpretations. The bird-scarer with blackened face and hands could be Hanns Head-in-Air from *Der Struwwelpeter*, or a mischievous evacuee, or Freud's younger self: the long-jumper of Matthäikirchstrasse 4, the Agility pupil of Dartington. He could be Lautréamont's Maldoror, "carried away upon the wings of youth," or even Morgenstern's *Palmström* ("Can't you turn yourself into a fish?"), but, if he has to be anyone at all, the leaping boy fits best into the role of the nursery rhymester in "I had a little nut-tree" from *The Poet's Tongue*:

> *I skipp'd over water, I danced over sea*
> *And all the birds in the air couldn't catch me.*

Freud was not only learning to use paint; he was also realising the elusive, showing by painting that he could be free-ranging and answerable to nobody. Broken walls, swollen waters and red-socked levity: as Spender had written when they left Capel Curig "Envy our happiness and laughter during a war even." And there was Cousin Walter being shipped away to Australia through U-boat infested waters.

Horizon, namely Spender and Connolly and Connolly's new girl-friend, "Diana," together with Peter Watson footing the bills, had left London in June for the seclusion of Thurlestone Sands in South Devon. They rented Thatched Cottage, a bungalow belonging to Micky Nelson's parents, and hired a cook. At Spender's invitation, Nelson and Freud came down for a brief visit, calling in at Darting-ton on the way. Things didn't go well: there was talk in the district of these arty types being German spies. Connolly, characteristically, turned sulky ("I spend my time here reading French poetry and wait-ing for meals"), while Peter Watson fretted about the paintings that he had retrieved from Paris before France fell and sent to America in the care of his boyfriend Denham Fouts, knowing that he would probably sell them to buy drugs. By mid-August the flames and searchlights marking the first raids on Plymouth could be seen nightly across the bay. At the end of the month they gave up the cottage and all returned to London except for Spender, who went to teach for a term at Blundell's School in Tiverton. Freud wrote to him on a sheet of flimsy paper adorned with formidable potential Miss Rights, fes-

tooned with tittle-tattle ("Peter hopes that Athens will be bombed in his absence") and touchline teases about the reluctant teacher "in cap and gown steering the heavy cane, wielding it with a horrible hand on the spotty behinds of the boys of School house," Spender having told him that the Blundell's boys were ghastly compared to their Bryanston counterparts. One of his rhyming newsletters (here described by its recipient as "the wonderful ballad of Blundells jail") went:

> *Dearest old Lucio*
> *As we all know*
> *We mustn't worry*
> *How badly things go.*

The London Blitz began in September and continued for seventy-six nights. Hampstead was bombed on the night of the 8th/9th and within a week dozens of houses had been destroyed and people killed, all within a mile of Maresfield Gardens. Subsequently Freud produced what he described to me, thinking it had disappeared for good, as "a slightly war-ish thing of a town being bombed: a bit of a Bawden actually." The mapping-pen drawing *Man and Town*, which re-emerged in 2011, shows a boy in a hat fashioned around a pre-existing blob of blue gouache set against a minutely elaborated townscape the architecture of which is construction-kit-modern with Germanic accents, sparsely occupied and detailed on a minute scale, down to a barely visible turd dropped by a flea-circus-scale dog. Bomb damage is minor but noticeable, rubble already cleared from pavements and neatly heaped. A distant hill, presumably Primrose Hill as seen from the highest window in Maresfield Gardens, appears unspoilt by enemy action. Above the streets, as though treading air, the boy displays a studied lack of reaction. Further drawings done around then about which Freud in retrospect had pronounced qualms were attempts to animate the stress of being there, in North London, when the war, phoney no longer, suddenly arrived overhead. He tried stamping a potato cut of the word "WAR" on skies swarming with Valkyries. He gave one of these essays in War Art—coils of barbed wire on a beach with "WAR WAR WAR" stamped over it—to Michael Hamburger but reclaimed it forty years later and tore it up. Being less obviously topical, and thereafter less dated, *Landscape with*

Birds survived. "When I re-found it I thought it was actually a proper picture."

In late 1940 invasion was likely. What then? New British passports would be no protection and émigré and refugee alike would have nowhere further to go. As David Low reminded readers in his introduction to a Penguin book of his war cartoons, put together that November and published the following February, Hitler had certain plans. "Politically, his work so far has been destructive rather than constructive, if one excepts the construction of new problems, such as the Jewish problem, for which he disdains to offer any solution but death."

An editorial in the *Studio* for November 1940 reported the experience of many, particularly in London: "To-day we arrive at our office to find it does not exist. It is buried beneath a heap of rubble, with all our London stocks." Piet Mondrian, after being almost hit by one of the bombs dropped on Hampstead in the September raid, left for America, spending two weeks on an open deck in a convoy before reaching New York. Peter Watson drove a Red Cross van, having been ruled too thin for active service; others joined up, Joan Warburton among them. By the end of the year Stephen Spender was wearing a fireman's uniform. Anna Freud made a collection in a bowl in the front hall at 20 Maresfield Gardens of pieces of shrapnel raked off the lawn or picked off the roof.

"I used to always put secrets in. I still do."

In 1940 Ernst Freud was commissioned to convert part of the Good Housekeeping Institute in Grosvenor Gardens into a British Restaurant, one of more than 2,000 set up under the auspices of the Ministry of Food "to secure minimum nutritional standards for members of the population hitherto unaccustomed to take substantial meals away from home."[1] Following on from that he was asked to design a test kitchen and laundry for the Cookery School. A mural was required for the shutter on the serving counter in the canteen and Ernst Freud got Lucian to submit a sketch for one. It was accepted. It was *Landscape with Birds* once again, this time with bats: "a fortnight's hard work. I had a lot of bats flying around, and then I put in a man. It was horrible, they said, and Father sided against me. He said he'd had trouble enough persuading them to let him do it in the first place. They painted it out."

Later on he did another mural, for a club in Leicester Square ("these clubs all had Caribbean names"), involving "sinister men sitting on horses glowering at the dancers" in orange, yellow and black pastel on rough walls. "Payment was two weeks at the club but I had just one night: the club was closed down just before I finished. I'd been hoping to get free drinks there." He also painted a mural for "some coffee stall off Leicester Square: the Anglo-Russian Café. When Russia came into the war, suddenly all the people who had pretended to be English decided it was time to be ethnic a bit. A displaced person—the sort of person who taught or had a café and made

sandwiches and wasn't interned—asked me. I did one wall and Johnny Craxton did the other."

Freud first got to know Craxton towards the end of 1941. Two months older than him, and several inches taller, Craxton was musical (his father Harold was a pianist and professor at the Royal College of Music); he had been brought up in a crowded bohemian household in Hampstead. He was a sociable being, considerably better versed and connected in cultural matters than Freud. He had even seen *Guernica* in its original location, the Spanish Pavilion at the International Exhibition in Paris in 1938. In 1939 he had enrolled at the Académie de la Grande Chaumière in Paris to do life drawing. The Craxtons had been bombed out of their house in Hampstead in January 1941 and were living—all five of them—in a tiny flat in St. John's Wood. Craxton was exempt from military service: a history of pleurisy. Through the musician James Iliff, from Bryanston, Freud got to hear of the lively Johnny Craxton with his signature style (he liked to think of himself, he used to say, "as a kind of Arcadian") and he went to the Craxtons' flat asking for him and, told that he was away in Dorset, left a note suggesting that they should meet.

Another beginner, similarly declared prodigious and several phases ahead of Freud in 1942 in terms of self-promotion and recognised achievement, was Michael Ayrton, recently discharged from the RAF (he kept the greatcoat) and at twenty-one already a developed bohemian character with beard and shooting stick and hair slicked back. He and his art-school friend John Minton had exhibited together at the Lefevre Gallery in 1940, and in 1942 jointly designed a production of *Macbeth* for John Gielgud. Having studied in Paris, Ayrton boasted acquaintance with Berman, Bérard and Pavel Tchelitchew, the three founts of Neo-Romantic expression. The self-styled "suave little Ayrton" invited Freud to come and see his paintings. He lived round the corner from Maresfield Gardens.

"I went to the house, a big ugly house in Belsize Park, and handed my coat to a woman who turned out to be Ayrton's mother. We went upstairs, he showed me the paintings and I said very little, just 'I like that one best,' felt I had to go and as I went he leant over the banisters and shouted down, 'Why don't you like my pictures?' and I got out quick.

"I was conscious of his superiority—knowing Tchelitchew, Ber-

man and life in Paris—but because of the twisted way he worked I had some contempt for it. I didn't get even a *whiff*, like from Cocteau or even from Miró's *Harlequin's Carnival*: he was much nearer to Arthur Rackham. His manner was so nauseating: a bogus insider talking. I can remember being rather touched at Johnny Minton's being sort of in love with Ayrton. But he was odious." Minton wrote him a letter which, seeing that it was laudatory, Ayrton kept in his wallet for others to admire.

"Unfortunately I had told him that I had this girlfriend, Lulu, and that I had had a dream that he was with her. But he drew himself up and said grandly, 'Oh, you need have no worry on that score.'"

Lulu was Lorenza Harris, another Coffee An' girl. "A glamorous, dazzling blonde from Wimbledon; it was with her that I went into my first pub, with Iron Foot Jack. We went to the Fitzroy and as I had never been to a pub, when he said, 'Have you got the admission fee?' I thought it must be like a club, but it was his genteel way of saying have you got enough for a drink. What would I have? 'Whisky,' I said, as it was all I had heard of. Lulu was sulky and nice. I went out with her for some months, but I never had any money and she wanted to go to the cinema and restaurants. I wanted her to be completely devoted to all my wishes and decisions and she wasn't at all." He was photographed with Lulu on the roof of 2 Maresfield Gardens. He had put a chair on the leads for sunbathing. "I quite liked the idea of a photo of me and her. I'd seen a still of Rudolph Valentino as the Sheik and thought I'd like her at my feet, so I asked Frankie Goodman to take some, in an appropriate film-noir style. Frankie had been one of the bright young things with the Tree sisters and Cecil Beaton. I met him I think in the Coffee An', then he joined the army and wrote me some letters. One of them said something funny: 'I feel I must write to the little friend at home and you are the only candidate.'"

The Lulu affair soon waned. "I didn't get on with her father, who was a great admirer of Sir Richard Acland." (Acland was an MP and the proponent of a liberal world order.) "He saw me at Roehampton swimming pool drawing and was deeply impressed; but I never had any money." The end came with a sudden spat. "We were walking down Piccadilly past the RA and she said weren't the gates beautiful? I said they were horrible and pretentious and she got very het up and we parted and that was it."

The deep basement of the Coffee An' gave shelter during air raids: "A sense of (probably false) security," a showbiz journalist Peter Noble wrote in his memoirs *Reflected Glory* published in 1958. "Lucian Freud was a regular here. Pale, excitable, good-looking, he usually attracted a group of fellow-artists to his corner table, as well as several exotic-looking actresses and artists' models (all of whom seemed to be in love with him!). Quarrels broke out around him, and occasional fights, but Freud remained imperturbable, a cigarette permanently in his mouth, his dark eyes glistening with amusement."[2]

Paper rationing and distribution problems shrank *Horizon* and prompted an appeal from Cyril Connolly, published in the February 1941 number, asking readers to reward individual contributors with tips. "Not more than One Hundred Pounds: that would be bad for his character. Not less than Half a Crown: that would be bad for yours." He went on to solicit, primarily on his own behalf, food boxes from the United States.

The same issue carried an advertisement for the East Anglian School at Benton End offering "instruction in the new forms and their recent development." This meant not War Art—too current a genre—but "landscape, head and figure from the model, birds, animals, flowers, design." As it happened that month Freud won a competition set for the students by Allan Walton for a fabric design. His motif was horses. "Horse with a repeat of jumps; it was produced as a textile, but instead of my careful spacing they put a wiggle in the space." He spent the prize money on a ticket to Liverpool. Skip over water, dance over sea: since his eighteenth birthday in December he had been old enough for conscription, but that was not the reason he decided to try his luck in the Merchant Navy.

John Masefield's poem "Dauber," screeds of which Freud had learnt by heart at school, tells of a sensitive lad, a would-be artist, "young for his years and not yet twenty-two," who becomes the ship's lamp man and painter. For Dauber the seafaring life was the attraction:

> *The fo'c'sles with the men there, dripping wet:*
> *I know the subjects that I want to get.*

Freud did not enlist for artistic purposes. He had an urge. "I never asked myself why. I won the prize—Allan Walton gave £25—so I went to Liverpool with the object of getting on a ship. Cedric and Lett knew Jack Barker, so I didn't exactly scarper there. I think I wrote to Cedric." That he may have done, but he told his parents nothing except that he was going to Liverpool while telling others that he was off on an exploit. Looking back with seventy years' hindsight Felicity Belfield wondered whether this was a sort of escape attempt. "That was a time when England was expecting to be invaded and his parents perhaps encouraged him to go abroad." Freud insisted that this was not what he had had in mind. Fear of remaining in Britain, prey to invaders, just didn't come into it. He thought of it as something of an excursion, that's to say a return trip: an epic jaunt.

He got the idea from Jack Barker, a Suffolk friend, "a completely wild merchant seaman, amazing, mad, gave wild parties." Barker had served on windjammers and later on was to open, the blurb of one of his books claimed, "the most successful fish and chip shop in the history of New York"; to Freud he was a figure of reckless charm, seven years older than him and in every way more experienced. There had been an affair with Stephen Spender in the summer of 1939 during which Spender wrote of him ("Jack Tar on the slippery boards") as "trim-waisted, cliff-chested";[3] a year later he had stopped off in New York, stayed in Brooklyn with W. H. Auden and began an affair with Auden's lover Chester Kallman. Back in England he made it sound easy to cross the Atlantic regardless of the war simply by signing on. Freud was convinced. "He was completely available for either sex; Auden influenced his trying to get hold of everyone, he was pathetic really. Jack Barker had this idea, and so I had this crazy idea, to 'meet Judy Garland' in New York." It was essentially a *Wizard of Oz* odyssey that he envisaged. Merchant seamen could get to Oz. Barker had contacts in New York, Peggy Guggenheim for one, and only by North Atlantic convoy could one hope to get there. With Michael Nelson and a friend of Barker, Tony Jacobi ("queer, my parents knew him"), Freud went to Liverpool to find a ship.

Barker's father, Lieutenant-General Michael Barker, a Boer War veteran prominent in Dedham society ("Lett-Haines loved saying 'General Barker'"), had been relieved of command of I Corps of the British Expeditionary Force at Dunkirk and in the spring of 1941

happened to be employed checking security in the Liverpool docks. "Through Jack he recommended me for a seaman's card; Jack said a friend had lost it." Old hands in the Seamen's Home advised him to say that he had been torpedoed and lost his papers, which would explain why he needed a card and had no kit.

"I liked the idea of adventure—*The Ancient Mariner*—but I was soon pretty desperate. The man who ran the Seamen's Home made it clear that you could go to bed with him and stay there free, so I went to Mrs. Schwenter's boarding house where the others were." This was an experience in itself. "I was very conscious, for the first time, of Catholic dirt: a poor boarding house with samplers and holy pictures and everything covered in bacon grease."

Tony Jacobi secured a berth immediately ("Such a tart: could be used instead of the rubber blown-up girl the bo'sun had on the ship"), and after several rebuffs Freud managed to get a berth on a New Zealand vessel. He got tonsillitis, however—"I'd been rather ill, on and off"—and the ship left without him. He later heard that it had been sunk.

Having kitted himself out with a jersey and seaboots he returned to London for a few days and, keen to show off, went to the Ritz Bar. "I had my white gumboots on and was so proud, but I was barred. 'I'm afraid we can't let you in,' the man said, 'as there's royalty present.' It was King Zog of Albania and his seven sisters."

Returning to Liverpool, he succeeded in securing a berth on the SS *Baltrover*. "I walked on to a ship and the man said 'fine'; I didn't realise he was just the man on the gangway." He was readily signed on, somewhat to his surprise, but soon found out why. The ship, a tramp, smallish at 4,900 tons and built in 1913, had been commissioned twice as a merchant cruiser, in 1914 and in 1940. Pre-war she had been sold to the United Baltic Corporation in London for cruises from England to Gdynia and Gdańsk on the Baltic. "It had a terrible list and was very very slow; it was chartered by Furness Withy to do the Atlantic runs for which it was entirely unfitted." Six years later, in reminiscent mood, talking to a war hero on a yacht in the Aegean, Freud said that when he signed on the ship's mate told him: 'This trip will be the making of you, my lad. You can't tie a clove hitch yet, but when you get back to England you will be a *man*."[4]

The ship's log shows that the voyage began, technically speaking,

on 7 January 1941, and that Freud enlisted on 5 March, as an ordinary seaman.[5] He was the youngest member of the crew of about sixty men. "The *Baltrover*, I discovered, didn't carry deck boys and had a terrific job getting crew. It took passengers and was slightly more comfortable than most, so it was the commodore ship when we went out. The ship was manned for the Baltic run, when the war broke out: half British and half Balts—all the fire people in the engine room were Balts—and when the ship was in British waters they were given the alternative of being interned or working at full pay as prisoners on the ship. Going out with all those Estonians in the engine room: imagine the atmosphere when we were being bombed."

The rest of the crew were housed in the fo'c'sle, where Christie the bo'sun dared not enter. "It was pretty anarchic there. Christie, a last-minute replacement, had a wooden leg with a doorstopper on the foot. He used drawing pins to keep his sock up.

"I thought I'd been brilliantly clever to get on to this ship and, until I started working, they thought they'd been quite clever to get me.

"I worked on the ship when it was in port for two or three weeks; I was set to watch the cargo being loaded as they thought I was the most honest person. One of the sailors said, 'Look, I'll give you a tip. There's a lot of drink in this cargo and they all have these knives. Unless you split one of these cases open and share it among the dockers who are loading they will *DO* you with one of these. That's why there are so many people with missing arms and legs around.' There certainly were, so I said thanks, opened a case, gave them one each and thought I don't see why they should have them all. So I put six bottles of Drambuie into my sack, which I thought would be nice for a rainy day."

He didn't have to stay on the ship when "working by" and, as it happened, social life came his way. The show *Sweet and Low*, with Hermione Baddeley, was in Liverpool and a member of the cast, Joy Penrose, sent a telegram to the *Baltrover* saying, "Hope you can meet at 8 at the Adelphi." News of this assignation at Liverpool's poshest hotel spread and Freud was stuck with a lah-di-dah reputation. "Such a thing had never happened," he said. "'Fucking drink in the Adelphi?' they jeered. 'Oh yes, you'll be late at the Adelphi.'" Off he went, determined to impress the touring company. Up Lime Street

he strode in his seaboots, the Liverpudlian song "Maggie May" running through his head:

> *She pox'd up all the sailors*
> *From the skippers to the whalers . . .*
> *She'll never walk down Lime Street any more . . .*

"In my seaboots I came into the Adelphi and into the bar where only men were allowed (apart from Hermione Baddeley and Joy Penrose) and got almost as much attention as I wanted. I thought I was living it up and they thought they were seeing life."

On the night of 12–13 March the Luftwaffe attacked Liverpool. "It was very exciting. Planes came and sprayed the docks with firebombs and in my special boots I had to kick them off the deck. Absolutely marvellous I thought this. So exciting."

Two days later, with a cargo of Drambuie and shoes ("booze and shoes: to stop thefts they sent left feet only and the next trip sent right feet"), the *Baltrover* set out under Captain Wells as commodore ship of Convoy OB.298: thirty merchant ships and eleven naval escorts. Sailing at the speed of the slowest, "absolute crocks, less than walking pace," they took over a fortnight to reach Halifax, Nova Scotia. There they berthed for a week, then went on to St. John's, Newfoundland, and back to Halifax before returning to Liverpool.

The crew did not know what to make of Freud. There was his black and white towelling gown. "I've always liked these gowns: 'Sheikh of Araby,' they called me, and 'Jack Shitehawk,' as I ate so much (it's their word for vulture)." Another name they gave him was Lucie Walters. "They were puzzled, but they were all right, they just couldn't understand what I was doing there. During a storm they'd say, 'This isn't the fucking Adelphi Hotel.'" He soon had to defend himself from their attentions. They took to waking him up every two hours when he was off-watch. "Coming off watch at three in the morning, to sleep in a tin bunk, someone would come in and stick a cigarette on my neck—they had saltpetre cigarettes that would burn even in the wind—and say, 'Time you had a pee.'"

"Some of the sailors were in the most terrible state. One way of getting money was to get money for gear after you'd been torpedoed: they'd taken the money and not bothered to get the clothes;

they thought they were on a winner. In the freezing cold I was the only person who had two jerseys and boots." They were curiously competitive. "When the men got drunk they started doing very complicated knots: showing off. And everything they despised, which was to do with learning, it suddenly came out." They suspected Freud of signing on in order to write a book.

He had brought paints with him in his sack, imagining he'd have a fair amount of spare time. "I hadn't taken much, but I brought the paints: absolutely mad. I had some very strange assumptions." His inks came in handy though. "They were useful for tattoos. Several of the crew wanted to be done. We discussed the designs. It depended on them what I did: birds and fish, hearts and arrows. Some had 'love' and 'hate' on them, and people and fiends. The scab forms and then you rub ink in. Indian ink came out a very deep blue." Some he drew. John Boeckl, a pensive twenty-three-year-old Czech seaman from Kobe in Japan, went into the Swift layout pad, and one day, after carrying food for the umpteenth time from galley to fo'c'sle, Freud did the cook from memory, unshaved, cigarette in mouth and cap on head in a collapsed state. A more elaborate drawing of the ship's gunner in a duffel coat was possible because, being assigned to the ship by the Royal Navy, he had to have his own quarters under the deck hut housing the four-inch gun.

Like Maldoror, Freud watched "the living waves, dying one upon the other, monotonously," saw the seas fancifully addressed by Lautréamont ("Ancient ocean: you resemble somewhat those azure marks to be seen on the bruised backs of cabin boys; you are an enormous bruise upon the earth's body") and, like Masefield's Dauber "drawing the leap of water off the side," he drew the lifting sea, a patch of it, mid-distance. "With semi-dolphin. I did report a submarine but it was a whale fin and I got a bollocking.

"One or two of the men had been on the clippers and they'd say, 'I'll show you how to fucking draw,' and they'd do a thing with all the rigging."

For a few days it seemed that this convoy experience would be uneventful, at least in newsreel terms. Then, suddenly, on the fourth day out there was violent, close-up action. "On the first or second

day the German planes saw us and on the third or fourth day there was this raid. When we were attacked we could see the tracer bullets and the plane was so low you could practically see the grins on people's faces, like in a comic. When at dawn and dusk the German planes circled the convoy, we sent the message 'identify yourself.' Instead, they swooped low over the convoy dropping bombs. The ship behind us was hit. It was a tanker." Laden with ammunition (not oil) for Singapore the *Benvorlich* was attacked near Bloody Foreland, at the dispersal point where the convoy was to divide: part continuing

Naval Gunner, 1941

to Halifax and part to Gibraltar. "Two lifeboats got away and then the whole thing went up into the air, the entire ship. Bits of the ship and bits of people rained all over and there was a cloud, like an atomic cloud—in fact years later, when I saw the atomic pictures, they looked very familiar—and then the ship was blazing and exploding as the fire got into the hold. Explosions followed by explosions, getting higher and higher: it must have been ammunition, which you don't expect in a tanker. Not surprisingly, after that, the morale on our ship was very low."

Just about the only shipmate Freud got on with was Boeckl, the Czech who, obliged to do so by Ship's Rules ("The one to which communications should be made in the event of the death of the Seaman"), gave his home address as Kobe. "He spoke German and knew poetry; he knew Goethe and could talk about it." Boeckl was an able seaman and well able to look after himself. "He was sitting in the fo'c'sle with stockings for his girlfriend and holding them up and stroking them and no one tried to pick a fight with him. He kept to himself with a grey box which he fiddled with all the time." This aroused suspicion, making him and Freud the ship's two oddities.

Although the cargo was destined for New York, the *Baltrover* was

too decrepit to pass inspection there so they unloaded in Halifax. For two days before docking Freud had been excused duty. This was recorded in the log—29 March: "Ship's surgeon says he has tonsillitis and sore throat and is unwell. Temp. 30 3:Ln Freude O.S. Ref LOI8 improving but still off duty."

Were he to slip off to New York, now was the opportunity. Getting Boeckl to keep an eye on his things, maybe for good, Freud went ashore, spent a day wandering around in the wet and a night in a freezing YMCA air-raid shelter. This was misery enough to convince him that desertion wasn't a good idea, so he returned to the *Baltrover* only to find that he hadn't been missed. "Sailors were often away overnight with their whores." His possessions however had already been distributed among the crew and it was two days before he saw the consequence of that. "I couldn't put two and two together. The men, lots of them, couldn't turn-to, they were feeling so ill. All the bottles of Drambuie had gone and they said the bo'sun, who had already been fined for being drunk and for bringing on board intoxicating liquor, had been sniffing round my sea-bag; so I jumped on the bo'sun, who had this terrifying syphilitic nose, and it was only by pressing his ear against a steam pipe that I managed to get away. He was really horrible. He used to threaten us. He'd say, 'I'll kill you's all, and if I can't kill you with my bleedin' hands, I'll kill you all with fuckin' work.' "

This went down in the ship's log in summary form. "J. Christie was drunk again and creating a disturbance in engineer's alleyway. Fine ten shillings."

"The bo'sun was frightened. He was supposed to inspect the fo'c'sle but as he never dared go down there in fact he never saw my sea-bag. Anyway, of course, the men had taken all the Drambuie and drunk it. Afterwards, on the way back, they said, 'What's this stuff, this Drambuie?' I said, 'Oh you wouldn't like it; it's an acquired taste,' and one of them said, '*We* fucking acquired it.' "

Alerted perhaps by the rumpus, Higgins the Second Officer became suspicious of Freud's papers and reported him to the immigration authorities, who came on board to check. "He said I was an odd bird and what was I doing on board ship? He thought I might be some sort of spy because my birthplace was Berlin and my date of naturalisation—1939—was highly irregular because no one was naturalised at that time. Higgins had an odd attitude to me. I felt that,

much as I liked being misunderstood, he actually couldn't understand and vaguely looked to catch me out. He did more than his duty; and certainly duty couldn't explain my presence."

As it happened the Canadian authorities were quick to confirm that Freud was a certified British subject, which, if anything, increased his peculiarity in the eyes of the crew. They noticed that unlike most of them he didn't go off to the brothels where women, tagged "White Boots" and brought in from Montreal, serviced shore parties. "No money. I was told once (by the Head of Medieval Antiquities at the British Museum) that Furness Withy arranged that when you had a whore you gave them a chit to get paid by the office. That was in London. One of the sailors was in America, he was having a whore, she was reading a newspaper and she looked up over it, put down her paper and said, 'Limey, have you slimed yet?' Well, even *he* thought that a bit rough."

Cold-shouldered by his shipmates, in Halifax he wandered around the streets on his own, bought himself a dark-green corduroy cap with flaps and went to the cinema. They were showing the Preston Sturges comedy *The Lady Eve*, with Barbara Stanwyck as a cardsharper's daughter and Henry Fonda as the innocent son of a millionaire. He enjoyed it but when he got back to the ship they asked him what he had been up to and he was caught out. "I said, 'Oh, I found a marvellous girl: we went to the cinema.' But it turned out that some of them had been in the cinema, sitting behind me, and had noticed that I was on my own."

He tried bluff. "You just didn't see her: she was very small."

"Did you go with her?" they asked and all he could say was—very Henry Fonda—"A gentleman's lips are sealed on this subject."

"They took me less seriously after that. I felt badly about it. I thought I'd better give up lying in future."

After about a week the *Baltrover* was directed southwards and around Cape Sable to St. John, New Brunswick, to pick up loggers for service in Scotland, recruits to the Newfoundland Forestry Unit set up by the Ministry of Supply early in the war: a consignment of boys, "illiterate and very wild." Freud liked them. Newfoundland girls, he had discovered, knew how to read and write but boys didn't. He especially liked the Eskimo ones. The mate set them to painting everything on the ship that could be painted. Then they went back

to Halifax. "The thing that terrified me was tying up the ship. It was explained to me why so many dockers had arms and legs missing, chiefly legs: they had been hit by these wires. So I used to go and hide when the ship docked." Three of the crew deserted; two of them were caught and put back on board before the convoy sailed.

On the voyage out Freud had found that his left hand, injured when he went through the glass door of the Matthäikirchstrasse apartment, felt the cold particularly acutely. Off Newfoundland, heading into the Arctic, winter temperatures resumed. "Every time I put my rag in the bucket for a few seconds it was frozen." Set washing the winches he would be swept off his feet; looking up he'd see the steersman smile, the joke being that he had deliberately steered into the swell so that a wave would slosh him across the deck. "Three watches (nine or twelve men) meant that they had to do my work virtually. The watches were eight hours on four hours off all through the day and night and, each separate watch, one had to steer and one was the lookout man and I can't remember what the third one was. I was useless."

He carried food from galley to fo'c'sle, scrubbed, sluiced, cleaned and greased the winches. Once, just the once, he was told to man the wheel and, failing to grasp why it took so long for the rudder to respond, he steered the ship off course. "Steering only reacts fifteen or twenty seconds after you've turned the wheel, so by the time that you have realised you've done it wrong it gets worse and worse. I was doing my absolute best but the crew thought that I was deliberately swinging the lead. They thought I was a joke. Sometimes they thought that it wasn't a very good joke, that I was endangering them."

The convoy to Liverpool was sent on a zigzag route taking thirty-four days at a maximum speed of nine knots. In those weeks, April to May, nearly 200 merchantmen were sunk; it was one of the worst periods for losses in the Battle of the Atlantic and although the *Baltrover* reached home waters unscathed it was to find Merseyside being blitzed night after night, leaving nearly 2,000 dead and 75,000 homeless, so for several days they had to lie at anchor outside the docks.

By then Freud had had enough. He went to the ship's doctor, a twenty-six-year-old whose first experience of convoy this had been. "He was called Tapissier and was known as Tap. My larynx was bleeding, I was pretty weak; I had a fever, not high, but quite high, and so

he signed a release. When I went to the mate he thought I'd swum ashore to get a doctor's certificate: he couldn't believe a ship's doctor had done it because they'd had such trouble getting men." He didn't tell the mate that he still couldn't tie a clove hitch, and if he had been made into a man by his shipboard experience, nobody mentioned it.[6]

Fifty years later, at the time of his exhibition at the Liverpool Tate in the Albert Dock (by then transformed into a marina and cultural centre), Freud had a letter from Dr. Tapissier's widow saying that he had often told her how good the young Freud's drawings had been. He was touched. "I wrote to her and said that if it hadn't been for him I'd still be on that ship. I was terribly lucky: within three months of my leaving the merchant pool was formed, so anyone leaving a ship was automatically drafted on to another ship. Before then it wasn't part of the services. Otherwise I'd have spent the rest of the war at sea."[7]

Discharged on 22 May, his ability listed as "Good" (which meant below average) and his general conduct as "Very Good" (ship's log 132840), Freud left the *Baltrover* to find Liverpool dramatically altered. "Lots of places had gone, just during these months." Indeed Liverpool had suffered far more that month than had the convoy. Half the berths in the docks had been destroyed.

Exposure to strafing, violence and extreme cold did not harden Freud appreciably; nor did being pestered and humiliated. He didn't respond when, sixty years later, a former shipmate invited him to a reunion. "The man said, 'I wrote to your brother but got short shrift.' Part of the reason for a reunion is to see that everybody has changed more than you, and I'm quite sure I haven't changed at all. Nor did I want to talk about old times. New times is what I want to talk about." He had spent less than three months at sea. "It wasn't long; it just seemed long. It was so unlike my life, it stuck out in a particular way." Masefield's Dauber, bullied and harassed and attempting to prove himself, fell to his death. Freud happened to have survived.

"I found myself with tears running down my face on the train, back through green landscape: I'd thought I'd never see anything like that again."

It so happened that the day Freud was discharged Sir Kenneth Clark donned earphones at Broadcasting House in London and declared

open an exhibition of "British War Art," selected by himself, at the Museum of Modern Art in New York. His brief speech echoed back at him across the Atlantic: words in praise of the ability of Graham Sutherland, Henry Moore and others to express and reflect, as Herbert Read wrote in the catalogue, "all the variety and eccentricity of the individual human being" in time of war. Sutherland's blitz-damage compositions based on sketches made in Cardiff, Swansea and the East End of London and Moore's drawings of people sheltering in the Underground like stockpiled maquettes were enlisted in the propaganda push to bring the United States into the war.

Ex-Ordinary Seaman Freud had only a few sketchbook pages to show for his grim escapade, studies of sea, gunner and cook, too scrappy to qualify as the advanced war art that Clark favoured yet in their wariness all the more telling. Over the years, as his seagoing exploits ballooned into legend, questions were asked. How precisely had he obtained his discharge? Was it true that he had murdered the ship's cook?

What Freud remembered was how sick he had felt. "I was terribly ill by the time I got off. My chest had got very bad. I ran a permanent temperature and had to go to hospital." He was sent to the Emergency Medical Services Hospital at Ashridge in Hertfordshire, in peacetime the Bonar Law College for Citizenship, but by then taking patients from London, Blitz victims mostly. "My throat settled down once my tonsils were out. There were huts in the grounds and beds were wheeled out into the sun. I was so weak that I got caught and the skin peeled off. In the bed next to me was a musician from 'Snakehips' Johnson's Caribbean jazz band whose legs had been broken when the Café de Paris was bombed. The bomb landed bang on the band as they were playing 'Oh Johnny,' killing Snakehips. We used to talk about night life and I enjoyed that.

"My mother came to see me in hospital; it was good because I had such strong sedatives I was asleep when she came." In June his parents moved back into St. John's Wood Terrace, thinking perhaps that Lucian should convalesce there and be under supervision; meanwhile Hitler invaded Russia; with that the threat of an invasion of Britain receded. Internees were released and in August Cousin Walter arrived back from Australia, disembarking in Liverpool.

Hospital was a bit like school. "This little boy of eleven came across the ward and spat into my face so I gathered all my strength, gave him a bash, passed out and the stitches in my tonsils came open. They kept coming undone: it was quite serious as they were so inflamed, so I was there over a month." He left hospital in late July. "After a lot of complications, I did some drawings in the ward, one of which is very good I think," he told Cedric Morris, assuring him that he would be back in Benton End by the following Friday. "I have to wait for my grandmother's birthday on Thursday; otherwise I'd be down now."

Hospital Ward could be an ex-voto, a thanksgiving in convalescence. "Done from memory, except the flower," Freud explained: patients tucked flat in their beds, a nurse checking for unruliness and a globeflower from Benton End ("One of those tough slimy things: really beautiful") laid on the coverlet, a reminder of the Comte de Lautréamont's image of "the child's face rising slowly above the opened coffin like a lily piercing the water's surface." The head rest-

Hospital Ward, 1941

ing on the pillow was not particularly the stricken Freud who, he told me, saw the figure as a war-weary soul: specifically Peter Watson with reddened eyelids and stubbled chin chafing under ward discipline.

In another little votive-mannered painting, done around the same time, Watson in open-necked shirt and tight jacket sits holding a tray of what appear to be etching plates featuring a Benton End bestiary: rat, rabbit, horse, dog, chickens, men. Behind him is a bed with a toothbrush laid on it and a view over bleak Nova Scotia in which the *Baltrover* is sighted offshore, lifeboats slung outboard in readiness for an emergency. A painted rendition of a drawing of a life model startled by the rooster on his knee adds comic alarm to this deployment of Watson as patron saint, a homage designed to flatter and implicate. "It was a portrait: the drawing is actually a drawing that existed. I did it in his flat, a crazy queer painting, very personal and like him. I used to always put secrets in. I still do."

Before going off to sea Freud had asked Watson to write to him in Halifax as he fancied the idea of being met with a letter post restante. Watson obliged. His keen interest was particularly valuable once Freud had become the seafarer returned. His flat in Prince's Gate was open house where spongers such as the Glaswegian painters the Roberts MacBryde and Colquhoun stayed and where all callers could hang around looking through copies of *Verve* and *Cahiers d'Art* and the pictures that replaced those left behind in Paris. Watson wasn't just the backer of *Horizon* and the London Gallery, he was everywhere making introductions and quietly exercising patronage. Through him Freud eventually met John Craxton for the first time. "Lucian turned up," Craxton remembered, "wearing a chic brown suit and looking very handsome—he had been in hospital and across the Atlantic since leaving me that note. He had incredible eyes and was very quick witted. He had a fantastic, riveting personality."[8]

Charles Fry, a publisher described by John Betjeman as a "phallus with a business sense," asked Freud if he would care to write an account of his voyage for a series of short books that his firm, Batsford, were producing. *Fighter Pilot* had already appeared. What about *Merchant Seaman*? No, absolutely not. "It would have been a crazy surreal novel." He did not want to relive the episode or, for that matter, be taken through it under questioning. Soon after the attack on Pearl Harbor in December 1941 he had a visit from the CID. They

asked him about Boeckl, the sailor from Kobe. "I thought he'd been caught: he had a grey box and was fiddling with it all the time, and he got very wary when there was talk about wireless. They said, 'You realise what we are asking you?,' implying that he was a spy for Japan, which had come into the war by then. They wanted to know where he lived. I knew his girlfriend's address in Liverpool and didn't tell them."

"Slightly notorious"

Freud went back to Benton End in the late summer of 1941 (his parents meanwhile returning to Maresfield Gardens) eager to tell of icebergs and high seas. "Lett was on about how he was a mariner in a submarine in the First World War. I had quite a lot of trophies in my room, seaboots and stuff, a hat lined with corduroy and a jersey with flags on it. And I had scabies from dirty clothes: it was painful; you had to shave yourself from head to foot. The balls stung." The pathos of *Hospital Ward* suited the image of this novice veteran. But no sooner was he back in Suffolk than the threat of call-up arose. "I fairly soon had to have my medical in Ipswich. Luckily I was passed on a very low grade because I was still pretty ill; I was so run down, very nervous and jumpy."

Manpower, a government pamphlet on mobilisation, made it clear that the authorities had the measure of those who were determined to prove themselves unsuitable for conscription. "An exquisite youth might announce—and genuinely believe—that his life would be misery if he were put into uniform, given a pair of heavy boots and marched up and down a parade ground with a bunch of louts." Vetting routines to cope with such scrimshankers had been devised. "Elaborate machinery of investigation and appeal was designed to reduce these cases to a minimum."[1] It took Freud a single session to qualify as one of those cases.

"It was generally thought that the doctors for the medical looked

at people imagining how they would fare in the services, and I could not have. I wanted to appear as not convertible into military guise." Asked if he had anything to say in support of his exemption Freud replied that he had no objections to the military, indeed he had been boxing champion at his prep school. But there was just one thing: "I said to them, 'I'd love to be in the army. But'—which was perfectly true—'one thing was *very bad* in the Merchant Navy and that was being pestered by men, especially at night.' I said that if I was in the army I'd insist on having a room of my own as men treated me like a woman." He added, meaningfully, that he liked *fires* very much. This was enough to convince them that he was not conscript material. "I suppose my hair was long. And I painted my boots white." Classified Grade III, utterly unsuitable, exempt even from fire watching, he took the bus back to Hadleigh and resumed painting. A rumour developed that he had persuaded the tribunal to release him on the grounds that he couldn't face being parted from his cat. He had no cat, but Stephen Spender had a photograph of him holding one. "Stephen always embroidered. That's how it got about. My strength has been on the solitary anarchic side. A psychologist's report called me 'a destructive force in the community.'"

After the war Freud used his convoy experience as a riposte. "When people used to be rude, I'd say, 'When I was fighting to keep the seas safe, you were wetting your knickers'; I had to stop saying that in the sixties." It was a line that served him well on weekends in London. His £23 14s ½d pay-off he spent on a girl. "Some of it was danger money: it was enough for me to take someone out for three weeks." That someone was Janetta Woolley, a *Horizon* assistant and at that time married to Humphrey Slater, author of *Home Guard for Victory!* (1941). Freud went to their cottage near Dorking ("it was being dismantled") and when Cyril Connolly lent her his room at Albany, in Piccadilly, she took him there, to Connolly's fury as he had a crush on her himself. He also took her to the Dorchester Hotel to show her off and show off to her: particularly pleasing as his father had found Clement a trainee job there. "I quite liked him being the waiter: he was rather a good waiter. Dressed in white he was OK. I discussed what the other waiters thought of him. 'Terrific,' they said."

While *Hospital Ward* had been his recovery picture, *Girl on the*

Quay (appealing enough to be included by Ernest Brown of the Leicester Galleries in a New Year selection for 1942) was Freud's venture into the "Sailor's Farewell" genre, a flat frontal composition worked up to show that he, having served, knew his way around waterfronts and shipping: "It was my ship's rigging and funnels and all my knowledge about where lifeboats are." The sea's seething surface came of having spent hours on watch looking out for periscopes; it was also the result of having discovered that terre verte and cerulean are a rich mix. "The idea was a joke idea: the girl I left behind me sort of thing: actually a girl who was at Cedric's when I came back."

The girl was Felicity Hellaby. Freud had already drawn her the year before, fancifully dallying with him in the silo tower; she also appeared, looking even younger, in the later pages of his convoy sketchbook and he had written to her from hospital telling her he missed her. "I liked her very much. She was very virginal: a terribly well-brought-up New Zealand girl; David Carr did things to try and put her and her family against me." Her lasting memory of him was that he used to make everybody laugh. "And he knew everyone." Although he gave her a drawing of a seaman off duty propping his head on his hand, he told her next to nothing about what he had so recently been through. She remembered him "writing about lying in hospital, how lovely it was lying in clean sheets."[2] She was at that point living in Norwich, working on spark-plug production, but occasionally at weekends she and Freud met in London.

The crumpled newspaper lying on the cobbles in *Girl on the Quay* was not—though maybe it should have been—the Ipswich *Evening Star* for Saturday, 30 August 1941, carrying the headline "Suffolk Artist Fined: for Damaging London Theatre." The artist was Freud. "On a weekend from Cedric's I was caught breaking into the Cambridge Theatre in Seven Dials. It got into the local papers and I was slightly notorious."

He was with Mary Hunt, his first buyer (*Stable at Benton End*) who, further back, had been one of the Coffee An' regulars that he had not recommended to Stephen Spender as a potential Miss Right. The lack of one foot and part of a leg had disconcerted him rather when she first took it off in front of him; but, as he explained, the reason he "didn't get it right" on that occasion was more to do with her having been only the second woman he had gone to bed with. Since

the previous January she had been married to Ralph "Bunny" Keene, a film producer and picture dealer.

"Mary Keene, 20, married woman of Park Walk, Chelsea, and Lucian Michael Freud, 18, of Benton End, Hadleigh, appeared at Bow Street Magistrates' Court," the Ipswich *Evening Star* reported, charged with "wilfully damaging, to the extent of £2, an iron bar, at the Palace Theatre, Cambridge Circus, on Friday night." The incident was unusual even for blackout circumstances in the West End. "Lance-Corporal Rush of the military police saw a woman disappearing through a door of the theatre. He ordered her to come out and she came, accompanied by a man. Both said they wanted to see the last performance of the show and the entrance was closed. The man and woman must have used their strength together to force the door open. He called the police."

"It was a 'how about in here?' situation," Freud explained to me. "We had pushed these iron bars and as we were crashing up the palatial stairs into the darkened circle we were caught by police and dogs and locked up in Tottenham Court Road police cells for the rest of the night. They said, 'What do you do?' I said 'painter,' she said 'poet,' and I laughed and she was very angry." A former girlfriend of Louis MacNeice and Henry Yorke (the businessman novelist, whose nom de plume was Henry Green), she resented being admired less for her intellect than for her good looks and tin leg.[3] "Yellow face and magenta lips," Augustus John remarked to Matthew Smith, as one of her admirers to another.[4] The Fauve in Smith appreciated her to the extent that, after many years of involvement, he bequeathed her his unsold works. She used to irritate Freud by telling him—assuming that as a Freud he'd be interested—her previous night's dreams.

According to the Ipswich *Evening Star* the defendants' explanation of their breaking and entering was unconvincing. "Mr. Freud said that he and Mrs. Keene had wanted to see the last performance of the show. They did not know that it had ended at five o'clock. 'I pushed the door and it opened,' he added. Freud was fined 10 shillings and ordered to pay 30 shillings towards the damage; she was fined 5 shillings and 10 shillings."

Stephen Freud remembered his brother arriving home the next day and telling their mother that he hadn't liked being in a cell. "'I got kleptomania,' he said."

· · ·

Letter to Felicity Hellaby, 12 December 1941:

> *Darling Felicity, I have just been bitten by an enormous dog in*
> *the blackout. I am doing a picture of a boy and a strange motorcar*
> *and trees rather like the one of the town but more coloured. How*
> *maddening for you that they are so slow about your factory! Are*
> *you coming to London at all soon? I probably shall be in Ipswich*
> *soon as I may go to Walberswick for a few days but I will ring*
> *you anyway. I saw a very good sad film called Honky Tonk.*
> *Its very dark here and most people have scars either on their*
> *noses or foreheads from walking into posts. I won a jackpot in a*
> *machine tonight and 75 six-pences came out. I drew a very old*
> *and amazing woman today who was very skinny and stood in*
> *edwardian postures with her eye balls just visible in the very tops of*
> *her eyes, lots of love Lucian.*[5]

London night life was hazardous Freud found, and not just because of dogs, lamp posts, magistrates and the Blitz. "In the blackout it was almost impossible not to catch the clap. I went to the family doctor and he said, 'You are going to die of syphilis or become a genius.' He made me take M&B as it was early in the war, before penicillin; he made me take it for too long to teach me a lesson, a modest Jewish lesson. Dr. Levy said, 'I feel I should let your parents know,' and I was nervous about him telling them. 'Extraordinary,' he said, 'that a member of *your* family should . . .' He lived with his mother, in his fifties, clients like my parents. Had a moustache. His mother told him not to get involved with girls and he was trying to tell me what a terrible thing I'd done." Having got the clap Freud took girls to the cinema more, he said, and courted them there.

In the spring of 2011, a few months before he died, the painter Catherine Goodman remarked to Freud how lovely the blossom was: had he never painted it? "Blossom? I knew her. In Soho once we found a phone box and I pushed the phone books off the shelf and put her on it and off we went."

· · ·

Early 1942, Maresfield Gardens NW3:

*Darling Felicity I am just rushing off to lunch to my
Grandmother where the Pekinese eats his three-course dinner
and coffee. I've been distempering walls and ceilings and going for
walks in the snow. The night I left you I went to Chelmsford and
stayed in a very strange hotel where I had to give a password to
get in and I gave the wrong one so they would not let me in but
later I went back and gave the right one. They are playing a tune
on the radio called "Prairie Mary." Is there any ice-skating in
Norwich? I saw the Garbo film yesterday and before there was a
wonderful film about a madman who lived in a shack with an old
man with one eye who bullied him. It began by the madman being
in the far corner of the room and the camera came nearer to him
until you saw the texture of his skin and then you saw his ear and
by and by you saw right inside his ear where an awful banging
noise was going on. I'll come down to Norwich soon but I'll tell you
when beforehand. Do send me some secret plans of some planes or
machines, lots of love Lucian[6]*

"Darling Felicity" appreciated the patter. "It was never a very
romantic affair from my point of view. It was rather fun. We used
to go to London to go round the art galleries and clubs and pubs.
He loved popping into the Ritz bar. It was very grand there. They
all did art, the people there, students in shabby clothes. Lucian
loved dressing up in smart clothes: nice suits made by a tailor in
Ipswich."[7]

February 1942, Maresfield Gardens:

*Darling Felicity Thank you for your letter. I shall come down
this weekend will you meet me on Friday evening at half past six
but Where? In the station Refreshment room or bar. Yesterday I
bought a lovely yellow jockeys waistcoat at an auction sale and also
six doumier lithographs handcoloured I've done a drawing of "The
Japanese Menace is daily assuming an uglier shape" which is what
Churchill said the other day.[8]*

The Village Boys (1942) could be juveniles up in front of the magistrates for rural misdemeanour, conscious of being examined. "Very weedy: nasty but strange," as Freud described them or, to be precise, what he made of them. They have a background of portraits at various stages of development to be taken into consideration: life drawings (possibly Tony Hyndman) done with the usual mapping pen on a "Sketching Pad for Layouts"—"I used a great many of them; they were the house thing at Cedric's"—pinned over a horse in profile, and two finished paintings, one "a funny figure, Van Gogh Zouave-ish," the other a self-portrait visible only from the eyes upwards.

"Images beget yet more images," Freud said of *The Village Boys*. But as they beget they relegate; the replication presented in the picture (a painted drawing and painting of paintings) is secondary to the dual proximity of the two sitters bored with being there all weekend, first drawn then painted, posed as part of a notion. Freud had already done a drawing of a framed portrait on a wall looking down on a group of figures such as these, the idea being that the portrait has more presence than the heads below it. *The Village Boys* reversed this. The two boys, one seated, the other standing, but diminutive, raise the question of which of them is the more immediate. The smaller figure is superimposed, like a donor in an altarpiece, and set apart, like Seneb the Sixth Dynasty dwarf in a funerary group reproduced in J. H. Breasted's *Geschichte Ägyptens*, the Phaidon book of "Egyptian things that are not made up": a gift from either his father or Peter Watson (he couldn't remember which) that he kept to hand all his working life. Freud's six recently acquired Daumier lithographs played a part too. For, like Daumier characters, those prime local specimens, the Hadleigh boys are conscripts in an arty set-up. It so happened that at the outbreak of war the doctor in Hadleigh had been landed with a pair of exceptionally troublesome seven-year-old twins from the East End. Could those two have been *The Village Boys*? It's unlikely, but their traits correspond convincingly enough. They had fought each other continually and killed the doctor's cockerel. Freud knew them a bit twenty years later: the premier gangsters Ronald and Reggie Kray.

At the beginning of 1942 Auxiliary Fire Serviceman Stephen Spender, newly posted to a sub-station in a school in St. John's Wood, asked if

he and his recently acquired Miss Right, the pianist Natasha Litvin—they had married in April 1941 with Tony Hyndman as witness—might move into the top-floor flat at 2 Maresfield Gardens. Freud had no objection and anyway his father had already said they could. "I didn't sleep there much; I just used a room there. And then Natasha moved her mother in as cook and cleaner. They were both absolutely foul to the rather nice deaf old woman, and when she left they turned on me." The trouble was that Freud didn't get on with Natasha. "I started a picture of her. In Ripolin [paint]. I think I destroyed it: there wasn't enough to be worth keeping. She thought I was an awful little squirt. She assumed—wrongly—I had been, or was, a boyfriend of Stephen; since she felt very much unloved she felt threatened by Stephen's past, by my finding him a replacement for his first wife. She did, however, behave disgustingly. Travelling in trains during the war she saw sad Jewish people and thought they were spies, so she reported them. They were just refugees. And she said to Stephen, 'Stop that silly Schuster nonsense,' meaning that he wasn't Jewish really. There was no row: to have a row you have to have a degree of trust."

Natasha Spender remembered being in bed ill one day and Freud coming upstairs with some buttery asparagus. They ate it on the bed, licking fingers, savouring so delicious a wartime treat. After he had gone his mother came upstairs and when Natasha said by way of thank-you, "What wonderful asparagus, how good of Lucian to bring it up to me," Mrs. Freud muttered, "Why don't I ever get to hear of my sons doing something nice?"[9] Nothing could prevent what had been a show of friendliness collapsing into hostility. "She stopped sitting and I think that Stephen said to me, 'Natasha said you have to go.' I felt humiliated and also felt that Stephen should have stood up for me. I was very naive. When he said, 'We won't disturb you in any way,' I'd have said, if I'd been less ignorant, 'No, please don't.' They were away a lot."

Monday [n.d.]

 Darling Felicity thank you so much for your letter with the Kandinsky on the back . . . I went to see a play called "No Orchids for Miss Blandish" which is perfectly amazing for the London stage. A wicked old woman sits in her horrible room which is supposed to be a den or lair and the walls are made like a spiders

web. I might be moving to a rather delishiouse place round the corner from here because Stephen can not work at his poems with the piano's noise and I have got the only sound proof room in the flat but its rather uncertain yet. I am painting a portrait of a boy who wont sit he thinks he's developed a neurosis about it, lots of love Lucian[10]

"I'd moved chairs—my father's—up to my flat and when I left, as they had no furniture, they used them. (Stephen was a bit what's yours is mine and what's mine's my own.) They had no eye, so they never wondered, I suppose, what were these strange plum-coloured Weimar chairs doing in their house, or where they came from.

"I like presents—having things I was given—and Natasha took my letters from Stephen and my Henry Moore drawing of him which Stephen had given me, and my etching—and he was embarrassed about this—the Picasso etching, the one of the boy with the violin being played on his bottom, a Saltimbanque thing. I went to my room and more and more things went." Eventually the Spenders changed the locks to keep him out.

"I hardly ever went there and then my father got them a house and renovated it for them: Loudon Road, freestanding, a good house, where they remained permanently. With my father's chairs."

Freud let it be known ("I slightly pushed myself") that he was aggrieved and soon enough, sure enough, Peter Watson responded, suggesting that he could have a room in a house near by, on the other side of Abbey Road in St. John's Wood where another of his protégés, John Craxton ("very friendly with Peter Watson in a different way from me"), was already installed. Freud and Craxton were almost exact contemporaries and, having become acquainted a few months before, were by then companionable enough to be photographed together—along with Tony Hyndman—on the flat roof at Maresfield Gardens. Craxton was slightly ahead of Freud in professionalism and social climbing. He presented himself as a gentleman of taste. Freud was to remark, frequently, in later years how often Johnny used to recall his father's advice to him, man to man: "Always hold a wine bottle by the neck, not—like a woman—by the waist."

A self-styled Arcadian, exempted from military service, Craxton had already developed a signature manner: curvaceous studies of

Dorset countryside graced with phallocentric outcrops and musing lads. Two such drawings, *Dreamer in Landscape* and *Poet in Landscape*, reproduced in *Horizon* in March 1942, attracted Graham Sutherland's attention, understandably so; they were, essentially, Sutherlands with blandishments. Freud too was impressed and intrigued. Here was someone his own age with an obvious sense of purpose. "There was a moment, a spark, especially in the drawings." Craxton could become his comrade in art if not a brother in arms, he thought. "His mother, Effie, said, 'Johnny, there are some men even more dangerous than women.' He did not take heed of his mother's warning. I never knew Johnny was queer. Not for ages."

Peter Watson had offered to pay for somewhere for Craxton to work. He took a maisonette in 14 Abercorn Place, the first and second floors of a large Regency terrace house, £40 a year. "I told Peter my problem and he said why don't you take the second floor?" Craxton used his floor as a studio only and slept at the family flat. Freud moved in.

Vintage postcard (girl whose voluminous underwear is revealed at the pull of a tab) to Felicity from St. John's Wood Terrace:

> *I haven't heard from you for so long I'm moving to a most delishiouse flat with John C. Im just rushing off to get a boy a job in a tiny shack where they put wartime ingredients into kakes do write . . .* [11]

Once he was no longer lodged under the parental roof, Freud assured himself, he would be "out of their orbit." As it happened, around this time Cedric Morris painted Lucie Freud in evening dress and a five-strand pearl necklace, spotted voile veiling the shoulders. It was an awkward portrait, not so much because Frau Freud was hardly one of Morris' usual Suffolk gentry types but because he was faced with the parent of a remarkably gifted yet peculiarly difficult pupil. For some time he and Lett had been rather hoping to see the last of him. The pupil sensed in the painting a lack of engagement. "I felt he was nervous about it; when he did the veil it got awfully sludgy, it just didn't work. Cedric had got that queer's thing of going on about

'a really good-looking woman: so good-looking I'd love to paint her.' Not good." Freud found himself avoiding his mother's eye and at the same time moving on from the nursery slopes of Benton End. Felicity Hellaby saw what a nuisance he was. "I did think he was brilliant, his drawings particularly; we all thought he was special. But he was terribly difficult. Cedric had written to his mother to persuade him to leave. One hears so much of his being admired so much but I know he made trouble. A blanket was cut up to use for something. Blankets were jolly difficult to get hold of then and Cedric was cross about that. Lucian was very difficult to have around. Other people helped in the kitchen with Lett. Not him. He always managed to get women to do things."[12]

For Freud the dwindling relationship between him and Morris was nothing to dwell on or worry about. "I admired Cedric, but I realised it was useless finding how somebody else did things. Cedric taught me to paint. And, more important, to keep at it."

It was only after having the best of his Benton End paintings framed at a shop in Swiss Cottage that Freud, not yet twenty, came to accept that his parents had no room for them and that they would clutter up his new workplace. So he asked Ian Phillips, "A Cambridge figure, cut rather a swathe, a rich Australian Jew who had a passion for furniture by Thomas Hope," to store them for him in his fine modern house (designed by Denys Lasdun) in Newton Road, off Westbourne Grove in North Kensington. There they remained for fifteen years until Ronald Searle the cartoonist bought the house and came upon them in the basement.

In the spring of 1942 a chance to exhibit in a West End gallery arose, not that any of his paintings were needed. Two drawings, "disjointed things, rather Surrealist in essence," were added to "Six Scottish Painters" at Alex Reid & Lefevre in King Street in May 1942: *Horse at Night*, in white ink on black paper and *The Town*, which was larger: "A horrible thing, crazy, sort of Paul Klee-ish and influenced by Tom Seidmann-Freud: very elaborate with bombed buildings and aeroplanes or not aeroplanes." Dylan Thomas, dropping in to see paintings by his Scottish cronies the Roberts MacBryde and Colquhoun, glanced at the Freuds and snorted, saying that they were rubbish. "He said, 'They're about nothing.' I was terribly young and not taken seriously."

9

"Slight *Dreigroschenoper*"

Fourteen Abercorn Place, tall and stuccoed, with a flight of steps up to a front door flanked by Ionic columns, became a bohemian abode with surreal trimmings. Craxton remembered it as an idyllic sort of squat. "There were these huge, spiky plants Lucian had growing all over the place at the top. I didn't sleep there. Lucian used to sleep upstairs." The place grew on them. "We lived and painted happily there for two years," he said. "We were inseparable at that point, like brothers. He was very unlike me and that's why we got on so well, because there was no clashing of styles."[1]

Freud worked on the first floor, Craxton on the second, and in the entrance hall they hung caps, hats and helmets acquired during nights out. This, Freud recalled, was one of the many aspects of their occupancy that infuriated the sitting tenant. "On the ground floor was a man called Clinton Grange-Fiske: he was a music critic for the *Ham & High* or *Hampstead Weekly Examiner* or something. Johnny's mother was shocked by us being there with him. She said, 'Clinton Grange-Fiske isn't as white as driven snow.' He had been rejected as a music student by Craxton *père* and harboured resentment; he'd been the driver for the Rector of Stiffkey when he was displaying himself in circuses." This connection with the notorious Rector, defrocked for socialising with prostitutes in the West End on the pretext of reforming them, intrigued Freud. The unfortunate Rector had been reduced to exhibiting himself in a barrel in Blackpool alongside *Genesis*—Epstein's graven hymn to pregnancy—and being prodded with forks

in a burlesque hell; he died in 1938 when, having been demoted to Skegness, a pretty girl in the audience caused his concentration to lapse and Freddie the lion who shared his cage got him by the throat, a fate that reminded Freud of young Albert who met a similar end in "The Lion and Albert," one of Stanley Holloway's cautionary music-hall monologues.[2] "Real social history," he commented, adding "Grange-Fiske complained about the mice." These came for the croissants that Craxton liked to draw.[3]

Freud's room enabled him to work more consistently than had been his habit. He took to using plywood panels—architect's samples—passed on to him by his father and concentrated on clarity. For want of ordinary oil paint—costly and scarce—he started using barge paint from a shop in the Harrow Road and Ripolin, the French brand of enamel paint advertised as "Perfection in Paint, Dedicated to the Service of the Craft." He had heard that Picasso had taken to it. "What I didn't hear was that he drained off the surface oil, so I stirred it and then used it." The discovery of Ripolin came about through the Craxton family doctor who happened to know the manager of the Ripolin factory and passed on the news that there were shelfloads of old sample tins going begging in the firm's Drury Lane office. Craxton pounced. "I went off with bags and bags of tins and Lucian got in on the act too. The idea is you put on masses of undercoat and then Ripolin on top, which doesn't discolour. We mixed tube colours with the Ripolin and they have retained a luminosity where other paintings of that period have not."[4]

Turned loose in their part of the house Craxton and Freud littered it with finds such as job lots of old pictures for ten shillings a bundle, some of which were intact enough to be painted over. "I used to buy a lot of old picture frames and smash the glass to use as carpet. I used to put new sheets of it down in the entrance hall so there was a nice crunch. One of the things I liked about bombing was the glass breaking in the shop windows." One morning Freud was roused by Ernest Brown of the Leicester Galleries foraging for his latest show of "Artists of Fame and Promise," referred to by Freud and Craxton as "Artists of Shame and Compromise." According to Craxton, "a naked Lucian, walking on this broken glass with bare feet, opened the door, to his amazement." Brown made a point of telling Freud that he was not used to dealing with "foreign artists."[5]

Prompted by Peter Watson, Kenneth and Jane Clark came to tea. Craxton maintained—and Freud disputed this—that their intention was to see him only but that Freud hung around on the stairs waiting to be introduced. Craxton told Clark that Freud was the nephew of Hans Calmann the dealer. "I can't stand these Middle Europeans," Clark said, but undeterred Craxton called to Freud to come down and meet their guests. Clark was in a tweed suit; the reason for this being that a visit to bohemians involved a degree of informality, much like dressing for the country. Lady Clark struck Freud as being "a gym mistress who never got over meeting this extraordinary person. Curtsied her way out of any possible social difficulty." She ("very shockable") insisted on going into the kitchen to make tea (Lucie Freud having provided a flan) and opened the oven door to discover two dead monkeys.

The visit was in keeping with Clark's magisterially stated belief voiced in the *Listener*: "I have often thought that ideally it needs two people to make a picture: one to commission it and the other to carry it out."[6]

"Kenneth Clark would come and, as it were, read the pictures; his advice was sort of good; I suppose he had belief. He was oddly helpful on sides that I didn't consider: Italian values. In an indirect way what he said was interesting; he said that if you want to help a painter—he was talking to himself of course—buy all their best work and give it to provincial art galleries. Were they going to turn down gifts of very odd-looking artists from a very highly thought of, aesthete, millionaire benefactor? I was only about twenty or so and it seemed an amazing thing to say to someone of that age. When you're very young, you're very alive to fame." As National Gallery directors go, Clark was remarkably stimulating and a good judge of audience. "Raphael became a museum bore," he remarked (not to Freud but to readers of the *New Statesman*) "until rediscovered by Picasso."[7] Once, after he had called, Freud walked with him along Abercorn Place to Abbey Road in search of a taxi. "In Abbey Road, opposite the recording studios, he looked up at a block of flats where you could see kitchen taps through windows above one another, floor by floor. 'Aah,' he said. 'Strange lives.'"

Clark's powers of patronage, extending as they did from the National Gallery to the Ministry of Information and beyond, gave

rise to an attitude of benign hauteur. He regarded young Freud as a prodigy with a name to savour. Patrician in outlook and practised at discretion, he kept a flat in Dover Street for trysts, Freud later learnt, and conducted his business affairs with a similarly compartmented poise. "He told me odd things about people's ludicrous behaviour. Willie Maugham, for example, asked him to smuggle pictures from Switzerland to France for him." He knew simply everyone.

"There was this thing called the Churchill Club. Soirées. Gatherings. I've got an idea that it was at the Clarks' on Thursdays." It was primarily at Ashburnham House in Little Dean's Yard, part of Westminster School, which had been evacuated. The headmaster, John Christie, had wanted the premises put to use: "Theoretically," his daughter Catherine Porteous remembered, "it was for officers from other countries, for their rest and recreation, but it was staffed by elegant hostesses: Pamela Harriman and Jane Clark were prime movers, so grand people went there."[8] Prompted by Craxton, Freud found this a good place to go and be seen in. "Eliot sometimes went, Spender—before his later rather admirable ridiculousness—David Cecil, Isaiah Berlin, Freddie Ashton. John Sparrow [a future warden of All Souls] was there, I'd just been to sea and he said, 'I'm a sailor'; he was a non-acting commander: what he *really* liked was policemen. There were outings and concerts. It seemed very heightened in an exciting sort of way." There was the opportunity to hear K. Clark, for example, lecturing on "Looking at Drawings." Being in the right place at the right time had its appeal as a form of luck: coincidence yielding opportunity, gossip triggering insights, disparate lives by chance connecting.

"After the war my father did some work for Philip Hendy in a large house that he had round the corner from Abercorn Place; this was just after Clark left the National Gallery and Hendy had been appointed Director. My father did the interior conversion. He said to me, 'He's got an awful problem now he's Director of the National Gallery: nothing he's got is good enough to hang in the house except Henry Moore drawings.' Hendy was known as 'the Bootlace' at the National Gallery. An odd coincidence: his daughter married—as second wife, my parents told me—Bob Woods, the farmer at Dartington that I had worshipped so." Such coincidence had potential. Ernst Freud's clients were useful contacts for Lucian the aspirant who could

now aim to draw well enough to match up to, if not better, drawings by Henry Moore, who happened to be K. Clark's most favoured artist.

Both sensible and idealistic, Clark's programme of exhibitions at the National Gallery—which included in 1940 a display of more than 300 examples of "British Painting Since Whistler"—and lunchtime concerts, principally piano recitals by the redoubtable Myra Hess, preserved the emptied building from requisition by a wartime ministry. Besides regular shows of war art, amateur and professional, there were exhibitions more to the Director's taste: in 1942, for instance, contrasting paintings by William Nicholson and Jack B. Yeats. At the time Freud saw nothing in Yeats' impasto. "I went round K.'s house with somebody and K. showed us a Jack B. Yeats of a flower in a washbasin. 'It really has a quality, don't you think?' he said. Being young, I said, 'No.' And he said to the man I was with, 'Now we've been told.'"

Halfway through *Much Too Shy*, a film shot in the summer of 1942, George Formby, the toothy Lancashire comic, enters an art school seeking tips on how to draw bodies, given that he can already do heads. The camera follows him as he gawps at students engaged in producing cloven faces and other Surrealistic derivatives. So this is Modern Art.

As in all his screen roles, Formby playing Andy the Handyman is an eager ukulele-strumming mock innocent, gormless yet canny. Sidling through the easels he comes across the character actor Charles Hawtrey, Soho layabout and future regular in the *Carry On* films but here the voice of student pretension, loudly echoing Isidore Ducasse. "Anyone can do the external!" he cries. "We see inside a man! We see his soul, his thoughts, his fears and his worries."

Barely seen, glimpsed as a profile and head of hair in a corner of the studio is Freud the film extra. Though referred to by the Hawtrey character as a "brother brush" (who, off screen, he said, "pursued me very much"), the director, Marcel Varnel, thought Freud pretty useless for he didn't even know that artists' palettes have to be held at a cocky angle in the left hand. "'Haven't you ever,' he demanded, 'seen a painter paint a picture before?'" Freud thought it pointless explaining that he was left-handed. "The director said this is how you do it, so I said thank you and did it."

After two days at thirty shillings a day on *Much Too Shy*, which he did not go and see in the cinema ("I felt a bit disdainful once I got my sixty shillings"), Freud had three further days at the Elstree Studios wearing a beret in a French Resistance drama that he remembered as being called *The Private Life of Jacqueline*, confusing it possibly with *Talking About Jacqueline*, in which there is no trace of a Frenchman in a Basque beret. Here he was required to pray in a cathedral during an air-raid scene and sit in an outdoor café. The film proved to be a stinker. "Incredibly crappy it was and a flop. The star a few years later was a doorman in a nightclub."

The suggestion that he might try getting work as an extra by signing up with United Castings had come from the actor James Donald, "quiet and sort of puritanical, very unqueer: just below being a top star." He was to make a career of playing admirable officers, culminating in the leading pretty decent one in *Bridge on the River Kwai*. In 1942 he was captain in Noël Coward's *In Which We Serve*, shot at Denham at the same time as *Much Too Shy*; Freud spent a day on the set and painted a mural for the bathroom of Donald's newly acquired flat in Primrose Hill, staying there for a while before Donald moved in. "It was a scene by the shore with slightly Russian opera girls looking out and a ship coming into harbour, from *The Threepenny Opera*, and a woman suckling a dog. Mixed materials: I used chalk and all sorts of stuff and he was really upset by it. He got a bit interested in art, especially Feliks Topolski, because he was a great admirer of Bernard Shaw who made that remark about Picasso and Topolski, that both, when they started a painting, it's an absolute mess, and when Topolski finished it's absolutely brilliant." No one going along with that, let alone baulking at the mural, could be regarded as a friend.

The Anglo-Soviet Treaty signed in May 1942 prompted shows of solidarity. The red flag flew over Selfridges and the following month, just ahead of an officially ordained exhibition at the Wallace Collection ("Artists Aid Russia for Mrs. Winston Churchill's Aid to Russia Fund"), the architect Ernő Goldfinger hosted "Aid to Russia" in his modernist house in 2 Willow Road, Hampstead, with a display of

works by Epstein, Hepworth, Moore, Nicholson, Schwitters, Klee, Sutherland and others, among them Craxton. Peter Watson was on the organising committee. A collector, Hugh Willoughby, formerly of Wildenstein's, whom Freud remembered as leading "a very ordinary retired person's life in Brighton," lent one of his Picassos ("he talked all the time about what they might be worth") and Craxton went down to collect it. The painting was *La Niçoise*, a larky portrait of Nusch Éluard, wife of Paul Éluard, the bulk of whose collection had been acquired not long before by Roland Penrose, most notably Picasso's *Weeping Woman*.

When the exhibition closed Freud was asked to take a Picasso to Brighton, where Hugh Willoughby had temporarily converted his flat into a gallery. It was a sunny day and having placed the picture on the opposite seat in the railway carriage he marvelled at it. "I was so amazed that the bright sunlight in no way made it any worse or more garish or weaker or more painty. It was as powerful and strong as possible." He always maintained that the painting was *Weeping Woman*, but it was possibly the portrait of Nusch Éluard that he was returning to Hugh Willoughby. Whichever, it was the blazing panache that so appealed.

"You can use your intent to make anything seem like anything: Picasso's a master at being able to make a face feel like a foot."

Undated: typed on his father's headed notepaper with the "Ernst" of "Ernst L. Freud" obliterated:

> *Darling Felicity*
>
> *I would love to come down this weekend. thanks very much for your letter I went to Brighton last Monday to see some wonderful Picasso pictures that a man has. I went too the opening of that enormous exebition for Russia in portman sqare* [actually the Wallace Collection, Manchester Square] *wich is rather awful, and saw many familiar faces including moudie, allan waltan, algy newton and two old ladies of ninety, who said to one another "what I REALLY like is pure spontaneous enjoyment"!*
>
> *I have finished my piture of those birds and men* [Landscape with Birds] *I might bring it down to show you. Jonnie craxton*

and I are thinking of opening a new Russian barbers shop where
you can get a timoshenko haircut sitting in one of timo's saddles
with cotton wool from turkistan in your ears, chewing some licorice
roots from siberia. I bought some lovely postcards from victorian
times where you pull leavers and people start doing acrobatics or
change their clothes disrobe and change into witches flowers start
sprowting babies and couples start having champagne dinners
behind the hedge . . . Lots of love LUCIAN.[9]

In September 1942 the Lefevre Gallery included *Landscape with Birds*
in "Contemporary British Paintings." "Newish-comers worth mark-
ing," the *Studio* commented: among them were Denis Wirth-Miller,
Betty Shaw-Lawrence, John Minton and Michael Ayrton. To Freud's
amazement the painting sold. "I heard it was someone French or for-
eign and the only person I knew to do with the Foreign Office was
Donald Maclean—the Russian agent—so I got him to do some spying
and he found out that a man in the French Embassy had bought it."
He remembered his reaction to being told that a complete stranger, a
Free Frenchman indeed, had bought it. What a boost. He was up and
running. As the nursery rhyme said:

All the birds in the air couldn't catch me.

Saturday [late 1942]:
 Darling Felicity thank you so much for the bugle it is
delishious so are you I find I can play many a strange note on it.
I got you a very old scarlet and dark blue coat with brass buttons
and white cord and strange decorations and R.M.F. written on
the shoulders its lined with white wool and red silk and its very
warm but I can not send it to you now because its being painted in
a picture but I will when its finished
 There is comlete chaos here and I have just managed to
recover an aluminium frying pan which I left in the garden a
month ago . . .[10]

Sitters were hard to find and harder to retain, Freud found. Ger-
ald Wilde, who stayed at Abercorn Place at Peter Watson's behest
towards the end of 1942, seemed well placed to do so; having been

discharged from the army as "psychologically unfit" he was presumed available but, being more squatter than guest, he felt no obligation to sit. Wilde, who was a spasmodic painter with a volcanic talent and temperament, had been taught, a little, at Chelsea School of Art by Graham Sutherland who, he maintained, had then stolen his ideas and a stack of paintings besides. Initially Freud was impressed by the little man's lively rancour. "He rebelled against his teaching and set himself up in the art school and Graham minded that. K. Clark went to see him and bought four or five things: he had a room of things he bought just to help the artist." This was, surely, a sitter in a million, providentially arrived at number 14.

Stories about Wilde abounded, mostly apocryphal but sufficient to make him legendary in Soho and beyond. Was he the sole survivor of a bomb-disposal squad? Certainly he had been in the Pioneer Corps for a while during the Blitz, working on demolition, but there was no record of any such incident. After his discharge he had done labouring jobs. Drunk or sober but mainly drunk, he had it in for policemen and would shout at them in the street; again, Freud liked the sound of that and his ability to paint profusely from time to time, not diligently but on the hop. Naturally, when Joyce Cary's novel *The Horse's Mouth* appeared in 1944, word went round that his Gulley Jimson, a rogue genius of a painter, just had to be him, though in fact Cary would not meet him until 1949. Yet Wilde assured Cary that he was the original.[11] Similarly, though not related to Oscar Wilde, he had succeeded earlier on, by virtue of his surname alone, in being taken up by Lord and Lady Alfred Douglas. Nifty opportunist that he was, no sooner was he settled in at Abercorn Place than he took to foraging locally: too close to home, where Freud was concerned. "He went round to my mother—he sensibly got her address, it was in the phone book—touching her for money, and telling Lady Alfred stories. My mother had this side of being a very good person and suddenly had a bit of scope. (Stephen and Cle weren't going to bring in degenerates.) But my father came in. 'This can't go on,' he said, seeing Gerald, with his wall-eye and everything. My mother said afterwards, 'I'm afraid your father shouted at him.'"

Freud couldn't get Wilde to settle. "It was difficult. He was difficult. Insensate rages in the mornings." A painting on panel—an architect's sample scrounged from home—was begun and developed

to a point where the incompletion reflected the sitter's character: Wilde as a toby-jug head in three-quarters profile, the skin translucent (thinned Ripolin), a curve of mirror frame lodged behind him like a broken halo, he who had just seen fit to shrug off the offer of a stipend from Sir Kenneth Clark. Why take money, Wilde reasoned, from the man who paid for the upkeep of that unforgivable Graham Sutherland? The marked discrepancy between the eyes was evidence of Freud's growing exactitude. His left eye had been damaged, Wilde said, when his mother threw a flatiron at him. Or was it, he mused, an accident with a knitting needle?

> *Darling Felicity, Wednesday night* [late 1942]
> *Do lets meet at Hadleigh next weekend or the one after.*
> *Let me know if you can and when? Ive just seen a play called "a*
> *month in the country" with Michael Redgrave which very good.*
> *Ive finished painting your coat so you can have it now Ill bring it*
> *down when we meet. I bought some red flannel today the man in*
> *the shop said that lots of doctors and Medical Men come in to buy*
> *it as there is a certain something in the die that does something to*
> *the eye, really most mysterious!*
> *My Wales trip has been postponed till March. Weve had a*
> *crazy boy staying here who kept on eating the crescents off Jonnies*
> *still life which he had procured with immense difficulty I am*
> *beginning to be able to play some quite eerie noises on the bugle*
> *write soon best love from Lucian*[12]

The sightless two-faced Janus head, a plaster cast belonging to Craxton lugged upstairs for *Still Life with Chelsea Buns*, was a good substitute for the irksome Wilde. Freud balanced it on the table edge like a chess king checkmated, poised to topple. The cracks in the bust, the hairline branches against the leaden sky, the faceted lumps of coal ("I was very keen on coal"), the rounded edge of the zinc-covered table ("partly Ripolin there"), the folds of the red jacket—Boer War period, bought from Bell Street market—and the raisins embedded around the navels of the buns from the Fitzroy Road bakery, are near-animate; the materials—dough, flannel, plaster, metal, coal—swap characteristics. The bust seems as rumpled as the cloth, as fossilised as the coal; the buns are sticky ammonites. Even the floorboards have

individuality. Freud was pleased with these. "I'm really laying them, I thought." Surreality plays no part here, for this is a clear account of actual things to hand enabling the imagination to take hold.

The Leicester Galleries New Year Exhibition for 1943 included a drawing by Craxton, *Landscape with Rocks*, which was reproduced in the *Listener* ("one of Jonnie's pictures did you see it?" Freud asked Felicity)[13] where, moreover, the critic R. H. Wilenski singled it out for comment: "Craxton gives us formal inventions conducive to some mood." The mood was elaborately wistful and the style over-exercised in that a prophet or shepherd was posed among crystalline rocks against a backdrop of pointy mountains. Wilenski went on to commend a number of "attractive works" by, among others, Paul Nash, Allan Walton, William Scott, Ivon Hitchens and Lucien [*sic*] Freud. In the pursuit of recognition any mention was better than nothing but, clearly, Craxton was establishing a lead.

In Freud's experience "You couldn't go out in the blackout without getting the clap." Adrian Ryan, a painter acquaintance, recommended a doctor, "Dr. Freumann, who became one of the Dr. Feelgoods in New York and was doctor to the Turkish Embassy; he lived in a modern block of flats in Bayswater Road with his mother in great style. I said, 'How much is it?' 'I'd have thought you need money,' he said and gave me some. And then I went back to him. 'Where do you find all these beauties?' he said. He [Adrian Ryan] had a luxurious flat in Maida Vale with Soutines—his uncle had money—and had deliberately made himself into something based on a photograph of Modigliani: how exciting, for someone very young—in his early twenties—to live with Soutines." Ryan bought *Man Wheeling Picture* and Freud gave him the drawing *Chicken in a Bucket*, which Ryan then copied. "He moved to Cornwall and never looked back; wrote two or three books, one on 'Still Life Painting.' Say no more."

Freud also got to know Dylan Thomas, then working for the BBC. "He was quite sneery and was rude to me, to do with making assumptions re my friendship with Stephen. Once he came away from Peter Watson's flat, having gone there to raise money, pulled a wad out of his pocket and said, 'Done well.' I thought that was a despicable attitude. I've never been alive much to repercussions."

After nearly ten years in England Freud was alert to social distinctions and attuned to the culture of understatement. He still spoke (and would do so for the rest of his life) with traces of German accent, syntax and intonation, but decidedly less so than his parents. His demeanour was obviously to some extent his own invention; he liked to appear elusive, partly out of shyness.

Postmark 24 February 1943 on a pre–First World War postcard of Japanese soldiers:

> *Darling Felicity Do lets go this weekend to Benton End I have not*
> *yet written to Lett but I will try and phone him at the pub but*
> *even if I don't get hold of him I am sure its OK anyway they like*
> *surprises also I feel that if I rang he might billet you with Lucy*
> *which would be a bore. Gee its foggy here! Note the smart and*
> *handsome japs love Lucian.*[14]

In wartime London, with its battered, spiv-ridden shabbiness and intensified night life, Freud liked to see himself as a zoot-suit *flâneur*. Opportunity came for those like himself who, whether relative newcomers ("gee its foggy here!") or non-combatant go-getters, hadn't the inhibitions of the born British, brought up to stick to their own and know their place.

Moreover, being a naturalised subject of the King he was in no danger of being shoved into the Pioneer Corps or, worse, interned. Getting by was his preoccupation, spelt out in the table-top parades of his still lives. The red jacket, the Janus head and glinting lumps of coal could be regarded as emblematic in time of war; however, they perform more convincingly as disparate objects brought together for no other reason than that they were there because they were there because they were there: things that served, things interestingly arrayed. Freud now knew the need to focus exclusively, to concentrate. The drawing habit that had been essentially an urge to doodle and adorn had developed into sustained impulse. Now that he had his own room to paint in he could regard himself as an assured painter, and now that he could achieve intensity there was more likelihood of his being able to move from graphic rhyme, as it were, into poetic risk.

An article by Kenneth Clark on "Ornament in Modern Architecture," published in the *Architectural Review*, expressed disapproval for new ways in complication. "Every line of modern poetry labours with meaning and imagery till we long to throw the floundering poet some empty, buoyant convention on which, for a few seconds, he could rest and recover breath. But conventions no longer sustain; they sink, deflated, and drag down the poem or musical composition with them."[15] Freud's *Man with a Feather*, painted at Abercorn Place in early 1943 and devised to mystify a little, is a portrait in questing mode examining the idea that conventionality is sustaining. In it the young man's dilemma, whether to be surreal or metaphysical, is resolved into a show of attitude. As pensive as a Memling youth, as impassively composed as Giovanni Arnolfini in the Van Eyck marriage portrait (which had just been restored at the National Gallery), Freud presents himself coolly, collar askew, tie awry, hands placed just so. The contrivances in pose and setting are actuality rejigged. Calculatedly puzzling, the set-up creates pit-a-pat intrigue with blank windows blanking the mirror image and every element itemised: black tie, black jacket ("keeping it all black"), black bird, black mannikin, black sky; pale face, pale fingernails, pale leaves, white feather. The artist's painting hand—his left hand, that is—stretches across his body in a studied measuring gesture indicating that this is a picture of consequence, not to be dismissed as merely School of Cedric Morris but rather to be seen, and admired, as an apprentice masterpiece.

Ambitious yet cautious, *Man with a Feather* exudes Maldoror dolour: "He waits for the twilight of morning to bring with its change of surroundings a derisory relief to his overburdened heart." Posed with "this imaginary house behind, with this imaginary man in the window," Freud's image of himself begs questions and proffers hints. "Slight *Dreigroschenoper*," he conceded: "the chambermaid's song about the hotel by the harbour, which I also used in the mural for the actor. The bird on the window sill flew in from early things." The leaf-shaped stepping-stones trail back to the North Atlantic ("I always loved the idea of icebergs; though when I went to Newfoundland I never saw any") and refer back to the shattered glass underfoot in the hall at Abercorn Place. They were also (this being an elaborated conceit) a childhood mealtime memory. "We used to have cold vanilla soup, a German dish, and it had islands of egg white in it. To me,

islands meant that a bit: Hiddensee. I always liked the early Auden poems that had islands in them, the thing about leaving islands: 'The little steamer with its hoot / You have gone away.'"

Characteristically, Freud's recollection was briefer than the original lines from the 1st Mad Lady in *The Dog Beneath the Skin*:

> *The tiny steamer in the bay*
> *Startling summer with its hoot.*
> *You have gone away.*

While Freud was still working on the painting, his most ambitious so far, Peter Watson slipped him £25 in fivers. "It wasn't terribly much but I thought: this is it, I'm going to start living." In the Coffee An' he picked up a red-haired girl ("Sort of whore: not a real one as she wouldn't have come back with me if she was") and took her to his room where she stayed a night or two. She was impressed by the fivers, astonished at the picture and puzzled about Freud. "He's absolutely mad," she told her friends back in the Coffee An'. "You know what he does? He does tiny yellow bricks; he just paints yellow bricks; fucking mad." He decided he rather liked being traduced. "I felt slightly proud at this; like it always says in the newspapers: 'My wife doesn't understand me.'"

The large pencil drawing *Cacti and Stuffed Bird*, a still life assembled on Cedric Morris's window ledge and completed during one of his last brief stays at Benton End, was reproduced in the May 1943 number of *Horizon*. Various breeds of cacti, some young and squirmy, others with lumps missing from their lobes, crowd the dead-and-alive sandpiper paraded in its glass case. Pleased with its edginess and complexity and the touches of Conté colour, Freud came to regard it as a sort of graduation piece, a parting view of the prickliness and parochialism of East Anglian School weekends.

Undated postcard early 1943:

> *Darling Felicity thanks for your letter I have been to Cambridge*
> *for a week. I did a picture of a baby there. Do come to London for*
> *easter I have bought an enormous stuffed fish. I sold that cactus*

picture I did in Hadleigh I am doing a very large self portrait I
bought a book called "LONDON" with engravings by Gustave
Dore for a shilling in Cambridge I had always wanted it. I am
overjoyed tonight as I have just found a tube of Francis Foxes
analeptic herbal ointment for the scalp which I had lost for weeks. I
quite agree with what you said about C and L [Cedric and Lett].
Im afraid there will be a great catastrophe there one of these days.
I have found a shop where all the garments are as interesting as
your red coat. You must come to us when you are in London lots of
love Lucian[16]

Rummaging through junk shops and street markets in search of
things to draw or wear or brag about was reliably stimulating, never
more so than when Craxton came upon a hand-embellished print by
William Blake: *Satan Exulting over Eve*. At a shilling Doré's *London* was
less of a bargain than the £15 Blake, but its scenes of the metropolis a
century earlier, alternately fogged and benighted, elegance contrasted
with grizzled poverty, backed Freud's notion of being, like Doré, a
graphic adventurer, slipping freely from posh to desolate to rakish:
"*so free, so free, so free.*"

"I've always liked buying things. At Bryanston the terrible picture
by David Barker. Craxton knew a bit about china and dealt in it and
I got to like things. Early imitation Chinese, as Bristolians liked it:
pottery imitation porcelain. I used to collect Bristol plates, an early
Queen Anne one, a Delft bowl, an early one with flowers on. Ian
Phillips borrowed it and broke it and felt terrible and gave me a piece
of furniture. I had a passion for Spanish rugs made in prisons and
monasteries: traditional Spanish birds and fish designs, very vigor-
ous, marvellous colours, blue and white and sometimes red and black.
Miró colours."

Social rummaging was a parallel pursuit and, again, Craxton had
the greater initiative. He introduced Freud to Tom Kendrick, Cura-
tor of Medieval Antiquities at the British Museum, who took them
to the Savile Club where the pre-eminent Robert Donat gave them
tickets for plays. "Craxton was a tremendous crasher. If he was in the
country he would just go to a house and ring the bell. 'The back door
is always open,' Jane Clark said to him."

In the spring of 1943 Peter Watson rented Tickerage Mill in Sus-

sex for a year from Dick Wyndham, known as "Whips" Wyndham on
account of his keen interest in chastising young women. Isolated in
woods up a long private track with its own pond (where the ashes of
Vivien Leigh, a later tenant, were to be scattered), Tickerage served
as a weekend resort for Watson's friends and protégés. Freud and
Craxton were among the first, and the *Horizon* hangers-on, notably
David Gascoyne, a literary prodigy six years older than Freud, who
had gone to Paris aged seventeen and there gained admission to Sur-
realist circles. He sat for Freud, eyes closed, pondering a phrase or
savouring the Christian mysticism that was already superseding Sur-
realism in his philosophy. "At night," he had confided to his journal
five years earlier, "I lie tormented on the yellow eiderdown, a prey to
acute mental conflicts and disintegrating doubts. A sort of dialogue
goes on inside my head."[17] During Gascoyne's fortnight at Ticker-
age Freud drew him awake and sleeping, his brow consistently fur-
rowed.[18] Gascoyne's talk of "the velvet crater of the ear"[19] was too
poetic for Freud to stomach; he did however design a bookplate for
him: "David Emery Gascoyne," the poet rejuvenated in a school cap
topped off with a leering dog, and with an assortment of fur, flesh and
fowl plus four-legged fish trailing around the label's edges. An animal
garland for one who described himself as a "Poet-Seer" and, in later
drawings, looked blinded with despair.

> *Darling Felicity* [spring 1943]
> *I am sorry I have not written before I enjoyed the Sunday*
> *of that weekend very much I was forced to stay on till Tuesday*
> *as I wanted to finish that cactus picture which I did. Cedric*
> *wrote a letter to my mother asking her to persuade me not to*
> *come down again as I was too destructive and unscrupulous. It*
> *does not surprise me really as he was unusually friendly over the*
> *weekend. I think they must have found out that I don't come*
> *down to Hadleigh entirely to see them. Here is a proof of David*
> *[Gascoyne]'s bookplate. I have bought an enormous mirror*
> *shaped thus* [an arched frame] *the painting with your coat in it*
> *is finished at last Is it not getting rather near your easter holiday/*
> *vacation? I have asked a rather sinister woman to write a letter*
> *to the british council asking if I could be sent to spain to radiate*

british culture but I doubt if anything will come of it at all lots of love Lucian[20]

Though invited by Watson to stay at Tickerage, Michael Hamburger, emerging poet and translator, did not go. "Probably I couldn't get leave from the army; I didn't want to go because I knew he was homosexual and that put me off." Freud thought Hamburger—a living reminder, for him, of the Tiergarten and the next-door sandpit in Berlin—was too ready with his aspersions. He drew Watson, sharp yet diffident, as did Craxton: similar drawings, three-quarter face, but differing apprehension. "Peter Watson had the most immaculate manners and would never have tried anything." He and Watson cycled over to Berwick, near Firle, where Duncan Grant and Vanessa Bell had supplied fresco-like wall paintings for the church on sheets of plasterboard. All too typical Bloomsbury with their mildly cloistered air, they had been installed and dedicated a few months before. "They were not as bad as I thought, but no impact." Back at Tickerage, where Bloomsbury creativity was held to be exclusive stodge, there was every chance of drama: if not in the Mill itself, then on its doorstep.

"In the mill house, across from it, Natalie and Robert [Newton, the actor, son of Algernon Newton] lived. Natalie went off with Dick Wyndham. She was extraordinarily funny and witty; she escaped from a loony bin and they rang up Hermione Baddeley and said, 'She's heading your way.' I saw her once in the Gargoyle: screams of agony from the corner where she was with Jocelyn Baines (who wrote about Conrad) and I heard her say, 'I couldn't help it, darling, your eyes are so like little ashtrays.'"

Little Shelford [May 1943]
 Darling Felicity, How are you? Thank you for your letter. I've just spilt a bottle of Indian ink over my sheets. I did enjoy seeing you in London even though I did not really get a chance to talk to you, which I had wanted to probably because of the cold and everything being rather chaotic. I thought you were looking teriffically glamerous. Do come up and stay for whitsun if you would like to. I am staying at a very creamy place. Every morning

many parcels arrive each one contains a dead animal mostly
chickens and Roosters gamecocks sometimes a rabbit once a baby
Pig. I have been making pictures of them. I did one of a gamecock
in a bucket of hot scummy water and the fumes and smell of decay
was so overwhelming that it sent me into a coma. These animals
attract a special kind of fat blue and green fly they are terribly
depraved and eat so much of the carcas that they go mad, buss
slowly through the air in a dizzy manner and dive with a splash
into my paint water where they die.

Ive bought a stuffed deap sea fish with a beak and spikes
all over it like a Cactus of which Ive done a picture. Allso I got
a wonderfull book about Deseases of the skin with amazing
illustrations you must come and see it. Have you seen the Horizon
with my things?

I have been riding a great deal here it really is one of the most
exiting things there is it makes me feel about three times more
alive and powerfull than I do otherwise. I put some money on a
horse in the two thousand Guinnies next Tuesday called "Pink
Flower" I may go to Newmarket to see it run I wish you could
come along as well. Do write soon to No 14 as I shall be back there
soon lots lots of love lucian[21]

Kingsway (18:1) won by a short head from Pink Flower (100:9) in
the Two Thousand Guineas at Newmarket on 25 May 1943. If horse
riding made Freud feel about three times more alive and powerful
than normal, it beat betting by only a short head. The risks differed
but, being related, were in the short run equally compelling.

Craxton and Freud went down to Dorset together a number of times
visiting Craxton's friend Elsie Queen Nicholson, known to her circle
as EQ, who was then thirty-five and whose husband the architect Kit
Nicholson was serving in the Fleet Air Arm. She had left London
with her three children to avoid the Blitz and was living at Alderholt
Mill in Cranborne Chase, near Fordingbridge, a house of Regency
and Aalto furniture and an Aga, Satie, Kurt Weill and jazz records
and paintings by William, Ben and Winifred Nicholson, her father-
in-law, brother-in-law and ex-sister-in-law respectively. She designed

for Edinburgh Weavers and had a drawing of cabbage leaves reproduced in *Horizon* in April 1943. Craxton had known EQ since 1940 and the area of Cranborne Chase since childhood, so much so that it furnished him with his formulaic landscape of curvaceous hills. Freud suspected, unconvincingly, that Craxton had had an affair with EQ: they had been to Wales together in 1942 and "something happened; she was twice his age." The real attraction was her liveliness and hospitality and the busy disorder of family life.

The three of them went once to Swanage, where Craxton and Freud clashed on the dodgem cars by the harbour, so much so that the operator gave them each a ten-shilling note to desist. "We were completely alone, taking the cars in the morning, driving straight at each other," Craxton remembered.[22] "Lucian bought a lobster and drew it until it stank too high; it was thrown on to a roof where it broke in pieces and fell to the ground." They painted outdoors at Alderholt Mill and drew indoors, companionably and competitively; it was, Freud felt, a bit like Capel Curig all over again but more entertaining with Craxton as opposed to David Kentish. "Its very wintry here and luxurious," he told Felicity. EQ's children being there brought out the childishness in the pair of them. Her son Tim had a distinct memory—he was four or five at the time—of Freud and Craxton horseplay: fighting over a newspaper. There were parlour-game drawings in which everyone had a hand. Later, as fortunes changed, there was to be dispute over who did what and when, in which Freud was responsible, probably, for a man, a dog and a horse but not for the higgledy-piggledy setting coloured in by someone else, which reappeared decades later as *Man and Dog by a Tree* and lawyers became involved.

Fantasy was required, or stretched truth, and Freud responded. "I was very keen on doing tapirs. I did a picture, which I gave to David Gascoyne and which he immediately lost, and then I was in Dorset and started drawing these little tapirs and I thought they are too little and too silly, so I drew a canvas around them and then I thought what shall I do with it? So I put a barrow underneath and myself wheeling the barrow and wearing the cap that I got in Canada, which had flaps and was made of crinkly leather: a real memento." Freud suspected, in retrospect, that *Man Wheeling Picture*, a drawing worked up in ink, watercolour and varnish, represented, consciously or not, his depar-

ture from Benton End: the artist quitting the East Anglian School and trundling his bizarre accomplishment to town. It also declared his availability as a weekend guest.

"I used to cycle down to EQ's. I'd hold on with both hands on the back of lorries—they used to have a big platform with metal bar—and they'd brake suddenly and try and throw me off."

"We learnt a lot from each other," Craxton said. "I learnt from Lucian how to scrutinise, which I wasn't doing before, and Lucian learnt how to plan pictures and use colour. We were packed off to Goldsmith's College by Peter Watson. Peter was worried about Lucian not being able to draw. Peter said, 'Lucian must learn how to draw a hand before he distorts one.' It was Graham Sutherland who recommended Goldsmith's."[23]

Sutherland had seen in the May 1943 *Horizon* Freud's drawing of the poet Nicholas Moore's baby daughter sleeping in a basket with her rag-doll monkey sprawled across her. The drawing impressed him and he got in touch. "Small and neat (trousers creased) and intense, with a look of avian anguish," as the critic Geoffrey Grigson described him,[24] Sutherland was a generation older than Freud and prominent among Kenneth Clark's most favoured artists. For draughtsmanship, he thought, where better than Goldsmith's, where he himself had been a student; his friend the Principal, Clive Gardiner, had no objection to them coming in and drawing from the model, he said. "Provided it's not crowded and you don't keep anyone else out."

They did not take to life drawing classes, preferring to work freely elsewhere. One of the people who had been in hospital with Freud told him about the shelter in the crypt of St. Martin-in-the-Fields and another, for the homeless, by Charing Cross station, so he went there to draw. "The place had a St. James's club type name: it was an all-night refuge for tramps. They slept leaning on bars and mattresses, like birds." He also drew at the Roehampton swimming pool and in Kew Gardens. Then, a month or so later, Sutherland asked if they would like to go with him to Pembrokeshire, the corner of West Wales that served him as his spiritual landscape. He had rhapsodised over it in a letter to Peter Watson (readdressed to Colin Anderson of the Orient Line as a more eminent recipient) for publication in *Hori-*

zon, extolling its primordial seclusion. "A mysterious space limit—a womb-like enclosure—which gives the human form an extraordinary focus and significance."[25] In his Palace Gate flat one day Peter Watson suddenly took Sutherland's *Steep Road* drawing off the wall and gave it to Craxton.

Although Freud liked Sutherland's work he was never excited by it. The *Horizon* letter struck him as oratorical "to an embarrassing degree. A bit of a little boy performing in front of the class, I felt; Graham's reputation was enormous on the strength of the war things which were neck and neck with Piper." A few months earlier, in the summer of 1942, Sutherland had produced a suite of eight drawings for David Gascoyne's *Poems 1937–1942* published by Poetry London Press: ink-and-wash embellishments as high pitched as the lyricism of his *Horizon* letter—"steep roads which pinch the setting sun, mantling clouds against a black sky and the thunder, the flowers and the damp hollows," which, consciously or not, echoed Maldoror digging his heels into "the steep road of terrestrial voyaging."[26]

"What was wonderful about him," Craxton said, "was that he did not want to make one do Graham Sutherlands." Yet Craxton did.[27] His landscapes had Sutherland escarpments and shadows, the only difference being that, where Sutherland did without figures, Craxton usually had a male Dora Maar dozing, as it were, within earshot of the *Song of Maldoror*: "In a flower embowered thicket the hermaphrodite sleeps, profoundly hushed upon the grass drenched in his tears."[28] Emblem books with their formal arrangements of attributes gave him ideas about repertoires of information and adornment, part heraldic, part tarot.

Freud went along with Craxton's foraging—anything for stimulus—but eventually diverged, aiming for intensity by dint of detail and singularity; not so much life studies in the conventional characterless sense, more portrait designs in a Renaissance manner, often on Ingres paper, brown and grey, from an album that he found on a book barrow in Bell Street off the Edgware Road. While aiming for competence—"to give all the information I can"—he took in what others had made of the sort of objects that engaged attention. Dead creatures could be studied minutely, their fingernails examined, and the lack of reaction in their eyes. Plants could be similarly if not equally fascinating: gorse, sprigs of thistle raised, crab-like, on their

points. Detail was a measure of integrity. "I didn't think of it as detail, it was simply through my concentration a question of focus. I always felt that detail—where one was conscious of detail—was detrimental. I always liked Ingres." He may not have been aware then of Ingres having said, "line is drawing, it is everything," but he did see that precise delineation was worthwhile, that consistent focus gave a drawing coherence. "Freud is a mimic. He has to see continually what he has to paint," Craxton commented sixty years later.[29]

The elegantly cavernous nostril of an Uccello horse or an Ingres neck smoothed to perfection could serve to stir him more than an actual neck or actual nostril, particularly as he had problems finding suitable necks and nostrils to draw. Who would sit for him? There was next to nothing in it for them, payment least of all. Like any other twenty-year-old beginner, he had to be opportunistically persuasive. "My things were completely unconsidered." Most drawings were scrapped. Craxton, he later claimed, often retrieved them. "He jolly well went through the bins."

Throughout this period there was emulation and overlap. Picking up on Craxton's assured manner Freud's drawing became more rounded and trim, sometimes nattily so, firm outlines plumped out with schematic shading. "Before we met up he was always using a mapping pen to draw with," Craxton pointedly remarked. "Under my 'influence' he took to Conté crayon."[30]

Peter Watson wrote to Freud from Tickerage, commending the way that, since he had known him, his work had "improved in every respect, such as conviction and solidity of draughtsmanship, colour, all allied to an ever fertile imagination which I think will never flag." He told him that he was "one of those people who must learn everything by trial, error and your own experience."[31]

"A question of focus"

The white feather in *Man with a Feather*, indicative of war avoidance or a lovelorn state, was a chicken feather brought from the country and given to Freud in the winter of 1943 by Lorna Wishart. Nearly twelve years older than him and married to Ernest Wishart, owner of the Marxist publishers Lawrence & Wishart, whom she had married at sixteen, by 1943 she was an undeniable femme fatale.

"I used to stay at Glebe House, where Lorna and her husband and children were, and I was caught by Wish with Lorna. There was an awful scene in a field. She was concerned for me; he shouted and called her a whore, probably because of her being with a much younger boy. He was rather nice to me, feigned interest in painting. It's hard for me to say, but I think he was a stiff, unemotional, sedentary man and she was very glamorous and capricious. I was very upset and didn't go down there again."

Fanned by emotion, the involvement swiftly took hold. Lorna Wishart was used to acting on impulse while retaining a sense of social superiority. "She used to come to Abercorn Place and stay and she'd say about Johnny, 'Is he a gentleman?'" Being the youngest of a family of nine, she had an unusual number of siblings to learn from and outdo. Her brother Douglas had been involved with Peggy Guggenheim (who thought Lorna "the most beautiful creature" she had ever seen)[1] and her eldest sister, Kathleen, was Epstein's mistress. Their mother was the illegitimate daughter of the statesman Lord

Grey. All this impressed Freud. Smitten, he even took her to see his mother. "Everyone liked her. Including my mother."

"Their father was a doctor, who beat his children and sent them to German universities as he'd been educated there. They went wild when he died. Kathleen came to London and drove a horse and cart for Lyons, taking Welsh rarebits from Cadby Hall to the Lyons Corner Houses; she and her sister Mary saw this beautiful man lying in sick and blood, tall, thin and pale, and they picked him up and it was Roy Campbell, the poet, whom Mary married." By the time Freud became involved with Lorna she had a fifteen-year-old son, Michael, and ten-year-old Luke, also four-year-old Yasmin fathered by the poet Laurie Lee whom she had met six years before when holidaying with her family in Cornwall. She had a cottage at Binsted in Sussex and he stayed in a caravan near by; she also had a place in South Kensington, the Wisharts' town house having been allotted to the Czech government in exile.

Laurie Lee's short story "Good Morning," published in the March 1943 issue of *Penguin New Writing*, provides a telling description of the woman who became, for the following two years, Freud's muse. "Just before noon Jenny came shivering into the house, her hair plastered with coconut oil for some reason I could not discover. She had on her blue suit with brass buttons, and brought a bottle of wine, a goose's egg, a packet of porridge and a crumpled snowdrop." For "Jenny" read Lorna. "We kissed each other and she looked at me slyly. 'There,' she said, 'you do love me only you pretend you don't. Or you don't love me and pretend you do.'"[2]

Freud had been aware of Lorna before she took up with him. "She used to visit Cedric's. She came down to see David Carr: he was terrifically keen on her. There was an awful lot of talk about her always." The Wisharts had holidayed in Southwold in 1939 and her glamour had attracted attention. "David Carr was lusting after her but I wasn't really concerned then; she was sort of well off, wonderful looking, and was the first person I got keen on. (The first girl: I'd been very fond of the farmer at Dartington.)" To Lee in 1943 the threat from this "dark, decayed-looking youth"[3] was intolerable and—poetically speaking—lamentable. Lorna had made efforts to keep them apart but inevitably they met and clashed. "Lorna had a room in Bute Street and Lau-

rie Lee attacked me, walking there; I didn't know who he was. He slapped me."

By Lee's account, set down in his diary, the encounter was a ghastly shock. It was a wet night and so, taking her coat, he had gone to meet Lorna returning to the flat from South Kensington tube station. He saw them walking along hand in hand, Freud's head inclined towards hers. "That moment was the worst in my life," he wrote. Freud slipped away across the road to the bus stop and Lorna laughed. "What's the matter? You are white with fury." She told him not to be silly, but he went after Freud ("I wanted to hit the boy hard") and spoke to him. "He gave me a mumbling look and jumped on the bus."[4] Freud noticed that Lee seemed to be sweating with fury. "I went for him and beat him up . . . Well, I

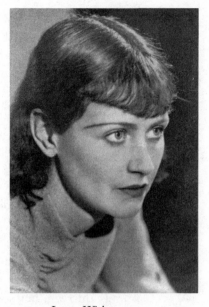

Lorna Wishart c. 1930

must have bashed him on the nose as I had his blood all over my hand from my great victory. His blood, or sweat, smelt revolting." Lee's diary entry recorded the torment of being spurned yet failed to mention the bloodied nose. By Lorna's account she called out to a passing soldier to stop them but he just said that he expected she was the trouble and walked on.

Back in her room Lorna told Lee that they had been to see Cecil Day-Lewis and that Freud was falling for her. "It isn't fair of me, I know." He reproached her for flaunting him. "Oh," she said, "I only wanted you to know so's you shouldn't worry." He watched over her while she slept, asking himself, "Is she a child or what?" Waking, she said to him that she was going to keep on seeing Freud and going to nightclubs with him and that he had better lay off. "I see no mercy or solicitude in her," he wrote, picking over his humiliation. "Why should you tell me how to live?" she said. "I won't be bound down." He noted that things had gone missing from her handbag. "No surprise to me," he added.[5] Freud in turn accused Lee of pilfering: "He broke into Abercorn Place and stole a lot of letters."

Freud had been aware of Lorna's inclinations as self-proclaimed muse and promoter. "I knew she was concerned with Laurie Lee as she showed Stephen poems of his to publish in *Horizon*. There were pseudo-Lorca poems published, never much good. He was such a 'simple fellow with his violin and quill.' He faked up things about the Spanish Civil War.[6] That was a bit disgusting." Lee was to become famous for *Cider with Rosie*, published in 1959, his memoir of childhood in a bucolic Gloucestershire village; when he tangled with Freud that evening he was engaged in writing *Land at War*, morale-boosting tillage for the Ministry of Information. His *The Sun My Monument*, poems published in 1944, was dedicated to Lorna; appropriately so in that his reproaches ("the peonies of my anger") pervaded it. "I think at night my hands are mad, / for they follow the irritant texture of darkness / continually carving the sad leaf of your mouth" ("At Night"). And: "she has no honour and she has no fear." In 1941, when he was thirteen, her son Michael prepared a book of drawings in a Lawrence & Wishart dummy, provisionally and appropriately titled "YESNO" and dedicated to his Bedales schoolmate, Thom Gunn, the future poet, consisting mainly of illustrations to the manuscript of *The Sun My Monument* in which he placed surrealistic images of his mother ("mistress of scarves and painted skins"),[7] her eyes and mouth and the crucifix at her throat.

Yasmin Wishart told Laurie Lee's biographer Valerie Grove that "Lorna was a dream for any creative artist because she got them going. She was a natural muse, a catalyst and an inspiration . . . She used to say she didn't know what guilt meant."[8] She told Freud, for instance, that she had dismissed Laurie Lee with a quip, telling him that the Bute Street incident was the end of their affair, so: "That's where you got the boot." Her son Michael talked about her "vast ultramarine eyes";[9] with these eyes (also remarked on by Peggy Guggenheim) and with eyebrows cleanly plucked she was a leftover from pre-war romantic thrillers, part Dornford Yates heroine, part Snow White's stepmother, given to driving around in an open-top Bentley, until petrol became unobtainable. "She never stopped talking about it," Lucian remembered. "But then she had to put it on grass, and birds were living in it."[10]

In the autumn of 1943, when he was in the throes of rejection, Lee would sit and type "Lorna Lorna Lorna Lorna Lorna."[11] Years

later he wrote in his notebook, "The betrayal & desertions she was capable of making in her passion for you never warned you that she would eventually do the same to you for another."[12]

Craxton considered Lucian a match for Lorna. "He was déraciné; he wasn't bound by conventions. He was very free. And so was she. Lorna was the most wonderful company, frightfully amusing and ravishingly good-looking: she could turn you to stone with a look. And she had deep qualities; she was not fluttery, she wasn't facile at all. She had a kind of mystery, a mystical inner quality. Any young man would have wanted her."[13]

It was probably Lorna that Freud was referring to at the end of his letter to Felicity written around Easter 1943: "I have asked a rather sinister woman to write a letter to the british council asking if I could be sent to spain to radiate british culture but I doubt if anything will come of it at all."

Nothing did. The Freud of *Man with a Feather* looks sharp yet tentative, hardly fitting Laurie Lee's description of him as "a dark and sinister presence." He could be a trainee Jehovah's Witness. His feather, as exquisite as was possible in shiny Ripolin white, is a disarming attribute but one that might have been calculated to rile the spurned lover. Lorna went on to buy him a more imposing find: a stuffed zebra head. This came from Rowland Ward, the taxidermist in Piccadilly. It was to keep him company, she told him, and it was an improvement on the monkey corpses from Palmers Pet Stores in that it didn't stink. The monkeys were pathetic, foetal yet aged looking, while the

Lucian Freud with zebra head, photo by Ian Gibson-Smith, reproduced in *Penguin New Writing*, 1943

expressionless zebra head ("a bit tiresome and quite heavy") was bulky
enough to be intrusive.

> *Darling Felicity here is an improved steer for you* [Freud having
> defaced a dim little postcard reproduction of a Wilson Steer
> painting of girls on the coastal path at Walberswick] *thank
> you for your Letter I am painting some quinces I am making
> some quince jam I will give you some of it if it comes off if! I am
> going off to Dorset on Saturday. I do long to see you! Lots of love
> Lucian*[14]

The zinc-topped table at Abercorn Place was shifted to one side;
against the blue sky of a presumed Africa the zebra head enters the
picture scenting a blemished quince. Its muzzle looms over the ser-
rated mouth of a paper bag.

Cumbersome in its dismounted state, the zebra head served as
stage prop and surrogate, or so it appears in a photograph taken by
Ian Gibson-Smith at Abercorn Place in 1943, around the time he shot
stills for the Powell and Pressburger production *A Canterbury Tale*, a
film riddled with emblematic teasers. Posed, zebra-like, in a striped
jersey, Freud, connoisseur of the junk-shop find, strokes the inert
head with the meditative air of a Saki character perfecting a trick.

> *"If you haven't turned my wife into a wolf," said Colonel
> Hampton, "will you kindly explain where she has disappeared
> to?"*[15]

The dandy—*flâneur*—character Freud affected was more Saki
than Baudelaire, as were his associates. "Ian Gibson-Smith wanted
to be part of things. He looked horrible: very old when he was young
(a schoolfellow of Michael Wishart, though a few years older) and
felt that money could overcome his ugliness. He had some money.
The photograph wasn't taken for any purpose." (It was reproduced,
eventually, in *Penguin New Writing* [no. 35, 1948] as one of a series
of images of promising young artists. Craxton also featured.) "He
wanted friends; he wanted to be asked to stay. Jewish partly and not
too happy at that, he had an unpleasant owlish look. I never felt com-
fortable with him. He had some rather spectacular naked poses, like

Greek athletic things, that I did at Abercorn Place. He was certainly not interested in me, but he bought a number of things: he got a couple of Picasso drawings and he bought from my first two shows."

Those who sat for Freud in the mid-forties were generally content just to be paid attention. Big-eared "Bobo" Russell, for example, whose father was the Arts and Crafts designer Gordon Russell, became more tiresomely affable than usual when being drawn. He had been a member of the Art Club at Bryanston, a painter of abstracts with a habit of playing the philosopher which involved, Freud said, shouting at the ceiling, "What does it mean? What is it meant to be?" There had been a poem addressed to him by Spender in the Freud–Schuster Book and by 1943—when Freud drew him, legs crossed, a novice pipe-smoker—he was painting vaguely, "all grey and tonality, like Sickert." Nigel Macdonald, who used to stay at Abercorn Place, posed as *Tired Boy* and *Boy on a Balcony* and *Boy on a Bed*, arms behind his head and then, in close-up, wanking; later, when he had a flat in Ladbroke Grove, he and Freud would fool around occasionally with his guns. His half-brother Ian was *Boy with Pigeon*, holding one of a number that Freud kept in a basket on the balcony at his next place, in Paddington. They came from Club Row market in the East End. "I once bought some homing pigeons. I asked the man about them and he said, 'You can let them out and they'll always come home,' so I did and they homed to him and were in the market again the next week. I was always excited by birds. If you touch wild birds, it's a marvellous feeling.

"I was always very conscious of the difficulty of everything and thought that by willpower and concentration I could somehow force my way, and depending simply on using my eye and my willpower overcome what I felt was my natural lack of ability. I thought that by staring at my subject matter and examining it closely I could get something from it that would nourish my work."

In the summer of 1943 Freud spent a week halfway along the northern shore of Loch Ness. "It was wild to go to Scotland in the war. Nothing but natives." He went with Nigel Macdonald and Betty Shaw-Lawrence from Benton End, who liked to think she was related to Bernard Shaw and T. E. Lawrence and was now Nigel Macdonald's

girlfriend. He had a photograph of the naked Betty on his mantel-piece but was also, Freud knew, involved with Peter Watson. "He was the same elegant shape as Peter Watson and wore Peter's suits and I said once, 'You're the wolf in Pete's clothing.' Peter Watson went to Wales with Johnny Craxton and I think it's why Nigel and I and Betty were going to Scotland. He provided £50 for the three of us. He gave us the money and Nigel wanted to take Betty."

They took the overnight train to Inverness and asked at the tourist office where would be a good place to stay. Drumnadrochit, halfway down Loch Ness, was recommended. The Drumnadrochit Hotel, "very Scottish, solicitous, quiet," thirty shillings a night. They took two rooms, one for the boys, the other for Betty. ("In those days he couldn't have taken the same room as her.") Being in Scotland, and unaware of Highland touchiness, Freud wore his tartan trews. "No one would talk to me: it turned out that the trousers were Royal Stewart and it was as if there were only two left in the clan."

He had with him a yellow-covered sketchbook, the dummy for Spender's novel *The Backward Son*. In it he had drawn his fellow pas-sengers on the train north and now there were figures in kilts gazing out on to Loch Ness, a face in the ruins of picturesque Castle Urqu-hart, Nigel Macdonald asleep and—awake—naked and playing with himself. Hotel life proved irksome. There he was, in "a really hot stuff tip-top hop-scotch luxury dive for old dames," as he described it in a postcard to EQ, isolated in countryside good only for travelogue. "It's really a fit subject for a new Fitzpatrick the Voice of the Globe Trav-eltalks films in technicolour." He sat himself in the bedroom window seat and over three or four days drew the view: *Loch Ness from Drum-nadrochit*. Out there was a landscape of bumpy complexities where the line of the far shore of the loch divided grazing from wilderness and where attention crept with mapping-pen precision over the rock and cement wall across field and graveyard to a hillside dotted with cattle and boulders, buoyant clouds above.

"The two fences next to the tree are the only thing wrong," he commented. "They're as straight as Loch Ness."

Drumnadrochit, Freud's furthest north, was not a place he ever wanted to revisit. Generally his excursions from London were week-

Loch Ness from Drumnadrochit, 1943

ends only; if not Dorset then Sussex with Lorna, staying with her in Binsted when circumstances allowed. Once they put up in a pub in Petersfield where he did drawings of a dentist pulling a tooth and of the house where Anna Sewell, author of *Black Beauty*, was born. The reason for being there was that it was near Bedales, Michael Wishart's school, and they went to see him, taking magazines. And cigarettes. A schoolfellow of Michael's, Bruce Bernard, recalled the visit as being "camped up" by Wishart, who boasted to his mother that he had this friend, Bruce, in dire need of ciggies. He was to become, decades later, a key sitter. They met again in the school holidays when Bruce, "very impressed by Lucian's exotic and somewhat demonic aura," as he later recalled,[16] was warned by his mother that, being Sigmund Freud's grandson, he might be dangerous to know. "Though this of course made me even more interested in him . . . I think that he regarded me and my family with only momentary curiosity and remember him calling me 'Bryce' with a soft German 'R.' "[17] The interest was not

entirely unreciprocated. They met again in the school holidays when Freud was rather shocked to see Bruce's mother swipe him across the face.

There was a trip to Cornwall where they stayed at Cadgwith on the Lizard and went from there to Tintagel Castle, worth seeing, Freud explained, because Freddie Ashton had asked him to design the setting for *Picnic at Tintagel*, a ballet based on Arnold Bax's *Tintagel Suite*. "A ghastly piece of music," Freud was quick to say, but Ashton's patronage was not to be spurned, for others, given the opportunity to do stage designs, had been conspicuously applauded; John Minton and Michael Ayrton for example had collaborated with great success on John Gielgud's travelling production of *Macbeth* and Graham Sutherland had designed Ashton's *The Wanderer*, producing small gouaches for enlargement into monumental backcloth cliffs and crevices. To see sketches transmuted into spectacle was an enticing prospect. Freud always found it stimulating to see his work put through the processes of being proofed or laid out on the page. "I got a kick when things were photographed." That was reproduction; this was transformation.

Picnic at Tintagel promised to be as whimsical a mix as any Cocteau scenario. A picnic party visiting the castle ruins was to be plunged into the Tristan and Isolde era only to return to the present day for the final curtain. Freud quite enjoyed the recce, but the production fell through. When Ashton revived the project in 1950 he commissioned Cecil Beaton instead, who, conscious of "the competition on the one hand of Wagner and on the other of Cocteau," proposed a skirtless Isolde and a Tristan modelled on Olivier's *Henry V*. The Tintagel venture was not a complete waste of time. Either there or at Lyme Regis (where they stayed two nights, long enough for him to manage a small view out over rooftops and sea), he picked up a dead puffin. As was his habit, he worked from it until it had served his purpose, the sorry creature far gone, its bones protruding like umbrella ribs through the bedraggled plumage. He drew it twice in pen and ink, the pen strokes that trailed, contoured, dotted, nicked and hatched, the dishevelled plumage intricately cloaking the rotting body.

During another brief jaunt with Lorna in Tenby in South Wales Freud occupied himself with a prospect of the town from across the bay, a picture-postcard view that, characteristically, he later regret-

ted not having destroyed. He drew jetty and huts, fishing boats and castle ruins: visitor attractions set out as though for a mariner's return from trauma, the sea silvery, the harbour bay as clear as glass and, moved inshore a little, the Horse Rock remodelled into a reminder of the three-legged sandstone horse on the mantelpiece at Walberswick. This was more an Alfred Wallis setting, a Toy Town on sea, than a Graham Sutherland Neo-Romantic haunt. "Tenby being so beautiful, Italian cafés were started there; not Deux Magots but nice, with Italian chips and quite cheap." No one was pretending that this was the real Mediterranean, but the taste was genuine enough. Whereas, Freud later observed, the Neo-Romanticism emanating from further along the coast with Graham Sutherland and John Piper seemed simultaneously sloppy and overwrought. "That rather horrible thing with greasy chalks and water, like washing up gone wrong."

In August 1944 he plunged briefly into this greasiness when lodging, with Craxton, at the Mariner's Arms in Haverfordwest; Graham and Kathleen Sutherland planned to stay there too but, finding the pair too boisterous, they withdrew to a cottage at Sandy Haven, the setting of Sutherland's 1939 *Entrance to a Lane*. Freud showed his disinclination to heed the prevailing *genius loci* by drawing in pencil on Ingres paper a Christmas cracker that he found in a box in the hotel attic. Gorse he liked too. It was the toughest plant around. He drew gnarled stems and barbed green baited with yellow. His gorse was specific, unlike Sutherland's gorse—interchangeably aligned with thistle heads and crowns of thorns—and Craxton's tusky specimens.

As the war dragged on, Neo-Romanticism thrived, a manifestation of insular escapism proliferating quicker than willowherb on bombsites. Freud saw it as Symbolism gone haywire, ludicrously so. "One thing amazed me: Michael Ayrton wrote, 'all but the very best people are affected by undergrowth and roots.'" An equally trying alternative was Cubistic pastiche such as that of the Scots duo Robert MacBryde and Robert Colquhoun who conflated Braque and Wyndham Lewis. Actually Freud preferred Colquhoun's work to that of his big influence, Jankel Adler, who, discharged from the Polish army in 1941, painted initially in Glasgow, then in London. Freud went to his studio once to see his work and thought it too prearranged. "He was making Modern Art for 'the stupid British who didn't know': boring angular things, all patterns. With Colquhoun there was a bit of talent,

but Adler was working from Czech people I hated. Supposedly more intelligent than Josef Herman, who did those square peasants all the time, and I suppose he looked at Klee."

Sigmund Freud's notion, pleasing to Neo-Romantics, that "the artist is an introvert on the edge of neurosis," gave special credence to subjective moods, even those as topographically distrait as Graham Sutherland's, whose "emotional feeling of being on the edge of some drama" whenever he went to Pembrokeshire failed him in France where he was sent in late 1944—his first time abroad—to draw wrecked railway yards. The critic Michael Middleton remarked that "painters who thought, a decade ago, that 'child art' or abstracts were The Thing, now put their signatures to a formula of rugose and ecstatic tree-forms . . ." Sutherland lived at Trottiscliffe in Kent, to the east of Samuel Palmer's "Valley of Vision," and gained inspiration from the ancient yews that grew along the Pilgrim's Way under the North Downs. Signatories to the manner, John Craxton and Michael Ayrton, who talked of "the sensation of the unremitting war fought by trees," were exceeded only by Charles Hawtrey in the character of Osbert the art student in the film *Much Too Shy* boasting his affinity to "a tree in agony . . . a tree who intimately lives with rain . . . a tree begging for mercy, crying out to be saved . . ."

Glorifying affectations, Neo-Romantics such as Hawtrey's Osbert expressed themselves like billy-o, homing in on secret places under waning moons. The style ranged from entanglement to turgid watercolour washes. Craxton saw potential here, but Freud regarded the vogue as platitudinous. "I just walked in on it. Keith Vaughan was the worst. A legal way to do men and he wanted to do *something*." Vaughan made a thing of deliberate generalisation, male figures blending with trees. There was, surely, more substance in the tangible, more purpose in concentration. Facts detailed, things realised, whether the intricacies of a wicker basket or the wrinkled paw of a dead monkey, could have a hard-to-define lingering quality, like the quick acrid whiff of one flint bashed against another.

Differences between the exacting and the generalised widened into a divide when, in 1944, Craxton illustrated *The Poet's Eye*, an anthology put together by Geoffrey Grigson, produced by Walter Neurath's book package firm Adprint and published by Frederick Muller as one of a "New Excursions into English Poetry" series

that included *Landscape Verse* with darkling lithographs by John Piper and *Poems of Death* adorned by Michael Ayrton. Craxton's lithographs, predominantly mustard yellow and blackout blue with white highlights, featured poets clasped in hollow tree trunks and a reconstituted Pembrokeshire where scything curves tidied every sandy cove. Craxton wrote to EQ that the proofs for these were "as hopeless as Auntie's split bloomers only more skitso prenick."[18]

Portrait of a Young Man (John Craxton), 1944

Darling Felicity I am sorry I have not written for so long to you though I have often meant to. I have been in Scotland and in Cornwall (last week) since I last saw you and I had a wonderful wavy bathe. Rushing about England nearly makes me feel quite different but not quite. My life is at a very crucial stage at the moment, one day I think I am beginning to make my work how I want it to be and then I feel so dissatisfied with it that I leave the house. I made a lithograph in Ipswich of a horse and jumping fish by the sea. I have bought a very large Zebra's head it looks very strange on the wall with big glass eyes and mane going up. By far the best thing I have ever bought. Do come to London. Surely its your Autumn Holiday Lots of love to you from me.[19]

As this letter suggests, by the autumn of 1944 Freud's concerns and predilections, not least his involvement with Lorna, had distanced him from Felicity. (The pair of lipsticked lips collaged to the bottom of this letter was jokey over-compensation.) Now was the time for applying himself and launching out. "Johnny was doing *The Poet's Eye* and I went to Cowell's in Ipswich with him and they gave

me a zinc plate." He drew a genial horse slithering on shingle and kicking out at a wicker basket filled with fish, sending them flying. He gave Peter Watson a print from this with the sea coloured in slightly and, provoked by Craxton's efforts, set to work assembling drawings to go with *The Glass Tower*, a book of poems by Nicholas Moore. This was to be published by Editions Poetry London, an imprint now backed by Watson. He had known Moore, Tambimuttu's assistant on *Poetry London* and son of G. E. Moore the Cambridge philosopher, for years on and off. He liked to compose his poems straight on to the typewriter using a red ribbon on yellow paper; he smoked scented tobacco or gold-tipped Russian cigarettes. "Will talk interminably about himself but diagonally, or in a roundabout way, by implication," wrote Charles Wrey Gardiner, the publisher for whom he sporadically worked,[20] while Tambimuttu awarded him praise in the form of a backhander saying that there was "little pretentiousness" in his poems.[21] Even Stephen Spender dismissed him, referring to him in *Horizon* as "the prime example of what one might call the Little Jack Horner school of poets, who put in a thumb and pull out a plum and say, 'what a good boy am I.'"[22]

The poems to be illustrated verged on the surreal with topical references cued in ("Hitler is love's taunting fable, the earth gone wrong"), so there was obvious imagery for Freud to pick up on. Not that he did. "I just used to read them and look for words I liked. Animals and so on. Definitely done for money: I got £40 cash." Two of his dead-monkey drawings qualified for inclusion thanks to the line "monkeys with sexes prevalently showing," also the head of a toy monkey belonging to Moore's baby daughter Juliet whom he had drawn with it not long before. A gull lifted from Thomas Bewick's *History of British Birds* stood in for "The Five Peculiar Gulls" and his zebra head served again, fitted with a unicorn horn. Moore invoked "Max Ernst of the peculiar birds and people," but Freud ignored that as too obvious a reference; and he resisted the lure of the line "The second egg was white, curved like woman's thigh, virgin," making do with a nondescript egg lolling in the crumpled paper bag from *Quince on a Blue Table*. A drawing of EQ's black cat asleep on a black and white cushion was submitted but not used.

The Glass Tower became more Freud than Moore. "I designed it all: the jacket and the binding, yellow and black on the front and black

Dead Monkey, 1944

on yellow in reverse on the back." The motif was a palm tree from the Loudon Road nursery, ghostly on the front cover, more elegant and effective than Craxton's bleached eye socket for *The Poet's Eye*. He toothed and feathered his lettering for the title page and placed in the centre a sad-eyed puffin viewed head on: the *Poetry London* colophon garlanded with barbs and bunting. Drowned birds and shells occurred at intervals, near-emblems gracing the page, rather like the fish and poppy tattoos that he was to apply later on ("as tokens") to favoured girlfriends.

Some months before *The Glass Tower* was proofed and despatched to the printers in Bournemouth, Freud and Craxton were thrown out of Abercorn Place. For one reason or another, particularly the noise overhead and the crunching glass, Clinton Grange-Fiske in the ground-floor flat decided that he had had enough of the pair of them. He particularly resented girls ringing his doorbell late at night and asking for Lucian. "Being a grandee, the Rector of Stiffkey's driver, he couldn't stand it." Craxton returned to his parents' house in Kidderpore Avenue and Freud found a house in Delamere Terrace, on the seamy side of Maida Vale.

"I could have had the whole house for £2,000 or something and

I said to my father, 'It's marvellous and not out of the question for me to get it,' but he said, 'When the war is over there'll be a housing shortage and you'll have to let it to people who never get to pay the rent, or to friends, and it'll be chaos.' He was sensible, being an architect and also a landlord a bit. So I didn't." His father said he could get him a twenty- to thirty-year lease "for a small sum" because everywhere was so cheap. "You'll be turned out if you pay rent: I can get you a thirty-year lease." He didn't. Freud took a first-floor flat at number 20 for thirty shillings a week, the idea being that he would pay the rent from his share of the Sigmund Freud royalties.

"It had a canal balustrade with columns like chess pieces, big balconies with the ironwork mostly gone, except where it was protecting basements. It was very broken down."

Delamere Terrace runs along the Grand Union Canal behind the Harrow Road, immediately west of the avenues around Paddington Basin or Little Venice, as Robert Browning, who had lived there in the 1860s, called it. In his day the Terrace had been quite grand, though unpaved, with its stucco fronts, gates at the end and a halfpenny toll to non-residents; he had walked along every afternoon to call on his sister-in-law, Arabel Barrett, who lived at number 7 and had been a dedicated supporter of "Ragged Schools" for the poor and other such amenities in the surrounding area. Before the war the London County Council had bought up most of the district—twelve acres of decay from Delamere Terrace to Clarendon Street (renamed Crescent)—with the intention of redeveloping it. "Much of the Clarendon Street area of Paddington is insanitary," the *Architect's Journal* reported, adding however, "it is a sociable, homelike place with a character of its own, and it is liked by the people who live there."[23]

The move could have counted as slumming, but for Freud it was more a venturesome plunge, like diving off to Liverpool three years before. "Delamere was extreme and I was very conscious of this: down the hill, down to the canal. It was through having been to sea that I moved to Paddington. There was a sort of anarchic element of no one working for anyone." He was now twenty-one; he had come of age.

"I like the idea of hideouts but the real point is privacy."

Around this time Stephen Spender wrote a short introduction to the *Air Raids* volume in a pocketbook series "War Pictures by British Artists"; as a member of the Auxiliary Fire Service he was well placed

to pronounce on the social impact of the London Blitz. A cultural easing had occurred thanks to the war, he suggested, slipping into Crown Film Unit commentary mode. "The gulf that has separated the man of imagination and creative power from the man-in-the-street has considerably narrowed. Both live now amongst the same grim realities."[24] He and Natasha had stayed on in the flat in Maresfield Gardens, two districts and a world away from the circumstances in which Freud now found himself. "Delamere Terrace was in a completely unresidential area, with violent neighbours. I felt very at ease." He was on his own now, he liked to think: lodged with a breed of people who got by on instinct and tribal habit.

"My mother used to go daringly down there and leave me food parcels on the step. I never liked having her round. She never called in." Which was just as well, he felt. It would not have looked good for Lu the Painter, as he became known in the district, to have been seen to be mothered by a fine lady with a German accent. Her concern for him was irritating. His father on the other hand was realist enough not to bother him. "He worried, understandably; I think his happy nature made him not want to know what I was doing in any way."

Among the few things Freud took with him to 20 Delamere Terrace were the zebra head ("my prized possession"), a top hat, a couch and his potted palm, the objects displayed in *The Painter's Room*, a picture begun in Abercorn Place and completed—"like I took *Box of Apples* to Wales"—in new surroundings. Shown off like shop-window items, accentuated in effect, they could be clues, though there is nothing about them to suggest mystery or significance. Freud acknowledged the painting to be "a bit out-of-Miró" in that the living space is as abstracted as the playground of Miró's *Harlequin's Carnival*, a painting that he had admired in reproduction for its "most marvellous elation" not knowing that the milling organisms were said to be hallucinations brought on by hunger. In *The Painter's Room* the scarf and top hat are, plainly, a boulevardier's trappings. The palm stands over the couch, as in the Douanier Rousseau's parlour jungles and the line in *Ubu Roi* about "palm trees growing at the foot of a bed so that little elephants standing on bookshelves can browse on them"; the zebra head may suggest a connection with Christopher Wood's *Zebra and Parachute*—shown at the Redfern Gallery in Cork Street in 1942—in which exotic coincidence is effected on the flat roof of le Corbusier's

Villa Savoie. But this was not Freud turned Surrealist. He admired the scissors-and-paste upsets in Max Ernst's *Une Semaine de bonté* collaged from old wood engravings; plonking the Lion of Belfort on a billiard table was a neat move. However, the incongruity of the zebra head is striking rather than surreal. He had lived with it long enough to regard it as familiar, as his familiar indeed; the metaphysics it scents and sniffs at is de Chirico's "furniture grouped in a new light, clothed in a strange solitude in the midst of the city's ardent life," that same strange solitude that his father aimed to achieve when designing consulting rooms and that stills the silenced mêlée of Uccello's *Rout of San Romano*. ("I thought I got nothing from art, but that didn't mean I didn't. I certainly looked at it for a long time.") The collapsed paper bag in *Quince on a Blue Table* and the scarf abandoned in *The Painter's Room* resemble the bits of kit on Uccello's pink battlefield floor. The creases in the muzzle and the shrivelled tip of the palm leaf, the nap of the hat, upholstery and neck, the studs and bristles, the skidmark shadows cast by the castors, are vivid transferences, like W. H. Auden's line "the tigerish blazer and the dove-like shoe."[25] A blazerish red galvanises the zebra patterning and casts the scarf as a detached stripe. The couch stands daintily, like a foal, below the watchful head.

"I never put anything anywhere odd; except, obviously, I used the zebra as if it were more native to the room than it actually was. I was working in a very cramped way of altering nothing and feeling that was the only way I could do things. I wasn't aware of that at the time—Matisse hadn't probably said it: 'Accuracy is not the truth.' If I had read that I can't help feeling that I'd have seen what he meant. But I was trying for accuracy of a sort. I didn't think of detail; it was simply, through my concentration, a question of focus."

For some months following D-Day, from June 1944, London came under attack from V-1 flying bombs. "Nobody in London has slept for four nights past," Freud's neighbour Wrey Gardiner wrote. "The flying bomb has passed over and exploded somewhere else. For the moment." Later he added: "As I write this the siren wails to herald the flying bomb which people fear more than the other kind for obscure psychological reasons."[26] Freud used to look out for them from the roof of Delamere Terrace; sometimes, when he spotted an

explosion, he nipped along on his bike to view the damage. One doo-dlebug landed in Maresfield Gardens, demolishing several houses and bringing down the ceiling of the Spenders' flat. Another day, leaving *The Painter's Room* on the easel, he went out to the paint shop in the Harrow Road to get pigments. While he was walking back a bomb struck behind the terrace and he was plunged into a cloud of dust. "As I started down the street I saw a red thing moving towards me in the fog. I put out my hand and it was wet, covered in blood. A thing just walking a few steps and then it was gone. Dead. No face. Completely gone."

The window of his room was shattered but the painting, on an easel at right angles to the window, was miraculously undamaged. With that the zebra head, craning through the aperture more in con-fidence than curiosity, became a backhanded take on *Guernica*, "full of life and hope. No horrors of war there."

"Living in a dump and going out to somewhere palatial"

Marie Paneth's *Branch Street*, a vivid sociological study of child life in a London slum street, identifiable from her descriptions as Clarendon Crescent W2, just up the road from Delamere Terrace, was published in July 1944. It focused on gangs of boys and girls aged four to fourteen, habitually fighting, wrecking, thieving, and with whom the author—an Austrian settled in London and a painter by training—tried to cope by operating rudimentary Play Centres in abandoned houses and a public shelter. Unlike *Young Children in War-time* by Dorothy Burlingham and Anna Freud, an account of "child development and psycho-pathology" from the same publisher, her *Branch Street* reported with a degree of appalled fascination on "a queer urge to break, to spoil and to besmirch." Feral behaviour was the norm there. "Disastrous evenings left us in queer depths of despair, when hasty fights, stealing and lewdness overshadowed our small periods of constructive activity."[1] The wariness and hostility of these children of prostitutes, coal shovellers and railway porters, she observed, was occasionally alleviated with touching spurts of trust. Freud, who at twenty-two was not much older than some of Mrs. Paneth's leading hooligans, saw at least one or two of them as potential sidekicks. For him there were parallels to be drawn with the juvenile leads in *Emil and the Detectives*: Gustav with his motor-horn, little Tuesday and the Professor, street-gang characters whose nicknamed resourcefulness matched that of the players in Damon Runyon's *Guys and Dolls*.

"My guide to a side of Paddington life was Charlie who lived

next door at number 19. He was under fourteen then and he used to sleep in shelters. He wandered along the balconies, along the terrace, into my room. There was one of these bombing raids, and then he suddenly seemed to sort of belong to me." Charlie Lumley said that his first encounter with Freud arose out of his habit of clambering on to the balconies, and whenever the retired greengrocer next door spotted him he would say "Bloody cat burglar!" as a joke. "Lu moved in and heard this—he was standing there with John Craxton—and that's when we first met."[2] To the Lumleys their new neighbour was as poor as they were. "He never had a penny and my mother used to make him a sandwich and that. She would say 'Pop this in to Lu,'" Charlie remembered.[3] He became attached to Freud, who drew him as an Artful Dodger sitting expectantly on his sofa and in an armchair wearing the red and blue uniform jacket, several sizes too big, from *Still Life with Chelsea Buns*, the ring on his finger and Brylcreemed hair denoting street savvy. "Going down the street he'd shout 'You're a goer' at a girl who'd been going with Yanks. He went to the Coliseum, the fleapit on the Harrow Road, and when I asked if he'd liked the film he said, 'I couldn't watch. There was a GI sitting next to me and his wallet was sticking out and I just couldn't concentrate.' The only low life Charlie had was to do with his thieving. He used to get caught and I had trouble getting him off because in Police Courts they always read out your record. His first sentence was when he was fourteen. He'd built himself a boat on the canal, rowed up to the back of a vegetable shop and flogged the veg lower down the canal."

Charlie had several brothers and a sister whom Freud took out once to L'Étoile. He asked her what she would like to drink and she said, "Cuppa tea please." The next day Charlie asked him when was he going to marry her. Charlie appealed to him. "He did funny imitations, made me self-aware. He had a real kind of quality."

Earlier in 1944 Freud had approached galleries hoping to be invited to exhibit properly somewhere. "I had asked Erica Brausen (as everyone wanted to show at the Redfern, it was so lively) to see some paintings at Abercorn Place and she hummed and haahed and said, 'Oh, Rex's lumbago is too bad for him to get up the stairs'; so then, within days of my arranging it, [Duncan] Macdonald came from the Lefevre

and offered me a show instead. I think on the strength of the Drum-nadrochit drawing. And of course immediately then I got a telegram from Erica: 'Rex will come any day now.'" Rex Nan Kivell was the owner of the Redfern Gallery.

Craxton having just had his show at the Leicester Galleries, Freud's debut at the Lefevre came a close second. The gallery had been bombed out of its King Street premises and reopened at 131 New Bond Street, upstairs from Beale & Inman the shirtmakers, with separate rooms for each exhibitor: Freud, Felix Kelly who did soft-focus bespoke paintings ("The Lefevre Gallery, on Mr. Kelly's behalf, will be pleased to accept commissions to paint Country Houses") and Julian Trevelyan, formerly a Surrealist and camouflage fabrica-tor in the Western Desert, whose gouaches of West Africa he himself described as "African tarts and mammies in their brilliant clothes."[4] To differentiate himself from such associates, Freud decided to have his own eye-catching private-view card. "I did something that was fairly unusual for an unknown: I did the card myself and had it printed myself. I didn't want to be on the card with Trevelyan and Kelly. I did a drawing of a crab and it was designed by Anthony Froshaug, a boy-friend of my cousin Jo at the Central. He taught typography. Older

Private view invitation, 1944

than me, very odd: he'd had a bad time in the Merchant Navy being abused. Had a thing about queers. It didn't occur to me—the word—since all the people I knew were queers."

The crab was not exhibited, for Freud included only drawings that he considered equivalent to paintings. Several of the most recent he signed and dated. A few had to be borrowed—Ian Phillips lent *Cacti and Stuffed Bird*, Ernst Freud *Juliet Moore Asleep* and Craxton *Quince on Blue Table*. This was his opportunity to demonstrate, and edit, his broadening and intensifying accomplishment.

The private view—his first and, until his final years, the last he ever attended—was on a Saturday afternoon, 21 November 1944. Two young painters of "distinguished families" were exhibiting, the *Evening Standard* reported, Trevelyan being the great-grandnephew of Lord Macaulay and nephew of G. M. Trevelyan, the historians, and Freud "the 21-year-old grandson of Sigmund Freud and Miss Anna Freud's nephew." Freud, the *Standard* added, had been co-editor, in his teens, of a Surrealist magazine called *Bheuaau*, which explained the Surrealistic tendency of his pictures: "an extraordinary variety of live and dead animals ranging from 'A Skinned Hen' and 'An Oil-Bound Puffin' to a stuffed zebra's head, one of the chief ornaments of Freud's studio over the Regent's Canal."[5]

According to the *Standard* ten of the drawings and paintings—about a third of the show—sold on the opening night. Freud was embarrassed. "All my relatives turned up and shamed me by buying things." His mother had been alerting family and friends. Cousin "Wolfi" Mosse picked a dead-chicken drawing and Anna Freud's companion Dorothy Burlingham bought the large Conté drawing of the palm tree that served as the design for the covers of *The Glass Tower*. Other buyers included Ian Gibson-Smith, Anton Zwemmer, whose bookshop-gallery in Charing Cross Road had for years aired the avant garde and who bought *Quinces* for fifteen guineas, and Wilfred Evill, a solicitor and collector (the legal guardian of Honor Frost, Freud's acquaintance from the Central) who chose the drawing of Charlie Lumley seated on the studio couch. Lorna Wishart took *The Painter's Room*, at fifty guineas the most expensive painting, and Colin Anderson, chairman of the Orient Line, went for one of the cheapest, the eight-guinea *Mouse in a Hand*.

Freud hung around the gallery. "I went and saw the show a lot.

It was very much 'yes, look what I can do.'" Tuberous fingers and staring eyes were what he could do particularly well, also earlobes, feathers and claws, pelt and leaf. He was pleased to see that he had style and, unlike Craxton, more than style. He had application. His patience tracing individual strands of hair, where Max Ernst would have dragged a comb through the paint, was phenomenal and most lapses into facility were redeemed by sudden brilliance: the glint in the eye of the dead rabbit. A drawing of Craxton, done just in time to be exhibited (he dated it "22.11.44"), featured what he saw as "that narcissistic look" through breathless attention to the zigzag texture of the jacket and the cultivated parting in the hair; this drawing caught the eye of L. S. Lowry, who had been taken on by the Lefevre and liked anything that smacked of Rossetti. Later on he bought it.

There were a few mentions (among them David Sylvester in *Tribune*) and two reviews. In the *Listener* John Piper addressed himself to Freud's technique. "His youthful mannerisms add up to a personality. Too many of the forms are depressed by having to deliver unimportant literary messages, but he has a cultivated feeling for line, when he can be bothered with it, and a natural feeling for colour." Coming from an artist who in his own work tended to deliver architectural messages in startlingly heavy weather, this was heartfelt comment. Michael Ayrton, heady still with Neo-Romantic vapours ("a sense of pain provoked my painting of Gethsemane in Wiltshire . . ."), wrote loftily in the *Spectator*: "The human figure defeats him because he does not observe it as he does dead birds but merely lets his pleasant line wander trickily round the form without relevance to construction."[6] This could be construed as retaliation, maybe, for Freud's lack of enthusiasm for his own work. He was equally dismissive of Craxton's drawings. "In that they lack a direct visual reaction to nature," he said, "they are empty."[7] Craxton was to take a pop at Ayrton later in life as "so puffed up with his own importance, he was the last barrage balloon over London that never got taken down."[8]

Edmund Dulac, whose bejewelled illustrations for *The Arabian Nights* had excited Lucian as a child, saw the exhibition and said that he liked it. He was a family friend. Others too were approached by Lucie Freud to lend support. "My mother was not excessive, quite modest, with all her pride. Herbert Read was a friend of my parents— his wife was German—and my mother said, 'Why didn't you write a

preface for Lucian?' And he said, 'I only write prefaces for refugees.'
I thought: fuck him." One such refugee, exhibiting coincidentally at
Jack Bilbo's Modern Art Gallery in Charles II Street, was Kurt Schwit-
ters. Read had been persuaded to pen a few lines for him. "My life is
of an unimaginable complexity," he protested, but obliged, Schwit-
ters being so much the opposite of young Freud.[9] "The bourgeois
loves slickness and polish; Schwitters hates them," he wrote. Schwit-
ters, he declared, was "one of the most genuine artists in the modern
movement."[10] Freud missed this Schwitters exhibition, as he never
went to Jack Bilbo's gallery if he could help it. "It smelt so horribly.
Sylv [David Sylvester] once showed there: brown paintings." Bilbo,
an ebullient chancer previously named Hugo Baruch, whose gallery
operated from 1941 to 1948, complained to Freud once about being
a dealer. "It's much more trouble than painting the bloody things."
His own paintings were shamelessly Picasso-ish, Freud remembered.
"He did a painting of Owo, his wife: *Owo after a Beating*, a red-striped
painting."

Despite lacking the Herbert Read stamp of approval, Freud was
entitled to consider his debut well received. ("He certainly arouses
interest": the *Studio*.) Craxton was recognised as being more obvi-
ously stylish than he, and Duncan Macdonald of the Lefevre did not
consider him to be in the same league as Robert Colquhoun. More,
perhaps, a match for Felix Kelly though with a sharper taste for detail.
But it was a start. At least he did not resort to sweeping manner-
isms. In his drawings he did his utmost with increasing capability. "I
always drew all the time, I never questioned why. Later, I deliberately
stopped because I thought it was holding me up." As for the paint-
ings in the show, "I thought some pictures were no good because
they were too infantile. It irritated me when people talked about them
being 'primitive.' They mistook an inability for an affectation."

When copies of *The Glass Tower* were delivered from the printers,
however, Freud was disappointed. He knew that the book, advertised
as being "illustrated in colour" and published at 8s 6d—two shillings
less than *The Poet's Eye*—was not going to be magnificent, but there
was no excuse for everything except the binding being skimped, even
by the prevailing austerity standards. The colours—yellow and cyan-
blue inks—on "that funny wartime paper, very shiny lavatory paper,"
were distasteful but the cropping of some of the images infuriated

him, and the silly discrepancies in the layout: images facing the wrong way and, at the end, a gull parked arbitrarily opposite a blank page. "I made a terrible fuss. I remember being in the office of Mr. Roberts, the director of Nicholson & Watson [Ivor Nicholson and Peter Watson] who had assumed financial responsibility for *Poetry London*, and saying to him: 'Look at this one: you've cut off two fish tails at the top.' And he said, 'What about our boys in Burma? They're having more than their tails cut off.' I smashed the photograph of his wife off the desk and said I was going to the Society of Authors, so I was offered some money. And then he said, 'Look, we're sending these books to Australia and New Zealand. No one will see a copy in England.' I accepted the extra money."

The blurb spoke of Nicholas Moore as seeing "with the clarity and innocence of childhood (the symbols are childhood symbols) or the cine-eyes of the modern sensitive," adding that the drawings are "in the same mood"; a review in the *Times Literary Supplement* three months later talked of Moore as "a surprisingly unselfconscious poet" and did not mention Freud.[11] *Our Time* carried an advertisement in which misprints prevailed: "with drawings by Lucian Frewd, 8/6 net." And the review (by Christopher Lee) was dismissive: "With rare exceptions they neither think nor feel sufficiently and they lack art. 'Words are red as fire and twice as hot'—but these are not." Again the illustrations went unnoticed. Yet, alone among the illustrated books published by Editions Poetry London, *The Glass Tower*, by virtue of the drawings, has sparkle. Where David Gascoyne's *Poems* was adorned with stifling Graham Sutherland vistas and where the Henry Moore *Shelter Sketch Book* was a reprocessing of common humanity into swaddled grubs and where the colour lithographs by Gerald Wilde in *Poetry London Ten* gave "Rhapsody on a Windy Night" a frenzied drubbing, *The Glass Tower* has unassuming lucidity. Freud eventually came round to recognising this. "It's got an 'I've got four hands and none of them work and only one eye and I nearly did it' sort of look. Not a luxury volume. And that's what's nice about it."

The poet-publisher Charles Wrey Gardiner, whose Grey Walls Press operated with diminishing success through the 1940s, recalled in his memoirs, *The Dark Thorn*, Craxton showing him his paintings, and

Freud's, at Abercorn Place. "You had to be careful not to step on a masterpiece if you were fascinated by a zebra's head sticking out of the wall."[12] Consequently he had reproduced in his literary miscellany *New Road 1944*, *Man with a Feather* (then called *Self-Portrait, Spring, 1943*) and *Still Life, Winter, 1943* (not yet *Still Life with Chelsea Buns*) together with a Craxton drawing called *Tree Root in an Estuary, Wales*. ("'The sensitive are being killed gradually,' as Craxton remarked to me sadly over the immense chequered pattern of his jersey.") Wrey Gardiner asked Freud to do a dust jacket for Franz Werfel's play *Paul Among the Jews*, but what he came up with was no good, he decided: "The odd squat figure with the two right feet because the girl he was using for the drawing was too cold to take the stocking off her left one. It was unsuitable and I was wrong to allow it to go through."[13] He also commissioned a portrait, Freud remembered with a wince. "He asked me to paint Mimi, his girlfriend; usually they tried to stop me painting their girlfriends. I liked the idea, as it was the first that I'd been asked to do, but I couldn't get on with it. She was giggling and nothing happened." Wrey Gardiner himself acknowledged, "Mimi bores me, too, as well, and knows it,"[14] but he mentioned this with some resentment in *The Dark Thorn*: "Lucian has never finished Mimi's portrait, blast him. Lucian no longer wears his postman's trousers and solar topee. Living near the Regent Canal must have sobered him unnaturally." And there was more. "Lucian Freud's portrait. Memory is a curved curtain. Let us lower it over the sore places. The platform of Maida Vale Tube station should perhaps be avoided."[15]

A man of resounding declarations ("Let us dedicate ourselves to art for life's sake, for art is the life blood of humanity")[16] Wrey Gardiner had Nicholas Moore as a partner and assistant for a while and an association with Tambimuttu that helped lead him, as dealings with Tambimuttu generally did, to insolvency. Projecting his own feelings, Wrey Gardiner surmised that Paddington life was getting Freud down.

The dilapidated grandeur of the 1850-ish house now in a slum has its charm. But poor Lucian is not the same man we knew, jumping over posts in the street, laughing with Johnny Craxton. He is terribly changed and looks quite ill. Living a mad existence in the fungoid undergrowth of London night life hasn't done him

any good. I wonder whether he will ever finish the portrait of Mimi he has been doing so long. In the sun in the big airy room he has made into a studio I enjoy myself making acquaintance again with the odd objects with which he surrounds himself, the zebra's head he is always painting and drawing, the broken wheel hanging on the wall, the striped rug on the bare boards of the floor. The green water of the canal ripples and sings its strange melody. Perspectives open before me of other lives . . .[17]

Other lives. Freud knew how to make an entrance; he would appear in a crowded room evasively, with a diffident air, as though seeing himself as a mystery to others. He was seen, for example, to disappear into the bathroom at the *Poetry London* office in Manchester Square and emerge after a long time saying that he had been "thinking." John Richardson, the future biographer of Picasso, saw him one evening in the Café Royal standing on one leg, looking at the floor. "Young Freud at it again," someone said. Affectation was a flexing of personality.

"I was very very shy so I tried to overcome it by being exhibitionistic. I did things for that reason. To do with clothes quite a lot and to do with attitude."

The urge to startle masqueraded as the exercise of free will. There was dressing up. "I used to buy crazy old uniforms in Paddington Market. Boer War uniforms with piping on. Guardsmen's trousers with red stripes down the side. I saw a kilt in the window of Bantoft & Haines and went in and said I'd like trousers. 'We'll build you some,' they said. I only wore them for best." He went to parties in them, plus a dinner jacket on smart occasions. (When years later Princess Margaret asked about the trousers it was explained to her, "An old Portuguese tartan ma'am.")[18]

"I was stimulated by extreme economic change, going about. I've tried to cultivate it. It's to do with living in a dump and going out to somewhere palatial, not just physically but to do with people's ideas and easy-going attitudes, the way English people live, in London anyway. In Germany, I feel, it would have been linked to some more specific social life or vice or sex.

"The Caribbean Club in Dean Street: I used to live there, practically; it was the first place I ever saw Negroes. It had odd mixtures

of people, Euan Drogheda and Ronnie Greville—George Melly was kept by him when he was in the navy—Joy Newton and Bobby and Pauline Newton, were there, undergraduate parties, Etonians and queer actors, and it had a sort of intellectual side—Gerald Berners and the Heber-Percys. Esme Percy, an educated actor with a small private income, was a friend; George Bernard Shaw used to cast him in his plays and he used to try and take me down to see him at Ayot St. Lawrence. He said, 'He's fascinating. So mean. We'll go for tea. There'll be tea and only one cake and he'll eat it.' So I didn't go down."

Stephen Freud came home on leave. "He was an officer of sorts. When on leave he came to Delamere and I took him out to a pub in Maida Vale where they were playing billiards and things; they weren't used to people in uniform and officers were rare. There were so many tricks people did. A real tough young thug was with this girl and he hit the girl and Stephen said, 'I'm not standing for this,' and was very indignant, but I knew it was a put-up job to rob him, so I got him out."

While sex life had side effects, the show-off life had repercussions. In the Black Horse in Rathbone Street one evening in 1943 someone said to him that he would like him to meet this girl he was having a drink with as she was engaged to someone called Freud. He bristled. "I said, 'I'd be careful: there are very few Freuds and there are a lot of fakes about.'" This got back to the fiancé, who turned out to be Cousin Walter. Having arrived in England in 1938, too late as it turned out to be naturalised before war began, in the summer of 1940 Walter and his father, Martin Freud, had been interned on the Isle of Man as aliens. Walter was shipped to Australia on the *Duneira* but returned and, after a spell in the Pioneer Corps, joined the Parachute Regiment and then SOE. "Walter was dangerously active in the commandos," his cousin Lux observed. "He used to say to girls, 'I'm going off to be killed; this is my one last night of love.' He used to get engaged a lot."

In his autobiography, *Glory Reflected*, Martin Freud confessed to "what today might be called a complex about 'honour'" in describing his humiliation, as a cavalry officer and ladies' man who immediately on landing in England had taken to wearing an English-type blazer, at being issued with the overalls of an Alien Pioneer. To his nephew he was tragi-ludicrous. "It was like working on a slave ship being in

the Pioneer Corps and, because of his imperious manner, Uncle Martin got very mucked about. He lived, as his book makes clear, as the eldest son of my grandfather. He had fought some duels in his military career and when the Nazis came he, naturally, didn't stand for that and he was badly beaten up."

"We are very fond of your Uncle Martin," Virginia Woolf had said to Freud when Stephen Spender introduced him to her. ("She was rather terrifying.") But he himself was not impressed by his uncle's disposition. "My mother felt he treated my father too cursorily and he tried to get money off my mother. He was known for being a bit wayward." Unable to practise as a lawyer, Uncle Martin had tried business. "He had these business ventures, in a way like a Balzac character reasoning: 'How do you make money? Stupid people make money. I'm not stupid. Stupid people are very rich; they go into business and make lots of money. I've got it: toothpaste. Everyone has to use it. There's nothing in it, anyone can make it, the great thing is to put it about.' So he started making this thing: Martin's toothpaste. We were all instructed to go into the chemist's to ask for Martin's toothpaste." It was a failure. "There was a terrible bust-up with Timothy Whites & Taylors followed by completely non-speaks with Boots. By and by there wasn't a tube even in the Museum of Patents, or Toothpaste." After his stint in the Pioneer Corps, Martin Freud worked as an auditor for the Dock Labour Board and later owned a tobacconist's in Holborn. "He felt he was a grandee but found that the people running it had robbed him mercilessly of 6d a week." Hearing about the incident in the Black Horse, he wrote to his disgraceful nephew, this shameless wearer of uniforms off market stalls, who quoted the letter, from memory, as saying: "Your Cousin Walter has successfully learned the arts of destruction, and I know them of old, and should advise you to be *very careful* to keep out of our way."

"After the threatening letter I never got right with my uncle. Never saw him."

Poppy and Hand Puppet (1944), a painting exhibited at the Lefevre and bought by Freud's parents, begs interpretation: why the disengaged glove puppet with a stocking face, the poppy head lying like a dropped rattle? The puppet was one of several given him some years before,

when he was at the Central, by Inge von Schey with whom he had lunched on the steps of the British Museum. It had no particular significance. "I feel the composition is a bit haphazard." Just as the zebra head ("full of life and hope") had stretched over the crumpled paper bag, examining the quince by smell, the poppy and puppet, selected for shape and texture rather than for anything they may signify, are a play of contrast: limpness and husk. Inferences suggest themselves, most obviously the discarding of childish things.

By 1945 Ernst Freud could see that in setting out to make a life for himself as a painter Lucian was doing what he had decided against at the same age when he told his own father that "One should either regard painting as a luxury, pursuing it as an amateur, or else take it very seriously and achieve something really great, since to be a mediocrity in this field would give no satisfaction."[19] This view he handed down to Lucian, who rather agreed. "It always seemed understood." Apart from the two years at Dartington, when his declared ambition was to spend a lifetime working with horses, he always saw himself as a painter. Painting was his only prospect. Having exhibited at the Lefevre he could regard himself as a professional. To that extent his parents could relax and, naturally, Freud was keen to discourage them from taking too close an interest in his activities. Particularly his mother, whose devotion to him and love of domestic order he found stifling. "I always avoided her when I grew up. She was so intuitive. I used to go to see my father, sometimes in Walberswick, to get money. He was trustee of the Sigmund Freud copyright and I was always in advance." (Royalties, which were to become sizeable, were divided among the five grandsons.) "He'd say, 'Go and see your mother as you leave.' I'd say yes and go straight out. It was being forgiven I didn't like. My mother always put nobler motives on my actions than those they were actually prompted by."

Michael Hamburger, released from the army and now a poet, called on Freud occasionally. "He told me about some homosexual experiences he had had in the Merchant Navy; I saw him paint and I remember him telling me he took glucose to give him energy."[20] Gabby Ullstein, who was sent to school in England in the later thirties and stayed on, also visited him in Delamere Terrace. "It was cosy but grotty. I liked him: funny and unexpected." Whereas Lucie Freud seemed, to her, "A great beauty being beautiful, a dramatic lady, always

sitting or lying *en odalisque*. Intense. No jokes." Ernst Freud, whom she came across in Walberswick after the war, struck her as rather a rake. "Charming: a jolly scoundrel."[21] John Lehmann felt similarly.

As Dick "Wolf" Mosse said, "Ernst would make his own rules, write his own passport."[22] He set up odd unrealised business ventures such as Pasta Resin Products, for which Anthony Froshaug designed labels and letter headings and developed an involvement with the man who produced Kangol berets ("smart at every angle") who built a factory in Tottenham Court Road. John Lehmann found Ernst Freud "Not only an extremely able architect, but a man full of ideas and enterprise." In 1945 Lehmann wanted to buy a house in London and Ernst Freud went round with him and provided "eager and persuasive arguments" to "grab one of the many excellent properties still going cheap before everyone else joined the hunt." Lehmann liked the way he threw himself into the search, "sniffing for dry rot, pulling at peeling wallpaper, shifting piles of rubble-litter with his foot, calculating with lightning speed the cost of mending a roof damaged by incendiaries or a stairway shaken by explosions next door, remodelling interiors to my liking with a conjurer's dazzling patter—and dismissing the whole vision at once with a slightly diabolical laugh, when he saw me reluctant."[23]

"I lacked family feeling, a sense of being in a family," Freud concluded in distant retrospect. "I never made any gesture where, anything I did, I felt this was my family. I accepted things as they were. I didn't feel a unity. Not adverse, but not strings."

Lorna Wishart was still his muse. The older woman—by almost twelve years—she remained a passionate attachment. When he had first drawn her, three years before, in an ocelot coat of dramatic splendour, Freud had been more exercised over the markings than the face. He gave her the drawing. It was damaged slightly when Laurie Lee smashed the glass, which gave her the opportunity (Freud later claimed) to alter the mouth. The drawing shows her huge-lipped, wide-shouldered, eyes staring beyond the unseen artist, bead necklace embracing the throat, an innocent Amazonian, an unsmiling femme fatale. He drew for her ("For Lorna Wishart") an emblematic device of pierced hands, feet and heart: his heart or hers, with a nod to the faith towards which she was now turning. At the same time Laurie Lee, racked with jealousy, couldn't but regard the liaison as sordid.

"This mad unpleasant youth appeals to a sort of craving she has for corruption. She doesn't know how long it will last. She would like to be free of it but can't . . . She goes to him when I long for her, and finds him in bed with a boyfriend. She is disgusted but still goes to see him. And tonight she says she is going to Cornwall with him."[24] That boy, Lorna said, was Charlie. When I questioned Freud about this he denied it out of hand. "This is fiction; I wouldn't have; this was made up. Can't be right."

On trips together he and she had enjoyed feeling complicit and carefree in the spirit of "Over the Hills and Far Away" like the happy ending for the two little pigs in Beatrix Potter's *The Tale of Pigling Bland*. At other times the strains showed, as in *Woman with a Daffodil*, on canvas, and *Woman with a Tulip*, on panel, painted in the spring of 1945. Fixated and shrunken, they convey, as rarely—if ever—before in Freud's work, an apprehension of another person's susceptibilities. "The first person I got keen on," as he said, the Lorna of *Woman with a Daffodil* is sickly pale, sunk in grief and grievance, her hair lank with coconut oil, her look matching the sour yellow of the cut daffodil. *Woman with a Tulip* is head on but thoughts elsewhere, ignoring both the painter and the lopped tulip. The two paintings monitor a faltering relationship. "In a way they're devised. I was more concerned with the subject—she was very wild—than I had been before, so it was a more immediate thing." The fifteenth-century look (like a head of Christ by Antonello da Messina in the National Gallery) is weary and resigned; which of course goes with the process of sitting after sitting, mind a blank or simmering with resentment.

Lorna often stayed for weekdays at Delamere Terrace (where these two little paintings were done), returning to Sussex at the weekends; occasionally she brought sixteen-year-old Michael with her; he would sleep on the floor and overhear them in the night. At one stage there had been a plan, initially more Lorna's than his, for Freud to move into an estate cottage at Binsted but that didn't work out; Ernest Wishart objected and anyway the set-up wouldn't have suited him. The cottage was near where Mervyn and Maeve Peake were living. Theirs, he gathered from Lorna, was a rural slum existence. Rather them than him. "In an earth dwelling: no rent, no water. Very poor, but they were the sort of people who would give money to a beggar, quiet, modest, and the opposite of Michael Ayrton."

In the winter of 1944–5 Lorna found a dead heron on the marshes and brought it to Delamere Terrace; her gifts tended to be offerings, placed at his feet. So he painted it, laying down plumage like petals on a wreath, exquisitely inert. "I always had a horror of using materials that reminded me of art schools, and that's why I used Ripolin. I didn't like the idea of awful Winsor & Newton ready-made kit because I thought that tainted the idea of doing anything." Powder paint from the barge shop in the Harrow Road, mixed with oil or water, was closer to Renaissance practice than paint squeezed from tubes. The bedraggled heron is a legless device lopped from an Uccello helmet, cruciform on damp sand, graced with enamel shine. Neither commemorative nor symbolic, more magnificence brought low, it reminded Freud of the stuffed gull that had served as his albatross when he was the Young Mariner with the Dartington Eurythmic Players.

In April 1945, shortly before the war in Europe ended, Francis Bacon's *Three Studies for Figures at the Base of a Crucifixion* was exhibited at the Lefevre, along with paintings by Graham Sutherland, Matthew Smith, Ben Nicholson, Henry Moore, Craxton, Colquhoun and others. Bacon had been harbouring the painting for quite some time and this was a sensational addition to the original selection: three bloated deformities on tufts and perches, gurning and gagging in an orange hell. Freud considered *Three Studies* a work of freakish audacity catapulted out of nowhere. "Francis was not only little known, he was almost completely unknown." Sutherland's response was a small gouache, same orange field but instead of pilloried foetal forms a horned and nostrilled cow making eyes; and, as it happened, it was Sutherland who alerted Freud to Bacon. "I said, rather tactlessly, 'Who do you think's the best painter in England?' He said, 'Oh, someone you've never heard of: he's like a cross between Vuillard and Picasso; he's never shown and he has the most extraordinary life: we sometimes go to dinner parties there.'" Sutherland had come across him, Freud recalled a lifetime later, as "a quiet roulette-playing gent who lives in South Ken." Not as a painter. He and Bacon first met, he thought, in late 1944 or early 1945. "I feel disinclined to push that I met him earlier than I did," he told me. "I arranged to meet him at the station to go down to Graham's in Kent. Once I met him I saw him a lot. Francis said he hardly knew him."

That was two years after Freud wrote to Felicity Hellaby about the "wonderful" book he had found on diseases of the skin ("with amazing illustrations: you must come and see it"); his love of such books pre-dated the onset of Bacon's influence on him; however, his appreciation of the diversion to be had, and the advantage to be gained, by flouting composure and outraging convention was largely provoked by Bacon's flamboyance and scorn. The painter of *Dead Heron* and the perpetrator of *Three Studies* were immediately potentially complicit. The friendship was to spur Freud for the next thirty years. He talked of Lorna being "wild" and that was high praise, but Bacon was, he said, the "wildest and wisest" person he had ever encountered. His first sighting of *Three Studies* was when he went to Bacon's studio in Cromwell Place, which had once belonged to Millais (and more recently to the photographer E. O. Hoppé whose portraiture props were still there, prompting Bacon imagery). *Three Studies* was already in the gold frames that Bacon favoured; for him with his poor rotting heron, Bacon's three terrorised creatures of the imagination were utter spectacle. Poised like circus acts trained to rage, they were anything from horrors of war—blinded, deafened, crowing over Henry Moore's shelter sleepers—to Fates assembled to spook the punters at the roulette sessions Bacon had been organising in his studio. Freud did not attend them—he was more attuned to the roll-a-penny arcades around Leicester Square—but he knew the set-up: large cars parked outside, all-night sessions, flagrant law-breaking in respectable South Kensington, classic George Grosz.

"His nanny was the doorman. She was almost blind and she told him whom he must and mustn't see. She was unkeen on MacBryde and Colquhoun. I was OK, she liked me, fortunately, and had rather marvellous natural tact: she appeared with tea and disappeared. Francis had scaffolding put up and bogus window-cleaners as lookout men, because it was illegal, quite an elaborate thing. Not hole-in-corner. He took a lot of trouble."

"My first show made some money and I was in a position to take out anyone, so I went out with Pauline Tennant. She was a pin-up for the forces, a glamour girl, a bit of a kind of star at the Gargoyle, which her father owned." David Tennant's Gargoyle Club, on the top floor of a

fine Georgian house, 69 Dean Street, was tiled with squares cut from antique mirrors on the advice of Matisse, whose *Red Studio* had been part of the decor when Freud first went there. "You went up in the lift then down Matisse's stairs to a feeling of sub-basement." Its glamorous incongruity in the heart of Soho attracted the well-heeled and indefatigable of all ages; among its more opportunistic regulars were Brian Howard and Cyril Connolly, Dylan Thomas, Nina Hamnett and Bobby Newton. Also Freud. Driving back one night from the Q Theatre near Kew Bridge, the actor-director Esme Percy discovered him asleep in the back of his car and obligingly, on waking him, introduced him to his front-seat passenger: David Tennant's daughter Pauline.

Normally the Gargoyle was a place Freud could patronise only if someone else was paying, but once he knew Pauline Tennant he was well in. Her debut on the scene had been noted in a *Picture Post* feature in February 1941 under the headline "Mr. Cochran's Very Youngest Lady Is a Schoolgirl." "At fifteen," the magazine prattled, "Pauline has the looks of a young film star, the assurance of a society hostess, and all the coltish charm and restless enthusiasms of a schoolgirl, which makes an irresistible combination." Within a year she was a *Picture Post* cover girl. Photographs of Mr. Cochran's discovery showed her laughing and cavorting with her mother, the actress Hermione Baddeley. In reality, Freud maintained, mother and daughter didn't get on. "Pauline envied her mother and longed to be the daughter of her aunt, Angela Baddeley." He acknowledged that the ructions could have been to do with a mother's suspicion of him: a scrounging hanger-on from the Gargoyle. As Ida in the stage and film adaptations of Graham Greene's *Brighton Rock*, Hermione Baddeley was to be moral guidance personified, a blowsy saint attempting to save poor impressionable Rose from Pinky the juvenile thug; that didn't stop him spending nights with Pauline at the maternal flat over Salmon & Gluckstein, tobacconists, in Piccadilly. "We slept between two armchairs and her mother used to bring us tea in the morning on a tray, naked. Under Pauline's door once came a note: 'I expect either a brilliant career or a dull marriage.'"

Freud, Pauline Tennant, Johnny Craxton and Sonia Leon were a foursome for a while; there were evenings at the cinema down the Harrow Road and even a poetry-reading evening with Craxton's par-

ents in Hampstead where David Gascoyne read. "Very good but the audience full of long ladies with gloomy faces and enormous amber beads hanging down and clanking and deathly serious."[25] Pauline was impressed when, walking through Shepherd's Market one evening, Freud addressed by name every tart they passed. The girls called him "Luce," she noted. He remembered taking her brother David ("drunk, Etonian, pompous at sixteen in a double-breasted suit") to see Douglas Cooper, the virulent critic and collector. "He walked over to the radiogram and was sick into it: delicate mechanism completely covered in porridge and Douglas Cooper just laughed. Pauline was engaged to Julian Pitt-Rivers and she married a number of people. I drew her in Conté pencil, semi-profile, and a little picture, green and yellowy, her hair her crowning glory, long, blonde: a Veronica Lake look and 'one's mother was an actress' resentment." The drawing has her groomed to pin-up perfection, a single wrinkle, picked out in Conté white, traversing her forehead. The painting is little more than a haughty mask and brassy mane. It remained unfinished when in August 1946 she married Julian Pitt-Rivers in St. George's Hanover Square, then went off to Baghdad where Pitt-Rivers was employed as purser to the young Feisal II, King of Iraq. Her third marriage, in 1974, made her Lady Rumbold.

Kitty Epstein once told Pauline Tennant that she was, for Freud, "the first step up the ladder." She was also the most glaring cause of his break with Lorna Wishart.

In the spring of 1945 Cousin Walter of the SOE was parachuted into southern Austria in a squad of six with orders to raise resistance and establish a British presence before the arrival of the Russians; this was to involve seizing an aerodrome at Zeltweg. He landed, however, fourteen miles off-target and finding himself alone spent some time in the mountains before acting on his own initiative and seizing the aerodrome. He then went to the local Nazi headquarters to negotiate surrender, successfully bluffing them and afterwards falling in with a group of Austrian army mutineers who handed the aerodrome over to the Americans. "Cousin Walter came back the hero and married the daughter of some Scandinavian ambassador. He became an inventor." As a major in charge of a War Crimes Investigation Unit at Bad

Oeynhausen, he investigated Krupps and succeeded in identifying Dr. Bruno Tesch, the man who developed the poison gas for Auschwitz; he went on to spend most of his working life as a chemical engineer at BP and died in 2004.[26]

Freud, with no such involvements to vaunt, had given the war a miss as much as he could. However, he quite often dropped in to the news cinemas around Piccadilly Circus for the cartoons and the Fitzpatrick travelogues ("And now we leave . . . where nothing has changed for the last two thousand years . . .") and there one afternoon he saw something different. "I was in the cinema with Lorna and we saw the concentration camps and she burst into tears and I was amazed; I was affected by her being upset but it seemed completely like another world to me. I knew about it, but—something to do with the degree of being adult: young men see torture and suffering and think it's stimulus or neutral—those pictures of skeletons and all that . . . I don't know. It's to do with feeling *not* being like that. My mother was concerned, but I think that she would have thought that I must be sheltered from something like that. Even though on the convoy things were pretty horrible: are bits of the body going to fall over us? People weren't used to seeing horrors on films." The news that his four great-aunts had been deported and killed was something he was hardly aware of at the time. "I never knew them; I think my mother must have told me about them, but that was years later. She said they were placed in a concentration camp and one of them said, 'We consider ourselves distinguished because our brother is very distinguished; instead of waiting here to die we'd like to die right away.' And they said, 'Fine.' I didn't know how close they were; my father would never talk about anything like that as it would upset him."

VE Day happened in May. Demobbed, Stephen Freud went back to Cambridge, paid for by his Aunt Anna, and Clement Freud came out of the Catering Corps ("He served his country," his hostile brother remarked) to become a liaison officer at the Nuremberg Trials. For Lucian VE Day was memorable only for "trying to do what others did: head for Trafalgar Square to get lit up." Peace meant a future and, with any luck, a livelihood as a painter. There was talk of restrictions lifting and horizons opening up, some time but not soon. Foreign

travel remained impossible for non-service people except for those officially employed or able to plead urgent business. Mervyn Peake went to France immediately after VE Day, for *Leader* magazine, and on into Germany; his dazed drawings of Belsen were published at the end of June; Stephen Spender secured a commission to report on the attitudes of German intellectuals during the war; Cyril Connolly wangled authorisation to travel, being the editor of *Horizon*, and found Paris wanting. "The black market flourishes like a giant fungus, the Resistance is bitter and disillusioned." Flying back he saw, horrible below him, under "a vast thick cloud of sooty mucus, ringworm circles of brick villas, grey and gloomy factories and towers."[27] This was London, not flattened but decrepit. Auden, who had been in America throughout the war, arrived in London as a major in the US army attached to the United States Strategic Bombing Survey and, he boasted, "the first major poet to fly the Atlantic."[28] In the course of seeing again Spender and John Lehmann, Britten and Eliot and everyone else whom he thought mattered, he told Freud that he was the one person he really wanted to see.

"Auden made lots of amorous propositions to me. Jimmy Stern the writer, whose wife Tania, a psychiatrist's daughter, was my mother's best friend, came over with him, which is how I got to know him." Auden harangued his friends on Britain's impoverishment and loss of status and on the awful food and lack of heating. "London hasn't really been bombed,"[29] he said, not having seen as much damage as he had expected. "He felt that people in London didn't want to know him and I saw him in a very concentrated way for a while." He urged Freud to read *The Hobbit*; J. R. R. Tolkien's concept of a Nordic starter saga disguised as a children's book and realised in pedantic detail appealed to his donnish schoolboy streak; Freud found it tiresome, marginally preferring Mervyn Peake's labyrinthine *Titus Groan*, also recommended by Auden. Its excesses were more appropriate to the circumstances of being detained in England and longing to get away. "Auden was someone who decided everything beforehand. He had read Sigmund Freud at school and I think he decided that I was his new friend, which up to a point I was, but I think he also decided I was his boyfriend, or could be, which I wasn't. And then he wrote from America: he had ideas about art, which were completely silly, but some of his ideas were very stimulating, absolutely brilliant, up to

a point. He said, 'Violence is such a bore.' His last words, he said to me, were going to be: 'I've never done this before.'"

During the hot summer of 1945 Freud often bathed in the canal. "I used to jump in off the bridge. There was an electric cable in the mud and a boy dived from the bridge and touched it and was killed and so they looked round for the oldest person to blame and I was tipped off to keep out of the way, so I stopped bathing there."

In June Neo-Romanticism was in full flourish with the first performance of Britten's *Peter Grimes*, at Covent Garden, and the release of Powell and Pressburger's jaunty Hebridean odyssey *I Know Where I'm Going*. That month Freud drew Peter Watson on Ingres paper, marmoreal, near Neo-Classical, hunched slightly, with dandy-ish diffidence, in his furrowed corduroy jacket. This drawing, lucid, restrained, intimate and above all responsive in character, marked the onset of Freud's graphic finesse: since the comparable drawing of Craxton some months before (*Young Man*, 1944) there had been a sharpening of focus, a burnishing of perspicacity. Watson, still Freud's most generous and undemanding patron, was seeing his prospects begin to open out after six years of cultural insularity. Once again, he was thinking, he could live in Paris.

With beach defences dismantled and the more remote British Isles accessible once again, the Neo-Romantic impulse went island hopping, if only in fancy. "Perhaps we shall see islands again some day," wrote Wrey Gardiner in *The Dark Thorn*. "The Scillies, the Atlantic Islands of Madeira and the Azores, the West Indies: What an escapist dream they look like on the page. The island is a symbol."[30]

"Everything on the Scillies is in miniature, although once on the islands one seems to be walking up hills and down valleys; the Scillies form a little world complete in themselves," John Betjeman rhapso-dised in his 1934 *Shell Guide to Cornwall*. English holidaymakers there in the immediate post-war years could imagine they were abroad. Palm trees flourished on at least one of the islands and, marooned on shore, figureheads salvaged from wrecks strained towards the sea. Besides cosy scale and shoreline surreality, the Scillies offered oce-anic skies. As Geoffrey Grigson enthused in his 1948 *Vision of England* guide to the Scilly Isles: "Light is the energiser of the Isles of Scilly, a light sharper, clearer, giving more definition than the hazy light of the English mainland."

In this beguiling place, recommended to Craxton and him by EQ, Freud came as close as he ever would to slipping into Neo-Romantic idiom. But even in the Scillies, when Peter Watson paid for them to go there in the late summer of 1945, he drew plants, boats and black rocks on beaches roundly and singularly, as though Robinson Crusoe had just clapped eyes on them. The Scillies, Freud's first proper islands since childhood on Hiddensee, and as remote as one could be from London while remaining in England—"a tropic in a northern sea / where palm joins gorse," the poet Anne Ridler wrote[31]—were to be stepping stones, he hoped, to the continent. He and Craxton needed to get to Paris in time to see the exhibition "Picasso Libre." "I longed to go to France and couldn't so went to the Scilly Isles." Many refugees from France in 1940 had arrived in Britain by way of the Scillies. "I thought I could stow away on one of the Breton fishing boats to get to France. But they said we're not taking you unless you have a bicycle—there were no bicycles in France—so I went back to London, got a bicycle, went all the way back to the Scillies, gave it to them and stowed away on the Breton boat, and then the harbour police came. Obviously tipped off by them."

They stayed first on St. Mary's, the largest island, then on Tresco. "A horrible family the Dorrien-Smiths owned it and made it very feudal: everyone was subservient to them." They took rooms in a fisherman's cottage. "A slightly unusual fisherman: his wife was from Plymouth and made puppets." Meanwhile Major A. A. Dorrien-Smith, whose ancestor T. A. Dorrien-Smith had discovered that the Monterey Pine made the best windbreak and had initiated commercial flower-cultivation on Tresco, held sway. There were also the doctors: Dr. John Wells, who had ambitions as a painter and was about to remove himself to Cornwall where he became part of the St. Ives School, and "an Italian doctor—'The Count of San Remo'—he was rather old with a moustache and had been told that he'd better not move away while the war was on. His son, Giorgio, was very handsome and there weren't many hostesses around in the islands so he had a nurse—who I rather liked; he used to go with this fat nurse into the rushes, which was very exciting: pink on Scillonian sand." Craxton dallied with Sonia Leon, sixteen years old and half-Jewish, whom he had met on the boat to the Scillies and who later married the writer Peter Quennell. ("Fourth wife called Spider," Freud com-

mented. "Maddening giggle.") Freud struck up with another girl on the *Scillonian*. "She was being sick at the time, the boat pitched, and I went off her then. Her green face." She lived on the other side of the island and he watched out for her, using binoculars, only to find that he was being looked back at, through binoculars, by her father. Who, when they met, commented on the zoot suit he was wearing, made up for him by a Welsh tailor in the Marylebone Road for £3 10s: long jacket and trousers with wide knees and narrow ankles. "He was terrifically fascistic. 'It's a bit jewy,' he said." Freud used to lie around with the girl, not draw her; it was "a sort of holiday affair" and Lorna Wishart found out.

"She found some letters the girl had written to me and wrote back a letter signed 'Freud and Co' saying 'just leave us alone.'" By another account the letters were from Pauline Tennant; there were probably letters from both. "The girl on the Scillies proposed to me but I said, 'I can't; I'm sort of not free.' So Lorna said, 'I thought I'd given you up for Lent but I've given you up for good.'" The falling-out was violent. Freud did all he could to win her round; he gave her a white kitten, presenting it to her in a paper bag; and then he galloped on a white horse across the fields and up to her window at Marsh Farm, suicidally fast. "At the time of the break-up she had drawings, small ones, which she destroyed and she wrote to tell me so. It was the end. I wondered why. I was very cut up about it." One surviving drawing, inscribed "For Lorna 27.11.45," was a clean sweep of Scillonian beach with a single pebble, a lone sea thistle and black rocks like sharks' fins in the sea beyond. He also sent her the emblematic bleeding heart and pierced hands and feet the size of a prayer card. "She was more and more Catholic."

Craxton said, "Lucian was really in love and when she dumped him he was terribly hurt."[32] He went after her, and there was an incident with a shotgun. "I remember shooting," Freud admitted. "I wasn't aiming at her; it was, as it were, an Annunciation." The Wisharts always associated one particular tree as being the one that Freud had shot. Or was it that he hit a cabbage?

When Freud went to Paris the following year he lit candles for Lorna. "Without being religious, it was a way of keeping in touch." He hardly saw her again. "I'm never any good at going back." She constructed a shrine in the form of a grotto, destroyed the letters that

he had sent her, took up gardening and attended mass daily. Reconciled with her husband, she nursed him devotedly at the end of his life; he died in 1987, she in 2000. For Freud she remained an ideal figure, a true muse; her dismissal of him was all the more disheartening in that he had obsessed her and she had forsworn him. This was a passion that he could all too easily understand. Did her newfound faith diminish her liveliness? "I can't say. Probably a lively religious life."

Preoccupied yet readily diverted, Freud had appetites to slake. Dick Wyndham's daughter Joan, whom he had first encountered, by her account, at the poet William Empson's New Year's Eve party in Hampstead (presumably 1945/6) was one such distraction quickly realised and, in terms of involvement, about as weighty as a couple of picture postcards.[33] Freud took her down to a basement nursery where Empson's children, Mogador and Jacob, were sleeping. Empson discovered them there and chucked them out so they went off through the snow to his studio where a hawk sat in a cage eating a mouse. They went to bed. Next morning, she recalled, he drew the hawk and then, wearing his grandfather's long black coat with a fur collar, took the hawk out for a walk. An involvement developed and she went around with him for several weeks, often with Johnny Craxton, "his inseparable companion,"[34] to the Café Royal, to concerts in Chelsea Town Hall, to a performance of Picasso's jibber-jabber play *Desire Caught by the Tail* and to second-hand clothes stalls in street markets. "A new twist to our relationship: we were in bed when a girl's voice said 'Cuppa tea, love?' and I saw this dark girl with huge eyes who totally ignored me and didn't offer me any tea. The next two nights she slept on the sofa . . . I think her name was Kitty." What Freud really liked, she reported him as remarking, was to pick up unknown little girls in the park and bring them home like stray kittens. "One thing I liked about Lucian was that he always told me the truth, no matter how painful. And," she added, "you never knew where you were with him, and he liked it that way."[35]

A mixed exhibition at the Lefevre in February 1946 included Ben Nicholson, Sutherland (thorns), Craxton, MacBryde and Colquhoun,

Bacon's "Figure Studies" picturing tweedy rumps and, on one wall, four paintings by Freud: *Dead Heron*, *Scillonian Beachscape* and the two portraits of Lorna Wishart. Bryan Robertson, writing in the *Studio*, in March 1946, on "The Younger British Artists" ("a brave company . . . carefully probing in different directions") cited Ayrton, Craxton and Minton, but made no mention of Bacon or Freud. They did not fit in. Maurice Collis on the other hand, writing in the *Observer*, singled out *Woman with a Tulip* for comment: "a tiny portrait by Lucian Freud, the youngest of the young men here, shows remarkable skill. He may turn out the most gifted."[36]

Freud's drawings of sea holly and cacti among the pines and palms of Tresco came as close as he ever would to the profuse ground cover effected by Craxton and Minton. His preferred objects were prickly and stranded. "On the beach in Tresco there was an old lifeboat and I did an elaborate drawing, the same size as Drumnadrochit, in ink, quite hatched, with the bottom of the boat with old green paint on it which I used." A similar boat painting—"a little long one on a bit of board, slight hole in it"—he gave as a thank-you to Peter Watson.

Cedric Morris kept two or three of Freud's Scillies drawings stuffed in a cupboard at Benton End and would show them to visitors, smoothing out the creases. Dr. Hoffer bought one, as did Podbielski, who had returned from Australia anxious to advance himself socially and write a novel. "I think he thought either a high-powered social life would help with the arts or the other way round. Suddenly he was a great friend of Princess Margaret: she gave a party for him in the fifties."

Dead Heron was reproduced a few months later in *Orion III* (a literary miscellany published by Nicholson & Watson), illustrating "Some Young Contemporary British Painters," an article by Michael Ayrton, who wrote: "Oddly enough the work of the young painter who seems to me to approach nearest in treatment and conception to Stanley Spencer is Lucian Freud. Whilst not British in origin, he may be said to be of the 'School of London.'" Comparisons with Spencer always irritated Freud (Spencer, it is safe to assume, never noticed) because of their basic dissimilarity. At most they operated at cross-purposes with occasional overlaps. Spencer invariably composed, proceeding from drawing to squared-up drawing transferred to canvas and then filling in systematically; whereas Freud, even early on,

painted by aggregation, building up the image not from drawings but from unmediated observation. The "School of London" tag, applied here for the first time, was to be rather more irksome, indeed something of a stuffed albatross around his neck. Ayrton emphasised that Freud's work was "completely divorced from Sutherland's and from his friend John Craxton's, in that the content is utterly static." He argued that painters such as Freud were essentially northerners. "The core of that tradition is northern, whatever overstrains and undercurrents of Mediterranean art may be present. Its strength lies in this fact, and its individuality."[37]

Freud was learning to be unambiguous. As he went on he became more aware of the ways people operate, the ways things appear, the chances to be taken, the ramifications of acquaintance and the demands of involvement. The paintings were beginning to reflect his feelings in distinctive ways. For example, unlike the vanilla icebergs of conceit in *Man with a Feather*, the black rock islets in *Scillonian Beachscape*—painted back in Delamere Terrace in the winter of 1945/6—slit the stillness of the dark-blue sea. The aggrandised pebble, so neatly flawed, was a find; the puffin came from a Bewick wood engraving; the sun-dried sprig of sea holly was taken from a drawing. Rocks, puffin, holly, stone: rhyme, contrast and singularity in a clear morning light, neither symbolic nor surreal. The play on scale (puffin, pebble, seed head) and the clarity of touch create a sort of vigil. Freud's Scillies become Shelleyesque:

The birds did rest on the bare thorn's breast.

Scillonian Beachscape was bought by F. S. Hess. "A great friend of my father for a time. Bought a house in Walberswick. Hess had been an incredibly successful financier in Germany, his wife was a sculptor who studied with Barlach, and he was monstrously dishonest. When he played chess he cheated, my father said. He had *Scillonian Beachscape* above the fireplace and it flaked, got dandruff and had to be restored."

France, Greece, First Marriage
1945–9

"French malevolence"

Lieb Mut

 Thank you for your letter. No no no I've not got pap's shirts and nightshirts. I wish I had as it is cold at night here. I've told you once allready I've not got them so try and remember that I haven't got them! I suppose you found a piece of material covered in paint in the Rue Jacob which you took to be pap's shirt tail but you made a mistake it was not a piece of material at all, but a piece of Paper resembling shirt material owing to the fact that it was damp. The marks on, what you imagined to be the remnant of shirt, were not Paint marks but bread crubms [sic] which naturally attached themselves to the paper. Now there is one thing which you will justly accuse me of: if your explanation is correct why did the marks which you claim to be breadcrumbs vary so much in colour and texture to give me the illusion of paint marks? You will say. Here is the answer. This optical illusion was made a possibility by the poor baking materials in Paris at the present time. Many loaves (such as the one in question) come out of the oven unevenly baked. I admit that the quality of fuel used in the oven as well as unexcusable carelessness on the part of the baker may be responsible for such a loaf.
Love L.[1]

This letter, written from Paris on pink wrapping paper in August 1946, was posted without a stamp. Lucie Freud folded it up, stuffed

it back in the envelope and put it away. As a reply, sufficiently spun out to fill the crumpled tissue, it was elaborate enough to appease her. It was playful bluster designed to screen his needs. He wanted, he told me, "to avoid a confession that could occasion forgiveness and the threat that posed of resulting intimacy." So it was worth insisting that he was having a quaintly hard time in Paris. Cold nights and dodgy bread: forget the missing shirts. Cloth become paper and paint become crumbs. His mother, he assumed, would pick up on the echo of Morgenstern's "Song of the Derelict Shirt":

> *Kennst du das einsame Hemmed?*
> *Flattertata, flattertata.*[2]

"By the time the war ended I was longing to go to Paris. I went in 1946 when you were allowed to go; before that only those such as Peter Watson, who had property there, were allowed."

Gradually, after four years of occupation, six years of hiatus, Paris became attainable again. Kenneth Clark and John Rothenstein, Director of the Tate, were the first cultural emissaries, flown in by RAF bomber in October 1944; once there, Rothenstein jumped the queue of well-wishers in the rue des Grands Augustins and twice had brief audiences with Picasso. Herbert Read, who went nine months later for the British Council, remarked, in an article "Art in Paris Now" for the *Listener*, that Surrealism was in eclipse, that "the general trend might be regarded as reactionary" and that Picasso, Matisse and Braque were being productive. "And though they tend to repeat themselves they are all still far more inventive than any of the younger painters." By "younger painters," he meant those approaching the age of forty. "There is little evidence of artists of a still younger generation," he added.[3] Read, in Paris because of his role in selecting an exhibition of British Children's Art, buttonholed Picasso at the vernissage and was gratified to be told by him, on looking at the work of twelve-year-olds: "At that age I drew like Raphael: how long it took me to unlearn all that and paint as naturally as these children!"[4]

Paris was taken to be, above all other cities, the world capital of Liberation. Here lay future prospects, young artists from Great Britain could assume, though currency restrictions rendered travel there more or less impracticable. Nonetheless, Craxton managed to

get there, aided by Peter Watson, in early 1946 and quite soon after wrote to Freud saying that Pierre Loeb might show their work at Galerie Pierre. Coincidentally the May 1946 number of *Horizon* carried poems by the eighteen-year-old Olivier Larronde interspersed with Freud drawings (a rose in a glass and an oyster) which gave Freud a pretext for contact and a sufficient connection when he arrived in Paris a couple of months later, Peter Watson, once again, providing introductions and wherewithal.

"I stayed in the Hôtel d'Isly at the corner of the rue Bonaparte and rue Jacob. Jean-Pierre Laclocche and Olivier Larronde were there together in the hotel. It was a kind of slight arrangement; the idea was, they were supposed to teach me French and I was supposed to teach them English. Olivier learnt English in about ten minutes and I still can't speak any French."

Olivier Larronde came from a wine family in Bordeaux. He had run away to Paris and had been living in a hotel when discovered and taken up by Jean Genet. "His room was so filled with books that when Genet tried to open the door he couldn't." Larronde's first book of poems, *Les Barricades mystérieuses*, was published in 1946. He and Jean-Pierre Laclocche (who had occupied Peter Watson's rue de Bac apartment during the war) packed their room with furniture and pictures, birds, snakes, scorpions and monkeys, an Italian greyhound and opium-smoking paraphernalia. "The flame was always there and the pipe was ready: it was good, supposedly, for Olivier's epilepsy, though he only had it at night in his sleep."[5]

"Jean-Pierre was the son of two whores and adventurers; he had been brought up in America by his mother, who had had affairs with Charpentier the boxing champion and Maurice Chevalier: she went out only with very rich people. She said, when paid hollow compliments, 'Put it in the bank.' His father had a colostomy bag as he had been on opiates since

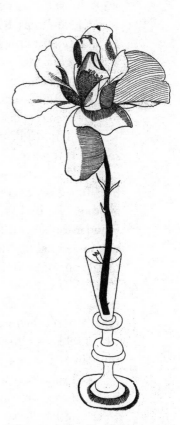

Rose reproduced in *Horizon,* 1946

he was very young. He took him on burglaries, pushed him through the window of houses where he had dined. Jean-Pierre was nearly caught, and his father said that if he was caught he would denounce him. Jean-Pierre had been a war hero."

Finding the pair "friendly but distant," Freud fended for himself. "It was clear that I was a tourist among natives and that they had no use or interest in me. Olivier invented words that should be in the language, words that he thought I'd understand. He knew I had two friends, so he would say, 'Which would you rather do: kill Johnny Craxton or be killed by Peter Watson?'"

Looking out for attractions, Freud cycled around Paris until his bicycle collapsed under him. The seamy Paris of Brassaï beckoned, the pungent Paris of Marcel Carné's *Hôtel du Nord* with Louis Jouvet as the crook and Arletty as the faithless tart, a Paris breathing still the studio mists of *Les Enfants du Paradis* ("I remember feeling uneasy about Jean-Louis Barrault in that and liking Arletty"), the Paris of seeping poeticism where Christian Bérard's designs for Cocteau's *La Belle et la bête* made magic a dreamlike reality.

"France is in an extremely fluid situation today and intellectual life is also fluid, tending to pour over everything," Stephen Spender told *Horizon* readers after his short tour of inspection in the spring of 1945.[6] "The winds of Existentialism," *Studio* magazine's Paris correspondent reported, "blow so fiercely through the literary salons and cafés of Paris that some of our young protagonists of the brush are threatened by its contagious philosophy."[7] If existentialism stood for anything beyond attitude it stood for an elevated realism, free will founded on scepticism as opposed to the despicable self-interest of wartime collaborators, say. Accordingly it could be seen as the Second Front or second wave of Liberation. Young Meursault in Albert Camus' *The Outsider*, which Freud read and admired ("terribly good: the funeral, the mother"), was existentialism personified: "a modern type of hero, the man who is truthful and detached through a despair which releases him of obligations to others and to himself—to everything in fact except the truth that life is essentially absurd."

To Freud this was tonic, not in any intellectual sense. Intellectual attitudes were anti-instinct, he felt; though admittedly in France, where he hardly spoke the language, the idea of intellectuality had an abstract charm and allure. "It just seemed amazingly exciting.

The thing that was so stimulating was the intelligence. In London if you saw people, you didn't know what they were doing or where they were going; in Paris their urgency and feeling seemed strongly expressed, unlike in England. Even the way they drove. There was a joke: 'Why are there so many collisions in Paris? Because there are so few pedestrians and all the cars are trying for them.'" Auden, who had been through Paris the year before, told Freud that he had seen signs posted up for the American troops saying "Drive Carefully: Death is So Permanent." More Audenesque than existential it was, nonetheless, admirably terse. Under sentence of death Meursault says, "I laid my heart open for the first time to the benign indifference of the world."[8]

In a basement cinema opposite Saint-Sulpice Freud saw Buñuel and Dalí's *L'Âge d'Or* (1930), since 1945 one of the long-running showpieces of a free Paris. What particularly appealed to him was the play on sensation: overt lust and quest compared to Neo-Romanticism's soppy dolour. "The lovers in a formal garden, the politician and mistress spring round the tree trunk and then he gets a message to go inside and she, in her frustration, starts sucking the toes of the statues." Prompted and heartened he would buy a bottle of triple sec and lie in a boat moored on the Quai Voltaire thinking, he said, "I'm in Paris" and watching the river move. He went to Les Bains Deligny, the floating swimming pool anchored in the Seine, and drew the people there. "I remember thinking you couldn't tell whether they were rich or not or what their lives could be." Denham Fouts, who was occupying Peter Watson's flat, "used to go and stand on the diving board and just jump up and down, posing, watching out for young boys to pick up." It was a hot summer.

The way a life goes happens by chance: someone met, something read. Lucien Fleurier in Jean-Paul Sartre's story "The Childhood of a Leader" reads Sigmund Freud on dreams and this fires his imagination. ("'So that's it,' Lucien repeated, roaming the streets. 'So that's it.'") Like Lucian, Lucien finds inspiration in Rimbaud, Lautréamont and the Marquis de Sade. He learns ruthlessness. "The first thing to convince yourself of," his seducer tells him, "is that everything can be an object of sexual desire, a sewing machine, a measuring glass, a horse or a shoe."[9] For the newcomer from London, Paris was persistently enlivening. "Montparnasse was very like *Les Enfants du Paradis*:

the street life, wandering round, booths and shouting girls, so matey and friendly you couldn't believe they were whores." These particular objects of desire were not for him. "Couldn't afford them. I think if I thought of them as whores I wouldn't have fancied them, the look and everything: trained in two and a half minutes. It's also their sinister, horrible malevolence, and it's to do with their intelligence, the way they were pressing and showing an interest without any knowledge." At every level the culture seemed fierce and perverse. "Every restaurant had ridiculous prices which weren't real prices," the understanding being that the true black-market cost would show up in the final bill. Sometimes, however, Olivier and Jean-Pierre would go with him to a restaurant and take the menu at face value. "They just paid that and left and of course couldn't go back again." There was also the casual melodrama of the circus. "I went a lot. The Cirque d'Hiver and Cirque Medrano. You could go round afterwards and look at the poor animals in cages. I saw a charwoman brush aside the lions that had been roaring just before. They were doped of course. There was a cage with a wolf with three legs and a stump, gnawed away, and I heard a very ordinary French woman saying to a little boy, her son, '*Comme elles sont jolies les blessés.*'" What a peculiarly French thing to say, Freud thought. Could she have been aware of the Marquis de Sade's fetching remark: "*Comme ces sont jolis les mortes*"? No. That woman's remark struck a chord. "There's something noble and beautiful about stumps, it's to do with noble pity. In England, if that happened, someone would say, 'Talk about fucking morbid . . .' Some things are formative and this affected my aesthetic sense, so to speak. It was to do with the French attitude—French malevolence—because they are detached, in a way. With them, the eye plays such a strong part."

Quite apart from the distractions, it wasn't easy to settle to work in a hotel room. Freud made a drawing of a castor-oil plant on the balcony railings outside his window, etiolated in comparison with his previous Scillies gorse and pines. "The feeling of the plant being different, potted in a different way. Very French. I felt—even though I didn't use it—the balcony would imply what was behind: the shutters of the room opposite." Podbielski, who had introduced him to the Coffee

An' and since then had been to Australia and back, came to Paris. "Seeing the drawing, he said, 'I had hopes of you, but didn't think you'd do anything like that. It's absolutely no good at all.'"

Two sketchbooks were filled with Olivier and Jean-Pierre and their monkeys. "The good ones of Olivier were stolen by a girl in love with him. Lena went into my room and took the drawings." Lena Leclerq, a nineteen-year-old farmer's daughter and aspiring poet, had met Giacometti in a café and then been introduced around. A few years later, at Giacometti's suggestion, she became housekeeper to Balthus at his Château de Chassy, a job that ended with her attempted suicide.

Michael Wishart arrived, sent by Peter Watson whom he had first met in Delamere Terrace. "On him the stifled yawn looked good," he wrote in his autobiography *High Diver*, published in 1977. "Peter's cure for boredom was to interest the young. No one was better at it."[10] "Bright and clever and lively," as Freud saw him, and a persistent reminder of Lorna, Wishart came to Paris with Ian Gibson-Smith who, incidentally, now owned *Woman with a Tulip*. "As he [Gibson-Smith] was pestering him, feeling slightly protective I let him move in with me—in my small room." There was an involvement, curtailed because Freud found it "physically painful," he said.[11] Anne Dunn, young heiress, aspiring painter, future Freud intimate (and later to marry Michael Wishart), confirmed this. "Michael himself told me of the affair with Lucian but I think it was of brief duration when they were both staying at the Hôtel d'Isly."[12]

Wishart sat for a painting of the Sunday-morning market on the Île de la Cité. "A barrow and a bird keeper: 26 by 22, on canvas," Freud recalled. "He was distressed if I blinked while he was painting my thumb," Wishart wrote. "However the extraordinary wit and originality of his conversation when he was still barely more than a child was so rewarding that I underwent this torment willingly."[13] Not for long though and when Freud went back to London to get money the painting was put aside. And then, returning to France, he met on the cross-Channel boat a young man called John Margetson en route to Switzerland, suggested that he break his journey in Paris and why not at the Hôtel d'Isly? Margetson spent three days there and sat each morning for the bird-seller painting. The head had been completed and Michael Wishart was not around, so Margetson's green sweater

and blue corduroy trousers substituted. After each sitting Freud took him out and about. "Lucian introduced me to an amazing variety of people including Giacometti and Jean-Paul Sartre (how existentialist we all were!)."[14]

A few weeks later Freud scrapped the picture, which left him with *The Birds of Olivier Larronde* to complete: parrots bright as tin toys in a red tin cage. For this he did a number of preparatory sketches, and a drawing of a bird in a cage intended as a bookplate for Larronde. He also produced a small, chilly portrait of Robert Lemarle. "A queer, drunk, bitter man. He had been a doctor, struck off, and I met him through Peter Watson in London just after the war and he said, 'If you come to Paris will you do a head?' and as I had no money I rang him up. He used to ring me at the hotel at three or four in the morning. Olivier and Jean-Paul were amazed at me not realising what that was about, it was so obvious." Needing an easel, Freud asked Lemarle if he could help. "He said, 'Let me see . . .' and borrowed one for me from the Galerie Zak. The gallery had Soutines. Soutine would bring in marvellous pictures and then demand them back to repaint the hands. So the gallery would get a man in to paint the hands in so that Soutine wouldn't take the paintings back and destroy them. And it worked." Watson also gave him an introduction to Wilhelm Uhde, the Prussian art critic who had bought and sold Picassos before the First World War and whom Picasso had painted, purse-lipped, in his prime Cubist manner. He lived in the Place des Vosges and was the authority on primitives, most notably the Douanier Rousseau. "He discovered Bombois and other primitives and I said, 'Why didn't Bombois do the Place des Vosges?' 'Probably because he didn't get a picture postcard.' He wasn't a dealer then: he wrote, and he was melancholy; reminded me a bit of my grandmother, he was so affected by things. It was a modest apartment, an entresol where servants had lived, with lots of books. Not nasty: lonely. He was very queer and there seemed to be some feeling . . . I felt quite pleased to get out."

A weekly fixture during this first stay in Paris was lunch every Sunday at the residence of Prince George of Greece, in the Avenue d'Iéna in the 16ème. "It was my poste restante; my mother was worried when I first went to Paris and so it was arranged. Very formal: servants in white gloves. One side of the dining room was hung with portraits of Kings of Greece and Denmark and on the opposite side

were Bonapartes. Prince George—he was the favourite brother of the King of Greece, had a castle in Denmark and somewhere else—said, 'We both like to look at our ancestors at meals.' In his youth he had collected drawings, a mixed lot, lesser nineteenth century, but I was looking round, rummaging in the cellar, and he had amazing things: I saw this Goya in a very rough frame. He had Goya drawings and Zurbarán still lives. They lived completely separate lives."

Princess Marie had just finished her three-volume book on Edgar Allan Poe (*Edgar Poe: étude psychoanalytique*) and she talked about it. "He was necrophile," she said, and Prince George said, "Ahem: we are at lunch." She was also preparing for publication, by John Rodker in London, *Myths of War*, a psychoanalytical study of the phenomenon of nations regressing to "primitive barbarism in time of war," focused on the circulation of racist myths, slur and hearsay: "France, crushed as she was, could not resist this German anti-Semitic pressure which, moreover, many a French reactionary welcomed in compensation for the generous welcome which France, before the war, had accorded the persecuted of Central Europe."[15] From what Freud remembered this too was not a topic for discussion at table.

"Their ignorance of life was so extraordinary. Princess Marie said, 'We are lucky: we have strawberries from a place at Versailles, it's so lucky getting these as ordinary people can't.' But I'd just seen piles of them in Les Halles on my way there." The food was an experience in itself. "A whole head of parsley deep-fried in oil, drained, and you helped yourself with a spoon. The luxury was that you would have had to have had two gallons of the best olive oil."

Having tried drawing and painting in his room, Freud decided to have a go at etching. Betty Shaw-Lawrence from Benton End, who happened to be staying in the hotel, gave him an etching plate. "Maybe I asked, maybe I said I'd like to try it. I just scratched the prepared plate." The washbasin in his room served for "biting in" (i.e. bathing the metal plate in acid) *The Bird* (a hummingbird that he had pocketed one night in a club perched in a cage the size of a toaster) and an even smaller etching of the French equivalent of a Chelsea bun. The printmaker Javier Vilató, whom he had met in the street on his way to the cinema one day, recommended a printer off the Quai Voltaire. Vilató introduced him to his uncle, Pablo Picasso.

The liberation of Picasso in August 1944 had been almost as

widely reported as that of Paris itself and two years on he was still the freed genie of Liberation, too famous to be seen in cafés or nightclubs. Vilató told Freud that when any American soldier came and was really crass and went on and on his uncle would say "I've got a friend who I'd really like you to meet who lives round the corner" and send him round to Gertrude Stein. Jaime Sabartés, his secretary, "his concierge really" Freud said, served to fend people off, leaving Picasso to live according to his image. "He fascinated me. His behaviour and the way he treated people and the way that he was so malevolent. I was wearing the tartan trousers left over from my exhibitionist period and he said, 'Oh yes, when I was in London'—I suppose to do with the Diaghilev Ballet—'there were people wearing those trousers, but they were up to here'—up to his chest they would have been on him— and then he said, 'I remember this' and he did 'Tipperary.' Slight English syllables, more the tune. Picasso was always a performer and the more people looked at him, the more he did it. He said, 'Do you smoke?' then put his hand on to a huge Moroccan figured brass lid and lifted it and there was a packet of Gauloises." On other occasions (he saw him seven or eight times, he thought, over the months) he and Picasso talked about their mutual acquaintance Roland Penrose's penchant for being tied up by "La Lutteuse," a woman wrestler. "Jean-Pierre got her as a treat for him and Olivier: a woman to make love with; there was talk about how nice it was. I felt sorry for her, as she was unmercenary, very simple, from Brittany. Then Roland and Lee got her to England and shared her and she had a nervous break-down."[16] Freud particularly disliked Lee Miller (Penrose). 'She had filthy manners: like lifting her legs up with no knickers so that young men could see: OK, but to do it after fifty was so disgusting.' And her war photographs "of someone who's being threatened or killed and makes it look like camping. It's true I'm biased, but her photographs: 'First Person Who Got into a Concentration Camp' . . . Ugh." As for Penrose, future biographer of Picasso, well-intentioned patron of the arts and Surrealist aficionado: given his "pathetic masochism" he was, Freud maintained, a mildly ridiculous do-gooder. "In London he thought he was just over from Paris for the weekend. George Melly was always dining there and once he introduced to Penrose a boy who had, he explained, been in jail. 'A convicted *thief*?' Penrose said. 'In *my* house?' He was shocked and alarmed."

The supremo of the dwindling Surrealist circles in Paris was André Breton. He assured Freud that he was one of his grandfather's greatest admirers. "One thing impressed me: during one of the late lunches at Lipp's with Giacometti, pompous Breton said to him, 'I know you're no longer one of us but your work is better than all of ours.' He felt he was the king, pope, and could confer these things. He was keeping up with things." Giacometti, on the other hand, was wholly admirable. "Very fierce and humorous, amused by things and quick." He loathed Picasso largely, Freud maintained, because when Annette Giacometti came to Paris wanting to see Picasso she was turned away by Sabartés. Freud told Giacometti about Lena taking his drawings. "He laughed and said, '*Aaaah, la voleuse.*' I think Alberto quite liked being stolen from." A pall of plaster dust covered everything in his studio: a small and narrow room behind Montparnasse with a single light bulb. "It took almost a mental discipline to distinguish between the paintings, the drawings and the sculptures. It seemed all the same activity: everything was white." He remembered posing for two drawings. "I used to work in my hotel until three or four in the afternoon and he'd take me to have a meal at Lipp's, which was terribly nice; I couldn't speak French much then and it didn't occur to me that we could have spoken German, I so dislike speaking German. Not that I can very well."

Jean Dubuffet, the former businessman whose first one-man exhibition was at the Galerie René Drouin in May 1946, declared himself an outsider, "warmly existentialist," he said, being involved in "the struggle with matter, rather than the aesthete attempting to capture the patina of an apple."[17] Freud was not impressed by his glib primitivism, expressed in larded scrawls. "I must say I felt very contemptuous. It was a rich businessman painting. In *Temps Moderne* there was an article saying 'to appreciate the genius of Dubuffet forget everything you know about Art' and I remember thinking well, I don't want to forget." The "mental spurts" of Wols, little nervous collapses on paper, were more genuine, he felt; and the busy automatism of Henri Michaux ("The ones where calligraphy is urgent drawing"), also the fervent battiness of Antonin Artaud, whose book on Van Gogh Peter Watson had published in English. "I wanted to draw him. We used to go to a Greek restaurant at the end of the rue Jacob, as Olivier and Jean-Claude could sign the bill there, and Artaud—he seemed very

old, but he died when he was fifty-two—came down the street with a young girl, his muse, and I asked if I could draw him and she said—they must have known I was connected with Olivier—'Yes, if you can give him some opium.' I couldn't oblige."

Larronde and Lacloche did little to encourage Freud. "When interesting people came to see Olivier and Jean-Claude in their large corner room—if Cocteau came, for instance—I wasn't really welcomed. They would freeze me out. Genet often came, Giacometti not a lot, but he did come to smoke opium; he had a pipe there sometimes. I looked after their birds when they went away, but I had no money, no status. They treated me as an idiot. I was a clodhopper, rather." As in London, however, Freud managed to insinuate himself wherever seemed best for him. The painter-heiress Meraud Guinness gave a party in her place, 61 Cours Mirabeau, in Montparnasse. She had once nearly married Christopher Wood, was subsequently involved with Picabia and had now become a patron of David Gascoyne. "The house or flat was a real little dump; the party was too bohemian to have been considered very poor. Lots of wine. Alexander Calder was there; he looked very big in the place and he fell down the stairs drunk and as he passed he called out, 'Your shoelace is undone.'"

Freud had to return to London once or twice, primarily to collect—and conceal on the way back—his share of the small but growing income from the Sigmund Freud copyrights and his £8 a week advance from the London Gallery.

The gallery was backed by Peter Watson, Roland Penrose and Anton Zwemmer and run by the Belgian dealer-Surrealist and promoter of Magritte E. L. T. Mesens, who liked to be known as Eduard. To his annoyance, Freud called him Ed. "Under the laws of Surrealism by Mesens it was easy for people of no talent to practise art. Mesens was a real dealer. When I produced things he was so greedy for more I felt he made it seem important. I'd never come across a dealer who did." This counted as professional encouragement.

There were also his birds to see to. "I had left my pigeons with my mother and her maid thought they were hawks and fed them meat and they became infested of course with worms and were half-dead, so the first time I went back I had to kill them."

"The world of Ovid"

The charm of Paris was wearing off by the end of a stuffy August when a letter arrived from Craxton saying that he was having a good time in Greece and pressing Freud to come and see for himself. After the Scillies, Craxton had taken a downstairs studio in Adrian Allinson's house two streets up from Abercorn Place, and when Allinson ("old Edwardian painter: Café Royal scenes") asked him to leave, he said that he just might have to mention to Mrs. Allinson that he had heard the creaking overhead of Allinson's studio couch. Whether or not he did resort to blackmail over those telltale sounds he stayed put. And, Freud added, "The amazing thing was that Johnny actually told me this." Craxton had been in Switzerland for a show at the Galerie Gasser in Zurich ("Gasser was about thirty and had come to England to see what painters and boys he could have") and, Freud gathered, the possibility had arisen of his being shot by the husband of the woman he stayed with. Consequently Lady ("Peter") Norton, who had been manager of the London Gallery in Cork Street before the war ("Art-mad, even madder than I am," said Peter Watson) and whose husband was now the British Ambassador in Athens, had flown Craxton from Milan in a bomber—"he was very thick with her; he had to tell her erotic things on the plane, I suspect"—fixed up a display of his work with the British Council and installed him in a room over the Embassy garage. The Ambassador, Clifford Norton ("A moustache is what I remember about him, not that he necessarily had one"), had a

civil war to preoccupy him and suggested that, given Craxton's undiplomatic tendencies, the best place for him was the island of Poros. Craxton wrote to EQ: "But oh how heavenly the place is & inside the church I felt like preying [*sic*] for the first time in years."[1]

"Greece is rapidly becoming a fascist state," it was reported at this time. "British prestige and moral standing is falling rapidly in Greece."[2] Greece was isolated in 1946, plunged in civil war and lacking ready communication with the rest of Europe. The only regular service by sea was from Marseilles to Piraeus on the *Corinthia*. Freud sent Craxton a telegram telling him to expect him and took the train to Marseilles. Waiting several days to embark, he whiled away the time drawing from his hotel window moored boats and swimming races in the harbour. His attention wandered.

"I was sitting in my hotel in the Vieux Port watching girls going with clients into houses and the clients coming out afterwards completely done in. A girl I talked to said her father or uncle was a painter and a girl with her said, 'She's lovely: why don't you go with her?' I couldn't fancy them but in the end I said, 'OK,' and went with her to the hotel. And they were absolutely furious as I didn't have a suite—as I had very little money—and she came to my single room. Because of my incapacity it took ages; but then she washed herself in the tin bidet, and that was rather nice, and in the end she left and her ponce was waiting outside the door and he beat her up—a frightful noise—because, he said, she had done more things than planned as she'd been so long doing them. And then there was a misuse-of-room row and would I pay extra to the hotel for not using *their* whores. I knew afterwards why she wasn't busy. Why she had been available. She had clap."

In London a friend, Nanos Valaoritis, "from an ancient Greek family," who worked at the Greek Embassy and knew his parents, had advised him to get a deck ticket. He had given him letters of introduction, including one to Nikos Kavvadias, a poet and womaniser nicknamed Marabou who worked as wireless operator on the *Corinthia*. "He didn't speak English and my restaurant French didn't get me very far but, anyway, we were walking up and down the deck and he said, 'Lid ooze go goo then you and I.' It was Eliot: *The Love Song of J. Alfred Prufrock*. We talked *Waste Land*. Eliot is loved in Greece." Kavvadias had become a Greek John Masefield, though with greater

sea-going experience, and claimed to be able to tell, blindfold, what country a woman came from by sniffing her skin.

"I'd got clap. It's a fever; it was very hot, and there was no medicine. Marabou commiserated and said he could give me the name of a doctor in Athens. He was the only one I told but whenever I passed the crew they put their hands to their parts and went Oooh Oooh." Living on deck he observed the other passengers and drew them: thirty or so drawings in a small sketchbook. Passing Stromboli ("it had got lava dribbling down, and orange") they went through the Strait of Messina into the Aegean and so to Piraeus, which had been devastated by bombing. "There were carts made of wood converted into prams to get passengers' luggage off and I saw a boy lying asleep with his bottom in one of these carts and his mouth open and a thick web of flies that went up and descended on his face as he breathed in and out. Between Piraeus—a lovely shambles—and Athens there was a mile of land where people were living and camping, shouting and selling from impromptu bars and stalls. I saw a car without any tyres on its wheels, rattling along. Athens staggered me: such an oriental town. I was one of five non-Greeks in all Athens, it seemed; it was very much civil war. And no sign of Craxton, he didn't meet me though he was staying in Athens; perhaps he didn't want me there. I only had ten pounds—enough for the moment—and the doctor's address.

"I wandered round. In a strange square, Omonoia Square, I found a hotel and a man at the counter who was drugged, half asleep, took me up to a room with two beds and two mattresses on the floor. One of those mattresses was for me and I thought, God. I left my sack there and went off to the doctor in a shoddy first-floor room with bright maps on the wall of human insides, the liver scarlet. That was the waiting room, divided by a curtain from the surgery, from which I heard terrible screams and arguments. Victim left. I went in. The doctor was a monstrous little man, like Mr. Punch, and he said, 'I'll give you an injection.' Obviously water. Penicillin? Never heard of it. 'What money do you have?' '£10.' 'I'll have that. You're a painter? Just give me your work for the other treatment.'"

Fortunately a friend of Craxton's appeared: "a queer, old-style, French-educated interior decorator. He had a furious argument with the doctors and I left with him and he gave me the name of a doctor who had penicillin. It wasn't M&B [sulfapyridine] but penicillin that

was needed. Those very strong strains [of VD] developed through GIs in Naples which was the absolute centre of VD in Europe: US soldiers were handed out M&B, took it and stopped and then got the very strong, tough little ice-cream-vending germs. Posters used to say *Clean Living Is the Only Safeguard.*" Successfully treated, Freud caught up with Craxton and went off to Poros with him.

Before taking the boat to Poros Freud had attempted a currency exchange with Andreas Kambas, who had been in love with Matsie Hadjilazaros, an intellectual girl who had left him in Paris for Javier Vilató. The plan was that his parents, with whom he arranged for Kambas to stay, would give him pounds in London and Freud would go to the Kambas family for the Greek equivalent. He went to their mansion in Athens to collect it.

"A portly merchant came down. 'I've come from Andreas.' 'We've not heard from him.' 'Did he tell you?' 'No, we've not heard from him.' So I said goodbye. It transpired he'd been turned out for having a girlfriend, or going with a married woman and getting her into trouble when discovered. It was very medieval. He was a real shit, big and never stopped eating. And he was staying with my parents. Naturally I didn't write to them or tell them; equally naturally, when I got back to London and saw him in a café I tipped his chair over. I did sell a picture to Matsie, who had been married to Andreas Embirikos, a psychologist, who bought a drawing of a quince as I was skint and invited me to his wedding in Athens and when I went I was the only guest. Because he'd been married before nobody else went. I gave him one of the few oils I did in Greece: a pigeon." Freud told Nanos Valaoritis that Embirikos was the only analyst he had ever liked.

Coming into Poros "gives the illusion of a deep dream," Henry Miller wrote in *The Colossus of Maroussi*, his tale of holidaying in Greece in 1939–40. "Suddenly the land converges on all sides and the boat is squeezed into a narrow strait from which there seems to be no egress." Four or five hours from Athens by ferry, a summer resort for Athenians, Poros, famous for its pinewoods, lemon groves and domed clock tower, hugs the shoreline of the mainland. "The island revolves in cubistic planes, one of walls and windows, one of rocks and goats, one of stiff-blown trees and shrubs, and so on."[3]

Freud did not see Poros in quite such Jungian terms as Henry Miller. To him at first sight it seemed more a Greek Tenby, "curved away from the Peloponnese with the village spread along the water, and a naval station." He and Craxton lodged with an Abyssinian Greek family called Maestro-Petro in a house with an iron gate, tangerine trees and chickens pecking around in the dirt. They had the two upstairs rooms, reached from outside up a flight of steps. Initially Freud painted Craxton (*Man with a Moustache*: open-necked shirt, blond hair, sunburnt forehead) and Craxton drew Freud. Both were barber's shop Adonis heads, dissociated from Poros or indeed anywhere. Craxton's mannerisms had become smoother with practice.

Life on Poros was basic, startlingly so, even for someone used to the insufficiencies of post-war England, and increasingly so as winter approached. "It was very very hard." When the money came through and they could pay their rent there was enough food, otherwise they and their hosts went short. "I had to pay two or three pounds a week board and lodging. The family—a widow and children—were rather desperate and relied on us. There were three sons and the daughter, no father, and the woman had a moustache. The elder son was a gambler and sold the family pig to get money. I had to hold the pig for him to kill it and tried to cover my ears with my shoulders while it screamed and the mother was crying. People bought the bits of pig to eat. There was a good smell as it cooked.

"We went round cafés on the island and maybe had a coffee but couldn't sit down. This went on for a month. And then one day a little boat bobbed up with John Lehmann and a British Council consignment from Athens and they sat down and bought us some drinks. Then Johnny bought a round, a £1 round, of drinks. And we had been there a month on nothing, not even lemonade. He was so mean. This was an opportunity for him and he arranged to go back with them to Athens, being friendly with Lady Norton: he had done Christmas cards and stripped furniture for her." In October, scaling up from pomegranates and lemons, Freud had painted Petros, one of the sons of the house. "A gentle boy, he said to me after one of his arguments with his catlike sister, Maria: 'I understand they voice their opinion in England.'" In the painting, *Greek Boy*, he is on his dignity, very much the young head of the house, immaculate hair catching the light like a raven's wing. "I was pleased with it. Brown and green: you could

see I'd been to the Byzantine Museum." Later, in London, Craxton swapped one of his drawings for it.

Guerrillas were operating in the mountains on the mainland. "I couldn't work at night because of the lack of electric light insofar as bandits raided the island and broke the light plant. I had to read and draw by candlelight. There were suspected communists in the village and the police were horrible. They would go around dirty, smoking, and they would pick on people if they thought they were communists and would go and push their chairs over in the café. It was obvious the poor people were communists." He was told that women were seized by bandits. "I was amazed when they said it. I thought WHAT? But it wasn't something you could ask about."

Over on the Peloponnese Freud had an encounter straight out of classical legend. "I went across and out of the village into the hills and met a shepherd with his goats and he tried to give me one of the kids and was terribly hurt that I didn't accept. It took me ages and ages to persuade him. He never saw a stranger. 'Stranger' and 'guest' is the same to them. A stranger is a guest, and you give something to guests and he only had his herd."

He learnt that Demosthenes had poisoned himself on Poros at the temple of Poseidon. Island life could indeed seem ageless, or perennially archaic. "There was no tourism. After all, even in Athens it was fairly dangerous: you could walk out on to the hills in ten minutes and if they saw a stranger they threw stones. And in village life there were customs that refer back to ancient Greece. One thing stayed in my mind: Poros had sea on one side and on the other just the width of the Thames from the Peloponnese. Across the water there was a primitive village called Galata with one whore in it for the whole place. Sometimes she came across to Poros.

Also a boat came once with a corpse and there were women wailing and crying; then as the boat approached, people started cheering and shouting and drinking. By the time they landed it got really lively. Not one of them went out to the boat though, they just turned up the volume." When he turned to locals for company he was charmed and beguiled. "I used to go to the lemon orchards and have conversations about religion with a friend I made. We talked about girls and religion. I said, 'Do you believe?' 'How do you mean?' he said, amazed. 'He's there, after all, whether you believe in him or not.' He

was younger than me, rough, worked in the orchards. (His parents had farms outside Poros.) Gave rather nice presents. Sweet lemons. They were like grapefruit. When we went for walks a cripple who hadn't got legs, only shinbones, came with us, on all fours, like a dog. He never went into Poros, as he was a freak. When it was dark he'd say, 'There are birds in that tree. I'll show you,' and he'd get a catapult out of his shirt front and shoot into the trees and there would be a terrible commotion. He could tell there were birds there as he lived outside; his parents wouldn't let him sleep indoors. It was that primitive thing that, if people look bad enough, they are either hidden or kicked out. He was very lively, very limited, looked very intelligent and animal-like, a very interesting semi-wild animal. He had this life on the ground.

"I'd draw in the cafés and people would come and watch and I'd put a bird on top of the head of the drawing of a man and they'd point to the man and say 'You've got a bird on top of your head. Ha ha.' I noticed that on several occasions. They looked at a drawing and believed in it and accepted it. Not like the British."

Language was not much of a problem. "I could get along. A few words. It was so simple. My mother said that knowing ancient Greek, as she did, was a hindrance to learning modern Greek. I knew the nouns, never knew the tenses. Suddenly you'd hear a word and get a shock, coming upon a word like kleptomania. Gestures were odd too. When the gesture for 'you come here' was a come-away gesture with a hand underneath. You got used to it. I used to play cards by candlelight. Conversations then were like in England, about sex, lamenting not having a sister and no girls. And wanking jokes. If one of the sisters was seduced by a man there was danger. They could do something with their older sister though: I think in fact it went on for a very long time." Ostensibly, segregation was strict, as was the dress code. "If a woman were wearing trousers in Athens, nuns would cross themselves as they passed by.

"When I was in Greece I didn't want to have a relief or anything. I wasn't like Robert Colquhoun, who would wander round the streets saying, 'I want me hole. I want to have me hole.' (What is it in Scottish? 'I want me *houle*.') I never wanted 'me houle' at all. I mean, I longed to meet someone who I could actually like.

"Once, when I went to Athens to try and get some money, I was

so homesick for London I went into a place where the British army drank and danced. There were lots of Greek girls. I was with one and she said, 'Would you like to stay?' 'No money.' 'You need only pay for the room.'

"So we went to Plaka and a huge five-storey house. She was a number there, it was a rooming house for whores, and I stayed. A tiny bed. Quite nice. In the middle of the night her friend came in and sat on the bed, on me, and asked how she'd got on. I told her in Greek to fuck off and she was so impressed I was allowed to stay two nights extra."

On Poros hand to mouth was the means of existence; to those painting there the way of life was similarly primal in that hand-to-mouth necessity paralleled the constant practice of eye to hand, hand to eye. Craxton told Geoffrey Grigson, who was preparing an essay on him to be published as a *Horizon* monograph, that in Greece he found it "possible to feel a real person—real people, real elements, real windows—real sun above all. In a life of reality my mind really works."[4] Freud wouldn't have said that: much too glib; he did, however, paint real elements by real windows. These were, Craxton was to remark many years later, "some of his most limpid and luminous paintings."[5] A tangerine, a pomegranate, sun-bleached bone and lemons with shadows bitten in like scorch marks glowed that autumn in the upstairs room, enhanced, Freud said, by "the idea of metamorphoses and the light." This exposed the widening differences between the two. Freud painted Craxton factually—a friendly specimen in daylight exposure—whereas Craxton drew him plumped up into a curly-haired Adonis. Freud's powers of concentration propelled him away from Craxton's terms of idyllic arrangement and generality.

Greek light denies distances. Everything, near or far, tends to appear evenly distinct. Freud's lemons, the renowned Poros lemons, are Neo-Classical fruit, glossy as stoneware in the winter brightness. They are not symbolic, yet—just as the lemons of Rilke's *Duino Elegies* ("Little lemon, lemon tree . . . an oil lamp and a blanket on the floor") relate to death—these painted lemons have a poetic singularity. Freud's small Poros pictures turned out iconic, literally so in some cases in that occasionally, for want of canvas or panel, he resorted to

using what pious souls would deem holy grounds. "All Greek houses have religious books and I did some paintings on the covers of books I stole. A reason why one of my lemons has eroded is that I tore a cover off one, to use, and glue stains have come through in the picture."

What Freud painted in Greece was not unlike what he painted in London (lemons and fig tree substituting for quinces and potted palm), sanctified a little in the stronger light. He had brought sketchbooks with him from Paris. One in particular, oblong with a brown cover, he filled with chickens and pigeons, a pomegranate split open, the yard outside his lodgings, lounging village youths and the son of the house with incipient moustache, posing manfully. There were also thumbnail drawings—little more than doodles—for a self-portrait, working towards what became *Still Life with Green Lemon*: a lemon leaf posed like a sail against horizontal strips of shutter and sea as the artist's eye and nose and a tuft of hair edge warily into view. He presented more of himself in a second self-portrait, *Man with a Thistle*, completed in the New Year. For this he had a canvas. Bleached out and baleful, the painting was an account of what it felt like to find mannerisms cramping one's determination. Nanos Valaoritis described its bristling quizzicality in a diary published in *Botteghe Oscure*: "L. looking at L. looking at L. in the looking glass thinks he is L. looking at L. In fact he only sees L. looking at himself. He is a sort of mirror. L. invents a personality for people which he imposes upon them by the force of conviction and concentration like a distortion imposed on one by a crooked mirror."[6]

"I felt more dissatisfied than daring. I set certain rules for myself and I suppose those rules were exclusive. Never putting paint on top of paint. Never touching anything twice; and I didn't want things to look arty (which I thought of as hand-made), I wanted them to look as if they had come about on their own. Working in this way and not wanting there to be a mark or guideline, I went wrong through lack of composition. In the way that people go wrong who make up the story as they go along." And he had to eke out the paint. "I'd taken tubes and I was very careful and used very little and painted thinly. I was very careful and then I got my mother to send some paint. Quite a lot of it was German paint, with wax in. It could be used more easily working in the sun."

Man with a Thistle, 1946

Lieb Mutt,
* I have a horrible feeling that you did not get my last letter,*
which included an urgent request for money and also my front
door key. Thank you very much for the clothes. I hoped to find a
letter in the pockets but then I remembered about how law-abiding
you are. Please write. I have had and have no money for over a
month and although I have almost no expenses I owe my rent to
the family with whom I live.[7]

The rent for Delamere was to go to Mrs. Harte, who lived downstairs
at number 20. "The rent man would come round and she'd pay for
me while I was away. The lesson is that neighbours must never be
asked."

. . .

In the first week of November a yacht appeared and anchored in a secluded bay. It was the two-masted converted lugger *Truant* owned by George Millar, one-time chief reporter for the Beaverbrook press in Paris. "Amazingly good-looking he was," Freud remembered. "*Time* magazine said of him 'the face of a fanatic without dogma.' Rather pretty first wife worked on *Horizon* and went off." Millar, who was thirty-six, had distinguished himself by escaping from a train taking him to a German prisoner-of-war camp and had then joined the SOE to become a liaison officer in the French Resistance, eventfully so, hence his book *Maquis*, published in 1945, which paid for the *Truant* in which he and his new wife Isabel made their way through French canals and along the Mediterranean from Marseilles. Their arrival off Poros caused a stir in that it was the first time an English vessel had been seen in those waters since before the war; and as Millar describes it in *Isabel and the Sea*, his account of the voyage published a year or so later, he and Isabel were in turn surprised by the sudden arrival on board of "a lanky youth in a faded blue shirt" who "drank two glasses of ouzo carelessly, with the speed of a rooster's seduction." This was Craxton, who rapidly established, Millar later wrote, that they had "mutual acquaintances in London, Paris and Hampshire."[8] Millar knew EQ (Kit Nicholson had been his supervisor in the Architecture School in Cambridge) and he too had frequented the Gargoyle. The following day a boy showed the Millars where Craxton was staying. "Craxton thundered down an exterior wooden staircase which trembled to his weight, and Lucian Freud followed him diffidently, a heavily built young man with a habit of carrying his head forward and glancing up through his eyebrows. He wore a football jersey marked with one thick maroon horizontal stripe on an off-white ground and, below that awesome garment, khaki-drill trousers." Craxton's room was the untidier of the two and Millar noticed pinned up beside his bed the photograph of Freud in the football jersey holding the stuffed zebra head. "Freud's room, like his painting, was neater, harder, and more self-conscious than Craxton's . . . Freud was working on a self-portrait. Only the chestnut hair, one enraged eye, a long nose, had been minutely and exquisitely painted. Down in a corner of the canvas the outline of a tall Greek thistle had been pencilled in."[9]

At first, Millar found, Freud was less forthcoming than Crax-ton. "The type of young man who is highly strung, yet who flings himself impetuously at certain types of physical discomfort and even danger."[10] His instinct had been to shy away when the *Truant* first dropped anchor. "But the Maestro-Petros were excited that we knew strangers on a boat—the civil war was going on so there was nobody else foreign around—and they bagged some things for us to take out there." To the Millars, returning Craxton's call, it seemed that they were starved of company. "They appeared to be delighted to see us, eager to drown us in impetuous descriptions of Poros and Greece," Millar wrote. "Freud talked fluently with a larger vocabulary than the average young Englishman, with more tendency to exclaim and to reiterate, and with only a hint of throat guttural in the r's. Craxton, pleasingly unselfish, was often prepared to listen to his companion."[11]

"My memory is retentive of faces, mannerisms, even long stretches of dialogue," Millar assured his readers in the preface to *Horned Pigeon*, his newly published prequel to *Maquis*.[12] Freud and Craxton were the most mannered perhaps, certainly among the most memorable char-acters he encountered on his four-month odyssey, and accordingly he assigned them prominent roles in Chapter 28. Craxton had a "wispy moustache growing outwards from the division of his upper lip, as though the besiegers had managed to land a feeble airborne force," and kept saying things were "delicious." Having retained his flair for perky detail (ever the Beaverbrook journalist), Millar continued: "his favourite adjective at that time was '*wonderful*' and while we talked with them we reeled under enfilades of *won*derfuls and deliciouses." As for first impressions, he recalled Freud saying to him that when he first saw *Truant* he feared the worst: "I feared that some purple-faced yachting cap, or some frightful lawyer from London, would leap out at me."[13] He rated Millar worth getting to know: a pretty good gos-sip. "George Millar was a taller, more athletic, more handsome, non-queer Bruce Chatwin; Isabel his wife was chickeny and asleep a lot. He was a hero and couldn't stop being heroic and that was the point. He was interesting about Beaverbrook, about his stable of women he used to fuck, including his son's."

Craxton wrote to EQ reminding her that she had told them to look out for Millar. (A letter, Millar noted, written "in characters one inch high on a blood-coloured piece of paper measuring three feet

by two.")[14] And there he was, providentially well equipped at that: "Their little cabin is delicious white with all the nicest books."[15] He went on to report "dough crisis as usual" and that he had run out of materials. "Lucian is about a month and a half behind with his payments here and things are a bit restless—still he paints all day & at work now on a wonder[ful] large self portrait of himself looking through a shuttered window ... Looch sends his love and congratulates you on discovering Miller [*sic*] ... It was pure

Boat moored off Poros, 1946

chance that drove them to shelter in Poros." Claiming later on that he had done "well over 60 pictures" and that it rained a lot he added: "Loochie and I still bath with pleasure and my swimming gets more and more mermanly."[16] With winter setting in they discussed how they might manage to return to England. "Craxton thought he might be able to prevail on some friend in Athens to send him back by air," Millar heard. "While Freud had been given the idea that he might return to England by reporting himself to a British consulate as a 'Distressed British Subject.'"[17]

Freud succeeded in selling a few of the smaller paintings. "I did once have the money to get back. Fifteen or twelve pounds or something: just not enough." And even that he lost. "The travelling roulette table came round so I didn't have any again."

Being more or less stranded in Greece, Freud was unaware of an article by Michael Ayrton in the third number of *Orion* arguing that "one or more facets of a single tradition" were the dominant concern in British art[18] and that Lucian Freud ("his paintings ... show a steady development") and John Minton represented those two facets. There they were, two of a kind but contrastingly so: Freud wintering on Poros painting lemons and consorting with misfits, and six

months later Minton on Corsica illustrating *Time Was Away*, Alan Ross's travel book commissioned by John Lehmann, his Corsica proving to be *Treasure Island* alleviated with café-bars. Currency-restricted ration-book holders in late forties Britain were to regard Minton's drawings of superabundant produce in Elizabeth David's *A Book of Mediterranean Food* as visions of plenty to come and, meanwhile, plenty elsewhere to be had. Even on Poros there was good food to be had, provided one's rent money arrived.

Towards the end of the year Craxton exhibited at the British Council in Athens where Ghika had been given a retrospective (aged forty) a few months before. Craxton, who had met Ghika in London a year before, was to derive from his take on the Byzantine every element of style: "colour used emotionally rather than descriptively" as he put it fifty years later in his obituary of Ghika, his lifelong exemplar.[19] Freud went too and took the opportunity to go to the Byzantine Museum. "I went quite a few times. It affected me, trying to do simple forms. I hadn't seen [Byzantine] things as part of the life. The portraits, and the trees and so on, seemed so robust and subtle." He had been told that when his grandfather went to Athens in 1904 he made a point of putting on his best shirt before going to see the Acropolis.

"Craxton was friendly with a man in the Canadian Embassy. He had a boat and we went out from Athens around the harbour and Greek soldiers started shouting something and then bullets were coming at us and I was lying down saying this is the most boring thing that ever happened to me in my life. They were shooting in dirty uniforms and the man from the Embassy said, 'I may have to report this.'"

Freud returned to Poros with Lady Norton and others in a motor launch belonging to the British commander-in-chief in Greece. "We shot across from Athens," he told George Millar. "It was *wonderful*. We only took an hour and a half and spray was breaking like mad over the thing."[20] He and Craxton entertained the party, taking them to a taverna and inviting them to breakfast in their lodgings the next morning. Craxton then returned with them to Athens, intending to go on to Crete, having wangled a lift on a naval vessel. "I think if there was something *he* thought worthwhile I doubt if I'd have gone: he never wanted any of the special treatment to go to anyone else

so he'd make arrangements and be off. Not only that: he very much didn't *want* me to come as I think he thought sponging doesn't work so well if it's joint."

Watching the boat dwindle to a jolting dot, Freud was downcast. "I remember being alone." He and the Millars were conscious of the sudden silence. Christmas loomed. "We all felt a little depressed," Millar wrote. "Particularly Freud, who talked, as he accompanied us to *Truant*, of the impermanence of life and the probability of early, sudden, violent, and tragic death."[21]

"I had no money and occasionally—to do with hospitality—I had to barter to buy something. I had fancy shirts from the Charing Cross Road and swapped a checked shirt for a chicken. And then, soon after, a boat arrived and there was my red-and-blue-checked shirt on a sailor: a shirt from Cecil Gee's. It made me think of the world of Ovid." The Millars invited him to lunch so he took the bartered chicken to them, its claws tied with yellow ribbon. He asked Millar how a chicken should be killed and, told that the thing to do was to wring its neck, he pulled hard and the head came off in his hand. Millar plucked and cleaned the remains and Freud "after the usual wriggles and grimaces, drew drawing materials from his bosom and set to work." He had decided to draw *Truant*, or rather they asked him to draw it for a Christmas card ("he said he only did that to get me off the boat") and he asked to borrow the dinghy to go ashore with his sketchbook and find a good spot. Millar was intrigued by his habit of carrying his drawing things inside his shirt and would shove a hand in and feel around to find his inkbottle. "He had another, equally disconcerting habit of glaring at you, and then looking swiftly down in sudden shyness. There were signs of greatness in him, and I wish that I had been as brave as he at the age of twenty-three."[22]

Freud took them to meet Giorgios Seferiades (pen name George Seferis) and "banged on all the doors and windows while we stood shyly before the house" until the poet appeared on the balcony above. Seferis was the leading figure in an article by Nanos Valaoritis on modern Greek poetry in the March issue of *Horizon*: an exile returned to a land of maddening wind, "a wind laying naked the bone from the flesh," "constantly haunted," Valaoritis wrote, "by the vision of a world and a happiness lost for ever."[23] Seferis, Freud knew, was "very grand, distinguished, elderly—aged forty-six—the T. S. Eliot

of Greece." Indeed, he had translated *The Waste Land* into Greek and
was spending a two-month holiday on Poros, "cleansed progressively
by such a life," he said. Millar was surprised "that good poetry could
issue from a man with such fleshy hams and thighs." Freud, on the
other hand, wondered at the classical restraint of another guest.[24]

"A man who was there said, 'I was swimming today in the sea,
I went far out and, twelve or fourteen feet down, I saw an archaic
Greek statue lying there. I stayed and looked and looked.' 'But didn't
you think of getting it?' 'No. It looked so beautiful there,' he said."

To Craxton such inhibition was plain silly, according to Freud,
who confessed to having been a lookout for him when he snaffled
icons. "I was fortunate enough to witness some of his more daring
acquisitions. On Poros there were wayside shrines, small, hollowed
out, open air. I used to watch outside. My father loved old things:
antiques and statues that he got from his father. These icons were
perfectly nice, very old, kissed away, and Johnny said, 'Do you think
your father would like one?' The icons were 'odds and ends of little
solemn gods,' as Hilaire Belloc wrote. It was pilferage, and that was
why later on he was kicked out of Greece, barred for four or five
years; he was just light-fingered, always pinched."

Winter set in. There had been the sirocco and then suddenly it
snowed. There was hunger on the island, not the starvation that there
had been during the war, but bad enough. "When it was Christmas I
really minded being there: I was upstairs and they were below having
a Greek Christmas, and because of being a paying guest I just
felt a bit bereft." He and the Millars were invited to dinner at the big
house belonging to a man called Christos Diamantopoulos. They had
Christmas pudding made with the help of a German cookery book
from the 1820s. Their host had two heart attacks that night. A few
days later the Millars left. It rained and rained and they called in at
Freud's lodgings to say goodbye and tell him that they knew that they
would meet him again. "Freud was in his small, cold room, concen-
trating on an exquisite painting of a lemon."[25]

The Millars sold the *Truant* to a British general they met in
Piraeus who told them he fancied sailing it back to England.

"What George Millar didn't know was that Lady Norton had said
to me, 'I'm going skiing in Italy: I can give you a lift as far as there.'
But she then met George and gave him the seat on the aeroplane

because he was tall and blond and she fancied him. Simply disgusting; especially as when I went to Athens to get a visa for going on the plane and said I was going with her, I got those looks, as she was a well-known nymphomaniac."

> *Darling Felicity* [December 1946]
> *I hope you like this card it seems the best I have seen for very long* [the card shows an old maid muzzled and clamped]. *Where are you? and doing what? I am on the most amazing Island but I think I will soon come to London. A very happy and lucky new year and I hope to see you soon. Write me c/o Lady Norton, British Embassy Athens Greece. Johnny Craxton is here but has dissapeaed I hope the Bandits have (not got him).*[26]

When Craxton returned they went by ferry to other islands. "I saw Ghika's amazing palace on Hydra, one of the merchant palaces. His family had been one of the few to resist the blockade against Napoleon. And I saw the Tombazes' palace with brand-new-looking, 1815, gilt Empire furniture. The Greeks didn't make furniture so they were paid in furniture. The hideousness of it: green striped silks and bright gold. You were allowed to go in and look; Craxton got in, anyway; he always knew somebody. He didn't notice he wasn't welcome. I hate that." The palace was to become an art school. "Craxton borrowed a house on Spetsai for a week, from a fashionable woman in Athens, Dora Morchetti, Nanos Valaoritis' aunt; he'd pressed on as usual and she'd said very well then. She lent the house to Johnny but the kitchen was locked. The servants—this was not unusual there—were poor relations (rather like the maids of whores in Shepherd's Market are often their mothers) and one of them was a rather tragic niece or cousin: a beautiful girl." Nothing developed between Freud and the girl. "The word in Greek is *gestinos*? Which means 'Miss' which means 'Virgin.' I didn't feel at all forward in a country where I couldn't speak the language, had no money and had colitis from the greasy food. There's no forcing anyone when you are a dodgy mixture between tourist and spiv and don't feel very well. I was fairly ill all the time."

Anxious to buy a ticket home he wrote to his mother trying to arrange for her to give twenty pounds to Nanos Valaoritis, who would

then ask his mother in Athens to forward him the equivalent. "I'm sorry that all my worries are money," he said. "But what is the use of a lot of saleable pictures on a Greek island?" The alternative possibility of being shipped back to Britain as a DBS (Distressed British Subject) proved impracticable. "I was in Greece as a perfectly ordinary tourist, so I couldn't have been a DBS, as it was for if you had been in the services. It was to do with the Merchant Navy; if you deserted and were caught you were sent back, but I knew that they took your passport away and only gave it back if you repaid them, and I must have known that was impossible."

Early in 1947 the Attlee government was getting round to telling the Americans that the British could no longer afford to maintain their presence in Greece, Britain itself being a Distressed Object. However, in February Freud succeeded in borrowing from Lady Norton the cost of a ticket to Marseilles. "I never gave the money back. I just thought she was horrible. I had a note once from someone saying that I 'owed Greece a lot.' That must have been her." He gave his hosts, the family downstairs, a little painting of a pigeon. When this came up for auction at Christie's nearly sixty years later he dismissed it as a "souvenir," hinting that Craxton had got it off the family and sold it on.

Freud owed more to Greece, in the short term, than he did to Paris. Greece gave him light and air. The elemental qualities of Poros, white walls and icons, the hovering falcons, sweet lemons and sour, represented astringency tempered if not mellowed by acquaintance, frugality and generosity intermixed. The paintings he brought back with him reflect, besides the blue and white of the islands, the virtues of insularity. Before Greece his still lives had been tinged with Surrealism. Greece reduced him to essentials. The reality, there on the table in his upstairs room, concentrated him for a while. He took back to England a clutch of distinctive work. "Ten things, mostly tiny, strapped together: lemons, portrait of boy, little head of Johnny Craxton, tangerines, lots of drawings, little self-portrait head half cut off. The drawings were in a book. Craxton stole some of those. Lots of fig trees.

"We came back on an Albanian ship or something. There were two merchant seamen travelling back DBS, their passports confiscated. They complained about the fish heads we were given to eat. I

said I knew a café in Marseilles and I would treat them to eggs and bacon there. So I did, but they didn't like it at all as the eggs were done in butter instead of the hair oil they were used to in England. One of them said, 'I don't like food with all them flavours.'"

In Paris Craxton ("just pushing in anywhere") rang up Christian Zervos, saying he was a friend of Peter Watson's. They went to his gallery where they saw *Night Fishing at Antibes*. "In came Picasso, looking like famous Picasso, and Johnny had his catalogue from the British Council in Athens with copied Picasso goats on the cover. '*J'ai quelque chose pour vous*,' he said and gave it to him. Picasso put it under his arm. And he looked at me and said, 'Who's that by? Who's that man?' It was rather sad: the three things he asked about were by Calder and someone else." The following year Craxton painted a six foot by eight foot *Pastoral for P*[eter] *W*[atson] in which goats and goatherd foregather in a hilly landscape based on formulae developed by Ghika and Yannis Tsarouchis, the Hellenic Cocteau. "I wanted to safeguard a world of private mystery," Craxton explained,[27] and did so by screening out direct observation. To Freud, who initially was to have been featured in the picture in the guise of a goat alongside further goats based on Watson and Lady Norton, such arrangements were too easy on the eye. "Johnny did compositions, which I didn't." This painting, so sleekly organised, marked a parting of the ways.

"Free spirits like me"

After what was to prove to be the longest spell abroad in his entire life, apart from his Berlin childhood, Freud returned to England and the worst London winter in living memory. "When you're young you don't notice the cold. The excitement of coming back was incredible after Greece." There had been developments in Delamere Terrace. Charlie Lumley was in reform school. "I couldn't get him out. (But I did manage to stop him getting in once or twice. I was a sort of dodgy guardian to him.) In the reform school he became head boy; he looked after the people inside; it was outside he got into trouble." Part of the trouble was that Charlie began carrying knives and razor blades; alarmed at this, Freud took them off him only to regret it when he came home beaten up. "It was like Genet. Charlie was always stealing: from me, from his parents. Nothing much though. A gang in Clarendon Crescent—just up the road—were doing cars, stealing, etc., and they gave him advice. Charlie was known to be a good fighter and Georgie Day said to him, when he was twelve or so, 'It's stupid, fighting. If you do have to have a fight, maim 'em, then they won't do it again.' They used to use him to get through windows or as a lookout."

In and around Soho Freud now felt that he had the savoir-faire of a traveller returned. "When I got back from Greece I found that one of the men from the Cypriot dive under the Coffee An' had opened a café in Charlotte Street." He tried demonstrating his familiarity with taverna language. "I went into the café and ordered something

in Greek and this man I'd known and was just about put-up-with-by started shouting at everyone else there: 'Why don't *you* lot learn Greek?' I could order certain things. I knew phrases like 'He's the best priest in Athens.'" Having let it be known that he had, of course, met Picasso he was invited by Roland Penrose and Sonia Brownell to take part in a staging at the London Gallery (which had space for this sort of thing) of *Desire Caught by the Tail*, Picasso's playlet involving a gaggle of Ubuesque characters, Big Foot, Tart and Thin Anxiety. "Picasso did it as a joke in cold evenings in the war. 'And then we all blew up in the air': that sort of thing." The play had been presented in Michel Leiris' flat in 1944: a reading directed by Camus with Dora Maar as Thin Anxiety. Would he, they asked, design costumes and decor? He said no. "I didn't do it, or see it, because I couldn't. It would have been *ridiculous* for anyone but Picasso to do it. Roland and Sonia were a bit put out."

Around this time Lucie Freud's erstwhile admirer Ernst Heilbrun reappeared. "He always called when he was in London. He lived in Switzerland, I think; he was blond and German and refined and educated and stupid: younger than my mother, a rich man writing poetry. His arrogance and stupidity were not of a Jewish kind; he seemed very insensitive. My mother showed him some Olivier Larronde poems, which I illustrated for *Horizon*, and he thought they were rubbish. Mother said couldn't I take him out to cafés where students went? I thought he was an ass." Given that being back in London meant the resumption of amorous pursuits, Freud had no time to spare for the "Swabian Nightingale." "I went out, slightly, with a niece of George Barker's (who George 'married': it didn't last); I went into the park with her, into a bushy hiding place; she was very young and a bit mental as she had the curse and didn't know what it was; it was really full on, blood on my hands. 'Gosh how odd,' she said."

Distractions apart, Freud had in mind more of a relationship. "I came back from Greece with Kitty in my head. I knew her a bit, just a bit, before and because of Greece being segregated I was very much thinking of girls. When I was in Greece I thought about her and thought I'd see her. Well, I came back. Hooray!"

Kitty (Kathleen) was the daughter of Jacob Epstein and Kathleen Garman, Lorna Wishart's sister. Like Lorna, she had been involved with Laurie Lee. Freud told me that he wasn't aware of this ("I never

ask anyone anything") until later on when Lee, having moved on from Kitty, took up with her cousin Cathy, then aged fourteen, whom he married in 1950. Kitty had been highly thought of by Bernard Meninsky when she was a student at the Central. She worked at a bookshop in Newport Court off the Charing Cross Road. "She was working for this insidious, sinister man, so low he was uncrushable; I bought Daumier prints from him (the colours had been varnished, so they were curiosities rather than valuables) and he was vaguely to do with abortions as well. Sordid, but kind of clever, careful about false tax returns and against free spirits like me. He was a strong case for anti-Semitism. He got killed in France in a car crash.

"The shop was 'The Book Worm' and Kitty was upstairs, she made tea and drew and was paid thirty shillings a week. She was very timid but spirited in a funny way, hair all over her face. When she was thirteen or fourteen she was told by her horrible mother: 'How horrible: growing those breasts.' So she hunched her shoulders and she had no clothes except her mother's evening-dress cast-offs. She was farmed out to her grandmother, who brought her up in a nice way in Sussex, and so she had young lady's pursuits and could cook. And then she was taken to London and didn't know what was going on: Epstein kept Kathleen, her mother, on an allowance from 1928 and never put it up because he was ignorant and selfish. Six pounds a week. So she went out and did jobs." By Kitty's account the "three most alluring and striking of the Garman sisters—Mary, Kathleen and Lorna—*were* sadistic towards their children, always streaked with a deep love: a bad mixture."[1]

Kitty Epstein became Freud's Aphrodite for 1947: his *Girl in a Dark Jacket* clad in an over-large, heavy-duty London Transport bus conductor's jacket. "With Kitty in the busman's coat I felt incredibly daring as I started over-painting. It was almost how some people must feel when they break laws: something between daring and dangerous." He painted it on an old canvas, a junk-shop picture of the Acropolis. An amateur view of ancient Athens obliterated by a full-face neo-Byzantine portrait could be regarded as inspired coincidence. Then came the more assured *Girl with a Kitten* (a title imposed by Mesens in preference to *Kitty with Kitten*) to which, though the paws are relaxed, Auden's line "after the kiss come[s] the impulse to throttle"[2] could apply. Initially Freud considered painting Kitty with a pigeon, put-

ting it to her lips, but that would have made a Neo-Pre-Raphaelite wan heroine of her, which was not in her character. The drama critic Kenneth Tynan, who relished impropriety, wrote that, when asked at a dinner party in the mid-fifties what three things she most loved in the world, Kitty said "with trembling candour: 'Travel, birthday parties, good food, and being spanked on my bottom with a hairbrush.'"[3]

Freud's involvement with Kitty Epstein was something of a surrogate reconnection, though in no way a rapprochement, with her Aunt Lorna (and indeed her cousin Michael Wishart) and some maintained that his substitution of niece for aunt was a sort of sideswipe; but from his point of view he was simply moving on through the eccentric and extended family circle. He had first come across the Epstein household during the war. "It was before I knew Kitty, through working at *Horizon* addressing envelopes: a bust had to be collected from Epstein and I went to collect it. I rang the doorbell at Hyde Park Gate. A dusty-clothed butler answered. 'Come for the bust.' He took a bunch of keys out of his pocket and unlocked the sitting-room door on the left, to get the bust, and there in a chair was sitting Mrs. Epstein, in a daze, under lock and key. Talking was out of the question and I was shocked and naturally curious, as Epstein was very famous. 'Do you do that Epsteeen stuff or do you do that Picasso stuff?' they would say in Paddington." Epstein was notorious. His *Genesis* had been exhibited in Blackpool alongside the disgraced Rector of Stiffkey and the popular press fanned the fame: "Disgusting, says Bishop, is Epstein Mad?" was the *Daily Mirror* headline. *Jacob and the Angel* was shown in an amusement arcade in Oxford Street with a gramophone playing "What is the Master Thinking Of?" His name (like Freud's) was a buzzword.

Kathleen Garman had known Epstein since 1921 and, having survived being shot by Mrs. Epstein in 1923, had three children by him. "He got angry—very peasanty—when people stared at Kathleen," Freud remembered. "She had huge gaps, missing teeth, and looked amazing. Lorna was incredibly beautiful, I thought, and her other sister, Ruth in Hereford, was very striking—I love the idea of a loose woman in Hereford—and Douglas Garman, the brother, was very nice looking." Kathleen didn't move to Hyde Park Gate from her house in the King's Road when Mrs. Epstein died—"Mrs. Epstein's Mystery Fall" as a headline put it—in March 1947. "Before, she was

the Mystery Woman, but Kitty thinks she only moved when Epstein was ennobled. When she went to the station to go to her palazzo in Italy she would send herself a huge bunch of white lilies. An announcement would be made, 'Would she please collect them,' and she'd rush through the crowd and clutch them to her with surprise." She was, her granddaughter Annie Freud remembered, brusque, impatient and with little time for children. "Kath went out on her own and I would go and talk to Ep as he was mostly alone. I found him rather nice. He talked about women he'd known and strange things. He had been to school in the Bronx with Edward G. Robinson."[4]

The first time Freud met Epstein, at 18 Hyde Park Gate, he took him along a corridor of chequered lino into a downstairs room. "He showed me his collection in his bedroom: African statues arranged higher and higher on the wall, and as we left I looked up the huge stairs. 'What goes on up there?' I asked. 'How should I know? I work and sleep down here,' he said." He used his Gabon figures as prompts for his big stone carvings, the works that had brought him the reputation of being provocative. He liked them for their barbaric sophistication, as he saw it. Where Sigmund Freud cherished his antiquities for the myths associated with them and the significance that he could attach to them, Epstein was the hunter-gatherer amassing finds. "These primitive statues he had, rows and rows of them: when Kitty was staying there she became ill and a Negro doctor was called and before he came Epstein cleared out the statues. She asked why and he said, 'He's a nigger: I didn't want to rub it in.' How Jewish."

Though famous enough to be a household word Epstein was no longer the most celebrated modern sculptor. "He had gradually faded. In the sitting room there were lots of magazines: the *Illustrated London News* from 1914–17. Looking through them he said, '[Augustus] John's getting a lot of attention.' And that was in '47. He was lonely and minded about not being in the public eye, and terribly minded about Henry Moore." While Moore, boosted by Kenneth Clark ("Moore seems to have created a credible alternative to the human race"),[5] was the safest pair of hands in modern sculpture, Epstein was eminent but disregarded, his reputation beached. "From about 1910 to 1930 Jacob Epstein was the best artist working in England," Clark said in 1980, more or less dismissing his work thereafter.[6] Seemingly it was his fate to be caught wanting to carve on a monumental scale

and having to oblige by modelling portrait busts. "Churchill, who lived across the road, sat for Epstein in 1946. Churchill said, 'Where do you find these awful-looking women?' Epstein was annoyed and said, 'They are my friends; I like them as they are.' 'You're alone there,' Churchill said and Ep said, 'They'd never have anything to do with you anyway.' One thing they had in common: though Epstein was simple, they both had an enormous sense of themselves."

Kathleen Garman used to spot potential sitters and secure them for him. "Every Saturday evening they went to the Caprice. I went sometimes with Kitty, and then, embarrassingly, Kathleen would say, 'Oh Epstein, isn't that rather an interesting-looking woman?' It was awful." At one of these dinners Freud met Anne Cavendish, the Duke of Devonshire's daughter, who married Michael Tree (amateur painter and celebrated gossip, nicknamed "Radio Belgravia") in 1949; he later painted both of them but not before "Ep did Anne Tree, then Michael. 'I didn't know how to do his moustache,' he said, 'then I thought of Frans Hals' . . .

"Kathleen was glorying in it, being the mysterious woman with eyes and earrings and a Mona Lisa smile and missing teeth with black behind. She had an instinct though: I made a date with Kitty, in the Station Hotel in Paddington, and Kathleen said it was a bad place to meet a girl, thinking, obviously, of [assignations during] the First World War. When I lost my key at Delamere I stayed there; it was an absolutely dead place. Ipswich or Iceland it was like."

Freud himself posed for Epstein, who wrote to him asking if he would. "I spoke to Kitty on Thursday and asked her if you could pose for me tomorrow (Monday). I am not sure that she has mentioned it and so leave this note hoping that that will be all right."[7] He made Freud faunlike, a tense creature unused to scrutiny. Head, shoulders and chest were rapidly modelled and only the head survived to be cast. "I was on this stool which turned and I could see him working, snorting and breathing . . . I felt I was watching a bit of a recipe.

"When I sat, Kathleen put ten-shilling notes in my hand. I never asked for money."

Once when he called for Kitty at Mary (Garman) and Roy Campbell's house in Campden Grove, off Kensington Church Street, Campbell—notorious right-wing, anti-Semitic South African poet—came to the door. "He tried to hit me, as I was a Jew, and I knocked

him down; he was drunk, a huge man lying very drunk on the door-
step, pleased I wasn't such a cissy after all: he loathed Stephen for
being a filthy cissy communist Jew in a beret."

Freud liked, and used to quote, Campbell's poem "The Sisters":

> *Two sisters rise and strip. Out from the night*
> *Their horses run to their low-whistled pleas—*
> *Vast phantom shapes with eyeballs rolling white,*
> *That sneeze a fiery steam about their knees . . .*

Soon after he returned to London, Freud placed his first adult bet,
not counting the Greek travelling roulette. "It was in the Old En-
gland pub near Delamere. Caughoo was the horse and an old man
said, 'Give your money to so and so' (betting was illegal; only gentle-
men with serious money could do it); so I backed Caughoo £1 each
way on the Grand National and he won at 100 to 1." Eighteen had
finished out of a field of fifty-seven and, phenomenally, Caughoo won
by twenty lengths. "Mist spoilt the visibility," the *Times* racing cor-
respondent reported, adding, "I do not think I have ever seen a Grand
National winner finish so fresh in soft going before." There was con-
troversy, particularly among the bookies. "I went to collect but was
told not even to try getting it all. The Grand National was run in a
terrific fog. People swore that Caughoo, which was an Irish horse, the
first Irish in the National, missed out a whole circuit in the fog. The
jockey was beaten up by the second jockey and never rode again."

It was a period suffused with discontent. Through the winter of
1947 and into a late spring there were power cuts and dire shortages.
Even potatoes and bread were rationed for a while. Peter Watson,
returning to Britain from America, talked about "this dying country."
George Orwell, in worsening health on the Isle of Barra, was writ-
ing *Nineteen Eighty-Four* with its projection of contemporary circum-
stances forward to a time when Britain, in thrall to the United States,
would become Airstrip One for the purposes of Oceania's unending
war against Eurasia. Government posters on hoardings on bomb-
sites exhorted the public to bear in mind the greater good. "Extra
Effort Now Means Better Living Sooner." Spivvery was the spirit of
free enterprise then. Spivs in camelhair coats were the bookies, the
black-marketeers, suppliers of fake petrol coupons and hot motors

to go with them. Spivs were among the celebrated murderers of the day; to them nothing was unobtainable or unfixable. Fictional spivs— Richard Attenborough as Pinky in the film of *Brighton Rock*, made in 1947, Orson Welles as Harry Lime haunting a disgraced Vienna in *The Third Man*—played the Dominion Cinema in the Harrow Road in the same ratio of romance to reality as existentialism to nylons off the back of a lorry. Dilys Powell of the *Sunday Times*, reviewing *The Blue Lamp* (1949), remarked that "It must be about three years since the British cinema, and Ealing Studios in particular, made the startling discovery that the streets of London were a perfect setting for the film of action." She described what could have been a manifesto of Freud's growing identification with, and use of, his part of Paddington. "There has been a growing emphasis on background, not at the expense of but in relation to character; the figures in the foreground, the shifty and the natty, the sober, the savage, the ironic, the cosy, could belong only to that jungle of streets with their steam of fried fish, their hoarse voices, their flapping leaves of dirty newspaper and their bleak bomb-clearings."[8]

The Blue Lamp was played out in the setting of the Harrow Road and Westbourne Grove, police cars screeching past the crossroads with Delamere Terrace and Clarendon Crescent. Cast as a low-life location in British film noir, this part of Paddington became the epitome of the decrepitude of post-war London. Which made Freud's 20 Delamere Terrace something of a frontier post for his visitors from higher society. Waldemar Hansen (Peter Watson's boyfriend at the time) was one of those who ventured there, as he described to his friend John Myers in the United States:

Saturday afternoon we went to Lucian Freud's studio to see his work. His portraits are very hyperthyroid and schizophrenic and rather compelling. He obviously has talent, but is very undisciplined and self-taught. Not being a primitive, this works against him. Lucian himself is very charming, rather wistful with mad, schizoid eyes, and a very shrewd perceptive ability. His studio is in an old Georgian house, in an elegant faded-splendor part of London. There is a zebra head on the wall, an old-fashioned phonograph with a huge horn, and a live falcon, which swoops around the room and alights on the master's wrist!! I think he is going to do a drawing of

*me, and I'm rather intrigued to see what I'll look like after going
through that strange personal prism.*[9]

The drawing, nothing like as sympathetic as the one of Peter
Watson two years earlier, was just what was required: a male glamour
study involving deft highlights in white Conté.

That month, May 1947, Freud painted *Small Zimmerlinde*, a
reminder of his grandmother's apartment in Berlin. Michael Ham-
burger remembered him calling at his parents' house to pick up the
plant. "Lucian collected several in succession as some died. They were
very common in Germany but I think unknown when we came to En-
gland. The original was raised from a leaf sent by post from Germany
to my mother."[10] At about the same time he was included in "Known
and Unknown," a mixed show at the St. George's Gallery, organised
by Mrs. Lea Jaray ("Mother Jarra," Mesens called her), who had man-
aged the one contemporary gallery in Vienna before the Anschluss.
"She really loved art. I bought a big Masson drawing from her. A
bullfight. Like a Ceri Richards, after Picasso, only more intelligent."
He exhibited *Scillonian Beachscape* rather than a recent work because
these were being saved for showing at the London Gallery later in the
year, and was photographed standing in front of it for *Time* magazine,
which, having recently launched an "Atlantic Overseas" edition, was
extending its London coverage. Their reporter, June Rose, had spot-
ted the name and asked to interview him. Freud refused but invited
her round the corner for a drink. It was her first assignment for *Time*
and, anxious to do well, she wrote up their non-interview conversa-
tion. On 26 May 1947 an edited summary of this appeared under the
heading "Don't be a Gentleman." Freud, the story went, was "like his
late, great grandfather suspicious of reticence. Grandfather Sigmund
thought it frequently concealed all manner of ugly things; grandson
Lucian, like Joan Miro, thinks it inhibits art."

> *Last week Lucian, a tousled, 24-year-old painter with dreamy eyes
> and frayed cuffs, exhibited a craftsman-like beachscape that was
> the standout of a not-too-brilliant show of "New Generation" art
> in London. He took the occasion to blast at what was wrong with
> British painting.*
> *Said he: "In Britain everything is so foul and filthy that*

artists either go crazy, become surrealist, or get into a rut.
The clockwork morality of Britain that one feels on a bus, the
inhumanity, the rigidity—it's a wonder that anyone paints at
all." His Two Minute Hate ended with the remark that British
art "is all just inspired sketching. That's what the people want.
It's not considered gentlemanly to have ideas, so even the best only
dabble."[11]

The "tousled" painter decided to sue; the exploitation of his sur-
name for Time Life purposes was bad enough, but what made him
particularly angry was seeing his remarks rehashed. "Obviously I
didn't say that. All that talk about licensing hours and so on: it read
like John Osborne's *Damn you, England*." Graham Sutherland's solici-
tor, Wilfred Evill, a collector of works by artist clients ("a collector
to baffle cynics and realists, a collector of almost dramatic propor-
tions,"[12] he had drawings of Charlie Lumley and of a beached Scillo-
nian boat), advised Freud that if he lost he could always go bankrupt
which, since he was skint, wouldn't affect him; and Sutherland sent
him a telegram, signed "inspired sketcher," agreeing to be a charac-
ter witness. Even so the lawsuit was risky. "It was a terrific gamble."
There was a long delay before it came to court. He and Kitty went
off to France.

Dolled up, Kitty sat for *Girl in a White Dress* with Holbein neck-
line and lacework worthy of a rococo bust. This was done in July
1947, when she and Freud were in Paris, staying in the Hôtel Pas
de Calais on the Boulevard Saint Germain. She mentioned the por-
trait, a flawless take on Ingres' *Madame Moitessier*, in a letter to her
mother ("I do so hope you will like it") and went on to tell her how
things were. "We stayed 2 nights in a cupboard on a level with the
top spire of Saint Sulpice, then found that we could not stay with
the girl that we were going to because she is not going away yet, so
we are in a very nice hotel, rather expensive with flowery wallpaper
and a bird cage (we had a humming bird in it but it flew away) and
a fuchsia plant."[13] Freud remembered Kitty being "fond of Epstein
but a bit scared. The first time we went to Paris she said, 'I've got
to get a *chapeau d'artiste* for him,' and she did: a funny blue hat with
a broad rim." They had themselves photographed together perched
on a wooden donkey—he in attentive pose, she amused: a pretend

Flight into Egypt. And they went to the opening of what proved to be Breton's last major throw as impresario with "Le Surréalisme en 1947" at Galerie Maeght for which Duchamp made arrangements at the New York end and devised the catalogue, the 999-copy "limited edition" of which had a foam-rubber falsie (*"Prière de toucher"*) on the cover with a hand-painted nipple. Kitty remarked on the Rain Room that Duchamp also devised. "Water was pouring from the ceilings!" "My pains are better," she added.[14]

From the hotel he wrote to the painter-heiress Meraud Guinness. "The Surrealist exhibition is very dark and rainy and beautifully built and arranged like the Ideal Home Exhibition," he told her. His aim in writing was to get her to invite them to stay with her in the South. "I would very much like to come down for some days with a friend. Have you a place on a shelf where we could sleep?? Or under a Bed? Do let me know I am at the Hotel Pas de Calais Rue de Saint Pere VI..."[15] Paris, he wrote, had become unbearable, it being August ("hot winds like from an electric hair dryer"), adding, "I am working in a dizzy state in my fifth thermos hotel room." Meraud Guinness was used to accommodating artistic spongers: David Gascoyne went there, ostensibly to cook, ten summers running. However her place, Parador near Aix-en-Provence, lacked amenities, Freud discovered. "It was primitive, a big barn with bedrooms off it, no sheets or anything and the kitchen was lumps of coal in an ancient fireplace." Rainwater was heated in a tin can. "What more could one need?" Meraud Guinness said, having painted the exterior ultramarine and planted cabins on a hillside for artists, writers and forty cats.

His thank-you note, dated 4 September, was effusive and apologetic. "I am sorry not to have written before now but as soon as I reached England I went completely stiff from head to foot and my blood got hotter and hotter and I've only recently got out of bed feeling very weak and light." Planning ahead, he piled on the gratitude: "The most delishers, luxurious and tranquil series of days I have EVER spent. I think you have done what everyone dreams of doing: you have perfected a mode of summer life which is in such comlete [*sic*] accord with your own tastes and desires that for you and all those around you the days pass in dreamy winy Harmony Parado has an atmosphere of mystery and of content and I long to be there again

SOON."[16] Decades later he backtracked on the enthusiasm: "I never actually stayed there; Kitty couldn't stand it, so we left and went to the Hôtel Nègre-Coste in Aix." Kitty suffered an insect bite and her thigh swelled so alarmingly that he went to find a doctor. It was lunchtime but, regardless of etiquette, he barged into the dining room, Kitty remembered, and a doctor with pince-nez emerged to examine her, irate at being disturbed.

In Aix a further image of Kitty was achieved. Graham Sutherland had given Freud some of his etching tools (he had no use for them as he no longer considered himself a printmaker) and he had brought some copper plates with him thinking it would be better to use one of them in a Provençal hotel room rather than try to paint; so at his window overlooking the Cours Mirabeau he worked on *Girl with Fig Leaf*, an etching composed of an impressive variety of marks—dots, dashes, hairlines, cross-hatchings—on a larger scale than he had previously attempted. "I remember thinking I'd done a really big one. There's a peekaboo look which I wasn't trying for." Also an affronted look: Kitty under strain, her by now familiar features—hair, forehead, eye and hand—employed as competition to the masking leaf. Getting hold of nitric acid for the biting-in was a problem. "I remember walking about and the old-fashioned chemist being reluctant to sell me any. He suspected me of planning a *crime de passion*. I remember thinking how Provençal that was." Back in Paris the plate was printed up in time for his exhibition at the London Gallery in November.

In late October the Sutherlands, who were developing a taste for abroad, took Freud with them to the South of France, more as passenger than protégé. "Maybe he was paying for me. Certainly driving. Graham wouldn't drink ordinary wine. He had a delicate digestion, of course, but I'd drink the ordinary wine from Algiers and say lovely and he would have to have estate-bottled." Though the Sutherlands had been to the Riviera earlier that year it was still pretty new to them so they fell in with Freud's proposal that they should stay at Meraud Guinness' place. Almost within sight of the Mont Sainte-Victoire, he told them. He wrote to her. "Tell me what your plans are and when you go to Aix to take up your winter quarters. Could I really borrow the house? I thought of coming over with the painter Graham Sutherland and his wife. They have a car so we could motor down

from Paris to Parador and if a mistral makes us too vicious we could quickly drive to a cinema. We would be most careful housetrained and domestic with the house of course! Write soon."[17]

They stopped in Paris for longer than they intended, as Sutherland was ill and in bed for three days. "He had prep-schoolboy dodgy health." While he was laid up Freud took Kathleen Sutherland to bars. In the Café Flore they came upon Brian Howard, the original of Anthony Blanche in *Brideshead Revisited,* making an exhibition of himself as was his habit. "Terrifically drunk: she hadn't seen anything as extreme as that." She was even more startled the next morning when she found that Freud had had a girl, whom he met in the Bal Nègre, in his room all night. "Christiane she was called. Kath was shocked to find I wasn't queer, which she'd hoped I was. She did imitations of her coughing all night." Once Sutherland had recovered they drove south, Freud taking with him two finches that he had picked up in Paris and let out each night to flutter around his hotel room. They lasted until he returned to London. There they died. "I was allowed these through customs. It was only the ones with curved beaks you weren't allowed."

Parador was not a success with the Sutherlands. "In the sixties it would have been desirable to stay there, but Graham was terribly proper, he had to have proper wine: everything had to be all right. It was to do with his background. I'd thought hooray, stay at this marvellous place, but he was shocked. There were all those large, Provençal, people-size pots and afterwards whenever I ate with them Graham and Kathy would roll bits of bread into little urns and say 'Paradoux'—'Parador'—because with Meraud everything was local pots. Kathy didn't want to be bog Irish (which was her background), so we went on to the Hôtel Nègre-Coste in Aix. While there I went to Monte Carlo to have a look at the flowerbeds. Hadn't got ammunition to gamble: just enough to stay at the Nègre-Coste." After a few days he returned to Paris by himself. The Sutherlands went on to Villefranche where they met Tom Driberg, the egregious MP and former gossip columnist for the *Daily Express,* who jollied them into calling on Picasso and Matisse with him. Sutherland was keen to launch out, trying the Casino ("there are times when one makes all the right movements, and one's whole interior mechanism places the chips") and emulating Picasso.

Though it was his name primarily—Freud as in "Sigmund Freud"—that had brought him to the attention of *Time* magazine, it was his newly achieved distinctiveness that secured his inclusion among the fifteen artists in "La Jeune Peinture en Grand Bretagne," a British Council exhibition at the Galerie René Drouin early in 1948; in which, as Herbert Read observed in his usual catalogue introduction, all involved were Expressionists of one sort and another, with three exceptions: Ben Nicholson, the Nicholsonesque Edgar Hubert and, all on his own, Lucian Freud. Read still preached the virtues of psychologically induced Surrealism. "The universe of painting—the universe seen by the painter—," he wrote, "hasn't been the same since [Sigmund] Freud showed the importance of irrational sources of inspiration."[18] The grandson was either proof of this or an exception. His *Dead Heron* and the drawing of a bathtubby boat in the Scillies looked to be odd ones out in an exhibition bristling with thornscapes. The exhibition went on from Paris to Brussels where Matthew Smith, L. S. Lowry, John Tunnard, Louis le Brocquy and Stanley Spencer were added. Freud was dropped—as was Edward Burra—but he did get a mention in *Painting since 1939*, a 1947 British Council pamphlet written by Robin Ironside, an assistant keeper at the Tate, an enthusiast for the Pre-Raphaelites and himself a painter of fey phantasmagoria. To him Freud's work was wilfully childish. "The very amateur pictures of Lucien [*sic*] Freud have a distinctly idiosyncratic nature, though the grotesque *naïveté* of his vagrant humour seems indebted to the almost philosophical infantilism of some of Klee's pictures."[19] Freud liked Klee's artful doodling but by then he was well beyond being influenced by it. Witness his singularly lucid drawing, reproduced in Ironside's essay, of a stuffed owl in a glass case posed on a chair.

"Robin Ironside was strange, twisty, very odd. I went to his house once. He said, 'I'll show you the view,' opened the shutters and there, less than a foot away, was a brick wall."

The paintings that Freud had brought back with him from Greece were shown at the London Gallery in Brook Street in November 1947 together with works completed subsequently. Three of them were reproduced in that month's *Horizon*, tangerine, lemons and *Girl*

with a Kitten presented in tart contrast to a Craxton scalloped shore-line.

This was the one occasion when Craxton and Freud showed as a duo, Craxton in the front room, Freud in the back room, down three steps. The *Studio's* review gave equivalent prominence to each in terms of column inches, noting Craxton's "desire to produce results notwithstanding the continual responsibility of show following show," while Freud, it said, with the inevitable Freudian spin, "continues to display a curious mind."[20]

Such reviews as there were ranged from the bland to the dismissive where Freud was concerned. Bernard Denvir in *Tribune* talked of "a quality of Germanic linear accuracy of the kind we associate with Albania, with a perfectly planned introduction of apparently irrelevant detail which is typical of some of the surrealists."[21] In *Time & Tide* Maurice Collis was even more dismissive: "He may be described as having an exquisite talent. As it has been revealed so far it is a small one."[22]

Parallels were drawn with the advent of the Pre-Raphaelites a century before. On the BBC Third Programme Patrick Heron, at that stage in his career more critic than painter, talked about Freud's "modernised Pre-Raphaelitism," a topical reference in that 1948 marked the centenary of the Brotherhood and, accordingly, Robin Ironside had organised Pre-Raphaelite exhibitions at the Whitechapel and Tate. Freud was happy to be associated with certain Pre-Raphaelite works such as *The Awakening Conscience*, Holman Hunt's painting of a kept woman suddenly stricken with shame in the confines of a St. John's Wood love nest. "Holman Hunt had a number of pictures that, if you didn't know about the Pre-Raphaelites, you would think: what a lot of marvellous paintings." He did object to being lumped in with the overweening poeticising of the Brotherhood. "I've always tried to avoid doing anything which had a double-entendre symbolism." Graham Sutherland lent *The Birds of Olivier Larronde*, a bright but doleful little picture. To him it was a souvenir of their journey south with the *oiseaux-mouches*; to Freud the image of the decorative red cage with two button-eyed occupants hung high on a wall was a far cry from—yet distant echo of—*The Awakening Conscience*.

Those who bought works did so mostly from personal involvement or connection. *Man with Moustache*, the portrait of Craxton,

went to the tenor Peter Pears; *La Voisine* (The Neighbour), a draw-
ing of Ruby Milton from Delamere Terrace ("Mesens told me that
'female neighbour' in French is 'voisine' and I liked the sound of
that"), was bought by David Carr. George Melly, the gallery assistant,
and Robert Melville, who did the paperwork, were daily witnesses to
the Dadaist side of Mesens competing with his greedy side. Mesens
organised Surrealist dinners on Thursday nights at a Spanish restau-
rant. "George Melly read a poem about 'a shower of knives and forks'
and as he read he let a shower of knives fall on the table and we were
thrown out." Others who attended included Jacques Brunius, musi-
cian and critic ("very intelligent and a nice wife"), and the film-maker
Humphrey Jennings, who impressed Freud as being quiet and sour
and not long after, in September 1950, went to Greece looking for
possible locations for a film to be called *The Good Life* only to fall
backwards off a rock on Poros and consequently die.

Mesens boasted that in ten years he never sold a painting to a
public gallery in Britain and the showing and selling of Craxtons
was a concession to his backer Peter Watson, as he disliked them. As
did Douglas Cooper, former backer of the Mayor Gallery and arch-
connoisseur of Cubism, who stood in the gallery one day shouting
that they were rubbish. He also picked on *Girl with a Kitten* (which
went to Stephen Freud) for ridicule. Absurdly so, Freud felt: "He
wrote, 'Academic painter tries to get interest by strangling the cat';
actually (though it's not in the picture of course), one hand was sup-
porting the back legs."

The show attracted little attention. "I think my work wasn't
thought to be a body." Unlike Craxton, who cultivated homogene-
ity on hessian, canvas and cartridge paper alike, Freud did not have
an overriding style. He sold less well than Craxton, who considered
Freud his junior. "He was dismissive of me on the whole. That didn't
bother me. He swapped a drawing of his for a painting of mine (*Greek
Boy*); that was his feeling about my work."

Grudges, some rivalry and the loss of contact as Craxton took to
spending all the time he could in Greece first diminished then ended
their friendship. Up to then Craxton had been the better regarded of
the two, generally speaking. Freud then overtook Craxton or, rather,
moved into other circles. He was to maintain, not altogether convinc-
ingly, that he had not been aware of Craxton's sexual preferences.

"I only knew that Johnny Craxton was queer very late, after Greece (there had been a tarty boy in Greece); it took me years to find out. He always mocked queers."

Frank Auerbach, Freud's great friend in later life, saw the falling-out as a deepening exasperation. "There was a resentment," he told me, "of Craxton continually adducing a close relationship which, if it had existed—which I suspect it did—didn't last for more than six to eight months. Lucian did rather grow out of Craxton's basic frivolity. Craxton's priorities, if you put it in order, were: having a nice time came first, slightly impressing people came second and doing some nice art came third."[23]

Occasionally, for a number of years from the mid-forties, Freud stayed with the Sutherlands at Trottiscliffe in Kent: Christmas '44 for instance (Sutherland returned from war-art assignment in France the day before) and Christmas '45. One year Graham Sutherland showed him a Cézanne drawing he'd just been given: "three or four squiggles: it seemed odd in this cottage: a large sheet with pencil squiggles," taken from a sketchbook that Kenneth Clark had bought at £3 a page and used as Christmas presents.

Once when Freud came down Sutherland asked him to go with him to Maidstone Prison ("a marvellous Regency building, a bit like the Manet with the green ironwork"), its tall white walls gigantic in the backstreets. He had been asked to give a talk. "He asked if I'd come because obviously he was nervous. He was a local celebrity." On the way there they joked about being careful not to say the wrong thing but the inevitable happened. "When we got to the gate there was a queer-looking, well-spoken man who ushered us in. Graham said, 'Lovely evening,' and the man said, 'It must be, out there.' The Governor said that he was a scapegoat from an international fraud." They showed slides of their work and answered questions. "One really well-known burglar: we looked at his things and thought they were pretty good. He said, 'You like them, eh? Do you think I ought to take it up professionally?'" The Governor asked if they would like to come again, regularly perhaps. "Through Paddington I had a kind of rapport with the inmates. I'd like to come back, I thought. Though

better not. It was not necessarily a question of take a sandwich with a screwdriver in, but they were so like the people I was living among. When we mentioned to the Governor—who was called Vidler and was by way of being enlightened—this very charming burglar, who used to sign himself 'Tiptoes' at his burglaries, in lipstick, he said he'd give his right arm to cure him. 'Tiptoes' was queer, the Paddingtonians said. And misguided.

"In Paddington I'd be talking about something I'd read and they'd say, 'Yeah, I read a book,' and you realised about the dreaminess: it was when they were in prison and it was something in a magazine they read. Because when they were inside they were thrown on to it."

Being with Kitty in Delamere Terrace, "living for the first time with someone at close quarters," Freud had a captive sitter. She became his extending theme through 1947 and into 1948. With her, towards the end of 1947, he began *Girl with Roses*.

The two pairs of eyes in *Girl with a Kitten* were a picture-book rhyme compared with the free-verse stripes of the jumper in *Girl with Roses* running rings round the body above the swirl of the velvet skirt. Seated slightly to one side, told to sit up, shoulders squared with some degree of confidence, Kitty has her head turned extra full face. "I was arranged," she said.[24] Her unease came of being so firmly put in her place. Some might see here the stricken expression on the face of the kept woman in *The Awakening Conscience*, but no double entendre attaches. The face is as "modern," as forties a face as the Cubistic visages of Robert Colquhoun's *Woman with a Birdcage* and *Woman with Leaping Cat*, and indeed Picasso's squint-profile portraits of Dora Maar who, in the first performance of *Desire Caught by the Tail*, had played Thin Anxiety. Kitty is Anxiety Caught by the Tail. "Kitty was someone who panicked even if nothing happened." If only she had been allowed to get on with her knitting. (Like Lorna, she knitted a lot.) Newly pregnant, cautioned to stillness, clutching one rose above the thorns and resting the other on her lap, she landed herself with the role of Virgin of the Annunciation, the birthmark a stigma, the fingernails touchingly uneven.

The pose was a rearrangement of *Daffodils and Celery*, a smaller, slightly earlier painting, in which three daffodil heads trumpet above the reflections in a cut-glass jug: warped images of the Delamere Ter-

race window melted into the curves of handle and spout. How much better it was to work from someone with breath and body heat and real presence.

In the etching *Girl with Fig Leaf* and a Conté and pastel drawing, *Girl with Leaves*, she has something of the Queen of Hearts look of Picasso's Françoise Gilot, celebrated in paintings, in lithographs and on the flanks of vases. Similarly *Girl with Roses* is Kitty armed with a device. Her fig leaf, roses—"Talisman" roses she said, "Peace" roses he said—and spreading chestnut leaves are protective, deflecting attention, potentially hypnotic. Nanos Valaoritis put a resounding spin on the painting in an essay in *Botteghe Oscure*. "Fear is expressed in the contracted body, the eyes, looming out, like those of a huge rabbit in the far end of the pen, which has seen a hand opening the door. She wants to be as small as possible yet she is enormous," he wrote. "She is possessed by herself to the highest possible degree."[25]

The painting preoccupied Freud well into the New Year and was his masterpiece in the proper meaning of the word. A miniature magnified, proving his capability, it was immediately bought for the British Council collection for just under £150, to Kenneth Clark's annoyance: he wanted to get the Tate to have it, as did Freud. "I think my career would have been rather different if he had done because I wouldn't have been, not exactly written off—I was never written on—but I'd have been more seriously considered; I think I'd have got requests to show and interest from collectors." As it was, Fleur Cowles reproduced it in colour in the launch issue—February 1950— of her plush magazine *Flair* as an exemplary opening double spread in a planned series of individual examples of "Memorable Art." This was the first—and for some time last—moment of journalistic recognition for Freud in the United States. The accompanying double spread on the artist made one thing particularly clear: "He wishes to be known only through his pictures." *Flair* folded within the year.

15

"Me with horns"

Some time in 1947 Felicity Hellaby received what turned out to be her final picture postcard from Freud. It featured a bathing belle retouched by the sender to show a toothy fish menacing her plus a man's leg sticking out of the water.

> *Darling Felicity How are you. A horse how delishous Id love to see you and it I have a sparrow hawk I'd love to see you soon. Where are you? Lucian.*[1]

Once she was no longer a current friend or correspondent, she put away the letters and cards. Talking from her home on the island of Sark in 2012 she told me: "I look back on it and think how lucky I was not to be too involved; it was great fun to be with him. But my husband shared my life and Lucian wouldn't have. I imagine it was '43–4 the last time I saw him. I never met him again. After the war I had nothing to do and I bought myself a horse."[2]

Freud was image-conscious in a guarded way, liking to look intriguing. In the photograph taken by Ian Gibson-Smith in Abercorn Place and eventually published in *Penguin New Writing* in 1948, he was the artist in a rugby shirt caressing his zebra head, stripes meeting stripes. In photographs taken for *Vogue* by Clifford Coffin in March 1947 the artist was equally pensive in his Merchant Fleet sweater, standing

with *Greek Boy*, his most photogenic painting from Poros, perched on the easel behind him and his sparrowhawk perched on his wrist. Coffin also posed him as the voyager returned, seated in front of the two Poros self-portraits, *Man with a Thistle* and *Still Life with Green Lemon* and, in several shots, the fine Dutch cupboard of which he was very proud. The caption for the photograph chosen for publication some months later was "Man with Bird of Prey." Editorially, the sparrowhawk was the lure.

When in 1944 Henri Cartier-Bresson photographed the elderly Matisse settled in with a roomful of doves, how benign he appeared, yet—seeing that he was clutching one dove the better to draw it—how tenacious. Freud with his falconer's glove was the imperious young artist sporting his twitchy possession much as Peter-John Hannay in John Buchan's *The Island of Sheep* "had generally a hawk of sorts tucked away in his change coat." Freud kept his at Delamere Terrace, learning and appreciating hawkish ways. "There was a letter to *The Times* from someone that said, 'I have lived near Lord's cricket ground for many years and for the first time I have seen a kestrel hawk.' It was mine, I thought to myself; it was one I tried out that got away." Far from being discouraged by the loss he bought two others and fed them rats from the canal bank, shot with a Luger that he had swapped for paintings with Billy Moss of the SOE. Moss was the author of *Ill Met by Moonlight*, his account of how he and Patrick Leigh Fermor, plus supportive partisans, kidnapped General Kreipe, the German garrison commander on Crete, in 1944.

One of the kestrels soon died. Peter Watson's boyfriend Waldemar Hansen, whom Freud drew at Delamere Terrace, remembered the survivor swooping round the room and settling on the artist's wrist to be rewarded with mice. Taking it on the Tube caused a stir. Besides being impressive to be seen around with, hawks were good to draw, better than dead rabbits or the zebra head which, outstaying its usefulness, was pushed out on to the first-floor landing. One of the birds accompanied him to Essex when he visited Michael Nelson and his friend Mervyn Jones-Evans at Felix Hall, a dilapidated country house they rented near Chelmsford. "It was so happy I left it there."

When Freud produced headscarf designs for Zika Ascher (as did other artists at the time, among them Sutherland—hectic ink blotches—and Henry Moore) he turned for inspiration to his hawk-

rations mice. "Ascher changed the colours, which upset me; either he or Mrs. Ascher made the mouse pink. The colours were too sweet. I got a dress for Kitty with mice and they somehow faded out through the colour; the mice were the only organic thing in the design."

"London," *Vogue* reported in 1947, "is still ecstatically ballet-drunk." Like Ascher headscarves, ballet in the post-war years was a deter- mined flaunting of style in the face of austerity. Since the reopen- ing of Covent Garden in 1945, after wartime use as a dance hall, it had become the most extravagantly venturesome of the minority arts, even succeeding on the silver screen in *The Red Shoes* ("An awful film: Freddie Ashton did the ballet and I'd go down and see it being made. Very banal suicide, at Monte Carlo"). Accordingly Richard Buckle's *Ballet*, having expanded from leaflet to pocket magazine, became spacious enough to carry drawings. Mervyn Peake, Michael Ayrton, Craxton and others contributed, adorning commentaries and reviews with sketches for decor and decorative devices. Set in and around an article on "Ballet in Paris" in the issue for January 1948 were drawings by Freud of a bird in a French cage, a jetty in Mar- seilles with a dozen or so boats moored to it like leaves on a stem and three thumbnail sketches for *Man with a Thistle* snipped from the Poros sketchbook. Buckle set a competition for the best suggestions for how he might improve the magazine and published some of the comments in the July issue. It transpired that balletomanes did not think highly of the illustrations. Readers described them as "silly," "hideous, disfiguring and irrelevant" and (in a comment by the critic Clement Crisp) "unnecessary and often ugly (e.g. Michael Wishart's work and recent work by Lucian Freud)." Another correspondent "A.C.B." suggested "engage as permanent illustrators André Beaure- paire, Lucian Freud and Jacques Callot." Given that Beaurepaire was busy being a designer for Ascher headscarves and the stage, and that Callot was long dead, that left Freud who was unimpressed by Dicky Buckle's business methods. He let him have further drawings, such as the Greek gods rejects and, from the Greek sketchbook, a study of George Millar's boat moored below a fig tree. "He was quite helpful as he bought tailpieces to reproduce but he didn't give them back." He hoped to be asked to design a ballet. After all Graham Sutherland

had produced costumes and backcloths for Freddie Ashton's tour-
ing production *The Wanderer* in 1941 and John Piper conjured up a
swirly magician's cave for *The Quest* in 1943. Ballet put graphic excess
on a formal footing. Michael Ayrton's unrealised *La Source* staging
of 1947, with music by Constant Lambert, for instance, was to have
involved an eighteen-foot sitting figure holding a jar through which
dancers were to make their entrances. Freud had opportunities only.
The invitation from Freddie Ashton to do sets and costumes for *Picnic
at Tintagel* went no further than the Cornish recce of 1944. There
was a possibility of designing Ravel's *La Valse* in twenties costume for
Katherine Dunham, but that too came to nothing. The London Gal-
lery performance of *Desire Caught by the Tail* he had decided against.
His only costume design to be made up was a "sort of shepherdess"
number for Elizabeth Cavendish—"A large woman: 'lovely girl' peo-
ple said of her; lived with John Betjeman"—to wear to a fancy-dress
party. "It was just my idea of a lovely girl: a white dress with a belt and
some flowers."

Auden was back in London in April 1948. "I booked him into
the Esplanade Hotel in Warwick Avenue, the hotel my grandfather
first stayed in when he arrived in London." There was an encounter
if not an involvement, one that he did not deny. "Made friends the
first time; the second time was when I saw him a lot." Bacon put it
about that, Auden being famous, Lucian had gone to bed with him
but found himself unable to perform. He did not draw Auden, an
obvious subject. Why not? "I don't know why," he said. "Probably
because he was very impatient and on the move."

The same month Alfred Barr, the founder-director of the Museum
of Modern Art, New York, came to Europe looking for Futurist paint-
ings, calling on Matisse, discussing the ICA with Roland Penrose
and making acquisitions for MoMA, among them Bacon's *Painting*
(1946), a picture riddled with portent: blinds drawn, carcasses skew-
ered, male figure lurking under the bat wing of an umbrella. He also
bought Freud's *Girl with Leaves*, which had been picked by George
Melly as part of his personal stock at the London Gallery. Mesens
was delighted, Freud said. "I remember him explaining to me how
important it was."

. . .

On 3 July 1948, with Kitty heavily pregnant—"almost on the last day of Annie's internal life," as Freud put it—they got married. "It was no odds to me. Her grandmother, who had brought her up, was dying—I never met her: she was married to a doctor in Herefordshire—she said, 'It would be so nice if you could get married before I die as I was the only one married.' Kitty came from a long line of illegitimates. Her grandmother was a daughter of Lord Grey of Falloden by the governess; Kitty's mother was only married when Epstein was ennobled."

Freud did not discuss the decision to get married with his mother. "I never discussed anything with her, but she did say, 'Kitty's not one of the world's workers,' which was pretty strong for her." Friends suspected that he was reverting to being a good Jewish boy for once in "doing the right thing" by Kitty. She was dismayed, he remembered, when they were photographed on the steps of Paddington Town Hall. "Thinking that the photographer had been tipped off to publicise her condition, she burst into tears; but it was really just ten shillings for a wedding picture." The witnesses were Michael Wishart and Peter Watson.

Not long after, on 16 July, Dicky Buckle staged a housewarming party for himself in Bloomfield Terrace with more than 100 guests. He noted that "Lucian Freud, whose baby was hourly expected, wore tartan trousers" and kept telling people how excited he was about the imminent birth. Annie was born days later."[3]

Characteristically Ernst Freud dealt with practicalities and took a house for them—28 Clifton Hill, St. John's Wood—on a cheap lease from the Eyre Estate for which he did a lot of work. (The Estate was founded in the early nineteenth century by Sir John Eyre to make accommodation for writers and painters.) "My father worried about Kitty living at Delamere and gave it to us for nothing: an 1830s, St. John's Wood–style, nice house, semi. Quite a nice garden." That done, Freud went to some effort settling in. He planted two bay trees in the front garden, one of which died while the other grew until it towered over the house. Lucie Freud was pleased to hear Ernst enthusing over the oil paint—barge paint—chosen by Lucian for decorating, particularly the restful matt green he used for the bedroom. The stuffed fish in its glass box, bought five years before, graced the bathroom and a drawing table went into the conservatory with the plants and birds.

It was however an abrupt transition and Freud was unprepared for the role of householder, a role magnified when others besides Kitty—and Annie—came to live under the same roof. A couple settled into the basement: "Slosher" Martin, who stoked the boiler, and his wife, who was the sister of Lucie Freud's maid. There were also the Landers: Ron Lander, "very very small, somehow pretty humble, an anarchist, made architectural models, I think; he and his wife moved into our house." His wife Joan had a baby and Freud drew her too. And Eduardo Paolozzi, a former sculpture student at the Slade who had spent the best part of 1947 in Paris, came and stayed for some months, on and off, at number 28. "He didn't pay. He had white plaster marine things (sea urchins), quite nice. He would be there and we'd talk. He left to go to Paris." Clifton Hill was one size up from St. John's Wood Terrace and rather more shabby genteel. The publisher James MacGibbon was a neighbour (hence a commission to illustrate Rex Warner's *Men and Gods*) and Melanie Klein, Anna Freud's rival, lived a few doors down. "I used to see her in the street, a ridiculous-looking woman in a hat."

"We had an au pair, an Irish girl with an illegitimate child. I tried something of her, *Girl with Red Hair*, pastel on black paper: tried and failed. Kitty got her in as she had a baby and we thought, optimistically, that she would be good with children. Stupid really. Charlie came back rather drunk one night and went to her room and next morning she said, 'I may have a baby but that doesn't mean I can be treated like a whore.' I asked Charlie about it and he said, 'I got a very good reception.' Anyway, the girl left, leaving her child behind. She became an usherette at a cinema in Kilburn and the baby was looked after by the woman in the basement. After a bit I got her address and sent a telegram using phrases like 'The Year of Our Lord'—biblical language to impress her—saying 'Unless you remove the child you will be completely suppressed.' That did it. The child went."

Though money was a problem, foraging for it could be stimulating and he was always on the lookout for opportunities to exploit. Feliks Topolski, celebrated for his drawings of personages and big events grotesquely awhirl, lived round the corner from Delamere Terrace. "Once I was ill and Kitty went round to Topolski's with a painting he had liked—*Still Life with Chelsea Bun*—I'd no money at all and he lived in splendour and for £7 he bought it. I thought I

would get £20; I thought it mean. He hadn't got much time for me. I went round occasionally. Topolski wasn't unfriendly, but what use would I be there? He went for well-known people. He gave a party for Picasso and I longed to go." Freud was not invited; Epstein was, and when Picasso arrived, late, they embraced. "Topolski talked about tall people as 'elongated' people; 'I'm going to hunt women in the park,' he would say."

Once in a while the possibility arose of getting the better of art dealers. Freud noticed, for example, that some works by Dufy exhibited at the Redfern Gallery in 1949 as artist's prints were, in fact, collotype reproductions excised from a book. "It was a book called *Mon docteur le vin*. Ivan Moffat, ex-Dartington and Bryanston, gave it to me; it came from his father Curtis Moffat the interior designer, who'd just died, from his grand flat in Fitzroy Square: a rather fine book, sponsored by a wine company, with vine leaves on the front. The illustrations looked like lithographs and the Redfern was selling them framed at twelve guineas each. I was longing for a Max Ernst painting *Fleurs*, done with a comb, so I took the book into the gallery hoping to be seen." Sure enough Rex Nan Kivell of the Redfern noticed him loitering with the book and invited him into the back room where he offered to relieve him of it. Freud suggested a swap and a deal was struck: the painting was his for £50, which his father paid. And so, for a while, he had his own Max Ernst. Some years later, having met the artist only to find him supercilious, he sold it to Gimpels for £120, telling himself that he had become bored with it.

Another time he spotted in the window of Shemilt's, the framers in Seymour Place where he had bought a Delacroix drawing of a candlestick for £10, a promising-looking painting: "A beautiful Constable: London with St. Paul's in the background, from Archway, stormy sky. It cost, I think, £60, £80—quite a lot—and I said to Mr. Shemilt, 'I really like this picture. If I bring someone in and they buy it, will you see me all right?' 'I'll give you half of anything over £80 they give me,' he said. He loved the idea of the picture going through his humble shop and going to a gallery. So I took K. [Clark] in and he was terrifically excited and thought he'd get it through the NACF [National Arts Collection Fund]. K. said, 'You know, I'd like to buy it but without a provenance enemies would get at it . . .' He paid an odd sum. 'How much?' 'I leave it to you.' '£900.' So I got £400. I

once asked Alan Clark, son of K. Clark, what happened to it. He said, 'Wish it was one.'"

Through Kenneth Clark, Freud had met Colin Anderson, finding him "huge and handsome, and soft (for a shipowner)." Anderson was Chairman of the Orient Line, lived in Admiral's House, Hampstead, and owned a number of Pre-Raphaelite paintings, among them *The Awakening Conscience* and two late Sickerts based on news photos: one of Churchill and the other of George V at the races. These in themselves made him worth visiting, but Anderson was also known to be good for a loan. "Somehow Lucian thought it was a gentlemanly transaction," Frank Auerbach thought. "If he gave somebody a drawing he thought, or knew, that in the course of time they got it very cheaply." So anyone who baulked at his request for a loan could be considered short sighted or unimaginative.

Freud was rather astonished by Anderson's reaction ("Is Lucian Freud living with proper frugality?" he queried on being approached for £200). "I'm not psychologically minded, but a curious thing was that Colin Anderson liked to get round to a situation where he'd suddenly lie on the floor. I asked him two times for money and before he gave me an answer he knelt down, then lay on the floor, then said, 'Well, I must think about this . . . You *may* have a certain amount of talent and I *may* have a certain amount of money . . .' He was very odd. He didn't really like my work. He had one of my drawings hanging in the loo and he and his wife had a drawing of themselves, a secret one. And he bought a mouse from my first show. His daughters had a poem: 'Coming to the house / The man who drew the mouse.'"

Later on, when he happened to have some money, Freud told Anderson that he would like to repay him. "But he didn't like my idea of repayment; he said, 'Give me something that means a lot to you personally,' so I gave him the Freud–Schuster Book."

"Sometimes," Freud said to me once when we were discussing his borrowing habits, "I think you make me more moral than I am, less amoral than I am. I don't suffer from guilt.

"Asking for money made me feel so nervous. The odd thing is, the need for money wasn't as straightforward as that. The money

itself became an issue. It wasn't that I wanted money *for* something; it was that I wanted a bit of money to have in my pocket."

Freud knew that the purchase of *Girl with Roses* by the British Council didn't mean that he could count on making a living from painting. No young artists did, everyone knew that, and few of any age, except those society portrait painters who had waiting lists and might make as much as £10,000 a year. To sell to the British Council or to the newly established Arts Council or the Contemporary Arts Society was a boost; to be taken up by Kenneth Clark, choosy in his patronage, ubiquitous in his influence, was advantageous; but the usual, most reasonable ambition was to secure a teaching post, part-time, just enough to survive on. Having told himself that any money he might make from painting should go into buying time in which to work, and only ambitious work made the investment of time worthwhile, he more or less ruled out the obvious alternative which was illustration: the highest form of commercial art.

Immediately after the war artist-illustrators had found themselves suddenly and surprisingly in demand. Continuing paper shortages meant that would-be publishers of magazines issued them in hard-back formats, thereby evading restrictions on periodicals, and these needed illustrating. Besides which, publishers decided that a public starved of luxuries might appreciate added value in books. King Penguins and Picture Puffins flourished, and other imprints, notably David Gottlieb's Peter Lunn and John Westhouse, were set up in the hopes that good design and illustration would compensate for poor paper. John Lehmann launched his own publishing house; Paul Elek achieved a *livre d'artiste* look at moderate cost with Camden Classics, assigning *Huckleberry Finn* to Edward Burra and *Treasure Island* to John Minton who transformed the Corsican banditti of *Time Was Away* into chorus-boy pirates. Working in a style patently his own, Minton suffered a terrible diminution, his originality skewed and his spirit sapped through frantic generosity and conviviality. Others profited from his imitability. Michael Ayrton's imagination went to work on *The Picture of Dorian Gray*, producing a quick rendition of the ageing process, youthful aplomb giving way to spidery wrinkles.

For some, Ayrton and Minton especially, illustration was a job, or series of little jobs, an agreeably limited paid discipline, a means of keeping one's hand in. Mervyn Peake developed a frosted roguish manner for *Treasure Island, Alice's Adventures in Wonderland* and *Through the Looking Glass* and *Grimms' Household Tales*, while also producing novels of his own—the voluminous *Gormenghast* trilogy; for him illustration was key.[4] For others, most notably Francis Bacon, it was unthinkable. They felt they could not afford to curb their distinctiveness or let rip with it to become, say, another pervasive Ronald Searle. Freud was not too concerned about this (he had little to lose), but obviously illustrators could never be independent of text or editor. He liked seeing his work reproduced.[5] And, beyond that, if existing drawings could be sold as illustrations so much the better. He was happy to be prompted by given texts, even happier if his eye lit on phrases that coincided with what he had already drawn, as had happened with *The Glass Tower*.

The Freud–Schuster sketchbook—more or less filled and with Stephen Spender inserting the odd poem—and the *Black Book*, compiled with Michael Nelson, had been private not to say unpublishable, whereas his drawings for Rex Warner's *Men and Gods* were done with reproduction in mind. For these tales of gods with foibles and everyday metamorphoses it was advisable, Freud decided, to try a timeless look, which was not what James MacGibbon of MacGibbon & Kee, who commissioned the drawings in 1949, had in mind. Instead of typical scenes off Greek vases Freud delivered startling close-ups: mainly heads with fancy-dress attributes. There was himself ("me with horns") as Actaeon at the onset of his transformation by the goddess Diana into a victimised stag; Charlie Lumley posed as Narcissus (hands cupping face and reflection) and as Hercules, sporting a lion hood. He adopted a peppering technique associated with Robin Jacques, art editor of the *Strand Magazine* and a prolific illustrator, whose speciality was stippled costume drama. Freud did acknowledge a "slight technical similarity" to Jacques' busy half-tones. "The stippling relates and is a recipe, which is rather horrible, related partly to reproduction." This it could be said derived from Aubrey Beardsley, particularly the wigs and dimples of the Beardsley *Lysistrata*. ("My big influence.") Anyway, MacGibbon rejected the drawings and *Men*

and Gods appeared a year later adorned with placid little illustrations by Elizabeth Corsellis.

In the late forties illustrative drawing came neck and neck with the photography that paralleled it but eventually overshadowed it. Francis Bacon relied on photographic images to get his paintings going; Freud— well versed in drawing—was conscious of being inhibited as a painter. For Bacon drawing was out of the question: he was unpractised and in effect useless at it. For Freud, friendly with and impressed by Johnny Minton, illustration was worth a try. Following *The Glass Tower* and before *Men and Gods* he had done drawings for Princess Marie Bonaparte's novel, *Flyda of the Seas*, about to be published by John Rodker's Imago Press. "I was to get fifty or sixty pounds for them, I asked

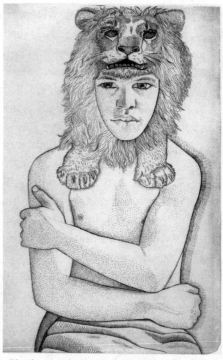

Charlie Lumley as Hercules (1948)—rejected illustration for Rex Warner's *Gods and Men*

for an advance from Princess Marie and she said, 'Yes yes of course. What would you like? Five francs? Or would a thousand do?' She had a strange sense of money; money was just a commodity to her. You just want a helping of it, she thought, I felt. She gave me a cheque and the banking house it was drawn on was Paul Cocteau, brother of Jean, who kept him.

"Rodker came from one of those Russian-Jewish families, was very intelligent, a poet, and had furniture painted by Duncan Grant. He did a superb edition of *The Lay of Maldoror*, the one Peter Watson gave me; I'd heard about him through Cedric and Lett[-Haines] and, as he published my grandfather and translated him, my father knew him. (One of my father's few remarks of a philosophical nature was, 'I have yet to hear of one translator speaking well of another.') There was turmoil in his life: he looked very vulnerable and was obviously in a terrible state, an erotic state, over loves past present future. He

had a lot of wives. My aunt was quite a strong influence on him." To Freud's annoyance Rodker advised Marie Bonaparte against using his drawings. (*Flyda* was eventually published in 1950 in an edition of thirty copies on hand-made paper with elaborately dull colour litho plates by John Buckland Wright.)

"Princess Marie had no visual sense and Rodker found the drawings offensive; they were, oddly enough, influenced by being in Greece." Among them was a recumbent head of a girl representing Gina the temptress (actually Anne Dunn, a student at Chelsea School of Art, with whom he was becoming involved), also a stylised study of Kitty and a large one of himself as *Man at Night* ("I was on my own one month in Paris"), a feat of pen-and-ink dotting and flecking suitable for translation to collotype or line block. "I really wanted to get a strong image."

Most of the *Flyda* illustrations were done in Paris, as was a pencil self-portrait with a hyacinth in which a sallow yellow background sours the gap between squirming petals and Neo-Classical wavy hair. This was Freud using crayon on paper as a hotel-room substitute for paint on canvas; it was also something of a dapper Showtime graphic. The look was too groomed, too measured. *Man with Hyacinth* (listed as *Man at Night*) was included in "Forty Years of Modern Art," the inaugural exhibition of the Institute of Contemporary Art, staged in a basement beneath the Academy Cinema in Oxford Street in February 1948. (Picasso's *Les Demoiselles d'Avignon*, too big to go in through the door, was manoeuvred through a hole created by bomb blast.) The exhibition was declared an unchallenged success by its chief organiser Roland Penrose. Freud disagreed. "The show should have been very good but it was an awful dose of medicine. Very much not Peter Watson but Penrose." Yet, disregarding what he considered Penrose's lack of acumen, being included meant that he was already, at twenty-five, recognisable, locally at least, as one of the moving spirits of Modern Art.

Given its air of cold appraisal, *Man with Hyacinth* could have served as a frontispiece for *The Equilibriad*, a Kafkaesque novella by William Sansom published in 1948 in a limited edition by the Hogarth Press, by then part of the firm Chatto & Windus. ("They thought let's have an *edition de luxe*; Sansom might have suggested

me.") Sansom had aimed to achieve a sense of hallucinatory disorientation and Freud followed this through with literal illustration, as though clicking from contact to contact, closing in on Paddington brickwork, poking the crossbar on a lamp post into a man's eye. "The thing in the book about losing balance with the street: so I put the lamp in front of the face." Ron Lander posed on the Clifton Hill balcony for the "walk to the office" drawing, awkwardly balancing himself in mid-stride ("swaying in an excess of excitement," Sansom wrote,[6] describing the derangement of Paul, his protagonist, in cinematic terms ("a sudden shadow caught the top lid of his left eye"), which suited Freud, who used himself as the model for Paul staring. Cut to another character, Cousin Ada, in a

Startled Man, illustration for William Sansom's *The Equilibriad*, 1948

monkey-fur hat, seated nervously at a café table, her mind elsewhere. She was Ruby Milton from next door at Delamere Terrace, whom he had also drawn as *La Voisine*. Charlie Lumley's younger brother Billy posed too as a savvy jackanapes.

Although Freud's drawings for *The Glass Tower* had been more striking than the poems, the review in the *Times Literary Supplement* had failed to mention them; those for *The Equilibriad*, excellently reproduced in collotype, could not be ignored. Yet, remarking that "the influence of Kafka on English writers has been almost wholly bad," the *TLS* observed only that the work was "rather heavily illustrated by Mr. Lucian Freud."

Bill Sansom, who had become well known for *Fireman Flower*—short stories based on his experiences fire-fighting in the Blitz—and for his prominent role in Humphrey Jennings' 1943 documentary drama *Fires Were Started*, was a worthy recipient, Freud decided, for one of his early wartime paintings. Characteristically, he later regret-

ted the gift. "A night sky with Valkyrie heads in it that really annoyed me and when he was dying—mid-seventies—I got it off his son and scrapped it."

Freud kept 20 Delamere Terrace—"I'd go there and come back"— for privacy and work purposes. According to Charlie Lumley, who at sixteen was his accomplice and occasional sitter, "Lu would tell Kitty that they were going to work together when really they worked an hour or so then would 'go down the West.'"

Marriage, Freud gathered, involved domestic demands and a loss of privacy. Regular meals at regular mealtimes, such as his mother had always provided, were irksome and those served at 28 Clifton Hill could irritate. David Beaufort, a friend and later his dealer,[7] said that Freud would sit waiting for his dinner while Kitty cooked it and then she had to sit with her face to the wall while he ate as he couldn't bear being watched eating. Further, being married to Kitty meant supporting her to some degree ("She was always getting new clothes") and taking her out in the evenings, which was fine except that she tended to get tired long before he did. "She loved dancing. We'd be in Soho, at three or four in the morning, go up to Cambridge Circus to get a taxi and she'd burst into tears and say she just couldn't walk another step." Then there was his mother-in-law. He and Kathleen Garman didn't get on. "I really grew to hate her. She used to take Annie out to show her off at the Caprice and wouldn't bring her back and I used to shout at her. Kitty was too frightened to say anything to her." He himself took Annie with him now and then, but this could be a bother. "I remember taking Annie to the Clarks' at Upper Terrace House, she screaming and crying, and K. Clark saying 'I'm afraid she doesn't like us.' He said it as if to say, 'They don't know when they're lucky.'"

Because he saw no reason to curb his urges to suit a marriage there were, inevitably, occasions when his impetuosity went too far. "I went to the Parkway pet stores and came home with a buzzard and when I brought it back—Annie had just been born—Kitty said to me, 'It's me or it.'" He took it back to the shop, balancing it on his bicycle in a cardboard box. "I said, 'I'm sorry, but I'm afraid I've had domestic difficulties: you have to take this bird back.' They said: '*What?* Take this bird back? We're not having this fucking bird back. You've

bought it.' I said, 'You *are* taking it back.' Luckily I'd paid by cheque, so I said, 'You leave me with a melancholy alternative.' And I wondered if it was the first time a cheque for a buzzard had been stopped. I didn't go in for ages to the shop, they were so angry because they thought, 'Hooray, we've got rid of that horrible buzzard.' Huge it was. Fastened by a chain to a seat."

Freud also bought his first Bacon—over the years he owned nine—in the summer of 1948. "Had it framed at the Chelsea Art Store. This was the first time Francis thought about Van Gogh. A head of him over the Pope, with a proper shirtfront. I sold it to Helen Lessore for £80 and some American museum now has it. They were £100 in his first show [1949]. Francis said, 'It's terribly hard to make a living so if you charge more, and if you come into luck, you might be able to make enough to live on.'"

"Fed sweets by nuns on the coach to Galway"

In June 1948 Freud's friendship with the Sutherlands, much tested on the trip to the South of France the year before, came under strain. Sutherland had had a successful one-man show at the new Hanover Gallery, run by Erica Brausen formerly of the Redfern and backed by the banker Arthur Jeffress, and he had recently become a trustee of the Tate. This had brought him to the attention of Douglas Cooper who, agitating for change at the Tate, was hoping to bounce the trustees and the Director, John Rothenstein, whom he despised, into a more receptive attitude to foreign art. Cooper was preposterously overbearing; all the same, Freud appreciated his impatience and understood his resentment. "He should have had Robin Ironside's job but Douglas made it out of the question, Rothenstein being so petty and hating to be insulted.

"The Sutherlands were terribly excited about being taken up by the great collector. He invited them to dinner, so they said they couldn't have dinner with me as had been arranged; I refused to accept this, so they came to me after all and Kathy told Douglas why they couldn't come." Cooper was unforgiving, and there was more than pique behind the animosity. "Francis had quite a lot to do with it. Douglas loathed Francis and said that Francis had blackmailed a cousin of his. I asked him, 'Did you?' 'Did I? Maybe I did.' That was when Francis used to advertise as a servant: 'Young gentleman: do anything, especially illegal.' Douglas bought a bit of Bacon furniture and put it in what he called his 'punishment room.'" That was a few

years later, in the fifties, when he moved into the Château de Castille near the Pont du Gard, within striking distance of Picasso. Over dinner Freud told the Sutherlands what he knew about Cooper. "After the war, when Mervyn Jones-Evans (a friend of mine from Bryanston) was with Douglas Cooper, he offered Micky Nelson a huge sum to give up Mervyn, but this only cemented a long affair. I mocked Douglas Cooper and they—the Sutherlands—told him. He wrote me a letter saying, 'As you know perfectly well, I don't know you.'"

Impressed by Cooper's assurance as an art historian and entertained by his diatribes, the Sutherlands transferred allegiance with the result that Graham Sutherland became one of the names on the list of artists Cooper swore by. Freud thought it a Faustian compact. "Douglas Cooper, completely mad, gave him this promise to do for him what he imagined he'd done for Picasso. Graham felt he was selling himself." For years Cooper boosted him, asserting in his 1961 monograph that he was "recognised in European circles as the only significant English painter since Constable and Turner."[1] He (and Henry Moore) joined Braque, Chagall, Léger, Le Corbusier, Matisse and Picasso in Felix Man's reverential photo essays *Eight European Artists*, published in 1953, the first time any such grouping had included anyone British. There was also, for a while, social success. But then came Cooper's derision. "They wanted another painting," he would say, "and Kathy got her lipstick out." Sitting across the table from me in a BBC studio in the early 1980s, Cooper loudly denied that he had ever thought much of Sutherland. "He was never an artist that I was particularly interested in."[2]

Freud knew that Sutherland always needed reassurance. "He was so nervous and envious of other painters." In his studio one day Freud saw a painting that he rather liked and told him not to change it. Sutherland demurred. "It's too like a Sutherland."

"Graham was very modest as a gambler. 'This was the life,' he thought, very occasionally. They went gambling once a fortnight, I think. He was very timid as he had this terrible time in a drawing office when he was young; his brother was a gambler and Graham really minded; he went on thinking, until very late, that he might be a pavement artist in the end. Dependency on K. Clark was to do with it." To Freud the Sutherlands' married state was unenviable. He had no quarrel with them—"there were never any words"—but their

mutual reliance mystified him. "It was almost quite sinister, because they didn't know when the other was talking; it was like Siamese twins with the same bloodstream who shared the same brain. I remember K. Clark asking me once about Kathleen Garman. 'What's she like?' 'Like Kathy gone wrong,' I said. 'Kathy's Kathy gone wrong,' he said. Jane Clark said about Kathy: 'I do hope when Graham and Kathy are very rich and powerful she won't give me dresses as out of fashion as I give her.'"

In November 1948 Sutherland wrote to Robert Melville, "I think Lucian F. miles ahead of the rest although he's horribly restricted in ideas."[3]

In the same month as the clash of dinner dates, Freddie Ashton introduced Freud to Christian Bérard, who was in London designing a ballet to Haydn's *Clock Symphony* for Covent Garden. They hit it off. On the opening night of Katherine Dunham's *Caribbean Rhapsody* at the Prince of Wales Theatre, Dicky Buckle spotted them standing together at the back of the stalls. Freud was charmed. "His power was quite extraordinary. He'd go into a *modiste* on the Left Bank and move a hat in the window two inches and the smart women would all get a hat like that. Left-wing people would have thought of him as frivolous and flaky. I wasn't all that aware of what went on—his funny ménage—yet he was very aware of being treated frivolously. He said, 'I used to be a terrible Dicky Buckle once, but then I grew my beard.'"

Bérard's reputation overshadowed his accomplishments, and his versatility, ranging from sets for ballets to covers for *Vogue*, was often held against him. His designs for Cocteau's film *La Belle et la bête*, simple at best (Belle floating through muslin curtains down a nightmare corridor), had been animated Blue Period Picasso; and rather than create chic tatters for Giraudoux's *Madwoman of Chaillot* he had insisted on genuine rag-picker items of clothing being worn. Grossly self-indulgent, he had seen fit to wear as party gear the threadbare trousers he had inherited from Max Jacob after his death in Drancy, the holding centre for Jews before transportation. Picasso damned him for that.

"He waddled rather than walked," Freud remarked. "And yet,

when staying at the Pastoria Hotel in Leicester Square and walking to Covent Garden in the morning, workmen recognised him as 'one of them' he said. Extraordinary cufflinks and open neck and crazy smile."

Bérard was a fount of gossip, new and old. He told Freud why he thought the death of Christopher Wood, who had fallen under a train at Salisbury station in 1930, hadn't been suicide. "Bérard said Wood, whom he knew, was very ambitious, with career, friends, etc., but he had an opium-induced paranoid obsession that he was being followed. In France, where he travelled, the stations had no platforms unlike in England and, thinking he was being followed, he was taking evasive action by crossing the line. Bérard thought that he was quite OK, had seen his mother, got a bit of money off her, wasn't in a bad way, but he instinctively ran from the platform and it was high so he fell and the train went over him; it was unlikely to be suicide: he was so full of himself, quite tarty and vain."

While in London Bérard had to go to St. Thomas's Hospital to be detoxified. "One day, when I was showing him round near Leicester Square we suddenly saw this shambling figure appear." It was Mervyn Peake, looking for illustration work and already showing signs of the Parkinson's disease that was to overcome him. "Tall, gaunt, aged: I remember him possibly having sores. '*Romantique*,' Bérard said." Peake's colossal Gothic novels, the first of which, *Titus Groan*, had been published in 1946, defeated Freud. Why he hadn't read them through, he said, was because "they're all about a man going up a corkscrew staircase and finding nothing at the top."

Bérard the wheezing *flâneur* was a master of guises. In *Triple Self-Portrait* he represented himself in parallel: as a young man, a young girl and a middle-aged woman on a beach. To Freud he was socially fascinating and physically a potential subject. "The Clarks thought he was very good. K. said, 'We ought to get him to paint Vivien Leigh.'" Bérard himself asked him to do a drawing of him when he was next in Paris. Through Bérard he met Cecil Beaton, the pre-eminent society photographer and, as the critic Clive Barnes once put it, "the rich man's Christian Bérard."

Beaton thought Freud very decadent, Bérard told him. He promptly invited Freud down to Wiltshire that August to stay at Redditch House, "Mr. Beaton's Petit Trianon," as *Lilliput* magazine

described it, previously owned by Christopher Wood's parents. There he drew Beaton—a prissy impression save for the eyes—his dog, his apples and his summerhouse, and Beaton photographed him posed in a harvest field with Clarissa Churchill and a Polish prince, Stanislas Radziwill, a trio meeting the requirements of a *Vogue* pastoral.

"His mother said, when I was drawing him, 'Are you having trouble?' 'Yes,' I said. 'You aren't expecting him to look natural are you?' I said yes, rather playing along. 'Cecil hasn't looked natural since the day he was born.' Beaton loathed his mother. When Greta Garbo came to stay Mrs. B. moved out." On the table in the hall there was, invariably, a letter to Garbo ready for the post. "I'm not sure it wasn't always the same one." Freud was delighted to be there once at the same time as Garbo. "I thought she was wonderful. She said, 'Comm and sit 'ere,' and it was a chair for one, not two and I squeezed in. She looked marvellous. She drove Cecil mad and he'd become gruff and manly and say, 'We must go for a walk,' and she'd say, 'I've left my shoes in New York.'" Beaton wanted Freud to go on holiday with him to Sicily but took Truman Capote instead; according to Freud, "Cecil was shocked as Truman was a writer but was *only* interested in stock exchange news."

Paying tribute the following year to the dead Bérard, Beaton described how he had showed him round London. "In a poor region of Paddington he was captivated by the ballet danced by the poor children who lived their lives in the mean streets. Suddenly in our walk he stopped still. 'We can't go down there,' he said. 'That is a bad street where even policemen don't enter, for as soon as they do people throw pots of geraniums from the windows on to their heads.'"[4] The warning had come from Freud. "Direct from me: it was Clarendon Street. They did that; it was famous for being no-go-ish. The 'ballet' was children skipping in and out and making those squares (hopscotch); they'd sing an early feminist song:

> *We're in the Boy's Brigade*
> *Covered in marmalade,*
> *The marmalade is mouldy,*
> *So's the Boy's Brigade.*

A few weeks later Freud took a break in Ireland with Anne Dunn, the other woman besides Kitty in the *Flyda* illustrations. She was eighteen, a daughter of Sir James Dunn, the Canadian financier by his second marriage, to the ex-Marchioness of Queensberry. They had met in a nightclub, Antilles. "I stalked him," she said. "Saw him flickering about. I never quite understood what was happening: when he was young he was so beautiful. And the way he moved: like quicksilver."[5] Enamoured as she was, she had made friends with the actorish Miltons next door in Delamere Terrace in order to be near him and had seen *Girl with Roses* unfinished on the easel. This she thought was more alive and exciting than any painting she had been exposed to as a student. "When I first knew him I didn't know about Annie. Then I overheard conversations with him being asked how the baby was, but I didn't put two and two together or think that there was someone else in the background. When I found out, I used to lurk outside the house in Clifton Hill: I was frightened he would never speak to me again if he thought I was lurking."[6] She wrote to him adoringly from Ireland. "In church the mission priest put us all under pledge not to drink for a year but I said privately to myself, 'Until I next saw you again' . . . save me Lucian."[7] They arranged to meet in Connemara, which she knew because she had been there once during the school holidays and camped on the beach with her sister. Freud liked the sound of it for there was no food rationing in Ireland and maybe he would find distant Galway congenial.

"She went on about this strange hotel pub, the O'Neill Arms, I think, in Cashel." Peter Watson "lent" him some money and he set off with pastels and paper. "I started alone; got the boat from Liverpool to Dún Laoghaire. I remember walking through Dublin and it being so exciting, like Joyce. Having read *Ulysses* it added to my enjoyment; I was amazed by the Irish and how all the cream in their buns turned sour by four in the afternoon; the butchers were amazing in Dublin too: because they were Catholics you saw blood and guts. I asked, 'Can you tell me where the coach station is?' and a man—he was a policeman—said, 'Don't be in so much of a hurry.' I was fed sweets by nuns on the coach to Galway."

Anne Dunn's memory of their rendezvous was that it was at the railway station. "The Zetland Hotel was forty miles from Galway, quite a long journey, arriving at midnight, and I'd come to meet him

and he got off the train so fast that I missed him. There was one more train after that and, of course, he wasn't on that either."[8] It was midnight, no trains until morning and no way back to the hotel. "So I went and got drunk, desperate, and lay down on a bench and found myself being raped by a porter. Rather a sad beginning to that romantic interlude. Next day I went back to Cashel thinking that he hadn't turned up and found, of course, that he had been there all along. Got a taxi somehow from the station.[9]

"He seemed to be happy at that point. It was quite a primitive Irish life. There were ceilidhs at the schoolhouse opposite with the girls all dancing with each other. He was light on his feet and he'd go bounding around, not realising that there were hazardous patches in the bogs and suddenly he vanished from sight which was, unfortunately, hilarious."[10] He reappeared with muddied tartan trousers and, back in the hotel, drew *Interior Scene*, on black paper, keeping on at it over the weeks as it darkened in tone, sharpening the pastels for fine lines. "Anne looking like a real Red Indian; she had Red Indian blood through her father." Net curtains, billowing into the room, veil her face (looking remarkably boyish) and a sprig of blackberries with browned and tattered leaves binds her to the rose-pattern wallpaper. He later said that he disliked the composition. "Too illustrational." Tensions arose. "The husband of Audrey Withers (a very nice woman, lived on the canal-side, a communist, and Editor of *Vogue*) was also staying at the Zetland Hotel, in tweeds. I'd met him some time on the canal and as I was talking to him Anne was standing outside the door with a huge knife. We went back to Dublin and met a friend of Bo Milton's, an arty woman, Deirdre McDonagh." This led, Anne Dunn said, to "intense embarrassment. I'd done two paintings which I took, and Lucian had his between two sheets of paper and she said, 'Oh Lucian, what progress you've made,' looking at mine. 'You've come on, Lucian!' We stayed there a couple of weeks. Did that several times."[11]

Dublin was welcoming. Freud took rooms in Baggot Street and met a number of congenial painters there, one or two of whom proceeded to emulate his style. "The operative person was John Ryan, rich writer, failed painter, who owned Bailey's Hotel and all the dairies in Dublin; he bought my drawing of Cecil Beaton. His sister was a famous film star, Kathleen Ryan: she was the girl in *Odd Man Out*.

Then there was Oonagh, who married Paddy Swift, a painter who with a deaf poet, David Wright, later—in London—founded a magazine, *X*." He didn't see much of Anne who became aware of his attention straying. "There was a girl called Helena Hughes, who had been a girlfriend of Michael Wishart's, very gamine-looking, and that was my first feeling of real threat. I realised that if I turned my eyes to left or right he would have vanished with Helena. And he did, later on. There was also another girl (though I don't know that anything happened) called Claire McAllister, who was an American poet with red hair. There was always an element of hidden relationships lurking."[12]

At least one painter whom Freud came to admire greatly was to be seen around Dublin: Jack Yeats, aged seventy-seven, brother of W. B. Yeats, down on his luck and still painting with fitful brilliance: "strangeness so entire," as Samuel Beckett put it,[13] spelt out in titles like *Boy Jumping over Water* and keyed to melancholy. There had been an exhibition at the Tate that year: pictures slipped loose from their origins in illustration into images of wistful souls, roused seas and drizzling skies. Freud hadn't thought much of the first Yeats painting he had seen, a flower piece belonging to Kenneth Clark, but after Galway he thought much more of him, feeling, he said, "very sympathetic to his whole life. I didn't talk to him. He walked in St. Stephen's Green all day. He had no market, and Victor Waddington—the Dublin dealer—sort of saved his life. Victor told me that as he hadn't got any teeth his friends clubbed together to get him some and had a dinner to give them to him and they all shouted 'speech speech' and he got up and said, 'Now I've got all these teeth what am I going to eat with them?' He must have had a little money—not been on the floor—because poverty in Ireland was so poor."

Inevitably, for there was no avoiding him in the bars of Dublin, Freud also came upon Brendan Behan, famous for having been in prison in England for IRA activities. "Lots of people disliked Brendan as he stole from very poor people and gave to the rich. Things like overcoats. I saw a certain amount of him and knew his brothers; I went on the back of Dominic's bike to his parents' house; best house painters in Europe, marbling and everything, over many generations, they were, and literary: his grandfather wrote the Irish national anthem. 'You can make money out of being a house painter, where you can't out of being a writer,' he said." Behan, who had been

employed repainting everything from a lighthouse to the railings of St. Stephen's Green, was a mighty boaster.

"Very early on, at *Horizon*, they received a story from him which they couldn't print, about this workman going to work, makes a friend, a great friend, they spend more and more time together, the young one is BB and the other is married, and the wife dies and they go home together. When Behan became famous—through *The Quare Fellow*, which was mostly due to Joan Littlewood—Cyril Connolly said, 'You know, I remember that story. I couldn't print it: he was obviously queer.'" By then the story, "After the Wake," had appeared in *Points*, a magazine published by Peggy Guggenheim's son, Sinbad Vail.[14] "Brendan Behan just had sex, not affairs. I was told, when I first went to Dublin, that he really liked getting pinky Trinity College boys, especially if English, and he'd take them down to brothelling parts on the other side of the Liffey. He came to London to boast and I remember him in the French Pub and Dylan Thomas really putting him down: Dylan ridiculed him, being quicker, more worldly and sophisticated. There used to be cigarettes, De Reszke Minor and Major, and the packet had a separate little hinged box that said 'four more for your friends'; I remember Dylan saying, 'I wish I had four friends,' and I thought four friends would be quite a lot."

In November 1948 Freud exhibited once again at the London Gallery. "A small roomful of his work is almost lost in half a dozen shows—a houseful of absolutely worthless stuff," the painter William Townsend, a colleague at the Slade, wrote in his journal.[15] The other exhibitors included a painter Cawthra Mulock, just a name to him ("a funny name"), two Australians, James Gleeson and Robert Klippel, who was a sculptor, and John Pemberton, who was "a sad Charlotte Street Surrealist. Went to Paris and starved to death, I think. Modish: did magazine illustrations for a living, vaguely to do with sex. Lived under duress but always elegant, wore a bow tie."

Girl with Roses dominated the show. "This portrait," William Townsend judged, "looks like the work of someone quite simple minded—using simple in the right sense—pressed by the business of tracing out his subject in all its particularity, down to the last irregularity of the sitter's fingernails, and never flagging, convinced to the

last minute of the importance of the job." He added: "The painting has a large rhythm, a sense of the whole thing in each part like an early Florentine portrait; though German is perhaps a truer derivation."[16] The British Council paid for it in December, enabling him to go to Paris again.

Paris, more than Dublin, remained the preferred destination. "It was so nice to be very easy about it. I felt a bit of a native. I used to go to Paris and with my small case arrive at the Gare du Nord on a Saturday night and go straight to the Bal Nègre and stay all night dancing and look for a hotel in the morning. I may have been broke but it didn't mean I was without money in my pocket. I never connected movement with money. Movement and money hadn't got any link. Kitty used to give me money sometimes. And copyright money was distributed and I'd be in debt to my father." Any work he did in a Paris hotel room had to be small scale: the drawings for *Flyda* were as sustained a group as he could manage, their air of fixation cooling into indifference. He took Kitty with him several times and it was there that he made the etching in which she becomes a character with a past, like someone discovered by chance, as it were, in a Sickert print: this woman under the blankets, lips parted, eyeing a rose. Kitty, who was prone to spending days in bed feeling exhausted or faint—migraines coming on—remembered him being solicitous, holding her head. He had come to expect her to wilt. "'I might become ill,' she'd say."

Ill in Paris has an air of incipient disdain. "I bit it in the washbasin: one dip, really quick and dangerous." The face half buried in the pillow looks trapped, squinting a little, gasping at the nearness of the rose, its leaf awkwardly inserted into the scene like a levelled blade. This is *Girl with Roses* nine months on and an aggravated version of *Interior Scene*: the drawing of a stem of Connemara blackberries and, half concealed by net curtains, Anne the interloper whose view of the Freud marriage—once she had found out about it—was that it just did not work: "I think Kitty was so needing, needful, it got on his nerves. Lucian couldn't bear anyone asking too much of him."[17]

Nine or ten impressions were printed of *Ill in Paris*, one proof of a smaller previous try—both eyes showing above the bedcover (he gave this to Dicky Buckle)—and two or three of an etching of a single rose, one of which he gave to Christian Bérard's lover Boris Kochno—a survival from the Ballets Russes who ran the Ballet des

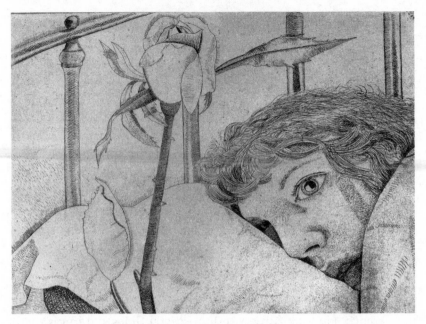

Ill in Paris: Kitty in bed, etching, 1948

Champs-Elysées. After that he gave up etching, telling himself that it cramped his style. When he took to it again, in the early eighties, eventually on a far larger scale, he did so as a painter resorting to it as a welcome alternative activity to painting with the practical advantage of each image being editioned.

Meanwhile he got on with drawing Bérard in bed. A first sketch he gave to the restaurateur of the Mediterranée, inscribing it "To Jean, Christmas 1948"; the second, his graphic masterpiece, turned out to be the final image of Bérard. "I worked on it probably for a month, went a lot. I went in the morning and we had lunch after." He finished it in December. Immediately before, Bérard had been drying out at the Saint Mandé Sanatorium. He drew him in his flat, fifth floor, 2 rue Casimir Delavigne, where from the roof terrace Kochno pointed out the attic where Rimbaud had lived. Henri Cartier-Bresson had photographed Bérard seated dazedly at the end of his bed, greatcoat buttoned up, a half-read Peter Cheyney thriller to hand. Now Freud drew him recumbent, his beard more neatly trimmed. He came closer to him than Cartier-Bresson had done, the better to examine the glazed

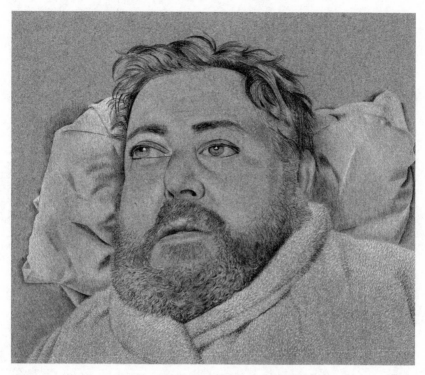

Portrait of Christian Bérard, ill in Paris, December 1948

eyes, the gourmet jowls. His Bérard was Holbein's Henry VIII, a lord of misrule laid low. Two months after Freud drew him, Bérard had a stroke—collapsing at a rehearsal of a play by Molière—died and was buried in the cemetery of Père-Lachaise. Beaton composed a eulogy for *Ballet* magazine.

> *With his fine beak-like nose, his untidy red beard and lank wisps of silken hair [he] was one of the best-known personalities in Paris. So great was his innate dignity, that even under the most farcical circumstances, such as when, in a violent fit of enthusiasm, he would try on himself the latest bonnet in the most fashionable hat-shop, his wild eyes defied one to laugh at him. When he walked down the Quais in his dirty cigarette-ash-covered shirt, his soiled coat and unbuttoned trousers, with his dirty little dog Jacinthe hooked underneath his arm, Bérard was the quintessence of French taste and elegance.*[18]

"One must start with everything," Bérard had said, "then begin to eliminate detail after detail until only the vital core remains."[19] Freud's drawing shows, with delicacy and candour, the exhaustion of the epicurean maintaining the pose, eyes turned up, lower lip slightly askew, the stubble on the jowls exquisitely flecked, white on grey.

Having drawn Bérard, Freud took Kitty south, to the Hôtel Welcome in the old port of Villefranche-sur-Mer, where Bérard had stayed, and the backstreets of which Jean Cocteau used as the underworld for his film *Orphée*, released in 1950. Christopher Wood and Nina Hamnett of Soho had been there too, as well as, most recently, the Sutherlands. Freud painted *Portrait of Kitty* (1949) in their room, her head in profile against the winter light and the blistered paint of the shutters, looking markedly older than in the previous portraits. "Very different character, a change very much," he said. When he exhibited it at the London Gallery the following November Epstein bought it, loudly remarking that he could not see what the fuss was about, it was "so traditional" a painting. "Kitty was the most patient model," Anne Dunn commented.[20]

Kitty returned to London, where Epstein made a wide-eyed bust of her. Freud remained in Villefranche for more than a month. Itching for company he went over to Meraud Guinness' Tour de César. "I walked, maybe got a bus; I never actually stayed there; I longed to meet someone who actually I could like." He also went to the municipal casino in Nice. "I was winning and it was rather late at night and the chips started piling up and suddenly there was a girl on one knee and another behind me looking over and there was another one on the other knee nearly. God, this is the life, I thought. Then of course, as I went on being watched, I went down and I didn't notice it, but then I just looked on my knees: the girls were nowhere to be seen."

As it happened, his younger brother was working on the Riviera. "Clement had progressed from the Dorchester to the Hôtel Martinez in Cannes. I saw him there because, playing roulette at Villefranche, I had not a franc left, so had to walk back from Nice. I arranged for him to give me some money. He made it difficult, making arrangements about walking to a special place." They met at a funfair in Cannes. His choice. "There were those machines that climb slowly up and come crashing down round a curve. Big Dipper. He wouldn't go on it. Two people had been killed the week before: a mother holding on

to her child. Well, of course, I'd spent all my money on it. Anyway, in the afternoon, after getting the money off him, I managed to make him go on it. (I may have a sadistic streak, I think.) I was down below watching him go round, roaring with laughter at his fear and anger; he couldn't get off he was in such a state. Then we went to a restaurant, a modest restaurant, and he said, 'This isn't quite right,' and walked into the kitchen and told them off."

By the window in his room he painted *Lemon Sprig*, *Still Life with Aloe* and, on an etching plate, *Still Life with Sea Urchin*, with ink dribbling under the doleful eye of the punctured squid. The hotel threw him out. "I left the Welcome because they thought I might burn the hotel down. There had been a burglary and it happened during meals and I didn't take meals, just had potatoes, so I was arrested."

The armpit creases in *Portrait of a Girl* (1950) are tellingly intimate. This was Anne Dunn again. She remembered the painting as having been done at a time of great strain: "Things in my life, things in Lucian's life, hidden relationships lurking." For one thing, her mother had no time for painter or portrait, which she did not recognise as being of her daughter, bare shouldered, nakedly independent. "My mother hated him. She couldn't bear the way he moved. He'd sidle in through the front door, he'd come in like a crab and she'd say, 'What's that rat doing in the flat?' So I had to tell her a lot of lies." She had moved to a flat in Alma Place to be near Freud in Clifton Hill, bought an Australian fruit bat as a pet and a cageful of doves, and took to painting like him. "I can't believe how innocent I was; I thought I was very sophisticated but in fact I'd been to bed with only about two people."[21]

Freud thought the innocence superficial. "Anne was competitive, particularly with her sister, Patricia, who had been having an affair with Aly Khan. Anne, aged sixteen or so and envious, managed to go to bed with Aly Khan and he was taken with this jerky, wild, younger sister and said, as she got out of bed, 'If there's anything you want, just ask'; and when I met her three years later she was desperate for money so she said, 'I'll write to Aly Khan.' She asked for a hundred pounds and he sent her it, a lot in those days. He was a wild gambler and short of money himself."

A predictable crisis propelled her back to her mother. "The first time I was pregnant my mother was naturally absolutely furious and wouldn't help in any way and then eventually she did but she said, 'He's got to pay for it,' and I knew perfectly well that he wouldn't, and so I had to get someone called Derek Jackson to pay for it. He was wonderful."[22] Then for a while she lived in part of the house Cyril Connolly had in Sussex Place near Paddington station. Freud "saw a lot of her" there, he said, and she began a portrait of him. Connolly had a crush on her and bought Freud's painting of her, selling it on to her many years later.

Looking back she saw that the competitive possessiveness was stimulated by devious urges. "A lot of people like Cyril were a little bit in love with Lucian and Cyril wanted the relationship with 'his women' as it were, for himself: Lucian somehow put his signature on something that Cyril wanted. Lucian was very scathing to me at the time about Cyril and I was so enamoured of Lucian and so completely his creature I kept seeing people through distorted vision: I thought everybody was ridiculous, that Cyril was ridiculous." Freud's hold on her was, for a while, absolute. "It is hard to remember: I thought it excruciatingly painful and life without Lucian would have no meaning whatsoever. He was the sun and he managed to downgrade and diminish everyone else in his eyes. In removing himself he removed the reason for existence. I was very influenced by him; it took a long time to break away."[23]

By Freud's account the pursuit was primarily her initiative. "She sort of chased me. She had an amazing energy and determination about money, which was rare then, in 1949 or whenever. She came in for quite a lot of money quite a bit later, but she had a lot of half-sisters and her father decided, as old men do, that she wasn't his. She looked at art a bit and pre that was a nice girl who painted horses. Her mother showed her work to Salvador Dalí." The effect on her of Freud's energy and impulse was devastating. "His invasive spirit transformed my world and my perceptions of it. A firefly in the fog of a drab and exhausted post-war London."[24]

The firefly flitted from woman to woman and "one never knew how many," she said. "That was very worrying. An analogy is Barbara Skelton who used to drive Cyril [Connolly] absolutely mad: every time he turned his head she'd gone off with a waiter or something.

It was extraordinary how quickly Lucian would work. Next minute he'd be gone."[25] One night at the Gargoyle Freud met Stella Clive, a dancer in the Royal Ballet who later became a hoofer in *The Boy-friend*. They went off together in a taxi and she appeared at the ballet the next day with a sore lip; there had been a struggle, she explained. This strange young man phoned her and made demands; she was not prepared to sit for him and as she was working she saw no more of him. Frank Auerbach, who first knew Freud a few years later, felt that the womanising wasn't wholly predatory. "Lucian didn't speak like somebody who put notches on the bedpost or anything like that, he was actually absolutely romantic." It was more a matter of hoping for reciprocity or indeed matching psyches. "He had a relationship with a girl he picked up in Soho who had a terrible stammer; he on the whole was very discreet but he told me he found the stammer very erotic. At climax she called out 'Mummy, Mummy!'"[26]

Anne Dunn recognised that he had a perhaps compulsive desire to have the upper hand. "One doesn't walk into a victim situation but if one perhaps had been victimised in one's childhood Lucian was quite productive at bringing that out. I think he looked very like his grandfather and behaved like his grandfather. The same control. One was clipped on to a dynamo."[27]

Freud gave her a heart tattoo on her thigh, taught her how to hold on to the backs of lorries and buses when they were cycling around London and did his bit to advance her professionally.

"Ann Rothermere asked if I'd give out a student prize at the *Daily Mail* Ideal Home Exhibition. I said yes. It was quite a grand prize—£100 first prize—all these pictures were put round a room and Cathleen Mann and I went along, and an art critic with a double-barrelled name, I forget who, very bored. All very bored. And there was a picture I really liked. I was excited. I thought I'd not seen a better one and I got it the prize. It was Anne Dunn I gave it to. (There was a connection: Anne was Cathleen Mann's mother's ex-husband's daughter by another wife.) If someone's very keen it's stronger than not being interested."

Some years later, Freud heard, Anne Dunn talked to a doctor in New York about not drinking. "She said, 'I'm very awkward and shy and so I really have to drink to make me talk.' 'Why talk?' he said."

First Recognition
1949–58

"My *large* room in Paddington!"

"I used to go to lunch with Marie-Laure de Noailles in the Marais: *hôtel particulier*, a large shady garden. She'd say, when I first went, 'Would you like to stay back?' Bérard took me the first time and she was shocked that I'd only been once to Vienna. She had a lover in the war, an Austrian count, who lived in Vienna and she said, 'Why don't we go for a trip?' Yes, I was married to Kitty by then . . . Marie-Laure was famously mean but stupendously rich."

She was in her mid-forties. Her father had been a banker, her mother was a poetess. ("There's a late Vuillard of this tiny woman in bed with manuscripts around her.") And she and her husband, the Vicomte Charles de Noailles, were seasoned patrons of the Moderne, Surrealism in particular. They had commissioned Buñuel and Dalí's *L'Âge d'Or*, the Vicomte insisting that Stravinsky write the score and Buñuel insisting that he should not. Even their wealth was surreal. "They owned New York harbour . . . I think they had a very bad time at the beginning of the marriage, which was arranged: grandeur marrying money." She had come upon the Vicomte embracing his gym instructor; subsequently they lived in separate parts of their house in the Marais, a *hôtel particulier* with dark mirrors set into the walls of the garden. He had his own staircase.

A woman of varied accomplishments, she was a painter. "They had something very nice about them," Freud said. "I think she made anagrams and screens. She had a collection. She had a letter from Picasso about going to brothels (in Barcelona I think), all illustrated.

I loved going with Marie-Laure to the theatre and so on, but the idea that the chauffeur was outside waiting—I didn't like that. One of her lovers was a painter called Tom Keogh; his wife was a novelist and she did something absolutely brilliant: she started an affair with Baca the chauffeur."

In May 1949 Freud and the Vicomtesse went by plane to a Vienna soon to be used as the location of *The Third Man*: Graham Greene's "city of undignified ruins" abjectly split like Berlin into American, British, French and Russian zones. "The Russians being so contemptuous of the Austrians they arranged for the airport to be Russian ground, where taxis wouldn't go, so we had to be met by a car at the airport: she'd got that thing of making things rather special. (She quite waved it around that she was a vicomtesse. Monstrous behaviour.) Vienna was amazingly gloomy and beautiful; the Habsburg tombs; the beauty of the river going through. I noticed no children anywhere: very odd. We stayed about a week.

"She took her amazing heavy jewels, worth a million and so heavy on her neck they made bruises. We went into antique shops and two assistants were kneeling on the floor looking at the things on her neck and wrists: she had all these jewels on, very bizarre. Then we went to some nightclub and I separated from her and she rang at 4 a.m. 'Darling, I've been robbed of all my jewels.' But it turned out that one of her friends—she was drunk—took her jewels off for safety. Something I only noticed when we travelled was that she'd got immaculate behaviour. She said, 'Darling, if you'd like company I'd be delighted to see you,' and gave me her room number. I was several floors above her." They were staying in the Grand Hotel. "I went to the barber's shop there and the man said, 'You are a self-shaver? *Selbstscherer*.'" Which sounded to me like *Selbstmörder*, suicide.

"I did some things with Marie-Laure and some not." At night Freud preferred to be unaccompanied. "I rather went out on my own. I met a girl I thought wonderful, married to an American at the Embassy, an upper-class Italian girl; and I went round the nightclubs. The same people were going from club to club. These places, in basement rooms, were unbelievable: curtains shaking and groaning behind, Russians in ill-fitting uniforms and all the Austrians being terrified of them."

Proud of being the great-great-great-granddaughter of the Mar-

quis de Sade and owner of the manuscript of *The 120 Days of Sodom*, Marie-Laure had an idea. "She'd got that thing of making things rather special. We were introduced to Dr. Masoch, a sort of professor at the university and the great-nephew of Sacher-Masoch. So she said to him, '*Sie sind Masoch, er ist Freud und ich bin Sade.*' There she had it: sublime coincidence, a surreal royal flush. "The man ran for his life."

Another expedition brought out her dynastic bent. "We were in the Habsburg tombs. At the very very end of the rows of barred cells, which begin in 1400, there were empties waiting and she said, 'Oh no, Charles's little nephews!' She was proud of it and said it in English."

They looked at the Freud house at Berggasse 19. "I only saw it from the outside. Marie-Laure was shocked that there was no notice and arranged to have a plaque put on it." This could not be done overnight. It was five years before a plaque was unveiled, and then only because the opportunity presented itself when the World Federation for Mental Health met in Vienna.

By day Freud went to the museums and found them deserted. Many of the Kunsthistorisches Museum's paintings were away on a tour: as it happened, they were in London that month, at the Tate. "But the Brueghels were there, as they are on panels and couldn't tour, and I was very impressed by the Bellini: the woman looking in a mirror, his only secular picture." He went repeatedly to see Brueghel's *Christ Carrying the Cross*, its trail of humanity obscuring Christ, the gibbet and the crow, the leaping dogs, the thistle in the foreground, the muddied cartwheels, the cutpurse—a Paddington face in a Paddington crowd—and the skull. "I thought how marvellous, how *far* things are, how extreme to have a momentous event incidental: the action, the tragic story, leaving it in the middle distance. The fact that it could mean so little to someone."

One week of Vienna was enough for him. "Vienna is about as Baroque as I can stand." In later years there were to be calls from Vienna for the Sigmund Freud furniture to be shipped back for a Freud museum, and there was to be a Freud memorial on top of an underground car park ("A bit of turf: park your car, go upstairs, and jump about on this tin roof with turf"). To the grandson the objection to such amendments was not political, let alone moral. "Just something to do with their reactionary attitudes and smug optimism." Though a drawing by him of two pigeons had been included in a

British Council exhibition for Vienna the previous year, he vowed that he would never exhibit in Austria. The deaths of his great-aunts were not to be put aside.

Back in Paris, Charles de Noailles asked Freud whether Marie-Laure had got into trouble at all in Vienna. He was reassured. Marie-Laure, Freud found, was prepared to be helpful. Impressed by the drawing of Bérard she said that she would get Freud a commission to paint Count Alexis de Redé. "Where did he get his title?" he asked.

"Marie-Laure was naturally active, very impulsive, sophisticated and very emotional." She also wrote novels and painted. "One was of a man with a sword, three-quarter length. Snot colours. 'I got so tired of people saying they looked like me,' she said. She obviously did get passionately interested in people, but mostly with queer people who were all in competition. The first time I went with Bérard to one of her grand lunches—distinguished people, Poulenc was there, and tarts, and there were footmen posted behind the chairs—she kept me back and said, 'How do you like my collection of reptiles?'

"There was a party where the house was turned into a village, Daisy Fellowes did the food and her huge Spanish lover, a faker of Picassos, was there: Óscar Domínguez, who stole things from the house and copied them; he was really wild and quite dangerous. He charged me like a bull, probably because I'd been talking to Marie-Laure. His pictures were spectacularly bad. He did ballet decor and killed himself. There was a photo in French *Vogue* of a party of Marie-Laure's. *Tout Paris* was there, apart from the very grand people who thought Marie-Laure was immoral. Georges Auric, Poulenc, Dior, were named and in the spine was me: my name wasn't there, but my mother found the photo and kept it."

Two full-length portraits by Goya hung in the dining room. Freud noticed some years later that they had been removed to a drawing room. He asked why. "Darling," the Vicomtesse said, "people kept comparing me to the Goyas." Once she had proposed to Picasso: "You be Goya and I'll be the Duchess of Alba." Portraits, some flattering, of Marie-Laure hung in a ballroom, portraits by Bérard, Berman, Dalí, Tchelitchew. And by Balthus who, when he painted her in 1936, had told her that he couldn't manage it in such surroundings. "So he took an obscure room—bed and chamberpot—and locked her in and went away for three hours." Though Freud thought the por-

trait good, he didn't especially like it. "Why have this hard wooden chair? I thought. Marie-Laure called Balthus '*Ma jolie petit rat.*' Quite accurate."

Balthus claimed to be more nobly born than Marie-Laure, to be a Polish aristocrat indeed: namely Balthasar Klossowski de Rola. "He wasn't the Comte de Rouelles in those days, he was M. le peintre Klossowski." In fact he had been brought up by his mother in straitened circumstances, initially in Berlin; Rilke had been a surrogate father to him and had arranged for the publication of drawings of Mitsou, his disappearing cat, done when he was ten. His nickname, "Baltusz," on the cover became his name for life. He never, he said, stopped seeing things as he saw them in his childhood. The Balthus look, described by Antonin Artaud as "organic realism" and essentially polished Courbet, affected Freud, particularly the peepshow intensity of the illustrations for *Wuthering Heights*, published in *Minotaure* in 1935 and which he came across reproduced in *Lilliput*. Some of these drawings belonged to Marie-Laure, the rest to Duchamp. Peter Watson had warned Freud that Balthus was highly strung and liable to spit at anyone who wore a tie. Yet when they first met, Balthus was wearing a tartan tie, implying Scottish connections. He explained that the Gordons were among his ancestors; this he maintained gave him a claim to be related to Lord Byron. Freud appreciated the forging of a romantic link for its absurdity more than anything. "I wasn't in awe of him." Balthus' self-serving assertion that "paintings don't describe or reveal the painter"[1] was, he conceded, well worth saying, no matter who actually said it. Balthus then, and later, was apt to be disparaging about "Dear little Freud," saying, "He could have been good."[2]

They were in a bar once, the Bar Vert in the rue Jacob, Francis Bacon was there too, and others, and Balthus had been asking about Kitty, and Epstein, when he suddenly remarked, "How curious, to find oneself talking about Epstein." Pompous old fool, Freud said to himself. Already he preferred Balthus' early work to what he was then producing. Such as the landscapes: "There's a slight Nazi painting thing about them. Looking over the gate."

In 1947 a ban on the import of foreign art for sale in the UK was imposed. "If it is extremely difficult for a painter to move around the world or export his wares, it is quite impossible for anyone else to go abroad to look at painting," Cyril Connolly complained in a *Horizon*

editorial in 1947.[3] Anything brought in had to be returned within six months, which meant that, for practical purposes, smuggling became standard procedure in the international art trade, such as it was. Balthus asked Freud to take a painting through customs for him and deliver it to Connolly, the idea being that an article on him would be published in *Horizon*. If challenged he should say that it was one of his own. They wouldn't be able to tell the difference. "The customs will look at this picture *comme une vache regard un train*." Freud did as he was told and passed through Dover without a hitch. "The customs really liked that picture—a little girl up a ladder in a tree—and I said I'd done it because I'd got materials in my luggage." In April 1948 the painting, *Les Cerisiers*, was reproduced in *Horizon*, illustrating an article by Robin Ironside in which he talked about "the immediacy of reality."[4] Connolly failed to pay for the painting and soon sold it.

While Balthus could claim to be the modern Courbet, Realism (seen as sad reality) was more associated with Francis Gruber, the painter of emaciated figures on bare floorboards, who died in December 1948, a martyr to privation. Shortly afterwards Freud saw a group of his paintings. "He'd just died and round the corner, at the Ecole des Beaux Arts, there was a memorial exhibition in a brown room: a roomful of pictures which did impress me. Their influence on Giacometti, or the other way round, was it? I looked at them and I believed them: they seemed to work well, then less so, later on."

Once when Kitty joined him in Paris Freud introduced her to Giacometti. She asked him if he had heard of Epstein. "He said, 'Le grand Epstein, bien sûr,' and she said, 'Why do you say "Grand Epstein"?' She had no idea that Epstein was great, or that her half-brother Jackie's mother was Isabel [Rawsthorne], who was famous for having been with Epstein as well as Giacometti. Giacometti once lent me money. I asked him how would he like it back, and he said, 'Give it to Isabel.' We went out quite a lot together. I impressed him once. Kitty and I were at the Coupole with Annette and Alberto and as we left some louts started pulling girls about and I tripped them over and Giacometti thought me terribly heroic."

Giacometti had seen *Dead Heron* in "La Jeune Peinture en Grande Bretagne" at the Galerie René Drouin the previous winter. "He said he had seen it: out of politeness, not interest."

. . .

Still Life with Squid and Sea Urchin was bought—nominally by Robin Ironside, purchaser at the time, actually by Kenneth Clark—for the Contemporary Art Society (CAS), which presented it to the Harris Art Gallery, Preston. Clark maintained that distributing paintings to provincial museums was the best possible patronage for young artists; he often did this through the CAS, notably a number of Sutherland drawings, which he distributed to regional galleries in 1946. Freud was dubious about this skewed generosity. "He did something which I think was wrong, which is, he bought to encourage whether he liked the stuff or not. He was very lonely. Girlfriends, yes. He began buying when he was at Oxford: buying a Tintoretto. Ruskin he idolised and, unlike Berenson, he was a good teacher. The only lecture he gave at the Slade that I heard was on Classicism and Romanticism. I couldn't tell until the very end which side he was on."

Clark projected his inhibition and detachment on to others. "Great artists seldom take any interest in the events of the outside world," he wrote in his autobiography, the second volume of which tailed off into accounts of official commitments. He had perhaps led too charmed a life, Freud thought. To Clark, Freud was a young artist in the unclassifiable category. "In the history of English art a few of the most gifted artists have always stood outside the main tradition," he wrote in an introduction to an exhibition selected by him, with Robin Ironside and Raymond Mortimer, in 1950 for the English-Speaking Union of the United States, for which the Freud he chose was *Sleeping Nude* (1950). Consequently, and unexpectedly, Freud was offered some teaching. "Clark took Coldstream to see the painting and Coldstream wrote to me saying he was going to the Slade and offering me one day a week, 10–5. He felt that unreliability should be catered for; he thought I represented unreliability."

William Coldstream became Professor at the Slade School of Art, part of University College London, in the autumn term, 1949. His methodical painting, described by Lawrence Gowing as "the system that maps the visual evidence,"[5] had been written off ten years before by that inveterate writer-off Geoffrey Grigson in his magazine *New Verse*, as "a blind man's painting—clever, correct, well informed,

academic and frozen."[6] He had become a practised portrait painter (Bishop Bell, Lord Jowitt) and an accomplished committee man, notably as a trustee of the Tate. He brought with him to the Slade from Camberwell, where he had been head of painting, a number of staff and students, testimony to the fact that his teaching was more persuasive than Grigson allowed, and more tolerant. "If there was one thing I really did value it was the individual statement," he said, and that, combined with his constant advice to students to "look more closely," recommended Freud to him.[7]

Interviewed in 1965 by Rodrigo Moynihan for Anne Dunn's magazine *Art and Literature* Coldstream said, "what struck me early on was that there is no idea of representation that can be agreed on . . . it does strike me that there is a possibility for representational painting that leaves one with an extraordinary amount of freedom."[8] In a BBC broadcast on Holbein in 1947 he said how "deadly efficient" Holbein was, painting portraits from drawings. "I do become terribly interested, almost obsessively interested in anything—even still life—that I start really looking at."[9] The sitter's presence was essential, ensuring as it did that liveliness was at stake. "I can't work at all without something in front of me." Coldstream found the obsessive processes liberating. He became, for Freud, something of a marker: the dogged practitioner to be respected, not least for his forbearance as an employer.

Freud's teaching stints were as intermittent and evasive as he could make them. Initially younger than many of the ex-servicemen students, he was much too shy, or preoccupied, to be an engaged or indeed proficient teacher. There were exceptions such as Michael Andrews, six years his junior and fresh from National Service in Egypt, who impressed him with his astute diffidence. Taking students to the galleries was, he decided, a good way of avoiding the strain of conversations at the easel. He never had the nerve to work alongside them in the life room, as Euan Uglow—a Slade student from 1951 to 1954—did when he graduated to teaching. He needed his privacy. "I used to walk in and watch. I didn't like being watched." Stanley Spencer's daughter Unity, who was at the Slade in the early fifties, used to see him come nervously into the life room and make a beeline for one girl, being too intent, or uneasy, to pay attention to the others. He hit on a strategy for showing his face without being waylaid. "I had this

idea of an optical thing: if something goes round fast enough people think it's still going on. I based my visits on this thesis. Went through all the rooms three times, at enormous speed, wondering what I was doing there. Once I went in a room and was bitten by a dog and I thought at least *something* happened here: never been bitten by a dog before (I always get on well with dogs), so I thought, well, yes, there has been an interaction." Another time—another interaction—he paused for once behind an easel. "There was a very odd man, a big bloke. I did that thing of standing and looking at him working, which I felt uneasy about as I loathe being watched as I work. 'Are you the new Inspector or something?' he asked. 'I'm the part-time visiting assistant lecturer.' 'Well, I suggest you fuck off then.'"

Had the situation been reversed, Freud added, it was what he would have felt. The student was called Norman Norris and his reported remark ("Oh, fuck off, Freud," it was said) became Slade legend, according to a later painting student, the cartoonist Nicholas Garland. "What courage. What aplomb! The story would not have been told about Mr. Townsend or Mr. Rogers or anyone else because to speak to anyone else like that would have been simply rude and stupid."[10]

Duties at the Slade were undemanding in that, having no particular desire to teach, Freud felt that his involvement could only be marginal. "I was surprised how much it was for a day. £50? It wasn't that it wasn't useful, but I've never had a proper economic structure." Earning regular pay was a novelty. As for actually earning it, others who taught there found him hard to take. Claude Rogers, worthy co-founder of the Euston Road School, went up to him one day when he was sitting in the common room reading the newspaper, whipped it from him and sat down to read it. "He just took it out of my hands. And newspapers mean quite a lot to me. Enough to get out your gat and shoot 'em in the balls."

"It is worth trying for a moment putting oneself in the position of a foreign observer new to England but unprejudiced," George Orwell wrote in his 1947 essay *The English People*. An outsider, he suggested, would find "artistic insensibility" characteristically English, also "gentleness, respect for legality, suspicion of foreigners, sentimen-

tality about animals, hypocrisy, exaggerated class distinctions and an obsession with sport."[11] In *Camera in London* published in 1948, Bill Brandt talked of an imagined photographer of London—obviously himself, formerly of Hamburg—who had "something of the receptiveness of the child who looks at the world for the first time or of the traveller who enters a strange country."[12] Freud could still remember coming to England flush with just having read *Black Beauty* and *Alice's Adventures in Wonderland*. Restless, nervous, unsettled, he had spent what was left of his childhood being the Young Mariner venturing and floundering in a strange, in many ways baffling, intriguingly stratified society.

"If one likes Paris one tends to think that the Parisian will not like London," Stephen Spender suggested in a *Horizon* editorial published shortly before VE Day.[13] After the war London with its bombsites and general dilapidation took longer to recover than Paris; among the attractions of Paris were its denial of the immediate past and the verve with which its cultural pre-eminence was reasserted. Rationing soon died out there and licensing hours did not exist. Freud went to Paris whenever he could; Paddington however was where he worked, mostly, and carried on. The poet William Plomer wrote of it as a near-ghetto: "Long been favoured by the Jews and the Greeks as a quarter to live in . . . Its population has a grubby fringe, a fluid margin in which sink or swim the small-time spiv, the failed commercial artist turned receiver, the tubercular middle-aged harlot."[14] Given his passport to Paddington Freud felt he was armed against class distinction. The Slade in Gower Street was a weekly fixture, on and off ("more often off than on," he added); Soho was for seeing friends, St. John's Wood for intermittent domesticity. "My LIFE was at Delamere, and I'd sometimes go back to Clifton Hill. It was partly a class thing. I always felt that extreme social change gave me what travelling gives other people. My travelling is downwards, rather than outwards."

Popular belief had it that the rents of Paddington brothels went to the Bishop of London while across the canal lay respectability. Along the canal, towards Paddington Green, the populace was more mixed. "The Warwick Arms where I drank a bit, the Williams-Ellis bookshop and a café opposite run by a mad Polish woman; Feliks Topolski used to go there and he told me that she used to think people were wanking and she'd say, 'You can't have pleasure in my café'; the

Jewish fish and chip shop, really horrible, trying to make people more anti-Semitic." The bargee pubs by the canal had been busy until the war, but no longer. "The Old England, round the corner, had couples fighting and extraordinary old boys, twenty pints of beer in an evening, singing 'I never been done, never been interfered with.' They couldn't make me out. They thought I was some kind of either prince or foreigner. They'd got awfully good manners though. 'Do you do, like, photographs?' they'd ask."

"Crime belongs exclusively to the lower orders," says Lord Henry Wotton in *The Picture of Dorian Gray*: "Crime is to them what art is to us, simply a method of procuring extraordinary sensations."[15] To an outsider, Paddington ways were stimulating, not to say Nietzschean, and risky. The first time Freud took Frank Auerbach into the Old England he declined an offered drink and Freud had to explain to him that you didn't actually have to drink the drink but it was unacceptable to say no. Having taken to being something of a local character, Freud showed off his social gumption.

"I liked going to dice games, especially clubs where Charlie's friends met. Charlie was good with girls. I used to envy him because we'd be walking down the street and there'd be girls and Charlie would say, 'Hey, what yer doing later? Come and have a drink.' 'Oh we're busy,' they'd say. 'See you,' he'd say. I felt too tense to do that, too excited seeing girls; he was very good with them. We were generally known as friends. We got on very well. Sometimes things that I didn't understand Charlie would explain to me: the harsh ways and laws of the life there, such as the things people were respected and despised for. I went a lot to the Met in the Edgware Road and Charlie would go in the circle at the very top and fight, like in Sickert pictures: always fighting and shouting and making passes at each other. Max Miller used to slip out and drink in the bar at the back where he could watch the audience and stage. Marvellous jokes. 'If those five hundred dancers won't be allowed to dance with their brassieres off it'll be a thousand pities.'" Clocking his audiences from behind, Max Miller saw them as bawdy livestock.

"Charlie was in reform school quite a lot. I heard this clinking in his jacket; it was a knuckleduster and I took it out; next day he came back with an eye almost out and I felt bad. He and another boy had had a fight. I went to Humphrey Razzall, who was Johnny Minton's

solicitor, to brief him about Charlie and he said, 'You're living in a dream world. This is an attempt at a salvage job.' Razzall got to question the other boy, though; Charlie had hurt him rather badly and he said, 'What would you have done to Charlie if you'd caught him?' and what he said got Charlie probation, not jail."

Charlie Lumley—"Your Little Genie" as Douglas Cooper referred to him when taunting Freud—made Paddington seem at times almost a *Guys and Dolls* neighbourhood. Charlie was incorrigible, Anne Dunn felt: "I always remember Charlie Lumley stealing a watch belonging to a friend that I had undertaken to have mended. Lucian eventually forced him to give it back. There were serious raids on the Spenders' house when L was in his 'Genet' mode with Charlie."[16]

"In a way that's rather bad-mouthing," Freud commented. "I looked after Charlie. I made his life much easier: money and comfort. He was good company. He seemed to get into trouble more when I went away. I went round one of the Borstals he was in and there was a room without windows, with a concrete floor; they said, 'When they feel wild we let them in here to relax.' I got really nice letters from him in prison. He was very bright and quick-minded and he very much went about with me. Kitty quite liked him. He stayed at Clifton Hill a lot."

Frank Auerbach, who met Freud first in 1955, suspected that there was rather more involved than Charlie just tagging along. "One sometimes wondered about his relationship with Charlie because Francis told me that Lucian had told him that sometimes he woke up—and it's not entirely rare in Lucian's life—in the same bed as Charlie and thought, oh yes, it was only Charlie, and turned over. That was Lucian's story."[17]

Comprehensive Development Plan Area 13, Freud's part of Paddington, was itself a strange country in which, behind the stucco façades of Bayswater and the stews of Clarendon Street and Westbourne Grove, notoriety was more likely than fame. In November 1949, at 10 Rillington Place, less than a mile away from Delamere Terrace, Reg Christie the necrophiliac had to decide where to conceal the bodies of his latest victims: in the washhouse or under the floorboards? He was pushed for space.

"Strange lives," as Kenneth Clark had said. Strange but true: one of Freud's neighbours claimed to be a descendant of Anthony Trollope who, of all Victorian novelists, was the one who harped most on the contours of class. Freud came upon Mr. Milton shortly after he moved into Delamere Terrace: "They'd taken the railings for the war effort, leaving patches of earth in front of the houses, and the coal man next door, George Nightingale (who fed his horse on pineapple, as he had worked in a circus and knew a thing or two, and who dyed his hair, and children teased him as they can tell when people are vain), had a huge pile of manure with straw in his front patch. I came out one day and there was this gent, bald and in tweeds with a malacca cane, looking for something in the dung heap.

" 'Good morning,' he said, poking at the straw. 'I wonder if you've seen my false teeth anywhere? Of course you wouldn't. Silly of me.' He was sort of crazy. 'I've been thinking recently of going back to the United States,' he said. 'When were you there?' I asked him. 'I haven't been,' he said. He was a draughtsman and a gentleman, incredibly poor because he was too disorganised to get the dole."

In 1949, Henry "Bo" Milton found himself posing with his daughter for Freud, much as Balthus had arranged *Miró and his Daughter* in 1938: same restraining hand and a similar baffled look as he parts the bead curtains (bought by Freud at the Galeries Lafayette in Nice) with his knees. Well turned out in hat and cravat, he radiates tension. He knows that he is a gentleman, but does the painter appreciate this? Milton's pale eyes look less observant than his daughter's dark eyes, inherited from Ruby, her mother, who used to come and clean Freud's rooms. The Miltons lived chaotically but had a phone and Freud used to climb across the balcony divide to use it.

"Ruby had been in Soho and around a lot, at the Coffee An'. She was Italian, from Glasgow, and had obviously been very attractive." He had drawn her as *La Voisine* and painted her in 1949 as *Woman with Carnation* in a velvet-collared coat. "Her eyes were a bit mannered, I thought."

Over the years portraits acquire resonance. People ask who the subjects were, and what became of them. Ownership adds associations. *Father and Daughter* was bought by Richard Addinsell, composer of the pastiche Rachmaninov *Warsaw Concerto* for the film *Dangerous Moonlight*, a wartime hit. He hung it, this faintly hostile picture, over

his grand piano. Sitters live on for a while but their portraits generally outlast them; yet what happened later to the sitter may become part of the picture's hold on the imagination. Bo Milton's daughter Paula grew up to be a friend of Christine Keeler, the call girl at the heart of the Profumo scandal in the early sixties, an affair that unfolded like a twelve-part Trollope serial. (Her brother John dabbled in antiques and was involved with Stephen Ward; he burgled, widely, and killed himself in 1984.) "Things that are relevant and true are worth having," Freud argued. "Gossip is only interesting because it's all there is about anyone." A portrait defies the gossip. *Father and Daughter* is the moment before the beads lap together again and the figures separate.

When Bo Milton died a few years later, the family were moved to a council house opposite Freud's parents in St. John's Wood Terrace. There was a burglary. A number of figurines—"some Cycladic, very small, some good things"—mostly given to Ernst by his father were stolen and Freud had his suspicions. "I told my Aunt Gerda, not necessarily to tell the police, and she said she didn't want to do anything as they were about to get the insurance money."

To most of his neighbours in Delamere Terrace, Freud was not the bearer of a famous surname but the young bloke who used taxis and received telegrams and had posh visitors. Some called him Lu the Painter, like "Hot Horse Herbie" or "Benny the Blond Jew" in Damon Runyon or the London types in the Gulliver column in *Lilliput* magazine. When they referred to "saucepans" (i.e. saucepan lids/yids/Jews) he said that he replied, " 'None of that: *I'm* a saucepan,' and they said, 'No you're not: you're a gentleman.'

"In Delamere they used to say to me, " 'Ere, Lu, do you do that Epsteen stuff? That Picasso stuff?' There was a sort of anarchic element of no one working for anyone." Colin MacInnes dubbed the district "London's Napoli": a place that "the Welfare State *and* the Property Owning Democracy equally passed by."[18]

"Charlie's family of seven were living next door while I had a whole floor to myself—kitchen and bathroom in one room—so I was considered rich." Certainly Charlie thought so. The bank in Maida Vale called Freud in and told him: "Try writing your cheques properly, it's in pencil and pen, all over the place." Seeing that it was only a £4 cheque that Charlie had cashed, he explained that it was a friend

of his who had done his signature so there was no need to take the matter further. "He had amazing awareness and quickness and liveliness. In a store he'd say, 'Look what I've got,' and there would be something under his coat."

In George Orwell's Prole London of the late forties, projected into *Nineteen Eighty-Four*, boarded-up houses mark the divide between the salaried—with whom Freud could not identify—and the proles, a warm and feckless breed, swarming in their condemned dwellings. The ways of the proles, carrying on a world away from St. John's Wood Terrace and Clifton Hill, were pleasing because, Freud found, they never presumed, living hand to mouth as they did with close horizons and reckless etiquette.

"The Page family, neighbours, had costers' stalls in the Bell Street, Church Street, Broadley Street markets, veg and fruit stalls, so there were barrows sometimes outside the house. They didn't have shops because of their waywardness and what went on drink."

One of the Pages, the head of the family, died. He had been a regular at the pub and Freud, being "known a bit," he said, in the street, was expected to go down the road and pay his respects. "There were all these different generations—I was a little bit older than the young ones—standing in the front room and there was silence. And then one of them suddenly shouted, 'He was a great man.' Then it was quiet again. Black leather chairs round the walls and a terrible discomfort and this oak coffin at the window, which probably belonged to the undertaker." He was urged to view the corpse. It had been embalmed, the face thickly painted. "Very heavy brushwork, lots of impasto: it looked as though it had been laid on with one of those wooden spoonish things you do butter with. The *work* that went into it, amazing." He stared into the coffin, fascinated by this death-defying form of indulgence. The face reminded him of one of those Romano-Egyptian Faiyum funerary portraits his grandfather had collected. He stared and stared. Then suddenly he realised that he had been engrossed for perhaps ten minutes. Embarrassed, he tried to think of an appropriate remark. Eventually he broke the silence. "I said, 'You couldn't have done more for him.' It was the right thing to say because it had cost a packet."

. . .

A Delamere neighbour who knew a thing or two about court appear-
ances offered advice. "It's when you're in the right, Lu, that you need
a good witness." Acting on this, Freud asked Cyril Connolly, Sonia
Brownell, Peter Watson and Cecil Beaton to testify that he would
never have said what had been asserted in *Time* magazine only to learn,
when the case came up in the summer of 1949, that not more than
one witness was allowed. The magazine did not—as Wilfred Evill, his
solicitor, had expected—settle out of court. Henry Luce, who owned
Time Life, had a policy of fighting every case against his publications,
deeming them as he did above criticism and beyond complaint. In
August that year *Life* was to demonstrate its myth-making powers
when it published a photograph of Jackson Pollock posed—as Freud
had been posed—in front of a painting. The headline alone "Is he the
greatest living painter in the United States?" was enough to project
Pollock into notoriety. *Time* had labelled him "the darling of a high-
brow cult" and dubbed him "Jack the Dripper." Legitimate word-
play: he couldn't sue. Reacting to a later review he sent a telegram to
Time, "NO CHAOS DAMN IT," but his lawyers advised that no libel had
occurred. Compared to Time Life's handling of Pollock, Freud's case
was an obscure affair. Artistic reputation was not involved and the
hearing was over in a day. There was, however, a real grievance. Freud
resented being made out to be an alienated ingrate. And there was the
possibility of damages.

Gerald Gardiner, representing the plaintiff, described him as
"this young man who had been to an English public school" and
drew attention to his "war service"; he also sought to establish that
Time magazine had been pursuing a policy of disparaging the British,
Freud remembered. "It was at a very anti-British moment in Ameri-
can relations so, to give some idea of what this was, Gerald Gardiner
started reading something very rude about the Queen and said, 'I
think I will spare the judge and jury from hearing more.'" The judge
thanked him.

Cross-examining Freud, the defence barrister, Sir Valentine
Holmes, tried a cosmopolitan slant. "He was trying to break me
down; not break me down but get me to say something." He talked
about Freud's "travels in the South, in sunny France and beautiful
Greece," implying that he had no time for England. "No wonder," he
said, "when you got back to your small room in Bayswater—"

Freud interrupted. "My *large* room in Paddington!"
(Laughter in court.)

"Bayswater is the genteel name for what's nearest the park," he later explained. "I felt that was a turning point, rather . . . I was said to have said, 'In Britain everything is so foul and crazy that artists either go crazy, become a Surrealist or get into a rut,' and to have gone on about 'the clockwork morality of Britain that one feels on a bus . . .' It was talk about licensing hours and so on." Why clockwork? "I was talking about the symbolism of the clocks in the work of Giorgio de Chirico," Freud explained. It so happened that the judge, Lord Goddard, had attended a dinner held recently to mark the opening of a de Chirico exhibition at the Royal Society of British Artists so he let it pass. A hanger and flogger, Goddard was notoriously hard on softies. Observing that the plaintiff had been described in the article as having "dreamy eyes and frayed cuffs," he said, "I'm surprised you aren't suing about that."

"The summing up was so violently against me and ridiculing me that the jury—a special jury of higher rate-payers only—gave me the verdict, and costs, which must have been huge, were paid by them. Gerald Gardiner said to me, 'Lord Goddard is one of those old-fashioned lords who sums up in a way that goes against the way the case has been going, to make the jury think twice.' Costs were huge: people had to come over from America. I checked up a bit and saw the chairman of the jury drive away in a Rolls-Royce." The plaintiff was awarded ten pounds damages. Hardly a triumph, but then he had brought the case more out of irritation than anger. Once the case was over Gerald Gardiner asked Freud if he would paint Carol, his daughter, who was a student at the London School of Economics. "He said, 'I hope you'll charge a lot as I make a lot of money.' It was the only time I ever accepted a commission blind. What a shock. She was very nice: Dutch potato eater, nice expression on a rather potato-ish face. Gerald Gardiner and his wife came to Delamere when I'd nearly finished. Carol sportingly said, 'Well, I like it, anyway.' But some years after he wrote to me. 'I had a burglary,' he said, 'and the burglar must have had fine taste, because the only picture he took was yours.' I knew Mrs. Gardiner had destroyed it. Like Lady Churchill did. Cecil Beaton liked the painting, which was a bad sign."

His name having been what had alerted *Time* to an unremarkable

show in an obscure gallery, Freud felt it necessary to rebut any notion that he was less than appreciative of his adoptive country. "Obviously I was longing to go abroad. But it certainly wasn't to do with 'I'm fed up here.'"

"Always when I return I am overwhelmed by the ugliness of the architecture, the gloom of the people, the drabness of the sky, the obedience to authority." To Cyril Connolly, sounding off in the final issues of *Horizon* like a tetchy paying guest, "peevish, overcrowded, bureaucratic England, land of cut films, banned books and class-conscious little moustaches,"[19] was sinking fast. Across the Atlantic his diatribes could have passed for understatement. American commentators, isolationists especially, were apt to represent Britain as a bankrupt socialist state still fancying itself an imperial power. "On every side radio announcers and newspaper reporters bleated that Britain was mismanaging her affairs, running into debt, twisting America and persecuting the Jews," an English journalist, June John, reported in *Leader* magazine in September 1948. June Rose, the *Time* reporter, was perplexed by Freud's indignation at being made to sound anti-British. During the hearing she said, "I don't know why Mr. Freud's taking this line; after all, we are both Jewish."

Freud resented the assumption that, having been uprooted from Germany, he was unappreciative of the land he had grown up in. "All my interests and sympathy and hope circulate round the English," he said, and indeed this manifested itself in a knowledge of bloodstock and *Who's Who*, a liking for thoroughbred Englishwomen, fair-haired ones especially, and an appreciation of John Constable, Max Miller and good tailoring. Having been naturalised British meant being not more British than the British but more at home: enabled to come and go without question. He felt himself to be a free agent in Conrad's London, Sickert's London, the London of *The Waste Land* and *The Man Who Knew Too Much*. Michael Hamburger, his childhood friend from Berlin, arguing from a similar point of view said that the free agent is also one who takes cover, practising "extreme conformism so that you don't stand out. My work as a translator was to do with displacement: a way of keeping in touch with an earlier part of my life; Lucian I knew had a kind of double life."[20]

Mastery of a language is only achieved when what is implicit is recognised, not just what is said. The "clockwork morality" referred to in court was ambiguity. "Well, I like it, anyway" was mild defiance. Just as, in painting, he had moved beyond artless candour, so too in the language he used Freud was conscious of having replaced his childish German with a richer English. "My initial language has almost fallen away. I was terribly interested in words. You learn them and enrich your vocabulary. 'Why,' my mother said, 'do you say everything is "squalid"?'"

His acquired English came close, in conscious style, to the plain English of George Orwell, as indeed his drawing style matches the clarity of Orwell's prose. Though no question of his doing so ever arose, he would have been the ideal illustrator of Orwell. "I knew him from the Café Royal, I met him there with Stephen Spender, he was always hanging round. He wasn't very old when he died and yet he seemed so old. He'd got good manners. He always spoke in exactly the same tone because he had been shot in the throat; there was no intonation because it was coming out over an obstacle rather. He was very unphysical. He seemed terribly dry, everything about him seemed dry." He seemed to dislike art. "He was decent: to such a degree that his decency was almost a form of imagination."

Sonia Brownell, tiring of *Horizon* chores—she had become its one staunch organiser and, in Cyril Connolly's absence, effectively its editor—and realising that it had little future, took on Orwell. He became her cause—as Freud said, "she loved to sort out people's lives"—and, with the success of *Nineteen Eighty-Four*, published in the summer of 1949, and the worsening of his TB, he was an eminent if enfeebled literary lion to tend. In October 1949 she married him, in a bedside ceremony at University College Hospital, not expecting the union to involve anything more than her becoming the legalised organiser of his affairs. She had always been bossy and marriage, Freud maintained, made her more so. "She was very nasty to him; she was disgusted at his becoming amorous through TB. The doctor told Sonia, 'He's dying, but if you marry him he might get better. If they have something to live for it can change the metabolism.' He started getting better; Sonia panicked and said, 'If he's going to get well enough, we have to go away, and will you come with us?' I got on well enough with him so I said I would.

"Kitty and I used to go and see him—he was fond of Kitty, nice to women—and he said to me that when in pain, in hospital, he'd think of all the things he'd like to do to the people he hated.

"Sonia was a great friend, we were much involved, but she and I were not amorous. I never went with her and I never worked from her. It never occurred to me to draw her. She went away to France so much she gave me the key to her flat. But she was also a nuisance, trying to be helpful; she was always trying to solve people's lives which didn't need solving, always trying to get Kitty to leave me. She was a marriage wrecker."

It was arranged that Freud should go on a private plane with Orwell to Switzerland, thence to a sanatorium. His role would have been to help lift and carry. "I wouldn't have gone but at the same time it seemed churlish to say no for an unlikely event in the future."

On the evening of 21 January 1950, a few days before the planned flight, Freud had dinner with Anne Dunn at L'Étoile. Then, she remembered, they went to a club: "The Sunset in Percy Street, just opposite Sonia's flat. He said, 'Why don't we ring up Sonia and ask her to join us?' So that was what happened. She came over—she had stayed at the hospital until nine o'clock which was as late as they allowed—and we drank for a couple of hours and that was when they were trying to reach her from the hospital to tell her that he had died."[21]

Freud's view of Sonia Orwell, as she called herself thereafter, was coloured by her domineering traits in later life. "Sonia was heartless; the last five days she never went to visit him [in fact the hospital allowed her to visit him only one hour a day, and this she did]. Panicked when he got better." But talk of Sonia living it up with Freud while Orwell died was malicious, Anne Dunn insisted. "Lucian and Sonia did have an affair but that was earlier. He was with me that night: Sonia went back to Percy Street and we went back to Delamere Terrace."[22]

"My night's entertainment"

The December 1949 number of *Horizon* had been the last. The magazine was discontinued for a number of reasons: it had lost its wartime distinction, circulation was tailing off and, after ten years, those producing it were tired of the routine. Eighteen instalments of Augustus John's biography had appeared by 1949 and more were threatened. Sonia Brownell—to whom Augustus John once said, almost out of politeness, "May I fig & date [fecundate] you?"—had left, and Peter Watson was more interested in the ICA, which needed the money that he had been sinking into *Horizon*. He would have continued backing it had Cyril Connolly shown enthusiasm, but Connolly was fed up, self-indulgently so. His closing editorial ended with an epicurean bleat. "From now on an artist will be judged only by the resonance of his solitude or the quality of his despair."

When the *Horizon* office in Bedford Square was dismantled it was rumoured that Craxton took the Diego Giacometti chandelier. Typical, according to Freud, who by then had turned on him, initially more out of exasperation than malice. "Johnny Craxton was abroad a lot in Greece and Crete, where he bought a house, and he freewheeled for a while into the fifties. At twenty-seven he started copying his early works. Graham [Sutherland] was very bitchy about him: he referred to his 'mooning boys.' Craxton had imitated him. But there *was* a little spark at first." Reviewing Craxton's one-man exhibition at the London Gallery in 1949, Wyndham Lewis wrote:

"Craxton is like a prettily tinted cocktail that is good but does not quite kick hard enough."[1]

Bacon was now noted in terms of reputation among artists and Freud grew closer to him as the rift between himself and Craxton widened. "Johnny got very angry once when I said that I liked Francis's work. 'Oh that's the smart thing to like,' he said." Peter Watson included all three—Bacon, Craxton, Freud—in an ICA exhibition, "London/Paris: New Trends in Painting and Sculpture," held at the New Burlington Galleries in March 1950. They, together with Peter Lanyon, and the sculptors Maurice Lambert, Robert Adam and Reg Butler, were contrasted with the same number of French artists, among them Germaine Richier and abstract painters such as Bazaine and Hartung of whose "fuzziness" Patrick Heron, writing in the *New Statesman*, complained. To him Craxton was "possibly simply the most original painter in the entire collection" whereas, reviewing Freud's first show at the Hanover Gallery the following month, he wrote: "Nothing could be more opposed to the spirit of the School of Paris than the paintings of Lucian Freud." This could be interpreted as a distinction.[2]

Erica Brausen, whose Hanover Gallery opened in late 1947 to become for some years the smart place to exhibit, showed Gerald Wilde—once, in 1948, nothing sold—also E. Q. Nicholson. More to the point, she took on Sutherland, and Bacon too, as well as Freud. She had been involved with "Peter" Norton and Dorothy Warren's Storran Gallery and had worked for Rex Nan Kivell at the Redfern. Having grown up in 1920s Berlin she had stories to tell, Freud remembered, about cabaret life there then. "'This nightclub with this huge snake in the ceiling and the snake would piss all over us.'" He rather liked her contrariness. "If she sold something it was hers, and if not, not. She was tremendously impressed by Paris." Besides Sutherland and Bacon and an architect-turned-sculptor Reg Butler she showed Giacometti. "And Germaine Richier, which I hated much more even than that sculptor who did bogus Italian art: Marino Marini." As for Arthur Jeffress, he dismissed him as a decadent who discharged his money on male whores: "not ones off the street, but ones who were around."

"Erica was funny because everything was 'Darling' and then when money was mentioned she became hysterical. Francis brought in a

large picture, a terrifically good one of a curtain, a tiny person look-
ing through a curtain (and a safety pin, no doubt). 'You can't do this
to me,' she shouted." When young painters came to the gallery in the
hopes of her taking a look at their work she was merciless. "A young
man would come in with his paintings tied with leather straps. 'OK,
young man, put them round the room,' and he'd undo them and she'd
look and say, 'Where are ze pictures? I don't see any pictures.'"

Bacon's heads, shown at the Hanover in November 1949 on his return
to London after a spell of a couple of years, on and off, gambling
mainly in Monte Carlo, were sniffed at, approvingly, by Wyndham
Lewis as "those dissolving ganglia, the size of a small fist in which
one can always discern the shouting mouth, the wild, distended eye."[3]
Robert Melville, writing in the final number of *Horizon*, recognised
the hit and miss involved. "Bacon is not making it any easier to paint
pictures. When he works on a canvas, intellect, feeling, automatism
and chance ... sometimes come to an agreement." Such paintings
were lingering images of abbreviated sensation. Pathologically, oper-
atically, heads rolled, teeth bared, the paint built up alluvially, douche
upon douche hardened into slate grey, all reminiscent of Lautréa-
mont's "the drop of semen and the drop of blood which filter slowly
down my dried-up wrinkles."[4]

 "One of the problems," Bacon said, "is to paint like Velázquez but
with the texture of a hippopotamus skin." Not a problem that con-
cerned Freud then: his smooth-skinned *Sleeping Nude* was no paint-
erly big-game victim. Her pillowed head positioned, coincidentally,
at the same angle as Bacon's *Head II*, this Paddington Psyche barely
breathed. Freud devoted himself to details Bacon had no time for:
sheen of hair, weight of eyelids and individuality of wrist, fingernails
and nipples. Where Bacon went for affright Freud exercised himself
on the textures of wall plaster, marble, pallid skin, coarse blanket and
blackleaded grate. When John Minton saw the painting newly com-
pleted in January 1950 he described it, in a letter to Michael Wishart,
as a "rather haunting picture of an ill girl."[5]

 That girl, marmoreal on a mattress in front of the dark fireplace,
was Zoe Hicks, a daughter of Augustus John by Chiquita, a South
American model. Joan Wyndham, who had been in the WAAF with

her, said that she had "slanting gypsy eyes and the greasy hair of all the Augustus Johns." Freud disputed this (it was, he said, the skin that was greasy), but he was stimulated by the connection. "When, at sixteen, Chiquita had sat and lain for Augustus John she was excited to be pregnant and knitted garments so tiny they'd just go on a frog." The frog was Zoe, born in 1923, initially fostered with a policeman's family in Islington then appropriated, briefly, by Eve Fleming, Ian Fleming's mother, who, if she could not have a child by Augustus John—as she was eventually to do—thought the next best thing was to kidnap a love child of his. Chiquita married Michael Birkbeck, whom Freud remembered as "a squirearchical drunk supposedly on his uppers though he owned a Snyders; he'd go in the pub and say, 'We got some Rubenses in my house,' and they set his coat tail alight when he went home." The Birkbecks were living two doors away in Delamere Terrace, next door to the Miltons. "Poverty was why they were there." Freud wasn't involved with Zoe Hicks for long. "She trained as an actress, played bit parts, maybe once Lady Macbeth, but in a minor town in Japan. She was intelligent, personable and very good company. A wild dancer." She had sat for John, whom she discovered was her father when she was in her teens. One of his final acts, shortly before he died in 1961, was to get into bed with her.

A basic lack of involvement is apparent in the picture. "I liked her; she liked me better. I think it was just before Greece, or just after; I was quite mixed up with girls then." One of whom, Anne Dunn, found herself being bundled out of the way when Zoe posed. "On the landing there was a bath where he kept coal and I never understood what was happening, quite why I was being locked in there and whether he was having an affair with Zoe when everyone said, 'Of course he isn't, she's terribly in love with her musician,' but I was absolutely sure that he was. And I had to lie in, as it were, for some of that painting."[6]

"Are the forms of body and head really understood?" mused Patrick Heron when he saw *Sleeping Nude* at the Hanover Gallery in April 1950. "One is not sure. Terrific finish, no longer being idiosyncratic, cannot hide an uncertainty, not of drawing but of *volume*. And then there is a new element here: this work is atmospheric for the first time in Freud's career."[7] The Paddington daylight in *Sleeping Nude* was full sunshine, sharp on forehead and shoulder, soft on blanket and neck: a quattrocento light such as embellishes Botticelli's *Venus and Mars* in

the National Gallery. Kenneth Clark called one day while Zoe was posing. "She was on the bed half-covered and I noticed he was very pleased, thrilled," Freud remembered. The painting went to Canada, to Daisy Fellowes' daughter, a friend of Zoe's, a Mrs. Gladstone, and was shown in an exhibition of "British Art 1900–1950," organised in 1950 by Robin Ironside for the English-Speaking Union of the United States. When, nearly forty years later, Freud saw it again in London, he recalled how pleased he had been with it, his first nude, especially the handling of the blackness in the fireplace. He noted that the cloth draped over thighs and mattress fails to lie properly.

"Everyone is v. penniless," Minton told Michael Wishart that January. "Including Lucian, especially Lucian . . . I feel a certain alarm for him, for what can he do now? Photography?"[8]

The Hanover Gallery was prepared to pay Freud a retainer of £2 a week more than the London Gallery, which, by 1950, was so reduced that Mesens resorted to hiring it out; by then Surrealism was no longer even intellectually modish: Max Ernsts and Magrittes remained unsold in the cellars. An extra £2 was little help. Ahead of his first Hanover show Freud needed at least a dozen suitable frames and, being resourceful, he went foraging along the Fulham Road. "[Jacob] Mendelson the drug dealer, who used to be around in the Café Royal (always alone, and the waiters said he'd been coming every night for forty years and never left a tip) and who had been married to Lilian Bomberg (by then David Bomberg's wife), had a huge emporium of junk on the corner of Fulham Road. I thought the prices were daylight robbery so I put frames I liked near the back door, went with Kitty to get them and was caught by Mendelson. He began screaming as I ran down the street. People did nothing, but he got hold of Kitty's hand. She was wearing gloves. I pushed him and he fell back with one of her gloves. She was very upset and I dropped the frames."

On the night of the opening, 18 April, they held a party in Clifton Hill. William Coldstream took William Townsend with him and Townsend, scenting *haut monde* bohemianism, wrote it up at some length in his journal. Paolozzi—being the lodger—showed them into the drawing room. "A large red-plush carved settee, two screens, one of them covered in tiger skin." Champagne and whisky

were served. Francis Bacon was there, "fantastic enough, but charming and immensely intelligent." Townsend felt awkward. "This was a company in which Bill and I were like strangers, matter of fact and banal. There was Lucian's exquisite silent little wife and the only other woman the wife of a huge bearded man. The rest of the men were beautifully hairless, smoothest of all a young man so preciously and delicately turned out, a pupil of Cedric Morris's, whom it would be impossible to caricature."[9] That would have been Michael Wishart. He was attending the Cedric Morris School, as was Anne Dunn, briefly, before being asked to leave.

The exhibition, occupying more than half the gallery—the Parisian printmaker Roger Vieillard showed three dozen etchings in the remaining space—was a demonstration of Freud's virtuosity. His stippling and highlighting were immaculate, chillingly so. *Father and Daughter* and *Sleeping Nude*, the main exhibits, showed him to be concerned more with the look than the feel. This was painting not so much to order but, possibly, to ingratiate. *Boy with a White Scarf*, a painting of Charlie Lumley, was, Freud conceded fifty years later, "a bit soppy: cigarette-card glamour" (Kenneth Clark bought it for the Art Gallery of South Australia), and *Boy Smoking*, a painted variation on the drawing of Charlie as Narcissus, without the reflection, could have been bait for Arthur Jeffress. Four of the seventeen exhibits were the rejected drawings for Rex Warner's *Men and Gods*.

In his *New Statesman* review Patrick Heron harped on the "eccentricity" of Freud's approach and his "remarkable capacity for sustaining the craziest minutiae." At the time Heron himself was painting loose-knit Braques, so he laboured the point. "Freud needs a magnifying glass, one would say, to complete his incredibly tight and intricate surfaces with their fantastically minute details of touch and design." A painting of strawberries, on a four by four and three-quarter-inch copper plate, was precisely that: each fruit shiny, blemished and unblemished, pores flecked with seed, nestled in a box. Heron's conclusion was unenthusiastic. "It is good that Freud is abandoning what he could do to perfection. But as yet he is barely the master of the new realism he has invoked."[10] Such paintings could be seen as provocatively exquisite. Ann Rothermere, leading society hostess, bought the strawberries: such a clever little picture.

. . .

Cecil Beaton's disapproval notwithstanding, Freud saw more of Garbo in London. He being in his mid-twenties, she in her early forties, they were a generation apart but the cachet was none the less for that. There was a predictable and enjoyable stir when he accompanied her to clubs where the male clientele were apt to dress up as her (or, failing that, as Marlene Dietrich) and there was he, nervily escorting the real thing. "I took Francis [Bacon] out to lunch with her and he said, 'That marvellous director Pabst: do tell me about him'; and she said, 'Oh I was so young I don't remember.' Francis got up and walked out. She was very flirtatious and funny and friendly and denying. Driving over a bridge over the Thames she said—she was Swedish, after all—'Let's get out and stand in the rain.' I was wearing my best suit. Fucking hell. She looked wonderful but was extremely silly: when she saw Wallace Heaton (camera shops) adverts on the back of buses she said '*Wallace??*'"

She had confused Heaton with Beaton: "I asked Cecil Beaton about their romance on the *Queen Mary*. He said, 'I suddenly realised I was absolutely in love with her.' 'What did you do?' 'I took off all my clothes and danced and danced and danced.'

"The story goes that she had glandular reasons for carrying on as she did. If it's some time since you had sex, you must have a romance or your skin dries. I saw her once when someone approached her in the street and her face twisted up in a terrible grimace and her body shrivelled. She just became old, like everybody else. She wasn't remotely responsive but she had a strong effect. Old boys all over the world would leave their money to her.

"Ann Rothermere asked Garbo to dinner and she dressed in a trouser suit, and she wanted to have her hair cut and went to Selfridges boy department and had it cut sitting on a rocking horse. She looked marvellous. Esmond said she was a dreary old wreck." Esmond Rothermere owned the *Daily Mail*. His wife was a connoisseur of politicians, socialites, artists, writers and film stars, indeed anyone who appealed to her as worthy of the attentions of a consummate society hostess. Freud got on well with her after being asked to paint her portrait, a formal one, her face tightly composed, topped off with a tiara.

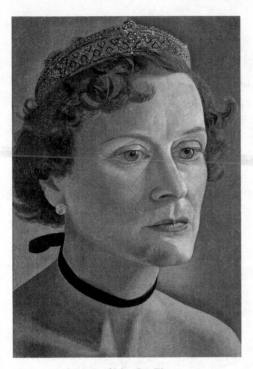

*Portrait of Mrs. Ian Fleming
(Ann Viscountess Rothermere),* 1950

"It was done through Cyril Connolly. I was asked to meet Ann with a view to doing her as Lady Rothermere. Evelyn Waugh later said the tiara wasn't painted straight. He was right." The portrait became a relic of her period as Lady Rothermere. "Being very intelligent, and unpretentious, Ann took an interest in the paper, which he didn't like. She noticed that people got TB there rather a lot. She found that the people who got it worked in a damp underground room and she told Esmond and he lost his temper and told her never to go into the building again."

She had married Lord Rothermere in 1945, a year after her first husband, Lord O'Neill, was killed in the war and a year or so before her involvement with Ian Fleming (whom she was to marry in 1952) led to pregnancy and a miscarriage.

"I took Kitty to Warwick House—the Rothermeres' town house—to some parties. Ann was head of a film something and once Kitty sat next to Lex Barker—'Tarzan'—and I was next to Vivien Leigh—awfully nasty—and we talked about my friend David Kentish who worked for Olivier. '*Such* a pity he got married,' she said."

"There was a fancy-dress party. I wore 1820s Lord O'Neill, out of the costume basket. It was winter, foggy and cold. Ann said, 'Would you like to drive home?' I hadn't really driven before and when I got to Hyde Park Corner I hit a van and an ambulance, both at once, got out in these amazing clothes—and drunk—and saw people being bundled into the ambulance and I said, 'Can I help?' And they shouted, 'Fuck off,' so I drove home to Clifton Hill and when I looked out in the morning I could hardly recognise the car, it was so bashed; and so I drove—I didn't know about gears or anything—to Delamere,

sobered up and rang up Ann and said, 'It isn't quite as you gave it to me.' A chauffeur was sent to collect it. I was rather nervous, so I tried a conversation with him about cars. 'Do you have TV in cars?' I asked. Rothermere cars had never had accidents, so the case came up without mentioning the Rothermeres. Since I wasn't licensed or insured I was fined £100, which took most of the money I got for the picture."

In tartan trews and dinner jacket and a top hat with implanted tulip, Freud played the salon Surrealist at a Headdress Ball at Warwick House, and was photographed there listening to Freddie Ashton (famous for his Queen Mother imitations) and his hostess. Dancing he enjoyed—"dancing comes out of frenzy, not energy"—particularly with Margot Fonteyn. He liked being a waspish firefly in such social circles and performed accordingly. Once he was spotted eating orchids from a bouquet.

His reputation travelled. In New York the Anglophile Fleur Cowles featured "Freud the Younger" in the February 1950 launch issue of her lavish, and short-lived, magazine *Flair*. It involved a double spread, an inset reproduction of *Girl with Roses*, a photograph of the stylish young artist in profile and a disclaimer: "Unaffectedly addicted to privacy, he wishes to be known only through his pictures."[11]

Freud's social activities, hotly pursued when opportunity arose, were more wilful than impromptu. What were driving licences actually for? He had no time for regulations, taking them to be interference, particularly those that threatened his freedom of movement. Marriage, he assumed, was no impediment and law was best ignored if it failed to suit the immediate purpose.

A monkey, for example, died in Paris (it had belonged to Olivier Larronde) and since he wanted to draw it the obvious thing to do was to smuggle it through Dover customs in his coat pocket. The consequent drawing, *Dead Monkey*, was bought by Lincoln Kirstein, a touchy and intermittently wealthy poet and impresario. Kirstein had lured George Balanchine to New York in 1933 where, together, they had founded the New York City Ballet. He brought the company to London in June 1950 for a season that, to his displeasure, was not well received.

The visit had begun with good prospects. A drawing of Balanchine by Freud, done that August, appeared in Buckle's magazine *Ballet*. Kirstein acquired it and there was talk, when he and Buckle paid a Good Friday visit to Delamere Terrace, of Freud designing a ballet and possibly going to America with him and exhibiting there as the British adherent of what Kirstein called the "Symbolist Realist School" involving, Stateside, paintings of jail-bait sailors by his brother-in-law Paul Cadmus and of keen-eyed Brandywine Valley folk by Andrew Wyeth. To Kirstein, who disapproved of Léger and Matisse for their lack of "stable technical processes and rational craftsmanship," Symbolist Realism, an exhibition of which he arranged at the ICA, was a timely modernisation of fifteenth-century Netherlands painting, the greatest masterpiece of which he himself had liberated in 1945. As a Private First Class in the Monuments, Fine Arts and Archives unit of the US Third Army, he had acted on a tip-off from a German dentist and gone to a salt mine near Salzburg and there discovered eight panels of Van Eyck's Ghent altarpiece, *The Adoration of the Lamb*.

Looking at *Dead Monkey* (such a wise little face) and contemplating being painted by Freud, Kirstein decided that he had discovered a Symbolist Realist in London, possibly the Van Eyck of the mid-twentieth century. Young Freud was worth cultivating. He began sitting for him. "Posing was calm," he later wrote. "Public encounters became stormy. Psychotic it was not but prone to hysteria." There was, he added, a fight in the crush bar at Covent Garden and another at Ann Rothermere's party at Warwick House after the first night of the New York City Ballet production of Benjamin Britten's *Les Illuminations*.[12]

"Kirstein had a ludicrous side," Freud said. "He made me into an enemy." By his account, one evening they and others piled into Johnny Minton's car for a trip to the Prospect of Whitby pub in Limehouse. It was raining. "Johnny's friend Rick was driving; the car skidded and Kirstein had a panic attack and jumped out, much to our amusement. And then he never turned up to sit and I sent him a rather stupid telegram:

> *He who after a sudden skid*
> *Jumps out into an East End street*

Before his portrait is complete
May from posterity be hid.

"This, understandably, drove him absolutely mad with fury." As Kirstein recalled: "Our sittings ended violently with fisticuffs in the crush bar of Covent Garden." Freud concurred. "He tore my shirt front out in Covent Garden and didn't sit again but wrote to Erica Brausen saying that he had paid for the portrait—probably he'd given me an advance—and would she send it." She despatched the head to him and that was that: a thin-skinned portrait, the haircut sharp, the back of the head singularly abrupt, the eyes ready-focused, suspicion hardening into disdain. "He was hysterical, really believed in Gurdjieff. He took offence at very odd things. Balanchine managed him well by keeping quiet and counting until it was over. If he thought people's work was no good he never bothered again. Rather mad, but he certainly minded very much and he got that famous (megalomanic) illness: he thought he was Diaghilev."

Charlie Lumley, writing to Freud in blunt pencil from his army billet in North Wales, asked how things were. "Have you heard anything about your trip to America or has Kirstein definately changed his mind." He had.

Kirstein bought *Woman with Carnation* (Mrs. Milton next door), but within a few years, when Freud's exhibits in the 1954 Venice Biennale were being selected, he wrote to the organisers saying that it was probably unavailable, belonging, as it did by then, to "people with a new house in the country." As a painting, he added, it was "by no means an important one."[13]

Freud's domestic life, erratic and hardly connubial, was set about with entanglements and disengagements. At Clifton Hill Michael Wishart found one of Pauline Tennant's earrings in the bed. "He rescued them so Kitty wouldn't see them," Anne Dunn said. "How Lucian fitted so much in I cannot imagine. Nerves of steel. Rotten nerves." She knew Pauline from dancing classes and child modelling sessions at the Gargoyle when they were six and Pauline had recited, "I wonder I wonder if anyone knows, who lives in the heart of this beautiful rose." She was competition. "She kept popping back in again. I always remember

mimicking her movements and I never knew we would find ourselves in a slightly antagonistic situation later on."[14]

There were further complications for Freud when he took off to Paris. "I was living in this hotel with Helena for a little bit. I had a Tyl Ulenspiegel change: I came with Caryl Chance then went off with Helena." Helena Hughes had caught his eye in Dublin when he went there with Anne Dunn; her father—Herbert Hughes, music critic of the *Daily Telegraph*—had written the title song for the Powell and Pressburger film *I Know Where I'm Going*, a song that suited her. "I had met her first as a great friend of Kitty, they were at the Central together and she was engaged, briefly, to Michael Wishart. Kitty gave her the *Ill in Paris* etching and was very upset when she sold it. She married an Irish actor, Liam Gannam, in Paris and later married Mr. Crackanthorpe, a North Country squire. She drank a lot; she was very reactionary. The involvement was quite a slight thing for her. She was quite a hard little thug."

Freud's portrait of Helena Hughes, *Girl in a Beret*, done in London in 1951, was bought for the Rutherston collection of paintings and drawings circulated in Northern schools as educational props. The beret, the cropped hair, gold earring and jersey of the stylish gamine suited the role she was to assume a few years later in John Osborne's *Look Back in Anger*: Helena the substitute girlfriend. She had a daughter who, many years later, got in touch with Freud. "She wrote something slightly odd: she asked about the portrait and said she was born 'not long after.'"

In the summer of 1950 Helena Hughes was in Paris working with Orson Welles who, between bouts of raising finance and shooting sequences for his film *Othello*, devised "An Evening of Theatre," a pair of plays showcasing himself. *The Unthinking Lobster*, a skit on Hollywood producers, involved a miracle on a studio lot and *Time Runs* was a version of Faustus for the atom-bomb age in which he played six roles. For these he had the stage of the Théâtre Édouard VII in the rue de Rivoli decked out in black velvet and he persuaded Duke Ellington to compose the music. Welles had as his assistant Hilton Edwards, who also played Mephistophilus, a role later taken by his friend Micheál MacLiammóir, the Iago to Welles' Othello. "The real link was with Hilton Edwards at the Abbey Theatre Dublin. Helena being an Irish actress, Hilton Edwards must have asked her to

be there, in Paris." The rehearsals, over three weeks, were reported as going badly, with false starts and setbacks and no one to gainsay Welles who decided to pad out the programme with magic tricks performed by himself.

"Helena used to leave the side door open so I'd slip in and watch rehearsals. She was a maid or something and did a lot of dogsbody work. Her letting me in came about slowly; it was my night's entertainment; I even took other people in. I used to be in a box quite often, but I got bored watching and went to the dressing rooms and in Orson Welles' dressing room I started reading his letters. One from a schoolgirl—'Girls say you are a big fat slob but I think you are wonderful'—he came in and was furious and said get out. As I got near the door I cocked my foot round a lighting wire on a spool and walked with it through the door and the wire got further and further, forty yards long, it went on and on: it was a theatrical gesture. Then I went and sat on a horseback in the square behind the rue de Rivoli and Hilton Edwards came and apologised profusely. He didn't need to. I'd be furious if I found someone in my room.

"I've always tried to leave very slowly: I've got this thing about running away. I didn't go back until the opening night. It was terrible rubbish: the only thing that stopped it being a failure was the names. Eartha Kitt was in it: she was unknown then: I did some drawings of the Katherine Dunham dancers and she was one of them. And in the front row were Aly Khan and Rita Hayworth. She had married Welles for a bit."

During this stay in Paris Freud ran into his ex-lodger Eduardo Paolozzi. "He was living on the fifth floor in a house with four floors. I was with him once at Les Deux Magots in the sunshine and girls going by and he said, 'In a few years from now I'll be in my Cadillac and there'll be a blonde next to me and a brunette next to her going to Saint Jean de Luz and you'll say, "There goes Eduardo: I knew him before he sold himself." Eduardo was always making up to Isabel Lambert [Rawsthorne] and one day he was going on and on, this huge man, and she thought why not? And went with him. How was it? 'Exhausting,' she said. 'I had to do all the work.'"

Paolozzi amused him. Unlike James Lord, aspirant American writer, whose short story "The Boy Who Wrote 'No,'" published in the final number of *Horizon*, had served as his introduction to Con-

nolly circles and who was now establishing himself in Paris as a go-getting confidant of those worth knowing. Freud having introduced him to Marie-Laure de Noailles, Lord commissioned a drawing of himself, sat for him in the Île de la Cité hotel, and failed to pay for it. "Such a crook; he said he was terribly sorry he couldn't pay because he was so poor but he'd give me the manuscript of 'The Boy Who Wrote "No"' (a bit Southern School) which he never did. He'd started in Paris: a GI on the game. Picasso put him up in the rue des Grands Augustins and drew him. My drawing of him he gave in the end to the Picasso Museum." Dining with Dora Maar and others, a few years later, Lord started going on about how boring it had been to be drawn. Freud responded. "I said how painful it was, drawing a crooked little cunt." Lord, in his memoirs, was to be hardly less critical of Freud.

"It was famously hard to get a flat in Paris and I never really tried. I'd have found a room. But I kept on Delamere."

There he began a minute portrait of Barbara Skelton (two and a half inches by four, on copper) as a wedding present for her intended: Cyril Connolly. A challenge, even by Connolly's standards, Skelton had the reputation, fostered by Connolly who revelled in self-pity, of being a hard-nosed termagant; her liaisons included spells with King Farouk of Egypt. Four or five sittings were enough for Freud to set down the essentials of what, he said, Connolly described as the face of an "angry despatch rider."[15] The marriage took place in October 1950, but the painting remained unfinished and was not handed over. "Partly, I realised I couldn't give it to him." After she left Connolly for the publisher George Weidenfeld, Freud showed it to him. "He said that if he had seen it then he wouldn't have married her. It's pretty nasty."

One night on the upstairs landing at Clifton Hill, Freud recollected, Michael Wishart had a shock. "He was staying in Clifton Hill—Kitty was away, she went away quite a bit to stay with her grandmother—and there was an Irish-Jap girl called Haru and Michael was drinking and drugging and saw this naked girl going to the loo and thought he had DTs." She was what Freud regarded as a passing fancy. "Haru was

around in Soho. She was very gentle, she had a sister, a stripteaser on roller skates, who was famous and pretty and a bit of a bitch. I wasn't in focus for her: no cars or weekends. Her father was something to do with the Japanese Embassy in Dublin. Ambassador he was, her mother a native. So there was a bit of a background."

One day Anne Dunn noticed two drawings in Freud's room at Delamere and asked whose they were. "Just a boy I know." It was Michael Wishart. For her this was opportune. "I met Michael through Francis Bacon at the Colony Room. I'd seen quite a lot of Francis and I'd said to him I'd had to have yet another abortion and he was absolutely angelic and came round with books and things to my squalid nursing home and was very consoling and sweet." Michael Wishart was something of a relief and soon after, in July 1950, she married him. Craxton said the unsuccessful suitors were furious about it as Wishart's homosexuality, they felt, should have put him out of the running. Freud saw it differently. "Anne imitated me by marrying Michael Wishart, Kitty's cousin. She imitated in moving next door to me in Delamere and getting a place near Clifton Hill." She had had enough of the uncertainty of being, or not being, with Freud. "I always feel, mixed up with the great attraction or affection or whatever it is I have for Lucian, an absolute horror of his viciousness about people and towards people. I feel even talking about him I should be doing something against the evil eye. I thought the worst revenge I could do was go off with Michael in fact. I actually thought: what can I do? And this seemed to be a real hit out at everyone: Kitty, Lucian and so on, but it turned very quickly into love. I grew to love Michael, and although it didn't work out as a marriage it worked out as a relationship."[16]

The day before the wedding Lorna Wishart persuaded Anne that it would be as well to have her hair cut short and to wear a conventional tweed suit. She did so and, she felt, looked completely awful while Lorna turned up with her hair loose looking glamorous. "She looked like the bride." Soho legend had it that the wedding party in Francis Bacon's Cromwell Place studio went on for three days. Whether it did or not (probably not: Michael Wishart was so drunk on the wedding night the bride spent the night at his mother's), Freud stayed away. Rumour—spread by Bacon—also had it that he and the bride spent some hours together immediately before the wedding.

This he denied. "I didn't go: difficult for me to go because of her. It went on all night and a friend of Lorna's came to stay in Clifton Hill for the party and he got terribly drunk and came back at five in the morning. Francis painted the chandelier red."

A child, Francis, was born in December 1950. Many people, notably the grandmother, Lorna Wishart, had views about the child's paternity. "Lorna would never believe that Francis is not Lucian's. It could have been Lucian's and I didn't know, quite frankly," Anne Dunn said. "It was born three weeks late: I had to be induced. I was so frightened of what might turn up. But he had brown eyes and all the things that made it impossible for him to be Lucian's. He simply wasn't. He was Michael's."[17]

"Being able to see under the carpet"

In the summer of 1951 a temporary bridge with flags flying was clamped alongside the Hungerford railway bridge over the Thames, there to feed the public across the river into the South Bank exhibition, the centrepiece of a government-ordained celebration of post-war recovery: the Festival of Britain. Here, from May to September, urban designers' hopes were briefly realised and the decrepit warehouses, the bombsites and slums of South London disappeared behind canvas screens. Those who crossed the bridge found themselves in an ideal plaza, a strange new world of pedestrian precincts picked out in what was, for then, a startling range of colours: sky blue, scarlet, lemon yellow and terracotta. They trailed up steps to viewing platforms and downstairs again, following a Recommended Circulation through pavilions housing The Natural Scene, Minerals of the Islands, Transport, New Schools, Sport, Seaside and Discovery. Never had there been a more genial exposition of British identity for, with Laurie Lee the chief caption writer (and organiser of "Eccentrics Corner" in the Lion and Unicorn Pavilion), verbal sweeteners eased the onset of modernity in the Festival narrative.

Three miles upstream, in the Battersea Pleasure Gardens, Osbert Lancaster and John Piper installed Regency pleasure domes and Neo-Gothick follies approached from the main entrance by a facetious Neo-Romantic rail-link. And for sixpence visitors could attend *Orlando's Silver Wedding* in the Festival Gardens Amphitheatre, a Group Theatre production with costumes, scenery and lyrics by the

marmalade cat's resourceful author Kathleen Hale. The Pleasure Gardens were designed to bounce people back to the good old days of popular culture before radio was invented, let alone television. The South Bank, on the other hand, had a Telecinema as a taste of futurity and novel features such as gas flames flaring through fountains and works of art placed beside pools so as to reflect well. Epstein's *Youth Advances* was on a plinth outside Homes and Gardens and Henry Moore's *Reclining Figure* was posed as a human landscape feature in the forecourt of the Country pavilion.

The organisers of the Festival had resolved to demonstrate the virtues of public art and provide employment for artists. For painters there were mural commissions: Michael Ayrton's *The Elements as the Sources of Power* in the Dome of Discovery, Keith Vaughan's *Discovery*, a landscape with male nudes, and John Minton's *Exploration*, a complicated historical tableau. Graham Sutherland's *Origins of the Land*, an array of fossil trophies on a backdrop of Festival orange and yellow with a pterodactyl dropping by, was slashed by vandals. Ben Nicholson, Eduardo Paolozzi and Victor Pasmore produced abstract murals for two of the exhibition restaurants, works complementing those of professional designers such as F. H. K. Henrion whose white plaster oak tree, a gigantic piece of shop-window Surrealism in the Natural Scene, anticipated the amplitude of later Henry Moores. Whimsicalities filled the Lion and Unicorn Pavilion. And there were casual jobs. Frank Auerbach, for one, worked as a barman in the Regatta Restaurant, serving beer and sweeping up below a Pasmore mural.

To the Arts Council the Festival of Britain was a perfect chance to prove itself indispensable, and it was Arts Council policy to embrace all sorts of artists, within reason. The leading sculptors were readily involved. Twelve were given commissions, of whom three—Epstein, Moore and Hepworth—had their work sited on the South Bank; others, besides them, exhibited in the London County Council's outdoor sculpture exhibition in Battersea Park. Painters, being more numerous, were awarded a competition. Sixty were selected and invited to produce "a large work, on a canvas not less than 45 by 60 inches, on a subject of their own choice." The canvas was provided (since art materials were still in short supply, this was an incentive) and the assumption was that most of the resulting pictures would be suitable for display in hospitals and schools.

Freud was pleased to be asked to produce a painting, subject unspecified, his biggest yet. "By far. Though it was the smallest possible under the specifications. I realised I'd have to work in a freer way, working on that scale." He also saw that he would need money to see him through. Kenneth Clark, he decided, was worth approaching. "I have been sent this canvas," he told him. "The picture would take me a minimum of six or eight months and I haven't got the money." Clark was happy to oblige. " 'Oh, I'd be very honoured to take care of that,' he said." He gave Freud £500 in two cheques, one from Aspreys, the other from Partridges, the antique dealers. "He would sell furniture and buy art. When I read Alan Clark [his son] saying, 'You know the sort of people who have to buy their own furniture,' I thought hmm: Kenneth Clark did that. Anyway, he gave me the money to do the painting. He was very generous: he made it possible to do it."

To show his gratitude Freud produced a study of the palm tree that had stood behind the sofa in *The Painter's Room.* "I gave him a little painting which I sort of did with a view to giving it to him. A detail, as it were, from the painting." The palm, too big now for the room, had been moved on to the balcony. Its lower half made for a nifty little vignette on a copper plate. That done, he brought the plant indoors and positioned it so that its tousled crown related to the top of the lamp post below the balcony and to the bare plane tree on the far side of the canal. "I was always very conscious of wanting to put the things I liked together. My palm tree: I really liked that." Previously it had been palm and zebra, woman and daffodil, Kitty and roses. Now it was man and palm.

The stroppy figure standing between fireplace and palm tree was Harry Diamond, employed at that time as a stagehand and there because he was available in daytime. Freud's first thought had been to use Charlie Lumley, but he was doing his National Service and had been posted to North Wales in a gun battery. "Hows the large painting coming along or have you finished it yet I loved the idea of the picture when I was home the palm tree with the figure I wish I could have sat for it, by the way who is sitting for it the drug addict? I think he would be wonderful for the picture," Charlie wrote.[1]

For nearly six months—late afternoon, early evening, occasionally all day—Harry Diamond stood there in the stance of a pub regu-

lar with a grudge against society, or the painter, or the palm. Bloody
thing: he feels like thumping it. He breathes resentment.

"Harry Diamond said I made his legs too short. The whole thing
was that his legs *were* too short. He was aggressive as he had a bad
time in the East End to do with being Jewish." Diamond claimed,
forty years later, to still being "slightly miffed" about the way Freud
presented him. "I don't really have short legs," he contended.[2] But he
did. "With short people," Freud observed, "their bodies don't vary as
much as their legs do." Rather than take the bus he often used to walk
across London from Whitechapel to the Harrow Road. Freud was
to paint Diamond a number of times through into the 1970s. "I was
born good-looking," Diamond said.[3]

"Everything begins with lucid indifference," Camus wrote.[4]
Interior in Paddington began with the familiar leaves of the palm and
developed, with the introduction of the near-stranger, into a confron-
tation: man versus indoor plant. Freud had known Harry Diamond
casually from before the war in the Coffee An'. He worked in the
Ferodo brake-block factory, then at various jobs. As a scene-shifter he
had watched others perform. Fist clenched, ciggy unlit in the other
hand, he doubles for Charlie, whose brother Billy is posted as lookout
in the street below, lounging against the canal wall. Freud has him
cornered. Were it a narrative painting, *Interior in Paddington* could
represent the moment in *Nineteen Eighty-Four* when Winston Smith
is arrested by the authorities. ("There was a snap, as though a catch
had been turned back. The picture had fallen to the floor, uncover-
ing the telescreen behind . . . 'The house is surrounded.'")[5] Under
scrutiny, Harry could be about to crack. He and the palm are a match:
same height, same dishevelment, both brought in from the cold. The
shine on the palm leaves corresponds with the sheen on the rain-
coat, the nicotine on the fingers matches the frostbitten tips of the
leaves. The prickliness is mutual. "I'm a person in myself," Diamond
insisted. "My actual existence is a damn sight more important than
any painting anyone could do of me. I'm a cooperative sort of person.
I don't usually hold a cigarette in my left hand (I'm right-handed) but
it's as he wanted. One thing he wouldn't let me do was look at my
watch. I thought it's my time as much as yours; I've got as much right
as you to know what it is." As for the palm, in 1988 he was to see it off:
"Well, I think I've outlived it!"[6]

Discussing, in 1951, his *Standing Form against Hedge*, Graham Sutherland talked of "the mysterious immediacy of a figure standing in a room or against a hedge in its shadow."[7] Freud's painting was more specific than any horned or topiary Sutherland; and while Sutherland admitted that he found it distracting to have someone in front of him while he was painting, Freud could not manage without that someone being there for him. The glints in Harry's new National Health Service specs are reflections off the window; the seeing reflects off the unseeing while the silence of the canal, behind the wall and below street level, diffuses itself into the pale light of a dull day.

In his prison cell Camus' Meursault says, "I made a point of visualising every piece of furniture and each article upon or in it, and then every detail of each article and finally the details of the details so to speak: a dent or encrustation or a chipped edge, and the exact grain and colour of the woodwork."[8] The same degree of concentration informs every square inch of *Interior in Paddington*. The dirt tamped down in the plant pot; the seam of grime where window pane meets window frame. Freud needed a good colour for the floor and found what he wanted in the rag-and-bone shop at the end of Delamere Terrace: a dense red carpet. "I very much bought it for the picture; it was huge and dirty and had a burn in it two or three yards square; I cut that out and made it fit into the corner of the room." To dress the room was to give it airs. Coincidentally, as another Festival attraction, Michael Weight created (or recreated, believers would have it) in Baker Street Sherlock Holmes' sitting room; every famous detail was there, down to syringe, violin, half-eaten breakfast and telltale cigar ash. Though less elaborate, Freud's set-up was a gathering of evidence around, and about, Harry Diamond, whose attitude was once described by David Sylvester in the *Burlington Magazine* in a phrase that can only sound familiar to readers of Conan Doyle: "the pathetic defiance of the stunted man."[9]

The idea of rucking up the carpet—"being able to see under the carpet"—came from a picture that belonged to Kenneth Clark and is now in the Tate: *The Saltonstall Family*, devised in 1637 by David des Granges who later became miniature painter to Charles II, in which Sir Richard Saltonstall is something of a time lord, seen showing his two elder children their mother on her deathbed and their

stepmother, the second Lady Saltonstall, sitting beside the bed hold-
ing her own baby, born six years later.

Interior in Paddington preoccupied Freud in the autumn and win-
ter of 1950/1. It would be wrong to poke around for implications
in the rucked carpet, yet the painting does exude a wintry tension.
The chill is systematic. ("The cruel intentness of a frosty morning,"
said David Sylvester.)[10] Attention centres on Harry Diamond's thumb
poised on the cigarette end. One false move, as it were, and he'll press
the plunger. The shadow behind his head has slipped to one side. Soft
and transitory, it is Lautréamont's "shadow brushing the wall like a
gull's wing."[11] It is a long-drawn-out here and now.

"I did feel I was being drained," Harry Diamond said.[12]

Before Freud was finished with the painting, it had to be pho-
tographed for the *60 Paintings for '51* catalogue. Subsequently he
aged the palm stem, added a crack to the plant pot, accentuated the
carpet pile and filled in the floorboards. Harry Diamond remained
unaltered, but a shadow disappeared from between his legs leaving
a splash of sunlight on white skirting board to shove him forward a
little. It pleased the painter to know that a catalogue illustration could
lag behind the real thing. "I always thought how exciting it was for
the photograph to be different from the picture."

The painting having been submitted, there was a wait while the jury
decided which the Arts Council should buy. "I remember being in
the Gargoyle at Festival of Britain time and Lawrence Gowing was
there. He was always very sour to me. I used to make for downstairs,
where the high life really was, and he was upstairs and said, 'You are
one of those persons who's going to win one of those prizes.'" On
18 April a telegram arrived from Philip James of the Arts Council
saying that his had been one of the five chosen for a purchase prize,
followed by another from Kenneth Clark: "Thank heaven judges had
sense recognised yr flair masterpiece which now looks better than
ever congratulations."[13] There was nothing like the Freud among the
other prize purchases (£500 each to Robert Medley, Claude Rogers—
both of whom taught at the Slade—Ivon Hitchens and William Gear)
or, indeed, among the rest, most of them School of Paris cover ver-
sions or doggedly celebratory romps. Gowing had no luck with his

Intruders in a Wood, a flirtation with Neo-Romanticism in dappled *sous-bois*. The most controversial prize winner was William Gear's *Autumn Landscape*, an abstract masquerading as camouflage (or vice versa) inadvertently reproduced upside down in the first edition of the catalogue. Bacon, who was in South Africa for the six months before the exhibition, submitted a pope but, once it had been approved, withdrew it.

"Francis had a good picture and destroyed it. It was in there and then it wasn't; he said he hated it; he was really upset." Coldstream had been invited to take part in the exhibition but refused: the scale was too big for him. Johnny Craxton, preoccupied with sets and costumes (contemporary tavern wear) for *Daphnis and Chloë* (Covent Garden in April 1951), was to complain in later years that he and Freud decided not to put themselves forward for the Arts Council project but that Freud completed and showed his painting after all. Frank Auerbach's view of this was that Freud was hardly surreptitious given the many months he spent on the painting while Craxton was otherwise occupied. Though it was true that a Craxton would have suited the general run of entries, which tended towards mural statement. Grudge to rift to feud: the Freud–Craxton friendship was ended. Freud, slightly younger than Ayrton and Heron, was the youngest exhibitor.

Fifty-four of the *60 Paintings for '51* (six failed to show) went on tour around the country, starting at Manchester City Art Gallery in May after a two-day preview at the RBA Galleries in Suffolk Street. The collector Colin Anderson noted in his catalogue of the Bacon (not yet withdrawn) "not a good example," of the Gear "good." As for *Interior in Paddington*, he thought it "Very good indeed—vision, design and craftsmanship."

The liveliest thing about the catalogue was the Sutherlandish red, black and green cover design by Gerald Wilde (Sutherland of course, Wilde relentlessly maintained, had pinched his ideas in the first place). Looking through the illustrations fifty years later Freud marvelled at what those involved had seen fit to produce: a Duncan Grant ("so horrible"), Edward Burra's comically blood-curdling *Judith and Holofernes* ("hopeless"). Michael Ayrton's *The Captive Seven*, a family group glumly representing the seven deadly sins, elicited a sigh.

Interior in Paddington was reproduced opposite *Still Life* by William Scott, a spread of ovals: office foyer material. Freud murmured

approvingly over the Lowry and he quite liked Victor Pasmore's *The Snowstorm: Spiral Motif in Black and White*, the painting in which he formally abandoned the figurative baggage of the Euston Road School. "Peter Watson told me in '46, 'You know Pasmore has gone into Zwemmers and ordered every book on abstract painting'; it holds up (if you think on the other hand of William Scott or Ben Nicholson); it's got a very odd, individual insistence; his things were made for their own sake, not done for a gallery or show. Better than Ben Nicholson keeping up with Europe."

On 16 April Matthew Smith, whose '51 painting Freud thought "a bit good," took him and a girlfriend out to tea. Freud, he reported to his mistress Mary Keene, "could not bring himself to say anything about my effort so I assumed he did not think much of it."[14] Freud remembered that when asked about the exhibition, he told him it was awful. "In that case I won't go," Smith said.

News of Freud's success got around. A Delamere neighbour, passing him in the street, said, "You 'ad it off, Lu. Don't know me now do you?"

The Arts Council presented *Interior in Paddington* to the Walker Art Gallery, Liverpool. Harry Diamond, whom Freud was to paint again, several times, went on walking for hours daily and took up photography. "It was like someone finding Jesus. He did some shocking and extraordinary ones in the French pub. And weddings."

As for the palm: "I had it a very long time. Then it became a stump left on the balcony in winter, and then it died."

Talking to me about *Girl with a White Dog*, Freud quoted William Blake: "When a man marries a wife he finds out whether her knees and elbows are only glued together."[15] The painting, begun towards the end of 1950 and half the size of *Interior in Paddington*, turned out to be his last portrait of Kitty. "I thought of it before getting the canvas." Kitty sits resignedly in what others would have used as the dining room, overlooking the garden at 27 Clifton Hill. The setting is neither boudoir nor a genteel salon like those where Balthus girls preened themselves and dozed. It is a contrived shallow space, reasonably comfortable, with the mattress pushed against the wall and a grey blanket draped behind, in which Kitty is a living effigy at floor

level, one breast bared, the other cupped through the towelling of her bathrobe. "It's not a nude at all. The breast is a feature." Statuesque but nervous, attended by their watchful terrier, she displays her birthmark on one hand, her wedding ring on the other. Her shoulder rests against the woodwork of the unseen window; her foot points towards an unseen fireplace. This is an ordeal.

Initially the dog was black. "I had a pair of dogs: bull terriers. One was white and one was black. I preferred the black, which was in the painting, but it got run over and so I painted the white one over it." The dogs had been a wedding present from Joan Bayon in Cambridge. Kitty said that his grief over the dog's death was the only time she had seen him so upset.

Where *Interior in Paddington* was to do with Harry Diamond's intrusive impatience, *Girl with a White Dog* is resignedly composed. This is how things are: stripes and folds, panelling and pelt, muzzle, mouth and exposed shoulder, every form and texture meticulously filled out. Where *Sleeping Nude* was a tryst with the unconscious, *Girl with a Dog* (as it was initially called) was on the defensive. "Different, very, very different. Slightly Greekish." Freud wasn't quite prepared for this: the painting became a testimony. "If you focus on their physical presence you often find that you capture something that neither of you were aware of before." Freud sat facing Kitty, looking down slightly, giving the same degree of attention to heads, hands and foot, to the sour yellow bathrobe, the plaited belt, the sag and pallor of the breast.

To their daughter Annie, speaking when she herself was twice the age her mother had been at that time, the painting is especially telling. "The other ones [portraits of Kitty] are girls-legend-reverential-madonnas: 'all of her loveliness.' This one I feel phooor it's almost like defiance: 'Do what you can with me while you've got me.' And also you've got to remember England and the nude and obscenity and it went on being very big until the mid-sixties and even then, when Yoko Ono and John Lennon took their clothes off, it was huge news. Henry Moore's naked people are not really *people*, they are all sort of lumps. That's a real breast with proper skin that someone's kissed and touched and felt and worn a bra. It's a real person. My mother was very very proud of this painting. Terribly proud of it. To the extent it was an ingredient in difficulties in later life."[16]

Looking back Freud himself saw in it "a sense of sadness, even some anger. I think a more complicated person is being portrayed here."

Marriage put years on Kitty. Still, she had agreed to pose and that was all there was to it. Conversation, once begun, would be bound to end in reproaches. She, "the consistent critic, the patient misunderstander" of T. S. Eliot's *The Cocktail Party*, sits there, studiedly remote. "All there is of you is your body and the 'you' is withdrawn." The canine stare and human demoralised detachment are all the more acute for being couched in what could be the makings of a padded cell. Expressive in its restraint, the painting is an exposure. "Finally," Freud said of it, "you only want people to understand what the point is."

"One night I was leaving a club at two or three in the morning, pretty dark, and I hailed a taxi, opened the door, and on the floor was an enormous snake: Donald Maclean. 'Hello, Donald, is this taxi taken?' I said. He said, 'You . . . !' in a fury, so I shut the door. It was just a few days before he left." Maclean and Guy Burgess, unmasked traitors, disappeared to Russia at the end of May 1951.

In July Cecil Beaton's play *The Gainsborough Girls* opened in Brighton. "Loyal friends went down, Ann Fleming and a lot of people. He got a young man to help him write." The play was not a success. "Two sample lines: 'Grind up the lapis lazuli, boy. We've got to finish *Blue Boy* in the morning.' What fascinated Cecil were the daughters, who went mad through snobbery, which took the form of illusions of grandeur. The costumes were marvellous; one exciting thing was the changes of clothes." The next night Lord "Grubby" Gage threw a coming-out ball for his daughter at Firle, near Brighton. Everyone who had been to *The Gainsborough Girls* was there. "I was wandering around and George Gage kept getting people up and setting them down at tables. He came over to me and he said, 'I'm making patterns.'"

During the late summer of 1951, Freud and Kitty went to stay for nearly a week with Anne Dunn and Michael Wishart in a house she rented at Cashel, near the pub. "I think she must have known about

us (Lucian and I) because I was friendly with Kitty on and off, and she was Michael's cousin."

In November 1951, at a party celebrating the opening of Coward's play *Relative Values*, Princess Margaret alternated between Freud and Orson Welles, Ann Rothermere noted.

"True to me"

For a year or so from 1950 Richard Hamilton lived round the corner from Clifton Hill. Born in the same year as Freud, he had since 1948 been studying painting at the Slade, also trying out as a fashion artist for *Vogue* and involving himself in the ICA. Painting, he became convinced, was pretty much a waste of time for someone his age. Freud remembered him saying, " 'You know, I can understand why Francis paints, but I really and *truly* don't see why you do it.' He said it quite nicely, considering."

They were on neighbourly terms and, looking on, Hamilton found himself, he said, "always wide-eyed at the way [Lucian] moved through the art world (and other worlds for that matter)."[1] Where he had left school at fourteen for a job as an office boy and had gone to evening classes in art, Freud had left school early not because he had to exactly but to evade further formal education. Socially Freud had the advantage: name and reputation already. "Lucian was a fashionable young painter." Hard to believe he was nine months his junior. Looking back he was surprised, he said, that Freud "would have noticed, or cared, that I had an opinion."[2] And he could never quite tell whether he was truly as untrained and impractical as he seemed to be. For instance he remembered him saying once that his canvases were "difficult to paint on because they flapped around like sails."[3] This from a Slade tutor whose idea of art was founded on technical accomplishments allied to design stimuli and perceptual knowingness. Hamilton couldn't believe that Freud was so unpractised. "When I

explained the purposes of the little triangles of wood in the corners of the stretcher he said he didn't feel up to coping with such a tricky technical problem and asked for help. I went round to his studio one evening with a little hammer in my pocket and was lucky to find him at work. There was a beautiful girl on a dirty mattress who wrapped an equally dirty blanket around herself—more to keep warm than to protect her modesty. I tapped in the wedges. Lucian marvelled at how beautifully taut the canvas had become in only a minute or two and admired my skill no end. I still think he was having me on."[4]

In retrospect, Freud thought so too. "I was stroking his leg when I said how clever he was; but I *was* amazed how handy he was. He lived in Springfield Road, he and his first wife, and they made money doing models that included 400 tiny people. They were making these models of New Towns for the Festival and their baby girl was going round smashing forty people with one hand, and they were so patient. They just said, 'no no darling.' They were saints in a way. And very skilful." He was curious as to why Hamilton chose not to paint personal things. Why not paint his wife, for example? "He more or less implied that it was an improper and unseemly subject." When he told Freud that his sort of painting was untenable ("You can't work in your style nowadays"), Freud said it was the only way he *could* work.

Hamilton synthesised as a rule, working within quotation marks so to speak, slightly aloof. His use of colour was mainly to tint or retouch. "Like lipstick on the teeth," said Freud, who was not interested in illustrative demonstration and, still less, demonstrative technique.

To Hamilton, presentation was key. For him the means of display and delivery were crucial to perception of content; he was attuned in particular to the containment of vision by viewfinder and lens; accordingly he was impressed by Bacon's framing devices and by his offhand yet celebratory use of photographic images. For "Growth and Form," an exhibition he organised at the ICA in July 1951 as something of a call to order there, following a Graham Sutherland retrospective, he devised a freestanding grid in which were suspended organic and diagrammatic bits and pieces: a variation on Giacometti's tableau-like *The Palace at 4 a.m.*, a refinement of window-dressing, a twinning of Surrealist legacy with quickening consumer appetites. Though not acting on Herbert Read's advice, Hamilton held the view, frequently expressed by Read, that the modern artist should be prepared to apply

himself to design problems "in the most efficient way possible."[5] Trawling for material in disciplines and forms of entertainment other than fine art was stimulating. And there was kudos in art advanced as a gloss on the latest scientific and sociological research. Eventually Hamilton was to be hailed, in England mainly, as the "Father of Pop Art."

"I would not have rated Lucian at quite the level I put Francis [Bacon] but I liked him very much," Hamilton concluded.[6]

Sir Herbert Read, courtly anarchist of an earlier generation, was all for independent-mindedness, but in his view young Freud could not be said to be more "independent of groups or tendencies" than Francis Bacon. "Generally speaking," Read wrote, "modern art is a personalist art, subjective in its origin and arbitrary in its conventions."[7] In his *Contemporary British Art*, an illustrated essay published by Penguin Books as a contribution to the 1951 Festival, he found himself in two minds as to the correct label for Freud. "Objective naturalism,"[8] he decided, was fair enough in that Freud, one of the few notable anomalies in contemporary British art, seemed to him to be enchanted by a sort of depiction disreputable in art since, well, Ruskin's day.

Was he a throwback? In "Meditations on a Hobby Horse," an essay for *Aspects of Form*, a symposium published to coincide with the ICA exhibition "Growth and Form," E. H. Gombrich quoted Sir Joshua Reynolds: "A history-painter paints man in general; a portrait-painter a particular man, and therefore a defective model."[9] Freud was with Reynolds there, being all for particulars and indeed defects. Particulars gave the lie to nostrums and platitudes; particulars defined and informed; particulars led one on. And, as Gombrich said, "no sooner is an image presented as art than, by this act, a new frame of reference is created which it can't escape."[10] For the painter (even Reynolds, in working practice) the frame of reference is not so much "art" as practicalities. Freud, who loathed intellectual carry-on, liked Van Gogh's idea of a portrait as "a complete thing, a perfection, a moment of infinity."

There was urgency in this. Bacon told a man he met once in Monte Carlo: "You have so little time in life and it is important to make an impression and get it right." To him it was axiomatic. "Presentation is so important."[11]

To Freud too, the thing was to conduct oneself by instinct, impulsively and resolutely if not calculatedly so. "The ancient Aristotelian principle of living by decision, which I think is good. It relates to that: if you allow yourself to follow the way your life goes. I didn't want my work to lean on anyone in particular. I wanted it to be true to me, and I had an idea—a very mistaken idea—that however much I might look at art I really like and go to the National Gallery, to use it in any way which it had been used by other people couldn't help me. I felt that what I must learn from the pictures was a way of dealing with things in paint and subject matter, rather than a manner in which to work. I've always loved Ingres but I've never even thought of in any way working like him—insofar as that's possible."

Picasso said, "Ingres drew like Ingres and not like the things he drew," and Freud drew like Freud, a lifelong admirer of Ingres. His "objective realism," as Read termed it, wasn't mimicry and his existentialism, if you could call it that, was—sometimes regrettably—spur-of-the-moment. Once when arguing with a girl in a club he banged her head on the table, explaining that he believed in "living by decision."

Decidedly, life in Delamere Terrace had more to it than life in Clifton Hill. Freud on the prowl was irrepressible. "I used to put on what were then considered de rigueur burglar's clothes, feed the dog and then start work."

Richard Hamilton noticed—everyone noticed—that where Freud went Charlie Lumley often went too. Charlie was a sidekick, a hanger-on and a liability, Anne Dunn said. "He always took Charlie along as a foil, both with men and women, and Charlie would nick things from them. Lucian was like Fagin." Charlie saw himself more as good companion. "I was in the West End every night with him. He used to try and make conquests, which he invariably did."[12]

Having been painted as cheesecake Charlie (*Boy with White Scarf*, 1949), and Charlie smouldering (*Boy Smoking*—Brylcreemed hair, jutting ciggy, 1951), Charlie qualified as part model, part minder. In United Casting terms he and his brother Billy (*Boy's Head*, 1952) could also have served as the poster boys of Dirk Bogarde's gang of tearaways in *The Blue Lamp*, the 1950 Ealing Studios crime thriller in which police cars were to be seen chasing past the end of Delamere

Terrace. When National Service claimed Charlie, he wrote to Freud as 22402206 Gunner Lumley, stationed in Merionethshire, seeking home news:

> *Has there been any excitement in town lately any more fights*
> *with Johnny and Ricky you remember you told me about the party*
> *someone was giving and Rich was caught having a girl in the*
> *bathroom. I thought that was very funny.*

"Charlie," Johnny Minton told Michael Wishart in January 1950, "like a rat has gone off with the blood-stained suit of a friend of mine."[13] Freud explained to me what that was about: "Charlie was attacked by this man who was married to a later girlfriend of mine—George Barker's younger daughter, Rose Barker—this violent person who died. Minton did a commercial thing [*Leaves of Gold*][14] for a gold-beating factory in Ruislip; there was a row to do with one of Johnny Minton's friends, and a hammer for beating gold was involved, an enormous hammer. Nothing to do with me.

"But Charlie wasn't bellicose. After the fight he was put on probation. His probation officer thought Charlie was my boyfriend—everybody thought that: impossible to prove it isn't so—so I thought if I asked the probation officer round and he saw Kitty in the sitting room, and the children, it would show this wasn't right. Anyway, the probation officer came round, perfectly pleasant, asked me could I help get his daughter into art school. But he wasn't in any way fooled; he went on making reports about my catamite."

Charlie took up boxing for a while and during his National Service talked of going in for the army boxing championships. "He didn't flower in the army: not even one stripe." There was a spell in an army prison on the Isle of Wight.

"Francis said Charlie had a queer life and went with Johnny Minton: that he was rough trade. 'Charlie's having an affair,' Francis said. 'I don't know,' I said, 'I don't think it's true.'"

Jaunts with Charlie took them beyond Paddington and Maida Vale. Bacon's admirer Eric Hall, a married man, patron of the arts and cricket lover, high in the London County Council, had them to dinner a couple of times. "He talked to Charlie about boxing. 'You know,' he said to me, 'I know how to get on with these people.' Picasso had a

show in Paris. He said, 'You *must* go: ring me in the morning and I'll get you a ticket.' Next morning I rang and said, 'You said you would get me a ticket to Paris.' He said he'd never heard such nonsense. He was absolutely horrible to me: he thought I was having an affair with Francis.

"Through Colin Anderson I got Charlie a job on a boat—a merchant ship—but I think he thought I was queer and getting rid of a boyfriend. 'We don't employ delinquents,' he said. He did go to sea and he didn't get into trouble."

Dublin suited Freud when he felt the urge just to get away. "I used to go quite a bit, for weeks at a time, went on those terrible ships, from near Liverpool, to Dún Laoghaire. The cheapest was in the front part: you got so dirty from the funnels. I always liked sea journeys." Freud took Kitty with him at least once, "moving from boarding house to hotel," she told her mother. "It kept erupting," Anne Dunn said. On his own he took a room in Lower Baggot Street with a balcony—like Delamere—recently vacated by John Berger who was about to become an art critic. "I took it off him. It was by chance. He left some drawings behind: so concerned with subject and trying to get a feel. They had a suspense and concentration; the romance of poverty sort of thing."

In the mornings Freud would go round to Patrick Swift's ground-floor room in a house in Hatch Street and work there. Swift, who later lived in North London, emulated him (*Boy with Bird*) to a flattering degree. Freud painted a cock's head and Swift, similarly, painted a woodcock, both on the same red plush chair. The tiny *Cock's Head*, its comb glistening like crispy bacon, its plumage exquisitely bedraggled, was seamy enough, surely, to excite in the Arts Council of Great Britain—which bought it the following year—the curatorial thought that maybe Freud could be the Géricault of existentialism. Certainly he disposed of the dead head he had used with barefaced not to say existential aplomb. "I made a little parcel and sent it—it was crawling—to Sean O'Sullivan. He was a painter, sort of fashionable, lived in Dublin. He had DTs and was offensive about my pictures. Not Irish rude: he was really nasty and bitter. Brendan Behan, whose great thing was being friendly with everyone—you know how senti-

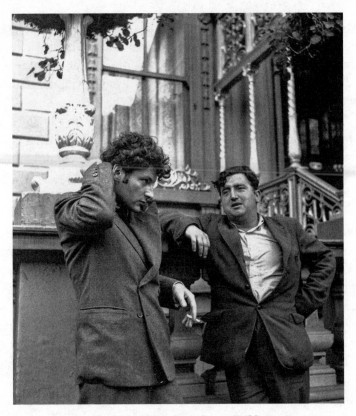

Lucian Freud and Brendan Behan in Dublin, 1953

mental drunks are—said I shouldn't have. 'That's a terrible thing you did to Sean O'Sullivan,' he said."

Augustus John's fourteenth "Fragment of an Autobiography," published in *Horizon* in December 1945, laid down precepts for the portrait painter:

> *No moral bias, to affect his attitude to the sitter. The exploration of character should be left, with confidence, to the eye alone. Heaven knows what it may discover! With a mind as blank as his canvas he sets to work concerned only with the phenomenon before him and its relation to its surrounding within the shape and area at his disposal.*[15]

The reassertion (a bit like the elderly Sickert bent on getting his name in the newspapers) was also a repudiation of the fanciful. Augustus John portraiture was supposedly face to face without preconception. Whereas in the hands of Graham Sutherland—from the late forties his obvious successor, it seemed to many at the time—portraits took on an attitudinised look easily mistaken for severity.

Between 1949, when he painted Somerset Maugham, and 1954, when his portrait of Winston Churchill was unveiled, Sutherland became famous for showing up eminent personages. His Maugham was bitterly jaundiced, his Beaverbrook was crabby, his Churchill, seated as though enthroned, pinstriped yet legless, had a fading obstinacy. Such portraits were newsworthy. "They made a terrific splash," Freud remarked. The painter himself achieved celebrity. "He has passed beyond taste," observed Benedict Nicolson in his *Burlington Magazine* review of Sutherland's 1951 retrospective at the ICA. That August Sutherland delivered a talk on the BBC's Third Programme in which he put a gloss on his motives. "Perhaps one of the reasons why I have recently tried to do portraits is that it is possible I feel the need to narrow the gap between my 'stand in' monuments and the real human animal."[16]

That gap thwarted him, Freud thought. "Graham said that his Churchill portrait was iconoclasm and that the Maugham was better. But he hated people's presences." He treated them therefore as cosmetic composites and latterday figureheads. "He gave Helena Rubinstein Kathy's legs (though her Australian Jewish legs were better than Kathy's little Irish dog legs). I don't think Kathy actually did the pictures, but she could have. I don't think he could have done without her.

"Francis said that Sutherland's portraits were 'coloured snaps.' Well, they weren't actually as good as that, because the one thing about coloured—or uncoloured—snaps that it's impossible not to marvel at is that it is *tonality*. Anyone who's alive to painting recognises paintings done from photographs because the tonality's always subtler than the drawing."

Admiring Sutherland's fabric designs as much as his paintings, and recognising international potential there, Hans Juda, the owner of *Ambassador*, a trade magazine dedicated to the British export drive, published in 1950 an impressive-looking monograph on Sutherland

with text by Robert Melville declaring him, in English, French, Spanish and Portuguese, the greatest British painter since Turner. A grateful Sutherland gave Melville *Men Walking*, a newly completed painting that he hoped might release him from the two narrowing options that so confined him: trophy monstrances (desiccated finds spiked on Riviera palisades) and trophy portraits. Melville would have known, indeed anyone could have seen, that *Men Walking* was an attempted breakthrough. A tall picture of moderate size, it featured two traipsing figures with triangulated necks and hands, and a dog to one side, clamped into a compressed arrangement of palms, railings, sea and sand and deep-blue sky. Freud saw through it: this was Sutherland being Baconic. "It comes out of a misunderstanding of Francis. His extravagant ideas—like leaving off the feet and so on—was a terrible influence on Graham. He gave Graham the idea of people trying to get on to a train and he had this marvellous description of them fighting and Graham tried to do that, but of course he couldn't draw. But then not being able to paint was a quality that worked in his favour I think."

Mindful of Sutherland's shortcomings Freud resolved to enlarge the scope of his concentration. *Interior in Paddington* had followed on from *Sleeping Nude* and the painting of Kitty at Clifton Hill, with dog, took him further. It was, intentionally, an emulation of Ingres' intense even-handedness. "The way [Ingres] liberated pictures seemed so potent. Through his extraordinary discipline: the drawing is as good as any drawing there is, you get really excited about an Ingres fold in a curtain. Said in such an incisive and economical way." So too with Bacon whose men in suits, as detached from the outside world as ghostly slivers in laboratory slides, were similarly all of a piece: not fussed, not contrived, but discovered and left, marvellously just so. Everything about them stimulated Freud.

Anne Dunn saw friendship develop between Freud and Bacon with Ingres an idol in common. "They had been suspicious of each other. Circling dogs. Then the relationship between Lucian and Graham soured and between Francis and Graham soured. Lucian had a sort of crush on Francis—non-sexual—and Lucian, who was never very generous in the years I knew him, would run after Francis with great wads of banknotes and give them to Francis to go gambling with. To my knowledge, Lucian was never a gambler until his rela-

tionship intensified with Francis. He may have been. I was completely ignorant of it. I never thought of Lucian as having a gambling nature. He's retentive."[17] She had a Bacon painting: the base of a crucifixion with a stricken figure vomiting a bunch of flowers. Years later Bacon tried to get it off her but she resisted and he agreed that she could keep it until her death, provided that then it would be destroyed. In the end she sold it[18] and it went to Bacon's avid emulator Damien Hirst.

Bacon was possessed by the desire to achieve vitality, not—as Ingres did and Freud tried to do—by dint of application but by fluke. His heads, three or four years before, had been bared in front of dirt-grey curtains: Eliot's yowling Sweeney over and over again, the "Oval O cropped out with teeth."[19] These roaring men, "imprisoned in transparent boxes," as Robert Melville hailed them,[20] were arresting enough to attract fashion victims. Freud saw it happen. "Nina Hulton, wife of Edward Hulton (owner of *Picture Post* and *Lilliput*), went with Robin Ironside, her walker, to enquire about having a portrait done by him. Francis said, 'Tops of Heads? You know I'm actually putting them *in* this season.'"

Frank Auerbach and Joe Tilson, students at the Royal College in the early fifties, were taken up by Johnny Minton; neither was gay but, as Tilson himself said, both were good-looking and went along with him to the Colony Room, the Gargoyle and other haunts. Tilson particularly—and resentfully—remembered going to a party at Delamere Terrace with his girlfriend Sally Ducksbury, a student at the Central. Freud spotted Sally and moved in on her and Tilson became aware of toughs hanging around, one of whom—Charlie Lumley, as it happened—was told to get rid of the boyfriend. He threw Tilson down the stairs. There was, Tilson said, a culture of thumping. "Lucian and Francis would engage that way. In Notting Hill there were Irish pubs, which everyone took care to avoid late at night, as there would be fisticuffs at chucking-out time and violence in the gutters. Getting into fights was a kind of rite of passage: being streetwise."[21]

Freud was to become keen on the Reg Smythe cartoon strip "Andy Capp" involving the workshy northerner Andy and his fearsome wife Flo in which pay-off lines and direct action were briskly,

ritually synchronised day after day. "Man lying on ground: 'I thought the policeman was going to hit me so I hit him back first.' Awfully good, don't you think?"

"If Lucian saw somebody with somebody he thought he might fancy he'd immediately make a beeline for her," Frank Auerbach said. "I've seen men, boyfriends, driven mad by him using his extraordinary power of picking people up at a party by the side of their boyfriends and taking them to the bathroom and the boyfriend looking absolutely furious, distraught and so on outside."[22] With sideburns and conspicuous trousers he cut a dash; to his elders he had something of the style and manners that were to be associated with "Teddy Boys," first so called in the *Daily Express* in 1953.

John Masefield's *The Widow in the Bye Street*, a narrative poem that had appealed to the schoolboy Freud, contains the lines:

> *Your father liked his cup too, didn't he?*
> *Always "another cup" he used to say*
> *He never went without on any day.*

In his memory Freud abbreviated this, making it, as he recited it, more to his way of thinking. " 'Your pa he was fond / Of a nice bit of blonde, he used to say.' Awfully good don't you think?"

One time, returning to the Slade after the holidays, Richard Hamilton happened to bump into him.

> *"How are you?" he asked.*
> *"Three breakdowns."*
> *"Oh dear."*
> *"No, not me."*[23]

Though not denying the story, Freud demurred. "I don't know."

The biologist J. Z. Young, whose dancing at the Gargoyle Freud admired, taught at the medical school next to the Slade. Coldstream remembered walking up the street towards the Slade with him once and him saying, "Please don't talk to me, I'm thinking important thoughts."

"John Young took things very far," said Freud. "He was very much to do with reptile brains and he made things seem so interesting. The last book of his I read was about the sexuality of fish. He says when you start studying these fish you might think that God (if you believe in him) must be obsessed with sex. He didn't take me seriously, thought I was a playboy. I asked him things occasionally: when I was at the Slade he'd be in the common room." He tried to persuade Professor Young to give him access to the pathology lab; Young refused, but that didn't stop him.

"There was a basement room with nothing but beds with corpses, grey, pinky grey, bluey grey, as they had been in formaldehyde. I took a look through the window at them then went into the room. An orderly in a white coat was standing with his hands inside a hole in a body. What do you do to get him to take his hands out of the stomach? I wondered. "What's the time?" I asked. Squelch, and he peeled back the rubber glove and told me and put his hands back, quick as a wink. These people get addicted to dead bodies, you see: one is fascinated by them. Though I've never been drawn to the corpse, it is part of life. Or the end of it. When I saw John Young later he was pretty hostile. Called me morbidly exhibitionistic. He was not interested in art."

The philosopher A. J. Ayer—understandably nicknamed the "Juan Don"—was another acquaintance of Freud's and even less friendly. "Our dislike which was almost instinctive had nothing to do with his marriage," Ayer wrote.[24]

Freud maintained that he always thought Freddie Ayer ridiculous. "He was at the Gargoyle a lot and had been a Jewish Guards officer: very rare." Ayer gave a party at which Freud overheard Henry Yorke warning someone against going out with him. Yorke, nom de plume Henry Green, whose recreation, listed in *Who's Who*, was "romancing over a bottle of wine, to a good band," took up with Kitty. "Henry Yorke used to take Kitty out sometimes. There were shouts outside Clifton Hill once and Kitty and Henry were outside and he grasped my hand and shook it: he was congratulating me on having the drunkenest wife in London. He was amorous, awfully nice. A good writer." His last novel, *Doting*, published in 1952, a chronicle of an extramarital pursuit that comes to nothing, ends with a shrug: "The next day they all went on very much the same."[25]

Freud's involvements, by contrast, were apt to be spontaneous. One night in the Gargoyle, according to David Tennant, "Sartre was there with his governess Simone de Beauvoir, sitting with Sonia Orwell. Lucian and I were both invited over to their table. Sartre got up and sat on it, waggling his short legs, and said, 'Who is that good-looking one?' Jabbing his Gauloise at Lucian."[26] She, Simone de Beauvoir, complained about the failings of Englishmen, spotted Freud and disappeared with him into the night.

He had more of a relationship with Andrée Melly, sister of the jazz singer and ex-London Gallery assistant, an actress who went on to title roles in *The Belles of St. Trinian's* (1954) and Hammer Horror's *The Brides of Dracula* (1960). "I didn't paint her, I just used to see her some nights; never went away with her nor was she there for long." He gave her the etching *Girl with Fig Leaf*, subsequently—decades later—buying it back from her.[27] And there was Wendy Abbott, renamed Henrietta by Michael Law, a film-maker with whom she lived, and who became *Girl in a Blanket* (1953), seated in the window at Delamere where the palm tree had stood, a painting reminiscent of Bellini's *Young Woman at Her Toilet*, the painting that Freud had most admired in the Kunsthistorisches Museum in Vienna. He stippled *Girl in a Blanket* to excess; technically ambitious—"I was trying to do what Daumier does: *contre-jour*"—what had begun alert (the sitter sitting not sleeping) went numb, so much so that later on Freud dismissed the painting as a "graphic artefact." It reproduced well on the dust jacket of *Henrietta* the autobiography, published in 1994, in which she wrote, "I was in Lucian's power, like a mesmerised rabbit, but being in a trance doesn't stop pain and after I discovered somebody else's menstrual fluid in what I thought of as my bed I decided that I could take no more."[28] Freud explained that the inadequacy of the painting stemmed more from his lack of conviction than from her lack of concern.

"She stayed quite a bit, but she left because I was so promiscuous. She was casual in her degree of involvement, liked scoring but had a funny temperament. Sometimes when we were out, a bad lot, David Milford Haven, the Marquis of Milford Haven, friend of Prince Philip (his best man), would follow us and obviously she was carrying on with him. Henrietta liked quite a lot of angles to these things, and one thing I realised: there was this very odd thing with mothers. She took

up with people she said were tricky and dangerous, young men who had affairs with their mothers, and she had to get in their way. She was a devil for a threesome: a terrific rivalry with the mothers. This wasn't fantasy: some people make their inventions. She was good-looking for a very long time." The relationship did not end with the last sitting. "It drifted on a while in a fairly spasmodic way long after the picture. She came to Paris." Her second marriage—following the one to Michael Law—was to the actor/body-builder Norman Bowler and her third, in the sixties, to the poet Dom Moraes. Bacon's portraits of her, worked up from photographs by John Deakin, upstaged Freud's laborious picture.

Among the alternatives to Henrietta was Caryl Chance (*Girl in a Dark Dress*, painted in 1951), blonde and determined-looking. "She was more fastidious, rather amazing, and was around Soho a lot." Once, at the Gargoyle, someone tried to rob her. "Don't be so silly, darling," she was said to have said. "You look absolutely lovely and I'm going to dance with you." She too went to Paris with Freud. "During the night, in a hotel on the Île Saint Louis, someone came and took her handbag. No one can do these things with me about, I thought, and I told the landlady. Tears started running down her face. 'We've had a thief here for years,' she said, 'and it's so awful: because we have seven residents and it's one of them and we don't know who.' I did go with her, but I never lived with her. She was loud and tiresome, lovely-looking, and never stopped talking; could be funny, but not brainy. I'd ring a number and get her. She was very much about." She had her eye on Tony Strickland Hubbard, the Woolworth's heir.

Kitty went round to Delamere Terrace one day, saw *Girl in a Dark Dress* on the easel and reacted. Freud regretted this. "Kitty smashed it." The painting was repaired and Caryl went on to become, briefly, a cat burglar, enjoying the buzz and initial success. This did not last. Her partner in crime, Henrietta Moraes, fell out with her. "'My idol had feet of clay,' she said."

When in the spring of 1951, after some months in South Africa, Bacon returned to England it was to be devastated by the death of Jessie Lightfoot, his nanny, housekeeper, surrogate mother and, on occa-

sion, bouncer. Freud heard him out. "He told me the sort of things that were happening to her, shitting herself in the bed. And about his making things easier for her. She then got much worse. After she died he painted me." This was the first portrait from the life that Bacon attempted; that's to say, the first to enter the oeuvre. It was done at the Royal College of Art where, for a year or so, Rodrigo Moynihan gave Bacon the use of a studio. Freud expected to have to be there, to make his presence felt as Harry Diamond had done for him. "He asked me to sit and when I came the first time this painting was already virtually finished." Bacon never normally worked with someone else in the room. He talked, mainly to himself— "exasperation, explanations, self-criticism, unselfconscious"—and there was "a lot of movement and noise and lots of mixing colour on the forearms, very, very, strenuous. And a lot of irritation, but not for me though: he'd got such good manners, making it clear that him and it, not you, were the problem. He had a photograph of Kafka leaning on the doorway and he had been using that. I was amazed; it looked terribly good to me. First time he just did the foot. Then I came and stood about four or five times and it got worse and worse every time and then, at the end, not very good. It isn't very good, but it's lively."

The Bacon *Portrait of Lucian Freud* (1952), in the Whitworth Art Gallery, Manchester, bears no resemblance to Freud and little to Kafka. A coltish young man enters through what could be a revolving door into blinding glare. Soon after this Freud rejected an approach from a Slade student, Lorenza Mazzetti, for him to play the lead in her film adaptation of Kafka's *Metamorphosis*. It would have been, he thought, an impersonation too far. Another Slade student, Michael Andrews, took on the role.

Michael Hamburger, who had known and quite liked Freud longer than most, liked him least, he said, when he saw him in Soho with Bacon. "He adopted a sort of manner, which I disliked: being very sophisticated and smart and making remarks supposed to be shocking."[29] Bacon, a practised exerciser of charm, urged him to think about how he presented himself. "I thought the best thing was to be rude. I don't mind being on no terms or bad terms. I just don't want to be on false terms," was Freud's response. But Bacon insisted that good manners were useful. "Francis opened my eyes in some ways. His work impressed me, but his personality affected me."

During the war, when he was summoned to a tribunal to assess his fitness for military service, Bacon had hired a dog from Harrods and spent the night with it knowing that this was a good way to bring on an asthma attack. "He had got this idea about Harrods: if he was near Harrods he couldn't go too wrong, he thought." The store was his universal provider. "Everything was linked to Harrods. At first, early on, the bills came and they got more and more nasty but he took no notice and eventually they just pretended that they had been paid. He had a little man there who made these round-cornered suits for him that suited nobody but him." And he used to filch from the Food Hall, initially out of necessity, then out of habit. It was, Freud thought, simply a case of him helping himself rather than exercising sleight of hand.

"Francis made a great thing about the sensuality of treachery (which wasn't original) and he used to go on about the cult of the hands, which, in his pictures, he tended to miss."

Bacon turned to advantage his lack of conventional expertise. To adapt William Empson's phrase, he learned a style from a despair.[30] Or, in John Berger's equally arresting phrase, "horror with connivance."[31] It obliged him to be summary, to skirt formal difficulties, exaggerating to disguise incapability, swiping in the hopes of hitting it off, passing off anguish as hilarity and, occasionally, hilarity as angst. He said, "We live our life through our whole nervous system"; he thrilled to violence, or to the image of violence. Orwell's image, in *Nineteen Eighty-Four*, of the fascist state "stamping forever on the human face" is verbal Bacon. The paintings were as showy as figures of speech, as impressive as the ludicrous warning from Mrs. Joe in *Great Expectations* when Joe and Young Pip hurry off to watch convicts being recaptured: "If you bring the boy back with his head blown to bits by a musket, don't look to me to put it together again."

Where, intuitively, Picasso used to slice profiles and reposition eyes, Bacon, relying on reflex, made faces that loomed blurrily: ghostly monoprints lifted from the sticky tonalities of photo culture. Like André Gide not knowing "whether I feel what I believe myself to be feeling," Bacon found expression in having a stab at things. "Art is a method of opening up areas of feeling rather than merely an illustration of an object," he told a reporter from *Time* magazine in 1952. "Real imagination is technical imagination. It is in the ways you

think up to bring an event to life again." Matthew Smith, he stressed, in the introduction he contributed to the catalogue of Smith's Tate retrospective in 1953, had this essentially painterly imagination. "He seems to me to be one of the very few English painters since Constable and Turner to be concerned with painting—that is, with attempting to make idea and technique inseparable."[32] What was true of Smith was even more true of himself: "I think that painting today is pure intuition and luck and taking advantage of what happens when you splash the stuff down."[33]

Suspicious of such notions as happy accident, Freud baulked at this. "I don't know with Matthew Smith. It's impossible not to like it, but you don't feel that *truth* plays much part in it." Listening though to Bacon, seeing him most days, he found himself echoing his words. "I used a phrase, 'memory-trace,' to Colin Anderson. He said, 'You're talking like Francis: is that *right*?' Sort of bitchy."

Bacon, Freud found, was better to talk to than anyone else he knew, deft and provocative, always stimulating. And he even agreed to be painted. "It took two or three months. He grumbled but sat well and consistently." Bernard Walsh, who ran Wheeler's in Old Compton Street, their favourite eating-place, used to go on at them to do portraits of one another. "What I want is a Bacon of Freud and a Freud of Bacon," he said, so it was a virtual commission. Freud saw it as a favour rendered. "That little picture I really did for him; but when I left Kitty and married Caroline he was so unpleasant. 'I didn't know Lucian was a ponce,' he said, and I was so depressed I fell off the bar stool on to the floor. I couldn't do anything else as he owned the place and was thirty years older." Otherwise, he said, he would have thumped him.

As with most of the other small portraits he did around that time Freud used a copper plate, small enough to be hand-held if the detailing demanded it. "Life-size looks mean," Bacon said, whereas shaving-mirror-scale looks intimate. Freud's Bacon is side-lit, half dour, half sunny, his voluptuous features, nostrils and chin, temples and jowls, uneasily patted together. Sitting knee to knee, within three feet of him, Freud caught the air of unconcern, or diffidence even, the heavy-lidded eyes downcast, blond hair mussed over traces of pencilling, a flicker of disdain crossing his mind possibly.

Freud was prompted—shamed even—by Bacon. "I got very im-

patient with the way I was working. It was limiting and a limited vehicle for me and I also felt that my drawing and my making artefacts—graphic artefacts—stopped me from freeing myself and I think my admiration for Francis came into this. I realised that by working in the way I did I couldn't really evolve. The change wasn't perhaps more than one of focus but it did make it possible for me to approach the whole thing in another way." He appreciated that expression—as distinct from Expressionism, which was pseudo-primitive Mannerism—involved a degree of emphasis bordering on abandon. Bonnard said, "Draw your pleasure—paint your pleasure—express your pleasure strongly." As Delacroix wrote in his diary, "One never paints violently enough."

Francis Bacon, 1952

Shortly before Freud's second Hanover Gallery exhibition in May 1952, John Rothenstein of the Tate came to Clifton Hill to see his latest work and, compensating for having failed to secure *Girl with Roses* for the Tate, went one better by buying both *Girl with a Dog* and the portrait of Bacon, which was thereafter referred to by Bernard Walsh at Wheeler's as "my picture of Bacon you sold." Conveniently, when Eric Hall presented *Three Studies for Figures at the Base of a Crucifixion* to the Tate the following year, Freud's *Francis Bacon* could be associated with it as the very head within which the dream of reason had produced monsters.

Walsh, who had been an actor and at one stage owned the Ivy Restaurant, was a racehorse owner with a family background in oysters. He continued to complain about being cheated of the picture. "I thought you were a friend of mine," he said. Freud told him that he saw no reason to keep to any arrangement they might have had. "No doubt you were drunk," he added, to which Walsh retorted: "*In vino veritas.*" However some years later Freud did a similar sort of portrait

of Walsh himself. "Done for oysters. It didn't hold together. He was a big Irishman; his daughter, married to a Maltese man with a restaurant in Charlotte Street, had it on show there."

Erica Brausen was furious too when she learnt that Rothenstein had bought the two paintings ahead of the Hanover exhibition for it deprived her of the best potential sales, as the other exhibits, such as *Girl in a Blanket*, *Girl with Beret* (Helena), and *Portrait of a Girl* (Anne Dunn), were all small, except for *Interior in Paddington* which had been presented by the Arts Council to the Walker Art Gallery, Liverpool. David Sylvester did not specifically mention either painting in his review for the *Listener*, published a couple of days after the opening. *Francis Bacon* however was reproduced with a caption dating it 1950–1 and saying that the Tate had bought it. The early paintings, Sylvester wrote, had been "hysterically still and airless," but the new ones had more to them. "The impression they make of a presence as complex as that of real people. And as unique. For while Freud's work might be called affected—as a dandy is affected: that is to say there is deliberation in its unconventionality—it is entirely free of mannerism, of any inclination to impose a preconceived character on the subjects."[34]

Other reviewers aired what had become the usual preconceptions. "The tension here is at snapping point," wrote Michael Middleton in the *Spectator*. "Or fairly frequently so."[35] John Berger in the *New Statesman* recommended the mildly Coldstream-style paintings by Martin Froy, a recent Slade graduate, in the upstairs room at the Hanover as "well worth investigating" but did not mention the Freuds. But Robert Melville praised the Bacon portrait unreservedly. "For once he has suppressed all his sinister proclivities for the game of out-staring but we are on safer ground if we think of it simply as one of the great portraits of the century."[36]

Bacon appreciated that Freud had caught him all but unawares. There he was: close, guarded, troubled, solitary really, and manifestly private. Unusually for him, Freud was relieved to be told that he approved. "He liked it as it went on."

More so, it may be assumed, than Robert Buhler's half-length portrait of him in open-necked shirt and jacket, painted in 1950 and exhibited in the 1952 Royal Academy Summer Exhibition. Buhler's Bacon sat further away, distant enough to appear to be a fairly aver-

Landscape with Birds, 1940

Girl on the Quay, 1941

Man with a Feather (Self-Portrait), 1943

The Painter's Room, 1944

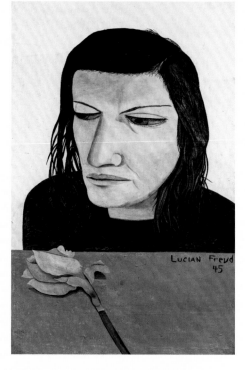

Woman with a Daffodil, 1945

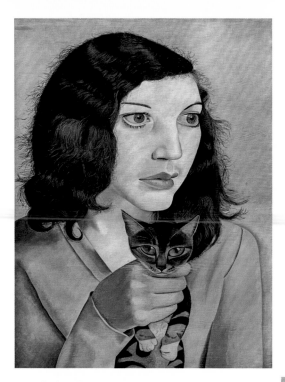

Girl with a Kitten, 1947

Father and Daughter, 1949

Girl with a White Dog, 1950–51

John Minton, 1952

Interior at Paddington, 1951

Hotel Bedroom, 1954

Woman Smiling, 1958–59

Pregnant Girl, 1960–61

Baby on a Green Sofa, 1961

age sort of chap acting nonchalant for a fellow painter despite inner uncertainty and a lack of proper training.

When Nanny Lightfoot died in 1951 Bacon was so distressed he couldn't bear to go on living in his Cromwell Place studio. Buhler took it over and came upon some discarded canvases there, which, Freud heard, he later sold. "Francis was really upset and confronted Buhler about restretching stuff of his and putting it on the market. Buhler said, 'You don't *really* care so much about your reputation, do you?'" Bacon didn't pursue the matter. "He said, 'These are my drinking companions, Rodrigo, Robert and Ruskin [Spear].' Francis was far too intelligently realistic to make anything more of it." Better to shrug it off than make a belittling fuss. "Francis had a brilliant gift of finding qualities in people." Better to seem to find qualities in people than to be seen to lose face over them. Presentation, after all, was so important.

"Francis would not be photographed in the ordinary way, so when [John] Deakin was photographing several people a day in the *Vogue* studios in Shaftesbury Avenue and asked him, he said he would only be photographed naked to the waist with sides of beef: i.e. fuck off. But Deakin got sides of beef and Francis' bluff was called. He had to do it." Bacon submitted to being posed between two sides of beef like a peculiarly ineffectual meat porter. "If you look, no hand could hold them; the sides of beef were hooked." Rather than waste an outlandish pose, Bacon did a painting of Deakin's photo session, the sides of beef closing in on a pope like two wings of a triptych. Freud told him that he liked it. "I don't," Bacon said and not long afterwards offered it to him as a wedding present.

Freud found Bacon good to draw impromptu. He drew him tetchy, scratching the top of his head like Stan Laurel bemused. Then one evening at Clifton Hill Bacon stood up, tugged at the waistband of his trousers and, wiggling a little, offered himself up as a poseur. "He said, 'I think you ought to do this, because I think that's rather important.' He undid his top fly buttons. 'Oh, you ought to use these,' he said. His hips: such a good tip. He rolled up his sleeves (his forearms were very well developed) talking about how to edit himself. He recognised the hips were a great feature, part of his allure." Three impeccable line drawings resulted, drawings defining the twitch of the pelvis, the roll of the hips.

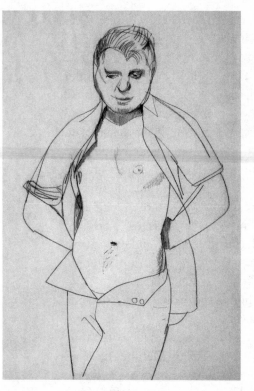

Francis Bacon, 1951

Freud was to paint Bacon once again some years later, "a half-picture," he said, extending to facemask proportions: eyes, nose, mouth and the bulge of a cheek completed, the rest unrealised. "Francis got bored, sort of, with sitting." There being no likelihood of ever getting it finished, he decided after a while to let go of it to Nicholas Luard (co-founder of the magazine *Private Eye* and the Establishment Club in the early sixties) to settle a debt of £80. But Luard wrote back saying that he actually owed £280. Offended, Freud withdrew the offer ("I thought not giving it to him was some sort of fine") and eventually the dealer William Darby bought it off him one afternoon for an urgently needed £600; he nipped into a nearby betting shop with the money and there lost it.

"Lady Dashwood, sorry to have kicked you"

When, in 1952, John Minton asked Freud to paint his portrait he was surprised at his working method. "He said, 'Do you actually look at people when you paint them? You keep looking really really hard.' I did it on a kind of slatey undercoating." As with the white dog painted over the black dog, the dark ground gave Minton's skin a ghostly tinge. Where Freud's Bacon had been sun-blessed, his Minton was moonstruck, distracted and faintly chivalric, like a doleful Arthurian knight "making good and properly absurd camp jokes," his friend Bruce Bernard said, "mostly of mock despair."[1] According to his friend Susan Einzig, the illustrator, the Minton crowd viewed the portrait "with shock and anger," seeing it as a travesty of the Minton they knew. Mercurial, yes, and prone to bouts of depression, but why the feverish melancholy when he was so loudly, and so passionately, the life and soul of the party? A critic spat at it. Minton, however, hung the painting in his house in Allen Street and when, the following year, he painted a self-portrait his mirror image reflected Freud's painting, with modifications: a straightening of the nose, a firming of the chin and no wistful brimming of the eyes.

"He was very witty and engaged about being 'doomed.'"

Freud liked Minton, who was six years older than him and streets ahead in reputation, though falling back into corrosive disillusionment as the style that he was associated with lapsed from vogue. He had arranged for Bacon to take over from him at the Royal College of Art in the autumn term, 1950, while he went off to Jamaica; Bacon

was not prepared to teach, but it was felt that he would be good to have around. And so it proved. "John Skeaping said of Francis, 'I don't really like him, I don't understand his work, but I'd back him on character alone.'" In the College, in Soho, and beyond, Bacon was becoming the painter to watch, the reveller to follow.

Robin Darwin, Rector of the Royal College, was set on improving the collegiate image, and to this end he promoted the idea of the staff room in Cromwell Road as a gentleman's club to which he could invite the highest in the land. "Darwin said, 'I've got the Duke of Edinburgh coming to lunch in the Senior Common Room: I would prefer it if none of you talk to me while I am in his company.' They sort of made me a member. But then something happened at one of the balls, I can't remember what, and I was barred." Within a few years Minton too relegated himself from being a star of Darwin's smart new Royal College to being miserably disaffected.

"I saw a bit of him when I lived in St. John's Wood with Kitty. He lived then in Hamilton Terrace, not far away, in the same house as Keith Vaughan, who was anti-Semitic, very ashamed of Johnny, prim and bitter. (The best subject's the human animal and Keith Vaughan used it as an excuse for the softest possible porn; he was so shocked by Johnny Minton's life he asked him to move out.)

"Johnny used to take us out, Kitty and me, as a couple, which never happened at any other time in my life. For instance to *Goody Two Shoes*. He was a sort of rather nice, rather lonely, avuncular figure, a bachelor taking out a married couple. Going to dinner at Venezia in Dean Street, Johnny would say, 'How about a nice bottle of Chateau Hysteria?'" In 1949 he had come into the Minton china fortune and spent his way through it, generously and despairingly.

"A picture must succeed or fail according to its own nature," Minton said in *Picture Post*, in March 1949. His *Jamaican Landscape*, in *60 Paintings for '51*, was touristic; his *Death of Nelson* (1952) was stagily composed with a sorry crew crowded on to vertical planking. Unlike practically every new painting by Bacon, each new Minton was a disappointment and, worse, predictably so. "On the whole he didn't lose himself enough in these things. On the other hand his Elizabeth David drawings are very nice." That was no comfort to Minton whose drawings of Mediterranean fruits and fish were visions of the unattainable in post-war Britain.

The portrait—finished in late 1952—is Minton the lost soul, gasping slightly. "He was forever dashing off," Michael Middleton wrote, "afraid he might be missing something round the corner—another party, an evening at the Jazz Club, a drink on the Soho circuit."[2] "What does it all *mean*?" he would say.[3] David Tindle, whose portrait by Minton represented him as a younger Minton and who painted a self-portrait in the style of Freud, said that Minton told him, "You're the first to see something in Lucian." Freud had little time for Tindle and his paintings. "He started by doing Johnny Mintons then moved over to me and then tried to do MacBryde & Colquhouns. I did go out with one of his wives for a minute. Then he used to do various things to court me. He asked me to be godfather to one of his children."

Minton grew morose as Bacon's star rose and this, Freud saw, smouldered into resentment. "He slightly minded his style." Minton jeered at Bacon in *Ark*, the Royal College magazine, calling him "Ferdie Ham" and "Ferdinand Delicious" and mimicking his volubility: " 'I'm simply going to Monte to make a fortune. I simply am . . . You must all come but you must, we'll all go and simply destroy one another.' " Bacon responded with greater derision. "Champagne for my sham friends and real pain for my real friends," he cried, rubbing champagne into Minton's hair. It was one of his favourite sayings.

Freud had read on Poros George Millar's copy of Henry James' *The Tragic Muse*, in which a young English diplomat decides to become a painter and young Gabriel is sitting for him, splendid in a cloak. Looking at him posing, the former diplomat says, "I wonder what you will do when you are old?" The Minton of Freud's portrait sweats distress.

Freud's distraction throughout 1952—beyond the completion of *Girl/Woman with a White Dog*, and over and above the portraits of Bacon and of Johnny Minton—was his other sitter, supplanting the rest: Caroline Blackwood, elder daughter of the 4th Marquess of Dufferin and Ava and great-niece of Basil Blackwood, the original illustrator of Belloc's *Cautionary Verses*, a connection that pleased him. He had first come across her, aged eighteen and a debutante, at a Rothermere party in 1949, an occasion when, he remembered, Princess Margaret

tried performing Cole Porter numbers with the band, persisting until Bacon's hisses from the back of the ballroom silenced her. ("Princess Margaret sang and Francis heckled and Binky Beaumont said how dare he, and I said, 'You are very lucky to be in the company of someone so talented,' and he said, 'Pounds, shillings and pence will tell.'") Because of this upset it wasn't until late 1951 that Freud met her properly at White Cliffs, St. Margaret's Bay, on the Kent coast, a holiday house lent by Noël Coward to Ann Rothermere who held parties there for her O'Neill children. He fell for her, obsessively so.

The writer James Pope-Hennessy recorded in his diary for 18 February 1952 a glum dinner with the smitten Freud. "He was so exhausted by the emotion of seeing a girl he is in love with in bandages after a motor accident (Lady C. Blackwood) that he collapsed, or wilted like a flower on its stalk, at nine, and I sent him home."[4]

Such ardour was striking and, to the Dowager Marchioness, Maureen Guinness, (the 4th Marquess had been killed in Burma in 1945), repulsive and alarming in that, to her, Freud was the embodiment of pretty well everything she most loathed: poor and spivvy, and Jewish, a painter too and married.

Caroline Blackwood had been brought up to be eligible. Cutting off her allowance was the mother's first resort. But that didn't stop her; indeed the more her mother raged the better it suited her for, not unlike Lorna Wishart a generation or so earlier, she sought the freedom and escapades of upper-crust bohemian circles. Having been at school with Anne Dunn and at Queen's Secretarial College in South Kensington at the same time as Wendy Abbott before she became Henrietta Law, she found herself among heady competitors if not rivals. Freud appreciated the complications. "When I started going out with Caroline, Henrietta was very excited; one evening Norman Bowler, Johnny Minton's boyfriend, was dancing with Caroline and he said, 'Henrietta, I think I'm going to fall in love with you.' Caroline had a fit." Norman Bowler went on to marry Henrietta, who was pregnant by Colin Tennant at the time. Yet Tennant was reported as being a possible husband for Princess Margaret. "He was sort of very well known and very style-conscious. I went out sometimes with Princess Margaret and him. (I certainly didn't take her.) Princess Margaret was very pretty but she had a way of spoiling everything."

In what was for Freud a spell of ferocious attachment, he found

himself newsworthy for the first time, uncontrollably so. He became not a playboy (he hadn't the money) but a social climber, a reveller in a sharp suit (later to be dubbed the Teddy Boy style) regularly sighted in high society. "I had Fortnum suits. Delicately stitched. I wanted to be let into places and there was a pub in Shepherd's Market I was turned out of. Why? 'No reason given,' the man said. It was because all con men had suits on and went into clubs and took overcoats."

From suspected con man to accomplished dance partner (albeit impulsive rather than rhythmic) was achieved in two moves. "It was all one year when I was doing the deb scenes to see Caroline. There was Kitty at home and papers ringing up, saying was I the person with yellow socks dancing in the Café de Paris with Princess Margaret? I fell on top of her on a sofa at her sister Perdita's dance at the Hurlingham. 'Would you care to dance?' I said. I'd had so much to drink: it's exciting to test your balance then. She said it was the most terrifying thing that had ever happened to her. She got panicky once at the Café de Paris as she couldn't find her comb. I used to have a comb in those days—long hair—and I put my hand in my pocket for it. 'Is that it?' 'Did you use my comb?' 'No. But I may have.' Absolute horror.

"When I first met her—about 1949—Princess Margaret said would I do a picture of her and Elizabeth Cavendish, her lady in waiting? She would shine, and Colin said don't ask anybody too pretty to be with her. Elizabeth Cavendish I did paint [*Head of a Woman* (1950)]."

Caroline Blackwood, blonde with startled eyes and impulsively applied lipstick, looked, to him, the perfect ingénue. "When I first went to her room in Hans Crescent the only book she had was *Lady Addle Remembers*, a book of bogus grand memoirs like *My Royal Past* by Cecil Beaton. When I met Caroline the adjective she used was 'heavenly' and I started using it to try and get used to it: my way of not jumping when she said it was to inoculate myself against it." With no thought at that time of herself becoming a writer, she was working as secretary to Maurice Richardson at the Hulton Press where he was Literary Consultant to *Lilliput*. "He and Claud Cockburn started a paper without Edward Hulton's knowledge and I did horror comic sci-fi drawings for it, never used, but I did them to please Caroline.

Maurice Richardson, very crazy, manic-depressive, a cousin of John Richardson, Picasso's future biographer, said to Claud Cockburn how exciting it was to have both the paper and her. 'You can't take her out,' Cockburn said to him. Then Edward Hulton, pompous autocrat, found out about the magazine and stopped it."

Freud already knew that the best way of impressing a girl and ensuring that she devoted her time to him was to paint her. Hence the life-size, and surviving, representation of her left eye, intended as one of a pair. (The other was to have been sister Perdita's right one but the whim blinked so to speak.) Having given Caroline a dead starfish—"I always liked marine life"—strung on a thread, a more romantic adornment than any jeweller's necklace, he set her sitting for a portrait. The resulting *Girl with Starfish Necklace* was a taster, testing the reliability of someone possibly rebellious, certainly impressionable. It had worked with Lorna and Kitty, so why not with Caroline?

"I did it before I knew her. It was pretty overworked and it's got that thing I slightly despise of people saying 'You are so beautiful I must paint you.'" Pin-up that it was, more image than portrait, he sold it to his younger brother as a pin-up to boast about. "I made Cle buy it. He beat me down to £40."

Needing more than that if he were to conduct his pursuit of Caroline successfully he decided to sell *Fleurs*, the Max Ernst that he had bought from the Redfern during the war for a bargain £50, and approached Roland Penrose. "I needed money badly and he said, 'I can't *buy* it from you; I'll give you £50 or £100 and if you *really* have to sell it then sell it to me.' I rang him six months later but he was away, so I sold it to Gimpels and he was angry; it was hopeless making any excuse." With £120 from Gimpels he had enough to take him for a while to Ireland where Caroline was to be found. There he stayed with Ann Rothermere's son Raymond O'Neill. "Raymond was way under twenty-one, so questions were asked. Why was I there, with Caroline, star of County Down?" The O'Neills had been Kings of Ireland. "Raymond's middle name was Clandeboye and he was very angry that these fucking Scots, like the Dufferins, were put in and given lands and houses. He was disdainful. He sold villages now and then.

"Went to the North, to Belfast, new to me. I remember thinking how desperate it was. Clandeboye, where Caroline lived, was barred

to me but Caroline took me there on a surreptitious trip when her mother went away." Clandeboye, a handsomely dilapidated country house outside Belfast, is stuffed with relics of the Raj accumulated by the 8th Viceroy and 1st Marquess of Dufferin and Ava. It was a favourite weekend resort of John Betjeman who had been a bosom friend of the late 4th Marquess. Freud was not so much overawed as nauseated by the pressures of the place. "The gloomy lake. The library. The stuffed bear in the hall with a tray: it had been tame and it had scratched someone, so it was shot and stuffed."

He soon had enough of Ulster. "I got Caroline to come across the border too and fled to the South, first to Dublin, then to Janetta [the Dorchester dinner date from 1941] and Derek Jackson who were about to have Rose." Jackson was a distinguished but by all accounts fascistic spectroscopist, war hero and steeplechaser, chairman and part owner of the *News of the World*; he rode in the Grand National three times and had twice that many marriages. "He left her—Janetta—when he realised it wasn't a boy." Then in August they stayed with Caroline's aunt, Oonagh Oranmore—Lady Oranmore and Browne—at Luggala, a Gothic Revival shooting lodge where Rose La Touche (Ruskin's too-young love object) had lived, in a house party that included new and old acquaintances, among them the writers Claud Cockburn and Francis Wyndham. It was the week of the Dublin horse show and Lord Powerscourt's Ball, to which Freud went in his tartan trousers. " 'You can't come dressed like that,' the butler said. I assaulted Powerscourt on the race course as he had been rude to Oonagh. Huge great angry-looking thug and I said to him, 'You were very rude to my hostess.' So I took his tie, very yellow, and pulled it very tight. A racing official came."

Freud persisted in his courtship, and relations with the Marchioness worsened to venomous farce. At the end of the year he stayed again with Raymond O'Neill. Ann Fleming, as she now became—she married Ian Fleming in March 1952—wrote to Cecil Beaton giving Raymond's account of how Freud played retriever at a pheasant shoot on the O'Neill estate, shocking the Governor and the Prime Minister of Northern Ireland. "He was socially a disaster in that parish-pump border state and of course," she added, "I am blamed for encouraging bizarre tartan-trousered eccentric artists to pursue virginal Marchioness's daughters." There was scandal: O'Neill's agent, himself an earl,

discovered Caroline and her artist friend together on a hearthrug. "The agent," Ann Fleming added, "is a pompous ass and he told R that that kind of thing would do him no good. Oh dear."[5]

By his own account Freud was relentlessly harried. "It was very sticky. Absolutely terrifying. On New Year's Eve we went to a dance at Newtownards and Caroline said, 'Do dance with Mum, if you can face it.' She was a dream in pale blue." They danced. "Just then midnight struck. Horrors. I wanted to be with Caroline, and so I shot away to Caroline. Maureen thought I was a ridiculous person." Then there were his table manners and eating habits. Once, at dinner, he came, piled up his plate, didn't touch it and just disappeared. Table manners and eating habits were a contentious matter. Altogether she loathed him.

"She used to quote Cole Porter ('These Foolish Things') at me."

Noted for being a friend of the Queen (then about to become Queen Mother), for being the inspiration of Osbert Lancaster's beady-eyed *Daily Express* pocket-cartoon character Maudie Littlehampton and for having a wayward, if not deranged, sense of humour, this parodic potential mother-in-law was said to have appeared at social gatherings—private ones, it must be said—wearing such accoutrements as a comedy penis nose, horror teeth and a fart device between her legs. She could not countenance Freud's twitchy tenacity. His pranks did not appeal. Particularly the horns he drew one night on her portrait at Clandeboye, a normally anodyne Augustus John.

Such sympathy as the romance attracted was provoked, in part at least, by the rabid hectoring to which the couple were subjected. "Cyril feels protective towards them both and is keen on Caroline," Barbara Skelton—then still married to Connolly—wrote in November 1952, describing Freud's "sly bluey-green cat's eyes" and adding— she was at a house party at White Cliffs at the time—"if he is not there, he is invariably talked about."[6] The talk was often vicious. On sighting Freud at one of the Marchioness's cocktail parties, Randolph Churchill shouted: "What the bloody hell is Maureen doing? Turning her house into a bloody synagogue."[7] The next time he met him, Freud claimed, he knocked him down, for what was there to say?

"At a party of the Hultons, Reresby Sitwell saw me and said, 'Fuck Freud,' and disappeared in the crowd and I walked after him and gave him a penalty kick but Reresby got his behind quickly out of the way

and my foot landed in the behind of old Dowager Lady Dashwood. She rocked but didn't fall. I apologised. 'Lady Dashwood, sorry to have kicked you; I had no reason, never having met you.' Which I then realised meant that if I had met her . . ."

On 18 May 1952, Kitty gave birth to a daughter, Annabel. Getting pregnant had been a final bid "to keep Lucian"[8] she later said.

"I left very soon after. Kitty stayed in the house. Then she went to Epstein."

Freud considered himself to be acting logically, considerately even. "I felt, as I wanted to be with Caroline, I couldn't really stay at Clifton Hill; I couldn't pursue my courtship of Caroline from home. It was under siege and Kitty was very upset. There was a column in the *Evening Standard*, 'In London Last Night,' about parties and so on: Caroline and I were always in it. So I moved to Delamere. I remember lying on the couch there, first night, mice all round me, thinking this is the bachelor life."

It wasn't just that the marriage hadn't suited him. It had fallen away. It had been nothing like the domestic containment enjoyed by his parents, not that he wanted such a restrictive felicity anyway. Guilt over the children was inescapable, however, and the need to provide for them in some way was pressing.

"When I left Kitty my father said, 'OK, you left your wife and children; she may be very attractive, but she has no income and her only chance is to contract another marriage, so make the royalties money over to her.' It varied quite a bit. Royalties got more and more." The income from his share of these became larger than anticipated— "something like fifteen hundred a year"—as the Sigmund Freud cult grew through the fifties and, as the only regular income he could rely on, it seemed that this was the only settlement possible.

A picture postcard of Southwold from Kitty:

Darling darling Please forgive gloomy letter. I do love you & the children just have this wretched nature. Doctor's bill for Annabel's eczema and will have asthma when she is older poor little lamb,

inherited from you I suppose, and must never be in the sun. Wire
some dough quickly please.[9]

"I find it difficult to be optimistic about Lux and Kitty and your
grandchildren," Lucie Freud wrote to her husband. "All the thought
that I may see little even less than before saddens me deeply. I do
not only love this child [Annie], her presence never fails to make me
happy for days. Perhaps one can make an arrangement with Kitty
that we do see the children. One could of course post the [royalties]
cheque only after the event but that does seem neither fair nor to my
taste and would entirely spoil or at least endanger any friendship she
might have for us."[10]

Looking back, the adult Annie Freud saw her grandmother as
reliably admirable. "The distressing adult circumstances never were
transmitted to me by her. Like most children do, I felt somehow at
fault," she added. She was just four when the marriage ended. "When
you marry somebody you are prepared to give up some of the things
that you want for the other person. I think she [Kitty] had to give up
too much. As fable has it—but fable happens to be the truth—Dad
was spectacularly unfaithful to her the whole time but she minded
more his pushing after the aristocracy because she came from a bohe-
mian culture that loathed the aristocracy—uneducated, fascistic,
narrow-minded bastards—and for her the thought of running after
dukes and duchesses was disgusting. And then Dad got terribly, ter-
ribly excited about titles—Lady this and Lord that—and I think Mum
lost patience and it was not going to last."[11]

She remembered her father doing handstands in the park.
"Always throwing me around." Her grandmother, by contrast, was
simply reassuring. "I remember a very particular thing was she asked
me how long I wanted to stay at her house in Walberswick and I
said, 'Sixty days and sixty nights,' because to me sixty represented an
eternity. Another very important aspect of who she was to me was
that she was a foreign person and she spoke with a very pronounced
German accent: 'Sousvold' (Southwold) and 'booty' (beauty)? And
the way their house was set out and decorated was to do with a kind
of Austro-German aesthetic. Chinese things, reeds, a kind of very
European informality: beds in every room (this was at Walberswick).
Indeterminate colours. A complete absence of anything like chintz."[12]

While Lucie Freud concentrated on the wellbeing of the children, "the spiv Lucian Freud," as his estranged father-in-law referred to him ("who turned out a nasty piece of goods"),[13] was variously distracted.

"When Kitty and I split up I used to go and stay opposite where Kitty was living, in Hyde Park Gate, with Pandora. She was Mrs. Jones. Mr. Jones was away. I wasn't spotted though there was the Joneses' doorman sort of asking names and I had to . . . It was such a curious circumstance. Enid Bagnold [Lady Jones, Pandora's mother-in-law, author of *National Velvet*] let the house to the Churchills. She said, 'We are all friends here, we have no keys here.' They scrapped them, except for hers. Pan was married to Lady Jones really, not to Timothy. I worked from her a bit in 1953. Nothing survived. She was very beautiful and when Brigitte Bardot first appeared she looked exactly like her."

From *Who's Who* came the invitation to be listed among the 30,000 people deemed to be "everyone who's anyone in Britain and beyond today." Submitting his details for publication in 1953 he gave his address as 20 Delamere Terrace and did not mention being married.

Richard (Wulf) Mosse took over 28 Clifton Hill and Freud would call there from time to time. "I had a cupboardful of drawings and scraps and occasionally came in and took some. Cousin Jo had seen the painting of Pauline Tennant on the mantelpiece and told me. Hooray: money, I thought. Wulf was very upset when I asked for it. He said it had just been left in the cupboard. But when I heard of it being there I thought I must have it." Passing the house one day he saw that the surviving bay tree of the pair he had planted in former days had been felled.

"A marvellous chase feeling"

In the New Year of 1953 Ann Fleming pressed Freud, not for the first time, to come and stay in Jamaica where Ian Fleming wintered. It would be a respite for him, she thought and a relief for her, given the tedium of winter months cooped up in a small house that Fleming had designed for himself, basically a three-bedroom bachelor bungalow perched above a coral beach.

Freud took ship on a banana boat, the SS *Cavina*, with reluctance and foreboding. "I was in the middle of this very emotional romance; I'd been asked two years before and said, 'Of course I'd love to come,' and so then—having no money—Ann got me a ticket."

He did not expect a welcome, for Ian Fleming took a dim view of arty types. As Noël Coward, a neighbour in Jamaica, wrote in "Don'ts for my Darlings," on the occasion of their marriage:

> Don't Ian, if Annie should cook you
> A dish that you haven't enjoyed,
> Use that as excuse
> For a storm of abuse
> At Cecil and Lucian Freud.

"Because of not getting on with Ian, I knew very well that if I didn't go he'd go on at her ('typical of your friend, you know'), so if I hadn't gone I'd have really let her down. And so I went."

During the five-day voyage (so much quicker than in 1941) Freud

was disturbed to find himself up on a list as a co-host on a Brains Trust. He protested to the purser's office and the purser said, "Oh be a sport," but he refused, telling him that he had never been one for sport. He began a painting of himself, caught in the cabin bathroom mirror. "Self-portrait on copper, biting my thumb." This he gave, unfinished, to his hostess, who had arrived by air a few weeks before. His own disembarkation in Jamaica was blocked for a while. "I had five or ten pounds which they took off me because it was English money which wasn't allowed into Jamaica. So I didn't have any money and Fleming had to stand surety for me." Fleming was not pleased at this, nor was he overjoyed to see his father-in-law, Guy Charteris, a gung-ho John Buchan type ("ornithologist and one of the best shots in England"), who was on the boat too. "He didn't change his clothes a lot and Ian didn't like this."

Freud found Fleming "ghastly, phoney, depressing, snobbish." His first James Bond novel, *Casino Royale*, was about to be published and he was engaged on the follow-up, *Live and Let Die*, a title that reflected his attitude to an unwelcome houseguest.

"He said, 'You're just like my hero.'" Which surprised Freud, in that Fleming wasn't being sarcastic, for once, and obviously Bond was more the Ian Fleming type. Some years later Ann Fleming introduced the illustrator Dickie Chopping to her husband and consequently (as Freud said, "You could get Dickie to do anything. Five things beginning with . . .") Chopping designed the dust jackets for the British editions of the novels: a rose and sawn-off Smith & Wesson, for example, for *From Russia with Love* in 1957, the pin-sharp detail of which—virtual *trompe l'oeil*—was not unlike the rose stems and utensils of early Freud and indeed the two small banana-plant paintings that he completed during his stay. "I'd have made a killing there: me and Fleming linked," Freud said, mock ruefully, had they become friends.

The dislike was mutual. If Fleming disliked Freud, Freud loathed him. "He was a cunt and horrible to the locals. He was jealous. It was to do with Ann whom I was not having an affair with, whatever he thought."

The routine at Goldeneye was oppressive, Freud found. He noted Fleming's taste for Viennese Riding School prints: sure sign of a disciplinarian. Days were short and dull. Ann Fleming did watercolours—

"shells, in a way people do in Jamaica"—and Ian fussed. "The first night I was sitting in a chair reading, about eight-thirty, nine, and Ian said, 'One goes to bed rather early in this part of the world and gets up at four,' and left the room and turned the light out with me reading. I got up and put it on and he looked at my book. '*Kafka's Diaries*: no wonder you're in such a state.' Which I was. I was waiting for letters from Caroline. They arrived by boat, by banana boat probably. I got four of them. Ordinary but funny. Well expressed."

Among the island's distractions was Paul Crosse, of Crosse & Blackwell soups, who had bought Benton End for Cedric Morris, his former lover, and lived partly in Wiltshire with his friend Angus Wilson ("not the novelist but a tough who died first") and with two of Matthew Smith's models, Eve Discher and a friend of hers, housekeeping for them, cooking food flown across for them from Cuba. "His house in Jamaica was amazing, full of Impressionists, faded in the sunlight. They lived in great style with lots of black house boys." Crosse, calling himself Odo Cross, had written a children's book, *The Snail that Climbed the Eiffel Tower*, illustrated by John Minton, published by John Lehmann and part-inspiration of the John Lennon song "I Am the Walrus."

Noël Coward appeared. "When Noël said, 'I had a letter from Dickie,' I said, 'And what did Dickie say?' (Dickie being Lord Mountbatten.) And Ian said, 'Ann, you and Lucian are destroying poor Noël.' Noël attacked my painting. He wanted to attack *me* and I couldn't help liking him. I was doing bananas and he was looking and Ann said, 'Don't you think that's lovely.' He went on looking. If you look hard enough you can always find a face among bananas. 'Why did you do that face?' he said." Graham Greene was around—Noël Coward telling him that his play *The Living Room* wouldn't succeed—and Rosamond Lehmann. "Fleming was having an affair with her. Huge woman. She made the running always. So vain, these men, so how could they refuse?"

In mid-March 1953 Ann Fleming, following her usual migratory routine, flew back to London and Ian Fleming to New York. Catching up on faraway events, Freud read about the Christie murder case ("Three women found walled up in the house of Murder Unlimited," *Daily Express*) at 10 Rillington Place, no distance at all from Delamere Terrace. When Notting Hill was described in the *Daily Gleaner* as "a

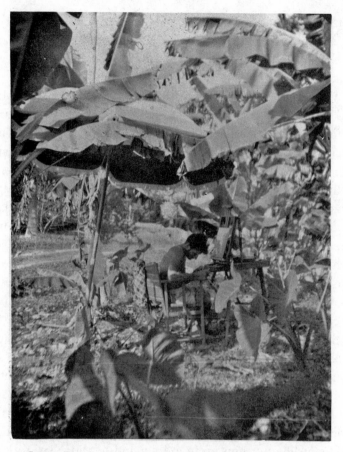

Lucian Freud painting bananas at Goldeneye, Jamaica, 1953

district of low huts" he felt faintly homesick. "I thought gosh, I must go there."

Left to his own devices he worked outdoors, seated in the garden, set about with exotic foliage. He wrote to Ann Fleming:

> *I am still sitting in the banana wood in almost the same place and am now such a fixture there that birds sit on me and spiders use my head to hold up their new webs . . . The clouds appear only when I need them.*[1]

He painted in sharp yellows and greens, bananas springing upwards, deliciously fresh, and, in another small painting, ground

cover and the foot of a banana tree, a realisation of what, on the balcony at Delamere Terrace, was the smallest oasis in West London. Suave leaves, crispy leaves, heart-shaped leaves, feathery leaves: this was the Scillies again, but properly tropical.

"When are you bananaring back?" Caroline wrote. "Mummy asked me suddenly at lunch yesterday and her blue eye nearly fell from its socket with disbelief when I quite truthfully said I had not the faintest idea."[2] She added that Stalin was dead ("definitely means war within the year") and that she was about to go to Spain. Then from the Ritz in Madrid she wrote to say that life in Madrid was village life. "Not that I've ever had it—everybody sees everybody every day, and everybody is everybody's brother in law etc and everybody is waiting for news all the time and waiting with baited [sic] breath for the scandal which can really only be provided by foreigners as no Spanish woman thinks of leaving her house as that constitutes a scandal in itself."[3]

Eventually Freud made his escape. Goldeneye had become solitary confinement, but he had no money for the fare home. "I was in rather a state and I couldn't face the journey on the banana boat and Ann bought me a ticket to London which meant I had to stop in Miami for two hours and even though I never wrote to my mother I did send her a postcard from Miami, because I thought it was such an incredible place to find myself: I'd like her to think I was in Miami. I jumped off at New York for a week."

The airline put him up in a hotel and he did New York in five days. "I went to Harlem, to the Baby Grand. Joe Louis was doing cabaret there and I shook his hand; I was the only white person in the club. I went to Third Avenue, which still had the El railway, and to the Frick. And I saw a de Kooning show on the thirtieth floor of some building, which I thought sort of good, just about, and some Pollocks. Absolutely horrible, I thought."

At the Museum of Modern Art he was particularly struck by Kokoschka's *Hans Tietze and Erica Tietze-Conrat* ("That thing of the couple holding hands") and he showed Alfred Barr the paintings he had done in Jamaica. "He said, 'one of the best techniques of anyone working today,' which meant he loathed them, I would say. Alfred Barr was one of the three people in New York I'd met. He was very kind, showed me round and then said, 'Would you like to go to the

cinema?' An Anna Magnani film was showing at the MoMA cinema so I saw that.

"People said 'look me up' so I did. Auden was away but Chester Kallman was there. We went to a bar in the Bowery, called the San Remo. A man walked in, the biggest man I'd seen in my life: he lifted people up by the collar and put them down, to make his path. A girl said, 'Are you on my possible list for me to sleep with tonight?' I didn't speak: I never liked being approached. 'Pretty weedy for an English-man,' she said. I was sunburnt from Jamaica. Then an odd-looking man in an Etonian tie came up. He was called Patrick O'Higgins, a former Guards officer and Helena Rubinstein's secretary. He said, 'I last saw you at a Cecil Beaton party. Would you like to have din-ner tomorrow night?' So I went and had dinner with a family— Claude Herson. He was absurd, she was sinister and grand; Balthus painted them, very rich." Explaining that he needed some money to buy clothes for his fairly new-born daughter, Annabel, he tried Fleur Cowles, she having given him a good write-up in the launch issue of her magazine *Flair*. "I had no money so I borrowed some, £20 or £30 from Fleur Cowles, who was with American *Vogue*. And I rang up [Iva] Patcevitch at *Vogue* and saw all the models changing and went out to a place called Voisin with huge, polite and grand waiters. I knew Patcevitch through Ann Fleming; he was a Scott Fitzgerald type and had a Monte Carlo look: everything was blue, his hair, his suit, his shoes, his tie. He had been the lover of Mrs. Condé Nast and had been left Condé Nast, or perhaps it was just *Vogue*.

"Curt Valentin, the dealer, took me to the opening of a studio that he'd built for Jacques Lipchitz. A boy, Johnny, who worked for Curt Valentin (who had left Germany in 1936 for New York, where he dealt in paintings seized from German museums) and whom Francis said was a blackmailer and a tart, whom I'd known slightly in London, took me to his apartment and there, in a small room, over the bed, was the worst man-in-boat-with-a-crown Max Beckmann triptych: knights in boats. In the end it's not about anything. He had the draw-ing from *The Equilibriad* of the girl with a spoon."

Every night there was somewhere to go. "I went to a strange party in the Chelsea Hotel with Mary McCarthy. It seemed amaz-ingly sinister, going up in the lift. This famous musicologist who had

lived in Paris—Virgil Thomson—was there; he had precious things he'd bought in Paris, drawings by Berman and Bérard. Lincoln Kirstein refused to speak to me. Terribly rude, it upset me rather. And James Agee was at another party in the Chelsea Hotel; I really liked him. He was very drunken, went to the telephone and dictated this scene of Van Gogh and Gauguin, *Lust for Life*." [The Agee screenplay, in fact, was Agee's adaptation of Gauguin's *Noa Noa*.] "Amazing: he described their movements and the whole thing, over the phone."

In London the Coronation of Elizabeth II, on 2 June 1953, was marked by outbreaks of bunting and window displays throughout the land. Freud put a little painting of daffodils and celery in a Coronation exhibition at the Redfern and, more to the point, went along to Clarendon Crescent and drew the tatty cheer of slum dwellings decked out in red, white and blue. Looking down from a first-floor balcony he traced the fluttering shadows of washday bunting cast across a hopscotch pitch, children squatting on doorstep and pavement and, framed by a window, a diminutive sulky image of the Queen. He thought this would do for Fleur Cowles, who had arrived in London as President Eisenhower's representative at the Coronation: just the thing to repay the dollars she had given him in New York. Cowles, who as a painter herself was particularly drawn to tiger and sunflower motifs, did not appreciate his idea of a Coronation souvenir and returned it to him some years later with a covering note: "You can have your rotten drawing, in filthy condition . . ."[4]

While he was away Lilian Somerville of the British Council had written to Freud inviting him to exhibit in the British pavilion at the 1954 Venice Biennale and asking him to suggest works for the selection committee to vet. The idea was that he would show with Ben Nicholson, Gwen John and Francis Bacon but, being junior to them, would be allowed only twenty or so paintings at most (compared to Nicholson's fifty plus) to be hung in one of the four small side galleries. That said, being chosen for Venice was an accolade; it made him an official

Clarendon Crescent, Paddington, 1953

candidate for international recognition. In the absence at that time of much in the way of overseas exposure for British art this was a rare opportunity.

The first post-war Biennale, in 1948, had brought Henry Moore sudden pre-eminence, thanks to the renowned Mrs. Somerville. Her diplomatic chivvying behind the scenes had resulted in his being awarded the chief prize, the Golden Lion. Freud was no Moore, as Mrs. Somerville made clear. His role in Venice would be to counter-

balance Gwen John, who had been dead nearly fifteen years. He and Bacon would contrast well with Ben Nicholson whose drawing-board abstractions became ever neater.

For the moment Freud put the letter aside. The Biennale was a year away and finding Caroline was all that mattered.

"When I got back to London she had moved, so I lost touch with her. It was at the time of the Coronation and her ghastly mother was so worked up, angry and embarrassed that Caroline had not been chosen as a maid of honour, she arranged for her to get a job in Spain so that she could say she couldn't leave her job. She was now secretary to a pilot who had his own plane; he had been a pilot for Franco and later flew Spanish carpets back to England for me. I got desperate. I sold one of my two paintings of bananas and used the money to go to Madrid to try and find her. I went every weekend and couldn't find her." He had the door number of the place where she was staying but not the street. "It was terribly nerve-racking—I don't like flying—and I nearly went off my head. I knew she lived at 85 something and went round knocking at all the 85s."

While searching, Freud stayed in a noisy hotel on the Gran Vía. An old acquaintance, Joan Rhodes, happened to be lodging there together with circus people. Headlined "The Strong Lady of Variety," capable of tearing telephone directories in half, she was glamorous besides.

Freud remembered her from art school days. "Joan Rhodes had modelled at the Central when I was fifteen. She had become a strong-woman act in nightclubs. I saw her name on a circus poster, so I met her and wandered about with her—I'd have gone crazy otherwise—seeing skeletons who lived outside Madrid coming in at night and looking through the bins and beggars, blind through congenital syphilis (which Franco said didn't exist so it was never cured; it's like mules: they can have children but the children are blind and sterile, so it can't go on). Being half-Spanish, Joan Rhodes knew Madrid very well: night spots and coffee stalls. "We were larking about and one night a car came and I jerked her across the road and sprained her wrist, as a result of which I had to go to the circus and make inlets in iron bars so that she could still bend them. I drew the dwarfs at the circus. A lot of dwarfs are Spanish: it's a bone disease. They don't look like midgets; they have a strange format of nose. Later, I came across

some of the ones that I'd drawn in *Snow White and the Seven Dwarfs* at the theatre opposite Wheeler's in Old Compton Street.

"I also drew buildings with female angels on. And I saw a lot of the Prado." In the Prado of course he saw the Velázquez blind men and dwarves, *Las Hilanderas*, *Las Meninas*—King, Queen, Infanta and their dogs—the Titians too and Goya portraits. The paintings exhilarated him to exhaustion. "I was in such a nervous state that, walking back from the Prado to Gran Vía, where my hotel was, going through the promenade towards Plaza de las Cortes I saw someone walking beside me: I saw this person, between the trees, and it was *me*. I was beside myself. I was too nervous to eat very much. I was half starved, just eating *callos* (tripe) and tiny eels in coffee stalls, and doughnuts made of skewers of dough. In the end, about the fourth weekend, I found Caroline. I got some clue through her cousin Daphne. Quite romantic. She was quite weak."

They stayed at the Ritz, in Madrid, for a while then, when the money ran out, in a boarding house where, being unmarried, they met with disapproval. "A woman opened the door in the middle of the night and threw in a bloodied towel." At the beginning of May they had a photograph taken of themselves in a bar: he, "incredibly smart in a new suit,"[5] she the image of saucer-eyed innocence in a gingham blouse, planted behind an array of tumblers and wine glasses with a cigarette in her hand. "The joke with the glasses: lots of glasses in front of her at the café table, which she wanted to send to Maureen. 'There is drink on both sides of the family,' she said. In that Dublin club, the Constitutional Club, with carved animals playing on the mantelpiece, someone once said, 'There goes the Marquis of Dufferin and Ava, and they're both drunk.'

"She had this strange sort of Irish nose and then, because of smoking all the time, several hundred a day, her nostrils were tinged with black like the entrance to a tunnel, which I must say I loved. She smoked in her sleep. When she lit a cigarette the match always went out and I used to watch in fascination. After five, six, seven, eight, matches she just got a light, but she never ever held it downwards, it always went up and then went out. I once asked her about it and she just laughed and went on doing it. It's a nervous thing.

"I got her out of Spain. We went to France. I was married still. Her mother said, 'You know it's not that I mind Lucian being mar-

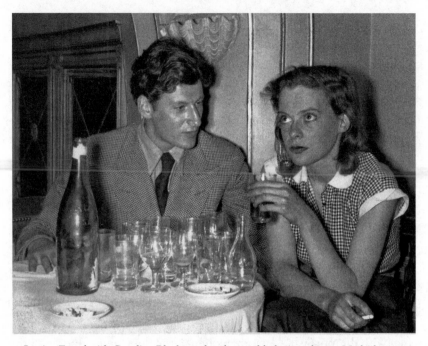

Lucian Freud with Caroline Blackwood and assembled wine glasses, Madrid, 1953

ried; if only he was *nice*.' I asked Caroline what did she mean by 'nice'?
Caroline said, 'Oh, a title, of course.' Her mother tore up her pass-
port." "Sunny" Marlborough, a future duke, had been her preferred
suitor for Caroline.

"Caroline told me that her father barricaded himself in with his
girlfriend at Clandeboye and Maureen tried to starve them out. And
a bit later he was begging her for money and said, 'If you give me
some money I'll have a cure' (he drank) and she did, so he took his
girlfriend to Brighton. At Oxford, when he was twenty-two, he sud-
denly inherited a title and married Maureen. He was extraordinary
about money, he'd pick up the phone to the bookie every day and
say, 'Put the money on anything likely,' and would occasionally win.
Caroline said he'd never written to her, but she and her brother and
sister, Sheridan and Perdita, had identical letters saying, 'Look after
your mother.' He was in Malaya and walked into the jungle." He died
in a Japanese ambush.

Forty-five years later, interviewed for a television documentary
on the Guinness dynasty, Maureen Guinness accused Freud of mak-

ing Caroline drunk on neat whisky. She said that when she asked him whether he loved Caroline (who, according to her, was in tears all the time) he replied, "in a frightfully affected way, 'I don't know . . . if you *do* love someone.'"

Freud found himself an object of press attention and held the Marchioness responsible, thinking her determined to see him off whatever it took to achieve this. "I went to Lord Beaverbrook's flat, Arlington House next to the Ritz, a boiling-hot flat with a eunuch butler. It was at the time when I was being chased by the press, to do with Caroline and me, and they were camped outside Delamere. I said to Beaverbrook: 'It's a waste of your time; I'm never going to do anything interesting.' 'A great pity,' he said.

"The press was all Maureen's doing. She then tried different things, crooked gangster things; tried to get my father deported. She thought he'd have to take me along." Representations were made to the authorities and investigators were sent. "Father didn't take it in at all. He thought that it was people to do with giving me an honour. When Caroline was being pestered, by my arrangement she stayed with my parents." This gave rise to slight perturbation in St. John's Wood Terrace. "My father asked, 'Does she take wine with meals?'

"I rather got Caroline off drink. Afterwards she felt better with one."

In May 1953 Ann Fleming drove Freud with David Sylvester ("well mannered and vastly intelligent," she told Evelyn Waugh)[6] to Oxford where they stayed the night with her friend the convivial classics don Maurice Bowra. Freud was nervous at having to perform. "I gave a talk—a lecture called 'Lightning Conductors'—to the Art Club and took Sylv as stooge. (I used to think of him as a huge Turkish lady in a harem.) My idea was that if he asked questions it would get me going. After he transcribed it, I put it into English in my Viennese dialect and he edited it, and in that way he was good." As a thank-you he gave him his half-realised spectral head of Gerald Wilde.

"Caroline was so excited I'd been asked, but there were twenty-five people only in a huge auditorium. Alexander Dunluce [a future chief restorer at the Tate and Earl of Antrim] was drunk and asleep in the front row."

With Sylvester egging him on, Freud subsequently read the revised transcript on the BBC Third Programme. Then, edited down to 1,000 words, it appeared as "Some Thoughts on Painting" in the magazine *Encounter*, of which Stephen Spender was the editor and Sylvester the arts editor: two pages of text, four of illustration. The drawing of Bérard and the paintings of Minton and Bacon, together with *Girl Reading*, more than complemented the article, their clarity exemplary, their sensitivity attuned to the wistfulness, the weariness, the detachment that he had perceived and, in the case of Caroline as *Girl Reading*, a slightly pert air of self-possession newly achieved.

"My object in painting pictures," he began, "is to try and move the senses by giving an intensification of reality."

"Some Thoughts" shaped up to being an argument for the necessity of achieving "a certain emotional distance from the subject," sustained scrutiny being entirely preferable to the "aesthetic emotion" cultivated by "painters who deny themselves the representation of life and limit their language to purely abstract forms."

"The picture in order to move us must never merely *remind* us of life, but must acquire a life of its own."

In what Maureen Guinness, had she cared to read it, could only have taken to be outrageous special pleading, he linked this to personal behaviour. "I say that one needs a complete knowledge of life in order to make the picture independent from life . . . A painter must think of everything he sees as being there entirely for his use and pleasure." Priding himself on being instinctual, not intellectual, he argued that the model served "the very private function for the painter of providing the starting point for his excitement"; it followed that "the aura given out by a person or object is as much a part of them as their flesh."

"The painter must give a completely free rein to any feelings or sensations he may have and reject nothing to which he is naturally drawn. It is just this self-indulgence which acts for him as the discipline through which he discards what is inessential to him and so crystallises his tastes." Ruthlessness justifies itself, therefore, as necessary concern. "A painter's tastes must grow out of what so obsesses him in life that he never has to ask himself what is suitable for him to do in art." And if the painter is to truly illuminate—not to say transmogrify—he must relay the fierceness of loving attention. "Unless

this understanding is constantly alive, he will begin to see life simply as material for his particular line in art. He will look at something, and ask himself: 'Can I make a picture by *me* out of this?' And so his work degenerates through no longer being the vehicle of his sensation."

Disappointment of course was bound to set in. "A moment of complete happiness never occurs in the creation of a work of art. The promise of it is felt in the act of creation but disappears towards the completion of the work. For it is then that the painter realises that it is only a picture that he is painting. Until then he had almost dared to hope that the picture might spring to life. Were it not for this, the perfect picture might be painted, on the completion of which the painter could retire. It is this great insufficiency that drives him on.

"The process in fact is habit-forming."[7]

Evelyn Waugh, who drew a bit himself, or had done in earlier years, wrote to Ann Fleming after hearing Freud on the wireless. He waxed jocular. "How dare Mr. Freud lecture to the young about art while he can't even paint a tiara straight on a lay figure?" Freud's comment on that was a near disclaimer: "My only tiara."

Through the summer of 1953, Freud painted Caroline at Arcachon near Bordeaux (*Girl in a Green Dress*) and in Paris, where they stayed at the Hôtel La Louisiane in the rue de Seine, where Sartre and Simone de Beauvoir had lived and where Cyril Connolly ("writing from the table by this my window where I can watch the streets light up") had installed himself twenty-five years before, extolling its cheapness and atmosphere. "I am for the intricacies of Europe, the discrete and many folded strata of the old world, the past, the North, the world of ideas," he wrote: "I am for the Hôtel de la Louisiane."[8] But even here, initially at least, Caroline's mother tried to thwart them, foisting on them Venetia, an eighteen-year-old deb acquaintance, telling her that she and Caroline would share a room. Freud found Venetia, and the arrangement, annoying. "I didn't like the threesome aspect."

Freud's paintings of Caroline, from 1952 to 1953, were acts of courtship. Four times over, and more, she was all that Kitty had for-

merly been, and more an enchanting object of attention. She was amazed at his demand not to alter the folds of their bedclothes so that he could paint them. As she posed, mostly in bed, she got on with her reading. "Nice long books," Freud said. No longer *Lady Addle*: now it was *The Idiot* and *The Tragic Muse*. She came to identify with the title. "I used to read, and just look up when it was necessary for him to do the eyes," she said. Forty years later, by then a novelist, she recalled "the amazed interest that he once took in the human vulnerability of his sitters. The portraits he did of me were received with an admiration that was tinged with bafflement. The results were only half-me, I think—after all it was Lucian's vision."[9] They were trophies achieved in the course of a long elopement, each a radiant defiance of the Marchioness.

In September 1953 Ann Fleming organised a fiftieth-birthday dinner for Cyril Connolly, and they were there, together with Cecil Beaton ("a lot of talent, brilliance and erudition was gathered here"),[10] Freddie Ayer, Maurice Bowra, Elizabeth Cavendish and Clarissa Churchill, newly married to the Foreign Secretary, Anthony Eden. Shortly after, on 29 September, James Pope-Hennessy wrote: "Lucian and Caroline turned up here unexpectedly this morning, had baths and breakfast and wandered away again . . . They were sweet, but like somnambulists and wrapped in that impenetrable unawareness of people in love . . . entirely unaware of the outside world, and rather expecting everybody else to do things for them. People in love are rather like royalty, I think. I can't see any sense whatever in their marrying; but this, in Paris, they propose to do."[11]

They needed money. Caroline "wasn't allowed to have any" and he objected when she said she'd get a job. "He said if I did that he'd give up painting and become a baker. And I did think it would be rather awful if he gave up painting."[12] So, reverting to the sort of work he had done during his first stay in Paris seven years before, he painted birds in a cage, on copper plates, one for Caroline which, characteristically, she lost, another for Fleur Cowles. His strawberries—lustrous flanks pitted with pips—were exquisitely fleshy. "It was a way of getting £50." A ready buyer, he found, was Leonora Corbett. "A sort of sinister woman—friend of Cecil Beaton, a well-known county lady who made a success in New York and Hollywood and told me interesting things to do with people; she was very English and aban-

doned, like Ann Fleming. I made her little pictures. I said, 'Give me a clue, what do you want in them?' Two I did maybe, of flowers and fruit: two things I liked doing. She lived then with an old man called Baron Egmont Van Zuylen, much older than her, who had a castle in Belgium." They died in 1960, gruesomely, Freud was inclined to believe or liked to think: "He ate her. They found a half-eaten body and the disconsolate Baron." Nolwen de Janzé-Rice, "then married to a Frenchman who had a hunt in Normandy, gave me money in advance but I didn't happen to do paintings for her; later, when she was married to K. Clark, she wrote about helping the Brompton Oratory: would I help them? And she made a snide remark: 'You owe so much.'"

Ever the patroness, Marie-Laure de Noailles again recommended Freud to Count Alexis de Redé. He sounded interesting to paint. "His father shot himself (he was a banker, lost his client's money) and friends got together to put Alexis into something back in New York. Arturo López-Wilshaw, who was married—like all South American queers—walked into a bank there, cashed a cheque and said to Alexis, who was behind the counter, 'I'd like you as well,' and set him up as second-string boyfriend in terrific style: he bought him a house, the Hôtel Lambert, on the end of the Île de St. Louis. I went there to do my little portrait." This painting ("Didn't like it: kept it") on copper, postcard size, was undeveloped: face emerging from a grey ground, cupid lips and dark eyes, highlight on the forehead, a polished look.

"I was sent back afterwards to the Hôtel Louisiane in a basket-work Rolls."

Lesser cars, parked in the streets around the hotel, served him as stepping stones when in nocturnal dashes he reverted to schoolboy rowdy. "Rushing down the rue des Grands Augustins and jumping on top of cars, which were generally parked with more gaps at night, all cars the same, all black and one or two oxtails; and if people were in a car they looked up through the sun-roof with absolute horror. A wing-brush by a huge bird. A marvellous chase feeling."

David Gascoyne took to coming round and reading his poetry to them. He was unstoppable. "One night we went to bed and in the morning he was still there, on the chair, still reading."

Being with Caroline meant that he saw more of the artists he had met before, particularly those who liked the look of her. "Balthus was

very good company. He'd take us out and say in English to Caroline, 'I'm afraid I'm not at all hungry,' and by the end he'd have had five courses. I went round to Cour de Rohan and he showed me things. I thought it all came out of Courbet and nothing like as good." Once, when they called on Picasso in the rue des Grands Augustins, he took Caroline into another room, and when they returned ten minutes later it was obvious that something had happened. "She was whiter than white, paler than usual, wide-eyed and dishevelled. I said, 'What happened?' She said, 'I can never ever tell you.' Something shocking. Naturally I never asked her. He drew on her fingernails faces and a sun shape in black ink. We were leaving and looked back and he was very high up, in the top floor of this house, and there was a bare bulb outside the window and he was doing shadow pictures against a blank wall with his hands, birds and creatures. To be observed, knowing that we were going to look back. Really marvellous. It was something he learnt in Spain: birds and creatures. I saw him about six times."

No sooner had Picasso pounced on Caroline than Dora Maar asked Freud to sit for her at her studio in the rue de Savoie. "Picasso made a play for Caroline so, I felt, that's why she asked me to sit." He went a couple of times and she did some drawings, nothing to match the drawing by Picasso of Max Jacob with a crown on, over her mantelpiece. "He put 'this crown that graces my head is due to you rather than to me, Picasso mon ami, mon maître, roi du peinture, peinture du roi.' Vilató said that he was so malevolent. Picasso must have liked that."

"I am working here now," Freud wrote to Lilian Somerville in September,[13] when she asked him if he would start thinking about what paintings he would like her selection committee to see. She had already written to him in July saying that they would of course exhibit the British Council's painting: "your own of your wife," i.e. *Girl with Roses*, in the Biennale.[14] Three months later, as plans developed, she wrote again enclosing lists for him to mark: quite certain A, second choice B and possible C. "Thank you for spending so much time with us this morning. I think we have assembled the basis of a very good show."[15]

The committee—Philip Hendy, Herbert Read, John Rothenstein, Philip James of the Arts Council and Roland Penrose—rejected the Minton portrait, Charlie (with white scarf, recommended by K. Clark

for the Art Gallery, Adelaide) and *Girl Reading* which still belonged to
Cyril Connolly. The idea of showing Gwen John had been dropped—
replaced by artists' lithographs—Moore, Sutherland, Scott, etc.—
and, though the Ben Nicholsons were to outnumber the rest, the view
was forming that Bacon should be given particular prominence. In
this light Freud began to think of producing a largish painting, as big
perhaps as *Girl with White Dog*, so that it, and *Interior in Paddington*,
should not be the only sizeable paintings he could show.

Freud returned several times to London that autumn while sum-
marily the divorce was going through, but by late November he was
stuck in Paris unable to pay the hotel bill. Desperate, Caroline rang up
Barbara Skelton urging her to get Cyril Connolly to buy *Girl Reading*;
this he did since, as Skelton wrote in her diary, "Cyril feels paternal
towards both and is keen on Caroline. I say it is not worth putting
himself in a state of debt for the whole of the next year."[16] While in
London he saw Bacon's painting, after Deakin's photographs, of the
Pope flanked with sides of meat. "The only thing he did that had meat
in it and a pope. Spectacular, made people gasp. I said I liked it. He
said, 'I don't. Would you like it as a wedding present?'"

The opposition marshalled by Maureen Guinness went on exert-
ing what pressure it could. On one occasion Lady Astor—Nancy
Astor—started pulling Caroline's hair. "She considered herself the
leader of London society and women like Maureen adored her. And
she got hold of Caroline because she was letting the side down. I com-
plained about her appalling behaviour, her cruelty, and wrote to her:
'Don't you think it's disgusting when old women attack young women?
Anyway I THOUGHT YOU WERE DEAD.'" She answered my
letter, in a slightly arch way. Another time I was smoking Gauloises.
She asked, 'What are you smoking?' 'Gauloises. French cigarettes.' 'I
loathe the French. Are you French?' she said.

"Caroline was Maureen's victim as she was the eldest child
and blamed, and one reason I married her was that she felt Mau-
reen would vilify her to Sheridan and Perdita less if she married."
Another reason was that she would have more inherited money at her
disposal—£17,000 a year.

"The marriage took place very quietly yesterday at Chelsea Reg-
istry Office." The wedding notice in *The Times* on 10 December 1953,
two days after Freud's thirty-first birthday, was minimal. "Freud's

Grandson Weds." The couple were photographed leaving Chelsea Town Hall: Freud in his sharp double-breasted suit sporting a cigarette and Caroline in a jacket adorned with a pony brooch, holding his arm and smiling with triumph or relief. "Maureen was there and Annabel—Annabel Birley—was best man, also Francis, and my father and Peter Watson. And Charlie Lumley: he liked the wedding." The best man was to have been Ann Fleming, but Maureen Dufferin suspected her of having had a fling with her late husband and knew that it was under her roof that Caroline and Lucian had first met. She was a witness, together with her other daughter, Perdita, and Caroline's cousin Doon Plunket.

Lunch afterwards was in the top room at Wheeler's in Soho. "Wedding luncheon given by Lucian a perfect expression of his taste," Cecil Beaton wrote in his diary. "This was a wedding feast of near-intimates. No strangers, no unpopular relations, and all the real friends, from far and wide." He listed the more notable guests. "My beloved Peter Watson, as teasing as ever . . ." Also present were Bacon, John Minton ("very drunk, warm and over-confiding"), James Pope-Hennessy, Clarissa Eden, "Ann Fleming (over-excited, her blackbird eyes blazing), the new Baths, the widow Orwell, Cyril Connolly, Harry Hambledon, Maureen, disarmingly benevolent because it cannot be the sort of marriage she planned for her daughter."[17] She was, Freud recalled, "pretty sort of poisonous, in pale blue." Billy Lumley served drinks.

"The curtains were drawn, candles lit, dark-red carnations splayed out," the diarist continued, delighted at the exclusivity and style of this travesty of a society wedding. "The guests drank too much champagne and ate too much caviar and lobster. By four o'clock in the afternoon one had the impression that it was four o'clock in the morning." He overheard some tart exchanges. "Kathy Sutherland, perhaps a little tactless, was telling Lucian's father the rumour had gone round that his new daughter-in-law had eloped with Picasso. The Freud father asked: 'Surely that would be a little over-indulgent of Picasso since he has just recently been married to a seventeen-year-old girl?'" Night fell and it was time to catch the plane. "The young marrieds, after much wine, lost their passports; but somehow they got to Paris where they will remain in one hotel bedroom for months on end. It seems an ideal match."[18]

Lucie Freud stayed away, saying she had a sore throat. "I asked my mother to go, but she'd cry, I knew. I did my best to keep her out of the way, always. Never asked her to anything. She minded that I didn't. She was very modest. You see I never liked her interfering or knowing. I never discussed anything with her. There's a history there of my being difficult and impossible and dodgy."

Caroline's perception of his relationship with his mother was unsympathetic. Her story "The Interview," published in 1972, involves a painter who does not get on with his mother: "a disapproving old prune of a woman, and it always upset and embarrassed him whenever she came to see him."[19] The reality was that Lucie Freud did all she could to keep pride and curiosity satisfied. She had the small comfort of a New Year letter from her friend Tania Stern in New York:

> We had heard rumours and more than rumours in the shape of newspaper photographs of Lady C, sent by my brother for some while . . . We both had to admit that we would very much like to have been present at that lunch. The bride I met two or three times with Lux, last time after that lunch at Wheeler's which I think I told you about, nevertheless I'm sure that you can count yourself "not unfortunate" to have contracted a dose of French laryngitis for the occasion. I think I myself would have been glad not to have been there at the end. 8pm![20]

Freud remembered his father telling him, man to man, that he was doing much as he himself had done. "He did say something that stayed in my mind when I married Caroline. He said, 'You aren't the only one in the family who has done well for yourself. Your mother had money too when I married her, you know.' I was rather pleased that he talked to me in this way because he never ever had. 'You know you aren't so clever anyway . . .' he meant."

That Freud had married well was the line taken in the Beaverbrook press and in the correspondence of Evelyn Waugh whom Freud admired as a writer. ("A real artist. And touching. When his eldest son is born, he writes, 'Laura won't be as happy again.' Extraordinarily detached.") Five months after the event, in one of his harrumphing letters to Nancy Mitford, Waugh referred to the Freud marriage,

rearranging the sequence of events in the interests of anecdote. "You know that poor Maureen's daughter made a runaway match with a terrible Yid? Well, this TY has painted a portrait of Ann Fleming with a tiara all askew, obviously a memory of his mother in law. It's a very careful detailed neat picture not like some I could mention and that makes the tiara funnier."[21]

It was indeed a skewed tiara in a portrait verging on caricature: the former Ann Rothermere looked remarkably like Maudie Little-hampton.

"My ardour in the long pursuit"

The resumed stay at the Hôtel La Louisiane was no honeymoon. Rumour had it that one particular girl had walked past their restaurant table and that Freud went after her and didn't reappear for two days. He denied the story in some respects. "To say 'on the honeymoon' was not quite right, because we had been together for some time before the marriage. There was this girl who came round to the room. She was said to be the most beautiful girl in the world: a crazy American model called Ivy Nicholson who later appeared in Andy Warhol's Factory and was a model and star in 1965 and then had twins. There were some rather amazing photos of her and Caroline lying on the bed. Caroline didn't know what was happening." With him Freud had his indispensable *Geschichte Ägyptens*. "It had the address of a boy in it: this boy, who died, was Ivy Nicholson's boyfriend when I met her, and I subsequently became very friendly with him."

The Claude Hersons, whom Freud had met in New York, invited them to Christmas dinner. "They had Victor Hugo's house, rented from Jean Hugo. Giacometti was there and we all had presents and lots of guests had Giacometti drawings. Unfortunately I had a bauble."

With marriage came deflation. "My ardour in the long pursuit was spent; the whole thing exhausted it instead of happy ever after. Byron wrote in *Don Juan* about how lots of full-length portraits are painted but only busts of marriages. I wasn't suited to being with

someone really." The infatuated Cyril Connolly described Caroline as "a femme fatale with large green eyes, a waif-like creature who inspires romantic passion."[1] She was it seemed, to Freud almost as much as him, at her most attractive when an object of unavailing pursuit. The newlyweds were photographed lounging on a bed, a book lying open between them, he watchful in a houndstooth suit and tie, and she—heavy-lidded eyes, hands clasped, wedding ring on finger—looking warily at him, sidelong, hair brushed over one eye.

"Caroline was the model for quite a while, about two years. I didn't really settle. She was awfully quiet."

Hotel Bedroom (1954), the only sizeable painting that Freud ever did in Paris and completed just in time for Venice, is his version of the Arnolfini marriage: similar proportions, and equivalent concentration of fine detail; but here, far from pledging themselves to one another, the occupants of the nuptial bedchamber are singularly disengaged. Dark against the light, the artist interposes himself between the bedridden woman and the world outside. First seated (in an initial drawing that he later gave to Patrick O'Higgins), then standing centrally, then to one side as though about to slip away, he arrived at the final uneasy pose. Hands in pockets, he takes in the situation, a little less edgy than in the Poros self-portrait of 1947 and now the wiry adult in comparison with the pallid youth that he had been in *Man with a Feather* eleven years before; yet, virtual silhouette that he is ("I was terribly aware that I was two-dimensional"), he has made himself aloof, inserted between bed and third-floor window (framework omitted) with no room to spare. Though laid to rest, Caroline's head is a disturbance. Day after day through the winter she lay there, frigid under his scrutiny. "It was freezing," she remembered, with a novelist's amendment of fact. "It was winter when everybody was freezing to death in Paris. And that's why I'm sort of huddled under the bedclothes." The narrowness of the room cramped the composition and made work on the picture hard to manage. "We were tense because he didn't have a studio. And the room was so small that Lucian broke the window, because he couldn't get distance enough to paint and it was never repaired. That's why I look so miserable and cold."[2] Her left hand is exposed, the nails dirty and uneven, the little finger lodged dispiritedly in the corner of her mouth like an unlit cigarette.

The cracked façade of the building across the street and the slats

missing from the shutters were facts, but the neat bend in the drain-pipe behind Freud's shoulder was, presumably, an accommodation. The windows opposite conceal and disclose like an advent calendar. At one point Freud put a man into the room opposite then painted him out, leaving his coat hanging by the door. That room reflects the discrepancies in the painting. The coat, the washstand and the light bulb are composed into a closet Morandi, a cameo Giacometti. Silence is implied. In actuality there was a metal workshop bashing away below, and street-market clatter.

"You might have thought I made it up, the building at the back, like in *Man with a Feather*, but I used what was there. The bed was big in the room and I worked between the basin and the bed. I used the bevelled mirror in the door of the wardrobe. The whole thing is a portrait. I don't think she liked posing much."

Hotel Bedroom preoccupied Freud in daylight hours, the pent-up detail gradually accruing. Then, out of hours, Anne Dunn reappeared. She had enrolled at the Académie Julian and, though still with Michael Wishart, she remained susceptible. "Michael was a marvellous mentor in a way and taught me a great deal and when he wasn't blind drunk he was wonderful to be with; but we spent the winter that Lucian painted the portrait of himself with Caroline in Paris and of course then we took up again. Then I got pregnant and I had to pretend to go to Italy; in fact I did go to Italy and sent a postcard and sneaked back to Paris and had an abortion, the third or fourth abortion of Lucian's. The odd thing is, though Caroline was not tough, then she became quite tough." Afterwards, she added, she was bereft. "It was like being flung out of the Garden of Eden."[3]

An unwelcome fellow guest at the hotel, where Freud was concerned, was Vassilakis Takis, later to become prominent as a kinetic artist. "That Takis, Greek, ghastly, arrived in Paris, addressed to me at the Hôtel Louisiane; he was Nanos [Valaoritis]'s present to me. I didn't write and thank him. Takis was very naive: drawings of pots and things. And he said he didn't understand why, but artists like him *had* to live off women. He was bald, probably hairy everywhere else."

One day Freud heard the *Pastoral Symphony* being played on a gramophone in a room above, thundering away repeatedly, on and on

and on. "I went to the room and found a bronze body, medal, crucifix. I hit him in the stomach and shoved a toothbrush down his throat to make him sick. He recovered. Others came. Obviously he had made arrangements to be discovered in his plea-for-help suicide bid." The unhappy man was Kenny Hume. "He married Shirley Bassey and successfully killed himself."

Another sad case at the Louisiane was Peter Rose Pulham. "He was dying there in an entresol room without a window. He was very much to do with the twenties and thirties, friend of Bérard and Cocteau and Peter Watson. Francis knew him: he was very successful then. Before the war he'd been a *Harper's* photographer, had lived well, had an affair with Isabel [Rawsthorne] and been with elegant women a lot; he talked of having them on the kitchen table when erotic fetishism was de rigueur. He could cook. Obsessed with food and wine." Tired of being a photographer, Rose Pulham turned to painting—thinking, he told Freud, "perhaps that it would be simpler to paint a human figure than to photograph one." In London during the war, he used a horse's skull as a surreal motif. "Erica [Brausen] did a show of him: paintings of mantelpieces, and he painted paraphrases of Poussin of girls with legs crossed. I had some admiration for him. A sybarite, very intelligent, had boils everywhere, face and neck, which he ignored. Drank himself to death."

For English-speaking writers, a way of getting by in Paris was to write for Maurice Girodias, whose Olympia Press published a Traveller's Companion series of porn and erotica, most of it paid by the page, some of it literature. The occupants of the room in the Louisiane have that air. "These books, two of which I actually read (one lady is simply called 'Lover'), I had some difficulty forgetting, not that I tried to, but it was clearly poignant. This girl in Paris told me she had written some. She gave them one book she'd done and they said, 'Look this really is too crude . . .'"

In January 1954 Freud wrote to Lilian Somerville, irritated at the doings of her Venice selection committee.

> *I'm back in Paris and have just received your letter of the 11th. I'm sorry about* [you] *having removed "Girl in Bed." Here is a*

photo of it. I am anxious that "Girl's Head" belonging to Cyrel [sic] Connolly of Oak Cottage Elmstead nr Ashford should be included. You told me the committee had rejected this picture on seeing a bad photograph of it. Conolly's [sic] phone number is Elstead 272 and he is prepared to lend it. So do please show them the painting! Enclosed also is a bad photo-graph of the Berard portrait. Perhaps after the meeting you could let me know what paintings have so far been decided on.[4]

Lilian Somerville reported a meeting at which they agreed to withdraw, at his request, *Zebra and Sofa (The Painter's Room)*, *Landscape with Boat (Scillonian Landscape)* and *Kitty with Cat (Girl with a Kitten)* and to include the drawings of Bérard and *Woman with Carnation*. She wanted the final selection to be made by the end of January.

Paris Tuesday 18th Jan:

Dear Lilian thank you for your letter and the very helpful list! I am rather depressed by the recent activities of the selection committee as concerns my work. I realise of course that they/it are/is quite within their rights to reject my work when it fails to please them but why did they chose [sic] me at all if they then reject so much that is representative of my work? In view, then, of their recent purge, there are some small changes that I would like to make: (1) withdraw "Leaf and Head" (2) include "Kitty with Cat" after all.

"Kitty with Cat" is medium size so to replace "Leaf and head" from a size point of view I want to include "Balcony still life" 1949–50, owned by Kenneth Clark.

The size of the painting on which I am working is 36x24. I definitively [crossed out] definately want to include this painting and will bring it to London as soon as it is complete. I think it will take 3 more weeks. There are various mistakes in the titles and dates on the list you sent me but I better correct these for you when we next meet.

Love Lucian

p.s. It is hard to make further suggestions to the committee when they reject paintings I know to be less bad than those I have not yet suggested! L.[5]

Asked to lend *Woman with Carnation*, Lincoln Kirstein replied that he no longer owned it. "The picture is by no means an important one," he added. Alfred Barr was unwilling to lend because of the Museum of Modern Art's 25th Anniversary. "A rather devastating blow to us," Somerville wrote to Barr,[6] though she was concerned more about their Bacon, *Painting 1946*, as she had decided that it should be the centrepiece in the main room of the pavilion. If the painting could not be borrowed Bacon might withdraw entirely, she hinted; in the end Barr agreed to make it available, together with Freud's *Woman with a Daffodil* for the first two months of the Biennale only. The woman with the daffodil herself, Lorna Wishart, was asked if she would lend *The Painter's Room* ("without this, any important exhibition of his work would be very incomplete," Somerville wrote)[7] but she did not reply and the painting was dropped from the list.

Somerville to Freud, 26 February:

> *I was very glad that Roland Penrose was able to see you when he was in Paris, as he was able to refer to his conversation with you when I told the Selection Committee at their last meeting of your disappointment at their not choosing certain of the paintings you had suggested for Venice. They have, however, agreed to withdraw "Leaf and Head" and we are writing to Sir Kenneth Clark to ask him to lend "Balcony Still Life" instead. As you may know your brother has kindly agreed to lend "Kitty with Cat."*
>
> *The Committee fully understands how anxious you are to include the painting you are working on at the moment, but they do hope that it will be possible for you to let us have this in about two weeks' time. Roland Penrose described it as it was when he saw it and it sounds a very exciting composition.[8]*

She offered to frame it. "Time is running rather short."

Anxious to settle titles and dates, Somerville wrote again a week later, also suggesting that Frank McEwen of the British Council in Paris bring to London Princess George's (Marie Bonaparte's) picture of lemons which Freud had collected from her. She wondered whether she would be able to show the painting to the committee before sending it off to Venice in mid-April. Freud replied to the

effect that *Hotel Bedroom* was taking longer than he had anticipated and that the committee would have to wait.

> *Alas your list never reached me I think you have not got my London address quite right . . . I am in the middle of a large painting and will return with it when it is finished. Love (and to the man in the green tie) from Lucian.*[9]

The man in the green tie was Major Somerville, whom Freud remembered as "a musician, who had a studio in Abercorn Place and used to wander round St. John's Wood. She kept him in ties."

A week or so later, in mid-March, Freud reported that the painting would be ready, he thought, in ten days or a fortnight. "The moment it is dry enough to travel I will bring it to London."

Brassaï photographed the Freuds in their room for French *Vogue*, which published a short piece by Cyril Connolly that April in advance of the Biennale. He decided to have them adopt the same pose as in the painting. For Freud this was disquieting. "I was slightly aware of the drama in the photo and was a bit dismayed, rather naively. Isn't it odd how the most convincing photographs are staged? I asked Brassaï about the brothel photos he had taken. He said, 'I set it all up, of course. They were very cooperative with me.' Brassaï was charming and friendly." He gave Freud a copy of the photograph, of which only the Caroline half survived. He snipped himself out of it some time later.

As for the painting, it became something of a sequel to the *Ill in Paris* etching: another room, another marriage, and this time more disturbing. "She was so disorientated in every way. I was terribly restless and Caroline was terribly nervous." Living in one small room was bad enough without the strain of the relationship itself, Freud emphasised. "The picture was at a difficult time. She wasn't amorous, not very well. She got ill in Spain, lost a terrific lot of blood, anaemic, didn't have her periods, very run down and never getting strong at all. Smoking day and night. I was conscious of that. If I'd been aware of it being drama, in the theatrical sense, I wouldn't have . . ." There was a fight during which he pushed her naked into the hotel corridor and locked her out.

Caroline was dismayed by how she now looked. "Others were mystified as to why he needed to paint a girl, who at that point still looked childish, as so distressingly old." Yet in later life she came to appreciate the sleight of art involved: "the genius ability to make the people and objects that come under his scrutiny seem more themselves, and more like themselves, than they ever have been—or will be."[10]

The painting was seen as "shocking and violent and cruel" by most of those who saw it in progress, Freud remembered. "There were horrible remarks from Bill Chataway, a sculptor who married a cousin of Kitty's, lived in Paris, knew Giacometti and drew in the streets, very bitter. He used to push at the door and come in." The Cuban painter Wifredo Lam on the other hand (introduced to him by Peter Watson) came to see the picture and, as he left, said, "*Ceci c'est pour toujours*," which pleased Freud enormously.

Bifocal in aspect—half looking down at the head in the bed and half across the bed into the mirror—*Hotel Bedroom*, like *Interior in Paddington*, involved sitting or standing, depending on which part of the painting needed working on. Studying himself he stood; for the rest of the picture he mostly sat. "I had a lot of eye trouble, terrible headaches, because of the strain of sitting so close, painting so close. So I went to the oculist who said, 'Straining so hard, you must focus your eyes on the furthest point out of the window.' My eyes were completely going mad, sitting down and not being able to move. Sitting down used to drive me more and more agitated. I felt I wanted to free myself from this way of working. Small brushes, fine canvas. That's the last painting where I was sitting down. When I stood up I never sat down again."

When William Coldstream saw the painting he said, of the self-portrait aspect, "He's thinking of doing a bunk without paying."

Freud brought *Hotel Bedroom* to London in early April. A telegram awaited him at Delamere Terrace. "Essential to have your painting by eleven o'clock Friday at latest."[11] Meanwhile the commissioning of a catalogue essay had become contentious. He did not want one, but Lilian Somerville was adamant. "You will remember we discussed

it when you were last in London and you liked the idea of Robert Melville doing it, who had been suggested by the committee. He has now written a very good introduction and I enclose a copy in case you would like to see it."[12]

"Freud has affinities with Balthus and Otto Dix," Melville wrote. "But every so often energies play like lightning around one of his automatons, and at such times he is in the exceptional company of Rousseau and the early Chirico." Such energies were distracting maybe. "The uncertainties of his spatial and volumetric illusionism do not decrease as his ambition to paint like David expands, and in England we look upon him as the finest of our living primitives. His art has the exquisite laboriousness of Sunday painting relentlessly pursued throughout the week."[13]

Having returned to Paris Freud objected to this. "The thing was unappreciative; and I found offensive the fact that he said 'he's a naive painter,' and I thought he suggested that Rousseau is a naive painter. (That he said I couldn't paint, I didn't mind.) 'I can't have this,' I said." His response—written out by Caroline at his dictation—was to say that he had been told that no such essay was required. "I do very very strongly wish it to be confined to a biographical note. Robert, as a good friend of mine, would I am sure be the first to understand my reasons for not wanting a preface."[14] He suggested asking Cyril Connolly instead. In reply Lilian Somerville telegraphed him at the Hôtel La Louisiane:

AGREE NEW BIENNALE FOREWORD UNFORTUNATELY CONNOLLY CANNOT ACCEPT OWING OTHER ARTICLE ON YOURSELF STOP SUGGEST ASKING PETER WATSON OR JAMES POPE-HENNESSY OR STEPHEN SPENDER STOP CABLE OR TELEPHONE AGREEMENT AND ORDER OF PREFERENCE.[15]

"I said there was an article by Noel Annan—who I just knew as the husband of Gabby [Ullstein]—in which he said that apart from me there was no other good artist of real distinction except Benjamin Britten, which I liked. Annan refused though. He sent a note saying, 'I know nothing about painting.' And I had a letter from Kenneth Clark and he said, 'Please don't think badly of this, but I feel this

article of Noel Annan's is intolerable.' That was because how *could* he not mention Moore and Pasmore. 'We can't have Henry left out.' So Rothenstein did it. It irked me a bit."

Rothenstein's preface was unobjectionable. Where Herbert Read referred airily to "the range and beauty of the visual poetry" in Ben Nicholson's work,[16] Rothenstein drew attention to a "wide-eyed penetrating stare," describing Freud as a "coolly eccentric, ruthlessly observing young man, the subject of a modest legend" even before becoming known as a painter. Briefed, no doubt, by Lilian Somerville, he added that it was a mistake to think of him as a "sophisticated Sunday painter" or as "a wilful prickly follower of Ingres. He is neither a painstaking embroiderer nor an aspirant after classical laurels: he is, in fact, a man of feeling."[17]

The 27th Venice Biennale opened in June. Ben Nicholson had just received the Belgian Critics' Award for the best show of the year and, as the main British contender for the Golden Lion for best artist, had fifty works in the British Pavilion, a neo-Palladian former tea-room, sharing the high ground in the Public Gardens with those of France and Germany. Freud considered Nicholson too concerned with "keeping up with Europe." Bacon, "trapping a reality without naming it,"[18] according to David Sylvester's catalogue essay, dominated the main room along with Reg Butler, a late addition, exhibiting the drawings and maquettes for a towering scaffold that had won him first prize in the ICA competition for a *Monument to the Unknown Political Prisoner*. Both were better attuned to the Europe of 1954 than Nicholson, for 1954, effectively the last year before American art arrived on the European scene, was the year for salutes to Surrealism at the Biennale. The Golden Lion went not—as had been widely anticipated—to Miró but to Max Ernst. (When, around this time, Freud met Max Ernst the only thing he could think to say to him was "Are you working hard?" To which the reply was "No, I never work very hard," which Freud considered gratuitously flip. He thought him "rather German but with a malevolently French streak.")

Alfred Frankfurter, editor of *Artnews* in New York, visited the Biennale and was pleased to note that "this year's Biennale is the first one to indicate an influence on Europe of how Americans have trans-

formed what came originally from the European abstract idea." He commented on a sort of Realism still abroad in Europe (witness a Courbet show in the central pavilion) "completely diluted with ice water and drained of all vitality."[19] A reference to Freud, possibly, though more likely the epic anti-American compositions of Renato Guttuso. Ben Nicholson he barely mentioned. Herbert Read, who considered Nicholson a crucial artist in the modernist cause, saw nothing but irrelevance in Freud's efforts ("objective naturalism") and, mindful of having been one of the selectors, took to alluding to him with a touch of sarcasm: "What are we to make of Lucian Freud, the Ingres of existentialism?"[20] A decade later he was to reshape the remark for a freshened edition of his *Contemporary British Art* into "What terms . . . do we reserve for a Lucian Freud, the Ingres of existentialism?"[21] Writing—ahead of the Biennale—in the *Architectural Review*, Robert Melville gave consideration to *Hotel Bedroom*. Freud, he wrote, "after a period of gloomy realism in which he made great technical strides is now recapturing the sparkle of his early work, and his latest autobiographical study of sleeping and staring almost ranks with the well-known *Kitty with a Rose*." Hung as they were in one of the pavilion's side galleries it is hardly any wonder that the paintings attracted little attention. By 1954 criteria—those of abstract expansiveness on the one hand, dedicated miserabilism on the other—they were singularly out of keeping.

When Douglas Cooper came to review the Biennale for the *Burlington Magazine* he was scathing about Courbet and Max Ernst but reserved his fiercest jibes for "a central European tradition of nasty illustration for nasty children's books," the work of Ben Shahn, of the Austrian Wolfgang Hutter (initiator of the Viennese School of Fantastic Realism) and of Freud. Particularly Freud. "His faulty draughtsmanship and his modernistic distortions (contrasting oddly with the naturalism of his pretty-pretty flower and fruit still-lives) produce paintings that are affected rather than forceful."[22]

Freud did not go to Venice. "It never occurred to me to go; it didn't impinge at all."

Some weekends he and Caroline took the plane to Paris, though often he went alone. "Straight off the plane to the clubs and a room at the Louisiane. We used to go abroad quite a bit in the summer, to stay in Ireland where Caroline used to take houses." Flitting around was

displacement activity, an exercise of spending power at the expense of sustained work. A photograph of "Lady Caroline" with radiant smile headed an item in the *Sunday Express* gossip column on 16 May. "They have been living in Paris in a small hotel in the Latin Quarter, patronising the arty bistros and cheap restaurants. Now they are in London. The other night they were dancing—in the plushest, costliest night club in town, where the nightly price of their Paris room would just about buy a couple of drinks."[23] Then they went south, to Menton, staying with Caroline's aunt, Oonagh Oranmore. "There were a lot of people, coming and going. I quite like the idea of lying in the sun for a bit. Just for a very short time." Disengaging from seaside lassitude, he began a painting of his hostess's son Garech Browne, sunlit, pensive, like a character out of *Lord of the Flies*, William Golding's fable of contaminated innocence, published that summer.

Back in London, after lunch one day at Wheeler's, the Freuds and Brownes went on to the Gargoyle. Twelve-year-old Garech being too young to be allowed in, Freud shoved him under his overcoat and walked him past the doorman, feet resting on his own feet, just as his father had done with him in Berlin days. Browne, who grew up to become manager of the Irish group the Chieftains (and whose younger brother Tara was the man who "blew his mind out in a car" in the Beatles' song "A Day in the Life"), said that Freud in effect taught him to see. *Head of a Boy*, cropped a little, comes closer than Bacon in the 1952 portrait, the face a sensitive mask catching the light.

Cyril Connolly's article in the February 1954 French *Vogue*, illustrated with Brassaï's photograph and *Girl in Bed*, had caught Colin Tennant's eye. In Menton, where they coincided, he asked Freud to paint him. "A brilliant talker," he later wrote. "Captivating both physically and intellectually to both men and women. His viewpoint was refreshingly original to someone like me with a traditional and somewhat unchallenging upbringing of Eton and Oxford."[24] The painting, begun in Menton and finished in London, was itself unchallenging. Here was the ideal type of youthful aristocrat that Caroline had been bred to marry: polished complexion, receding hair tended by Trumper's of Curzon Street, tie resolutely knotted. Forget Venice: in England those who counted as friends and patrons were unconcerned about what an editor of *Artnews*, for one, might decide to deem "the most authoritative new style of the mid twentieth century,"

namely Abstract Expressionism. Freud's diversions, in Menton and elsewhere, were taking him on a route set about with compromises into a career pattern strewn with prominent examples from the past, from Augustus John back to Sir Peter Lely, which meant ending up as leading portrait painter of the day. In a matter of months, having succeeded in marrying into the upper class he was, Ann Fleming wrote to her friends Joan Rayner and Patrick Leigh Fermor, in the process of becoming a bit player in high society. "Lucian returned from holidaying in Menton with Lady O and B to finish the portrait of Colin. He was arrayed in discreet cotton-striped suits acquired in San Remo and unsuitable for English weather, he was in tremendous spirits and as Colin likes to sit to him from dawn till dark I suspect Lucian of being a strong influence in the royal drama."[25]

This drama concerned the attachment of Princess Margaret to her mother's equerry, Group Captain Peter Townsend, a divorced man whom she was not to formally renounce until the following year. In August 1954 Tennant was a guest at Balmoral for the Princess's birthday, which prompted press speculation about an impending engagement on the rebound. The portrait became part of the news story with Freud involved. He found himself cast in a cameo role: "There was a headline in the *Evening Standard* 'To Paint Peer's Head.' He sat very well. Strange expensive eyes. Princess Margaret sort of ruined him. Caroline really liked him at Oxford but once, when she saw him packing—they were going on a weekend somewhere—she was horrified by his precision." The portrait caught his look, more pernickety than dapper.

Freud regarded Tennant as a good ready buyer and companion about town. "I went with Colin Tennant to see Nina Hamnett. She was living behind Delamere and I was friendly with her. I knew her first in pubs. The Fitzroy Tavern. Among other things Colin did was publishing—Max Parrish—and Nina wanted to publish a version of her book *Laughing Torso* about her affair with Modigliani—'best tits in Europe' she said he said—and she had a manuscript and I said, 'I've got a friend in publishing, bring him round, shall I?' She said, 'If you come round to see me you won't find any rubbish with me.' (She had a drunk merchant seaman, forty years younger—she was seventy— who used to come home on leave; I asked her why did she like sailors? 'Because they go away.') So I took him round to her flat. It was sparse:

grubby not dirty. She had broken her leg and was in bed and she said, 'I've made tea,' and threw the cover off. 'I've kept it warm,' she said and 'it' was a pot of tea and she was curled round it. Colin was impressed at this bohemian behaviour and published her."

Christmas 1954 was spent at Luggala. Freud's contribution to the festive stint was a bunch of friends, notably Patrick Kavanagh the poet and Brendan Behan. He had been photographed by Dan Farson a year or so earlier with Behan, lounging outside the Shelbourne Hotel in Dublin, scratching his neck while Behan railed at him. Behan was married now and swollen with drink. Each night at Luggala Freud had to haul him upstairs to bed.

"I was most of the time in Delamere. Getting up to things to do with girls, chasing around a lot and dancing and nightclubbing, dice games and parties and Soho. And we used to go abroad quite a bit in the summer." It was not a domestic life. The Delamere Terrace room being no marital abode, a possibly more accommodating alternative presented itself: Bacon's room at 19 Cromwell Road, a house belonging to the Royal College of Art. The painter Vic Willing remembered seeing them there. "L slim and beautiful as a knife and a pretty blonde girl with enormous blue eyes who looked straight at you. Sylv lived below or above."[26] ("Was Sylv," Evelyn Waugh asked Ann Fleming around this time, "the fat man dressed like an American Soldier lunching in the Cromwell Road?")[27] Bacon had left the Cromwell Road to be with Peter Lacy, someone whom Freud came to regard with dismay mostly. "When Peter Lacy came along it was love: some people's lives are fucked up by this very thing, but with Francis things started to get very good. It was when imagination coincided with subject matter." Lacy was a former fighter pilot. Debonair and a drunk, he could be violent. "Peter Lacy threw Francis out of a window and he was very badly cut and I was very upset and violently abusive to him." Freud hadn't appreciated that, to Bacon, Lacy's violence was welcome—"a sexual thing"—and his own behaviour upset Bacon and alarmed Lacy. "He wouldn't speak or come near me, though obviously I saw Francis. And when Peter Lacy was in Italy we gave Francis money to go there—to Ostia. I didn't see Francis so much at that time. Peter Lacy would summon him to the Imperial Hotel Henley-on-Thames where he worked, terribly well, in a shed." There, in what Freud described as a "little medieval prefab," Bacon produced his fin-

est take on a Muybridge photograph, a ghostly yet substantial conjuring of wrestling into copulation: *Two Figures in a Bed*, a painting they used to refer to as "The Buggers." "Francis said, 'I sometimes think I'm the figure underneath.'"

"I grandly bought *The Buggers* and sent £80 (£20 off £100) to Sylv, who did quite a lot of dealing then—Francis said he always gave him half at least, sometimes more—and was selling it to Freddie Mayor at the Mayor Gallery, but it was indecent, so cheaper. Freddie Mayor said it went too far." Buying a Bacon was a commitment, a sort of bet placed, a complicit gesture like seizing a baton in a relay race. Each acquisition was a provocation to be entertained, a challenge even, for how could he live with such vigour and panache and not attempt somehow to match it? The paintings accumulated. They included *Figure with Meat* (1954), the wedding present from Bacon, which ended up in the Art Institute of Chicago, *Two Americans* (1954), declared unfinished by the artist, and *Pope* (1955): the Holy Father figure, largely derived from a photograph of Hitler making a speech, pulling the cord of a blind as though it were a lavatory chain or remote shutter release. They and the rest, nine altogether, came and went, all but "The Buggers," which Freud kept hold of, on and off, over the years and which used to hang where he could see it best, just beyond the foot of his bed.

Living with Bacons was demanding; after all they needed wall space as well as attention. Ferociously precarious, they dramatised the rooms they occupied, railing against security and indeed domesticity. Freud saw them as calls to extremity. The same as Bacon he loved what Balzac said about the arousal factor in losing everything, being cleaned out: "The sensuality of debt. Basking in it. It wasn't so much that I was broke, which I always was in a way, it never bothered me, but I got some credit through being married to Caroline, to buy things. Not that I'm a great buyer of things. Once you've got money it's easy to fix things." Ready money was there for the losing. It was, he often said, "ammunition." Caroline maintained that, to him and Bacon, it was litter to scatter. "Like paper or Kleenex."

She bought him a car, an Alvis—"it was quite expensive; she paid," he explained—and he taught himself to drive, idiosyncratically so, treating the steering wheel like reins and bridle. No driving instructor for him. "I drove a bit during the war when you could buy a licence

from the Post Office." For some years he made do with provisional licences and then was helped to a full if dodgy licence by Ted, a Delamere neighbour, with the assistance of a professional getaway driver.

"I was incredibly ignorant because when anything was wrong I rang up the Old Burlington Street shop—I bought the Alvis new—and said, 'I can't find my car.' 'Where did you last leave it, Sir?' 'Near Berkeley Square or Grosvenor Square.'

"The showroom rang back. 'We found it, but I'm afraid the wing's awfully damaged: nowadays people are so careless.' I couldn't get insured after the first year."

"Francis had a friend, a cousin of Ian Fleming's, at Scotland Yard, and we went to look at photographs of a body under a rhododendron bush. The photographs were so beautiful, Francis thought; he wanted to use them but the man wouldn't let him. He came round and talked about how this woman didn't deserve it at all, as though other women did. Pure sadism."

After the Cromwell Road there was a month or so living over the Venezia restaurant in Great Chapel Street, between Dean Street and Wardour Street, an address that invited misunderstandings typical of darkest Soho. "People asking for the Ladies were always shown up to Caroline's room and she got very annoyed." A stay in a suitable hotel seemed the best alternative. "Staying down with Anne and Michael Tree they said, 'You can never get into the Cavendish Hotel without connections,' but Michael said, 'I could get you into the Cavendish because Rosa is in love with Anne's Uncle Cavendish [the 10th Duke of Devonshire],' and so we stayed some months there." Over several generations the Cavendish Hotel, an Edwardian survival in Jermyn Street, labyrinthine behind a private-house façade, had been owned and run by Rosa Lewis. "She was long dead. I used to go in there towards the end of the war. She'd sleep in the downstairs lounge on a chair with broderie anglaise behind, beautifully dressed, and American soldiers would be there and she'd get ladies down to entertain them—upper-class daughters who didn't know what to do. 'Thank you very much, boys, for winning the war for us,' she would say, and

I'd be irate. We lived there when her servant Edith ran it. She talked to you via her dog: 'I don't think these people are very nice, do you?' I was teaching at the Slade still and we had a dog with us in the hotel, a red setter called Tanis: Tanis III, actually." He took Tanis to a dance at the Slade. The novelist and playwright David Storey, then a student there and in charge of organising the annual Slade dinner, was asked by Freud if he could bring his dog instead of his wife, who couldn't come. Storey said yes, and Freud arrived with the dog on a rope. "Can you control it?" Storey asked. "No." Tanis sat on the chair next to him at the dinner table and ate off a plate the same as the other guests, who refrained from complaining as that would have been deemed unsophisticated. The occasion degenerated, with fires started and fights breaking out. By that time Freud had left.

" 'I'm not going to dance with you and that dog,' a woman said—it could have been [the sculptor] Liz Frink: wonderful neck and shoulders, at every party she was—so I rushed down to put it in the car, fell over the lead, sort of broke my leg, limped back, couldn't dance and drove home with one foot, hitting a lot of things on the way." Disingenuity, he liked to think, could deflect blame. Coldstream banned further student functions and asked Storey to leave.[28]

"Idyllic, in a slightly maddening way"

After months of peripatetic lodging Freud and Caroline Blackwood moved into a flat in Soho with a controlled rent at only thirty shillings a week, previously occupied by Edward Williams, the composer whom Zoe Hicks had married. They paid Williams £1,000 to get it: 86 Dean Street, Soho, a formerly elegant town house owned by Townsends, a firm of builders. "It was above a radio shop in St. Anne's Court on the corner of Dean Street, a lovely seventeenth-century house, panelled. It had been a brothel with the rooms divided. Henrietta [Moraes] had been sort of living there. She had a go with Colin [Tennant]; he was a grandee and she was keen on that." It was handy for the Gargoyle and the Colony Room.[1]

"It was a large room, quite dirty, and had room on the rooftop for drinking. It was not nice, waking in the morning, because it was opposite a synagogue. And the neighbours were neighbourly, which I've never liked." Their predecessors, Edward Williams and Bill Howell, architect, who had shared the flat since 1948 and kept open house on Sundays, had once heard, Williams said, "a peg-legged visitor clumping upstairs at night" and discovered it was a rat dragging a potato. A young solicitor's clerk, Jeremy Gordon, sent to serve a writ on Freud for non-payment of rent, remembered him opening the door to him and appearing even more nervous than he. Freud disputed this when I mentioned it to him many years later. "Maybe he was delivering something for Townsends, but I feel it's unlikely that a writ was for the house rent, for a few pounds. It wasn't a lease—it was

on a weekly basis—but we could only be evicted for enormously long non-payment or, obviously, something completely disgraceful.

"Too many people on the run from the police knew I was there and would ask if they could stay a couple of nights."

Freud's range and variety of potential, if not necessarily willing, sitters broadened a little with the move, the prerequisite being that they could spare the time, the snag being that some needed paying.

Joan Rhodes, the strong woman, previously encountered in Madrid, reappeared in Soho. "I sometimes took her out to a club or to dance and would take her back to Swiss Cottage where she lived." She came upon Freud once having a bath in her dressing room. "Didn't talk about her life: she was with someone quietly for a time. Later on the only people she knew were people she'd known. I said, 'Have you ever used your strength for something?' 'Once there was a man who was groping me,' she said. 'He gave me a push. I got angry and hit him and he went right down and I burst into tears.' Her main thing was tearing telephone books in half. I saw her in music halls; she'd say, with a nice shy smile, 'I'm not much good at singing or dancing; not much I can do,' and absent-mindedly pick a phone book off a table, say, 'Oh dear I can't find the number,' and rip it in half. In her memoirs, *Coming on Strong*, she wrote how King Farouk would send for her for birthday parties and she lifted him. Quite a feat.

"She told me she was having driving lessons and when suddenly the man said, 'Put your foot on the brakes' she did, and his head went through the windscreen. 'That will do,' he said. I liked her, and she would have sat, but she didn't quite interest me enough to paint. There are a couple of ink drawings. An amazing thing happened: an offer from Hollywood to be the first female Tarzan. But she had to sign up for seven years and therefore didn't; I was terrifically impressed. Fame takes a bit longer than the performance. Her parents, who had kicked her out at twelve or thirteen, tried to contact her. She was not ambitious, always put money away and saved it. Later she got a coffee stall outside London somewhere."

Napier "Napper" Dean Paul, whom Freud knew from Coffee An' days, came from "an ancient family with some spectacular black sheep in" that had even been mentioned, Freud was pleased to note, in the text to Gustave Doré's *London*. ("One of the family is Dean Paul": not every inmate of debtors' prisons, Blanchard Jerrold remarked, is from

noble families.) "Napper was drunk and druggy, full of hate, and he had quite a lot of inherited money. He would become Sir Brian, when he inherited. He was called 'Napper' because he dropped off to sleep all the time, stayed outside cafés and dossed. He used to sell gossip to Patrick Kinross for his column in the *Evening Standard*. He loathed the lower classes; he said, 'Without homosexuality there wouldn't be a link between lower people and myself. All we have in common is the arse.'

"Napper's father was an arrogant upper-class gent who married a Polish musician who was very wilful, loved her children, and didn't want to deny them the great things in life, so she gave them opium." Napper's sister, Brenda, was an actress who in her heyday had been engaged to Anne Dunn's uncle, Sir Philip Dunn, and hardly ever worked because of her opium habit. "Once—in 1956—when she was in a private theatre off Leicester Square, in a one-person performance of Firbank's *The Princess Zoubaroff*, I took Clarissa [Churchill] to see it and took her backstage after—Clarissa might have been married to Anthony Eden by then—and while we were talking to Brenda she was changing her stockings and her whole thigh was a map of scars, very extreme. More than I'd ever seen, even when I used to go and draw at Rowton House and in shelters under Charing Cross." The portrait of Napper [*Portrait of a Man*, 1954] breathes grievance. "It's very like," Freud commented. "He's in a misery position, in a zip-fronted jacket, almost exhausted. It's before my discovery of Naples Yellow." Sour-faced in mustard and grey, an Old Etonian down and out and feeling his age—he was in his fifties—is as Orwellian as you could get. "I paid him to sit. I was working at the Slade then and they had a staff show and I put it in and people loathed it; I was conscious of that Winsor & Newton texture of canvas which I loathe too." Afterwards he sent the painting to Andras Kalman's gallery in Manchester where it sold for £50.

As a rule Freud did not identify his sitters in the titles of paint-ings. "The reason for not naming is to do with discretion, chiefly protecting people, not bothering people who are alive." To name fel-low painters such as Bacon and Minton "seemed relevant," he said. "Because they did something." Other portraits were given descriptive titles. *Man in a Headscarf* for example was initially called *The Procurer*. "And it was quite a bit bigger. I used to have a lot cut down. The paint

went on over the edge so to make sure I put undercoating on to prevent anyone painting over." He cropped it to pressurise the furtive air of a portrait that involves both an assumed and a mistaken identity.

"I was in a club in Wilton Place where there used to be a theatre and the Berkeley Hotel now stands: Esmeralda's Barn. I was taken there—never been in there before—and it was very lively, full of exciting people like the very young Mary Quant and lots of rather grand girls. And as I went to the bar I heard the barman say, 'Is that on your bill, Mr. Freud?' and the person said yes, and I looked and I saw what was, I thought, the most repulsive person I had ever seen in my life. When I got to the bar I said, 'Excuse me, who was that just

Portrait of a Man ("Napper" Dean Paul), 1954

buying a drink?' and he said, 'Oh, that's Mr. Lucian Freud.' So I said, 'Oh, thanks.' So then, understandably, I took some trouble—though none was needed—to get to know this horrible man. And I thought, well, I can do a self-portrait without all the bother of looking in the mirror."

The Procurer, shrouded with a scarf like a suspect bundled from a police van, was David Litvinoff. "Which wasn't his name either. He could be funny. Walking along, he'd say, 'Did you see the photograph of Mussolini and Claretta hanging from a lamp post?' and, chin up, he'd do the pose of both of them. He was always trying it on. He spoke rapidly and excoriatingly, lived without possessions and with a degree of fearlessness. He walked into St. James's Club in Piccadilly, waited, saw an old gent reaching up for his coat and helped him into it. 'Extremely kind,' said the old gent. 'Anything to help a fellow Jew,' he said.

"Everything about him was fake," Freud reckoned. "'Isn't there anything straight about you?' I asked. 'Even your name is false.'

Man in a Headscarf (The Procurer,
aka David Litvinoff), 1954

'What do you mean?' he said. 'Who told you that?'

"Levy he was really called. His mother had married a Litvinoff. His half-brother was Emmanuel Litvinoff the writer. He worked for [Peter] Rachman as a rent collector and then for the Kray twins, a wrong move and real trouble as he kept procuring girls for Ronnie. Then he procured people to do with the film *Performance*[2] and supplied lines of criminal argot such as 'Puttin' the frighteners on flash little twerps.'"

"David was the whole film," the film historian David Thomson said. "He knew the Krays. Very naughty boys who'd cut you up with a sword. And so David was the catalyst—he just brought the whole thing together. And that's why David gets a credit on the picture as dialogue coach and technical adviser. And well deserved."[3]

Freud suspected that Litvinoff had been a boyfriend of Ronnie Kray; certainly he lived hazardously. "He talked and talked and was sarcastic," Auerbach remembered. "So much so that the Krays threatened to slit his tongue, it was said."[4] When George Melly gave a lecture on "Erotic Imagery in the Blues" at the ICA, Litvinoff put his hand up and asked if it was permitted for members of the audience to wank. Melly hailed him "a dandy of squalor, a face either beautiful or ugly, I could never decide which, but certainly one hundred percent Jewish, a self-propelled catalyst who didn't mind getting hurt as long as he made something happen, a sacred monster, first class."[5] His tirades were famous for their unstoppable venom and flow.

The vicarious self-portrait went ahead until Freud decided that Litvinoff's outrageous carry-on was too much for him. "Every time he came round he brought girls along and I used to mock him about it. Procuring gives people strange pleasure; it's actually a sexual thing and it was absolutely maddening. Once he brought a girl I really liked and I made a date with her behind his back. Anyway, it was impossible for him not to procure and I have a terrible snobbery about

being procured for: I like the illusion of romantic meeting—chance or something—not the idea of this awful, unasked-for service.

"I said to him, 'I'd like to call this picture *The Procurer*, but, knowing what you are like and I don't want any trouble . . .' (He told me he did not even trust himself not to sue.) I got him to give me a statement. So he wrote me a note saying he wouldn't sue me and then did. He went to the newspapers but he couldn't do anything because I had this letter." Thinking back, Auerbach suspected that Freud himself thought *The Procurer* would make good copy and that news of a possible lawsuit could provoke advance interest in his show at the Marlborough Gallery in 1958, much as Sickert had won headlines with eye-catching titles like *The Camden Town Murder*. Consequently the William Hickey column in the *Daily Express* of 25 March that year featured the painting together with mugshots of the two of them side by side and a report of Freud's "smart Bond-street opening" in which Litvinoff ("independent, and one of the smart Chelsea set") featured as a wronged innocent, his flow of contributions to the *Express* as a William Hickey stringer going unmentioned. "Mr. Litvinoff, who was not at last night's preview, used to be Mr. Freud's secretary. Mr. Freud's painting of him was originally to be called 'Portrait of a Jew.'"

One Easter weekend several years later Litvinoff answered the door at his High Street Kensington flat only to be punched in the face and have his head shaved after which, tied to a chair, he said, he was hung out over a balcony, regaining consciousness to the sound of ban-the-bomb Aldermaston marchers passing below singing "Corrina, Corinna." True to form Litvinoff, whose accounts of this ducking-stool outrage varied from telling to telling, let it be implied that it could well have been Freud who had set the presumed heavies on to him. Freud always liked the idea that he could deal with problems by threat, direct or directed, but this incident, so swiftly elevated into legend, smacks more of Kray reaction, say, than Freud over-reaction.[6]

"My dealings with him weren't for very long. Michael Astor had the painting: he thought *The Procurer* was improper and retitled it. Litvinoff killed himself later."[7]

Accusations and counter-accusations propelled gleeful if exasperated legend. Ten years after it had last served him as a motif, and shortly after Cecil Beaton photographed little Annie playing with it on the landing at Delamere Terrace, Freud lost his zebra head. "I had

it a long time and then in the end I had it outside my room as you walked up the stairs and David Litvinoff or somebody took it. It was a bit tiresome and quite heavy. The impetus of theft would give extra strength."

In his Romanes Lecture on "Moments of Vision," delivered in May 1954, Kenneth Clark examined the phenomenon of sudden insight. "We can all remember those flashes when the object at which we are gazing seems to detach itself from the habitual flux of impressions and becomes intensely clear and important to us." Clark singled out Graham Sutherland as someone good at spotting such moments of vision, when things "will suddenly detach themselves and demand a separate existence. His imitators think that they can achieve the same effect by going straight to the thorn bush and painting its portrait; but it remains inert and confused, like any other casual sitter."[8] In other words Neo-Romanticism, or whatever one chose to call the inky excesses of the previous decade, was now dead. No more thorn-girt coves.

Accordingly, Lawrence Alloway told the mainly American readers of *Artnews* in November 1954 that there was a "terrible casualness" in Bryan Robertson's choice of "British Painting and Sculpture 1954" at the Whitechapel Art Gallery. His omission of Nicholson, Suther-land and Bacon—and Freud—was deliberate, it could be assumed; not so his parade of what Alloway took to be "evidence of the collapse of artists who developed in the 1940s." That generation, he argued, had exhausted themselves. "Colquhoun and MacBryde seem to have painted themselves out, John Minton is no longer able to hold apart his fine art and his commercial art styles and John Craxton's lyrical glimmer has gone out, behind tedious and inflated Ghika-like pat-terning." The prevailing style was "still rather Festival of Britain—spindly, whimsical and bright."[9] Alloway was the coming critic associated with the Institute of Contemporary Arts, tuned into the urban, the progressive, the colourful and the consumerist; David Syl-vester, by contrast, spoke up for a more seasoned Realism, reflecting not the allure of things American but the shortcomings of a penny-plain Britain. The time had come, he sensed, for a new movement to be identified and labelled by someone such as himself. Stung to

barracking cynicism, John Minton, writing in *Ark*, the Royal College student magazine, coined the term "pre-Sylvestration" for "the period before one's ideas were pinched by David Sylvester and the bandwagons rolled on."[10]

In the December issue of *Encounter* Sylvester came close to deploring the dingy tonal look yet inadvertently helped give it currency by remarking that the painters dumped everything they had in their pictures, including the kitchen sink. "The dreary greys and browns of the pictures and their general air of depression had little to do with the observation of working-class life as it is, but were the products of a sentimental preoccupation about working-class life."[11]

Typical of what caught on as the Kitchen Sink School was Jack Smith's *Child Walking with Check Tablecloth* (1953), a domestic scene featuring brown lino and nappies strung up to dry. Smith protested at the label and later repudiated what was, to him, a novice's straitened phase. "I didn't find a language to suit my imaginative needs until the early 1960s." He particularly resented being assigned a role in the class struggle: "I don't identify with any class. The artist is classless and any identification of that kind is creative death."[12] Rising above such concerns he later devoted himself to abstract scintillations. However, in the years when Jim Dixon, Kingsley Amis' *Lucky Jim*, became a byword for cheerful truculence, many took Smith and others to be similarly motivated, railing in their duffel coats against the intrusion of chic Parisian miserabilism and Yank Abstract Expressionism. Lavish spreads of household goods cluttered John Bratby's tabletops: packets of cornflakes and canisters of Vim lumped together hugger mugger in profane emulation of seventeenth-century Dutch still lives, motor scooters parked in the hallway, Mrs. Bratby driven mad and he himself in horn-rimmed specs squinting through cigarette smoke at his own chaotic profusion.

The place to see Kitchen Sink painting was the Beaux Arts Gallery in Bruton Place, a former mews off Bond Street, run by Sickert's sister-in-law, Helen Lessore, who had taken over when her husband died in 1951. She showed Bacon in 1953, John Bratby in 1954, Frank Auerbach in 1956, Leon Kossoff in 1957, Michael Andrews in 1958 and other Slade graduates, such as Euan Uglow, Craigie Aitchison and Jack Smith. Having bought and sold Nicholas de Staels in order to pay Smith's stipend she then dismissed him for producing work

she considered "non-realist."[13] She had strong views on the canon of Realism. Bratby startled her with his output and for a while she welcomed it. He painted, she declared, "with almost incredible speed, with something like the torrential passion of Balzac."[14] No Balzac he: his novels, a sideline, were as headstrong as his pictures and as indiscriminate. With what she came to regard as "stupidity and arrogance" he told her in 1960 that he planned to stop painting completely to give his pictures rarity value. In 1958 he was the obvious choice when someone had to be found to supply turbulent Gulley Jimsons for a film version of Joyce Cary's novel *The Horse's Mouth*. Already by then this Angry Young Painting phase was obsolete. The Kitchen Sink fad irritated Freud. Not least, he admitted, because Sylvester had supplied the label. "I felt none of it was especially good. It was obsessive in a rather mindless way. Especially Bratby. I knew it was knitting."

In late 1954 Ernest Brown of the Leicester Galleries invited Freud to exhibit in his annual New Year show, "Artists of Fame and Promise," the thought being that, following Venice, his fame was as great as his promise had been ten years before. It was agreed that the four paintings of Caroline were to be shown; agreed that is until the possibility arose of winning a sizeable amount of prize money.

The possibility was complicated. A South African con man, LeRoux Smith LeRoux, who had recently left the Tate—where he had been Deputy Director—having waged a vicious campaign with Douglas Cooper to dislodge the Director, John Rothenstein, had immediately—on Graham Sutherland's recommendation—secured a job with Lord Beaverbrook buying paintings for him and organising a *Daily Express* Young Artists competition and exhibition to be held at the New Burlington Galleries in April 1955. Freud had nothing more suitable than *Hotel Bedroom* to enter for the competition but had already promised it to the Leicester Galleries along with the other Caroline paintings. He decided that he would have to have some assurance from LeRoux that he was likely to win. "'Unless you can guarantee a prize,' I said, 'I won't enter.' 'I think I can guarantee you'll get one of the prizes,' he said."

Trust LeRoux Smith LeRoux? In the circumstances it seemed a safe bet and Freud decided to pull out of "Artists of Fame and Prom-

ise." "A letter came from Mr. Brown and he was very angry. 'We are used to dealing with *English* artists who keep their word,' he said."

With or without the LeRoux guarantee, *Hotel Bedroom* was an obvious potential winner. Like *Interior in Paddington* in 1951, it stood out as different. If in Venice it had gone more or less unnoticed, in the New Burlington Galleries it stood to appear more focused and more testing than anything else submitted. "Being done for a competition meant *aimed* rather than painted; the reason to work in that tiny detail way was that it had to be substantial." In the end "that tiny detail way" proved substantial yet stifling.

The judges, Sutherland, Herbert Read, Anthony Blunt and LeRoux, deliberated. Freud was awarded a second prize, of £300. "I had an odd note from Graham Sutherland. 'We wanted to give you first prize but it had to go to an unknown.'"

Two unknowns in fact each received the first prize £750: Bryan Kneale from the Isle of Man, brother of Nigel Kneale (the creator of *Quatermass*, television's first documentary-style sci-fi drama), and Geoffrey Banks from Wakefield, for his painting *Street Scene with Tram*. A £100 prize went to Edward Middleditch, for *Dead Chicken in a Stream*. "No responsible painting master in any art school would agree with the award of the two first prizes," John Berger commented in the *New Statesman*. "The exhibition as a whole is of a low standard, full of easy tricks."[15] He didn't mention Freud who felt cheated somewhat. "It was a completely crooked prize: I got this money but they said they'd have to take the picture. 'You are very lucky,' they said. 'The prize goes to New Brunswick.' Beaverbrook was setting up his collection there. I'd have got £400 otherwise, if I'd sold it." Two of the portrait heads of Caroline were also on show, priced at £180 and £100.

The *Express* declared *Hotel Bedroom* a mystery picture ("What does it mean? What is the human story behind it? That is what people long to know . . .") and speculated about what the "33-year-old grandson of Sigmund Freud" was up to in the picture, so glum for some reason. "Why has Freud painted himself and his wife as if they were overcome by sadness or had had a quarrel? That is their private affair."[16]

The reaction to the news along Delamere Terrace was one of astonishment. A telegram always meant bad news but this one was different. Lu the painter had done it again. "When I got a telegram

when I won the *Daily Express* competition, they were amazed. 'I hear you had it off,' they said. In Delamere, when pictures were stolen, whatever they were—photos they called pictures—they would ask me to look at it. 'It come out of a good home,' they'd say, meaning a doctor's house."

Frank Auerbach remembered Freud telling him that becoming a painter was for him the alternative to "going up the ladder," that's to say burgling.[17]

In June 1955 Stephen Spender went to a party at Ann Fleming's where, he noted in his journal,

> *there were Lucian and Caroline Freud. This began a bit stiffly, Lucian obviously being embarrassed by the presence of John Craxton and myself, towards both of whom he has behaved rather badly. He was wearing a bottle green suit, and as Cyril [Connolly] remarked afterwards, one noticed what an extraordinary rise has taken place in his life since we first knew him. Formerly he was bohemian and poor, now he has a car costing £3,000 and is married to an heiress, has danced with Princess Margaret, is always in the gossip columns and is an expensive and fashionable painter. In spite of his large income he does not seem to trouble to pay debts incurred to his friends before he was so fortunate. He always makes faces, talks for effect, but on this particular evening, he was rather ineffective.*[18]

Caroline Freud wasn't good company, Spender added later: "She seems never to introduce a topic of conversation on her own initiative. This seems characteristic of a whole class of girls whom Lucian, Cyril and their friends fall in love with."[19]

The following month, when Spender found himself at a Freud party in the Dean Street house, he noted that the place looked unoccupied almost: shiny white paint, not much furniture and huge "Chinese"-looking objects for decor. Freud told him that he had given Colin Anderson the Freud–Schuster Book and then, to his surprise, recited some of the poems that had been his contribution to it, ballads mostly. Undecided whether to be touched by this or irked, Spender could only think that there was after all a bond of sorts between them.

"I have this feeling of invincible ménage with Lucian, and also with Cyril. A kind of secret relationship which may last throughout life."[20]

A quarter of a century later a note from Freud to Spender went some way towards acknowledging this:

> *Dear Steve, Yes—Cyril was rather dishonest, but then, your behaviour was often far from honourable—as for me, I was extremely devious. I hope your mind's not wandering.*
> *Love Lucian.*[21]

The tension so clearly displayed in *Hotel Bedroom* had persisted. Being together was a strain and the urban life, strung between studio and Soho, never eased. "Things were quite hard for Caroline in London and I had this idea that being in the country would be better for her. She was nervous and she wasn't very well."

House-hunting began. "We were looking round for somewhere and stayed with a girl who had been at school with Caroline and her husband, who lived in a house that had been [William] Beckford's Fonthill." Clare Barclay, married to James Morrison, horse-breeder, felt that Freud was keen, all too keen, on being the country gentleman. She recollected the arrival of Caroline's horses from Ireland some time later and one of them escaping on Tisbury station. Freud's memory was more of his efforts to restrain and calm it, and the further mishap that resulted. "A grey filly, two years old, and it panicked being unloaded and slightly hurt itself. I was up with it all night and the next morning went to the station to see it and suddenly I went to sleep. The Alvis—rather a fast car—went off the road, turned over, and back on its wheels again. Lucky. Thank God nobody knew. Incredibly lucky, I felt, and the nearest thing to feeling ashamed."

The house they decided upon, Coombe Priory on the Dorset–Wiltshire border, secluded in its valley bottom, was not excessively large, and not too far from London. Being on the Arundel estate owned by the Roman Catholic Dukes of Norfolk, it had once served as a refuge for Cistercian monks escaping the French Revolution. "'Priory' is a nickname: it's a seventeenth-century farmhouse with a supposed secret passage to the abbey at Shaftesbury." If that connection was far-fetched, Shaftesbury being several miles away, there were firmer rumours of a priest hole behind the drawing-room fire-

place. The kitchen had a well in the floor and, Freud remembered, a sixteenth-century closed stove.

Unlike Balthus, who in 1954 bought the Château de Chassy in Bourgogne in fulfilment of his desire to be an aristocrat among artists, Freud had no great appetite for landownership, though undoubtedly— yet briefly—Coombe was for him a throwback to Gross Gaglow, Cottbus. Initially he enjoyed improving the place. "Coombe was idyl- lic, in a slightly maddening way: when you got down to the bottom of the lane you suddenly hit this idyllic end. I planted a lot there and there were some stables and a yard and a small park which was lovely, leading up to a girls' school (one didn't see them), trees all around and Austrian oak, sycamore, beech, lime, one of each alternately all along, light and dark, catalpas too (heart-shaped leaves). I had an idea that Caroline would be happy there and didn't think that her unhappiness was to do with me racketing about so much. She didn't like being alone, in the circumstances."

The house was long and narrow with stone balls on the gate- posts and assertive gables. There was fleeting pleasure to be had, Freud found, arranging impressive furniture in the three rooms on the ground floor and, that first spring, placing daffodils one by one in jam jars on the stairs. He also began painting a cyclamen mural in the dining room.[22] Spanish carpets were flown in for them by Caroline's former employer, in his private plane.

Ernst Freud advised Caroline on improvements: a new staircase, restoration of the attics and a studio of sorts. "Caroline and my father went down to do the house and they met John Betjeman on the train (he had been fond of Caroline's father) and he said to Caroline, 'What big eyes you've got. Doesn't it hurt?' Caroline let me build on a kind of studio shed just outside the kitchen door."

Not having anticipated the social obligations that went with country-house ownership, Freud became fretful. "People left cards and they were angry as we didn't return their calls. Lord Croft or something. It seemed awfully interesting in London, going into very odd houses and flats and rooms, but in the country it was limited, very limited." Tim Nicholson remembered his mother EQ taking him and his sister as teenagers to renew acquaintance. It was not a success. "We called in one afternoon on spec: I remember how overshadowed the place was: dark and claustrophobic." Cecil Beaton, living two valleys

away at Broadchalke, brought his mother to see the Freuds in their "new grey stone house."[23] He photographed them in the drawing room, innocent occupants but with a Bacon on the wall behind them flagging up unconventional tastes. A new, as yet unused, easel was to be seen. In some shots Beaton put Caroline in the background, complicit, mischievous even. Then he photographed Freud solo, posed with near-life-size bronze stags, with bay trees in tubs and with the cyclamen mural, three leaves and a single bloom (which is as far as it ever got) haloing his head like flying laurels. As it filled with acquisitions, a mansion complete with aviary, the house became reminiscent of Clandeboye where the hallways were replete with massive Indian Raj relics. Chessboard table, buttoned sofa, converted oil lamp and Empire chairs: these were all too obviously set dressings for Beaton portrait sessions. In which, lastly, Freud wore military dress trousers with a stripe down the side. It seemed he was emulating Clandeboye taste from days of yore.

The house, complete with housekeeper, was too ordered for him. He couldn't settle. "I drove down from London in the Alvis, once twice in one day. I was never there for more than a day or two at a time. I liked planting trees and I liked the idea of the horses—I always loved fields and horses—but not the idyll aspect. Nights were difficult. I rode at night a lot.

"After dark we used to go to a drinking club in Blandford Forum, not far from Bryanston, in the gatehouse of a Vanbrugh house—at Tarrant Gunville—where a queer called Farquharson lived: not many there, women in trousers. Lady Julia Duff's queer companion Simon Fleet, who helped Beaton, and Rattigan with his plays, and drank an awful lot, gave me a membership of the club."

Coombe became little more than a weekend place for Freud where, needing company, he could entertain. Peter Watson came down, also Charlie Lumley ("Me and Lu used to drive down in the car")[24] and Michael Wishart and Ted, a Delamere neighbour, of whose safe-breaking skills Freud was not yet aware, and also Caroline's admirers Cyril Connolly and David Sylvester. "Cyril and Sylv were courtiers." Two Bryanston boys, connections of Caroline's, came for tea. "I did a horrible thing to Sylv. Caroline made a huge cake and Sylv took three-quarters of it and the boys' faces fell and I said, 'I refer you to Mr. Sylvester if you want cake,' and he went red. Terribly unfair."

When Michael Andrews, ex-Slade student and by then a friend, was there he promptly busied himself painting a tree in the garden and drawing Caroline's shoes left on the doorstep; he was conscious of the two little daughters being around and the housekeeper being "very weepy and sniffy, as Lucian had behaved atrociously to 'poor Lady Caroline.'"[25] Freud drew Annie with a soft toy, but never managed to work much there. As for Annie, she found staying at Coombe uncomfortable: "I remember there being lots of strange furnishing things in their entrance hall: circus carousel horses, carpets in weird colours. The strangest memory there: Caroline's mother had sent her a black velvet matador outfit with sequins on and they decided sequins were disgusting and they sat there together giggling and snipped off

Lucian Freud at Coombe Priory Dorset c. 1957

the sequins." It was, Annie thought, no place for real children, namely herself and Annabel. "Caroline was young and gaga. Annabel was sleepwalking and sick. A nurse or the au pair came once or twice with us, but this time we were on our own and Caroline was useless."[26]

The nearest thing to an unconventional stimulus was the Augustus John household fifteen miles away. Freud went over to Fordingbridge a few times to see the aged doyen of British painters at Fryern Court. "When I went for a meal I'd hear roaring sounds of fury and frustration from his studio in the garden where he had a painting he had been working on for years, an awful huge thing. (It went to Dowager Lady Melchett; she had been fast and pretty and was, I think, still carrying on with the window cleaner and people doing up her flat off Sloane Square.)" Once, just the once, he drove Augustus John up to London. "Dodo [Dorelia John] said, 'Stop every now and then and get a drink at a pub,' so we did and in one pub they said, 'Would your father like another one?' He was furious. He couldn't hear very well and was very funny and melancholy. He talked about speaking Romany: 'There's not many Romany-speakers left. Nor many Romanies.' He was very lame: he'd fallen out of a tree chasing a girl.

"We had dinner in Sloane Square, the Queen's Restaurant, quite dingy. 'Tell me, do you think I'm on my last legs?' he asked as we were walking to this restaurant. It was raining and he said, 'Let's dodge the drops'—old-fashioned words—and pulled me into a shop doorway. He was certainly likeable. I think that he was heroic. He and Epstein were forgotten, in a sense; Ep was making money but he was hardly doing anything. Dodo was terribly good to all the children."

A night on the town with Augustus John was still a possibility. "This girl, she was a burglar from Chelsea, an illiterate sort of one that people with car showrooms used to hire to savage rivals; I didn't draw her, only saw her a few times, didn't know where she lived. But after I saw Augustus he said, 'This girl keeps ringing, asking where you are.' She was quite exciting: semi-gypsy, living in Chelsea, doing all kinds of guilty things."

Soon afterwards Freud handed Spender an article that Augustus John had given him. Would he care to publish it in *Encounter*?

. . .

Samuel Beckett, writing on Jack Yeats in *Les Lettres nouvelles*, said: "The artist who stakes his being comes from nowhere and has no brothers."[27]

"Magnificent at night the view of floodlit Battersea Power Station from the bar," the *Architectural Review* guide *London Night and Day*, published in the early fifties, said of the Royal Court Theatre Club in Sloane Square. "The inspiration of [Clement] Freud whose witty news letters are worth reading in their own right." It was a dinner-dance venue and it became the scene of yet another Freud-on-Freud conflict.

"I found that, having been amused, quite, by his servility and 'sweet' manner, he became cloying and ghastly. Beckford had a person called 'Kitty' Courtney, Lord Courtney, whom he persecuted. I felt that my turning against him was almost physical. When he stopped being a waiter there was a time when Clement ran the Royal Court Theatre Club above the theatre and I was turned out of it for being improperly dressed (no tie). He said there was royalty present, which would have been Princess Margaret and Rory McEwen in tartan. He would play and she would sing. I wrote to him:

> *Dear Cle,*
> *We are told not to trust appearance and to look beyond them for the real depth and value of the nature of the person. But in your case, try as I might, I cannot avoid concluding that you are a prize cunt.*[28]

Clement's recollection was that Lucian had come to the club to borrow money off him. It was, he said, "Lucian's last social call on me."[29]

Another incident that forever festered was the occasion, some time earlier, when the brothers raced along Piccadilly and Clement, falling behind, shouted "Stop, thief!" Hideous discomfiture. Clement used to claim that Lucian was the one who shouted. Either way, there was enmity and a brandishing of long-held grudges.

"Early in the war Clement had a girlfriend. I read a letter from him that he'd left around about a visit somewhere, saying they had rather nice pictures: 'Not Lucian's kind.'" Around then, their cousin Wolf Mosse remembered with incredulity, he heard the brothers in

the road discussing the girls they had had. Lucian thought this an exaggeration. "I think I once went with a girl who said she'd been with him," he told me. "A girl from Trinidad, very simple. There was a rivalry in his head: appropriating them mentally. I said to my mother, 'Why's he so awful?' 'It's entirely your fault,' she said. 'Because you bullied him so much.'" He asked her if she could think of any precedent for Clement in the family. "She said, 'Yes, there's a great-uncle who had a similar personality.' When the Kaiser decided to tax the population he sent round to find out everyone's earnings and he, being what he was, gave a most enormous sum for his income, had a huge tax demand and thereupon killed himself.

"A conversation I had with Sylv long ago. He raised his eyebrows in misery. 'I'm often taken for your brother,' he said. 'I'm not,' I said."

"Mad on heat and running round, pissing all the time"

David Sylvester's profile of Freud for the British artworld fortnightly *Art News and Review* in June 1955—the first attempted characterisation of him on the printed page—was cogent and deft. He noted that his work had softened and thereby been deprived "of most of its intensity."

"Lucian Freud has succeeded Dylan Thomas as *the* legendary figure of the younger generation. It is partly his patronymic that intrigues, partly his physiognomy, but chiefly his knack of making the outrageous appear commonsensical and his refusal ever to disclose why, at any moment, he is behaving as he is and not in some other way . . . Freud has a genius for bringing out the worst in people."[1]

He also brought out the worst in Queenie, an Alsatian bitch belonging to Joe Ackerley, Literary Editor of the *Listener*. In December 1955 Ackerley's *My Dog Tulip*, a moving account of his passion for Queenie, was about to be published and he asked Freud to do a drawing of her for the dust jacket. "I used to go and have lunch with him and E. M. Forster at Chez Victor, early on. I hardly knew him." He knew though, as the world was later to learn in Ackerley's *My Father and Myself*, that Ackerley's father, a banana baron, had not only managed to conduct an elaborate double life involving a second family but had also had, Ackerley suspected, indeed was pleased to think, homosexual inclinations. Ackerley, who made no secret of his orientation, took John Minton out to a restaurant once, Freud had heard. "Johnny was wearing jeans and he suddenly realised that Ack-

erley thought, because he was in jeans, that he was a boy. And he was thirty something. He couldn't think what to do. Probably said he'd got the curse."

Ackerley wrote to Freud giving him directions to his flat in Putney. "I hope Queenie will not baffle you . . . If you are content to sit by the window and draw her she will present a fairly steady picture, I think, staring watchfully at you. But if you are a mover about, I'm afraid she will be noisy. It is her ineluctable way. But she does not bite people—at least she has never done so in ten years; she only speaks her mind, rather deafeningly, I fear."[2]

One session was enough to make Freud discontinue. "He left me there and I was in this room trying to avoid this crazy dog. Mad on heat and running round, pissing all the time. It was absolutely impossible." Other such jobs for publishers could be accomplished without fear of injury. For example the jacket for *Cards of Identity*, a novel by Nigel Dennis, published a few months earlier, had presented no difficulties. He had treated it as *The Glass Tower* revisited: a line drawing of a face in a shaving mirror balanced on a trestle of playing cards. He also supplied the drawing and lettering for Dennis' *Two Plays and a Preface*, published in 1958: two male faces peering through a gap in a curtain.

Such designs were strictly cash, whereas *Portrait of a Writer* (1955) was done with the idea of producing a clear image of a consummate man of letters: James Pope-Hennessy, Assistant Editor of the *Times Literary Supplement*, whom Freud had known since the beginning of the war when, being a painter, he had painted his name on his trunk for him. Pope-Hennessy, who was primarily a travel writer, asked Freud to provide a frontispiece for *The Baths of Absalom: A Footnote to Froude* and this he did: a Jamaican face peering from a mass of tropical fronds, a drawing based on the snapshot

Lucian Freud book jacket for
Nigel Dennis' *Cards of Identity*, 1958

of himself working in Ian Fleming's garden at Goldeneye and the closest he ever came to matching the mannerisms of Edward Burra. (He hoped that the publisher, Mark Longman, would give him £12 for it, but he got half that.)

Behind the immaculacy of the portrait Pope-Hennessy's private life was turbulent. A tussle one night at the Gargoyle involved commandos and "James's sort of boyfriend" as Freud put it: Len Adam, an ex-paratrooper whom he had met in the lift at Holland Park tube station in 1948. That didn't stand in the way of his being appointed the official biographer of Queen Mary. In 1974 he was murdered: someone he knew brought two mates to rob him, tied and gagged him, became enraged and went too far. Freud's portrait has the disdainful poise that in the end was to be no protection. "His oriental look came of his great-grandfather, a governor of Malaysia, marrying a native. He was very brave, so self-deceptive; he wasn't able to defend himself physically."

Freud happened to be with Pope-Hennessy, among others, in Harold Nicolson's rooms in Albany, off Piccadilly, to hear Anthony Eden's broadcast on Suez in August 1956; Nicolson went to bed leaving them to discuss the crisis, one that skewed into focus a whole range of issues from the management of post-imperial decline to the covert exploitation of Middle East divides. Unusually for him Freud found himself talking politics and, contrary to the flow of events, defending Eden's actions. "Then at Ann Fleming's I was talking very strongly—without being a Zionist, I felt strongly—about Suez and Boothby walked out of the room, and that later Labour minister, Tony Crosland, walked out in disgust too. They were so pompous. High Tory knives were out for Eden.[3] Everyone walked out except Gaitskell [leader of the Labour Party] and he put his arm round me and said, 'I absolutely understand.' He was nice, not pushy, but so careless: in love with Ann and married to dumpy Dora, he put notes through the letterbox. 'He's crazy,' Ann said. 'He leaves letters, quite open.' She wasn't at all like that, not tremendously monogamous, and she loved Ian, who was well known as unfaithful, and she said: 'If he's going to do that as prime minister he'll be finished.' Ian was sadistic and Gaitskell wasn't, so not so exciting for her." At Ann Fleming's Freud savoured, and was beguiled by, the frailties of prominent figures. His instinct was to disregard the public face (unlike Richard

Hamilton who, with his 1963 *Portrait of Hugh Gaitskell as a Famous Monster of Filmland*, made him a pop-eyed embodiment of B-movie villainy); for him the curious thing was that political identity—the recognised mask—bore so little relation to the person maintaining it. "I asked Gaitskell, 'Do you see yourself as prime minister?' 'I always look at the step immediately ahead,' he said. Didn't seem the strongest man in the world. Delicate."

Gaitskell died in 1963, a year before Labour took office. "Even though a true-blue Tory, Ann was more interested in people when in power." Her soirées were occasions for taking up with, or getting in with, those who amused or mattered, for example the philosopher-turned-novelist Iris Murdoch in her first flush of celebrity and her husband John Bayley: a strikingly odd couple, Freud thought. "I used to take Francis and met Mr. and Mrs. Bayley and Francis told me that next thing he had a letter from Iris: 'Could you meet me in a park beyond yonder tree?' He didn't answer of course, and this went on for eighteen months, more dates, more trees in the park. He never went. Then the letters were every four weeks and then none. I thought he'd be mocking about it but he just looked puzzled. Her publisher wrote to me that she was publishing a new novel and would like you to do a drawing for the cover. Two months later she came to Ann's and I said, 'I had a letter about a drawing: a jacket for your novel,' and she said, 'Are you telling me in a roundabout way that you want me to ask you to do one?'"

In November 1955 Professor Isaku Yanaihara, of the University of Osaka, translator of *L'Étranger* into Japanese, visited bohemian Paris. He met Giacometti, posed for him, had an affair with his wife, Annette, and then met Jean-Paul Lacloche and Olivier Larronde, now living in the rue de Lille. Freud, who occasionally stayed the night there with Caroline, helped them twit the professor.

"I had some copies of my grandfather's books in Japanese, which I took from my father as a joke. The Japanese professor came to see Jean-Pierre and Olivier. We left copies of Grandfather on the hall table and Jean-Pierre said to him, 'Here are the works of Freud.' And he said, 'I so much prefer to read them in the original.'"

Jean-Pierre was friendlier than he had been ten years before and

no less ostentatious. He had an Alsatian, Otello, which he used to throw off a bridge into the Seine. He and Freud went out into the street with a gun: Jean-Pierre would fire blanks, Freud, acting shot, would stumble into an appalled passer-by and Otello would go into a frenzy of excitement. Some time later Jean-Pierre came to London and proposed seeing how Londoners would react to this same stunt. "Impossible," Freud told him. "It's absolutely different here." Jean-Pierre disagreed, fired, and Freud fell across the pavement, bumping into a passer-by who instead of reacting with gratifying alarm told them to piss off.

The apartment in the rue de Lille was stocked with monkeys and opium. The monkeys liked opium but, incapable of handling the pipes, contented themselves with sniffing the smoke. Giacometti though was adequately proficient. "He used to go to their apartment for the odd pipe; they had an opium table and things and he smoked to clear the clay from his lungs. He did lovely drawings of the apartment for Olivier's *Rien, voilà l'ordre*.

"No one ever says, 'Do you like opium?' In Paris I had it with Olivier and Jean-Pierre, as they were so hostile if you didn't; it was really 'DO have a pipe.' Smoking it is quite an art. Jean Cocteau was proud that in *Le Sang d'un poète* the shadow of an arm smoking a pipe is him; he was a very good smoker, he would boast. When I was with Caroline I had it occasionally, specially when we took the house, Le Pilat, at Arcachon: it's delicious, but you can't really work with it. You get paranoia."

At Arcachon Freud made drawings of ducks and of Caroline laughing, and they went to bullfights. "There's a kind of equivalent in painting to the matador who waves the picadors away. The picadors make holes in the shoulder muscles so that the bull isn't quite so dangerous, and there are painters—Manet is the real example—who actually waved the picadors away because they wanted the bull to be itself." Marriage did not suit Freud, who told Frank Auerbach at the time that he and Caroline didn't have sex much. "Lucian said it didn't work." Here was a case of the painter wanting the bull to be itself, not hemmed in, let alone tormented by the picadors of polite society. Throughout the marriage there was a price to be paid for access to unearned income. Even the interludes—getting away and going

south together was what one did in the appropriate season—were try-
ing, for then whatever work he did had to be, to some degree, extem-
pore. "We went one winter to Pedregalejo, near Málaga—black sand
and a tiny railway and a very small train—and had half a fisherman's
cottage." There he worked a bit. *Girl by the Sea* (1956) was Caroline
in profile, as Kitty had been in Villefranche set against the siesta shut-
ters; this one, head on bare shoulders, showed signs of recalcitrance,
the hair tangled, the eye downcast and the sea below and beyond,
scumbled into a tepid calm. "It's the last one I did of her: a bit druggy.
I avoid doing profiles: Italian (Renaissance) profiles annoy me."

The holiday was interrupted. "Cyril Connolly appeared, to seek
us out. He was staying with his American brother-in-law Bill Davis
at La Consula, an old house in the hills outside Málaga. It was luxuri-
ous and horrible, but he collected Giacometti. Connolly had a close
hostile relationship with Bill Davis, who had known Hemingway."
Davis had been a leading collector of Jackson Pollocks, second only to
Peggy Guggenheim. "I couldn't quite understand his link to art and
culture; I never got to know him. Or wanted to."

According to Barbara Skelton, Cyril Connolly was already infat-
uated with Caroline in 1953. Dan Farson, Soho chronicler, photo-
graphed the two of them outside Wheeler's, he smug, she studiously
detached. By the spring of 1956 Ann Fleming was remarking that
Connolly was "hammering nails into the coffin of the Freud mar-
riage."[4] Freud had always been struck by the way Connolly looked at
people. "His dead malevolent eyes."

"You are a mirage of happiness," Connolly wrote to his unrespon-
sive chosen one.[5] Such avowals irritated her, and particularly the most
presumptuous, which was: "I know you really want to settle down and
have a child as much as I do."[6] He even rejigged his cuckolding by the
publisher George Weidenfeld into a boast that he had engineered it
himself for her sake and his: "I helped Barbara to marry Weidenfeld
to free myself for you."[7]

Connolly had a high regard for his own writings, taking them
to be literary history. "He wrote love letters to Caroline which he
insisted would be worth something later. He made her go to the bank
and take them out. The ink had completely faded." By then Freud
had come upon him loitering outside the Dean Street flat and had

felt this to be a good moment to kick him in the shins. "The reason I kicked Cyril wasn't to do with that really. The reason was a letter about him having me followed, and lots of evidence."

Kicks or thumps: Freud's violence was part reflex but more retort, stimulated when provoked and unthinkingly pursued. "I did used to get into fights under drink; I didn't know when I'd lost." Frank Auerbach remembered an occasion in a pub at that time where a drunk came up to Freud from behind and kept pawing his shoulders. Freud went outside with him and the man stumbled back into the bar a while later, his face covered in blood.[8]

Friendships with the painters who, after Bacon, were to mean most to him were established meanwhile, most notably and longest lasting with Auerbach who thought him exceptional right away. "When I first knew him, in the fifties, we were all nervous and careless but Lucian was quivery and feverish in a way; he seemed to be in a continual tizzy all the time and I had a sense that the act of painting calmed him down. For instance he said to me that when he asked Mike Andrews to stay with him in the house he had with Caroline in the country and suggested that, because he, Lucian, was restless, they should drive somewhere for tea or something, Mike said, 'No, I don't think so, I'll stay here,' and that impressed him."[9] Andrews had progressed from student to colleague and friend; Auerbach on the other hand was not an ex-student of his. Freud had first noticed his work in 1955 and had been struck by the weight of paint involved. "I got to know him gradually. Four pictures in the *Daily Express* Young Artists Exhibition were by Frank. I thought these were the most ludicrous things I'd ever seen, but they certainly stayed in my head; they looked like the most appalling threatening kind of mess. I remember going back and looking at them and thinking, 'What on earth is this?'"

Auerbach had been aware of Freud when he was still a student at the Royal College. "He would sometimes lunch at the college and I would occasionally see him near the common room, occasionally with a little girl on his shoulders. I probably spoke to him once or twice in Soho, but it cannot have been in a terribly familiar way, since I remember seeing him at the Beaux Arts Gallery, at my first exhibition, in 1956; Lucian bowed (slightly) and said 'thank you'!"[10] In his review of this show for the *Listener* David Sylvester lauded Auerbach's "fearlessness, profound originality; a total absorption in what pos-

sesses him."[11] The paintings were densely grounded, accumulatively encrusted. Lack of money for expensive paint largely accounted for their subdued colour, but in every other respect they were dramatic in their concentration of impulse. Almost immediately Freud recognised the elation involved and, essentially, a lightness of touch. Not many did. "Mesens said, 'I went along and looked and looked and realised it was Rembrandt and not interesting, no advance. It had already been done.' Not interesting for *him*, maybe."

Auerbach for his part was struck by how constant the friendship was between Freud and Bacon. (As it happened he and Freud were to be friends much longer.) "They saw a great deal of each other and Lucian had an enormous admiration for Francis and Francis— someone with a fairly low boredom threshold—said, 'You're never bored with Lucian.' They were close friends and understood each other. In those days I never quite knew why Francis should have his pockets full of fivers. People said at his first show at the Marlborough Gallery, 'What have you done with all the money?' 'I haven't any money, haven't even bought a suit yet,' and they said, 'But you're earning more than the Prime Minister,' so Francis said, 'But I *always have* earned more than the Prime Minister!'" There was a sort of understanding that, after meals, they would spar with one another. "Both of them would pull wads of five-pound notes out of their pockets and fight over the bill as to who should pay. Lucian's was Caroline's money, yes; but possibly on occasion from the track. More often than not I would meet Lucian and Francis and far more often than not they would go for a meal somewhere and ask me along."[12] Auerbach appreciated Freud's tact in addressing his extreme lack of money by appearing not to notice it. In the early years he would get a bottle of fine brandy from Lucian at Christmas: far beyond his means and all the more cheering for that.

"In those days I don't think he would actually work for more than three or four hours a day and gradually, as he got older and as his restlessness began to abate, he became slightly calmer in his behaviour and got a terrific lot into a day; but I always had a sense that here was somebody volatile in life. As soon as he had a brush in his hand he had an extraordinary magisterial sense of cause and consequence, and a sort of intellectual sequence of thought that made total closed sense that wasn't present in his life at all."[13]

During a Spender dinner party in the early summer of 1956, at which Freud was not present, W. H. Auden, by then well into his Testy Great-Uncle phase (and newly elected Oxford Poetry Professor), displeased Bacon by pronouncing Freud a crook. "He just isn't straight about money and I don't approve of it," he boomed. Spender agreed. However, realising that Bacon ("who happens to be very fond of Lucian") could turn nasty, Auden then backtracked, muttering that "Lucian was very nice and he liked him very much etc."[14]

On 3 May 1956 Peter Watson drowned in his bath. The verdict at the inquest, ruling out suicide or heart failure, was "accidental death." Latterly Freud had seen little of him. There had been a cheque or two and he had done his portrait. "He was more keen on philosophy and ideas. I remember a mocking letter from Cyril. One of his boyfriends did a burglary and blamed it on me." The boyfriend was Norman "Digger" Fowler, an American ex-sailor. Fifteen years later he too died in a bath. Cecil Beaton aired the suspicion that Fowler had been responsible for Watson's death. Evidently there had been a row. When told that Watson had died, Beaton's first thought was that he had neglected himself in recent years. "Awful mackintoshes. His hair, once so sexily lotioned, was on end. He was a real bohemian—gone the elegant clothes and motor cars."[15] He composed an obituary: "With his feet in the gutter he had indulged in every vice, except women, but he was really like a saint."[16] To Freud, Watson had been the patron rather than the saint and he remembered him with gratitude for his unfailing generosity. He left money to Connolly and Sonia Orwell but not to Stephen Spender, who felt hurt, given that Watson had been his longest-serving backer. "No one was more exploited," he wrote. "And yet, although this depressed him sometimes, he expected it and could see beyond the motives of the exploiter to the person behind . . . Peter really lived for other people."[17] In the *New Statesman* he remarked that "no other patron was so individual, so non-institutional: even the word 'patron' seems wrong for him—perhaps a better word would be friend."[18] Spender attended the cremation at Golders Green in a throng of trustees and lawyers, together with Cyril Connolly, Graham Sutherland and Roland Penrose. Not Freud.

Spender was lunching in the Perroquet ("popular with theat-

rical people") on 12 July 1956 with the young poet Dom Moraes. Enter Freud. "With his friend Charlie. They were both dressed like workmen, Charlie almost in rags, without ties. The restaurant was appropriately shocked. I thought: this is part of the war of bohemians against bureaucrats."[19] It was more Freud's old urge to be conspicuously anonymous. Anyway, small world: Freud came over to him and complained about Auden.

In August 1956 the Whitechapel Art Gallery staged "This Is Tomorrow," a set of installations devised by members of the ICA's Independent Group demonstrating, in the words of the Whitechapel's Director, Bryan Robertson, "painting, sculpture and architecture in an integrated relationship." They included *Patio and Pavilion*, by Eduardo Paolozzi and Nigel Henderson—a mocked-up East End backyard with scrapheap adornments—and a fairground attraction put together by John McHale and Richard Hamilton in which Robbie the Robot, with headlamp eyes, a lifesize cut-out of Marilyn Monroe from *The Seven Year Itch* and a giant bottle of Guinness featured: key images from popular culture slotted into billboard perspectives. Two exhibits had some relevance to Freud: a photo-collage head by Henderson, its meltdown deformities making it representative of the nuclear age, and Hamilton's small expository collage *Just what is it that makes today's home so different, so appealing?*, a scene composed of clippings of consumer desirables, among them a pin-up laid on a sofa and a Charles Atlas hunk pumping his pecs. This squib collage was to serve as a frontispiece to almost every catalogue of what came to be labelled (British) Pop Art. In retrospect, long after the exhibits had been dismantled and dispersed, the project gained in significance, serving as a prospectus for things to come, particularly those relating to mass media. It made for great claims as to the redundancy of old media in the new age of popular demand and jukebox choice.

In May 1956, three months before the opening of "This Is Tomorrow," John Minton was reported in the *Daily Express* bitterly downcast, saying, "Painting is outdated like the horse and cart. Modern art is getting nowhere. Traditional art—it's all been done before. The cinema, the theatre, possibly television, are the mediums in which painters must express themselves."[20]

Freud did not bother to go to "This Is Tomorrow." "I think I was aware, but didn't see it: I'd have remembered it." The creaming of motifs from mass culture was too appreciative to count as slumming; even so it was essentially second hand and as such it did not appeal to him. If anything it provoked a greater certainty that painting was an urgent pursuit, one in which temporary devices had no place. His ex-student, now friend, Michael Andrews had taken part in a film *Together*, made by another Slade student, Lorenza Mazzetti, in which he and Eduardo Paolozzi played deaf and dumb labourers adrift in dockland, but for him, as for Euan Uglow, paintings were monuments "to [an] inexorable approach, based on measured observation." So said Andrew Forge, a lecturer at the Slade, who in January 1956 published an illustrated article in *Encounter*, "We Dream of Motor Cars," commissioned by David Sylvester, in which he tentatively pursued Sylvester's line that the coming thing was to be receptive to the marketing of consumer goods, cars especially: "Watch for the characteristic unfolding as it travels, the three-quarter view of its approach wheeling into full length, and the final closing of the form as it passes us."[21]

"A difference," Forge wrote, "between US models and English is that the former range over a wide field, drawing on many sources while the references of the latter are almost exclusively concerned with cars." Extrapolating from this he preached the get-up-and-go of new American art. Pollock had killed himself in a crash the year before but de Kooning, Jasper Johns and Robert Rauschenberg were now engaged on reconstituting the figurative.

Freud was unimpressed by such selective adulation and generalised dismissal. "I once heard a talk that Andrew Forge gave at the Slade. He said how marvellous art in America is and that there's something soft in England—'people are so apologetic always'—and I couldn't bear it, and I actually shouted, 'Bollocks,' threw something— blotting paper, maybe—and left."

Frank Auerbach, for one, regarded Freud as very much more than a concise heckler. He had such searching powers. "When I was at art school in the fifties there was a certain atmosphere of bated breath around Lucian and even when he had a show at the Hanover Gallery, which John Berger rubbished with fairly imperceptive drivel, even then when people went to see it there was an aura about him. I think

he was regarded as special because of his extraordinary fastidiousness, from very early on, about what he would let out. I mean Keith Vaughan and Johnny Minton and Colquhoun and MacBryde seem relatively perfunctory: they set the target lower than Lucian did. You couldn't help noticing that there was always *something* about his work that stuck in your mind. The few pictures that came out almost *all* became famous in the time they were done, for example the portrait of Johnny Minton."

Nina Hamnett's second batch of memoirs, *Is She a Lady?: A Problem in Autobiography*, was published in October 1955, the problem being that she had run out of anecdotes and rattled on with inconsequentialities, such as: "Lady Somebody adored charladies and used to have tea parties for them in Yeoman's Row." A year later she herself became the subject of anecdote. She impaled herself on the railings forty feet below her window. Soho talk was of suicide, pointing out that a stool had been placed beneath the window to enable her to climb on to the sill. Freud thought otherwise. "She threw herself out of the window, they said. But Cedric [Morris], who knew her, said he was sure she didn't jump out of the window because, having so often lived in hotels and rooms, when she wanted to go to the loo she'd squat on the window sill and he was sure that was it.

"I went to the hospital in the Harrow Road, a desperate general hospital, and they took me to see poor Nina and there was this jolly sister of hers from the country. The sister said, 'It's so exciting; so many important people have rung up. You an old friend of Nina's? Have a look at her. Same old Nina.' So I went through the curtain and saw a triangle, a lump of meat with forty wires sticking out of her, and lots of noise coming out: her harmonica breath. A horror carcass. She died the next day. She had twenties legs, like matchsticks."[22]

At the Marlborough
1958–68

"Do you think I'm made of wood?"

On 20 January 1957 John Minton committed suicide. "Down being in, and Hope being out," he had said, a disparaging remark about the Kitchen Sink vogue that all too readily applied to himself. Six months earlier he had been reported in the *Daily Express* as saying, "after Picasso and Matisse there is nothing more to be done."[1] He could see his own work go stale, the lanky, hollow-eyed graphic style outmoded, the paintings dulling into academicism.

Told by Freud while sitting for *Man Smoking* that Minton had died, Charlie Lumley simply shrugged.

Under the headline "Yesterday There Died a Purple, Melancholy Genius" the *Daily Express* reported Minton as having been a wit, "given to brainstorms and acute fits of depression. His moments of genius were marred by long periods of alcoholism." Freud's portrait of him was reproduced as "John Minton—self-portrait" alongside a photograph: "John Minton by camera."[2] Another newspaper also identified the painting as "A brilliant self-portrait . . . found in a corner of his studio."[3] Freud believed that Minton, having commissioned it in the first place, had intended it to serve as a legacy. "Johnny had a plan, I think, to leave it to the RCA. It was a sort of commission." It was to hang, ghostlike and reproachful, in the grand new Senior Common Room. Apart from that he had little to bequeath. Freud, MacBryde and Colquhoun were left £100 each, of which Freud received £50, and Henrietta Law got his house in Apollo Place.

Minton's despondency had been aggravated by changes imposed at the Royal College where the Rector, Robin Darwin, had decided to improve its image and strengthen its standing by promoting the industrial design departments and cladding the teaching structure with Oxbridge pretensions. There was, said Freud, a depressingly managerial aspect to all this. "They sacked John Skeaping as he was too fond of girls according to Robin Darwin who, in a mumbling fumbling way, went after girls too. Skeaping would give us tips for greyhounds." The shake-up had repercussions. Rodrigo Moynihan left (he was to go abstract for the second time in his career) and students took to reacting against the perky-but-insular Festival of Britain style, with which the College authorities were identified. For the venturesome, New York not Paris was now the place to reach out to and, in a few instances, actually reach during the summer vacation. America, they assured themselves, was where art's future lay.

To Freud, Minton's death was half expected. He heard about it only a few days after he himself had suffered a reversal so shattering that—as Bacon told people at the time—he too for a while seemed suicidal.

The story went that he had arrived back from Ireland, where he had been working on a portrait—Garech Browne again—and Caroline, by her account, had welcomed him home with lamb chops with mint sauce, petit pois and potatoes dauphinoise cooked specially for him and Bacon. He looked at it and, without even tasting it, lit a cigarette and pushed the plate away, whereupon she went to the bedroom, packed her bags and left.[4]

There was no conciliation, no meeting even to be had. Frantic to find her and persuade her to return, Freud felt injured as well as distraught. Not so much because it was she who had left but because, ultimately, she had gone even further than he in nullifying the marriage. "Things could have been better for her with different behaviour on my part. I wanted to talk to her. She was all mixed up with this friend of Oonagh's, someone called 'Deacon' Lindsay, partly Italian, supposed to be dying of TB, and never did, who wrote a famous novel about a sanatorium called *The Rack* under the name of [A. E.] Ellis out of sympathy for Ruth Ellis."[5] He searched the Dean Street flat for clues to where she had gone. "I remember—not that I'm a reader

of letters—looking at a letter from Deacon to Caroline which said, 'Have you never wept, woman?' Sickening. I felt completely murderous. I didn't really know him: he was very very literary, interested in Proust, a very difficult prig; lived in Mount Street, in chambers, near the Connaught Hotel. She may have stayed with him. Made himself responsible for hiding her."

Learning that Caroline was in Rome, he went after her. "When she was on the run I went to see her, went for two or three days. I went to her room, and to the horrible museum in the park—Raphael and things—dry and dusty. I've always been wretched in Rome. All these statues every time you go out: statues standing in fountains. Rome has a silly atmosphere of people wearing ties to match their eyes and cars to match their shirts and driving on pavements to show off. I remember staying in this hotel below the Spanish Steps, on the balcony floor, and an American walking along the balcony into my room, a dealer talking about pictures, how he bought Keith Vaughan and how my things weren't buyable."

Sigmund Freud's *Libidinal Types* (1931) divided the "amorous" into "erotic," "narcissistic" and "obsessional." The need to know, compulsively pursued, prompted the foray to Rome, a miserable sequel to the trips to Madrid in search of Caroline four years before. Unsatisfied, unrewarded, the obsession ebbed. There seemed no point in travel elsewhere. Paris dwindled in attraction. "I went less and less. I was less and less avid to go away. I was in a very agitated state. Not many hours painting. A period of chasing about a lot." Besides his pride being injured, the loss of control, Anne Dunn thought, confounded Freud. "I don't think that he believed she would go." Michael Andrews remembered that in all the years he knew him this was the one time he saw Freud in tears. As did David Sylvester, who was disconcerted when Freud, unaware as far as he knew that he himself had been "going out," as he put it, with Caroline, talked to him about his unhappiness. He told people that he had never really known Caroline that well. That she had left him, not he her, was only part of the misery. At a party given by Sonia Orwell Freud turned up and found that, tactless as ever, she had also invited Caroline. "Do you think I'm made of wood?" he said.

"Six months or a year after Caroline left I read a thing in an Italian paper that I'd stopped her writing. I don't think that was so. I don't

think so because she was so spastically untidy and hopeless. And she had been living in Rome for quite a while." In Rome she took up with Ivan Moffat, whom Freud had known at Bryanston. "I always despised him. Quite friendly. Too boring." Moffat had become a scriptwriter in Hollywood and was friendly with Christopher Isherwood, who mentioned in his diary the following February that Caroline was getting a divorce. "Only capable of thinking negatively," he wrote. "Round-eyed as usual. Either dumb or scared."[6] In Los Angeles Caroline tried to get into films, underwent therapy and doses of stuff called LSD, Freud heard. "Had dinner with Sinatra. It didn't work."

She was also linked to the photographer Walker Evans (who was "inclined," she said later, "to boast about sexual conquests that may or may not have taken place").[7] This did not rile Freud. "He said—and we'd been apart for a bit by then—'I want to tell you, my intentions towards Caroline are strictly honourable.' Very American in a way, a mixture of noble behaviour and alcoholism." Evans, who was working for *Fortune* magazine at the time, nosed around Delamere Terrace with his camera and photographed Freud in his room, lounging on the bed and standing beside his Dutch cupboard in a sharp suit with ex–Crimean War soldiers' quilts hung behind him. Freud remembered Evans as nervous, not knowing whether he was aware of his affair with Caroline. He was happy, he told him, to have someone take her off his hands.[8] The sexual side of things had never been satisfactory during the marriage.

There was talk of a financial arrangement to tide him over, but he shied away from that. "I think when we parted she wanted to give me an allowance and Dean Street. A bad idea. Made me a slight concierge."

The end of the marriage was news, briefly, after which Freud found himself to be of no great interest any longer. "Maybe because she was so glamorous we were always hounded a bit by papers, but it wasn't that when she left." Some people dropped him. "Naturally. I think nothing was closed to me, but I didn't want to see Oonagh, Garech and people. It made no difference to my life, in that I never went anywhere except where I wanted and it didn't stop me working. I was at Delamere. Feeling very solitary you quite like to isolate yourself and I always had Delamere Terrace. I seldom didn't work during the day, but I did very little night work then."

Sitters were few and the money went. He only had what he could get by selling work—what little there was—and by gambling. "I always went all out at that." He now lacked such credit as marriage to Caroline had afforded him. "I [had] bought *Le Repas frugal*, the Picasso etching, which Caroline, in her crazy way, left at the airport. (She always left her clothes behind; she left everything everywhere; I quite liked it; it impressed me in a funny way: it was so anarchic.) The etching was sent back to the Redfern and they sold it for eight or nine thousand pounds. They knew whose it was but, since it hadn't been paid for, they (not quite properly: they should have given it back) repossessed it. Caroline had quite a lot of pictures of mine and they're all lost. Then afterwards, long after, she bought some things and kept them, and her other treasures, in a bank vault. I never really knew her that well."

She wrapped the paintings of her in newspaper, put them in a cardboard box and deposited them in an office cupboard in the basement of a West End bank. "To be married to Lucian," Debo Devonshire remarked years later, "would be a killer."[9]

In January 1957, the day after Minton's death it so happened, Fritz Hess wrote to Freud taking him to task for his irresponsible, not to say devious, financial dealings and for having the temerity to accuse him, of all people—old family friend and patron indeed—of wrongdoing, and reminding him that he had had the nerve to ring him up in 1951 asking for another loan when he already owed him £60 from 1948.

> *Because you were not in a position to pay the money back, you agreed to offer me one of your new paintings. You never kept that promise, nor that you would paint Yvonne in the garden.*

What particularly annoyed him, even more than the slighting of his wife Yvonne, was Freud's demand that he should return the Delacroix drawing that he had bought during the war for £10 and had placed with him as security on a loan. What Hess assumed to be a purchase was to Freud (never one to regard such transactions as conventionally binding) a pledge. This, Hess argued, just wouldn't wash.

Later in the same year 1951 you won your £500 prize from the
L.C.C. [sic] or they bought your exhibition picture for £500.
When I heard of it I visited you and you gave me your cheque for
the settlement of your debts. This certainly would have been the
occasion to offer me that small sum of £25—to get the drawing
back, if you would have thought you had a right to it. But no—
not a single word, not even as much as a hint. The reason is quite
simple; your memory was quite fresh so shortly afterwards, and
you knew you had no right to it. Since you paid your debts in 1947
we had not the slightest sign of life from you until you rang up last
month after nearly 6 years telling this strange story. There must
have [been] certainly hundreds of occasions during these years
when you were in a financial position to claim the drawing if you
would have thought you had a right to it . . .

I think you are a great painter, but I must say as a person and
a friend I feel very hurt because when I look back over the years we
have known each other I realise that I have only been visited when
you thought I could be useful. I feel most wounded, that in the end
I had to listen to your offensive remarks over the telephone.

I can and do forgive you because I have always liked you and
know you are going through an unhappy period.

With my best wishes and may this year bring you good luck.
Yours sincerely
F S Hess

PS Since I value your father's friendship very much, which
I do not want to be disturbed by possible one-sided information, I
send a copy of this letter to him.[10]

Ernst Freud swiftly responded.

Dear Fritz
Thank you for sending me the copy of your letter to Lucian.
He had of course told me his version of the incident and you may
have noticed that I avoided a discussion about it at Walberswick.

Both Lucie and I remember that he had mentioned previously
that he had pawned a drawing with you—so we must concede him
the right to believe you to be wrong.

But we accept your facts and that you have acted in good faith.

Unfortunately Lucian is quite hopeless in all money matters and it is almost impossible to help him. I was glad to hear from your letter that he paid at least his debts to you.
 Kind regards
 Yours
 Ernst[11]

Freud was used to farming out such possessions as he had, always assuming that he could get them back when he wanted. Hence his repeated use of the Freud–Schuster Book as a hostage-like form of security. His account of the dispute with Hess was, accordingly, one-sided. "I bought a Delacroix drawing—candle and night table—from a framer's for £10 and pawned it with Hess and two or three years later, when I wanted to get it back, he said I'd sold it to him. I was naive and shocked. He wrote a letter saying I had 'some psychological difficulty.' I told my father and he broke with him."

Divorce would enable Caroline to remarry and settle in the United States; grounds were already ample enough but Freud obligingly supplied fresh evidence to suit the courts. "The divorce was not my chief motive. I went on giving more and more evidence, going off to hotels with women for her. Ivy Nicholson thought she'd be the right person to use so we had some days at hotels, but she had a boyfriend who said we shouldn't do it. It seemed very hard to manage. I had high-powered advice: don't go to the very *best* hotels—Claridge's, the Savoy—because they are too discreet. Draw attention to yourself by leaving an enormous tip or an ostrich in the bedroom. I kept on trying. I always told people why we were staying in this hotel in Bayswater Road. And then there was this girl who was ideal but then I found she was under age. 'We'll *never* get divorced,' Caroline said. It wasn't straightforward."

The marriage was dissolved on grounds of cruelty in Juárez, Mexico, in 1958. Sexual incompatibility would have been a more accurate assertion. Caroline testified that her husband told her he did not care what happened to their marriage. She told friends that while with Lucian her ovaries had ceased to function; LSD therapy in California after she left him had restored them to working order. The follow-

ing year Caroline married the musician Israel Citkowitz, a former protégé of Nadia Boulanger and twenty-two years older than she; they had three daughters. Citkowitz was voluble and touchy. When someone insulted him, as he saw it, in the Colony Room one day he let out a torrent of invective and abuse, excessive even by late-afternoon Colony Room standards. But he wasn't, Frank Auerbach remembered, "quite as contemptible as Lucian made him out to be. Actually he looked like him: a brutal anti-Semitic caricature of Lucian though with hair dyed dark, possibly. I said, 'What does he do?' And he said, 'Oh, he plays with stocks and shares,' which wasn't entirely true: he was a pianist and a sort of psychological teacher of pianists. One of Lucian's terms of contempt when you asked him about some-one was: 'Oh, he plays in stocks and shares.'"

There were for Freud repercussions from the marriage well into the sixties and beyond. "I was in Annabel's and I saw Maureen with one of her walkers. She was sitting there and as I passed she beckoned to me and I, with a vestige of old-world manners, bent down and she gave me a thwack with her handbag. Her man—a Prince Philip sort of person—I saw him later and he said, 'It must have hurt terribly.'

"I haven't connected it, but I think I must have questioned every-thing much more after Caroline. I'm not gregarious especially, and being unhappy makes me want to see people much less. I either talk a lot or absolutely not at all. That's why I'm no good at dinner, where you are supposed to turn halfway through: 'And where have you been this summer?'"

At Delamere Freud worked on his portrait of Elinor Bellingham-Smith—*A Woman Painter*. An older woman, a soup-dispensing painter of wistful figures-in-landscape, apt to be tearful, fond of a drink, she was married to Rodrigo Moynihan and had been briefly involved with Michael Andrews and Lawrence Gowing, though not with Freud. "Lawrence said to me: 'Tell me, did you have an affair with Elinor?' 'No, I didn't: oddly enough it never occured to me. Why?' I asked. 'Oh what a shame. When I was a student I did. And Mike told me that he had been overcome. So if you had it would have been a treble.' I mentioned it to Mike and he said, 'Oh dear.' She was terribly nice and she minded about her friends." The Moynihans had been a hos-

pitable couple running what amounted to a salon in their house in Old Church Street, Chelsea, attracting Freud and the Slade crowd, also Bacon and Minton. "She overdid everything. Adored Rodrigo, who went his own way; Francis said of her, 'She's got real human concern'; she shared a boyfriend with Johnny Minton (a deserter from the Navy who attacked me because of my portrait of her which he thought cruel) and another with Henrietta [Law] and was often in the Gargoyle. A Dr. Boyd was in love with her and she cut her wrist so he'd have to come and bind her up, and he did it up especially tight. Elinor overdid everything." The Moynihans divorced in 1957 and Freud's painting of her was to some degree his show of sympathy. "She moved to Suffolk and things got rather bad; she was crippled, in a chair." Rodrigo Moynihan proceeded to marry Anne Dunn.

One evening in 1957 Freud, together with Bacon, entertained Matthew Smith to dinner at Delamere Terrace. They thought of it as a late-in-the-day commemorative occasion, rather like the banquet Picasso organised for the elderly Douanier Rousseau in 1908: a tongue-in-cheek yet wholehearted tribute. Auerbach remembered it as an uplifting event. "Lucian was living by the canal in very grotty circumstances and I think the dinner party consisted of Sonia Orwell, Isabel Lambert, Elinor Bellingham-Smith, Eduardo Paolozzi, Matthew Smith, Francis and myself. Oysters first and he had on the landing, down one flight of stairs, the man who opened oysters at Wheeler's—this is so characteristic of Lucian—opening the oysters and then there was a *poussin* and then strawberries.

"Lucian had put the picture of Elinor Bellingham-Smith on the mantelpiece for people to see while we were eating and he also brought down a picture by her that he had bought and she saw it and she said, very perceptively, 'How nice of you.' It had a very unfortunate fate: Ken Brazier—a Slade student—picked it up ('an old canvas in the corner of your studio' he said it was) and painted over it.

"Matthew Smith was very reserved but pleased to be there (it wasn't long before he died). I believe he felt a bit like that man in Aldous Huxley who's dragged out of a cellar where he's been forgotten and fêted by a younger generation. Francis was brilliant at getting conversation going. He got talking about 'genuine abandon' and he said of himself that he wasn't in the least abandoned, at least not by his standards, and he said, 'Matthew, have you ever known anybody

abandoned?' And Matthew Smith, sitting there quietly, said, 'Well, you know, the word abandon has several meanings.'

"The wine was terrific and the champagne, everything, in these very humble surroundings. Both Lucian and Francis did a thing that was very grand and lovely—Francis too gave a dinner on occasion— they'd go to Covent Garden early in the morning and buy not a bunch of flowers but a whole box of flowers meant for a florist—and they laid the flowers all round the table before we started eating.

"At half past eleven or so Eduardo and I felt it was time to go home and we shared a taxi. But Matthew Smith had just got going and he said, 'Are there any clubs we could go to? Where can we go on to?'"[12]

"Everyone got plastered and wilting," Freud remembered. "But Matthew Smith got really perky and said, 'Where shall we go now?' His daughter wrote to thank me. She said that it was a great thing for him."

Matthew Smith's habitual self-effacement, his instinct for privacy, had meant that he had sheathed himself in diffidence. He bequeathed his unsold paintings to his favourite model, Mary Keene. "Like all great painters, Smith cannot and will not be tied down," Henry Green (Yorke) wrote in the catalogue of the Tate's Matthew Smith retrospective in 1953,[13] to which Bacon too contributed "A Personal Tribute," describing the paintings as "a complete interlocking of image and paint, so that the image is the paint and vice versa." For him, for Auerbach and—particularly then—for Freud, Smith was a painter of true conviction. "Every movement of the brush on the canvas," Bacon wrote, "alters the shape and implications of the image."[14]

"George Barker thought it was a matter of morality," Auerbach said of the notoriously philandering poet. "If a girl expressed a desire to have a baby, the thing to do was let her have it; and given that Lucian only very sporadically and later (unlike George Barker) had the means to support these, in a sense his was a religious faith that these babies would be all right."[15]

For Freud the dwindling of his second marriage more or less coincided with the period during which his "gadding about," as he put it, resulted in births and related complications.

There was Katherine McAdam. "I met her at a party. She was at St. Martin's and worked in a milk bar in Charing Cross Road." Born in 1933, Kay, as she was known, had been educated at convent boarding schools; when she told her teachers that she wanted to be a nun they said there were better things for her to do, so she enrolled at St. Martin's to study fashion. Freud pursued her. "Her Irish father was a driving instructor. The villains in Delamere had a flat in Maida Vale, which they used as a hideout; they used to stay in her parents' flat in Stafford House. The father disappeared to America." Kay McAdam became pregnant in the summer of 1957 some six months after Caroline left. A daughter, Jane, was born in February 1958 in the Royal Free Hospital in Hampstead; Freud saw Kay in hospital and, after mother and child had moved from a flat above Kay's parents in Stafford House, Maida Avenue, he found a basement for them in Fernhead Road, Paddington, in a house belonging to the notorious slum landlord Peter Rachman. He couldn't understand why she put up with it. "People in the ground floor blocked the stairs with junk, rubbish and shit and the few times I went there I was worried about things to be done." She told him not to interfere. She had her independence—she had taught a bit and designed Emu knitting patterns—and, recognising that Freud was not someone to rely on, she had learnt to cope. That he was married to Caroline had been news to her when she read about it in the papers.

When Jane McAdam was old enough to ask, she gathered from her mother that she had taken up with Freud on the rebound. "Lucian pushed everyone out of the way. My mother was dreamy, very able, practical: when the electricity was cut off, for instance, she didn't fuss. She would never have wanted to be full time with Lucian. She didn't want babies, but having been brought up a Catholic she didn't want contraception or abortions. They never argued, she told me. And she never modelled for him. She never talked about anything 'personal' unless pushed."[16]

Though detached from Freud and not publicly linked to him, Kay McAdam became, as he saw it, an object of contention. "A man, her boyfriend of some sort, came and attacked me at Delamere once and I threw him out and he was always hovering round the car. I had an accident going down to the country with Caroline: he had slit the tyres and they exploded."

Freud had given her a small self-portrait, ten inches by six, done in 1949. She told her son Paul (born in April 1959) that this man, John, who ran a screen-printing business in the Edgware Road, had brought out a knife and pinned the picture to the wall together with a pair of knickers. "They had a fight and Lucian won." Later the painting was stolen, Freud heard. "The man who thought she was his girlfriend made a slight hole through the eyes. It was found by someone on a barrow in the Portobello Road: she'd left it in a rooming house and someone at the Slade bought it."[17]

Around this time—in 1957—Alexander ("Ali") Boyt was born. His mother was Suzy Boyt, a student at the Slade whom Freud had taken up with in the course of his duties there. "She did nice pictures," he said and he told Coldstream that coming upon her there had made teaching obligations finally worthwhile. He painted her as *Woman Smiling*: not so much smiling as happy to sit thinking to herself. Her robust appearance—lank hair, reddened eyelids—was good to work from not least because she looked complicit. Standing over her, he attended to her with scratchy emphasis, roughening yet blending what he saw, using the springiness of hogshair bristle to realise touch and denote familiarity. "A turning point rather."

Woman Smiling (1958–9) was a venture into animated expression. Previously drawing had been the means, now he wanted to achieve in paint not so much the look of life or—more subtle—the breath of life, more a sense of thought and weight of mood. "Something that impressed me was the thing Walter Trier did, illustrating a poem in *Lilliput*, a German poem about a man on the Tube. It suddenly occurred to him that it was a very long time since he last laughed so he considered how it was done and, travelling on the Tube, he made a very loud noise. It was really about *existence*. It appealed to me because of that."

Working the paint he tried a marbling touch, pressing the flesh, as it were, to establish the terrain of a complexion. Once embarked on and intently studied, everything experienced could come to be realised: the puckered flesh of a strawberry, fretted palm leaves, greasy hair, the tightening fold of skin over a collarbone, the glint of an eyelash. Not for him the bullying descriptive passages in nearly every Bratby, or for that matter the narrow range of panic stations typical of

Bacon. He inched in effect towards a greater freedom of application: a greater give.

Moving around as he worked—touch by touch the assiduous barber—he took more notice of the way the head informs the face and the face reveals the disposition. Gradually his expressive awareness quickened. In the late fifties he was still not yet fully charged with the ambition to graft something perhaps of the card-shuffle idea of Cubism on to the sheer fullness of Rembrandt. Achieving "dimension," he said. He also talked of landscape painting being something "in which you can walk around." His hope was that he could lose himself in the effort of making each painting take its place convincingly, indelibly and, with luck, unimprovably so. "I'll know that face again," people say. That face will flush in an instant, skin will redden, crack, scab, flake. "Skin's so unpredictable."

The late fifties was for Freud a period of floundering and scrabbling for bearings during which painting was a standby, a distraction even, rather than—as it would become—the overriding concern. It was a period of sudden starts and elaborate lunges from painting to painting as he tried for intensifying liveliness in the paint. This at a time of life going haywire and responsibilities left dangling.

"Nice Bill [Coldstream] would sometimes say—of course thinking about himself—'Really, you ought to make a will.' I said, 'Why, as I have nothing to leave to anyone?' 'Yes, but you ought to think about Ali.'"

He and Suzy took the baby Ali on a trip to the Scillies once, by air. "Flying over you could see the dolphins."

In August 1956 Stephen Spender spent an evening with Freud at the Peter Brook revival of *The Family Reunion* and in his diary the next day recorded at some length what a disappointment it was; he felt that the otherworldly quality of the play was missing and that the choruses were desultory, failing to convey "how the spiritually unreal realise that they are so and that their preoccupations are meaningless."[18] However, some of Eliot's lines were apposite still:

We like to appear in the newspapers
So long as we are in the right column.

Freud's portrait of Stephen Spender, worked on in 1957–8, is a thin-skinned study of a face adjusted: the poet, plumper than in the 1940 painting and drawings, now turned academic, his hair grey and receding, his mouth composed for reticence as he sits through the sessions, pondering the grievances that he could well air, were he to have it out with the painter at some less inopportune moment. Spender had settled well in middle age: co-editor of *Encounter*, a visiting professor on campuses in the United States and still, by perpetual association, the perennial Thirties Poet. He became plaintive, complaining to Anne Dunn that Freud had behaved very badly to him, that "things disappeared from the house."[19] Freud on the other hand complained that the paintings he had given Spender in Wales in 1940 had been mislaid. This was more than carelessness; it was evidence of a seemingly vague self-serving self-absorption. He felt that the portrait, softish as it was, indeed borderline bland, was not a success. "I rather hated it: a slightly ectoplasmic look. Stephen said it made him look queer, the mouth. Stephen was very susceptible: he liked that thing about Cecil Collins being a genius." Freud regarded anyone who had time for the spiritual bent of the poetical painter Cecil Collins, whose works all too frequently involved gingerbread angels and a dunce-capped Holy Fool, as intolerably gullible.

Leaving the Slade in the Alvis one day in February 1958, with Stephen Spender in the passenger seat, Freud drove headlong through the gateway of University College out into Gower Street. "It said, 'Proceed at no more than 3mph.' Went right into a passing car. Collided." No one was hurt but the driver of the other car was abusive, Freud maintained, so he and Spender left the scene. The case took nearly a year to come to court because Spender, his witness, was absent for some months in Japan and Freud told Clerkenwell Magistrates' Court that he too was abroad. Summonsed the following January for failing to stop after the accident, he pleaded not guilty. Spender was called to give evidence. Thinking to be helpful, he assured the magistrate that Freud had been going at under fifty.

The Times reported that the man in the other car, a dress manufacturer from Finchley, told the court that Freud had driven his large black Alvis out of the quadrangle, crashed and vanished. "When I asked him for particulars," Mr. Lawson said, "he pushed me aside, hailed a passing taxi, jumped into it and made off."[20] Mindful that Freud was grandson of *the* Freud, the magistrate said: "What an extraordinary thing to do. Did he seem to be in a dream?" "He seemed very agitated," Mr. Lawson replied.

Freud maintained that when the other car came into view he was stationary. "He abused me almost non-stop until I decided to reverse the car and clear the entrance. Mr. Lawson continued his abuse and it was almost impossible to exchange particulars so I took a taxi along with Mr. Spender." Unconvinced, the magistrate reprimanded the accused and thought fit to add a personal comment. "I think you are temperamentally unfitted to drive a car. I think you ought to see a psychiatrist and having regard to your name I think you will see the point of that."[21] He fined him £5 and ordered him to pay the costs. This irked Freud. "Stephen was hopeless. I only had one leg at the time, so I could not drive at any speed. Unfair. Shockingly unfair."

He pleaded guilty to a further summons: failure to accord precedence to a pedestrian on a crossing in Fitzroy Street on 13 October. He was fined £1 for that. "If you are not careful, Mr. Freud," the magistrate said, "you will be up for manslaughter one of these days."[22]

The Bishop of Lincoln was reported on the same page of *The Times* for speeding. But the records differed. It was revealed that Freud had fifteen previous convictions.

"I used to be banned quite a lot."

Stephen Spender and *The Procurer* were bought by Michael Astor, with whom Freud stayed once, in the early sixties, at Bruern near Oxford. "One weekend only. Michael Astor, married to Pandora [the former Pandora Jones], was very friendly with Stephen: the Spenders had a cottage on his estate. Staying there was so awful I started wandering in the woods, but a servant came and said, 'Sir Martyn Beckett is playing the piano, really well.'" Being told that Beckett—an architect—was at the piano seemed all the more reason not to go back into the house. "In the rooms there were basins in cupboards and a light went on in the mirror; I loathe mirrors, except for self-portraits. So I tried to shave with the door shut."

"Brilliant ones fizzled"

Frank Auerbach ascribed the change in Freud's work around the time Caroline left him as being triggered by his unhappiness rather than by purely technical concerns. Certainly he was at a loss. Casting around, his instinct was to strike out and take chances, be the prodigal and make opportunism ("potential," as he saw it) prevail over timidity or prudence. Accordingly he maintained that it was no good taking on commissions for these came larded with unacceptable considerations: the cosmetic perjury associated with bespoke portraiture. Occasionally however, when debts became unnervingly pressing, he found himself detecting potential in individuals accustomed to regarding themselves as patrons. One such was Charles Clore, the shoe mogul and property magnate. And Judy Montagu was the go-between. "She said, 'He's always wanting you to.' And he had quite an interesting face. He owned a roller-skating rink in Cricklewood and he got the rights to the Dempsey–Sharkey fight at the age of twenty-two, which was pretty extraordinary." A maroon Rolls would wait outside Delamere while he painted this phenomenal tycoon. Twelve inches by twelve, *Man in a Grey Suit* (1960) has a time-is-money look: yellow eyes wary, silver hair swept back. "It was all too busy and formal." Not that much bigger than a passport photo, Freud's Clore was, quite obviously, the least he could do.

The contrast between *Man in a Grey Suit* and *Woman in a White Shirt* was one of scale, commitment and empathy. The woman, Deborah, Duchess of Devonshire, whom he first met at the Gargoyle, sat for

him from 1957; this was no commission though there was never much doubt but that any painting produced would end up at Chatsworth, the Devonshires' stately home. She was three years older than Freud, the youngest of the six noted and notorious Mitford sisters: among them Nancy, author of *The Pursuit of Love* and many other novels; Jessica, author of *Hons and Rebels*, who was ardently left wing; Unity, who developed a passion for Hitler and died in 1948; and Diana, who married Sir Oswald Mosley, leader of the British Union of Fascists, and had been interned with him during the war. Deborah ("Debo") became renowned as the chatelaine of Chatsworth, largely responsible for turning the place into a great visitor attraction.

Given the social traversing involved, an activity less taxing than social climbing, the progress of the friendship was, for Freud, restorative. He stayed with the Duke and Duchess when they were still living in Edensor village waiting to move into nearby Chatsworth, which had been unoccupied by the family since the early thirties. His first visit was in August 1957. His hostess wrote to her sister Diana: "He seems very nice & not at all wicked but I'm always wrong about that kind of thing. He's mad on tennis, rather unexpected."[1]

Andrew Cavendish, the 11th Duke, came to believe that Freud owed his interest in horse racing to him. Initially therefore Freud found him exasperating. "I thought how affected he was, saying how he wished he had never been born; his elder brother had been killed in the war so he inherited unexpectedly." A girls' school had been installed in Chatsworth during the war and the place needed restoring to what it had formerly been: the Palace of the Peak with its great collections and gardens, and Emperor Fountain 276 feet high. Meanwhile there were 80 per cent death duties to be paid, £7 million, exacerbated by tax payable on Andrew Cavendish's sudden and unexpected profit in 1950, the year he inherited from his father, when he bought a horse for 500 guineas and won £50,000 with it. Paintings had to be sold, among them a Memling *Virgin and Child*, Holbein's Henry VIII cartoon and Rembrandt's *Aristotle Contemplating the Bust of Homer*. In 1959, having reopened the house to the public, the Devonshires themselves took up residence. "A new visitors' book was commissioned by Andrew from some very artistic person; Debo said, 'I dare you to put "By hook or by crook I'll be first in this book."' I didn't as it would have upset Andrew." He first stayed at Chatsworth

that November. To those whose names filled its pages, Freud's among them, Chatsworth restored was a post-war Brideshead, on a grander scale and free of Waugh's sycophantic nostalgia.

The Duke maintained that there is "generally too much talk of sex nowadays." As he remarked many years later, in an A–Z of English characteristics that he compiled in the first instance for the *Sunday Telegraph*, dalliances are best conducted with one's compatriots: "The French have their strengths and the Italians are very agreeable but, if you want my advice, stick to English women. They know the rules."[2] This was an informed view. It was—as Hilaire Belloc said and Freud quoted—well understood:

> *The husbands and the wives*
> *Of this select society*
> *Lead independent lives*
> *Of infinite variety.*[3]

Freud enjoyed the company of *Woman in a White Shirt*, her no-nonsense aplomb. "She had just had her youngest when I met her and I saw a lot of her fairly soon after Caroline left. I remember a slight upset and her saying she thought I didn't like her as much. And she said, 'I thought it might help you get over Caroline.'" Gossip ensued. "Debo was seen hopping in a London street with Freud holding up a foot, calling the attention of passers-by to her new shoes," Evelyn Waugh was pleased to tell her sister Nancy Mitford in June 1960.[4] She asked to be introduced to Bacon "The Horror Painter." Her husband testified to her strong character. "She is on the bossy side, of course, but I've always liked that in a woman."[5] She had a whippet, Studley, a breed with which Freud was to be associated. He particularly remembered her taking him to Renishaw Hall, home of the Sitwells. "Met me at Chesterfield station and we had lunch there. In the hall was a huge, dull, glinting brass pot on a table, been there forty years, with bulrushes in, and poking out of the bulrushes was a dark-looking duck with a beak: a Sitwell joke. Osbert was there, not Sacheverell, who wouldn't speak to me as I hit Reresby, his son, in the lift at the Gargoyle, as he was rude to me. Nor Edith: Debo told me that Edith had become a Catholic in order not to murder Osbert's boyfriend. Osbert said, 'So pleased you illustrated that book of mine.' I couldn't think

what he meant, then I realised what it was: *The Equilibriad*, which Sansom had dedicated to him as he had praised him once.

"Debo took me to a party at the Dorchester for Dirk Bogarde's boyfriend, Tony Forwood, who had been married to Glynis Johns. Judy Garland was there, very exciting—she looked rough and bloated—I put my hand out and got four of her fingers. 'Do it again, you missed one,' she said."

Freud had already painted the Duke's sisters, Elizabeth Cavendish, whom he hardly knew, and Anne Tree, with whom he was more friendly, and who conducted investigations into bird sperm at Mereworth in Kent; he had met her through Epstein, who made heads of both her and her husband, Michael Tree—owner of Colefax & Fowler, the interior decorators—whom Freud also painted and with whom he used to enjoy staying. (He had a snapshot of his host naked painting himself.) They had a chauffeur called Waters formerly employed by Peter Beatty, the previous owner of Mereworth who had become blind and committed suicide in 1949 by jumping out of a sixth-floor window at the Ritz. "He liked Waters to wheel him up to people he disliked at the races and insult them, which he could do as he was going blind." Freud thought Waters indestructible, so much so that he took to calling himself Louis Waters ("Louis as like Lucian") in later years when occasion demanded, such as staying—ostensibly incognito—at the Carlyle Hotel on Madison Avenue.

While sitting for Freud at Delamere, three hours a morning on and off for well over a year, posed in the same room as an old bath, the Duchess noticed that he was using an Epstein drawing, a drawing of his son, to shovel coal for the fire. She offered to buy a proper dustpan and do a swap. He agreed and the drawing was hers. She enjoyed the excursions to Delamere Terrace, driving there in what he described as "her small Austin canvas-roof car," a car that she lent to him once, he having pawned the Alvis, only to get it back damaged. In October 1960 she wrote to Nancy that, "awfully jolly," she would be in London all week "because of dear little Lucy & his picture." Nine months later she mentioned the painting again to her: "Dear little Lu's likeness of me is nearly done. I think it's *marvellous*."[6]

Indeed *Woman in a White Shirt*, unprimped, unflattered, intimate, a painting that began with one eye, lone on the canvas, was marvellously different from the previous portrait of her by Pietro Annigoni,

whose painting of the young Queen, a Madonna of the House of Windsor in Garter robes, serene against a clear sky, had been widely hailed in 1955 as a flawless icon for the New Elizabethan Age and was destined to hang in the Fishmongers' Hall. In similar spirit the Duke of Devonshire had been quick to propose a painting to celebrate the renaissance of Chatsworth. The Chatsworth Annigoni was completed in 1954. The artist boasted Renaissance draughtsmanship and an affinity with Leonardo, altogether loathsome to Freud. "I've never got anywhere with Leonardo. He tried so hard for that awful airless idyll in everything. And Annigoni—all he concentrated on is the foul glaze. He did it in a modern way, with a Horlicks mixing machine or something, and he certainly got it: the Leonardo look." Having told the Duchess that she was not the type he preferred to paint, Annigoni made her eggshell complexioned, her arched eyebrows complemented by the limp obeisance of distant trees.

"Diana Mosley said to Debo, a blazing smile across her face, about Annigoni: 'Did he let you put the lipstick on yourself?' Diana was a bit brilliant. In jail she read a lot. She said Hitler had fine hands. That famous story of her and Nancy Mitford, who was ill, and how she sent out on a Sunday for a doctor. 'First the good news,' she said. 'I've found a doctor. Now the bad news: he's a Jew.' 'Haven't you had enough?' Nancy said. 'Your friend Hitler killed six million.' 'It was only three million,' Diana said. 'And he did it in the kindest possible way.'

"Jessica ('Decca') was a friend of Sonia Orwell's, and Nancy I never got on with—she said she never liked me—but I met the mother, Lady Redesdale, who lived in a large house in Rutland Gate. I went with Debo once or twice. Works by Unity on the stairs: *Napoleon Crossing the Alps*, with thousands of figures: it had madness to some purpose. Lady Redesdale was pouring tea and her hand was shaking and she had to hold it and she said, 'Down vile limb,' with real fury. Debo told me she 'used to adore Decca. Something terrible happened. We were so close, she eloped and never told me and I practically had a breakdown.' Odd."

Freud's paintings for Chatsworth joined the grand assembly of works of art in the house: Reynolds, Landseer, Ricci, Murillo—and Annigoni—but, more gloriously, with Hals and Rembrandt and Poussin.

"One could ask for the key to the library and look through the Rembrandt drawings. Debo, when her monstrous sister stayed, put Van Dyck sketchbooks on the night table.

"I'm always interested in family over a period. From first to last I painted them over twenty-five years. It didn't seem like a plan. Andrew's mother, the old Duchess, said, 'Why have you got this interest in my family?' I said, 'I'm not claiming I'm uninterested.' She told me that when Andrew's uncle, Charles Cavendish, whom Rosa Lewis had been so in love with that she named her hotel after him, married Adele Astaire and brought her home from America to Devonshire House in Piccadilly where the Rootes car showroom now is, he came in with tiny Adele Astaire into this long room. 'And there was my husband and she did cartwheels all down the room, and that immediately won his heart.'" Adele Astaire was tough and rude, the 11th Duke remembered, where her brother, Fred, was unfailingly charming and polite.

The Devonshires had Freud to stay with them at Lismore, their estate in Ireland. John Betjeman (deeply involved with Elizabeth Cavendish) saw him there, starting on a watercolour of a salmon that got no further than the one dead eye before putrescence set in. Being a houseguest was no way to work. Aristocratic ways were seductive but, Freud felt, ultimately lowering. "Can the upper classes do art? They just don't. Not since Rochester and Byron, who could at all? Dick Wyndham? Roger de La Fresnaye? When he had consumption in hospital and drew self-portraits they were pretty nice."

When in the course of a chat Betjeman remarked that there they were, the two of them, outsiders to some degree, Freud wondered quite what he meant. Anti-Semitism? Or did Betjeman really regard himself as socially excluded, being lower class than the Cavendish family? Either way, he didn't agree. For one thing he enjoyed the perks of being an artist, authorised to stare, to roam freely throughout society, to enjoy a freedom that his parents could never fully experience and his brothers barely. There was satisfaction to be had from weekends spent with Reynolds portraits and Rembrandt drawings and weekdays at Delamere, slipping from the world of *Burke's Peerage* back into the circulation areas of the *Evening Standard* and the *Police Gazette*.

. . .

June Keeley, a twenty-one-year-old from Wimbledon, "a little suburban girl with a strong Catholic mother," as she later described herself, found herself splash-headlined in the *Sunday Pictorial* as "The Five-Hour Bride" who, regretting her marriage to an older man, albeit a millionaire, escaped during the wedding reception. The groom sued her for desertion and the case was widely reported. In the heyday of *My Fair Lady* this jilting June Keeley was a real-life, bang-up-to-date Eliza Doolittle: a proper caution. She was even given a day in jail for contempt of court. "Being the Five-Hour Bride, I thought I might as well enjoy my five minutes of fame and met Tim." Tim was Tim Willoughby; he asked her for a weekend to a place near Henley but when passion flared, she said, she put on cold cream and curlers. "It was six or eight months before I'd actually sleep with him."

Tim Willoughby de Eresby, son of the Earl of Ancaster and heir to parts of Lincolnshire and Perthshire and much else, including two of Hogarth's *Four Times of Day* paintings, was also a grandson of Nancy Astor and, arguably, the leading rake of his generation. Through him Freud became involved with Jane, his sister, fifteen months older than he, who had been one of the maids of honour at the Coronation and had told Freud, when introduced at one of the O'Neill parties at Whitecliffe seven or eight years before, that her great-grandfather owned half New York. "And it has declined since," she added.

The two Willoughbys were intrigued by June Keeley and titillated, she reckoned, by her line of work. She could tell them about dealings with punters and about life on the margins of show business. "I introduced Tim to Danny La Rue at Winston's Club. People say I was with the Willoughbys for their money; they hadn't any then: their parents were alive. When I didn't want to go to work they'd say, 'You have to go: we need money for the weekend.' I was the milch cow."[7] She became head hostess at Churchill's nightclub in New Bond Street, skilled at wheedling lavish tips out of Greek shipowners. "They'd say, 'Won't you come home with me?' I'd say, 'I don't do that, but I'll find you a girl who will if that's what you want.'"

Freud, who knew June initially as Tim Willoughby's attachment and a lively girl about Soho, took her to L'Escargot and ordered snails: she kept hers in her mouth, went to the loo, she said, and spat them out. "I couldn't swallow them. But I wanted to be sophisticated. One of my best teachers was Francis [Bacon]. He sorted me out. Henrietta

Tavistock (née Tiarks) cornered me at a party and said, 'Which finishing school did you go to?' and Francis said, 'Henrietta, June never did go to a finishing school and how glad we are, because if she had she'd be as fucking boring as you are.' Then he said to me, 'Don't ever be cornered like that again.' He taught me a lot of my bitchiness, I didn't realise it at the time. He'd be at parties and keep an eye on me.[8]

"Lucian would come in sometimes, arrive at the bar in his chef's trousers and chef's shirt—from Denny's in Soho—that he painted in and Harry Meadows, who ran Churchill's, would say, 'Lucian Freud is here and he wants a drink with you. Don't bring him out of the bar into the club.' So I'd say to the Greek I was with, 'I've got to sort something out. Give me ten minutes,' and I'd go out to the bar and Lucian would say, 'What time are you finishing? We could have breakfast in Covent Garden.' So we did, occasionally. I'd come home from Churchill's at two or three in the morning with flowers, photos and five hundred fags, and there'd be Jane sitting in bed with Tim. 'How much did you make?' Tim wasn't a very pleasant person; but I'd retaliate even worse." Once she found him in bed with his lodger, "not even shame faced; like naughty schoolboys." The lodger was Colin Clark, son of K. Clark, and he was later to shiver at the memory of Willoughby: "Timmy was very dangerous. He ran his life entirely according to his whims. Timmy never took his eyes off you while he was talking to you. He spoke quietly, even gently, but he expected to be obeyed."[9]

Freud was dazzled by Willoughby's Byronic shamelessness and quite envious of his capacity for dissipation. "Tim liked the idea of being a big-shot ponce and living off immoral earnings. I think he was queer and ashamed of it. Sodomy: quite keen on that. I know that some girl light-heartedly mentioned it and he was terribly angry. He had a nasty streak. I rather liked a ginger-haired nightclub hostess who never charged and he said, 'Come and see my new girlfriend. Aren't I lucky?' and I went in and it was the redhead from Surbiton, amazed at the place she'd woken up in." Willoughby introduced him into high-stakes gaming circles. "He took me gambling. I didn't know how to play chemmie. These games were illegal, held in different places; odd flats round Eaton Square, Sloane Square. I got some money, then several hundred pounds. I never tried to keep any, because my father had the copyright money and I could generally get some."

Until the 1960s gambling in Britain was more or less covert. As Bacon had done, but on a grander scale, John Aspinall organised games, renting houses—he used Tim Willoughby's place in Wilton Row at least once—and sending in caterers and florists to lay it on thick. Aspinall's first wife was known as "The Spirit of Park Lane"; she and his mother, Lady Osborne, used to play for the house. "Cheat: she'd push tokens forward and whip 'em back," Freud noticed. The law changed in 1962 partly as a consequence of the Willoughbys and others being arrested at one of John Aspinall's floating crap games. "Aspers" was successful because he could tell a punter's capacity to pay up. The word was that Lord Derby sold off parts of Liverpool to meet his losses. Freud could not hope to match such resources, but the urge carried him on. "I was always in debt. Mildly stimulating. Bailiffs I was always on good terms with. Winning is like sex. Better than sex."

The lure was the exposure, the yielding to abandon, not just the thrill of the risk. "A dangerous illegal world. Tim was terribly, terribly vain. Billy Hill—the gangster—was there once, interested to meet a rich, crazy, handsome young blade. Tim was flattered at the attention and Billy Hill suggested him taking one of his 'people' to Aspinall's: a most monstrous thing to do as Tim considered Aspinall a friend."

Jane Willoughby differed fundamentally from her brother in that he lived for pleasure but she primarily, Freud felt, had an energetic social conscience. She happened to have been in Vienna in 1956 just over the border from the Hungarian uprising and, back in London, had helped set up British Aid to Hungary. Her participation was practical and imaginative; she recommended that cosmetics be added to the first vanload of relief supplies for the refugees, guessing that these would particularly and disproportionately boost morale. Freud was to appreciate and benefit from, over the years, her loyalty and practicality. "Tim turned against her when she went to Hungary, very ashamed that she did charity work or (something more ignorant, to do with style) it embarrassed him." In the course of this venture she met Dr. Noel Moynihan, a newly qualified doctor who, in the seventies, was to become Chairman of the Save the Children Fund. "Dr. Moynihan worked, being a Catholic, at the St. John and St. Elizabeth Hospital, where I had my appendix out. It was near my parents. Dr. Moynihan

was wanting to get in with the surgeons and he said, 'I looked in while you were having your appendix out: your liver's in perfect shape.'"

Moynihan's solicitude extended well beyond medical concerns. "A spiv, good in some ways, he asked me, 'Is there anything you are particularly nervous about?' 'My motor car's not insured,' I said. (No one would give me cover after the first year.) So I told him, and he said, 'I used to be in insurance and I'll take care of it.' It was, I found, a criminal offence not to be insured. I was banned every so often." Dr. Moynihan was also happy to prescribe pills to Freud. "I used to have purple hearts. He'd dish them out. Didn't have them much, liked staying up all night. I stopped and then got them just for Mike [Andrews]. Mike and Frank had them." He never needed much sleep. "I used to drink. I used to get into fights all the time out of drink and be sick—wake up in the nightclub lavatories upside down when the cleaners came round at three in the morning. But to drink you must be able to go on."

Freud persisted where instinct drove him. One of his rivals talked about "his amazing intensity just to get his end away." He could be violent when thwarted, going wild, pushing a girl out of a car when she would not go home with him, kicking a man in a pub for talking out of turn. There were scuffles in the Colony Room lavatory, a girl emerging with her mouth bleeding. Once Henrietta Law woke up to find him standing over the bed (she was expecting someone else) and taking his belt off, readying himself. His ardour needed frequent recharging. He took a girl to stay in a peculiarly drab hotel in Villiers Street that Jean-Pierre Lacloche, who had a nose for gloom, had discovered on a trip to London. They spent three nights there and when they left the man who took the key said: "All good things must come to an end, eh?"

In Soho competition might be intense but turnaround was fast. "Frank Norman I knew through Buhler's Café [also known as "the Swiss"]. A marvellous girl, an anarchic, brainy girl, always with Negroes, took up with Frank Norman, to my amazement. I said, as I fancied her—not a question of a very good horse refusing—'I thought you only went with Negroes.' 'There you are,' she said. Frank was half black." He was also, after a spell of "corrective training," about to become a celebrated writer of wide-boy memoirs. "She left him and I

said to her, 'Why did you go?' 'I can't do it when people get success-ful,' she said."

Living beyond whatever means he might have, Freud dressed well and drove in style. Why have a motor car if not a good one? Why regard money as anything but ammunition? Serious-minded colleagues like Patrick George marvelled to see him drive into the courtyard outside the Slade in the replacement for the Alvis. "Artists never even dreamed of having a grand motorcar, not unless they were Sir Alfred Munnings, and here was Freud, as broke as any lord with ancestral credit, handling a Rolls like an MG." At the Slade he liked to be paid in pound notes, then he could go down the road immedi-ately to the bookmakers.

Patrick George saw Freud in the life room one day "flicking open his cigarette lighter to more closely examine the pubic hair of a pos-ing model." Freud was surprised at this. He doubted that he had ever had a cigarette lighter ("I rarely smoked"), but, coming from Patrick George, he said, the story had to be true.

Slade students too had stories to tell about their intense and eva-sive tutor. The cartoonist Nicholas Garland, a painting student in the mid-fifties, said that they found him alarming. "You could sense his presence in the corridors of the Slade before you saw him. He always wore grey suits and white shirts and his belt always looked very tight around his slim waist. Somehow or other he managed to be almost painfully nervous and menacing at the same time. When people imi-tated him they raised an imagined Gauloise to their lips while mur-muring, 'It's rather marvellous,' rolling the R of rather in the back of their throats.[10]

"I was a hopeless student at the Slade," Garland said. "And Lucian, who was a visiting tutor at the time, never spoke to me as a tutor. But he became a close friend of Tim [Behrens], my flatmate, so I got to know him a bit." One day Garland went to the National Gallery to look at the Rembrandt self-portrait and found Freud there, gazing at it. "I walked away and returned a little later to find that he hadn't moved. There was something tremendous about the intensity and concentration of his look. That painting always reminds me of Lucian. I wished I could have talked to him about it and found out what he was looking at so hard." Garland was envious of Tim Beh-rens being taken up by Freud. "I was terribly jealous of Tim's very

close friendship with him. Once I went to join Tim at the bar of the French Pub where he was drinking with Lucian. Lucian smiled and said, "Here comes the tallest living pixie." His words, drawled so contemptuously and comically, amused Tim who laughed and repeated them. I can still feel the awful shame of the would-be hanger-on who has just found himself outside. So I was scared of Lucian."[11]

Freud's Slade teaching ended, for the time being, in 1958. "I went less and less and less and less, and then I thought I'd better resign, and when, finally, I resigned, Bill Coldstream said, 'Oh good, I was going to have to ask you to resign as you are so irregular. And I've never asked anyone to resign ever.'" He went with the Willoughbys to pick up his things. It was a relief rather than a retreat and, given gambling odds, a not necessarily serious loss of income.

"Lucian may have felt that he was simply too lucky, too good-looking, too extraordinary," Frank Auerbach reckoned. "Athletic, too. Really clever. Géricault was the same: had a lot of money and gave it all away to put himself in a situation where he thought he might paint better.

"The funny thing is, once people have been a bit spoilt their whole attitude is utterly different, they have a sort of freedom the rest of their lives. They're not as cautious as people very poor from childhood. Francis had that famous thing of a tiny, tiny allowance; Lucian had that thing too—an allowance—till he gave it away. He gave far more away and spent far more and gambled far more. It must have helped that Lucian was one of those painters, and they are pretty rare: dropped into Ecuador he'd start painting flowers in the town square and people would immediately recognise that he was remarkable."[12]

Ken Brazier (*A Young Painter*, 1957–8) qualified as remarkable and Freud tried helping him out. "I liked him and never asked myself why. He was a friend and in a bad way. I met him in Robert Street, a boarding house that belonged to a Pole or Czech where Tim Behrens and Ann Montagu lived as students. I took great trouble with Ian Tregarthen Jenkin—Bill's deputy—to get him into the Slade. He'd been at an approved school and since that meant supposedly that he'd already been supported by the state we had to make up a new life for him, which worked. He was desperate but he was interesting. Came from a very broken home, mother French, father a violent workman. He was a really good Vorticist: it was as if he worked with shovels and

drills to discover something that had been discovered before. It had graffiti-like urgency. Coldstream said there were only two people he took against to do with me (he didn't know about how Jenkin and I had played this trick). One was Ken."

Some years later, when Freud taught for a while at Norwich Art School, he wangled some teaching work for Brazier. "It didn't work. He dossed down in the art school and borrowed money from students—2/6—and the head rather meanly stopped him. Ken was just very touchy and went completely mad and married Nina, a girl I knew who then married an abstract painter and he [Ken] went off to become a professional beggar. He used to ring bells and run away. When I moved I made sure he didn't find out where I was. 'I've painted a picture,' he said. 'I buried it on the South Downs.' He was desperate and interesting and a bit talented."

Women students such as Nina tended to have promise unfulfilled, Freud noticed. Too readily distracted, he rather thought. "They fizzled out. Brilliant ones fizzled." Schoolteaching, if not marriage, was their most likely prospect; indeed, one of Coldstream's predecessors, Professor Tonks, used to tell well-heeled women students that they should marry poor but talented male students and thus keep them going. Some women students were sidetracked. Suzy Boyt, in her time at the Slade considered a promising painter, had more children by Freud after Ali: Rose in 1958, Isobel (Ib) in 1960 and Susie in 1969.

Of all Lucian's girlfriends that he knew of, Michael Andrews told me, Suzy Boyt was the one who had fewest illusions about him, the only one who did not seem to want to change him.

"I'd like to thank you for the children," she said to him one Christmas, forty years later, somewhat to his bemusement.

"Actually it's all I can do"

In March 1957 Bacon exhibited at the Hanover Gallery six *Studies for a Portrait of Van Gogh*, variations on Van Gogh's *Painter on His Way to Work*: paintings prompted as much by Vincente Minnelli's *Lust for Life*, in which Kirk Douglas lurched wildly around Arles, as by the original painting which had been destroyed in the war. The artist became a haunted figure, "a phantom of the road," Bacon said, mired in the paint like a skier forestalled. Hastily produced to make up a show (two paintings were delivered wet to the gallery), the series was a dramatic outburst, upstaging the colour reproductions that now stood in for the vanished picture. In a way Bacon was repeating what Van Gogh himself had done when, in the asylum at Saint Rémy, he painted studies after Delacroix, Millet and Gustave Doré, livelier than the originals. Bacon then returned to Tangier where Peter Lacy was a pianist in a bar drinking himself to death. For Freud, Bacon remained supremely companionable.

"I saw him most days for a very very long time, obviously when he was in London: he was abroad a lot with Lacy. Francis told me I wouldn't like it in Tangier. 'Not a girl in sight; they're all in yashmaks anyway,' he said."

By the late fifties Bacon had his imitators readily expressing anguish. Freud never troubled himself even to consider moves in that direction. But Bacon talked about "the need to deepen the game" and that was appealing. "Francis had an effect. I had never before thought of paint, even though I'd always looked at other paint seemingly freely

done, like Matisse for instance. He talked a great deal about the paint itself carrying the form, and imbuing the paint with this sort of life; he talked about packing a lot of things into a single brushstroke. Things which amused and excited me and I realised that it was a million miles from anything I could, or would ever, do.

"The idea of paint having that power was something that made me feel I ought to get to know it in a different way that wasn't subservient. I wanted to see what it could do. I hardly ever saw a painting of his that I couldn't really admire or be surprised by. I went round there an awful lot. He only worked in the mornings. I worked longer hours, not obsessively, and we'd meet at lunch: Wheeler's or the Colony. I always worked fairly long. Not at night. Nor did he. Sometimes he wouldn't drink and we'd just stay there in his studio and go out locally; it's not so much that he drank so much but so consistently. He had this marvellous discipline."

Bacon despised inhibition and dealt out money and drinks as though honour bound to impress friends and strangers alike. Don Henderson, a former dental technician, Detective Sergeant in the Essex Police, Royal Shakespeare Company actor and General Tagge in *Star Wars*, was barely a nodding acquaintance in the French Pub, yet Bacon treated him, he said, with extravagant open-handedness. "His vast generosity (when offering to buy somebody a drink—even a stranger—as often as not it would be a *bottle* of champagne) and his genuine delight at meeting a friend. His eyes and whole face would light up and actually SHINE in a most extraordinary way until he became one huge grin of sincere pleasure. He was one of the most charming, honest and open people I have ever met."[1]

On one occasion, Freud remembered, the conviviality soured and the grin faltered. "Late at night, in a room near the Colony Room, Muriel, Ian [Board] and people were there and Francis had this huge workman with an enormous erection and the man had passed out and Francis was sucking him off, and people were shouting and carrying on, and as the man came he was sick and Francis shook himself and said, 'God, I wish I hadn't done that.' What was good was Francis doing it like an unsuccessful lark. Normally Francis' exhibitionism hadn't been of that nature. Though it was probably no more extreme than what often happens upstairs when the pub closes, it was very spectacular. The man was so huge, so unconscious and yet amenable."

This singularly untoward act matched the reflexes of retch and spasm graphically rendered in many a later Bacon: as with weaknesses of the flesh, so too with the paint. "Those sexual feelings: even if unconscious, you can have them. It's to do with survival instinct. Like Hitler, or those doctors: freezing people to death and putting glamorous women in with them. The cells are most closely grouped where those senses are. The man was, perhaps, not very wildly alive when he was awake.

"It seemed odd for Francis to do something private in public. Not stylish. I suppose it was a mixture between desire and 'let's go there' and alcohol. When he shook himself, he seemed dead sober."

In 1953 the Metropolitan Police Commissioner, Sir John Nott-Bower, had announced a drive "against male vice," the plan being to "rip the covers off all London's filth spots." Following this, the conviction and imprisonment of Lord Montagu and Michael Pitt-Rivers for consorting with airmen was a cautionary stunt. The Wolfenden Committee Report of 1957 recommended that homosexual behaviour between consenting adults in private should no longer be a criminal offence but the relaxation in the law was not effected for some years and when, eventually, it came about Bacon was not best pleased. "Francis said it ruined his amorous life because, he said, it took the excitement out of things."

In 1958 Sonia Orwell married—briefly—Michael Pitt-Rivers, a landowner, who, having served his sentence, qualified as another of her quixotic ventures. Freud took advantage of the new connection. "He had this cottage and I took Anna and Annie for a holiday. Under the rules of divorce I had to have an au pair so I took Kay [McAdam] with us. It was quite nice having her there. Charlie [Lumley] came down and one night we went to Lepe on the coast, near the New Forest, and took a car ferry to the Isle of Wight and drove round the island. He showed me where he was in jail. An army jail."

Charlie was available once more to pose for *Man Smoking*, the cigarette savoured—a contemplative smoke—an air of indifference finally achieved after fifteen years or so of being on call for sittings. *Man in a Mackintosh* (1958) was another update: *Interior in Paddington* seven years later and several steps closer, with Harry Diamond older,

balder and ever more resentful, re-equipped with black-rimmed National Health specs. His raincoat became him: the coat of a street character, a pub acquaintance, who considers himself put upon but fancies himself to be as fly as they come. Frank Auerbach told Freud that he saw Diamond once in the French Pub with a girl; Harry had a knuckleduster in his pocket to bring out if his "fiancée" was approached by anyone.

"All who were barred from the French Pub went to the Caves de France. Harry and his friends Bruce Bernard and Willy Willetts—a translator who became amazingly expert in Chinese art, unhappy marriage, always in Soho—were in the Caves and Willy said, 'I've been talking to my publisher who says in some years to come your Chinese book will be indispensable; I've been making my will and will maybe leave you the royalties.' Harry left. Then next day he said, 'I've been thinking about your offer. Leave me out. I'm damned if I'm going to be a butt for your philanthropy.' I thought what an extraordinary thing to say: 'butt for your philanthropy.' It cannot ever have been said by anyone before."

Freud liked Harry Diamond's ex-pugilist stance. "I remember him saying, 'I'm five foot four, I'm a bit thin on top: am I a monster?' Yes, I thought, but not because of that. Harry glassed a lot of people in his time." Bruce Bernard stuck up for him as one who "understandably felt aggrieved at his lot, and who had to work as a stagehand with what was then a clannish bunch of right-wing cockneys—sometimes nice to know, sometimes not."[2]

In the portraits from the previous few years, most notably those of Stephen Spender and Elinor Bellingham-Smith and now Harry Diamond once again, the handling painstakingly loosened. "Learning to paint flesh was a conscious decision and I got very impatient. It is also as Degas reported of Ingres, his visit to his studio when his companion saw *Bain Turc* and said, 'Oh, that is yet another style.' 'But,' M. Ingres said, 'I have several brushes.' Degas repeated that. 'You can't quote a remark of Ingres' that isn't a masterpiece,' he said."

Bacon always claimed that ideas dropped into his mind like slides into the projector. Technique—"using paint to do things"—gave rise to style; if an idea worked it did so because it clicked, so to speak, and, with any luck, a sort of effusion occurred. Freud had little versatility;

like Bacon, he painted as he did because he had no choice. "They think I'm painting in this way but actually it's all I can do."

More brushes: more variety of effect, different strokes for the pull, the sag, the sheen of skin, and the tight whitening where boniness shows through. That said, Freud was not hankering after virtuosity. He wanted to be able to achieve more immediacy, more fullness, more body. "A picture should be a re-creation of an event rather than an illustration of an object."

"Use the shadows," Bernard Meninsky had told his students at the Central. "Draw from the shadows. There is nothing else." And he quoted a Chinese sage: "Art produces something beyond the form of things, though its importance lies in preserving the form of things."

This could be construed as exhortation to obfuscate, but it is encouragement to deepen and enlarge. As Cézanne said, explaining why the Beaux Arts Academy of Aix had seen fit to reject his application to study there: "a head interested me, so I made it big."

Freud admired D. H. Lawrence's essay on Cézanne, published in 1929, for its acceptance of the idea of painting being intelligent—and restrained—intensification. "He wanted true-to-life representation. Only he wanted it *more* true to life." Cézanne would say to his model, "be an apple, be an apple," and Lawrence had thought this a metaphysical bull's-eye. "He knew as an artist that the only bit of a woman which nowadays escapes being ready-made and ready-known cliché is the appley part of her." Such talk was, Freud accepted, "impressive and ridiculous." But what Lawrence had to say about Cézanne's substantiality had a bearing on what he himself was beginning to want to achieve. "The true imagination is for ever curving round to the other side, to the back of the presented appearance." To Lawrence, Cézanne's struggle was to regain an initiative. "Our instincts and intuitions are dead, we live wound round with the winding-sheet of abstraction. And the touch of anything solid hurts us."[3]

To Freud, Cézanne was the painter who, above all, made expression (as distinct from skittering "Expressionism") the very stuff of concentration. "Eliot said, 'Art is an escape from personality.' In my head this rules out Expressionism. The art element is what has been concentrated on. Expressionism—as I think of it—it isn't an escape, it's a direct transmutation of the personality; it's an attempt to express

feeling direct and that's why it's so awful. Expressionism is exaggerated. The concept of overstatement: that's what it is. I can only think of it as a term of abuse."

He was sensitive about this because it was so often assumed that having been born German he was surely predisposed towards the Gothic and, even more surely, influenced at an early age by the Neue Sachlichkeit artists, particularly Otto Dix. This he baulked at. Wilhelm Busch, yes, not Dix. "Terribly not. I might have seen them; I disliked it intensely, with the exception of Grosz. I hated the overstated atmosphere of them: medieval German drawing all slipped up. And I thought they were political." Obviously such denials could have been bluster, as he himself acknowledged. "It could be like people turning into the parents that they loathed." Yet he had put a distance and a barrier of disinclination between himself and such presumed influences. He had been unaware of the work of Christian Schad, which did not come to attention in Britain until the 1970s. "Schadenfreud," he suggested, was the pun to apply, and art historians were too keen to bundle together presumed influences simply by date, nationality or, if desperate, genetic propensity. The greatest influence on him, he insisted, was French painting. Why? "Because French painting is better . . . I felt more discontented than daring. Suddenly, for the first time, I felt I was pursuing a method rather than painting and I think that made me very dissatisfied. I felt I wanted to free myself from this way of working. Also people said that they liked it, which I thought was really suspect. I felt with such approval in the time I got it that it was being appreciated for something that I felt wasn't of great account. I felt that the linear aspect of my drawing inhibited what I wished to do in my painting. Though I'm not introspective I think that all this had an emotional basis. It was to do with the way my life was going and to do with questioning myself as a result of the way my life was going.

"Gradually I used more and more and more hours. I started standing up. And then I used bigger brushes, different hogshair brushes. I was very aware of the terrible things I was doing in the process."

Now in his late thirties Freud could see how real the risk was of being for ever associated not only with long ago and faraway German painting but also with the types of painting that a dealer such as Arthur Jeffress had espoused: mindless detailing to *trompe l'oeil* effect, Vene-

tian swagger as with recent Graham Sutherlands and brimming close-ups of youngish Dorian Grays. How easy too it could have been for him to catch up with and overtake Dickie Chopping, say, who by then was becoming celebrated for his fetishistic James Bond dust jackets. And there was also mischief to stomach. His Bryanston schoolfriend Michael Nelson published anonymously in 1958 *A Room in Chelsea Square*: a bitchy comic novel "about the world of smart Bohemia" in London featuring an all too recognisable cast of characters. The late Peter Watson appeared, lightly disguised, as "Patrick . . . rich, indulgent, tortured" ("he still retained that schoolboy charm which he went to such lengths to preserve"), also "Ronnie Gras," a Cyril Connolly figure bent on feeding well off a literary review called *Eleven*, and "Christopher Lyre," who was unmistakably Lucian Freud. ("Everyone laughed at Christopher. But they had to concede the fact that he was a talented painter.") Nelson caught Freud's speech patterns and faint Germanic lilt: "Stephen Spender in one of his better poems says that changing place isn't changing mind. That's terribly true, you know. We all find that as we grow older. Don't you agree, Ronnie?"[4] The talented painter lost his wife. "At the time I was terribly upset. I thought she should have understood that there is more than one kind of love. The nature of love is promiscuous and uncontrollable."[5] That said, "Christopher put down his brush, took a tie off the mantelpiece and twisted it round his neck, omitting to put it under his collar."[6]

"I did notice that those people—Paddington people—age. They really age. I noticed girls who were playing in the street: ten years later they were grandmothers."

"I've never minded being overlooked or forgotten. It wasn't that I was abandoning something dear to me; it was more that I wanted to develop something unknown to me."

"People being monogamous seems to me an extraordinary and imaginative situation"

Freud's first exhibition at Fischer and Lloyd's Marlborough Fine Art, in April 1958, was significant for them, though in itself a minor affair. "I was their first modern person after Paul Maze." The Marlborough had risen fast. "Frank Lloyd had operated petrol pumps and service stations around Vienna before the war; Harry Fischer had been a bookseller." Interned at the outbreak of hostilities, then in the Pioneer Corps, they set up in 1946 in a basement in Old Bond Street dealing in prints and books initially, then in paintings; they had backing to start with, Freud learnt, from Ernst Heilbrun, Lucie Freud's admirer from decades before. "He turned up after the war. 'The Swabian Nightingale.' A German poet, rich, and had been interned with Fischer. He lived in Switzerland, I think. When they did well they gave him his stake money back, nothing more." Before long the gallery had branches in Rome and New York and began dealing in living artists. Enhancing reputations with impressive catalogues and international sales pitches could be more profitable, they suspected, than trading on old esteem. Besides, supplies of readily saleable Impressionists were dwindling.

"They called it the Marlborough after Lord Ivor Churchill, a philanthropist, very civilised, who had this marvellous collection of nineteenth- and twentieth-century paintings and swapped them all with the Marlborough for paintings by Paul Maze, who was a friend of his in the war." Maze introduced David Somerset, heir to the Duke of Beaufort, to Lloyd and Fischer and they recruited him to add class,

Freud explained. "They had a number of very rich clients who didn't speak to one another and he would sell from one to the other." David Somerset, who backed Freud throughout his years with the gallery, said that Frank Lloyd didn't approve of him, partly because he didn't produce enough but also because he had a habit of selling a painting to more than one person at once, and—worse—not through the gallery. Freud maintained that the partners behaved at times like Delamere costers. "They would shout at each other across the street. Traffic would stop. They chucked Eduardo. 'Mr. Paolozzi, if you don't like the way we do business, we don't need you,' said Frank Lloyd and hung up."

Freud had no gallery when the Marlborough took him on. He had fallen out with the Hanover where he had been anomalous, particularly after Arthur Jeffress pulled out. "Jeffress backed Erica, then she was so dishonest with him. I didn't show much at the Marlborough; there wasn't all that much to show. The paintings weren't easy to sell, but they did sell. David Somerset paid me in cash." The latter knew from the first that Freud was going to be a difficult artist to handle. "Such a bad producer." Lloyd had been against taking him on, but Fischer was in favour, considering him similar to himself in that they both came from a posh Viennese background.[1]

"There was a moment in the late 1950s," John Russell, the *Sunday Times* critic, wrote, "when the Marlborough seemed to have in mind a monopoly, with every living artist of consequence on the payroll." Ben Nicholson was lured from Gimpels and Henry Moore from the Leicester Galleries. Freud asked Fischer once if there was any artist he wouldn't show. "Graham Sutherland," he replied. "And that was only two years before he showed him. Fischer was a shoddy, fat, pompous fool. He came round and borrowed a book of poems and I never got them back." David Somerset said that actually Fischer liked Freud; after all there was the same Viennese background and so showing him seemed to him to be a reinforcement or corroboration of his taste for Klimt and Schiele, which he extended when, in 1972, he split with Frank Lloyd and founded Fischer Fine Art.

A couple of weeks before the Marlborough exhibition opened Quentin Crewe of the *Evening Standard* talked to Freud in his "condemned house in Delamere Terrace in Little Venice." He found him, he reported on 17 March, "a nervous man whose eyes dart about like

fleas in a snuff box. He beguiles with charm and alarms with an air of suppressed violence. The painting of his last wife, Caroline Freud, seems almost vicious," Crewe added. "He calls it *Girl by the Sea*."

Freud explained why those he painted were mostly nameless. "I don't give them names as I think it distracts people. This one I call *Procurer* because the subject is a sort of procurer. I hope to finish this one for the exhibition but I have been delayed as he has been in prison." "This one" being *Man Smoking*.[2]

The *Evening Standard* article was intriguing and favourable advance coverage but then, on 5 April, an article by John Berger headlined "Success and Value" appeared in the *New Statesman*. Berger began with congratulations to the Trades Union Congress on commissioning a sculpture by Epstein for their headquarters in Great Russell Street. "Both affirmative and tragic . . . a most effective expression of the determination of the Labour movement to prevent war." He then laid into the show with fervent scorn. Freud's failings were graphic, he argued, and not unconnected, he implied, with lack of moral fibre. "The new Freud portrait heads are done with a painstaking naturalism somewhat reminiscent of the covers of *Time* magazine. Only they are more startling because they all emphasise decay—like touched up photographs of rotten apples."[3] Berger ("like all communists, married to a very rich woman," Freud contended) exercised what he himself later acknowledged to be a "puritanism" of judgement. "They appear to be fashionable but are worth very little." The article caused consternation at the Marlborough. "Fischer panicked. He almost stopped the show."

Freud was not the only exhibitor. Drawings by Marcel Frischmann, a contributor to the satirical magazine *Simplicissimus* between 1926 and 1933, who had died in 1951, were shown in the front gallery while Freud, in the room behind, showed paintings such as *Man in a Mackintosh*, *A Woman Painter*, *A Procurer* and *A Poet* (the unfinished portrait of Stephen Spender). Whatever Berger said, compared with Frischmann's somewhat dated graphics, the Freuds were fresh and immediate.

The opening was overrun with art students and the Soho crowd, "teddy boys wearing day-glo socks and flat-chested, flat-heeled, young women in torn polo sweaters," as Ann Fleming, Maudie Littlehampton incarnate, described them.[4] At her urging Ian Fleming, flush

with James Bond money, bought *Man Smoking* ("a splendid portrait of Lucian's favourite thief ") as an investment, she suggested, for their son Caspar; however, the *Evening Standard* ran a headline "James Bond prefers Nature to Art," for Fleming liked the paintings no more than he liked the painter. Charlie Lumley—"a young man with Tony Curtis hair"—was also quoted. "He took a long time to paint my picture. Three years. Course a lot of the time I was in and out of jail."[5]

Several other reviews were as scathing as Berger's. In the *Listener* Lawrence Alloway characterised Freud as "a compulsive painter, given to the elaboration of tiny forms and perfect surfaces. He lures the spectator close to the portrait, as for an embrace, there to repel him by the desert of the face, with its falling skin, rising veins, cracking lips . . ." For Alloway the change of look from the early Freud, who "began as a kind of Sunday Fleming who gripped the world in bright fragments," was deplorable. "The new portraits reveal a disastrous interest in painterly values. This does not mean that colour and atmosphere sweep across the heads, unifying each hair and crease. It means that the richer pigment he uses is subjected to the same obsessional fussing as his line, so that it takes on a weird surface animation." He particularly disliked *A Woman Painter*: "The elaborated paint turns the head into a soggy mass, like wet bread."[6]

Not everyone dismissed the show. The anonymous *Times* reviewer (David Thompson) talked obscurely of "faces ripe for betrayal," yet Freud, he added, "sheds at last his more perverse and provocative qualities and becomes an artist of real intensity."[7] In the *Sunday Times* John Russell—known among colleagues as "Hearts & Flowers" Russell—talked of "works of compassion," concluding: "compassionate these pictures may be: but not charitable."[8] Neville Wallis in the *Observer* drew attention to "Freud's method of so enlarging a head within its confines as to give it the appearance of a rare, exotic fruit outgrowing, and all but bursting, its greenhouse frame." He summed him up as "a phenomenon of our time, destined, I suspect, to outlive most contemporary reputations."[9]

The paintings sold well enough, priced at up to 400 guineas, a scale slightly lower than Erica Brausen's prices for Bacons. Clearly, if the thirty-five-year-old Freud could no longer be regarded as promising it was reasonable to assume that the paintings qualified as mature works. For Bacon, ever quick with a tongue-lashing, the time had

come for him to say that he really wasn't interested in what Freud was doing. That it was nothing. That it was worthless. This was a characteristic betrayal, Auerbach said, and at that stage more a snub. Freud had no business rivalling him at all.[10]

Sir Kenneth Clark, by now Chairman of the Arts Council, took a look at the pictures. Relations had tailed off. In 1954, shortly after he bought Saltwood Castle isolated behind its curtain walls on top of a hill above Cinque Port Hythe, Freud, Ann Fleming and James Pope-Hennessy had been invited to tea. Arriving at the twelfth-century gatehouse, remote from the inhabited parts of the castle, Freud rang the bell. Some time later the Clarks came along the drive, not to greet them but to fuss over the bell-pull. Tugging it he had jammed it and they failed to hide their vexation.

"I was very friendly with him and then less so, though I got books—*The Nude*—with dedications to me. I remember being near Saltwood and thinking I'd better not go there. At the Marlborough I saw him and he came over, looked pretty angry, 'admired my courage,' and I never heard from him again."

Clark tended to veer away from artists he had helped once they had outlived or outgrown their suitability as protégés. He seemed taken aback by Freud's loosening-up, by the loss of flawlessness, by the spectacle in painting after painting of rather ordinary-looking sitters with chapped skin and straggly hair where, previously, exquisite specimens had been provided for the connoisseur's delectation. Harry Diamond in his grubby raincoat was precisely the type of scruff one might come upon making a nuisance of himself, not for the first time, at one's castle gate. In his Presidential Address to the English Association, in November 1962, Clark addressed the topic of "Provincialism." "No open-minded historian of art would deny that English painting is provincial," he remarked. While commending "independence" (in Stubbs, for example) he cited Samuel Palmer as one who had lapsed from lyricism into "false poetry"; so too, implicitly, with the new Freuds. What a loss. "The occasional, unpredictable man of genius from the perimeters—Turner, Kierkegaard, Ibsen, Munch—is outside the sort of classification upon which criticism must usually depend." There was, implicitly, the reproach that Freud had removed himself from serious consideration by one who had provided invaluable backing and advice. As he had said, "The ideal patron . . . is a

man with enough critical understanding to see the direction in which the artist ought to go."[11]

Having pronounced the paintings superficial in his *New Statesman* review ("The 'compassion,' which is probably meant to be inspired by the care with which the long-sufferers' grimaces are recorded, is really only a form of self-pity"), John Berger implied that painter and sitter owed it to the viewer to be glum to some purpose, such as the prevention of war.[12] His exhortations were wholesale and not of course aimed only at Freud. Turning his attention a couple of months later to the 1958 Royal Academy Summer Exhibition, he wagged a forefinger at Academy portraits. "One could say to the artists who painted them that, if they looked more searchingly, selected with more discrimination, drew better, asked themselves more thoroughly and exactly what they thought was important about their subjects, they might produce worthwhile works." There was plenty at Burlington House to inspire derision: an official portrait of the Queen in an overly spangled evening dress and tiara by Anthony Devas, a chamber of dimmed conferring lawyers by Norman Hepple and, more "modern" but no less conventional, portraits by William Coldstream and Lawrence Gowing (the epitomes of Slade mid-tone academicism), by Rodrigo Moynihan and Robert Buhler (Royal College academicism) and even—carrying on as ever—paintings by Augustus John. Berger singled out none of these for specific comment; he even resisted describing the "Picture of the Year," a title applied by the press—a portrait by John Merton of the Countess of Dalkeith, porcelain-pretty in an alcove overlooking the Dalkeith estates. Yet it reflected everything that he condemned in Annigoni whose portrait of the Queen ("a badly composed, weakly drawn, grubbily painted picture, totally lacking in grandeur") had been, in his view, the presiding picture in an exclusive category. "It is the nearest that, with respect, we can get to a Royal pin-up."[13]

What Clark took to be a loss of clarity or application in Freud's work Berger regarded as a lack of compassion, feebly expressed at that. Either way the charge was that he had veered into a sort of academic naturalism. Yet Freud had moved on, concerned in his paintings more with "the life in them" than with the exercise of accomplishment within narrow bounds. To Auerbach the difficulty was that the transition had now been made public and Freud was exposed for the

first time (Douglas Cooper's 1954 denunciation didn't really count) to the discomfiture of being written off. "Lucian said—actually of Leon [Kossoff]—'I don't think he realises the luxury of being ignored.' In the very courageous period when he transformed himself and had the first show at the Marlborough, Lucian just carried on in his own way and knew exactly what he was doing and what he was heading for: what turned out to be an enormous gap in art history where there isn't anything like Lucian's lumps of flesh and human animals. And nobody had written or suggested that this was a gap; they'd written things saying that painting should come off the wall or that there shouldn't be any literary reference or that it should be like music is.

"What Lucian did was like what Baudelaire said: 'the term *avant garde* should be given back to the military and we should look for the absolutely new.' With Lucian it *was* absolutely new and nobody recognised it. And if there was a tiny element of copying Francis (and perhaps even to a tiny degree myself) about the way the paint was put on, he went through it and digested it. We were—Francis much more than me—the associates that he had chosen and then forged his own language with this addition of more varied ammunition."

That summer Freud went with Jane and Tim Willoughby and June Keeley to Expo '58 in Brussels, via Paris, a weekend during which he was stopped for jaywalking in Paris and saw Brueghel's *Fall of Icarus* in the Musée des Beaux Arts. He also retained a vague memory ("It's sort of in my head, as in everyone's head") of seeing Annigoni's portrait of the young Queen in the UK pavilion, installed there despite Philip Hendy's protests to the pavilion's designer, James Gardner. Hendy had even arranged a special showing at the National Gallery of the wretched picture. He had it placed on an easel beside a Rembrandt self-portrait and summoned Gardner. But Gardner knew his business and in Brussels, predictably, the "Royal pin-up" was a hit.

Expo '58 was one of a number of occasions when Freud, the Willoughbys and June Keeley were a foursome. Sometimes they went to the Stork Room in Swallow Street on Sunday night where, as June remembered, they sat on the left, near Pip the manager. "If the police raided, a bell was rung. Those on the left were served in coffee cups and would turn the cups up and tip the booze on to the carpet. Jane

didn't dance with Lucian, as she couldn't: no rhythm. So I danced with him on the postage-stamp stage floor. Six couples were about all it held. He'd lead in, kicking out to left and right, and he'd clear the floor. He was a kicker." June often acted as the hostess for Tim Willoughby's parties. "Once Tim put me to bed drunk, as I didn't like the guests, and I passed out and woke up, heard voices, and Tim was saying, 'Lucian, what are you doing?' Those were the days of stockings and suspenders and Lucian had come up quietly and was removing my suspenders. He said, 'I was trying to make her more comfortable.' And have his wicked way. Tim didn't hold much brief for Lucian."[14]

Willoughby conducted himself as a neo-Regency buck; his dissipation so extravagant that, marvelling at it, Freud felt moved to compete. "I used to go with Tim to Aspinall's on Thursday nights. 'Let's go and play cards,' I said, 'I feel really lucky.' Ludicrous behaviour; I always lost; I'd lost £100 or so before; anyway, I'd go halves with Tim. He said, 'I'm feeling incredibly unlucky; oh, OK, I'll be lucky.' We went to the Clermont Club and I, amazingly, won £980, a huge amount in the fifties (I remember Aspinall saying, 'It's the first time I ever wrote a cheque for £980'), and gave Tim half, and bought the Rodin *Crouching Woman*, for £200 or £400, amazingly modest. I thought this is the life and went back a few weeks later. The only genuine players were Lord Derby and me, the others were house gamblers, phoney." These were known as "the good furniture": bait for the big money. Freud was neither bait nor prey. He would push his fellow gamblers aside, avid for action, manners be blowed. "I hadn't got any money. I started losing and after, maybe, £2,000 I might have had £150; John Derby kept winning: winning £10,000 [worth £300,000 now], and they reckoned I was out of my depth, £10,000 down; I felt dizzy and stopped. And so then everybody knew about it, and people said Aspinall should be struck off for losing my money."

Ann Fleming told Evelyn Waugh that she had asked "poor Lucian" if he really had lost this amount and he had replied, "Not strictly, for I haven't ten thousand to lose."

"Aspers" Aspinall now discovered that Freud had no money whatsoever. Eventually a deal was worked out, not least to sustain Aspinall's reputation: Freud would pay him off in paintings. "Pictures at £400 a time."

Freud became accustomed to dealing with losses. "If a huge

amount, I have settled over a long time, but then the person has taken a lot off." On this occasion Aspinall became muddled, which helped. "He was so stupid. He said, 'I hope you don't mind me asking, but your pictures, is it £400 or £4,000?' He said, 'Could you pay £100 a month?' As I certainly didn't make £1,000 a year, I thought that was too much."

Aspinall had a private zoo near Canterbury. "So I did drawings of his tiger, but he lost them all. His mother, Lady Osborne, was his zookeeper and she came to Delamere in a taxi with a gorilla in her lap. She was fat and around fifty and the baby gorilla would piss—when frightened they piss—and try and bare her charlies under a sweater. 'Here's my daughter,' she said." Aspinall wiped off the debt, but he went on about Jews. Later, going to dinner at the Clermont with John Wilton, they said—and I was really furious—I couldn't come in. Naturally, I was put on a list."

Being barred from clubs was as irksome as being banned from driving, but such penalties were insignificant obstacles to anyone inclined to run risks. Losing and winning exercised his nerve. "It's the quickness which is very nice." To hazard was to override inhibitions: the vicissitudes were testing, the stresses were rapid entertainment. Ultimately the jeopardy was a pastime whereas painting, slow, unsure, was a process of devotion; yet of course in neither art nor recreation could success be willed or forced.

"I have to say I never linked painting and economics in any way. For instance, when I went to crooked card and roulette games they asked if I'd like to work with them. Though I'd lost all my money, I really didn't want to, because the exciting thing about gambling was the risk; also I was very conscious of getting money from the punters if I did that." The aim—if the itch to gamble one way and another could be so described—was to venture, to cut a dash, and Freud was careful not to subsidise risk, or diminish it, by making up for losses with paintings that he would not otherwise have let go.

"I was very aware of never selling anything that I didn't like; though I was in very serious debt I thought it out of the question. From very early on I had the professional attitude: that it's the only harm you can do yourself." Freud remained resolute about this, though when most pressed he did occasionally let trivial drawings help him get his way at the bookie's. Gambling, after all, is largely

about self-deception laced with the undeniable thrill of loss. "Gambling is one of the few activities that quite honest people lie about. And dishonest people, God knows . . ."

The pressures of work and the other pursuits were readily accommodated. Freud had no domestic ties to speak of and no concept of unsocial hours. He never needed much sleep and he liked the idea of working at all hours, as Giacometti did. "He did that day and night working, rather. Always in that studio." That presupposed not living with anyone, still less being answerable to anybody. "I had a period when I'd go and sit all night playing cards and then work in the morning till the first race at two in the afternoon, go to the betting shops, play all afternoon and someone would say, 'If you've got any money left I know a really good dog at the White City.' I'd go along and have just enough to see me back. I did sometimes spend really long hours."

Jeffrey ("Jeff") Bernard, a fellow student of form and brother of Bruce Bernard, went into a betting shop in the Portobello Road one day with Freud who put £500 on a horse called Whipsnade ridden by Lester Piggott. "The beast was left in the stalls and was last to three-quarters of the way," Bernard remembered. "Then he began to make up ground." After a photo-finish and a fifteen-minute wait the stewards awarded the race to Piggott and Freud's thrill was over. "During the running of the race never have I seen a man so adrenalin-filled. Not white, he looked almost transparent with nerves." Besides admiring Freud ("nerves and a mind of steel"), Jeff Bernard, speaking as one of the most celebrated spongers in Soho, admitted to envy. "I have spent endless afternoons with him in betting shops, but then Lucian goes home, puts on the flannel suit, shaves and bathes, then appears pristine and lovely, standing toe to toe with Andrew Devonshire."[15] In the Devonshire box at Epsom, Andrew Parker-Bowles remembered, he was seen cowering from sight, scruffy where everyone else was in morning dress. "My Aunt Kath was doing his bets for him."[16]

Terry Miles, who worked at the Marlborough, watched Freud take a wad of money—over £4,000, he guessed, others said more like £2,500—from the gallery to the betting shop and lose it in the minutes it took for him to order and pay for cups of tea for the two of them; this at a time when Miles made perhaps £500 a year.[17]

When heavily pressed Freud pawned car or Bacon. "'The Buggers' (*Two Figures*) I pawned to Keith Lichtenstein, for quite a few

years, and I kept on getting more money for it: £4,000 or £5,000. When I got it out—my father gave me the money—I tried to sell it and failed." It was the only Bacon he kept. "I lent 'The Buggers' everywhere for twenty years after that. Francis said, "Would you lend it?" and I said I'd never lend it again." Eventually Jane Willoughby had it but left it with Freud. It hung opposite the end of his bed until he died.

His own early work was potentially saleable if not valuable by the late fifties and worth tracking down. For example he discovered Clement to be hoarding some and a ferocious clash ensued. In 1951 Ronald Searle and Kaye Webb had moved into Ian Phillips' house in Newton Road where, during the war, Freud had left a stash of pictures. Searle happened to know Clement so, having found the paintings, he passed them on to him, assuming that he would return them to his brother. Some years later Lucian found out that he had them. "Guy Harte, who was a jockey, heard Cle at a race-meeting saying to someone that he'd got a better collection of my things than anyone. When I asked him about it he said that 'in due course' they would come to me. Nothing happened. I went round and his wife was there and she burst into tears and said, 'You can't take them because they are behind some wine, which is very rare and can't be moved.' So I took them." Back at Delamere Terrace he went through the paintings—there were ten or so—with Tim and Jane Willoughby picking out those that might be saleable. But as quickly as the Willoughbys set aside those that they thought worth something he returned them to the pile. *Village Boys*, *Memory of London*, *Evacuee Boy* and *Woman with Rejected Suitors* went to Jane Willoughby: two he gave her, two she bought.

"Clement can't stop boasting and lying; if he hadn't done so, I wouldn't have got the paintings back." And not long after, in 1964, came an opportunity to extract payback. "Clement had a cookery column in the *Observer* and wrote things like 'As Socrates said (wise chap, Socrates),' and he wrote: 'As my brother Lucian said, before he abandoned poetry for painting,' and quoted from my 'Ode to a Fried Egg' ('On a chalk white plate you lie . . .'). How *appalling* that he used something without permission, something private that my mother had." Freud tried to sue the *Observer*, for breach of copyright. This didn't work, so he decided to settle old scores, involving debts, by letter. "Luckily I owed him the £200 France money. So I put 'I am

fining you £185 for this offence. You may wonder why my fine is so modest. The answer is, however serious the offence, prisoners always have some remission.'"

Drawings could be exchanged for cash with compliant dealers such as Andras Kalman whose gallery in the Brompton Road was two steps from a William Hill betting shop. But reckoning that winnings were bound to exceed losses he preferred to borrow. He borrowed off his cousin Wolf, his brother Stephen, off anyone he could prevail upon, even Helen Lessore at the Beaux Arts Gallery. "Obviously I tried when the chance was that I'd get it. And I always paid her back. One day I borrowed some money and it transpired that Mike or Frank asked urgently for some and she refused. She was capricious and, I think, valued her own caprice. I questioned something once and she said, 'You must remember I'm a frustrated artist.'"

Capricious himself, and foolhardy, blind to obligations and regardless of risk, Freud even touched the self-styled King of Soho for a loan: Billy Hill, the gangster who lived over Gennaro's restaurant in Dean Street and was big in the fifties. The Krays had worked for him in their heyday as protection racketeers. "They all worked for him. I knew him and would play in his clubs. I tried to borrow money off him once. I went to see him in Moscow Court. 'A lovely flat you've got,' I said to him. 'It's an upholstered pisshole,' he said. He lent money to people he frightened but he wouldn't lend to me as I wasn't frightened. When I played at his crooked games, Charlie Thomas—who I knew later—would be standing there with huge boxes of money. Charlie—whose father was a tic-tac man—thought my betting was terribly funny. Such as when I got some money to pay a debt and took my car, the blue Rolls, to the betting shop. People like Charlie thought of betting as serious where I thought of it in a completely different way. If you've never been in a very bad way your attitude is different and I sometimes won a lot. I don't like 'That was a nice little win.' I want to *change* things with the bets. Either be dizzy with so much money or otherwise not have my bus fare. As I used to when I was at Villefranche and would go to the casino in Nice: I sort of winged my way home, I felt so light. What Francis used to refer to as 'that wonderful feeling of purge,' when you've lost everything. I knew it well."

The distractions of gambling and "amorous pursuits" affected

the circumstances of painting, the hours spent, the concentration achieved, the sitters involved. The urge to drive furiously or, as the charge sheet often said, "without due care and attention" also had consequences. There was, for example, in May 1958 a smash in Lower Sloane Street. "Little girls crying on the pavement," Ann Fleming reported. "Blood-stained father being shoved in an ambulance."[18]

"I'd been up all night," Freud explained. "But they wanted to go to the Battersea Fun Fair. Coming back to Sloane Square I fell asleep at the wheel for a second and hit the back of a bus. It took off my nose. Chipped sinuses. I was in hospital two days; no nose came off and I had to have my sinuses done; Annie had a cut on her face."

"If you want to know what Lucian is like," Caroline Blackwood told Cecil Beaton, "just see him drive." "Mercifully," Beaton added, "Lucian has now been forbidden to drive, for he is reckless at the wheel."[19] Bans were imposed every now and then, but he went on getting into trouble. A policeman thought he had spotted Freud, the defendant, in charge of a vehicle but the case was dismissed on the grounds that Freud claimed that he was the passenger, Jane Willoughby the driver.

"I got off the one with Jane. 'I've seen a lot of cases,' the magistrate said, 'and *when* you go inside.' But I had a jury: you could then, in some cases, because the police told worse lies. I had lots and lots of offences and then, suddenly, I changed my driving technique. I was quite excited once: a magistrate said, 'I don't doubt your brilliance as a driver but it is not relevant.' I had been going at a huge speed down the King's Road, incredible I didn't have a crash. I was in this Alvis, which was good for that."

The Alvis bought for him by Caroline was succeeded by a blue Rolls ("The name of the colour was 'blue over special blue'") and then, from the mid-sixties onwards, Bentleys. Whatever the make, Freud drove like a jockey, spurring the car, overtaking and cutting in, provoking angry scenes at traffic lights. Auerbach noticed that he kept an iron bar beside the passenger seat for emergencies. Once, when they were out together and there was an incident, a man came from the car behind, took a look at them—Auerbach was unshaven, Freud glared—and backed off.

Kitty wrote to Freud after the Lower Sloane Street accident on 6 February 1959 objecting to his driving Annie and Annabel around

town. "Fifteen car incidents in the recent past. I've not known a moment's peace of mind when you've taken the little girls out." He and Annie had to go to St. George's Hospital to have stitches put in. "I thought that your love for the children would have been strong enough for you not to disregard my request that you didn't drive the children yourself." There had been a "torrent of abuse" when she raised it with him in front of them. "Which was very hard for them, apart from being distressing for me." She asked her solicitors to get a ruling that he should not have the children until he gave her an undertaking not to drive any car with them in it. Wednesday afternoons and Sundays were the usual days. "They both enjoy going out with you," she said, cancelling a plan for them to go to Ireland with him in the Easter holidays unless she received "a satisfactory undertaking."[20]

"It took me a while to realise that the tenacity of memory isn't necessarily correct, and that touching 'Ah, I remember it well' even less. I've got a good memory, but whole areas I've slightly, subconsciously, left uncharted."

In October 1958, Erica Brausen was dismayed to learn that Bacon had signed up with the Marlborough. Freud was partly responsible for this. "I persuaded Francis to leave the Hanover. He'd done a painting of birds, two owls, very nice, not a million miles from Cedric Morris (which Francis would have been sick at). Erica had paid him £37 10s and Ann [Fleming] said, 'Do you think that it'll be very expensive?' I said I thought £60–£70, and Ann went the next day and it was £120–£140, which she thought a little much. And Francis was furious." To profit out of her artist was one thing, to profiteer, as it appeared she was doing, was quite another. So I said he should leave, and he left, and Erica said she'd see I never showed anywhere again. I wasn't worried very much." Bacon himself was seen weeping over what he had done, seeing it as necessary treachery.[21]

Since the Marlborough settled Bacon's gambling debts as a sweetener Freud felt that he deserved a tangible thank-you. "When Francis had his first show at the Marlborough—1960—I wanted to buy a picture and Fischer said, 'This is embarrassing,' and offered it to me at cost price." However, David Somerset, good friend that he was, per-

suaded his colleagues that in the circumstances the painting should be a gift. "Worth £400. A good one. Green figure. Soutine-like." Bacon became, over forty years, the Marlborough's most valuable artist. He told Helen Lessore in 1960 that they wanted him to do sixty paintings a year and that if he did so they would make him "a Really Big International Figure."[22]

X, a quarterly review of the arts, launched in November 1959 and backed by the elderly Mary Hutchinson—a Bloomsbury associate— was edited by the deaf poet David Wright and Patrick (Paddy) Swift whose studio Freud had shared in Dublin and who, calling himself James Mahon, wrote on "Official Art and the Modern Painter," taking as his text Rimbaud's "*Il faut être absolument moderne.*" He complained about the American ascendancy, widely perceived and promoted as a New Deal, and called for plain old individuality. "It may be that it is the odd, the personal, the curious, the simply honest, that at this moment, when everyone looks to the extreme and flamboyant, constitutes the most interesting manifestation of the spirit of art."[23]

Bacon, Freud and Michael Andrews were enrolled with Giacometti and Kokoschka in a roster of admired painters to tally with admired writers: Pound, Pasternak, George Barker, Hugh MacDiarmid. The first number included Samuel Beckett's *L'Image*, a 1,000-word sentence in French covering two pages and "Fragments from a Conversation" in which Frank Auerbach, edited into a monologue, said, "the thing is to get other people's rules and destroy them and get one's own." He talked about energy, discipline, practicality and vision. "Rembrandt and others seem alive because they are reaching out for something." He stressed the use of intimacy. "One paints the things one loves because one is aware of all the relevancies; maybe, it's the only way to get power over the things one loves . . . that's why in the Jewish religion it's forbidden to make images . . ." And he glorified information. "What I like to know about painters is where they live, what time they get up in the morning, and all these things . . ."[24]

Auerbach had admired the de Koonings in the "Abstract Expressionists" at the Tate the year before; he had been drawing heads, painting naked figures and building sites in Oxford Street and on the South Bank. His "conversation" was a spate of ambitious sayings, theatrical in tone, ending with: "The only possible progress is to destroy . . .

then one's left with nothing one began with but a new fact."[25] Conversationally, he and Freud were close, as Freud was with Bacon.

Patrick Swift had tried to get Bacon to write something or talk to someone for *X*. Knowing Bacon, and his touchiness about younger painters, particularly those he regarded as potential rivals, Freud was not surprised that nothing came of it. "Francis was supposed to have written about me and Frank. He said to me, 'I went round and called on him yesterday: a pupil come to see his master.' He said it in a really angry way. It was to do with having written this thing and then minding about having done it." In lieu of Bacon on Freud, *Woman Smiling* was reproduced in the fourth number (greatly to Freud's satisfaction: he always liked seeing his work reproduced) together with *Man's Head* (1959–60), his final painting of Charlie Lumley. "Which," Freud remarked, "my mother liked best. After he married it was sort of drifting apart. Lookout man, driver, plumbing, bus driver and other jobs. Had a son, Doug."

The penultimate *X*, three months later, featured "A Note on the Development of Francis Bacon's Painting" by Helen Lessore. "He has arrived at a Grand Manner entirely his own," she wrote. In 1961, only Bacon and Michael Andrews, among the painters associated with *X* and with the Beaux Arts Gallery, were attuned to the prevailing modes of the coming period: the enlargement of picture area and patent exposure to other media.

"Art is always new," Auerbach had remarked, meaning that art resides continually in an ever-present. While Bratby's Gulley Jimsons for the 1958 film version of *The Horse's Mouth* were galumphing inserts in an uninspired production—his climactic mural spectacularly demolished in the final scenes—Bacon's owls and popes, after-images from Goya and Velázquez, were expressions of the regenerative powers of painting. New art, late modern new art, was still, predominantly, colour-wash abstraction or textured Expressionism, complemented by skittish innovations such as the annotated samplings of gestural clichés produced by David Hockney in his last year at the Royal College. Hockney turned blond and went to New York for the first time in the summer of 1961 and exhibited *Grand Procession of Dignitaries Painted in the Semi-Egyptian Style* in that year's "New Contemporaries." Hockney's fellow-student R. B. Kitaj fed fresh content into

painting too with his pictorial makeovers of revered reading matter. And elsewhere Robert Rauschenberg's *Monogram*, the stuffed goat with a tyre around its midriff, and Jasper Johns' *Target* motif, supplemented with plaster-cast body parts, became totemic if not iconic successors to *Studies for Figures at the Base of a Crucifixion*.

For Freud, eyeing all this output without envy, the concern now was how to perpetuate immediacy, to achieve the impact of Bacon, his so convincing perpetration, by more thoroughgoing means.

The fourth number of *X*, in November 1960, carried an article by "James Mahon" in which he called, above all, for intuitive spontaneity. "A real painting is something which happens to the painter once in a given minute; it is unique in that it never happens again and in this sense is an impossible object."[26] "New American Painting" at the Tate in 1958, a show of boldly expansive Abstract Expressionism blown in from abroad, and "Place," at the ICA, involving colour-field paintings by John Hoyland, Robyn Denny and others, were in practically every respect what *X* was set against; there was more "actual fury," obviously so, in Willem de Kooning's glaring women all shook up and in Yves Klein's use of naked young women as paint rollers, imprinting themselves bodily on canvas. However, between Klein's "Anthropometries" and Rothko's rectangular flotations of the colour-field sublime, depiction was squeezed in the mid-century until it seemed safe for pundits to declare it irrelevant. Sir Herbert Read's *Concise History of Modern Painting*, published in 1959, was prefaced with a disclaimer to that effect: "I do not deny the great accomplishment and permanent value of the work of such painters as Edward Hopper, Balthus, Christian Bérard, or Stanley Spencer (to make a random list); they certainly belong to the history of art in our time. But . . ."[27]

Read, who also omitted Rauschenberg, Johns and Klein, saw modernity as formed within the psyche. "As Klee said, not to reflect the visible but to make visible." That saved him having to consider pictures from the life or pictures representing circumstances. Their very genres ruled them out. In an article "My Favourite Picture" in the magazine *Books and Art* in January 1958, he declared, "I am rarely in a mood for Munnings or even for Manet."[28] He did, however, reproduce Freud's *Cock's Head* (painted in Paddy Swift's studio in Dublin) postage-stamp size at the back of the book, one of over 300 extra illustrations added as makeweight.

Freud had no reason to resent being a supernumerary in the best-selling *Concise History* for, besides being indifferent to the shaping and naming of art movements ("That horrible word 'curator': what does it mean?"), he had no illusions as to his standing in the art world. To the Marlborough his work was unimportant, that he knew. He heard that they had recommended Mrs. Drue Heinz, one of their most valued clients, to buy, in preference to his head of Charlie Lumley, a Sidney Nolan; but then Nolans were in ready supply (Kenneth Clark championed his work) whereas Freud produced slowly and what he did produce John Berger had written off. Nolan, if not Bacon, had to be the better buy.

Manet, inspiration of Baudelaire's *The Painting of Modern Life*, maintained that one must be of one's own time and paint what one sees. Freud saw no option but to paint what he saw and therefore knew. He alone. "I've got a strong autobiographical bias. My work is entirely about myself and my surroundings." This was not the narcissistic bias, the Wildean slant ("We live in an age when men treat art as if it were meant to be a form of autobiography," quoth Lord Henry Wotton in *The Picture of Dorian Gray*). It was the arm's-length principle with brush in hand. Standing close enough to touch, close enough to feel the body warmth. "As a man is so he sees," said William Blake.

Where Bacon clapped his figures into situations resembling the exposed privacy of shop-window displays, Freud painted his sitters just as they were, just where they happened to be, in whichever room was serving as his studio, aiming to accomplish paintings that held true. Which involved not so much a shift in handling (sable brush to hogshair was as much to do with scale as touch), more a relentless capacity. Delacroix wrote about "amplifying where it is possible and prolonging the sensation by every means." To amplify is not to distort. Cedric Morris had treated faces as social masks; Bacon saw faces as betrayers of character; Freud wanted to take what was there and make what he could of it, inching outwards, from sinuses to eyes to cheekbones, consolidating the accretions. With any luck the painting would be more than a depiction, it would be a perpetuation, a feat to match Flaubert's vaunting authorial assurance: "*Madame Bovary, c'est moi.*"

. . .

Kenneth Tynan, best friend of Caroline's admirer Deacon Lindsay, referred in his diary to that "reptile Freud" when David Astor, the editor of the *Observer*, took him and Freud to the Mermaid Theatre. They never got on. Kitty had an affair with him.

"Tynan completely lost his temper with me at Cecil Beaton's once. Because he said somewhere 'a critic is equal as an artist' and I said this idea wouldn't do. I said critics, as such, were parasites and it was up to them to be go-betweens between artist and public. It's not a question of it being interesting or not as writing. But Tynan did a marvellous demolition of Truman Capote: 'Mr. Capote has a new art-form: the semi-documentary tantrum.' Capote was toxic."

Writing to Michael Andrews in March 1960, Helen Lessore described how Derek Hill, son of the interior decorator John Hill and in Freud's view one of painting's silliest pretenders, reacted to a cold-shouldering. "We've just had a visit from Derek Hill, who said, 'Last time I was here, Lucian Freud was here, and I've never felt such an emanation of hatred from anyone before. Did he say anything afterwards?' Henry [Lessore] with graceful alacrity turned a portrait of Lucian by Frank [Auerbach] to the wall . . ." This was a drawing. "A girl bought it," Freud remembered. "She knew neither of us, so I wondered why."

"The real is never beautiful," Sartre says in *The Psychology of the Imagination*, a sharp thought that he proceeded to bloat: "We must forget that she is beautiful, because desire is a plunge into the heart of existence, into what is contingent and most absurd." Freud found the real beautifully stimulating. "I hardly ever want to paint anyone from mere appearance. The idea of starting with an existing beauty and trying to do something with it isn't in itself at all an exciting idea, really. I can think of one or two people whose behaviour deteriorated because they were considered beautiful and sailed through on the flag or passport of their generally acknowledged beauty; not that, very often, there was any further it could deteriorate. Because you were immediately forgiven, excused and admired because of your beauty, when the beauty disappeared—as in the case of Lee Miller—the filthy manners remained. (I'm assuming her manners were as filthy when she was beautiful as when I knew her in the war.)"

Woman Smiling, Freud's portrait of Suzy Boyt, and Bacon's *Miss Muriel Belcher*, similar in size and both completed within a year of each other at the end of the 1950s, are brilliant opposites. Bacon's Muriel is a sudden apparition, a mocking tongue-lasher, pink on green; Freud's Suzy is withdrawn slightly, slower on the eye. "I wasn't caught up with her. I never really knew her." Both still breathe the then Modern Life.

Woman Smiling was painted at 357 Liverpool Road, Islington, a house where Suzy lived with Ali and Rose. "The house I took off Norman Bowler, Johnny Minton's boyfriend, who was in *Z Cars* and had a mouth like a zip fastener someone said." Bowler had married Henrietta Law in 1955. "He left and I rented the house for years and years—Ken Brazier [*A Young Painter*] lived there too, and Tim number 357—and then I bought it or something. I tried to do some pictures of Suzy in the garden of the house, but she was so busy always. I scrapped them all, except one: I worked a lot on it and I remember putting it away because of the children. The house was hers and the children's for a long time, until her mother died and she inherited a lot of money."

Suzy had a Morris Minor and once, when he went to see Frank Auerbach in Camden Town, he left it and returned to find little boys clambering in and out of it. He didn't say anything and one of the boys asked: "Why aren't you narked?" And he said, "Should I be?"

Another house, another milieu: at Chatsworth, on a sheet of notepaper, Freud drew the Duke of Devonshire, bow tie askew, sunk into a snooze. While staying there he also began a mural in a bathroom off a bedroom decorated in full-blown Baroque manner by Hogarth's father-in-law James Thornhill. The Duchess had in mind something to distract from the bedroom, it being "stuffed all up to the ceiling with Sabine Women being tweaked. It is Horrific, so whatever Lu does will go nicely."[29]

Cyclamens inched across the wall, as they had done a few years before when Freud was playing householder at Coombe. Four leaves, five blooms, six stems. The nightwatchman looked in every now and then saying, each time, "Oh, so you've landed, then." The Duchess remembered him coming in to breakfast saying, "I've had a wonderful night taking out everything I did yesterday."

In his *The Interpretation of Dreams* Sigmund Freud tells of having dreamed that he saw in a shop window a copy of Friedrich Hilde-brand's *Die Gattung Cyclamen eine systematische und biologische Monog-raphie*. Cyclamens were his wife's favourite flower and in this dream he reproached himself for not bringing her any. What sort of met-onymic trigger was this? His grandson was unaware, as far as he could remember, of the significance of cyclamens to his grandparents and he had no idea why he himself had chosen them for the drawing-room mural at Coombe. "I mightn't have done it if I'd known that." The Chatsworth greenhouses supplied fresh specimens whenever he wanted, but he liked to see them wilt. Their fleshiness appealed to him, and their operatic aspect. He painted them again, in 1964, rear-ing up over the edge of a kitchen sink. "Lovely forms certainly. They die in such a dramatic way. It's as if they fill and run over. They crash down, their stems turn to jelly and their veins harden."

Outsize and diva-like, the specimen cyclamens were left floating around the bathroom mirror, late expressions of hothouse Baroque, livelier than the Thornhill murals crowding walls and ceiling around the adjacent four-poster bed but, as a decorative scheme, far from completion. Ten years later, when painting the Duke, Freud decided to give them a mention in *Who's Who*. "Cyclamen Mural, Thornhill Bathroom, Chatsworth House," making it sound important rather than discontinued, as it was. The entry appeared in a couple of edi-tions and was then deleted. "A joke gone too far, so I took it out."

Since first appearing in *Who's Who* in 1953 Freud had made an unusual number of alterations to his entry. Being listed a mere fif-teen years after getting his British passport and fifteen years ahead of his Aunt Anna (and eighteen years ahead of Clement) was a bit of an achievement and far from being blasé about it he tinkered with the details. For some years he was "painter; teacher at Slade School, London University," and even after he stopped teaching he put the Slade as his address, not the Marlborough let alone Delamere Ter-race. There were shifts of emphasis. Only in the mid-seventies did he insert, under "Educ.," the East Anglian School in place of Goldsmith's and he omitted to mention his first marriage until the late sixties; yet he retained the "m. 1953, Lady Caroline Maureen Blackwood, *d* of 4th Marquess of Dufferin and Ava" intact until 1970, when he added "marr. diss. at Juarez, Mexico, 1957." From 1972 onwards "two *d*"

were listed, but no further children. *Who's Who* records conventional accomplishment from volunteered information only and on personal matters he was reticent. "Naturally I've always had a feeling about covering my tracks. There's an enormous difference between preparing a crossword complete and putting things as they were."

During these years there were more births and one or two paintings related to these. "I can't help noticing that some of my children are born awfully near each other, from different mothers. Some are a bit double: I think Ib and Esther. All one can say is that's how it was," he said once when we were discussing birth rates. "You ask me why are these children all the same age. Don't you realise I had a bicycle? . . . There are some [children] which I haven't come across as I didn't paint the mother or them."

The impetuosity that had startled George Millar on Poros ("a wild figure burst through the foliage above me and slithered rashly down the bank")[30] landed Freud with heavy debts of one sort and another. Relationships might yield paintings or be brought on by painting; involvements could depend on painting relationships; painting demanded subject matter and subject matter, in human form, was apt to become disheartened or irate at the threat or onset or discovery of replacements.

"People being monogamous seems to me an extraordinary and imaginative situation. One thing why it's hard to imagine is, if one's happy and someone you really like . . . The actual happiness makes me very attracted to other people if feeling very buoyant. And conversely I don't feel abandon and freedom when I am unhappy."

The need for models kept him on the lookout. Cyclamens could be replaced once they flopped; suitable and reliable sitters were rare. For him, as for Matthew Smith and Augustus John (who died in 1961), sitter recruitment tended to be tantamount to courtship and emotional turnover was unavoidable.

Pregnant Girl (1960–1), belly draped, breasts bared, heavily asleep, was Bernardine Coverley, her head averted into the buttoned upholstery on which, a few months later, Freud placed their daughter for *Baby on a Green Sofa*: Bella (as he named her) with a glint under one eyelid. He had recommended Dr. Brass, Bacon's doctor, for an antenatal examination but the doctor distressed her by saying that he didn't give abortions to girls like her. She wanted the baby and was

outraged. She was "about seventeen," according to Bella, when Freud met her and she became pregnant. Esther, their second daughter ("called Esther, thinking of Kitty's sister, Esther Amaryllis Garman," Freud explained), said that her mother was never one for domestic set-ups and that her father appealed to her because of that.

Bernardine, Freud found, was not necessarily available to sit. Not that this was uppermost in his thoughts. "I didn't paint her before she was pregnant, and I did one small one, on copper. Either she really wanted me to or really didn't. I can't remember. I remember a letter: how she hated it if I did, or didn't. There was resentment one way and another. A lot of tension." Six weeks or so after Esther was born he took Bernardine off with him to the South of France. Someone photographed them there sitting outside a restaurant, he intent on her and she in a gingham dress looking back at him radiant and over-whelmed. She had wanted to escape a dull upbringing and live life to the full and there she was carefree. Except that he scared her quite often and there was always the risk of possessive violence. "I didn't really see Bernardine for all that long. She wouldn't sterilise bottles, which I'm sure you are supposed to. She thought I was completely Victorian and absolutely mad. It was hippiness. Bernardine as a hippie said, 'Never say no to a child.'"

Though Freud liked to keep his involvements separately con-tained, June Keeley became aware of Bernardine being around. "She was suddenly there. Terribly young and had beautiful legs. Through Tim, Jane found out about her; and she must have known about Suzy. I remember Tim saying to Jane—yah yah, sing-song voice—'Jane, you want to drop your boyfriend, he's got two new children.' Ber-nardine's Irish parents knew nothing about her having two kiddies either. Lucian told Jane that he liked debby women 'because they've got such good manners.'" More so than Freud himself, were one to believe some of the stories. ("Apparently Lucian came down and the husband came in and Lucian saw a suede and sheepskin jacket on the chair and he said, 'What a horrible man,' and took it.") Brought up to be socially confident, debby women tended to take for granted the freedoms that were to be enjoyed, purportedly, by all young women in the sixties. Debby women were quite likely to be married, births might occur and "everyone" might know, but the less said the better. The cuckoo told itself that it could only behave as cuckoos do.

Lucian Freud and Bernardine outside a restaurant in the south of France

Freud's broods were disparate, whether recognised or not and recognisably his progeny or not. Whether relationships developed depended very much on what he saw in the various children as they grew up, if indeed he saw them at all. "A lot of children are not of their parents. We don't know. People say, 'Have you noticed?'"

"I like the anarchic idea of coming from nowhere. But I think that's probably because I had a very steady childhood."

"He was rather nice and repulsive"

In January 1960 Freud, accompanied by a journalist, went to Stockholm to draw Ingmar Bergman. This was a commission from *Time* magazine. He did not like the idea of being obliged to deliver, but gambling debts left him with little choice. Anyway, he told himself, there was not necessarily any great difference between a task imposed and work self-imposed. "As Auden said: 'You either get commissioned or commission yourself.'" Besides, the money was good. *Time* magazine offered first £500 then £900 for a cover picture, which he accepted on the understanding that he would be paid half the fee if it were not used. He wondered if his suing them thirteen years before might be held against him. "They said, 'We know you've had some trouble with us but don't worry about that.'"

Time covers usually consisted of a portrait in a red surround overprinted with title and headlines, a design little changed since their Sigmund Freud one in 1924. The layout had advantages, Bacon suggested. "Francis gave me this idea: prepare the canvas dark blue and then you've got the ground. Less work. After all, it was what he did always." As for the artwork, a positive emphasis was required, for impulse sales at the news stand depended on each week's face being attractive or arresting with probity wrinkles on elder statesmen. To make the cover of *Time* was widely considered ultimate recognition. The accolade however did not impress Bergman who, having recently made *Virgin Spring* with Bibi Andersson, was still in the first flush of

international reputation. He didn't feel like putting himself out for the cover artist.

"Bergman was terribly unpleasant, offhand, very much why need you bother the great me? He wanted to fuck Bibi Andersson that afternoon so kept me waiting. His excuse was that he had 'family' and 'music' at the weekend. I would have stayed two weeks but I left. 'Some people go to the cinema just to hold hands,' I told him. My real difficulty was turning the journalist against Bergman and persuading him too to leave after a few days. He had a crush on Bibi Andersson, and so I said, 'Look, he goes off to have Bibi first thing in the morning, they leave the studio and that's it.'" The studio was in a converted ostrich farm outside Stockholm with Crittall steel windows and flies.

He brought back to London a small dark glimpse of Bergman on navy blue, an image verging on the Baconian. And given that Bacon used to dismiss literal-looking portraits by saying that they were like *Time* covers, it was imperative, Freud felt, not to please the art editors awaiting his submission. "I told them I hadn't done the painting. I did a sort of profile. But I hated the idea it would be reproduced and sold four million times. Since I never gave them the cover, it was a slight scam." Instead he gave the preliminary sketch to Sir Oliver Scott, a cancer specialist, whom he knew through Joan Bayon from Cambridge. It was a repayment. "He had lent me a bit of money. I did a portrait of his wife Phoebe and a daughter and he admired Bergman."

The trip to Stockholm proved memorable not for Bergman but for a Rembrandt: *The Conspiracy of Claudius Civilis: The Oath*, in the National Museum, intended for Amsterdam Town Hall but not paid for and returned to the artist, who cut it down, removing the setting, reshaping it into a profane Last Supper in which the one-eyed chieftain presides over befuddled heads and lambent sword blades, his passion setting the table eerily aglow.

"My favourite Rembrandt. I've been terrifically affected by it. It's the largest painting he ever did. He cut three or four feet off it and put a crazy figure across the bottom in the foreground. And he made it night."

Cecil Beaton spent an evening with Bacon shortly after Freud's trip to Stockholm and they discussed what had happened. "There had been too many interruptions for Lucian to produce any result,

and he now hated *Time* magazine, Bergman and Sweden." Freud had
returned to England "fuming," he wrote.

> *We then talked of Lucian's latest painting—how he seemed, in an*
> *effort to paint quicker, to have lost some of his intensity. Lucian*
> *was intelligent enough to know that his painting up to now was*
> *not a complete expression of himself. He now found himself in the*
> *awful predicament of having to try and discover himself again.*
> *That, for someone of Lucian's vanity, was a difficult thing to do.*
>
> *We discussed Lucian's intellectual brilliance, his complete*
> *independence and strength as a man who knew exactly what he*
> *wanted out of life. But we admitted that Lucian is no angel.*

Beaton told Bacon—a Bacon grinning at him no doubt—that,
to him, in some respects, Freud really was impossible. "I admitted I
found it difficult to be loyal to Lucian all the time. I could not under-
stand the mentality of gamblers and it worried me that Lucian should
lose so much so readily."[1]

To Freud this diary entry, which he read when Beaton's *Selected
Diaries* were first published in 1979, showed the ageing photographer
bent on keeping in with a younger set—"his being with-it"; but it was
true, of course, that gambling programmed him and propelled him,
willing the win and stomaching the losses. It was a draining routine.
Lunching at Wheeler's once, with Auerbach and Bacon, he fell asleep,
head hitting the table top, then woke up suddenly and proceeded to
an evening's activity.

After 1960, when the Gaming Act legalised gambling, there was
chemmie or roulette to go for at the Clermont Club above Annabel's
in Berkeley Square or at Siegi's in Charles Street, at the Playboy Club
in Park Lane, Apron Strings in Chelsea and anywhere else where his
credit held. But he preferred the horses. "Horses are the most sym-
pathetic way of losing money because it's done without other people.
Baccarat is OK as it's against the bank." Frank Auerbach, whom he
took to the Playboy Club, marvelled at his ability to keep three games
of chemmie in play simultaneously. Yet the consequences were often
awkward. ("There were lots of streets I couldn't go through.") Not
so much the losses, which he liked to think of as spent ammunition,
but the retaliation over sudden debts. "Bailiffs came quite often. Not

for gambling debts: you couldn't send the bailiffs for those; that's why they build up this code of honour, this 'gentleman's word' nonsense. Heavies came. They realised I ran into money every so often and they knew I couldn't be frightened. (You can tell from people whether they can or can't.) I always minded being threatened."

He usually tried reasoning with the enforcers. "I actually went round once. 'Look,' I said, 'I haven't got any money but I'll come on Thursday afternoon.' When I went round to the court in Marylebone Road, the heavies were there and one said, 'Look who's here. You're supposed to say you'll come and then not come and then we'll chase you.'" His experience of bailiffs and their demands prompted a habit of parking works with friends so that he could swear they weren't his. Auerbach felt that his opportunistic feel for a deal or gambit was fundamental. "Lucian was keen on that business life. He knew exactly how to operate. He was very good at all that and he had a sort of awareness of the art market."

Certainly similarities between the operation of criminal or dodgy concerns on local turf and transactions in the equally localised art world were not lost on him. In Paddington, Mayfair or Soho, at the Marlborough or in the car showrooms of Berkeley Square, close connections were a safeguard and local convention the rule. "In Paddington the violent gangs were locals, who had been boys together. The more skilled ones were brought together. They weren't gangs: rather like in the art business, they'd form a team to do a particular job and afterwards, if successful, they'd disband, dissolve, like an art movement or syndicate or ring. It was a way of operating and they all had 'jobs.' They had 'Profession: florist.' They lived quite well: very good Indian restaurants, clothes and girlfriends. With cars they had to be careful, as it wouldn't do to be too noticeable. No drugs: none of the people I knew took drugs. Sometimes they raided chemists for things, but to sell them only. They had funny stories about the watchmen in some places. 'Sorry, mate, got to tie you up, don't want to hurt your wrists,' and the watchman saying, 'You got to do it harder.' They despised gambling and kept well away. They knew punters were mugs."

This was thriller territory extending from literature to identity parade. Much of the Paddington of Margery Allingham's 1952 crime novel *The Tiger in the Smoke*, "winding miles of butter-coloured stucco in every conceivable state of repair" scheduled for slum clearance, was

only the length of a street or the width of a canal from districts infiltrated by venturesome members of the upper classes such as Patrick Kinross and Diana Cooper, who settled in Little Venice in the early sixties. By then other cultural shifts had occurred and prejudices were inflamed, leading to racist agitation and brawls.

Verlaine had discovered London to be, for all its vastness, really "only a group of little scandalmongering towns in rivalry" and, Freud found, so it remained in Paddington, though with changes in the populations involved. "When the Negroes came in the fifties it changed very much. Even burglars. People who snatched wallets and broke into cars said Negroes would cut the finger off a woman with rings. 'D'you know what they do? It's absolutely disgusting, they live all together, five to a room, in a house given them by the council.' They were terribly anti-Negro." They were not the only ones. One night he took the Everly Brothers to a club. "They were amazed that I was friendly with 'all those coloured people,' being Southerners."

The biggest slum landlord in the area was Peter Rachman, an ex-concentration-camp and Siberian-detention-camp inmate five years older than Freud, who played cards with him occasionally in a basement club off Old Compton Street. "Mandy Rice-Davies used to be on his lap. He was rather nice and repulsive. 'Millionaires: that's a word people use a bit freely these days,' he said. I was walking once with Ann Fleming from Delamere to Diana Cooper's, in Warwick Avenue, and we saw him, red in the face, in this pale-blue open Bentley and, Ann said, 'straight out of Ian's book.' A Bond villain. He met Negroes and gave them flats and said 'make yourself at home' to them: rooms already let to Paddington natives. Poor families from Paddington thought this terrible really."

Rachman was driving along Lower Wardour Street one day in the open Bentley and somebody said something, or made a rude sign, or flicked the paintwork. Freud saw Rachman stand up in the car screaming at the man and a gang outside a club turned on the man and roughed him up.

In 1960, two years before he died of a heart attack, Rachman came under pressure from Ronnie and Reggie Kray, the gangster twins, who had previously operated mainly in the East End. They did protection for Rachman, Freud learned. "Reggie said: 'His rent collectors were big, but our boys were bigger.'" Hoping to divert them

or placate them, Rachman brought to their attention the possibility of taking over Esmeralda's Barn in Wilton Place, Knightsbridge, a gambling club patronised by Guards officers and the like. Through his "violent landlord operation" as the Met put it, Rachman was connected to Stefan de Faye who "owned" it and Rachman gave it to the Krays. The Gaming Act had opened up the West End to clubs so this was their entrée into the classy world.

Freud knew Esmeralda's Barn from the days when David Litvinoff had masqueraded as him there. Once it became a casino operated by the Krays he went more often. Litvinoff still hung around there and irked the new owners with his lip and his sarcasm. "They didn't like that. He worked for Rachman. Rats painted with fluorescent paint were put through letterboxes to flush out tenants." It was rumoured that the Krays each stood to make £40,000 a year from the tables but their East End practice of enticing punters into debt then leaning on them for favours proved inappropriate for what Ronnie described as "a real posh West End club." Those who wouldn't pay up could be thrown downstairs but, in Belgravia, this was not the way to handle such matters. Worse, the tax inspectors began making demands.

Freud would often call in at Esmeralda's Barn after staying overnight at Wilton Row. "I'd get up at 4:30, summer mornings, and go there for an hour or so on my way to Delamere: the Yahoos gambling, crazy, and Ronnie Kray in evening dress. 'I suppose you think they're a real lot of cunts,' I said to him. 'They lose a lot of principle this way, I know,' he said.

"At the club a smooth, pleasant, absolute crook oily businessman— Lesley Payne—said, 'I know your work is valued, but could you give me someone to paint my wife?' So I suggested Mike [Andrews], who was broke and delighted, and he worked from her. Then Lesley Payne told him to stop and so Mike left it; he would have finished it and asked for money, but he couldn't go on as the wife was ill. And so the smooth con-man manager stole it. I felt badly about it."

"It became amusing to be seen with the twins," Auerbach added. "Francis [Bacon] quite liked a villain. I remember him saying, 'I've got to go and get some chrysanthemums because the Krays are calling. And I want to fill the studio with chrysanthemums to soften their hearts.' They would come round and suggest he gave them a picture. Francis managed to charm them off." He and they established,

Freud gathered, mutual interests: boys, sadism and so on. "Francis met the Krays and Billy Hill in Tangier. They were there on some rackets and they discovered about Francis's work: how he could do this magic." When the Krays, or their associates, heard how much money his paintings fetched some were stolen and he had to pay a lot to get them back.

"Both can be overwhelmingly hospitable," Francis Wyndham wrote, tongue in cheek, in his note on the Krays for *David Bailey's Box of Pin-Ups*, published in 1965, three years before they received life sentences. "To be with them," he added, "is to enter the atmosphere (laconic, lavish, dangerous) of an early Bogart movie, where life is reduced to its simplest terms and yet remains ambiguous."

Under the same roof as Esmeralda's Barn was the Cellar Club. "The lesbian club downstairs was pretty nice," Freud recollected. "When I went there it was run by this girl Patsy Morgan-Dibben, fearfully attractive, so I asked her out and said, being polite: 'Like to come to Annabel's?' She said, 'No, let's go to bed straight away.' I hardly knew her at all; she was married to Horace Dibben, an antique dealer from Salisbury, a long-sideburn man, a fetishist. In her flat there was a kind of replacement person in the next room, called in before I left. It was fairly nasty because she was having amyl nitrate. Smells horrible. 'What are you doing?' I asked. She said, during what might be called a poignant moment, 'You'd like a man—or boy—on top of you.' 'No I wouldn't.' It was not a memorable success."

Patsy Morgan-Dibben went off to the mountains of Bavaria with an Argentine millionaire. "She was glamorous, started a hotel in Venice and had a huge success with that." Esmeralda's Barn—Cellar Club included—closed in 1963, the year some of her regulars (Michael Astor, Stephen Ward, Christine Keeler) achieved extreme notoriety.

"It was a terribly muddy pool Lucian was in," said Michael Andrews. "The Kray twins' henchman called him in one day. He'd lost a great deal of money and he was told what he was going to have pulled off and broken and he said, 'Well, you'll have to do that, but if you do, and kill me, you won't get the money.' They found it very amusing."

Freud himself remembered that encounter as a touch more conciliatory. "I said, 'I'm going to pay you when I've got the money and if you kill me you won't get the money,' an argument that impressed

them; in fact the Krays never had any money and no one ever got paid. Other gangs had big things going; the Richardsons—Charlie and Eddie—actually had investments, but the Krays never had big funds. They had protection money, but I doubt if they ever had £100,000. They were thieves' ponces, unsuccessful villains; they would appear at a share-out and would say, 'Well done, boys, we're collecting for the widows.' The only heroic thing they did was long before I met them: Ronnie couldn't bear being in jail and Reggie didn't mind much and so Reggie went in over the wall and took Ronnie's place. People were impressed. They talked about the twins as having hearts of gold. The only people they did things to were their own. I kept out of their way. I took the precaution of not going to boxing matches, where bullies show their front, or going down certain streets. I didn't want to anger them. When they were amongst their own people, in the East End, the police left them alone, as they were brothers and friends of the villains. In the West End it was out of the question for them to be left alone.

"Bill Lloyd—friend of Tim Willoughby's, in love with Jane and wanted to be one of the boys—paid my debt to the Krays. It was two or three hundred pounds. 'I thought it would be better to,' he said. I didn't say how dare you. I've got this thing I could never do anything under pressure." Yet Kray pressure did have its effect. David Somerset remembered one particularly urgent call. "He rang me up at four in the morning. 'Dave, can I come round?' 'What's it about?' I asked. 'Fifteen hundred pounds and if I haven't got it by twelve o'clock they're going to cut my tongue out.'"

At one point Freud was rumoured to have owed the Krays half a million. "I can't be threatened," he claimed, but he took care not to infringe Kray taboos. "It was all no swearing. If anyone said, or was rumoured to have said, one was queer—which Ronnie was—their life was in danger. Ronnie said, 'I'm not a poof, I'm homosexual.'"

"It got out of hand and the police warned me. I wanted to paint one of the twins and the other said no."

In 1968 Ronnie Kray went to Broadmoor, the asylum for the criminally insane, and Reggie Kray to an ordinary maximum-security prison. "Ronnie wrote to me from jail. 'We've got a boy here: Francis would love him. He's good at painting . . . Would you do something for him?' I didn't reply; I never knew them very well. I wasn't really

properly connected." Years later Reggie Kray heard on Radio 2 that two Freud paintings had been sold for £2.5 million; which reminded him that in the old Esmeralda's Barn days "he offered, as an act of friendship, to paint a portrait of my late wife Frances and me. For various reasons," he added, "we never got round to doing it."[2]

Then there was the Killer. Freud knew him by repute long before he met him through Charlie Thomas ("a gangster for Billy Hill, a very bad gangster as he couldn't bear bullying, which is what they did") who, as a friend, warned him to watch what he said: "Not so much of that 'Killer' stuff." Villains are snobs. The Killer was marginally amused that the Krays claimed his crimes as theirs, as they had to have people afraid of them. He would say, "Anything I done, the Krays took credit for it." The Killer, Eddie Power, was a real killer. "Shot a man who had a private bank in Park Lane. A friend of his put some money in there—you could get cash day and night for a small extra sum—and the man took it, spent it, and the Killer went up to him in the street, in daylight, and shot his legs off. He became an art dealer in the art boom."

"The Killer had a car showroom south of the river, in Wandsworth somewhere, on a roundabout, and there was a car smash, and a man was thrown against the showroom window and his severed leg was lying on the ground, and Eddie shouted at him for making a mess. Villainy wasn't quite the point. He said, 'Lucian, I don't do them stupid things now.' Probably he didn't. He was never inside as there was no motive and nothing could be proved. He did moneylending. With moneylending with interest, you weren't allowed to get late. People were frightened. I never asked him for money. The thing is, everyone knows that people who bet aren't serious about money. Even with banks, it's difficult to get the tiniest overdraft if you don't regard money as the holiest substance.

"The Killer had lots of money and wanted things of mine, such as a painting I did of Charlie. He was small and quiet. A psychopath. Blotchy. Bad indoor complexion. Like quiet people do, he did imitations. He had a house near the Lefevre in Bruton Street and Thomas Hardy's house in Westbourne Park Road. I gave him some Hardys once. 'You never tell me where *you* live, Lu,' he said. His elder brother hanged himself in the house in Westbourne Park Road and the Killer made the room a kind of shrine. I went there, had some tea, and the

Killer's wife, who was quite old, produced the wrong kind of bread. 'It's all I've got,' she said and he shouted at her. He once invited me to a party and all the guests were murderers and had done at least fifteen years inside. They all knew each other, and I knew these names from the *News of the World*. Eddie said, 'If you fancy a girl, Lu, let me know. I don't want misunderstandings.' I didn't go again."

Lordly about money matters, loftily discriminating in that he came to prefer a Bentley to a Rolls (meanwhile complaining that it cost him more in parking charges than the rent of his flat) and took to appearing in Savile Row grey flannel suits nattily dishevelled, Freud enjoyed being as distinctive among the Killer's cronies as he was among the writers and politicians in Ann Fleming's drawing room, where menaces went no further than backbiting. "Gore Vidal threatened to have me bumped off at Ann Fleming's. He started talking to me the way he does and I said, 'How's the other tart?' (i.e. Truman Capote). 'I've had people rubbed out for less than that,' he said. He considered himself irresistible then."

Freud the predator was more restless than obsessive, not the fox in the chicken run but the jockey and racehorse going all out. Work was dominant and when the going was good it absorbed him entirely, but still he pursued distractions. Once locked on to these, whether amorous or risk-taking, there was no diverting him.

Man's Head (1960)—the final painting of Charlie Lumley—was reproduced, free of commentary, in *X*.[3] The pert or sly or glowering boy had become a tousled young man approaching middle age and thinking of settling down, maybe. He now qualified as the longest-serving sitter and was about to get married. Over the previous sixteen years or so Charlie had been on call, intermittently, and had been caught at every phase from street urchin to accomplice to incipient family man. Freud let him have the use of the room in Delamere Terrace for the wedding party. A recklessly generous gesture in Frank Auerbach's view, since Freud himself was absent. "Surrounded by Lucian's unfinished pictures, these on the whole villains would be celebrating a wedding. It seemed to me an act of enormous courage." No harm came of it.

. . .

During a dinner at the Café Royal in May 1958 to celebrate an exhibition of Cecil Beaton's Neo-Edwardian *My Fair Lady* designs, Freud and his table companions, the Duchess of Devonshire and Lady Lambton, Belinda Lambton—whose husband was to renounce his title of Earl of Durham a decade later—took to pelting the noted hostess Elsa Maxwell with bits of bread roll, mock violence being the done thing when bored, or the least they could do to assert a dislike of rampant cod poshness.

Freud had known "Bindy" Lambton since the war and had been involved with her to varying degrees from the mid-fifties; she was noted for having been expelled from eleven schools altogether; married at eighteen she had five daughters and an ebullient reputation. By June 1960, when he went up to County Durham for a ball given by the Lambtons at Biddick Hall on their estate, their lively friendship was long established and a painting of her begun; for quite a while one resort for afternoons spent with the children was her house in South Audley Street; he, Annie and Annabel went for lunch and afterwards watched racing, wrestling and *Juke Box Jury*. "I saw Bindy quite a lot. Did quite a few paintings." They were open enough about the relationship to be seen holding hands in the street. He stayed at Biddick a number of times, taking the children (he painted a small picture of Annabel in bed there wearing a frilly nightdress) and went riding in the grounds; also at another Lambton house, Fenton near Berwick-upon-Tweed. What he saw of the unprosperous North East was limited. "Went to Whitley Bay. It's a fishing place and the difficulty was that there were a few enormous catches in the summer, nothing otherwise, so Tony [Lambton]—he was MP for Berwick—built them a fish-canning factory or something; but it was a hopeless thing of glut and dearth, such a desperate place for people with hard lives to make their Côte d'Azur. I remember seeing people in very faint sun taking their clothes off. Amazing white under red necks. I swam too. If you can swim in the Regent's Canal you can swim anywhere."

An afternoon out at Whitley Bay was not the limit of his travels with Bindy Lambton. "She was very good at making plans and going to restaurants, and we went to see pictures over a period." The pretexts were rewarding but the journeys didn't always go to plan. They drove across France to Basel and thence to Isenheim in Germany to view Grünewald's Isenheim Altarpiece, only to find it was actually in

Colmar, Alsace. In those days one could open for oneself layer upon layer of triptych to reveal glut and dearth, St. Anthony, the Virgin and glaring demons behind the Christ nailed up, skin punctured and bruised, putrefaction setting in. "Loved the flesh but no influence," he said. He had read about Grünewald in J.-K. Huysman's *Là-bas*: "He was the most uncompromising of realists, but his morgue Redeemer, his sewer Deity, let the observer know that realism could be truly transcendent."

One jaunt was arranged by John, Earl of Wilton. "Bindy and I went with him for a gourmet tour of the chateaux of the Loire starting at the Ritz in Paris. With a chauffeur: safer that way. The only condition he imposed was 'please don't try and pay for anything.' John Wilton could do leisure well. He once referred to his 'lunch hour,' but he never had a job of any kind; he bought things and left them behind when he left and moved into smaller houses; we got on very very well. He was interesting on social history: broadly the topic What Family Are They? He knew all that."

"We welcome the 1960s," wrote Quentin Crewe as editor of *Go*, a glossy magazine launched in February 1960 as a sort of *Horizon* for "a new age. The age of travel for everyone; the age of comfort and leisure. And we are the people living in this wonder age. As we point out a little frivolously on page 21—YOU ARE THE JET SET!" He recommended the Prado ("One of the most famous paintings, Goya's *La Maja Desnuda*, is reproduced in colour," pp. 58–9); not that Freud needed any such prompt: Bindy's energy swept him along. On further expeditions she drove as a rule and they went away for up to a week or so. "I went with her to Castres, the Goya Museum, and Montpellier, where *Bonjour, Monsieur Courbet* and the portrait of Baudelaire are, and those Géricault limbs. Spent two days there. I looked at the Courbets a lot: *Les Baigneuses*, that marvellous nude going into the forest, like a rugger player pushing off others, lots of foliage, and the woman beside her, one stocking off, one at her ankle. I like Courbet. His shamelessness. But not the hack things. Since I hadn't his ability or facility, my paintings went wrong slowly."

Back in London Bindy sat for him, bare-shouldered, her long head lodged in the corner of the green sofa, hair sprung from the parting, brush marks going with the flow. Next, seated voluptuously upright, she scooped the hair back and, arms braced, thrust her chest

out emphasising an eighteen-inch waist. He found that when he painted her with her arms behind her head she could maintain the pose for hours; that made her his most athletic sitter; that is, until Leigh Bowery in the 1990s. "She was a spectacular shape, famous for it. She was a very good sitter, had this amazing discipline over her hips." Another head was completed from forehead to lips and then abandoned. Bacon told him he should keep it; so instead of destroying it he sold it.

If Freud could not paint the Viscountess as naked as a Duchess of Alba he could suggest as much. In *Head on a Green Sofa*, nakedness from the shoulders downwards is implied. Complicity enveloped these pictures. He did a small painting of her son, Ned Lambton, born in 1961, the frowning baby face as quickened as a Bacon mugshot, but tenderly so. "I was going to do a nude, a back view. I wanted to do the joke idea of Bindy like the Courbet of the woman walking away, a walking nude. I didn't do it because Tony Lambton made rather a fuss. I wrote him quite a strong letter about it. I said I thought it very bad assuming I was in some way degrading her. I think it was to do with conventional ideas of marriage, to do with licence and a long lead. People have a horror of looking ridiculous. If their wife has another life, it is not what they require. But surely, as Auden said, being laughed at is the first sign of sexual attraction? Tony bought the pictures: got the lot, four for £1,000. Including *Portrait Fragment*. I think he fancied the idea of being a patron." When in the early seventies—by then Under Secretary of State for Defence—Lambton was exposed by the *News of the World* for a tryst with three dominatrix prostitutes at once, his response, besides resigning, was: "People sometimes like variety. It's as simple as that."

After an interval of nearly thirty years Freud painted Bindy Lambton and her formidable composure once again, in 1991, dubbing her *Woman in a Butterfly Jersey*. As her obituary in the *Daily Telegraph* in February 2003 said, she was "never a martyr to the humdrum." An accident with a go-kart and another with a lorry on the A1 set her back for some years.

In the summer of 1962 a Frans Hals exhibition in Haarlem was the pretext for several days in the Netherlands. They stayed in Amsterdam, "the Dome Hotel: bathroom down the passage," Freud remembered. Hals he loved for what he saw as the good-natured way

his sitters, *Married Couple in a Garden* for example, suit one another, heads and hands animating such exquisitely sober dress. "The colour doesn't bother one; the fact that colours aren't done as blue, green, yellow and red: nonetheless they are nothing to do with monochrome. Degas said, 'I wish I had done my work in black and white.'" This rich blackness—'colour-for-black-and-white,' as art editors would have it—was not understatement but a voluptuous reticence. "Hals' amazingly fluid and immediate way of painting for a lot of people rules out his sense of life, which was of life absolutely fraught with warmth and with feeling. When people talk about his vulgarity they are really talking about his vitality, an element that time hasn't been able to kill off. They still shock people very much."

That the brilliance of Hals was lost on people like Henry Moore and the critic Geoffrey Grigson, who agreed with one another that Hals was the eminent artist they most disliked, could only make him even more admirable as far as Freud was concerned. "I think it's a marvellous idea making them all look like that. I mean they are all talking, eating, grinning, doing all these things—I think of Shakespeare a bit—done from a kind of detailed—and not all that detailed—observation. I think that's what people mean when they go on about the technique—people playing the piano and crossing their hands—but I don't see that any more.

"His exuberant notation, when he lights up something or twists something, never an unnecessary mark. I exclude *The Laughing Cavalier* which is probably not Hals as far as I am concerned. (Or perhaps it's the *only* Hals.) The marks of embroidery: this side of dapper."

With Hals it is often possible to gauge the speed of application. Flecks of light on the seams of clothing or the eye socket of a skull were set down in rhythmic strokes of the loaded brush, four or five at a time, exercising empathy over and above showy technique. For Freud this was encouragement, incitement indeed, to strike out regardless of Bacon and his growing array of recipes for spontaneity.

Epstein once told Freud about the difficulty he'd had making a portrait bust of Anne Cavendish's husband, Michael Tree: "He said, 'I found it quite hard because of his moustache. And then I thought of Frans Hals.'"

· · ·

A new edition of *London Labour and the London Poor*, Henry Mayhew's comprehensive survey of lowly occupations, originally published in three volumes, appeared in 1949, and was republished in 1951—its centenary year—by Paul Hamlyn's Spring Books as *Mayhew's London*. Freud had been aware of this treasury of bygone lives before then. Mayhew, a founder-editor of *Punch* magazine, took statements from his subjects, ostensibly verbatim, allowing each of them a voice and recording a more authentic individuality than the quirkiness that passes for character among Dickens types. Fascinated with the zoology of trades and occupations and pecking orders among the lowest of the low, he exposed the lives of sewer-rat hunters ("the rats is wery dangerous, that's sartin"), Chelsea bun sellers, costers, coster girls ("the lads is very insinivating and will give a girl a drop of beer, and make her half tipsy and then they makes their arrangements"), Punch and Judy showmen, dog thieves and "pure" (dog shit) finders, whose gleanings were used by tanners. Mayhew listed every variety of old clothes men, such as: "A Jew clothes man is seldom or never seen in liquor. They gamble for money, either at their own homes, or at public-houses." They were not to be confused with rag-and-bone men, one of whom had handled pictures of one sort and another: "For pictures I've given from 3d to 1s. Pictures requires a judge." The Mayhew rendition of a street photographer's patter particularly appealed to Freud who used to recite it when asked about portraiture: "People don't know their own faces. Half of 'em have never looked in a glass half a dozen times in their life, and directly they see a pair of eyes and a nose they fancy they are their own."

For Freud there was appeal in the way Mayhew's London Poor talked; verbally they were as fresh as anything; the illustrations, based on daguerreotypes, reminded him of the Bewick wood engravings he had worked from in *Glass Tower* days; their stiffness conflated the self-consciousness of the individual and the anonymity of the specimen. Combined with what the characters had to say for themselves, these were stirring and resounding portraits, part Daumier, part Hals.

Their presumptive successors, the modern characters in *The Big City or the New Mayhew*, published in *Punch* from the mid-fifties and in book form in 1958, were more fictional: "Street Boys," "Moving Picture Girl," "Exile," "Sellers of Ice-Cream." Drawn by Ronald Searle and written up by Alex Atkinson to miserable or at best poi-

gnant effect, their lives were acted out in graphically decrepit settings. Freud had no desire to treat people as representatives of their class or occupation. Nor was he a dramatist, summoning up telling figures in the manner of Beckett or Pinter. Nor, working from Charlie Lumley, Charlie Thomas or Harry Diamond, did he label them *Petty Criminal*, *Former Gangster* or *Soho Character*. Some might be minimally described (*Red Haired Man*, *Woman with Black Hair*, *Young Painter*) and a few were named, artists mainly. Yet these descendants of Mayhew's Londoners were made constituents of recorded history by process of scrutiny, by being painted. This was how Freud was to put portraiture on a freshly demanding footing. To be able to paint anyone, from any background, was liberating. "When I painted Harry, Jacob [Rothschild] came in and Harry couldn't believe it that he, Harry Diamond, had met a Rothschild."

The only regular in the Old England who was willing to sit was the man from a shop under the arches of the concrete bridge, the Ha'penny Bridge, on the far side of the canal. Freud was to begin a painting of him (*Scrap Iron Merchant*) in 1968, wearing a beret, two red stripes laid in either side of the head. "I did a drawing, a head, illustrative a bit. He was quite friendly. I used to put bets on there, as he had a phone, and used it for a long time. They liked me saying 'it's my office.' Scott they were called, half Jewish (very strong Jewish half), prosperous in their way, a lot of lorries coming and going. People tried to sell them lead off roofs but they weren't fences. I got my paint rags from there, five shillings a huge bag." Annie Freud remembered being taken there: "The rag-and-bone shop under the bridge. Huge fat men, bales of clothes and smell of sweat. Constantly seeing Dad tell stories, then watching him flirt with Diana Cooper or Judy Montagu, Diana's friend, or sneer at Cecil Beaton."[4]

The Paddington clearances gradually eliminated the slum heritage of Mayhew's London, as John Rothenstein of the Tate discovered when he arranged to call on Freud one afternoon early in 1962. He went to Delamere Terrace, saw the car parked—it could only have been Freud's—and scrawls on doors indicating that water and electricity had been cut off. "You're not looking for an artist, Mr. Frood, are you?" a passer-by asked him. "There's one or two houses in the street

that's left. He's there." In a "minute and derelict studio"—at number 4—Freud and a bottle of champagne awaited him.[5] In 1961 the Tate bought *Man with a Thistle*, Freud's chill self-portrait on Poros, prickliness exemplified.

Rothenstein was gathering material for what was to be the third and last and most perfunctory of his volumes of biographical sketches of British artists. Freud found him irritating. "He used to pester me a bit, kept on that I was the most underrated painter in England, and then he said he wanted to do a book and I wrote a rather rude letter as I felt this was the wrong time to do it. Francis and I asked him for a drink and he said, 'I was looking through my diaries and how heartening it was to find you and Francis so loyal.'"

In a vendetta conducted against him in the early fifties by LeRoux Smith LeRoux and Douglas Cooper, with Graham Sutherland, then a Tate trustee, acting as Cooper's cat's-paw, Rothenstein had been accused of mismanagement, embezzlement and poor taste. Rothenstein's offence lay in not responding enough to Cooper's violent directives, leading to accusations that he was parochial in outlook and useless when it came to acquiring significant foreign works of art for the Tate. For example, in 1940 he had failed to alert his trustees to Matisse's *Red Studio*, which for years had hung in the Gargoyle Club; eventually it had gone for less than £1,000 to the Museum of Modern Art. That was grounds for permanent reproach. However, those ganged up against him—a bully, a con man and Sutherland—were discredited and Rothenstein survived. He even biffed Cooper in 1954 at the private view of Dicky Buckle's Diaghilev exhibition, knocking his glasses off and gaining the attention of gossip columns and cartoonists.

Bacon had some sympathy for him, for Rothenstein had been viciously maligned. Freud felt the same. "Just a poor old thing. And he had this pathological passion for girls. He was so short-sighted; he could hardly see; he wrote something about how my circle 'ranged from Max Ernst to Princess Margaret.' He said he'd seen me with them at Les Deux Magots. I wasn't actually at a table with Max Ernst and Princess Margaret, but nearly."

He and Bacon dined with Rothenstein in the lofty stuffiness of the Athenaeum and planted the idea of Bacon exhibiting at the Tate. Happily, Rothenstein adopted the suggestion as his own idea

and a retrospective followed in the summer of 1962. Naturally there were complaints. Ben Nicholson, writing to Herbert Read, included Freud in a diatribe against the anti-modernists. "I never saw a more profoundly uninteresting ptr." Rothenstein was accused of conniving with commercial interests in promoting a Marlborough artist, a distasteful one at that. The exhibition, which was toured to Turin, Zurich and Amsterdam, established Bacon as the leading British painter, unquestionably Sutherland's superior and, among British artists of international reputation, second only to Henry Moore who consequently, and unawares, became his butt.

"I remember one day, when he hadn't been with the Marlborough for long, Francis said, 'I had a long talk with Henry Moore. I think I really managed to fuck up his work.'"

This was around 1964 when Moore and Bacon were shown together at the Marlborough in notional harmony: the human figure roundly celebrated thereby. By 1967 Moore and his representatives were discussing with Rothenstein's successor, Norman Reid, the possibility of establishing a permanent space at the Tate for a great legacy from his estate. This provoked forty-one artists, including several of his former assistants, Anthony Caro among them, to write to *The Times* objecting to the imposition on the nation of a Moore mausoleum. The thought of such a burden on the Tate was enough to put Bacon off any further contact with Moore.[6]

The possibility of turning to sculpture and solidifying the image rather than flatly depicting it tantalised Bacon. Freud (who was to order a load of clay some years later with the notion of trying sculpture again) became used to hearing Bacon holding forth on what might be achieved. "For a long time—a year or two—Francis talked about the sculptures he was going to do. People on beds. They were so exciting. He said he would do it because he was so practical and he was so stimulated by it, and he talked it away. The only thing they sounded like that had ever been done were effigies on tombs; but they were going to be . . . not wax: certainly a lot of metal was involved. All these things had real meaning early on, and then got somehow lost through drink and repetition and boasting. Which can be very good for people; I mean people can boast themselves into doing more. Egg themselves on."

"Awfully uneasy"

Talk, perhaps of sculpture, probably of more gossip-worthy pursuits, hangs in the air in the long afternoon of *The Colony Room*, Michael Andrews' conversation piece, exhibited at the Beaux Arts Gallery in January 1963 and immediately recognised by those involved as a true record of their daily encounters. In the secluded upstairs bar in Dean Street the regulars bitch and gossip and fall silent. Freud stands centre right, glass in hand, the only person wise to what the painter is up to, watching him compose his cast of characters. The others act unaware. John Deakin, photographer, faces an obstreperous Henrietta Moraes. ("The only person who painted Henrietta well was Mike, in *The Colony Room*," Freud commented. "See her shouting . . .") She could be laying into Deakin for selling nude snaps of her around the pubs. Above Deakin's head swells the mural, painted by Andrews, after Bonnard: the Colony Room's substitute for a window.

The mirror on the far wall augments the gaggle, fanning the conviviality and furthering Andrews' take on Manet's *Music in the Tuileries*, in the National Gallery, where Baudelaire can be spotted in the throng. Perched on one of Muriel's bar stools, Bacon replaces one of Manet's crinolined ladies. Could he be once again telling them all about the sculptures he swears he'll produce, any time now? Bruce Bernard, in profile, pays close attention. Not so Muriel Belcher, loudly presiding, skirt rucked up, legs crossed in a flash of nylons. Well set in her character part, she looks at Carmel her girlfriend, and

at Ian Board serving behind the bar and calls for someone—"Cuntie," "Lottie," "Miss"—to stand another round. While most of the figures in *The Colony Room* were at one time or another painted by Freud as key individuals, assembled by Andrews they interact, their show of confidence—their being the in-crowd—slyly observed; the scene is cinematic: Manet revisited, *La Dolce Vita* re-enacted upstairs in Soho. To David Sylvester, writing in the *Sunday Times* colour magazine, *The Colony Room* was yet another example of an Andrews composition "flawed by a fumblingness and uncertainty."[1] Sylvester was more at ease with the thrusts and wipes of a Bacon than with the cheek-by-jowl panache of Andrews' masterpiece. What could be more expressive than his pale, stroppy face of Muriel Belcher and the way he poses Bacon's shoulders and plumps his blouson and thigh?

When the Colony Room Club opened in 1948 Muriel had offered Bacon free drink and the odd tenner a week to bring in the customers; Bacon was the main reason for Freud going there so much. The one-arm bandit was also an attraction and he served his time on it. "Not like Harry Diamond, who played on knowing that it was fixed so that after a certain weight it would pay out." One day, just when he reckoned it had got to that point, he ran out of change. "An old lady, a villain's mother, moved on to it and he said, 'Stop it, I'm going to get some more money,' but she took no notice, there was a crash of money coming out and Harry hit her. 'He only hit X's mother,' said Muriel. 'I had to bar him.'"

At one stage, in the early sixties, the Krays were said to be charging Muriel anything up to £250 per week protection money; they would turn up in the Colony Room in business suits and people would think them quite respectable. One time, when they said they wanted a word with her, Frank Auerbach remembered, "she told them she was busy, could they come back Tuesday afternoon? Which they did. There were two men with her. She greeted the Krays: 'May I introduce Detective Chief Inspector Gosling and Sergeant Burton?' This worked. She probably paid the police to mind her." As famous in her setting as Rosa Lewis had been in the Cavendish Hotel, painted by Andrews and photographed by Deakin for Bacon to transfigure, Muriel Belcher was a prime subject for Freud, perhaps too obviously so. He began a portrait. "I liked Muriel and it was nice to work from

her, but she was easily frightened and then something went wrong, a legal issue, and she got nervous: she really wasn't at all tough. It went very well and then I destroyed it.

"Bernardine [Coverley] worked for an antique dealer in Islington, a crazy man, bisexual and promiscuous. (People often say they are bisexual and never are; but he actually was.) He'd been a pilot in the war, I think, drank a lot, married to a press lord's daughter and kept a tarty boy. He had the picture of Bernardine almost giving birth to Bella and commissioned the painting of Muriel. He was a hot financier, got into trouble and unloaded on to me. He then sued me for the money. There was a solicitor's letter, which meant they could come and take some pictures, plus one of their choice, and I had to sign something.

"Scrapping the picture put an end to it. Obviously I didn't *have* to destroy it, but it was a way of getting it settled, done out of panic. As he was a sort of ally, it was something I resented."

Far from the Colony Room and the Bacon retrospective, other, seemlier reputations were sanctified in May 1962 with the consecration of the new Coventry Cathedral, Basil Spence's compendium of Festival of Britain modernism, featuring Epstein's St. Michael (modelled on Kitty's second husband Wynne Godley), John Piper stained glass, and a hefty eagle lectern by Liz Frink. This was the older generation— plus Liz Frink—delivering contemporary church fittings. Behind the high altar arose Graham Sutherland's *Christ in Majesty*, purportedly the world's largest tapestry ever, every fault blown up out of all proportion. A wrinkled green immensity, it exaggerated Sutherland's habitual blend: plush naturalism barbed with thorny emblems. "As a work of art," John Russell wrote, "it falls some way short of the more extravagant expectations of Mr. Sutherland's admirers."[2] Douglas Cooper still championed Sutherland, by now a member of the Order of Merit, as "the most distinguished and the most original English artist of the mid-twentieth century."[3]

If Sutherland disappointed, so too did the cathedral. A design package conceived as the high temple of post-war reconciliations and recovery, it became a show home of compromise, the only surprise being the absence of a Henry Moore. Neither Bacon nor Freud nor

anyone they consorted with had any inclination to be involved in a project radiating consensus spirituality.

The consecration came at a time when blanket urban redevelopment, along with colour in advertising and Sunday newspaper magazines, bright new acrylic paints and bright new pop and abstract modes, betokened a jaunty spirit of the age, pressure for change and stirrings in the social mix. In Freud's part of Paddington one of the few buildings not listed for demolition was St. Mary Magdalene, a blackened landmark of Victorian Gothic by the architect G. E. Street, just beyond the end of Delamere Terrace in Clarendon Crescent where it occupied almost half of the inner curve. "Hard to find in dismal streets," John Betjeman warned in his 1958 *Collins Guide to English Parish Churches*. Magnificently incongruous, built to dazzle the poor and glorify the parish, it was a Coventry Cathedral of its period a century before with an elaborate interior complete with a chapel in the crypt adorned by Sir Ninian Comper with saints and angels decked out in blue and gold.

By the mid-sixties the new medium-rise Warwick and Brindley LCC estates reshaped the district, bringing patches of green space and leaving only the church and a few pubs untouched. Sitting tenants had no security of tenure but council tenants had the right to be rehoused so, knowing that there would be no reprieve for Delamere, Freud had managed to become a council tenant. "I moved from 20 to 4 as the terrace was progressively demolished. With demolition teams advancing along the road I was throwing cigars and bottles down at the workmen to give me one more day, I so liked it there." Number 4 had been a council flat, which meant that the council had to rehouse him in the neighbourhood. "As I was pushed out, I went to different places." Not for him the new housing. "The ones they wanted to pull down were the dumps that suited me."

He was offered a room just down the road: 12/6 a week for a first-floor flat at 124 Clarendon Crescent. Built in the 1850s for navvies and costers, the street was said to have come to serve exclusively as lodgings for thieves, prostitutes and laundrywomen. "It was the longest street in London without a road off it—because of the canal behind it—and people were so aware of the strain that the shop in the middle was called the Half Way Stores. I was dead opposite the church: in fact opposite the house where I had drawn the doorstep

and railings all decked up for the Coronation." The houses were narrow, one room per floor; his room gave on to a landing leading to a shared lavatory outside on a balcony to the rear.

"Much of the Clarendon Street area is insanitary," the *Architects' Journal* commented in 1938, the year it was renamed "Crescent." Since the war there had been no improvement. Yet, the *Journal* remarked, "It is a sociable home-like place with a character of its own, and it is liked by the people who live there." Previously owned by the Church Commissioners and compulsorily purchased from them by the London County Council in order to be pulled down, the Crescent curved in a long concertina squeeze of close-packed terracing from St. Mary's to the Harrow Road. Behind the peeling stucco and bent railings was authentic squalor. "It was known as Bug Alley, had to be debugged before I moved in." He was there for eighteen months.

Clarendon Crescent was not as notorious as the recently demolished Rillington Place, site of the Christie murders, had become ten years before, but it was celebrated for having been a location for several car chases in the 1949 Ealing film *The Blue Lamp*, authentically so in that the police encountered hostility there and it was a dead end. "Villains would run along the roof and throw chimney pots on their heads. It backed on to the canal with just the towpath running below." This too was used for the discovery of a vital clue, Dirk Bogarde's discarded raincoat, and the 1951 comedy *The Lavender Hill Mob* included footage originally shot for *The Blue Lamp*, now showing the inhabitants gathered on the rear balconies as police trawled for missing bullion. It was a prime location for seekers after outstanding mean streets, as did Walker Evans when he photographed in the area (principally the corner of Woodchester Street and Cirencester Road); his caption in an article for *Architectural Forum* in April 1958 identified it as "A perfect scene for a rousing manhunt or at the very least a pleasantly sordid heart breaking tryst." Rachman the slum landlord operated near by, out of an office on the corner of Monmouth Street and Westbourne Grove. Colin MacInnes, in his novel *Absolute Beginners* published in 1959 and focused on Rachman, singled out "this weird and fantastic region, in the triangle between Wood Lane and the Harrow Road and the Grand Union Canal . . . This is a place the Welfare State and the Property-owning Democracy equally passed by." Half a page of the *Observer* that January was given over to a set of

Roger Mayne's photographs taken in the area: "our London Napoli," a district of "huge houses too tall for their width cut up into twenty flatlets' swarming with the children of those children Marie Paneth had studied under wartime conditions and—hardly surprisingly—found to be uncontrollable. "Their background, their bagful of experiences had taught them not to trust and not to hope, but to attack, to grab, to lie, to steal and cheat, all of which are the reactions of people against a world they fear."[4]

Verlaine, Freud was pleased to learn, had hymned the street in *Romances sans paroles* (1874):

> *Ô la rivière dans la rue!*
> *Fantastiquement apparue*
> *Derrière un mur haut de cinque pieds,*
> *Elle roule sans un murmure . . .*

"Streets," subtitled "Paddington," was written in 1872, when Verlaine eloped with Rimbaud to London and stayed in Howland Street, Fitzrovia; though Freud could not be certain that Clarendon Crescent was the one, no other fitted the description better.

> *La chaussée est très large, en sorte*
> *Que l'eau jaune comme une morte*
> *Dévale ample et sans nuls espoirs*
> *De rien refléter que la brume*
> *Même alors que l'aurore allume*
> *Les cottages jaunes et noirs.*
>
> *Even as dawn illuminates*
> *The cottages yellow and black.*

The move to Clarendon Crescent led to a *saison d'enfer* for Freud. Clarendon was notorious for being a dead end or last resort. Once there he lived by extremes more than ever before. More often than not for daytime paintings he used neighbours but also sitters recruited from his other world. The Bentley transported him at noon and night to the West End and back again.

"I had a real desperation for money when I moved from Dela-

mere. I associate leaving Delamere in my head with a club called Don Juan in Grosvenor Street and the Casanova where I went a lot; at Clarendon I was working 4 a.m. to lunch, then off gambling. Lots of playing, day and night, horses and dogs. I was completely broke.

"There was a loo on a balcony (the inhabitants referred to it as the 'flat') in a shed overlooking the canal and in the winter, when pipes froze, I melted snow for water to boil." The woman in the flat below, whose husband was in prison, said to him, "It's unfair of the council to put a factory in front of the place with you there." It was improper, she thought, for an artist to have a room with so uninspiring a view. "I just knew her to say hello to and we shared the loo on the roof overlooking the canal where there was a poem in pokerwork, green and yellow:

> *"64,000 dollars may come your way*
> *But don't sit here and dream all day."*

One day Freud thought he heard someone say to him in the Devonshire Castle pub on the street corner, "Grapefruit. Are you related to the grapefruit?" What sort of question was that? Then it dawned on him: "The Great Freud."

The director John Huston, who spent much of his time in Ireland and the London clubs, told Freud around this time that he was thinking of making a film about Sigmund Freud. Would he be interested in playing his grandfather? Freud said the only film role he had ever fancied was to be a cowboy. Montgomery Clift got the part.

"My private money, from the Freud copyrights, I had made over entirely to Annie and Annabel; the money had gone up very much by the sixties with more translations. I thought I'd like to have a bit of money so I asked Godley for it."

In 1955 Kitty had married Wynne Godley, younger son of Lord Kilbracken, an oboist (in the BBC Welsh Orchestra) turned economist who became, in the late sixties, Deputy Director of the Economic Section of the Treasury and subsequently, in 1970, Professor of Applied Economics at Cambridge. "When Godley married Kitty, his mother said to a nurse: 'Marrying the daughter of a New York yid.'

"There was a lot of hostility. Godley wasn't in the Treasury for nothing. I wasn't allowed to see the children except under certain circumstances and under supervision. Under the terms of the divorce I was the guilty party but had 'reasonable access.' Godley was monstrous. I used to call for them and he'd slam the door. It was such a bad idea not to see them, particularly then, so I kept on going to court to see them and one rather human judge said, 'I notice that over the last x years Mr. Freud has had recourse to litigation in order to see the children and I notice that, with all the things that you have said against him, the one thing that has never been questioned is his affection for the children. And I notice under the terms of the divorce one of the stipulations was that in any litigation regarding access the costs should be borne by the guilty party. In future, I'd suggest, if there is any litigation, the costs should be divided.' I was never taken to court again after that. Things got easier then." As a manifestation of "reasonable access" he started taking Annie to restaurants, which she loved. "Robert Carrier's, I enjoyed that, also Soho: La Terrazza, Italian tiles and glass tables: non-pasta Italian. When we were going to Greece we went to a 'Greek' restaurant, the White Tower, every week."[5]

Going to Greece, in the summer of 1961, was a greater test of access. "It was a way of seeing the children. I hadn't been allowed to take them because of the car smash. We had to go with the Lambtons. Suited me very well. They couldn't object to them because Tony Lambton was an MP." A further claim that being with the Lambtons would corrupt the girls got nowhere. Annie found Bindy maternal: "mad but grown up." Part of the journey was by cruise ship, pausing at Naples to see Pompeii and the Museo di Capodimonte, which Freud particularly remembered for an operatic incident he provoked. Bindy, being heavily pregnant, put her feet up on a park bench and was told off by a park keeper in operatic style. "Naples is wonderful. One afternoon, with Bindy and the children, in a small park high up, a man in uniform came shouting in Italian and he was so like Mussolini I said 'Mussolini' and he went round hitting trees—because he couldn't very well hit me—and the children were so excited."

The holiday on Spetses, an island fast becoming another Monaco with shipping tycoons much in evidence, proved irksome in that Freud found himself on his own with Annie and Anna, whom he

took sightseeing in Athens (the Parthenon and Piraeus). Michael and Anne Tree were near by in another rented house where the Somersets joined them. Being with the children practically all the time was onerous. "The Lambtons had a villa; we had a hotel. Didn't go to Poros: the extraordinary distinction wasn't there any more. It was rather leisurely. We'd go out in the evenings, but not in the day. John Wilton, David Somerset, Caroline Somerset, Bindy. Met Paddy Leigh Fermor. Ghastly spiv, I thought.

"We were entertained by Niarchos out of doors: dinner, dancing on a tiny dance floor. Tina Onassis' daughter, Christina, said, 'I don't want to do that, Aunt Tina,' in an American accent, like they all had, and she said, 'I'm your *mother*.' Niarchos' son said, 'It's a bore. I have to go to the dentist tomorrow: he's in New York.' [Heini] Thyssen was there—on a yacht—the first time I met him was then. He had Fiona, a model, with him and a horrible child aged three saying, 'Could I have more jam?' and Heini saying, same voice, 'Could I have more jam too?' I remember thinking what the hell am I doing here?" The yacht was hung with Renoirs, Annie remembered.

Unlike the sharp little paintings of thistles and tangerines that had preoccupied him on Poros fifteen years earlier, Freud's output on Spetses consisted of siesta-time studies of the girls resting and himself seated, his image reflected with sea and distant isle behind. These were opportunistic watercolours for which he borrowed Annie's Reeves paint box ("with the greyhound on the lid, proud that Dad used it").[6] "I had those books of Ingres paper, from the war. I did a lot. Kept seven or eight." Two of them were of a bat that they had found, dead, on the table in their room.

Obliged as they were to laze around in holiday mode, all three fretted, he especially. "Dreadful hotel," Annie said. "He was on his own with us as he had pissed Bindy off, may have insulted her with something done with someone else. Anyway, he was miserable, lonely and out of sorts." She read Tintin books to him. "Slight worries about swearing. I said 'bugger' and he was bothered that I would disgrace him. 'Don't disgrace me,' he'd say at a grand dinner.[7] Bindy fell out with him: in the villa that they had they had a garden, it was full of children and we were in a sparse hotel far away from this and the three of us were alone and Annabel fell ill. Anorexia at eight: she gave up eating." "Alarming," Annabel remembered, "because I hadn't had

breakfast and Dad stuffed a roll down my throat and my throat was dry. He was terrified.[8]

"We flew home. It was the last of these hols. It was nothing to do with Dad that I got ill in Greece. He was worried."[9]

As soon as he was back in London Freud picked up a girl in the Caves de France. "After being with the children I was desperate to work again. I met her one night, took her back, she took her clothes off and I just did her head, and I really felt I had done a nude without all the difficulties. What was unusual about her was that she was a waitress in a coffee bar but so was her mother: hadn't gone up or down in the world but just level. She married a rather impoverished gent with double-breasted waistcoat and library and a little house in Chelsea. I did the painting in nine days, in six or seven goes, which is about like one go for anybody else." Some years later he gave it another go. This involved persuading Jane Willoughby, who had the painting *Sleeping Head* (1962), nicknamed "The Pig," that it needed altering slightly. "The shoulder had got one loop too many. I painted it out."

Annie and Annabel had spent a lot of time with their grandparents at Walberswick. Between 1960, when she was the nine-year-old *Child in Bed* in a pink frilly nightie (a painting Freud considered "a bit sloppy"; it belonged to his mother) and *Portrait of Annabel* (1967), in a striped dress, Annabel had become distressingly unstable. "When Anna[bel] got ill first, when she was thirteen, Tony [Lambton] said to Bindy that they—Anna and Annie—must be separated, partly as he had a brother who killed himself; his brother being Anna, as it were, he saw some parallel. It was astute of Tony. Anna turned against Annie whom she had adored.

"One of the principles in analysis is you must not treat anyone who's a relation, so my Aunt Anna suggested Dr. Winnicott to my father and mother and he established a sort of secret friendship with Anna: very impressive. I talked to him quite a lot. And then he said, 'I'm going to write to you periodically about Annabel,' and he wrote me these long letters. I didn't reply and he stopped. I think, because of my aunt's dislike and fear of me, he wanted me to know. Thought I was serious. He had rather an extraordinary lively mind. I felt it was an element of friendship."

The renowned paediatric psychologist Donald Winnicott, who worked at the children's hospital in Paddington, told Freud that Annabel's illness was anorexia, stemming from fear of puberty. "A death wish, to do with keeping puberty at bay. I saw so much of Winnicott that I asked him why men can't have it. He said that starving is a symptom, and a classical cause is if the father leaves the mother at the time of birth. Winnicott, or my grandfather, was responsible for the fact that the initial cause is the father leaving the mother. In my case, absolutely right, I left Kitty. Whether the father physically leaves is hardly it: it's the unhappiness of the mother transferring misery to the child. It's a cramp, being born in the mother's misery.

"A very odd thing: Kitty was terribly jealous of Anna being ill. There is such a lot of madness in that family. Inability to eat is nothing to do with eating disorders, it's to do with a cramp. Anna became an absolutely brilliant cook when she had it, absolutely brilliant at it and obedient. She went to hospital for ages, to the Fulham & Hammersmith Hospital by Wormwood Scrubs, where I used to see her a lot, and the Maudsley. On a drip for nearly a year. She's sort of Catholic.

"I remember Bella when she was about sixteen saying to Annabel that she tried to do something and it wasn't any good, and Anna said, 'You can't expect to be brilliant at your age.' She's got her funny old lady-girl manner, very aware of her own shortcomings, but in her crazy way she's sort of considerate. A genius in her way."

Lunchtime at Wheeler's in Old Compton Street, Soho. The scene is a set-up: two tables pushed together, an unopened champagne bottle lolling in the ice bucket. In the time available before the first customers appeared John Deakin, the Soho Brassaï, clicked off a whole roll of photos of four painters in a row. Right to left: Michael Andrews scratching his head and laughing, Frank Auerbach smiling in response, Francis Bacon, glass raised to his lips, about to say something to Lucian Freud who turns to give him incisive attention and who, in other shots, recoils a little then turns and fixes him with one of his sudden, amazing, locked-on, hawk-eye stares.

The photograph went unpublished at the time. Francis Wyndham had commissioned it for *Queen* magazine but he rejected it as being

out of focus; a blurry detail, from another shot of the scene show-
ing Freud alone, served as the frontispiece to his 1963 Marlborough
catalogue. However, twenty years or so later it was to become iconic:
a definitive group photograph of the leading figures of what was to
be labelled the School of London. Back then, in 1962, it was just
the four of them, plus Tim Behrens, a grinning hanger-on, indulg-
ing Deakin, hence the spoof conviviality and a seating arrangement
suggesting a Last Supper or, to be precise, the tramps' parody Last
Supper in Buñuel's *Viridiana*, released the previous year. Here were
Bacon the Saviour and Freud the bosom companion with Auerbach
and Andrews savouring the pretence.

Not just in Soho but way beyond, Bacon was now pre-eminent.
His Tate exhibition had brought him to prominence and the first
of David Sylvester's interviews with him was to be broadcast a few
months later, in March 1963, and subsequently published in the *Sun-
day Times* under the heading "The Art of the Impossible": conversa-
tion ranging over film stills, photography, Velázquez and accident.
On the wireless, in print, at the Marlborough (that July) and in Dea-
kin's photograph, he unquestionably held court.

Seated to one side, an acolyte only, Tim Behrens grins deferen-
tially at the pepper mill, the one person keen to be there, and to be

Photo by John Deakin of a staged lunchtime session in Wheeler's, Soho (L to R:
Tim Behrens, Lucian Freud, Francis Bacon, Frank Auerbach, Michael Andrews)

photographed in such exclusive company. Once the photographing was over he loudly demanded drink and food; but no: Bacon didn't even oblige with the champagne.

Behrens' involvement was principally with Freud, who had been using him as a sitter, as did Michael Andrews. From the age of sixteen (he was born in 1937) Old Etonian Behrens had been at the Slade, where his fellow student Suzy Boyt had painted him looking not unlike Freud's *John Minton*. He had lodged in the house that Minton had bought for Norman Bowler and that Freud had subsequently taken for Suzy Boyt and the children. Helen Lessore showed him at the Beaux Arts Gallery in 1960, '62 and '64 (paintings such as *Fashion Models, I and IV*, candidly indebted to Michael Andrews); he was considered promising, picking up on Freud, Andrews and Bratby, working against the whole tone of the Slade.

"I liked him. There are early things that are good," Freud said, acknowledging that Behrens had been around with him for some years, in effect replacing Charlie Lumley in the sidekick role. "Francis said it was my fault I had a terrible effect on him." Auerbach thought the same. "He should have taken notice of Patrick George–type teaching at the Slade where its structured ways would have given him something to work on; as it was he tried a Bacon–Andrews method and produced feeble paintings."[10] And he remembered being with him at Paddington station, employed by the GPO as student labour helping out with the Christmas post. Behrens had no idea, he said, about what it was to work, "he just posed on mailbags and didn't do a stroke."

"He had that thing of people whose fathers loathe them," Freud argued, tellingly. "He became terribly influenced by his father. There were three brothers and all tried to kill themselves: two or one succeeded. Tim always had a lot of money while 'not having any.' He was very vain." His father, an oil man and owner of the Ionian Bank, bought the Hanover Gallery on impulse when Erica Brausen complained of being bankrupt. "Which made it impossible for Tim therefore as a painter. If you have a powerful father it's difficult." The father had humiliated and bullied him. "You're a rich boy," June Keeley once jeered. "And never forget it, June, I am," he replied. He thought of himself as Dostoyevsky's Idiot and affected laceless boots.

Behrens was charmed by Freud, who painted him as a raw-boned gilded youth: the hearty *Red Haired Man* and, in three-quarter view,

Red Haired Man—Portrait II, a head leading with the chin. Then, as *Red Haired Man—Interior*, he squatted in docile posture on a mock-bamboo chair with paint rags heaped behind; "a surf of rags from the rag-and-bone shop under the bridge," besmirched and accumulating daily now that bigger brushes were used. The joist dividing the picture and stressing the suppliant crouch was all that was left of the wall between the front and back rooms at Clarendon after Freud knocked through.

In *Red Haired Man—Interior* Behrens is a hapless figure. Freud recognised in him a propensity to disappoint. "Tim's first wife had twins. Driving with her boyfriend and twins in Algiers or Morocco she was stung by wasps and swelled up and died and was tied to the boot of the car. Tim got obsessed with the boyfriend and was inspired to do pictures of him, and a whole series of pictures related to his wife dying. Janet had a Jewish conventional family (merchants, jewellery, or some trade) and Tim somehow hated her family home and Golders Green, and did these extraordinary pictures of this house and to do with the death." In 1970 Behrens left London for Italy. In 1988 he published a novel, *The Monument*, a thinly disguised account of another chapter in his family history. Freud found it not thorough-going enough. "Sort of well written, but what he doesn't say (which completely invalidates the book) is that the heroine, his 'sister-in-law,' was his father's girlfriend, and it explains the suicide attempts. She eloped with the brother. The father not being mentioned makes it romantic, this semi-incestuous story. I thought it ridiculous that he admired his brother for killing himself."

Well before this Freud stopped seeing Behrens. "I couldn't face him any more. I felt awfully uneasy about it, like I never have with girls. I was embarrassed by it. Generally, if you don't see someone, it's accepted; I think if you can't help your behaviour, it makes it less manipulative. Self-pity and suicidal gestures horrified me, and Tim tried a lot." One of the twins, a talented writer, killed herself, he added. "I used to see the other one a bit. She had a child."

As late as 1987 Behrens was airing his connection with Freud by putting on his CV: "1953–1963: protégé of Lucien [*sic*] Freud." Perched on the mock-bamboo chair he came close to being the victim on the ducking stool, poised to topple backwards into the rags. Looking back he was to talk of Bacon and Freud as latterday *flâneurs*. "A

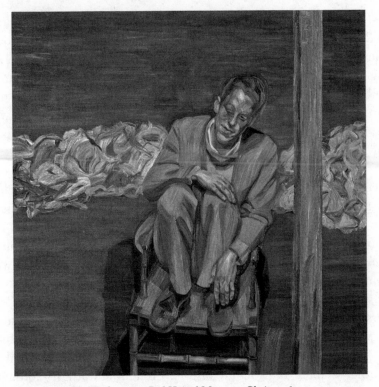

Tim Behrens as *Red Haired Man on a Chair*, 1962–3

Dandyish feeling: Bacon had something to do with Oscar Wilde and Lucian perhaps with Baudelaire." There was to be a rift. "My familiarity with Lucian dissolved and I left the country."[11] He went to live first in Italy then in Spain. While Frank Auerbach thought he was let down by Freud, who set him against his Slade tutors by encouraging in him a sense of superiority, Freud on the other hand thought that there was a basic lack in him.

"When Mike [Andrews] had his show at the Hayward [in 1980] someone (Jane perhaps) went there early one day and heard a sobbing noise. It was Tim weeping and looking at the pictures. Then she had a cup of tea and went back. He was still weeping. At the Slade I believed in him.

"I have a sort of prejudice about upper-class people doing art. They just don't . . ."

. . .

Clarendon Crescent was a step down from Delamere Terrace. Not only was the house overshadowed by the blackened redbrick church opposite, much of the street was already emptied and boarded-up. Besides knocking down the partition wall to create elbow room, he tried compensating for lack of space by painting bigger. "The room was terribly narrow: I think that's why I did those big heads. The change wasn't radical, just a change of idiom." The loaded brush smoothed and pushed with a sweeping touch. Initially Freud thought the paintings of Tim Behrens overblown; it took forty years for him to acknowledge that they had certain strengths, not least a gulping panache. "I've always had a strong thing against doing things people might like, things where my ambitions weren't tested." The broader handling gave *Portrait II*, in particular, a trenchant not to say pushy quality.

"I was very conscious of things that were unsatisfactory to me in my work, rather than working for somewhere to aim my response. I was very aware of the terrible things I was doing in the process." Such paintings bulged in effect. "I became conscious of that and I think that it slackened the tension in some of the pictures. By that time I'd come to terms, to some degree, with working in this way and I didn't feel debarred from any other ways in which I had worked."

Such "other ways" included the fine restraint shown in his first completed portrait of Jane Willoughby, the bare-shouldered *Woman with Fair Hair—Portrait I* (1961–2), a touching study of pensive character. In the next one, done immediately after, she turned her head to her right as though asserting her privacy a little. These paintings were as refined as anything he had previously done, but to test himself further he then determined to take on the entire person, full length and, for the first time, fully naked. "I think like a biologist," he said.

Two or three years previously he had started a painting of Anne Dunn: a nude against the light in his effortful sweeping manner. "It was done just before she married Rodrigo [in 1960]. I didn't show it because it was unfinished: a document, but it didn't look like a throw-out." An acceptable unfinished painting of a naked figure would be one with parts of the body unrealised maybe but with sufficient sub-

stantiality achieved from the top downwards to make its presence felt. "Until I started with nudes I started with the head and then I realised I very deliberately wanted the figure *not* to be strengthened by the head."

He was beginning to find it easier to get people to sit for him. And the more of them he enticed or persuaded the more his days and nights became subject to routine. Henceforward there were to be fewer periods of distraction. He began working from two sisters, Lucia and Jane Golding. "Lucia was really wild, very witty, amazingly abandoned and beautiful in a curious way: very much at large. The other had this passion for me at one time then lived in Spain; I started this and then one of Susanna [Debenham], for a bit. Didn't keep it." Susanna Debenham had been a girlfriend of Tim Willoughby and was then briefly with Tim Behrens before marrying the journalist Alexander Chancellor in 1964 and becoming involved with Freud, an involvement that was to last on and off the rest of his life.

When no one else could be prevailed upon to sit Freud used himself. Standing, shirt off, he looked down at himself in the mirror he had taken from the entrance hall at 20 Delamere Terrace. In two out of three portrait studies he inserted his left arm as a prop to the face and worked the paint as though modelling a bust, goading spontaneity.

Degas said, "I am more interested in talent at forty than in talent at twenty." Freud at forty was on the verge of full maturity. The three self-portraits from around then give us the protagonist emerged from the second round, his former accomplishment sloughed off, the odds increased, the strain showing. Unlike the heads of Jane Willoughby or *Red Haired Man*, these self-portraits, "very much at gambling time," he acknowledged, were startlingly brusque. Looking at a mirror propped on an easel, he examined himself. How to represent reflection? How to reconcile the two unaligned sides of one's face? How did Hals manage it? He tried a pummelled look.

"Goya did everything—all the portraits and I think some of those still lives—in one go. Maybe not: maybe the sheep's eye couldn't be so glazed in one go."

"The absolute cheek of making art"

A Contemporary Art Society exhibition, "British Painting in the Sixties," involving sixty-seven artists, was staged at the Tate and Whitechapel in June 1963 and, to coincide with it, David Sylvester published in the *Sunday Times* magazine an article—"Dark Sunlight"—in which he named those who, in his view, deserved particular attention: Bacon and Coldstream ("I'd say our leading painters") and Auerbach were prominent. The cover photograph, by Lord Snowdon, showed Coldstream in his front-parlour studio, steadying his wrist as he added a minuscule dab to a canvas, a sober contrast to the newly blond bombshell, David Hockney, "as bright and stylish a Pop artist as there is," who was awarded a double spread. His paintings had been a hit in the Royal College Diploma Show the previous June and he sold enough of them to get him to New York.[1]

With Bacon, Coldstream and Hockney to the fore and abstract painters in the ascendant, Freud went unmentioned in Sylvester's article. "The painter whose concentration upon his obsession isn't diverted by professionalism has a lot to gain" was probably him, however. The exhibition's selector, Alan Bowness, included three Freuds, "deliberately hung," Freud alleged in retrospect, "to look as horrible as possible." Among them was the *Nude—Portrait III* (1962) of Jane Willoughby, in which the head, the character part, sits uneasily on the body. "Naked, upright, fragmented (not deliberately)." Not having gone through the conventional art school, not having answered to the summons of Bernard Meninsky to knuckle down under his tutelage at

the Central, Freud had now set himself the difficulties of uniting body parts beyond head and shoulders. A portrait head was manageable but portrait shoulders, portrait arms, portrait torso and thighs as a whole defeated him. The *Nude—Portrait III* pose looked awkward, the sitter as stiff as a reader's wife featured in *Men Only* magazine. The lack of a thorough life-room grounding to fall back on was all too apparent. In *Resting Nude—Portrait IV*, the figure sleeps, hugging the buttoned upholstery: Fay Wray, as it were, rather than Jane Willoughby, proffered in the King Kong paw of the sofa. It lacked even the chill that had distinguished his *Sleeping Nude* of Zoe Hicks fourteen years or so earlier. After being shown at the Marlborough they went into the collection of an admirer not of the artist but of the sitter. Freud regarded them as write-offs. "Nudes of Jane, which don't really exist any more." He needed something of Picasso's ringing assurance: "A single look and the nude will tell you what it's all about, without any phrases."

Where talent at twenty feeds off impulse, talent at forty feeds off experience, and the realisation that, as Cézanne said, "nature has more to do with depths than with surfaces."[2] Underlying knowledge, coupled with the deepening intimacy that sittings brought about, informed the handling. With such knowledge came awareness of the peculiar nature of the painter's task. Time stilled, flesh and air conjured into telling paint. In their different ways, Bacon, Auerbach and Andrews, the painters who being nearest to him meant most to him, showed Freud that depths were attainable and achievable through working the material with vigilance and abandon. And experience told him that while potential was a sort of impetus it could all too easily become predictable: the pull of method was something to be resisted. "I suppose I'd be like Wagner and I'd have themes, introducing-themes, and my character would just come on."

A potential theme, potentially Wagnerian in spread, was painting his offspring. Annie Freud, being the eldest, was already the most practised when in 1962–3 she sat, first for a heavily elliptical head (*Child Portrait*, also known as *Head of a Girl*) and then for what came to be called *Naked Child Laughing*. Annie, grinning, still a Lycée Français schoolgirl, was convulsed with teenage self-consciousness.

"She must have been fifteen [actually fourteen] and things were easier by then. But Kitty was very upset and unhappy about that picture. She said she was very worried. But then, if you think of her father's 'scandals' and 'monstrosities' and how they used certain words, almost part of an advertising campaign, about 'creators of monsters,' it's understandable. And the unfortunate title of the Epstein autobiography *Let There Be Sculpture*, which I think was written by Kitty's mother . . ."

To her father, getting her to sit without clothes on was no more of an imposition than dozing for the siesta watercolours had been in Greece a summer or two before. "It was not unnatural for me. It wasn't putting razors round the sitter to keep her still." Later on he was to paint several other daughters, engaging them repeatedly as models, clothed and naked. "It has often been fine with their mothers, awfully hard if not. Intention, even if it doesn't affect the picture, counts for something. Or deliberate misunderstanding. Like the photographer joke: 'Do you want it mounted?' he asks. 'No, just holding hands.'"

Annie remembered sitting in the car outside the bookie's around this time, waiting for him, and him coming out white-faced. He was gambling uncontrollably or, rather, he was letting himself be exposed to outcomes beyond his control.

Naked Child Laughing, intimately small, makes the onlooker intrusive. Annie has settled herself, cringing slightly on the sofa where, during other sessions over the same period, the model for *Resting Nude—Portrait IV* was accustomed to nestle and doze. The contrast, the adult compliant, the child not knowing quite how to react to the close attention, demonstrated Freud's deepening ability to convey in paint his awareness of others and, for that matter, their feelings towards him.

"What is important," Giacometti said, "is to create an object capable of conveying a sensation as close as possible to the one felt at the sight of the subject."

In 1960 the first of what were to be three summer expeditions with the Lambton girls had begun in Paris where the whole party went up the Eiffel Tower and then proceeded down the Rhône valley in Bindy

Lambton's Land Rover and fifty-foot caravan, complete with nanny and maid. The caravan became stuck on a tight corner in a village in Burgundy and one morning Annie awoke to find a big fat inflatable Michelin Man, lifted by her father from a garage forecourt, wobbling outside the door of the caravan. The children were left in a hotel while Bindy and Freud went out all night to dine and sleep elsewhere. Their destination was a villa at Saint-Jean-Cap-Ferrat next door to the Chaplins. Jack Heinz photographed the girls there playing with hula-hoops. Two years later, in August 1962, they went, again by caravan and Land Rover, to Venice where Freud was delighted by the swish Boldoni watercolours in Daisy Fellowes' palazzo. At the Grand Hôtel des Bains on the Lido, they met up with Diana Cooper (and Cecil Beaton) with her granddaughter, Artemis. There were parental discussions. "I used to have arguments with Diana about how she brought her up," Freud said. "I took Artemis to see certain Renaissance things. She said to me, 'I absolutely loathe Picasso.' 'Why do you say that?' 'Because he imagines himself a better painter than Mummy,' she said."

Until that encounter in Venice Freud barely knew Lady Diana Cooper. She had enjoyed success in 1924, posed as a statue of the Madonna in Max Reinhardt's production of *The Miracle* and was the inspiration for Evelyn Waugh's Mrs. Stitch, an absurdly erratic driver; she was, Freud found, "pretty curious in her way. I occasionally saw her at Ann's and Bindy's and had always loathed her, as I was keen on Pandora Jones, her sister-in-law who looked like Bardot and was then married to Michael Astor. I heard her being bitchy about her, saying that she had every tooth a different colour." Her late husband, Duff Cooper, Ambassador to France in 1944–7 and a descendant of one of the illegitimate children of William IV, once referred to Freud, or so Freud claimed, as having "crawled out of the gutters of central Europe." After his death, in 1954, Diana Cooper bought a house in Little Venice only to have the radiators stolen before she had even moved in. "There are more burglars than occupiers in this dusky district, who laugh at locksmiths," she wrote. Freud was soon on friendly terms with her. "I went there quite a lot. Christmas parties, where Paddy Leigh Fermor would say: 'Diana, do sing "Shit hole."'"

"Oh no. *Must* I? Oh all right:

"Shit hole, Shit hole . . .
She told him he must be
Arse hole, Arse hole . . .
A soldier for the Queen . . .

"Applause . . . We went round listening to election speeches by a very dud man, a Liberal, and her friend Quintin Hogg. He was talking and people started to heckle him and he turned the hecklers against each other, and people took to fighting and she held her ground."

One night in January 1966, when Diana Cooper was alone in her house with her friend the actress Iris Tree they were tied up and robbed, Freud recollected. "'Who were they?' she asked me. 'You know all these people,' she said, thinking I knew all the criminals in the area. I said, 'I'm a terrific criminal snob; I wouldn't shit on people who did that,' and she was pleased and used to mention this." While being questioned after another burglary she spotted his name in the policeman's notebook. By then they were friends. "She said, 'I do hope Lucian Freud's not in trouble.' 'Oh Lady Diana,' said the policeman, 'you shouldn't look at my notebook.' And she walked round to Clarendon Crescent. 'Do look out,' she said."

A collision with a police car had triggered worrying repercussions. "The trouble was, I was paying the police to tear up a document and then their advice was go abroad for a bit. 'Then, if you wait, somebody bigger will get their attention,' they said. It was for driving under a ban. I always got off lightly. Two subjects I can't read about: one is the police and the other is drug-taking.

"The minute gossip becomes interesting it's social history. I remember reading Osbert Sitwell and complaining about the name-dropping and John Lehmann saying, 'It's social history.' It's Mayhew. The thing of who was *there*, rather than who mattered: the test is if one notices names not events. Generalisations are a mistake."

During the spring and summer of 1963 the Macmillan government suffered a run of scandals and debacles, the most resounding of which involved the War Secretary, John Profumo; Christine Keeler, a model and call girl; a Russian naval attaché; a West Indian pimp; and Ste-

phen Ward, an allegedly pimping osteopath. The themes of the Pro-
fumo Affair were deceit and betrayal compounded with startling shifts
in social codes. Peter Rachman and his entourage were drawn in.
Privileged lives were rudely exposed to common view, blanched and
captioned faces suddenly famous as, circle nudging circle, the fallout
spread with a neatness of coincidence and proliferation of reference
worthy of a Hogarth moral narrative. Stephen Ward, for instance,
had rented a cottage in the grounds of Cliveden, owned by Michael
Astor, a close Willoughby connection. And one of Christine Keeler's
best friends, peripherally involved in all this, was Paula Milton, who
had been the child in *Father and Daughter* (1949), wide-eyed between
the droplets of the parted bead curtain.

("There's a lot I suppress, right through. Things should be in the
book because they are interesting, because they are illustrative, not
to do with me.")

In 1963 June Keeley left Tim Willoughby and took up with Michael
Andrews, becoming thereafter June Andrews. Her first sighting of
him had been some years before, in 1958, at Delamere Terrace. "Tim
and I had been out to dinner and Lucian had served oysters and Guin-
ness, sort of thing. We arrived, sat around talking, and I saw Mike
running down the road waving his arms as an aeroplane. The first
few times I met Mike he was always pissed, bless his heart: crippling
shyness. Tim would say, 'I've got a nice artist coming. Do look after
him.' The door would open and in he would sway. Always pissed. I
was scathing, but Mike said, 'You were wonderful. All dressed up, and
you were so wonderful I fell in love.' I was being such a cow.

"Tim went round saying Mike had taken his girlfriend away. He
couldn't bear it: he liked to drop people, not the other way round.
He said, 'June, you're so common.' I said, 'Thank God I'm not a blue
blood like you.' He used to ring me up and say, 'When you've finished
with your artist in his garret, come back, I've got a cocktail party I
need you to hostess.'

" 'Fuck off, Blue Blood.' "

Freud, too, had had enough of Tim Willoughby. "He couldn't

bear anyone standing up to him or anything. I think he wanted Jane to be something different. He said, 'My father told me that, to get out of death duties, he'd give Drummond or Grimsthorpe [castles] to me. The minute I get it, out he goes.' His father had all kinds of illusions about Tim. Didn't know him, hardly. Thought he was sowing wild oats. He opened nightclubs all round: London and Spain. The most successful was Whips in the West End but it wasn't making money because he wouldn't let anyone in, so he sold it. The year before he died he spent £400,000 on things, going through the money rather."

On 19 August 1963, Tim Willoughby and Bill Lloyd, a South African painter friend who had tended refugees in Austria with Dr. Moynihan six years before, set out from Cap Ferrat to Calvi in Corsica, five to eight hours by power boat: he called the boat *Zero* as he had won it at roulette. Two days later, under the headline "Lord Willoughby Not Found," *The Times* reported that the naval and air search had been called off. Wreckage was sighted off Corsica on 27 August.

"I was at Clarendon Crescent, painting those nudes of Jane. She hired a plane and flew up and down searching for him, very shaken. Dr. Moynihan who was in love with Bill Lloyd's sister said, 'Do you think that Tim is alive?' A lot of people thought that. Stupid. (When Dr. Moynihan's wife died her last words were 'Does anyone know a good doctor?')" Bill Lloyd's easel was passed on to Freud.

June Keeley had asked Tim Willoughby if his sister would ever marry Freud. He told her she never would because she was so afraid of her mother. Freud was not so certain. "I was asked quite a bit to Grimsthorpe. I liked Jane's father: a one-legged courtier. Jane's mother wouldn't sleep with him because of the leg missing. He was lonely, didn't want to bother his friends when he was in London but would have liked to have seen them. And then there was Jane's mother's pressure, to do with my marrying her. So they can't have disliked me that much." His own father, brought in to convert the roof at Wilton Row, remarked on the difference between the Lady Jane Willoughby of public perception—presumed to be of a certain age—and the young and glamorous reality. "I remember my father saying, 'They'll be rather shocked if they learnt that this kind lady is rather beautiful.'

"Jane couldn't understand why I didn't want to get married. The situation of her houses and things—she takes trouble about tenants

and farms etc.—and being a nominal dauphin: the element of duty to it, foreign to my nature. Obviously after Tim died they were thinking of the line not dying out. I thought how odd that people think like that. Jane said, much later, 'I'm glad we didn't. It wouldn't have worked.' There would have been bad feeling."

Frank Auerbach admired Jane Willoughby's "very particular temperament, very controlled, very fastidious. Her mews flat had a whole bookshelf of those green cover dirty books [Olympia Press] and a painting that Lucian had discovered at a sale: an ancestor of hers that looked remarkably like her. Lucian once said to me, 'I realise I have really never been able to talk to her at all.' I think that had more to do with her soldierly, stoical reserve than Lucian's."[3] Her support for him was undeviating throughout his later life.

For Freud the disappearance of Tim Willoughby was somehow a contrived ending. "One interesting thing in retrospect: Tim Willoughby was suicidal in a frivolous sort of way. He was begged not to go out in the boat."

Bigger news in the week of that Shelley-like death was the suicide of Stephen Ward, chief scapegoat in the Keeler affair, and bigger still, the Great Train Robbery, in which a gang seized millions in used banknotes off a Glasgow-to-London mail train. "It had a terrifically heartening effect. Bargees by the canal talked about 'Don Charlie.' Villains are bigger snobs than anyone."

> *Our interest's on the dangerous edge of things.*
> *The honest thief, the tender murderer.*

Lines from "Bishop Blougram's Apology" by Robert Browning, who every afternoon, a century earlier, had walked along from Warwick Crescent to 7 Delamere Terrace to call on his sister-in-law, Arabel Barrett, an enthusiast for Ragged Schools and slum improvement. As another former resident, a boxer-turned-taxi-driver, once told me, the district behind the canal was, and always had been, a complete mix. People were attracted to it by its extremes, contained within so confined an area.

Freud's interest in the dangerous edge of Paddington was far from voyeuristic; he regarded the neighbourhood as a place of spir-

ited enterprise. "I was friendly with those burglars and they did spectacular things to do with banks. One I had to do with liked children; when I realised what he was up to it added to the painting. Rather like when children say, 'What's that person for?'—they do it in Walter de la Mare's *Memoirs of a Midget*—it keeps your interest going; and if you're aware of what they are thinking about, or what you think they are thinking about, that affects the way you depict them."

A Man and His Daughter (1963–4) harked back to the 1949 painting of Bo Milton and his daughter, without the fuss of the bead curtain and, instead, white hair-ribbon and open collar reminiscent of Hals. The girl has a pigtail and the look of someone keen to be a school-leaver as soon as possible; the parent, defensive behind a tough front, has scars like spent fuses running down his forehead and cheeks.

"This was Ted, the spiv who lived downstairs at Delamere. He must have moved into the ground floor at number 4 perhaps a year or two after me. I had known him a number of years: he used to come and stay with me and Caroline in the country. I always rather liked him because I couldn't work out what he did. I was fascinated with his appearance, and when I realised what he did, it suddenly made more sense to me. He'd got that odd thing of a criminal mind, con tricks really. 'I can't really afford his work,' he said of me, and I got him to buy a Tim Behrens (who always complained about having no money, though he did have it) and then he didn't pay him. I minded and thought he let me down. He used to get furniture off the pavement displays. Petty thieves have the romantic idea that if something's stolen it's more valuable.

"Ted did banks. He was a power in the district, a very good safe-breaker, completely non-violent. He was cut up by the husband or boyfriend or brother of who he was going with; it was that thing of glassing, a drunken thing in a pub. He had a very thick skin and was well stitched up and I suddenly thought, good. It's an interesting face. In the picture the scar was recent; it became fainter; I've always been interested in scars and everything.

"There was a Mrs. Ted. I remember going out with Ted and his girlfriend, who was very nice. Sylv met him and he had a name of a footballer [that he connected with him]: Bert Addinall of Bolton Wanderers or Huddersfield Rangers." (In fact, Queens Park Rangers,

Brighton & Hove Albion and Crystal Palace.) David Sylvester boasted an encyclopaedic knowledge of footballers and football form and Ted was impressed. "Ted said, 'Fancy him being my fucking uncle.' He'd got an aunt who'd spent the last nine Christmases in Holloway. She tried to go in for Christmas: nice times there. Ted was completely non-violent. He said when they did security boxes in a Baker Street bank, 'If any of your friends have got anything in there they might take them out, Lu.' They did the Burlington Arcade and I was rather pleased when it said in the paper 'Only a perverted foreigner could have done it,' and it was Ted. When I was paying the police to try and tear up some offence (Charlie was on a charge) the CID man knocked on Ted's door to see if he could put up some houses he could rob. Ted didn't do it. Ted was highly professional. He wouldn't work with the police.

"Round the time I painted him, Ted was had up for murder. 'The Bus Murder.' Dr. Moynihan came round one night to see me, as I was in bed, and Ted let him in and so I had this proof he couldn't have been in Deptford then: he was with me at the time. I got hold of Ludovic Kennedy to help. I knew him through Cyril [Connolly]. He gave me good advice, as I was being pressured by the police. He was helpful and practical." Kennedy had published *Ten Rillington Place*, an account of the Christie murders and the miscarriage of justice that followed with the aim of securing a posthumous pardon for the innocent Timothy Evans.

"Ted got off. The police loathed him, as he was so successful. They know who's got away with things and accuse them of things they are believed never to have done—'So give us a body'—and Ted was set up for this. Ted sorted matters." Driving licences, for example: who better than a getaway driver to sit the necessary test?

"I got a licence, a real one, through someone's help."

For Freud every aspect of driving was hazardous. Being out on the road all too often meant court appearances at a later date. "When I was painting Ted I was driving in the fast lane when a lorry swung over and crushed my car and I found, in that position, it's impossible to get a witness. (I'd stopped having insurance: with my first car I had smashes every day.) Ted said to me, 'You know, these cases where you have to have a witness: when you're in the wrong naturally you can get them, the usual ones, no problem. It's when you're in the *right*

you need a witness, Lu.' I was not often in that position: I think a philosophical one.

"Ted went on to legitimate business, the way criminals do. He had car-body factories. I didn't fall out with him exactly, but I saw him less." An art racket put a distance between them. "After the war," Freud explained, "there were German hoards of paintings and he thought he'd get hold of old masters and he tried, not very hard, to get me involved. 'Invest in a rare Leonardo sculpture: a few thousand and you've got your share.' Not in itself wrong, it was that the rare thing itself was so bad." More than once there would be an urgent request. "'Look after this, Lu.'" This being a suitcase full of money.

Freud painted Ted twice. "I was going into hospital and Ted said could he have one of the two pictures of himself to 'look at' and I knew it would have been stuck there in his house in Bushey Park and I got awfully depressed as it was worth possibly a thousand pounds and so I went up there and took it back, saying I needed it.

"I remember his daughter, Sharon—obviously copying her mother the way a child of ten does—saying about some woman whose husband had died, 'She's going out with a man and 'e's only just been buried.' Probably a grandmother now.

"I had a walking stick given me by Bindy, a malacca-cane .410 shotgun, prettily painted, nice horn handle and you twisted a silver ring and a trigger appeared. You could get them in a rather grand shop in South Audley Street where she lived. The bank robber under me at number 4 said, 'Could we borrow your walking stick?' There was a huge robbery and it was funny: twelve years later a man in a club said to me, 'Sorry, Lu, about not returning the gun.' He'd been in prison ten years."

By the time that Ted began sitting for him, Freud had moved from Clarendon Crescent. (Ted had refused to set foot there: it was too squalid for him, he protested.)

"After Clarendon I had various alternatives. What I wanted was nothing more slummy; whatever was most desirable and potential, somewhere facing north." Having displaced him again, the council were obliged to rehouse him but they did not take kindly to being quibbled with. "I wanted a north light and I asked them for that.

'Don't overdo it,' they said. 'You're not a unit,' they pointed out. 'Not too young, or so old, or with a family, so go easy.' But I got a place, looking north."

The new address was 227 Gloucester Terrace on the other side of the railway from the canal, a grand terrace of bedsits and theatre digs scheduled for renovation extending a good half-mile of increasing desirability to Lancaster Gate on the edge of Hyde Park. The street front faced north; at the rear the windows overlooked the back of a similar terrace, also bought up by the council, and a patch of rubbish dump. The first-floor rooms were a considerable improvement on Clarendon Crescent, spacious enough for larger paintings and good enough for Ted.

Freud's second Marlborough show, in October 1963, consisted mainly of the paintings done at Clarendon Crescent, together with *Woman Smiling* and the painting of Bernardine pregnant (listed in the catalogue as *Nude with Dark Hair*), priced at up to £1,000. "You seem to have trebled in stature—if that means anything to you!" his parents' friend Jimmy Stern wrote, congratulating him after the private view. "As far as I could make out, a picture was being sold every few minutes," he added. "The whole exhibition bursts with boldness, and you are still the master of hair. Charlie's head is a masterpiece."[4] John Russell in the *Sunday Times* was more mild but little less positive: "The signs of strain, effort, crisis and doubt are not covered up, as they would have been by a lesser artist; in the figure paintings, especially, the problems involved are as naked (and this is saying a great deal) as the models themselves." Once again, however, most of the reviews were dismissive. Eric Newton, in the *Manchester Guardian*, talked about "compelling nastiness," adding: "Gulliver's first impression on arriving in Brobdingnag must have been similar."[5] In *The Times* David Thompson spoke of Freud's "obsessively detailed realism. A rather facile cleverness of brushwork that puts one in mind of Stanley Spencer at his most literal somehow crossed with Sir Alfred Munnings."[6] The Peterborough column in the *Daily Telegraph* reported Freud as being "a shade put out" about this; nonetheless there were "many red stars on the £1000 canvases."[7] Ann Fleming bought *Woman Smiling* which she sold ten years later for £5,000.

. . .

One afternoon in November 1963, shortly after settling into Glouces-
ter Terrace, Freud was at work painting Harry Diamond (*Man in a
Mackintosh*) when the woman from the flat downstairs knocked on
his door and told him that President Kennedy had been shot. "I said,
'That's terribly good of you, really thoughtful of you, to let me know,'
and went on and on because I didn't know what to say." To disre-
gard the news from Dallas was not a problem, but Harry Diamond
somehow was. This, his third painting of him, lacked edge. Another
French Pub regular, trickier but less determinedly resentful might, he
thought, be more worthwhile.

"I met Deakin during the war when he was an officer, very maud-
lin and self-pitying in the transition between pretty boy and monster.
He'd been in Egypt, and was dark, scarry, rather drunk in clubs."
Before that he had been a window dresser in Dublin, had been kept
by Arthur Jeffress and had worked in Tahiti and elsewhere as a primi-
tive painter. Christian Bérard introduced him to Michel de Brunhoff,
the editor of French *Vogue*; consequently he had worked for Brit-
ish *Vogue* on and off until 1954, doing fashion shoots and portraits,
Picasso at seventy in 1951 for example. Photographs of Soho figures
were his forte: Dylan Thomas, George Barker, Elizabeth Smart,
Bacon of course, Isabel Rawsthorne and Muriel Belcher, who gave
"the little bastard," as she put it, a bollocking for pointing his camera
at her without permission. Freud, "such a strange fox-like person,"
as Deakin described him, submitted to being photographed by him
at Bacon's behest, wary in Golden Square, and also sprawling in his
chef's trousers on the brass bed at Delamere Terrace, head up, head in
hands, legs crossed, legs akimbo: poses possibly demanded by Bacon
himself standing unseen to one side.

Shortly before Freud started painting Deakin—it took two
attempts—Michael Andrews pulled off a telling portrait of him,
seated in shirtsleeve order (quite the cashiered officer), pleased to be
so appreciated despite often arriving late and not in good shape. Once,
before settling into the corner of the Andrews sofa, he demanded half
a pound of butter to rub into his skin. Freud in turn warmed to the
play of light on Deakin's greasy complexion, "working deliberately
in a very free way," on this not unsympathetic character—"The Ugly

Sisters and Cinderella rolled into one," he said; raddled, melancholic, Freud's Deakin stands comparison with the court dwarves and other poignant freak characters of the Spanish Habsburg court whose portraits were reproduced in the book on Velázquez seen lying among the scattered racing pages of the *Evening Standard* on the studio floor in photographs taken by Deakin four or five years previously.[8]

One morning Deakin complained of the cold. The next day, without ceremony—typically considerate—Freud presented him with a camelhair coat, as befitted a certain type of ex-officer. Not bothered that it was too big for him, he went off to the pub and flaunted himself as the self-anointed "Mona Lisa of Paddington."

Freud sold the Deakin painting straight off the easel to Dan Farson who, by 1963, had become a TV celebrity living beside the Thames in his own pub in Narrow Street, Limehouse. A good quick sale but, as he knew, it should have gone through the gallery. "There was some trouble. (Farson was in the right.) I said, 'Very sorry, I should have given the painting to the Marlborough and I must have it back.' I gave him the money back though." When he went down to Limehouse to reclaim the picture Freud bumped into Teddy Smith. It was a doorstep encounter best avoided. "Teddy worked for the Krays as a debt collector. Wrote poems. 'The best writer among us,' Ronnie Kray said."

When, a couple of years later, the Krays sent him and a colleague to Devon to pick up Frank "Mad Axeman" Mitchell after his escape from Dartmoor and deliver him to a safe house in London, Smith composed letters from Mitchell to the press saying that he would give himself up provided he was given a date for release. The Krays decided otherwise, Freud heard. "They got a girl for him from Winston's Club (the rival to Churchill's) and he liked her, so they started taking her away so he told them he'd go to their mother. They'd thought of giving him up after letting him have Christmas outside (unusual for him) but they got rid of him instead. Because of their mother." Nobody messed with the Krays' mother. Mitchell was shot, wrapped in chicken wire and dumped from a trawler into the English Channel. Smith was to vanish similarly.

"Dan Farson had no idea about people at all; the Krays got hold of him and took the pub he ran; everything they took off him. He had four chauffeurs and no car: that can't be right. The Krays gave him

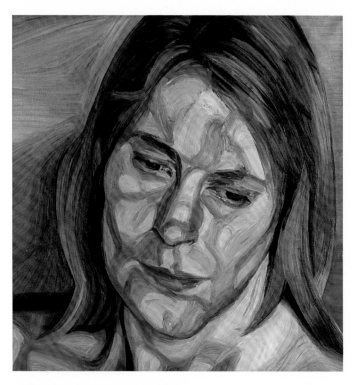

Head, 1962

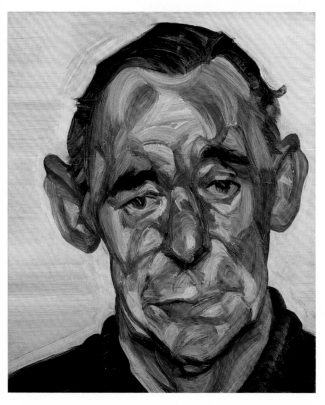

John Deakin, 1963–64

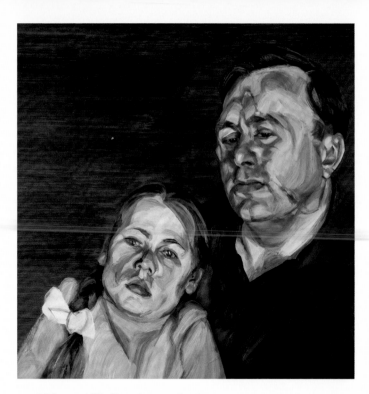

A Man and His Daughter, 1963–64

Naked Child Laughing, 1963

Man in a Blue Shirt, 1965

Michael Andrews and June, 1965–66

Girl on a Turkish Sofa, 1966

Naked Girl, 1966

Woman in a Fur Coat, 1967–68

Buttercups, 1968

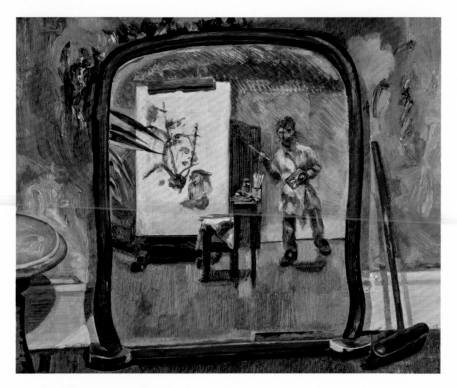

Small Interior, c. 1968–72

Reflection with Two Children (Self-Portrait), 1965

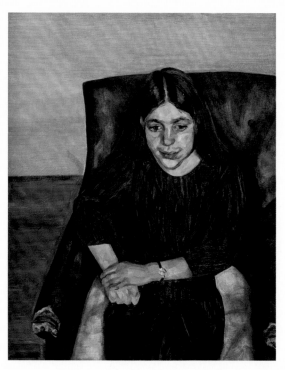

Annabel, 1967

*Interior with Plant, Reflection Listening
(Self-Portrait),* 1967–68

Large Interior, Paddington, 1968–69

the 'chauffeurs.' Deakin said to Dan Farson, 'When you go round the pubs looking for sailors and you look and look and get back to Narrow Street and have your high jinks, what do you do the morning after, when you see what you've got? Isn't it odd it's always the pastry cook?' "

Deakin's arresting mug shots of Barker, Bacon, Freud, Paolozzi, the actress Prunella Scales and others were as head-on as Freud's 1952 Bacon portrait, obviously so. It followed that, had Freud resorted to using such photographs as aide-memoires, he would have overlapped with Bacon. Painters prompted by photographs saddle themselves with photo characteristics and where Sickert, like Degas (and Bacon), turned to advantage the stilled qualities of photographic focus, tonality and optical distortion, Freud told himself that he had to have his subject in the clear, every time, right there in front of him. Nothing came of a suggestion that he might paint, from photographs, the former Prime Minister Anthony Eden, married to his friend Clarissa Churchill; however, he did make use of photos occasionally when pressed for a fleeting image or when circumstances persuaded him that a photograph could serve. Accordingly he produced a quick little painting—for Bernardine—from a snapshot of himself tending baby Bella on the towpath behind Clarendon Crescent.

Deakin's close-ups were startling and look startled, Freud's meditative looking and meditated; both had the virtue of direct approach. Unlike, say, Bill Brandt whose "Perspective of Nudes" series of 1961, patently indebted to André Kertész and Henry Moore, demonstrated a fondness for shapely cliché. When Brandt photographed Bacon in 1963 he cast him in a black mood on Primrose Hill and proceeded to augment the gloom in the darkroom in an attempt to make a "Bacon" of Bacon, whose reaction was gleeful scorn. Primrose Hill had been the photographer's idea not his, he told Freud. "He'd never been there before. All Art. The terrible thing of naked women sitting on the bed: pleased with himself that he has managed to get that far. I wasn't going to be photographed by him." Deakin, on the other hand, was acceptable to Bacon because generally he did what he was told. Even his most contrived photographs, such as the one of Dylan Thomas waist deep in a grave and those he took for *Vogue* in 1954 of Bacon stripped to the waist and beset with beef carcasses, were tolerable in that they catered to the sitters' fancies.

"Partly Francis had photographs because he was bored," Freud explained. "I was very surprised he wanted to include Henrietta." Deakin's photographs of Henrietta Moraes lolling naked prompted dramatic elisions of form and persona. "Thigh going into breast: how beautiful she remained. She was good-looking for a very long time. In Ireland she didn't wear any knickers, sat at a table, put up her legs and the pub owner came by and didn't really like what he saw and barred her. (Irishmen are puritanical, even though Catholic.) Deakin sold these photos to sailors. They like things a bit 'look, what a good bang.' Rather more than merely their stockings showing."

Bacon required Deakin to supply him with images readied for him, postures and skin tones sufficient to enable him to overlay in streaks and dabs the aura he associated with each person portrayed: arrogance, defensiveness, bafflement, fear. "One always loves the story and the sensation to be cut down to its most elemental state," he told David Sylvester. "That's how one longs for one's friends to be, isn't it?" Mostly presented as threesomes, his paintings of Freud were invested with the mannerisms that registered only on acquaintance: the quick-as-a-blink turn of the head, the dismissive wince, the screwing up of the eyes and tightening of the lips in silent laughter when a joke took effect.

Freud's *John Deakin*, by contrast, red-eared and elfish, is a saddened rake with darts of pain in the eyes.

The "Modern Art in Britain" issue of *Cambridge Opinion*, a student magazine edited by an undergraduate, Michael Peppiatt, and published in January 1964, included "A Short Text" by Freud composed to be read out loud in a Dr. Strangelove accent.

> *When man finally sealed his destiny by inventing his own inevitable destruction he also gave art absolute gravity by adding a new dimension: this new dimension, having the end in sight, can give the artist supreme control, daring and such awareness of his bearings in existence that he will (in Nietzsche's words) create conditions under which "a thousand secrets of the past crawl out of their hideouts—into his sun."*

This heady sentence, set in a bold typeface and squashed into a narrow space on the page above a reproduction of *Sleeping Head,* was supposed to give pause to the readers of *Cambridge Opinion* following the bluff and counter-bluff of the Cuban missile crisis, by any measure the greatest gamble of the era. "Having the end in sight" was that moment of mastery when "supreme control" is finally exercised. Freud wanted it known that he was on to something here. Something of greater potential than anything paraded as "figurative" not to say banal. He could now hope to do away with the gangling exaggeration he associated with, say, Egon Schiele. "I didn't use Prussian blue because I was afraid of the disease spreading." He found all he needed to be daring in a limited range of earth colours. "Terre verte and Payne's grey, or terre verte and charcoal grey; maybe with a bit of my staple colour which was Naples yellow even then. Mike [Andrews] started me on Rowney's Transparent Brown." He told himself that virtuosity was a shortcoming; what he wanted was disclosure.

"I don't think of highlights as highlights; more the light resting on it. I never thought of them as touches. It's what I want: to avoid accent. What's exciting is you ignore the guarantee of the accent and see what gets lighter. Painting, for example, fire tongs *not* like William Nicholson."

Not for him dabs of highlight expertly placed; and furthermore not for him the skidmarks and dribbles, silkscreened layers and collaged jump cuts that characterised the cinematic paintings and graphics of the period.

The sixties was a period of a more strenuous than usual cult of the spanking new during which the American ascendancy gave rise to ostensibly laconic shows of formality such as Jasper Johns' deadpan flags and targets (exhibited at the Whitechapel in 1963–4) and ostentatiously casual trawls of consumer litter, such as Robert Rauschenberg's combines or outsize collages. In February 1963 a thirty-year-old American in London, R. B. Kitaj, exhibited at the Marlborough paintings with provocatively abstruse titles (*Nietzsche's Moustache*), paintings combining colouring-book handling and scrapbook characteristics. "An Eagerly-Awaited First Exhibition," the *Times* said. Kitaj had recently left the Royal College where his bookishness and worldly ways (he had been a merchant seaman and itiner-

ant art student, on the GI Bill, in New York, Vienna and Oxford) had a bracing impact on, in particular, David Hockney. Freud had looked forward to the Kitaj show. "There was so much written I had terrific expectations. I expected it to be organic in some way, and when I went I got no more impact than from reproductions."

In October 1964 *Encounter* published "A Kind of Anarchy," a conversation between Andrew Forge—Slade tutor, painter and writer—and the art editor of *Encounter*, David Sylvester. Forge talked about the English attitude to art being that it was created by "the solitary man of conscience working simply with what God gave him in the studio." Sylvester agreed. Take Frank Auerbach. He had said, in answer to a *London Magazine* questionnaire three years before, that painting is "something that happens to a man, working in a room, alone, with his actions, his ideas, and perhaps his model." This was just not good enough, Sylvester argued. Auerbach's "sentimental glorification of inner necessity has some bearing on his not having advanced as a painter since he started to show ten years ago; he hasn't gone back, but he hasn't gained ground." And, Sylvester suggested, "the artist who appears to be taking his stand on everything that is associated with the idea of integrity may still be indulging himself in the repetition of a serious-looking formula."

This reprimand was issued on the assumption or understanding that London artists, unlike New York artists, were inclined to repeat themselves rather than push ahead. How that squared with the modified outputs of those he most admired in the School of New York (Barnett Newman, Mark Rothko, Willem de Kooning) Sylvester did not say. "Obviously," he insisted, "the big event in the experience of artists in this country was the first exhibition here of modern American art, the one at the Tate in early '56. This really changed everything." Really? It seemed then, perhaps, that expansiveness, on the US pattern, was the only way of getting ahead. In his interviews with Bacon he had asked him why he tended to paint in series. Bacon had explained that he always saw images "in a shifting way."[9] That was enough to make Bacon a modern, attuned to film and replication, compatible with Warhol, for example, whose mimicry of industrial production was as adulatory as it was numb. Warhol's *Blow Job* movie,

recording the expression on an actor's face while, implicitly, for thirty-five minutes the act proceeds off camera, comes close to parodying Auerbach's definition of his sort of painting. And his use of the electric chair, a lynching, some movie stars and Jacqueline Kennedy's grieving face as image-bank assets was, most certainly, the "repetition of a serious-looking formula." In terms of insouciant strategy Warhol was, Freud said, "always so intelligent." He particularly liked the version of the Campbell's can with the label coming off. "That's touching, almost like Hadleigh Castle tower." But, he added, "Constable's Hadleigh isn't Expressionist. It's fast but it all reads." Warhol's speed looks so static.

Freud wanted each painting of someone to embody that someone. More than a correspondence, more than impersonation: more the one and only. When Cézanne said, "Nature has more to do with depth than with surfaces," he went on to say (or is reported as remarking to his biographer Joachim Gasquet): "You feel a healthy need to be truthful. You'd rather strip the canvas right down than invent or imagine a detail. You want to know. To know, the better to feel, and to feel, the better to know." Cézanne's protestations ("I want to stay simple. Those who know are simple") snubbed notions of progress by dint of novelty superseding novelty. "The half-knowing, the amateurs, only half-realise," he added. Truthful painting is immeasurably exacting.[10]

"I don't think I could paint seven or eight hours a day every week," William Coldstream once remarked to Freud, who was not surprised at this. "He said, 'I can't bear that thing of people who agonise over pictures; I like to think of it as a sort of gentleman's activity.' You do it and then you've done it and you don't go on about it." Still head of the Slade, Coldstream had become portrait painter to the establishment (Clement Attlee, Anthony Eden, heads of colleges, tycoons) and served as Chairman of the Arts Council Art Panel, Chairman of the British Film Institute and Chairman of the National Advisory Council on Art Education under whose auspices the Coldstream Report on the organisation of art schools was published in 1960, recommending academic entry qualifications and art history courses for all students, together with pre-diploma courses involving disciplines such as Basic Design of the sort that had been developed by Richard Hamilton and Victor Pasmore at Newcastle University.

The aim was to improve the professionalism and raise the standing of art schools, maybe to the detriment of "people who agonise over pictures." Those art schools approved by the National Advisory Council set up to monitor standards became art colleges empowered to bestow degree-status diplomas; thereupon, as a token of their commitment to modernising themselves, most colleges keen to keep up took to abandoning traditional teaching methods. Plaster casts disappeared from life-room corridors and life classes were demoted. Lawrence Gowing, who in 1975 was to become Coldstream's successor at the Slade, went through an abstract phase himself at this time, though he argued eloquently and persistently for the central importance of painting from life. "Linked to a growing sense of painting in time, painting as narrative, painting in his model's life and in his own and most of all to painting as the image of mortality."[11]

In 1964 the new Principal of Norwich School of Art, John Brinkley, applied for diploma status and made Edward Middleditch Head of Fine Art. Among the visiting lecturers invited that year by Middleditch was Freud, who did not get on with him. "Unfortunately. He was a horrible man, had a real grudge, and he was semi-anti-Semitic." Freud went to Norwich one day a week, usually driving down for the day but sometimes staying in a hotel overnight. For a two-week life-painting course he demanded a studio where he could work uninterruptedly with those students who wanted to do life painting—a novelty at Norwich—and full-length mirrors for all.

"There were only eight or so students and they were duds as a rule as Norwich couldn't give diplomas. My swansong was in the last week: this project about doing naked self-portraits. And I gave them this talk: 'You'll be dead very soon and I want you to do naked self-portraits and put in everything you feel is relevant to your life and how you think about yourself and not think that this is a picture on the way to perhaps doing a better picture; I want you to try and make it the most revealing, telling and believable object. Imagine you are going to be painters. Tell people you've been alive and haven't been negligible, or little worth it. Make a visual statement and forget your inhibitions and be over the top. Take your clothes off and paint yourself. Just once.'

"The one thing the students had in common was a sort of innate timidity of a very agreeable kind but the antithesis, really, to the abso-

lute cheek of making art. So I thought the best thing I can make them do to reveal themselves is naked self-portraits. I tried to get them to do something really shameless."

A life-room rule was that male and female nudes were not allowed within sight of each other in the life room. Word got to Principal Brinkley about the project. "The head of the school said, 'I'm very worried about what you're doing.' He said, 'I'll go along with you, but I don't mind telling you I feel really uneasy about this.' Some of the parents objected." As it was, several of the girls agreed to take their mirrors and paint themselves in the privacy of their bedrooms. Lynda Morris, who came later to the Art School as curator and lecturer, was told about the peripatetic teaching practice to which Freud resorted. "The legend is that he spent most of the time driving around in a big white Bentley going round to each of the girls' homes to give them individual tutorials."[12]

Freud knew that misunderstandings were bound to arise. "I realised some of them felt they'd got to do it at home: they couldn't do it in the school. I went round and got bad receptions from one or two parents." He also recognised that getting others to paint themselves was a vicarious way of painting himself.

"I realised I was doing about eight pictures: 'look no hands.' I mean, I tried too hard; in fact it was a kind of winding-up: the end of teaching. And there was a bit of furore. The head said this put him in an awkward position as there were phone calls from parents, and so on, even to alert the police." Freud assured him that they were over-reacting. "I drove around for a week or longer going round blowing on these little embers. I was so keen to do it myself. They did specimens of my sort of work."

To paint oneself naked is a bracing exercise, not least because it obliges the painter to face up to the difference between bare truth and wishful thinking. A distinction laboured by Kenneth Clark in *The Nude*, published in 1956, a lecture series picking up, as he saw it, on the endeavours of "eighteenth-century critics to persuade the artless islanders that, in countries where painting and sculpture were practised and valued as they should be, the naked human body was the central subject of art."[13]

Freud found the book uninspiring. "I've got a copy. I couldn't read it all. I was put off by things like 'How come some naked sculp-

tures in the ancient world gave a *view of generosity*, especially when the knees are apart?' Even the most unadventurous person knows about knees apart. Even Henry Moore.

"I think K. loved a nude and that he was rather the opposite of some people who, through sex and love, become more loving and precious. His temperament sealed it off: it was *'pas devant les . . .'* I remember being rather puzzled, and slightly shocked, when he said, 'God, Picasso certainly knew . . .' 'What a wonderful figure,' he would say. And 'good legs.' Which was absolute bollocks. Though I can concede 'there's a damned attractive woman.' He made it clear he liked imparting information. It was something in his nature: being very strong, autocratic and rich."

Called upon by Herbert Read in 1958 to name his favourite picture, Clark nominated *Miss O'Murphy*, his explanation being that "Boucher has enabled us to enjoy her with as little shame as she is enjoying herself. One false note and we should be embarrassingly back in the world of sin."[14] To him, the student of ideal form, nakedness needed rectifying. "Photographs of naked models are almost always embarrassing. In almost every detail the body is not the shape which art has led us to believe that it would be." More than once Freud heard Clark state, with an air of off-hand profundity, "There are three great mysteries in life: sex, fear and death."[15]

Mysteries? Freud preferred the Goncourt brothers in aphoristic mode: "Man is a mind betrayed, not served, by his organs." And: "As a general truth, it is safe to say that any picture that produces a moral impression is a bad picture."[16]

Sickert's essay "The Naked and the Nude," written in 1910, lingered on the need to treat the nude, in studio or life class, as an unadorned proposition. No talk of mysteries, no lofty parallels. He argued that any ordinary naked person was better to paint than a statuesque nobody and that drapes—sheets, towels—were desirable. Degas had shown him that. "Perhaps the chief source of pleasure in the aspect of a nude is that it is in the nature of a gleam—a gleam of light and warmth and life."[17]

"I can't be pressed really"

A hazy shot of the sun setting between the shoulder and legs of a Henry Moore reclining figure was used for the dust jacket of a lavish seven-guinea coffee-table book. "A new kind of book about a new situation," the blurb claimed, the situation being that, arguably, London had become as much an artworld capital as Paris and New York. Published in October 1965, *Private View* was designed by Germano Facetti in collaboration with Lord Snowdon—husband of Princess Margaret and "artistic adviser" to the *Sunday Times*. Though it proved too expensive for the English market, it sold well in the United States, where Time Life were the publishers and where *Time* magazine was soon to carry a cover story on "Swinging London."

Many of Snowdon's photographs of dealers in their galleries and painters in their studios had already appeared in the *Sunday Times* colour supplement. He tried, he said, "to echo the mood of their work," meaning that most of his photographs had the pace, the swinging pace, of bright Sunday journalism. Beyond Sir Kenneth Clark, suave in Albany, and Anthony Blunt at the Courtauld and Harry Fischer yelling at Frank Lloyd over a business letter, the sixties scene unfolded, a world of veteran Surrealists and pullovered Constructivists, Eduardo Paolozzi testing his strength against one of his colourful Moloch sculptures, Hockney dazzling and nearly every art school busy discussing life-class replacement and the desirability of fibreglass sculpture. Kokoschka, Epstein and Moore, Hepworth and Nicholson, Sutherland, the St. Ives School, the ex-Royal College Pop

Art squad, as they came to be labelled (Blake, Caulfield, Hodgkin, Kitaj), dealers (Erica Brausen, Helen Lessore), administrators (Lilian Somerville, John Rothenstein), critics (David Sylvester, John Berger) passed in review, commented upon by the *Sunday Times* art critic, John Russell, and Bryan Robertson, Director of the Whitechapel Art Gallery.

Bacon's face filled a page, full face. As Freud had painted him and Deakin had photographed him. He was among the pre-eminent. Freud, now in the middle generation, came later in the book, inserted between Roger Hilton and Frank Auerbach. "Few painters can be more hypnotic in close-up," the caption read.

Freud's face over-exposed by Snowdon and enlarged to amazing graininess ("looking," as he said, "like a Mervyn Peake") was the biggest head on any page. "I had a letter and so on and he came over and we talked. I didn't want my room to be photographed so I said, 'I've got a really good place,' and when he came to photograph me I took him round to the rag-and-bone man's place under the canal-side arches." Over the page was a double spread, also grainy, of a deserted Clarendon Crescent: empty, that is, except for Freud in shirtsleeves with cigarette, standing in the middle of the street ("didn't know it was being taken, which makes it sort of good, surely?"), a van parked at a distance and, close enough to read the number plate, his own car parked outside a house with broken windows and crumbling windowsill. He could be a landlord collecting rents. "He has a habit of living by extremes," the caption says. "It happens that the car is a Rolls-Royce." The shots of him seated among heaps of old clothes as though he owned them were omitted.

John Russell summed up Freud in four paragraphs, three of them brief. He noted a capacity to talk his way out of anything.

As a serious painter in the mid-1960s Lucian Freud has almost every possible handicap. He bears, to begin with, one of the great names of this century. He has had the burden, hardly less heavy, of adulation in first youth. He is preoccupied, finally, with a kind of painting which is now widely regarded as disreputable.

By way of defence against all this, Freud virtually went underground: living in houses already overdue for demolition, seeing a very small number of people from the top and bottom

*ends of society, exhibiting his work rarely or never. In an art scene
infiltrated by puffery and public relations, Freud retains an entirely
radical attitude to the public.*[1]

Freud edgy in the Crescent, waiting for Snowdon to stop fiddling
around with his camera and then come with him to take a look at the
rag-and-bone shop, is the classic outsider, stylishly aloof. For *Private
View* this was the telling image and *Woman with Fair Hair—Portrait
II* and *Resting Nude—Portrait IV*, the two paintings reproduced, in
black and white, postcard size, were of little more than pathological
interest. "They might have been painted in the condemned cell at
midnight," John Russell suggested.[2]

The four McAdam children, Jane, Paul, Lucy and David, born between
1958 and 1964, were barely aware of having a father. Jane McAdam
remembered Freud turning up one day when she was about seven.
"Lucian—we always called him Lucian—suddenly appeared outside
the house. 'Jane, come here,' he said. 'Go and get your mother.' He
didn't like to come in when we were around. We always thought
he was famous, though he wasn't really then. We had a booklet—
the 1963 Marlborough catalogue—in the front room with pictures
of naked people." That gave them something to relate to. "People
would see it and change the subject." He never touched them, she
said, but would look at them intently.[3]

Freud avoided involvement and stood aside from responsibility,
even maintaining that Katherine McAdam had said to him that on
no account should he tell anybody that the children were his. Which
suited him. "I never saw them when they were children, mine or not is
not the point. I got a covenant made when I hadn't any money so that
they always had some money. They don't know that." After a while
Jane Willoughby acted as his banker; although the McAdams never
met her, it was she, he said, who saw to it that quarterly payments
reached them.

Eventually Lucie Freud found out about the brood (Jane under-
stood that her mother met Lucie Freud through Lucian) and for some
time sent monthly cheques. "£15 usually," Paul McAdam said. "She
was a real constant." Presents came for birthdays and Christmas.

"Generous presents," Jane said. "She gave me a recorder. We saw her as a sort of fairy godmother, even with her persistent manner, which I got the brunt of." How she had learnt of their existence she did not know. "She turned up on the doorstep in Fernhead Road where we lived."[4] Freud regarded this development as yet another opportunity for his mother to do the right thing, excruciatingly so. "She was very altruistic and had a very noble motive. I kept out of the line of fire."

Lucie Freud would collect Jane from Barrow Hill Juniors, round the corner from St. John's Wood Terrace, and wait with her until Paul arrived from the infant school, Robin's Field; or else they would both go and meet him. "She insisted on seeing our reports. She went through them, as she had done with Lucian's, and was keen to rectify my failings. 'Your writing shows such willpower.' I loved the attention. She sent me dictionaries as a response to a comment on my spelling and an art book on Henri Rousseau by André Salmon: it came after a good report on art. She took me to tea every day after school. A Danish pastry every day. And she wanted a copy of my school photo, but it was when my teeth were dropping out and I wanted her to have one with teeth. 'Please,' she said, insistent. We felt very secure with Lucie."[5]

Paul McAdam was shy, introverted, bullied at school. On the way to meet Jane after school one day, when he was six or seven, he was knocked down by a lorry and taken to the St. John and St. Elizabeth Hospital in Grove End Road, St. John's Wood. "I was in a coma for a few weeks. Lucian was in the hospital too, apparently, having his appendix out. A parcel of toys came from someone, from the lorry driver, I thought, but how could he have known where I was? I soon did for the toys; I used to take everything apart. It was two years before I recovered."[6] His primary school headmistress got him a place at Woolverstone Hall near Ipswich, a boarding school with free places for pupils from the Inner London Education Authority deemed to need the benefit. "I went to this Georgian country house with horses in the fields then home to the council estate. I was homesick always.

"All our security on our father's side was through our grandmother, not Ernst. He was reassuring and friendly but it was mostly Lucie. It was her thing."[7]

Freud reckoned that he did what he could, short of exposing himself to commitments of any sort. "I used to give Kay money and

sometimes hadn't any. And she said—and I hate being threatened, even if it's something I want to do—'If you don't, I'll go and see your parents,' and so I didn't, she did, and I didn't see her again. I dreaded my mother talking to me about it." The last thing that he ever wanted any girlfriend of his to do. In 1966 she moved with the children to a council estate in Roehampton, South London, where, as far as he was concerned, that was that.

"There was a massive rift when I was six or seven," Jane said. "We did a flit: my mother gave Lucie a forwarding address so that Lucian could find us if he wanted to."[8] He did not. She had gone to his mother.

Lucie Freud went on asking for school reports and sending money. "There seemed to be a sort of conversation going on through the type of presents she gave," Jane remembered. "We all looked forward to her monthly letters which always included her cash gifts. They arrived like clockwork in the same post on the same day each month. There was never any variation in about ten years and she never missed a month.

"When I was eleven or twelve me and Paul went to see her. Trooped off to St. John's Wood Terrace. She had the table laid for visitors, cakes on the table, and poured the tea from a teapot with a minute long spout, her hand shaking. 'How lovely to zee you,' she said. We talked about the past. Paul and I, we'd write letters talking about 'Pops.' (He didn't know.) When my mother was resentful sometimes it came out. 'Write to your father,' suddenly she said."[9] The aquamarine ring that he had given her was lost and the black lacquer box, given her by Lucie Freud, got broken.

Rationalising his undomesticity, Freud used to say: "If you're not there when they're in the nest you can be more there later." He often talked about being unable to treat all children fairly. "Fairness is a disaster. You have to go by what's needed at the time."

"I am still mystified by how L. managed to fit in the McAdam ménage with all the others," Anne Dunn said. "Poor girls perhaps, but why did the mother comply over such a long and fertile period? L's sometimes 'monstrous philosophy' of his life does mimic certain of Grandpa's more worrying 'betrayals' in his work and relationships."[10]

Certainly Freud could be monstrously possessive over certain things dear to him. "I had a passion for those covers made out of

Crimean War uniforms: red and white and black and insignia. I used
to have them on my bed. It was folk art and I had a really good one
and Kay said she'd mend it. Years and years and years went by and I
said, 'Could I have it?' But I didn't get it back. Terribly odd, as I saw
her very little."

"I've always thought of friendship as where two people really tear
one another apart and perhaps in that way learn something from one
another," Bacon said to David Sylvester in a broadcast interview for
the BBC in 1966.[11] At that time his friendship with Freud was still har-
monious and close enough for him to send a telegram telling him how
lonely he was and in need of his friendship. It was his responsibility
for George Dyer that had become exasperating, an involvement that
began in the autumn of 1963, as Freud remembered. "They met in a
club and went home and Francis was terribly pleased as George gave
him an enormous gold watch which he'd stolen the night before."

Bacon painted Dyer swerving on a bicycle, intently shaving, shy-
ing away as though just slapped, paintings that had the stamp of ardour
and affection then degenerating into impatience and, finally, drear
remorse over the sad, sozzled cipher that Dyer eventually became.
He came to treat him as a dramatic projection, his own worst enemy,
victimised and puking, baring the exposed neck; unlike Freud, who
painted him in friendly fashion. "All sorts of people liked George.
He had been with a gang—the Richardsons, I think—he had to carry
something for them and Francis said, 'I can't believe George could do
it.' Useless." When he came round to Gloucester Terrace and sat for
Freud, the idea was that this would occupy him regularly while Bacon
was working. "Francis said to George: 'Just let him do a head, not
more: he's only good at heads.'" Head and upper body only, shoulders
slumped, *Man in a Blue Shirt* is the engaging and inept petty criminal,
a man appreciative of this prolonged and unaccustomed attention.
"Really sympathetic. He wasn't tough. He had a cleft palate, a strange
voice, a hand-washing mania and a tidiness and cleaning-up mania:
never so shocked as when he went into Isabel [Rawsthorne]'s flat.
He was having lunch once with Francis and I and Hermione Bad-
deley, and her slave Joan Ashton Smith, who couldn't understand
George, because of his common accent, and his stutter. She wore a

huge toque, as women then did; George took his fist and rather gently hit her on the hat, which went over her face.

"George had never looked at any painting ever in his life. He'd been a sort of lookout man for a gang, a very bad one, and he saw a book of Hals, he looked at it, and his face absolutely lit up. He said, 'What a marvellous idea, making people look like that.' He thought they were modern. That's right really. George was always looking at books. He was very amused by things I took for granted: girls and whatever. His point of view was interesting. He was intrigued by some people and couldn't understand why, or what, or how; or being patronised by Deakin, who called him Georgy Porgy."

Once, in the Colony Room, Michael Andrews offered to buy Dyer a drink but he refused, insisting that he had more money than Andrews, as he understood him to be a painter. "What do you do?" Andrews asked. "I'm a thief," he said. Living with Bacon, he had found, was demoralising; there was kindness and indulgence, but the work habits and lordly ways plus the masochistic requirements took it out of him. The relationship drained Bacon's generosity. Freud regarded this as characteristic behaviour. "Francis used to say, 'I take up with these people because they are strong and tough and then it turns out that I'm so much tougher than them.' He said to me it was hard being with George, with someone he couldn't talk to, to do with ideas. He got terribly lonely. Queers do. Also Francis liked being knocked about a bit."

Bacon and Dyer went to stay at Saint Estève in the South of France with Rodrigo Moynihan. Anne Dunn, by then married to Moynihan, was not there but, she remembered, their child Danny was, and his nanny. "Francis was cruel to George. The s/m started upstairs and the nanny fled to Rodrigo's bed."

Freud took Dyer up to Scotland with him to stay at Glenartney, Jane Willoughby's Perthshire shooting lodge, passed on to her in a semi-derelict state ("a ruin, shepherds sleeping on the floor") after Tim Willoughby died. He painted him in an upstairs room at the end of a long corridor hung with antlers. "I took him there to get him off the drink. Francis was very odd about it. I said, 'We had a nice time, played billiards,' and Francis said: 'No he didn't: he was very cold there.' I think that he wanted to go on tormenting him in London. Going to Glenartney wasn't remotely done in any secretive way, I

talked to Francis about it and said that when things are bad I go up there quite a bit and work. I know it annoyed him. It was a bit like interfering in marriage rows. Francis said George was freezing there, but he could have asked for another blanket.

"George was the sort of person who would be protective if someone was in a bad way. He was incredibly brave and had been knocked about by the police. He was completely unvenal and had proper feelings. He had one ambition: he wanted to have a newsagent's; when he got more far gone Francis suggested it but it was no good by then; it was awfully tragic really: Francis stopped fancying him and George was in love with him. Francis got him these marvellous—horrible—grand flats, but he wanted to be with *him*. Francis hoped he'd get off with someone but, Francis said, under drink he was impotent and so people took him home and in the morning didn't want him any more. He had DTs.

"I took him down to Ian Fleming's awful place, Sevenhampton—Ann must have liked him—and drove him back in the middle of the night because of his DTs. He saw things and was terrified. Francis would always hide his strong pills for blood pressure and stuff. 'If I don't hide them I know George would eat them all and I just can't let him,' he said. And then he said: 'I've often thought of forgetting to hide them.' Francis was really concerned. George was so demoralised and jealous of Francis. It's impossible to judge, but Francis was horrible to him; it's very hard to behave well . . ."

Bacon's *Portrait of George Dyer and Lucian Freud* (1967) presented them as an odd pair on a bench in some eternal anteroom, stuck with one another behind a glass-topped table, heads irritatedly blurred, nothing to look at but an ashtray and a stuffed cat.[12]

There had been better times. In 1964 Freud, Bacon and Dyer went to stay in the Balmoral Hotel, Monte Carlo. "Francis invited me, so the three of us went, for a fortnight or ten days. We went swimming in the pool. Then there was a fuck-up as we lost all the money in the Casino." That left them idling at the hotel until relief came from London. "Miss Beston [Bacon's assiduous minder at the Marlborough] was away and when Francis sent for more money only dud Gilbert [Lloyd] was there and he said, 'How shall we send the money?' Miss B. would have just sent it. It was really hard and we had a couple of days without gambling money."

Both Freud and Bacon regarded Monte Carlo as a little Emerald City, for Bacon a familiar resort representing glamour and risk, for Freud the place where his grandmother Brasch had enjoyed a historic stroke of luck. "My grandmother married this wealthy grain merchant, very much older than herself, a man of the world who travelled and decided to go to Monte Carlo for their honeymoon. In my grandmother's journal she says her mother was really worried about this and sent her a letter: 'Can't sleep: a relation of yours ruined herself at Monte Carlo, lost a fortune. Promise me you won't go to the Casino.' Grandfather after a delightful dinner said, 'For a treat tonight we are going to the Salon Privé: I've often played roulette, very interesting game.' My grandmother thought OK, she wouldn't tell her mother, dressed up to the nines and went to the Casino. Even so they said, 'Have you got any identification?' Grandfather had his passport; Grandmother had nothing except, in her handbag, she had the worried letter from her mother and she got in on the strength of it, had three bets at the roulette on zero, which came up three times. Treble Zero. To her it was the most memorable occasion of her life.

"Francis was rather obsessed with a mysterious house, high up, at the end of the bay; he said it was where Pavlov had done those experiments with monkeys, and he talked about this Russian who had information on Pavlov. Miss Beston told me that she and Francis were walking somewhere there once and he suddenly said, 'This is where we lived,' meaning him and 'the Russian,' a real influence pre-war. He said to Francis, in French, 'You don't know how to behave yourself,' meaning how to hustle like the boy in Warhol's *Flesh*. He lived off his wits, anything negotiable—and women perhaps—and certainly had an affair with Francis. He made Francis feel that his strange eccentric behaviour needed style."

Hanging around, waiting for money to arrive and the Casino to be open to him again, Bacon had fretted. "Francis couldn't swim or walk, or only for short distances, and I wanted to draw George and Francis told him I wasn't any good at bodies, only heads, therefore not to do it." Accomplishment being in his view decorum, he was quick to decry aptitude. Not that he ever badmouthed Freud as witheringly as he dealt with those he really despised. As when he met Michael Ayrton who had asserted in a broadcast on "The Nature of

Drawing" that he, Bacon, couldn't draw. "Is drawing what you do?" he asked him. Pause. "I wouldn't want to do that."

To Bacon, drawing, Ayrtonic at worst, was something he liked to think he needn't be bothered with, it being—one way and another— the pursuit of stylishness if not exactitude. For him there was plenty to be done by other means, by shadow play and calculated swipe. He insisted that the reflections of onlookers and splashes of light added extra layers of accident and obscurity to his pictures. Freud too liked having his paintings glazed, not so much to gain reflections but (particularly when the quality of non-reflective glass was improved to near-invisibility) because of the protection it affords. "Mine is a substitute for varnish, plus keeping the London dirt from seeping into the paint when it's drying. I like people to be aware of the form and not the PAINT, which glass, by its nature, obliges them to do, to some degree and that suits me."

In 1967, the year Bacon was awarded the International Rubens Prize, he and Freud went to Paris to see an Ingres exhibition at the Petit Palais. Why Ingres? "My choice not his," Freud said. "The way he liberated pictures seemed so marvellously potent. Through his extraordinary discipline, the drawing is as good as any drawing there is. You get really excited about an Ingres fold in a curtain: said in such an incisive and economical way." He quoted Baudelaire on Ingres and the nude. "He depicts them as he sees them, for it appears that he loves them too much to wish to change them; he fastens upon their slightest beauties with the keenness of a surgeon, he follows the gentlest sinuosities of their line with the humble devotion of a lover."[13] Freud saw in Ingres what Baudelaire had observed of him: "His method is not one and simple, but rather consists in the use of a succession of methods." To be economical and incisive was to be more exacting, ultimately, than to be compulsively spontaneous-looking like any Bacon.

At a birthday dinner for the novelist Angus Wilson in the early seventies, Freud was seated next to the novelist Margaret Drabble. She turned to him. "'So you are an admirer of Angus' fiction.' 'I like him, not the books.'" She looked puzzled. Freud had first come across Angus Wilson at the *Horizon* office thirty years before. "'How can

you dislike his work?' 'Because it reminds me of Zola.' 'Yes, Zola probably is his hero.' 'I don't like Zola. Full of false feeling.'"

For all the "tremendous drama, excitement, sex and passion" of *La Bête humaine*, Freud was unconvinced. "The characters aren't real. I felt very uneasy about that type of realism." Not Zola, not Dickens, not caricature and stereotypes for the true realist. Henry Mayhew was more to his taste, and of course Balzac.

"Balzac is completely real, even when he is just saying what his characters spent on things."

Angus Wilson, on the other hand, tended to splurge adjectives ("'This is really wonderful,' cried John, with extra hearty laughter, pushing back his curly hair with a carefree boyish gesture"). The equivalent in portrait painting is the showy detail—presentation overriding particulars—and, being more susceptible than any other genre to whim and ingratiation, it interested Richard Hamilton for a while in the period leading up to his 1970 Tate retrospective. *Portrait of Hugh Gaitskell as a Famous Monster of Filmland*, a mix of mask and newsprint image begun shortly after Gaitskell died in 1963, was a vengeful death notice indicating disapproval of Gaitskell's attachment to nuclear weaponry as political instrument. A year later Hamilton turned his attention to celebrity constructs. A layout pad for *Time* magazine covers came into his possession, enabling him to pose himself in sketchy mock-up as a *Time* chosen one of world renown.

Deconstructive gambits such as these were of no interest to Freud. "I did find, less than I do now, Richard Hamilton oddly boring in the way that he kept out of his work the thing that I was trying to get in, while keeping himself in. Which I thought self-serving. Every now and then things came alive. At the Robert Fraser Gallery I saw a lot of his photographs of Whitley Bay." These were enlargements from a postcard of the beach at Whitley Bay in which half-tone dots vied with blobby bathing caps. Magnified beyond legibility, identities become indecipherable. As was also demonstrated the following year in *Blow-Up*, Michelangelo Antonioni's elaborate take on fashionable photography, grainy photography and Swinging London. Another Hamilton project involved persuading colleagues ranging from Bacon to Joseph Beuys, Henri Cartier-Bresson and Gilbert & George to take Polaroid snaps of him, the idea being that these would be delegated self-portraits with Hamilton provoking his fellow art-

ists to self-parody. "Lunching in Islington, he gave Francis a camera and said, 'Take a photo.' And as he did he jogged it to make it more a Bacon."

Inexhaustibly circumspect, Hamilton dissected the aims, the means and the foibles of portraiture. Bacon on the other hand endeavoured to out-Bacon himself or, as he put it, "Slightly complicate the game." Whereas Freud, possessed by the need to have the sitter present throughout, could not detach himself from his belief in character, real character, face to face, as the working conditions. "The act of sitting, which takes a long time in my case: that constitutes a connection, obviously."

Bacon's paintings of Freud from the 1960s, notably his 1964 *Double Portrait of Lucian Freud and Frank Auerbach* and his 1965 *Portrait of Lucian Freud* and groups of *Three Studies for a Portrait of Lucian Freud*, all closely informed by Deakin's photographs of him, were systematically dramatised in the making. Bacon amplified the feel of shapes, exaggerating how it feels to sit, to slump or to fidget to avoid a crick in the neck and cramp behind the knee. He loved a good whiplash assertion of fellow feeling. This often involved interchanged body parts. "He gave me his garters sometimes, and huge voluptuous ankles, which I never had."

For Freud portraiture was truth-telling and all-embracing. Where Bacon could only feel that he had to animate and quash, as though haranguing his every proponent into submission, Freud used people and things even-handedly once it occurred to him that they interested him; after that it was up to him to make something of them. And then in the mid-sixties the time came when he began seeing the face in the mirror not only as himself heroic, or himself moodily distanced in a hand mirror propped on a chair, but as himself related to others: himself parental, albeit detachedly so.

Placing on the floor the mirror salvaged from 20 Delamere Terrace, he studied his reflection from below. At that angle the ceiling swung into view and the light fittings floated overhead as though flown in from some recent Bacon. After leaving, barely begun, an initial painting of himself in the looming space he persevered with a second version into which he inserted Ali and Rose Boyt as diminutive onlookers keeping company with his towering image. *Reflection with Two Children (Self-Portrait)* is the closest he ever came to overtly

emulating a Bacon tableau. The children served as markers, stuck into the bottom left-hand corner like family snaps in a living-room mirror. Their incongruity may be variously interpreted (the artist's hand is clenched as though holding puppet strings) but essentially they were posed as duplicates of the son and daughter of Seneb the dwarf in a 6th Dynasty family group reproduced in Freud's constant resource, his much thumbed *Geschichte Ägyptens*. "They sat there. That Egyptian tomb idea rather."

Freud, foreshortened, holding himself stiffly in a blue-grey jacket worn without a shirt, substitutes himself for little Seneb, the electric light harsh on his forehead and glowing in dimmed reflection over his shoulder. The ceiling above is no mere background. Filling the mirror, it contains distance. "I used a palette knife to make the air round me."

"When we try to examine the mirror in itself," Nietzsche said, "we eventually detect nothing but the things reflected by it. When we wish to grasp the things reflected, we touch nothing but the mirror. This is the general history of knowledge." A mirror image, ready flattened and detached, contained on a surface, presents distortions as fact. Similarly, in his *Geschichte Ägyptens* the dense photogravure plates take the viewer back a few millennia to the anonymous yet idiosyncratic heads of sculptors from an unearthed workshop and to the heads of pharoahs, one of whom, Akhenaten, was arguably the first human being to have his individual image—his true portrait—propagated, potentially, for all time.

Rose remembered grumbling at having to stay still, their astonishment at the array of cakes laid out in the teashop afterwards and their amazement at their father taking a single bite out of several cakes. Liberating, they felt.

In August 1965 Andrew Wordsworth, a classics master at Bryanston, wrote on behalf of the school's Da Vinci Society asking if Freud would care to come and give a talk. "Because you are the Bryanston painter whose work I admire most and this situation hasn't changed in the past sixteen years." He enclosed a stamped addressed postcard but no answer came.

By this time Freud was establishing something of a routine, pro-

ceeding with painting by daylight and painting by artificial light, day shifts and night shifts. The need to find and secure sitters devoted enough and reliable enough to enable him to work meant that he was constantly on the lookout, readily on the prowl. A neighbour in Gloucester Terrace was out one day with her son, a golden-haired child, and Freud, whom she did not know, stopped and touched the boy's hair, assessing it. She stood by, Freud walked on. Nothing doing on that occasion but potential sitters, he told himself, could be sighted anywhere. Obviously Colony Room characters—Deakin, Harry Diamond—were available; amenable, that is, to putting in the hours for no more than the price of a drink or two. But keeping them coming regularly and on time was another matter. That he was not necessarily friendly with such sitters was not a drawback. "People who irritate me: that has sometimes helped. The dislike can be very strong, but I'm very strong. You can dislike two people in two different ways. And what they are there for is so interesting." The desire to be painted, he recognised, may indicate anxiety to please and lack of self-esteem while vanity, the obvious motive, is a shortcoming in that it demands indulgence or endorsement. Bernard Breslauer, another Colony Room regular at that time, seemed desperate for attention, Freud thought: "An animal of a peculiar kind." Breslauer was an eminent antiquarian book dealer; he bought a painting from Frank Auerbach's first Marlborough show in 1965 and at the same time commissioned a portrait from Freud who, while protesting that he never worked to order, was prepared to oblige when financially pressed.

"I did it as he looked rather like my brother Stephen. Father had been a book dealer in Berlin, an antique book dealer in New York. He was so horrible I changed the picture: I put a jersey on him to make his blubby chins more blubby and chinnish. He took the picture to Muriel's and passed it round and they said how cuntish it was. He told people he destroyed it, but I don't think that he did. [He did.] I saw him in the street in New York once, dressed in tartan, and bald."

News having reached the Bayswater end of Gloucester Terrace that a well-known portrait painter was living at the council-owned end, Freud was approached to paint a neighbour, a brigadier-general with a scar down his face, which tempted him. A fee of £500 was

agreed but proved more than the regiment was prepared to pay. David Somerset at the Marlborough steered several clients his way, Charles Clore's son Alan, for example. "He backed Polanski and others in films. David said, 'Have you thought of painting Alan?' I said no. He was always preening his hair. He said, 'Meet him: he longs to be drawn. Dinner at L'Étoile.' Alan, preening his hair, said, 'I'd really like you to paint me.' 'OK,' I said, 'but could you pay me in advance?' 'Yes,' but he wrote a cheque in pencil. Came to sit and I did lots but rubbed it out. Never came again. He said to David, 'You know it was awfully good, but he destroyed it.' So I got £350 for one sitting, and that was quite a bit then."

Commissions from persons prepared to sit for as long as it took and, ideally, pay in advance were not to be spurned, particularly when he was in urgent need of ready money. There arose, for instance, the possibility of painting an Oxford college head.

"I had a letter from a chemist at Jesus College Oxford and it said, 'We had a discussion about having our Principal painted, and we had a Fellows' dinner to decide, and I hope you'll be pleased to hear the choice fell on you.' I wrote back and said I've hardly ever done any commissions—successful ones—as I need to work in my room with people I know, not work from a stranger in another place. So it seems not realistic. I wondered could I see Dr. Christie before making up my mind.

"I got a letter back. 'We appreciate your difficulties because Dr. Christie would get upset if you decided no. But I have an ingenious way round the problem. Once every few years we have distinguished visitors to dine at Jesus, so we could invite you and place you strategically where you could see Dr. C.' So I went to Oxford, had a wonderful time. There are Elizabethan portraits in the dining hall, and a Henry Lamb of a blind Principal with four pairs of binoculars. Dr. Christie was sort of Scottish, youngish-looking, and a bit of an old woman. That's an insult to nearly every old woman."

John Traill Christie, Principal of Jesus from 1950 to 1967, was, the budding poet Dom Moraes had found, "a very kind man." Christie had admitted Moraes as an undergraduate, against advice, and supported him against most of the senior common room when his turbulent relationship with Henrietta Law, to whom he was later

married, interfered with his studies; he had even attended a poetry reading by Allen Ginsberg, arranged by Moraes, and though shocked had remained well disposed.

Freud agreed to do the painting. "I wrote that I'd have a try but must do it in London. 'Right,' was the reply. 'He comes to stay with his daughter.'" The daughter, Catherine Porteous, happened to be working as Kenneth Clark's secretary on the BBC series *Civilisation* and she told him about the proposed portrait. "K. Clark was both impressed and surprised; he knew my father slightly as they had been at Winchester together." Father and daughter arranged to meet Freud for lunch at the Great Western Hotel and took a corner table, Freud worrying about whether he would be turned out for not wearing a tie. "They seemed to get on well: seemed to spark each other off. I remember it being jolly and fun." Shortly after that, sittings began. "Dr. Christie arrived with his daughter, sat down and never stopped talking. 'And now, Freud, those paintings made of dots and dashes: what's so special about them?' He'd been headmaster of Westminster and Repton. He came three times, talked about Dom Moraes, it was talk, talk, or down he went, fast asleep. And then I wrote and said, 'Terribly sorry, I'm afraid I can't do it. Magnificent as Dr. Christie looks, I can't work with him in the room.'" Catherine Porteous agreed in retrospect that yes, her father did talk a lot. "But Freud could easily shut him up. He genuinely wanted to know. My father said he kept taking down drawings and chucked them in the basket and being a scrupulous nineteenth-century figure he didn't take one when Freud was out of the room. The excuse, my father understood, was 'the paint won't run.'" And that, Freud thought, was the last he would see of Christie.

"Two or three days later, bang on the door and there he was in top hat and spats. 'Your letter,' he said, 'played into the hands of my enemies.' I couldn't reply. Then he said, 'No hard feelings, Freud . . . What's the matter with me? Nothing, you say? Come off it . . .'"

Word went round the college that Freud disliked Christie and wasn't prepared to continue, so the commission was transferred to Peter Greenham ARA who painted him in subdued tones, to the satisfaction of the fellows of Jesus.

"I can't be pressed really. It put me off doing anything like it again."

A double portrait involving characters he knew well preoccupied him instead: two heads set together in much the same pose as *A Man and His Daughter* but with the charged air of a Hals marriage portrait. *Michael Andrews and June* was a non-conversation piece: two heads, two characters, mutually protective. Andrews, his stare averted, plays his part with resigned concentration. "The success of the marriage," Freud remarked, "was to do with her outraging his sensibility non-stop. His gritting of his teeth was the same as being fondled." Andrews admired Freud as a painter, considering him second only to Bacon, and sometimes went out drinking with him. Freud found it hard to get drunk, try though he might, and so drank little; Andrews got drunk easily, which was why he was arrested the night Tim Behrens married Harriet Hill.

Freud and Bacon called one evening at Duncan Terrace, where Mike Andrews and June lived. She remembered it clearly. "We were having a screaming row. The bell went. It was Francis and Lucian. 'We called round to see you.' 'June and I are having a screaming row,' said Mike. 'Oh are you?' said Francis. 'Maybe we can be of help.' Mike kept him out. He'd have had Mike and I killing each other. It took the sting out of it, being interrupted."

Freud tried working from the two of them together initially then scraped June out and did her separately; she ran the Perfume Centre in Burlington Arcade at the time, and sat for him after work. "Lucian would pick me up and drive me home to paint me. Once, outside his place, a man in leathers got off his bike and said, 'Mr. Frood?'

" 'Who wants to know?'

" 'I do,' and he tried to stick a paper in his hands, but Lucian kept his hands behind his back, so he stuffed the paper in Lucian's jacket and left and Lucian said, 'We are going to see Ted,' and drove somewhere, and I sat in the car while he spoke to Ted. Then I went off home with him, changed into the dress for the picture and sat. Mike told me to tell him that after a day's work I could only sit for two hours and I noticed, as the two hours were up, that he would start to paint more dramatically, all moves and pressure, to stop me saying anything. I said I was hungry once and he went off and came back with a tooth mug with toothpaste on the rim, sloshed it full of neat whisky and said, 'Drink that and shut up.' "

Experienced though she was at coping with men in the clubs, June

was nervous of Freud. Every time her arm slipped off the back of the sofa he would shout and during breaks he would edge up to her, she said, and she would calculate the distance to the window and tell herself that if he made a pass at her she could take a running jump. The room was on the first floor so at worst she would only break a leg. Ted appeared. He and Freud were going gambling and he suggested dropping June home. "We haven't got time," Freud said. "We'll drop her at Paddington station and she can get a taxi. I can't bear her company for another minute. She's been moaning." One night he did drive her back to Duncan Terrace where she saw that the light was still on so she asked him if he would like to come in and say hello to Mike. He said no. "I'd like to but I couldn't stand another second of your company."

"Another time a police siren was going when Lucian was driving me home. He jumped the lights. I said, 'Pull over,' and he did, and I suddenly saw a load of purple hearts on the dashboard. Police got out and came towards the car and I grabbed the bottle and put it in my bag. I thought if he got lippy they'd have him." Amphetamines, or uppers, were a boost, Freud found, when working long hours, or being otherwise hectic. "I used to have purple hearts, as Mike did. Dr. Moynihan would dish them out: he was always very nice in that way. Mike and Frank had them. Liked staying up all night. I must have stopped very soon because I had some left for a very long time. Didn't need them, got them just for Mike. I never slept much."

The nights Freud drove June home, Michael Andrews would have been working on *Good and Bad at Games*, a set of three paintings done between 1964 and 1968 in which he showed three filmic takes, as it were, of a nocturnal gathering by a hotel pool with each foreground occupied by a dozen or so figures representing friends and aunts, some bloated, some spindly, some palpably Giacomettiish, their size varying from picture to picture depending on how they were perceived, or how they felt about themselves on social occasions. Among them were his Slade friends Vic Willing and Craigie Aitchison (both of whom Freud strongly disliked). Sitting for Freud, Andrews nursed the thought of body bulk correlating to social skills, conscious throughout that he was being worked from as never before. The painting, completed in 1966, is primarily a portrait of him. Freud caught Mike's long-nosed angularity, his near cross-eyed concentra-

tion on keeping still under the overhead light whereas June is toned down, her arm and hand perfunctorily laid on the sofa's shoulder. "She is in a sense almost a pendant," Freud said. Mike's intent expression cuts across her thwarted expression, he being the guarded figure while she watches out for him. She smoulders; he brings his willpower to the sitting and a characteristic perturbed resolve.

Ten years earlier, in "Some Thoughts on Painting," Freud had remarked on the impact people make, filling the air. "The effect in space of two different human individuals can be as different as the effect of a candle and an electric light bulb." Andrews talked of wanting to feel, when he painted, as if he was "placing the brush on the place on the real thing." Freud put his finger on the congenial disparity between the two.

Michael Andrews and June went to a bookie, Benou Miller. "I gave him it in return for a debt. His place was in Dering Street, off Bond Street: first on the right 'B Miller Turf Accountants.' All the villains knew him. I owed £600 or £700 and said, 'I can give you this instead.' 'Fuckin' horrible thing,' he said. 'If you believe in me, keep it,' I said. But he put it into an auction and Jane bought it for £654, only a bit less than I'd said. He could have got more and when told he said, 'You've made my fucking day.'"

Before finishing the double portrait Freud began working from a new sitter. "I met her at a party at Sheridan's, my ex-brother-in-law. [Sheridan Dufferin, a backer of the Kasmin gallery.] I was a frustrated painter of nudes and wanted to do something about it. She sat mostly during the day, once she'd stopped being a nanny." Penelope Cuthbertson was twenty-three when Freud first knew her and game for being painted first clothed then naked on a sofa, her hair dishevelled, her lips parted as if to spout a trendy mid-sixties mock-cockney accent, the soles of her feet grubby from the bare boards of Gloucester Terrace. Evelyn Waugh (who had been besotted with her half-Dutch mother, Teresa Jungman, one of the original Bright Young Things) had remarked, on seeing her a few years earlier, that she needed a haircut and elocution lessons.

"A sweet girl," Frank Auerbach said. "She worked with the kindergarten in Brunswick Square where Jake [Auerbach's son (b. 1958)]

attended and spoke very highly of Jake as the only infant with whom one could have an intelligent conversation. Lucian thought there were lots of girls like her, very very nice. With the exception of somebody who cleaned for him while her boyfriend was in jail, they tended to be upper-class girls, available in the sense that they thought he was exactly the sort of person they read about in their literature classes: Byron and Heathcliff and D. H. Lawrence and Eugene Marchbanks, the young poet/lover in Shaw's *Candida*. Also the name Freud must have seemed a bit like a title. And also they had time on their hands, so if he called them at eleven o'clock in the morning they'd be ready."

Having had *Girl on a Sofa* photographed Freud decided to dispense with the dress; he then had the painting reproduced as "earlier version" and "final version" in the catalogue for his 1968 Marlborough exhibition, the removal of the mini-dress relating her to a Hogarth "Before" and "After" deflowering sequence. And, for that matter, to Goya, whose *Naked Maja* was, Freud maintained, a private boast. "It's not 'Oh, there's Gertie without her dress on'; you don't feel the clothed one is better: you do get a slight feeling of 'I've done it.'"

Around this period he was enjoying the gossip and memorising favourite diatribes in the journal of the Goncourt brothers. "Woman's body is not immutable. It changes with each civilization, age and way of life . . ." And "The person who does not paint the woman of his time will not endure."[14] He completed seven paintings of Penny Cuthbertson ("I did think 'I'm going to do a whole lot of them'") between 1966 and 1970; they were transformative; there was a dawning assurance in the way she presented herself and the way he painted her, there on the floor, first awake then sleeping, confidently relaxed, her skin lustrous, her status as a "nude" no big deal. Sitting up, as *Girl Holding a Towel* (1967), fist clenched and looking askance, she was the practised accomplice, inured to posing casually.

Reviewing the 1968 Marlborough show in the *New Statesman*, Robert Melville had wondered about the identity of *Naked Girl* (1966). "Who is the model? She is very lean and has straggling, straw-coloured hair and to make matters worse, the artist's ruthless concern with optical realism gives the rib-cage in the foreshortened nudes the look of a nasty swelling . . ." Not being able to put a name to Penny Cuthbertson's rib cage may well have frustrated Melville, yet argu-

ably talk of "optical realism" as an injurious mode was a greater bar to appreciation than Freud's practice of rarely naming sitters. "Partly to do with privacy, but it also seems to me to be pretty irrelevant. Portraits are all personal."

"I get my ideas for pictures from watching the people I want to work from moving about naked," Freud told John Russell. "I want to allow the nature of my model to affect the atmosphere, and to some degree the composition."[15] Each painting being an expression of some degree of intimacy, each was dependent, to some degree, on the complicity of each person involved; that meant there had to be confidence. "Of course a naked model is going to feel vulnerable," he told me once. "The naked person is more permanent."

Anonymity is intriguing. And titles such as *The Woman in White* and *Portrait of a Lady* stimulate curiosity. Similarly, the unnamed sitter lives by appearance alone. Asked if it is not worth knowing that Hogarth's portrait of a burly sea captain represents in fact Captain Thomas Coram, founder-benefactor of the Foundling Hospital and founder of Nova Scotia, Freud's answer was that one doesn't need to know. To name is to advertise: "rather like carrying material—canvas or frame or picture—down the street." And even plain titles carry implications. *Woman in a Fur Coat* (1967–8) was Jane Willoughby in the same chair as Penny Cuthbertson in *Girl Holding a Towel*, who was also *Girl in a Fur Coat*. ("When I did this I thought I was doing a nude.") All wording is loaded: "woman" and "girl" demarcate, while "fur coat" may seem to art historians to incite comparisons with Rubens and "towel" with Degas. A good title, Freud concluded, speaks volumes. "I still haven't read Conrad. My father's yellow-bound edition, which I knew from Dartington: I tried to read them as Francis was keen on *Heart of Darkness*, but I still haven't, except his marvellous titles: *Nigger of the Narcissus*, *Lord Jim*. Had he read further he might have come upon Conrad's wordy but bracing *raison d'être*: "The unwearied self-forgetful attention to every phase of the living universe reflected in our consciousness may be our appointed task on this earth."

"I always had this idea of being able to have an escape. Naturally I've always had a feeling about covering my tracks."

Like Sickert and Matthew Smith, Freud took rooms, not so much to work in but for use as boltholes. "Hideaways, really. I had several rooms I could use in people's houses, and a place up Leman Street, Whitechapel, over a café." One was near Holloway Prison: "a place in Camden Road, a council flat, which I got for Bernardine. Two rooms in a rather rough street, a real dump, up by the Brecknock pub, with evil-smelling stairs like old bacon, a scarlet-carpeted room and a kitchen—bathroom with red and blue glass. Bernardine didn't like Camden Road as Bella got burnt badly there; there were perfectly nice marble fireplaces, but hippies had horrible stoves with doors and put one in and Bella got burnt on it. It was a controlled rent, £140 a year, so I took it after she left, in 1965. Bernardine wanted to follow *I Ching* (3rd edition), and why she went was all to do with that: certain conventions. Like 'never say no to a child.' She took the children to Ladbroke Grove, another flat."

Freud liked the Camden Road flat and decided to do it up. "Rather well. I had 'The Buggers' there, and my red curtains, and the bed with straw ends, and a check table, which had been in Clifton Hill. (Kitty took everything of mine except the table, which was actually hers.) He also had some drawings there by Frank Auerbach. "Modest exterior, lush interiors," a girlfriend remembered. An interior decorator was employed to do it. "He put brown paper on the walls, an Aubusson carpet, great chandelier, beautiful gilt chairs." He was pleased with it after nearly five years of more or less slum conditions. "I liked having that flat clean, like a hotel room, so Wilfred, my crazy Jamaican cleaner, a kind of part-time janitor to blocks of flats, went there once or twice a week. Wilf liked polishing and ironing and stitching; he was a lady's maid who happened to be a man, loved bangles and uniforms, loved packing a suitcase and making breakfast. He had started working for James Mason as a kind of butler. He'd go to Golders Green and mingle with funeral people, when he wasn't working; and he had an absolute passion for Lena Horne: signed photos everywhere in his flat in Sutherland Avenue. 'Black Bess,' Muriel called him.

"Wilf only liked white men. I sent him round to clean at Penelope's, near by. 'You know I don't like working for women,' he said, 'I think it's degradin'.' But he liked working for Jane—her title—and he'd never nick things. He was childish. 'Can I have this?' he'd say." Freud let him have Gerald Wilde drawings, leftovers from Wilde's

stay at Abercorn Place. "I had good ones I gave away to Wilf: one of Brighton Pier." He found him sad. "Older than he seemed: he dyed his hair, as Negroes can. There was a lot of tart's morality: shocked by someone not being properly dressed. Slightly Noël Coward. The place he loved was New York, but he wasn't allowed there as he'd been caught for hustling. But he got on well, had good manners. A tiny bit like my grandmother, he was a grand retired actress but did all right. When these old boys died in the South of France they left him something."

He didn't paint Wilf. "I couldn't. I liked him but he was a bit irritating; there wasn't that instinctive understanding of difference."

A Slade student, Brian Sayers, who was taken to see the flat one afternoon together with a friend of his, another student, was impressed by the set-up. "We went up the stairs to the top like something out of *The Lady Killers*, an elderly woman opened her door on the way up and called, 'Is that you, Mr. Freud?' Clearly keeping an eye on his flat for him."[16]

Fully furnished and regularly tidied—John Russell described it as "a hallucinatory likeness of a room in a French provincial hotel"— the Camden Road flat amounted to domestic quarters, the first that Freud had had since childhood and marriages.

"It was quite nice to get away from Delamere for a night or two, and when I was in Gloucester Terrace." But after a few years he had to give it up. People on the ground floor had complained to the council that he was hardly using the place except for assignations. "The Camden weekly paper said: 'Millionaire's artist brother keeps luxury flat in Camden Road. Appears in a Bentley late at night, with beautiful girls, whereas a family with eight children need somewhere to live.' I was in a dangerous position: the house was bought by the council to demolish but I still had Gloucester, so—God—I suddenly had *two* council flats. I told Camden, magnanimously, I didn't need rehousing. So I moved out, and took out a fireplace."

"If work permits"

In the mid- to late sixties Freud often spent evenings with Frank Auerbach, usually in the Colony Room, but also in the Troubadour in Knightsbridge and the Stork Club. Auerbach was penniless. When Freud took him to Annabel's in Berkeley Square he was made to wear a tie and so he slipped the porter who provided ties a ten-shilling note as they left. Which was a lot for him and yet he felt that the porter was sniffy about so piffling a tip. Freud entertained no such embarrassments. For him, Bacon being his exemplar, there was perfect assurance to be had from a wad in the back pocket: money acquired, with any luck, through risk and dispersed freely. For Auerbach around then the Colony Room fruit machine was irresistible. Both used the hours spent away from painting as time in which to flush the sluices and wash away the studio tension.

Freud took Auerbach to the then newly opened Playboy Club and showed him that his powers of calculation were such that, calculating and anticipating, he could play three games of pontoon at once. "He only used those bits of the brain he found useful.[1]

"For about fifteen years we used to have a meal on Christmas Day afternoon because we both worked in the morning on Christmas Day. Lucian would come round in his Bentley around two or three, relishing the fact that we were the last persons left alive painting and we would either go to a Chinese or Indian restaurant. It was only after about twelve years that he confessed that he really hated Indian food." One Christmas they had dinner with Sue Bardolph, a

retired night club dancer. "Married and lived in Earls Court: she took the turkey out of the oven raw on one side, burnt on the other. Francis and Muriel were there too and the husband brought out pot, and all smoked including Lucian."

Mark O'Connor met Freud's daughter Annie—same age as him, eighteen or nineteen, and they started going out together and lived together for a while. "I was Annie's first boyfriend. The period was 1965–71. I remember we were in Kitty and Wynne's house in Kensington Church Street once, in a huge studio room with windows, and Lucian and Wynne had a ping-pong game. Never was there such a contest, going at each other to win. This was in the late sixties. He'd come round to collect the girls. I used to go quite often for dinner, Kitty tiny but exquisite, she was very neurasthenic: she'd say, 'I must go and lie down.' Nice and very intelligent, great fan of Proust." When Annie broke up with him he was upset partly because he had become attached to the household. "I was twenty-one, twenty-two, and I just got used to the idea there were people with Van Gogh drawings in their front rooms and if a poet was coming it was T. S. Eliot."[2]

Thomas Hardy's poem "1967," written in 1897, predicted, world-wearily, "new minds, new modes, new fools, new wise." And so it proved: 1967 was the year of the dope-and-pill-fuelled "summer of love," of Antonioni's *Blow-Up*, anthologising the modishness of *Time* magazine's "Swinging London," that phase when, hippie-wise, the footloose ventured as never before into alternative ways of life in lands afar.

That year Bernardine took Bella and Esther, aged six and four, to Morocco, an episode that was to serve as the basis of the latter's first novel, *Hideous Kinky*, published in 1992. "I think my mother was quite ahead of her time," she said years later. "Very self-contained. She had no resentment. She didn't want to be an appendage and once she realised she wasn't going to have as much as she wanted, that was it."[3] The day before they went off Bernardine brought the girls with her to the Colony Room to get some money from Freud. She needed to get out of London, she told him.

"Sometimes you've just got to do what you've got to do," he explained to me. "They were there two or three years. I had a request for money once: some notes to be sent between sheets of paper so that the strip wouldn't show up in customs. And Bella saw my letter lying in a field, an address and my artless writing on the envelope, a hundred yards away from where they were living." In Morocco the two children learnt to fend for themselves. "When they came back, Esther was six or seven. She said to Bernardine, 'Do you remember when we were in Algiers and begging and those Americans wanted to buy me?' I asked her, 'Why didn't you sell Esther?' And she said, 'She's invaluable to me.'

"Esther had the stronger character; Bella was more perverse: she was badly burnt and her whole character changed and she knocked her sister about a lot."

After North Africa the girls were sent to a Rudolf Steiner school in East Grinstead.

"I went down to the school. 'Does she knock you about?' 'Only when I'm very silly.' Very anarchic, but no problem: Bella was protecting Esther."

Freud's instinct about his acknowledged children—individuals and broods—was to consider them separately and to be available to them as and when he saw fit. They in turn were fit to be taken out to lunch only when they were old enough to participate properly. There would be presents, on impulse, every now and then, money in cash, when he had some to spare. "I didn't want the situation to arise where it seems to them I'm not interested. I have feelings for my children as they've grown up. I haven't had a domestic life," he added, unnecessarily. He felt a need for discretion in that to be disruptive or intrusive was never helpful to those concerned. "There's still a distance: if children are in a marriage it can only confuse and dismay them." Reasoning or rationalising, as he did, that women wanted the children they had, his instinct was to stay clear unless or until, as they grew up, they began to display personalities to which he could respond. Naturally, that tended to become apparent to him only when the children became aware of him. Typically, Esther said, "I remember when I was about seven being in a holiday camp thing with another family and someone asking if my father was Lucian Freud and feeling proud and belonging."[4]

She also remembered that Lucian wouldn't phone the house but would arrange to speak at a certain time to a call box and she would run down the road and be pleased to hear the phone ringing.

Obligations were best resisted, he liked to think, because obligations entered upon and then shirked were surely more damaging than obligations never entered into. Regular payments, for example, were impracticable given that his earnings, or winnings, were unpredictable if not startlingly awry. Besides, those he barely knew or recognised were literally beyond him. So, finally, he added with an air of dismissive diffidence, it was up to them. Jane McAdam learnt to be philosophical about the matter. "Be who you are."

Anyway, obligations were shelved when mothers decided to do their own thing. Suzy Boyt, for one, took her children away for many months between 1966 and 1968. "Suzy bought a boat, a schooner, for the man with whom she became involved and had a son, Kai, by. They went to Scandinavia and the West Indies and had some near misses." The boat, the *Inge*, intended for a round-the-world trip, got as far as Trinidad, whence they were deported back to England. She bought two houses in Lonsdale Square, one to live in, the other to let. Freud said, "She got one house, a huge Gothic Revival house in a private road, unpaved, a factory behind, and let the other one to people who didn't pay anything. When she got unhappy she changed houses quite a lot, about ten times." Learning that she was pregnant (with Susie, who was born in January 1969) Freud expressed surprise, he said, but not unduly. "I said something slightly polite about it not being mine and she said, 'It most certainly is. You can give me a child by looking at me across the road,' she said."

The Freud birth rate wasn't all that exceptional. "George Barker thought it was a matter of morality," Frank Auerbach remarked. "If a girl expressed a desire to have a baby, the thing to do was let her have it. And the fact that Lucian only very sporadically and later (very much unlike George Barker) had the means to support them: in a sense his was a religious faith that these babies would be all right. He sometimes said about other children (not the McAdam children, whom he never talked about to me except once when he said their mother said that on no account should he tell anybody that they were his) that he was very concerned that his mother shouldn't know of their existence."[5] Whatever she may have suspected, it was not until

the mid-sixties that Lucie Freud learnt of the existence of others besides Annie and Annabel and the two elder McAdams. Esther and Bella grew up not meeting her and not even knowing how to refer to her. Annie and Annabel called her "Limme," Esther later learnt. "We didn't have a name for her."[6]

Lucie made one discovery by chance at Walberswick. Freud said, "Harriet Hill was married to Tim Behrens and was in a bad way (Tim had gone off or something) and I said, 'Would you like to stay at Hidden House?' So Harriet and her two children went there. And then my mother came and the twins were precocious and forward five-year-olds and they said to her, 'Oh, we know Suzy's children, we're great friends. Do you have them here? You really should.' My mother said she didn't. I think it was news to her. 'Apparently I'm missing a lot of these children,' she said. I think she felt a bit put out."

Interior with Plant, Reflection Listening (1967–8) thrashes and strains for effect. "It was to do with being at Gloucester Terrace, by the big window on the first floor, cars outside." Freud wanted to paint his fine glistening *Dracaena deremensis* and didn't want it to be a still life, so he added himself. "I did it in daytime because the reflection was too dramatic at night, when it's black outside, and you get the reflection strongly, whereas in the day I could hardly see it. It's got that funny Berkeleyan look: that 'You just think it, but I can actually see it' sort of look." Swiping across the picture, serrated leaves glint, white edged on glossy green, fading where the sap has ebbed. "It was a night picture, but actually I did it in the day. I was conscious of feeling more overwrought at night. I've always loved working from plants."

The picture combines harsh proximity and distant longing, Freud seeing himself as a demoralised faun or Arcadian, his bare shoulders top-lit in the scumbled compost of the mirrored gloom, in front of which the leaves rasp and fall limp, tangling on the right, levelling out to the left. It's a contrived image, faintly Tarzan, one that represents frustration in several senses: the lone figure barely visible behind impenetrable fronds is trying to hear something or willing someone to respond somehow. It is unsettling in that he, the soft cameo, is maybe an apparition. This is no indoor pastoral or puckish

dream. ("My horror of the idyllic.") He is acting as a replacement for the Harry Diamond of *Interior in Paddington* (1951) or, rather, he is implying that Harry Diamond then was substituting for himself. He used to talk about self-portraits keeping him honest and he noticed that he tended to resort to them when feeling ill or out of sorts.

To paint himself ("one's certainly the most reliable model that I know") Freud put a hand mirror filled with his face on the chair usually occupied by other people; he also jammed it into the gap in the slightly opened sash window and painted it *contre-jour*, his reflection caught bat-like at a quizzical angle haloed by the darkness between it and the mirror's rim. Painting himself had to be trickier than painting others. For although he could try different expressions—the scowl of concentration, the contrived smile—these were of course pretences to be seen through. "Painting myself is more difficult than painting people, I've found. The psychological element is more difficult. Increasingly so. You're working in a mirror but in the end when you have been staring extra hard—perhaps too hard—I've noticed I could see the outside circumference of my own eye."

Unsurprisingly Freud was interested in, and always concerned about, the state of his eyes. It wasn't only that he valued sight above hearing; he saw it as an absolute necessity, quoting Ralph Waldo Emerson's "I am become a translucent eyeball. I am nothing. I see all." Any hint of anything wrong with his eyesight caused utter alarm. Twitch the mirror and the face would vanish.

"Non-Specific Infection causes all the blindness in the East. I got it once. I said, 'I think I've got clap,' and the doctor didn't examine me, he gave me a huge injection. But my eyes had an infection so I went to Moorfields—the Eye Hospital—and the doctor there said, 'Have you had NSI recently? You didn't have clap: you had NSI but the penicillin masked it.' And he treated me for NSI, not for the last time. There's a very subtle mention of NSI in a William Empson poem: 'It also affects the eye.'

"The thing is, if you spend your time working and have no time for courtship and flowers and things you are very susceptible or, rather, if you go out and find someone you are more likely to pick it up. I was slightly susceptible. Clap is all I've ever got. And NSI."

Rose Barker, one of the many exposed to Freud's susceptibili-

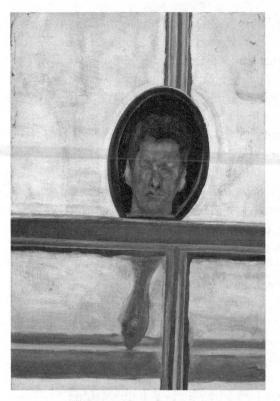

Interior with Hand Mirror, 1967

ties and herself hazardous, was a daughter of Elizabeth Smart, author of *By Grand Central Station I Sat Down and Wept*, and George Barker. "George made a little brood of snakes. I met Rose very early as a child—she was born in 1944—in a flat in Westbourne Grove: mother and children, and Paddy Swift was there and Higgins the Irish poet. The two Roberts [Mac-Bryde and Colquhoun] rather brought up Rose. 'My Father and Mother,' she referred to them as. Elizabeth Smart said of her children—a bit ghastly this, saying it to your friends—'at least I've taught them what *love* is.' Rose had been married to the man Charlie [Lumley] hit, famous for being violent and hysterical; she said how pathetic he was, being impotent. And then I knew her slightly. I took her to my flat in Camden Road and she said, 'I've got some rather bad news for you.'

" 'But I've never really met you before,' I said, thinking she can't be, not by me. 'Nothing to do with that: I've got clap.'

"That's considerate isn't it? I went down once or twice when she lived in Norwich and called in on Liz Smart on the way. Liz didn't know I was going to see Rose. Complete misunderstanding: she didn't see me as part of the Soho life she had, she thought of me as outside it.

"When I stayed with Rose her little girl said to her, 'No wonder everyone wants to stay with you, because you are so beautiful,' and Rose was cross, in case I might think she was available. (She was, probably.) On the Sunday, going to the pub with her—it was so suburban, where she was—she said in a loud voice, 'Of course people seem to think it extraordinary to have one black and one white child.'

She was always behaving like George [Barker], aiming to draw attention to herself, bursting into tears and gazing up at people and saying, 'Scusi.' She said I was just like Wittgenstein. 'It's funny,' she said, 'all the men I took up with ended up beating me up.'" In 1977 she took a fatal overdose of sleeping pills; an accident, Freud thought.

"Once someone I was out with for a minute called me by somebody else's name at a time when you're not supposed to. Like in the song: 'You spoilt it all when you called me Paul.'"

Buttercups, painted in the early summer of 1968, is no conventional flower piece, no posy. The buttercups are bunched with clover, dock leaves, knapweed and ribwort thrust into an enamel jug, the yellow petals shining against the shinier white of the butler's sink. Freud wanted them plonked in the jug, as lively as Dürer's clump of grasses, as vigorous as Van Gogh's awareness of flowers, "full of soul and idea, something more real than the real; something terse, synthetic, simplified and concentrated." Cedric Morris, painter plantsman, had addressed in *Studio* magazine, twenty-five or so years earlier, the dreadfulness of Royal Academy–equivalent floral display. "English love of flowers has found a nasty mate in English lack of taste." Namely the Chelsea Flower Show: "Where it would be surprising that such a hideous result can be contrived out of such abundant choice of material . . ."[7] Penny Cuthbertson drove up through Maida Vale almost daily to replace the flowers that wilted. "She kept picking fresh ones from the side of the road near Finchley or Hampstead and arranged them for me as I didn't like my own arrangement."

David Somerset bought the painting for himself when Freud took it into the Marlborough. To him it was an exquisite display, enamel jug and all, and with delight he showed it to Bacon, but he turned away in disgust. Such a painting, so uncomposed, so subtle a challenge to Van Gogh's sunflowers, was beyond him: bright and telling, like a lyric from the hedgerow poet John Clare. Frank Auerbach remembered Freud saying, when Wolfgang Fischer told him how much he liked it and how good it would be if he produced more of the same, how bad

it would be if he did more like it. That is, such subject matter could set him on the primrose path to commonplace popularity.

"There is now only one consuming interest left in our life, the passion for the study of living reality," the Goncourts wrote.[8]

Wild flowers, ditch flora, free of the hothouse stylishness of the cyclamens he painted in a grander sink ("they die in such a dramatic way"), Freud's Hampstead buttercups are as spry as the marsh marigolds he picked from the stream and painted in his room at Glenartney during holidays with Annie and Anna. In the hunting lodge at the head of Glenartney, where the road ended and only a scribble track went on over the hills to Callender, Freud set himself day tasks: a portrait of George Dyer one year, marsh marigolds another. A tomato. A self-portrait. A dead bat. A second bat, which he brought back from Italy some years later, became *Another Dead Bat*, painted in London.

An aggrandised Institute of Contemporary Arts transferred to premises in The Mall and reopened in April 1968 with "The Obsessive Image" selected by Robert Melville and Mario Amaya. The ICA Chairman, Roland Penrose, described the exhibition as "a stock-taking of our human condition," involving works from the sixties. Here Giacometti and Bacon, Balthus, de Kooning and Magritte were pre-eminent elders, Yves Klein, Warhol, Kitaj, Hamilton, Hockney and Peter Blake were the reinterpreters, and for novelty there were two gruesome effigies: Colin Self's *Nuclear Victim*, a corpse in caramelised resin, and Paul Thek's *Death of a Hippie*, a tableau of a body surrounded by trippy grave goods. Previews of what over the next decades were to become dominant trends.

Freud's work had never been more out of keeping with the norms of taste, which at that time were more polarised than usual: avid Expressionism or cool contrivance. He favoured neither. That his third and, it transpired, last exhibition at the Marlborough coincided with the rebirth of the ICA was of no account. "He was rather mismanaged," David Somerset conceded. "He was so tricky in those days. Bored."[9] Nothing in the exhibition was more than two square feet in size except for *Interior with Plant, Reflection Listening*, leaves from which filled the brown-varnish-tinted cover of a thin catalogue.

The reviews were not all dismissive, but it was generally assumed

that Freud was out of touch, aspiring perhaps to be the latter-day Rubens when others, more versed in modern fashion—Allen Jones for example with his *Bikini Baby* and his supine fibreglass women serving as chairs and tables—paraded groovy variations on catwalk chic. Paul Overy, a critic undeviatingly well disposed towards the compulsive geometrics of De Stijl, went so far as to approve Freud's handling, remarking in the *Listener* that only in the "rather contrived" *Interior with Plant, Reflection Listening* did he overdo things. "It is a remarkable exhibition," he concluded. "To paint well in a figurative idiom today is virtually impossible, yet Freud has done it."[10]

Few paintings sold. Lord and Lady Beaumont (Mary Rose Beaumont was to sit for him a couple of years later) bought *Naked Girl Asleep, I*; the Duke of Devonshire bought *Naked Girl Asleep, II* and *Small Fern*. Kathleen Garman, who helped Freud out more than once, bought two of the smallest: the marsh marigolds (*Souvenir of Glenartney*) and *Annabel*; since Epstein's death in 1959, Lady Epstein (as she now was), and a wealthy friend, Sally Ryan, had been assembling what was to be known as the Garman–Ryan Collection, consisting of works by Garman's immediate family—by her late husband, by her son Theodore Epstein and by her nephew Michael Wishart—and by others, Freud among them. She added to these a Degas portrait, a Monet landscape, Van Gogh's drawing *Sorrow*, a flower piece by Matthew Smith, Rembrandt etchings, Dürer woodcuts and Cézanne's *Bather* lithograph and bequeathed the lot to Walsall, the town nearest to Oakeswell Hall, Wednesbury, where she had been brought up. For Freud, whose Villefranche portrait of Kitty, bought by Epstein in 1948, took precedence over the two new purchases, her patronage was an embarrassment in that it smacked of helpfulness, even more so than the supportive buying instigated by his parents at the Lefevre in 1944.

"Lots didn't sell and so I made a deal: Colin Tennant bought some for a lump sum and then, later, he bought more." Tennant took *Interior with Plant, Reflection Listening* and several others. "Quite a lot were remaindered: seven or eight. He had a roomful in a house he built. Francis went to see it and said, 'I suppose it's a kind of a shrine.'"

To the Marlborough Freud was rather a nuisance. The years of promise were long gone and now—unlike Sidney Nolan, say, or Graham Sutherland—he was proving unreliable and, worse, unpre-

dictable. And there was his persistent refusal to go along with their lucrative printmaking schemes. To Freud, the gallery was useless to the point of being inimical in that he was disliked by both Fischer and Lloyd and, more to the point, he was considered a busted flush. Despite David Somerset's subsequent friendship and the enthusiasm for his work shown later by the young gallery assistant James Kirkman, it failed to help him out when cash was most urgently needed. The situation demoralised him, particularly when things went wrong in other sectors of his life.

"I miss you," Freud wrote on a drawing of the entangled plumbing of bath and wash basin, together with newspapers, used plate and broom in the back room at Gloucester Terrace: a plaint for Jane Willoughby, away on her travels or busy on her estates. It was the summer of 1968. "She was so loyal," Frank Auerbach said. "And the laundry went to her, as far as I can tell, all his life. I don't think he had the faintest idea what laundry was, he put it into this basket and it came back from Jane immaculately laundered. In a way, Lucian at the lowest points of his life kept some of the habits of a spoilt bourgeois upper-middle-class Berlin person."[11]

Drawing c. 1958

In the mirror behind the basin is the reflection of the rim of the plant pot in the middle of a painting just begun, the progress of which some days later (shoots arising, child's head and body

dabbed in) can be made out in *Small Interior (Self-Portrait)* (1968), where the big mirror from Delamere Terrace rests against a paint-smirched wall together with the broom. From drawing to painting, from painting to painting, certain objects recur, layered by reflection.

"I really used the mirror, which I like and know, as a device for an interior on a small scale. Always the same mirror," Freud said. Within the confines of the mirror the opposite side of the room rearranged itself, the floor rising like a drawbridge, a picture plane barely formulated on the easel and the painter dancing attendance alongside it, catching sight of himself, as it were, between one picture and another. The painting gives pause, complicatedly so, for he has included in the mirror image fronds of *Dracaena deremensis* from *Interior with Plant* brushing against the image on the canvas. A representation of a reflection set against the representation of a reflection of a representation of a painting that was to become *Large Interior in Paddington* (1968–9), six foot by four foot, his largest painting since 1951.

"I wanted to work from Ib. Suzy was very amenable, Ib liked it and I was working from Penelope and they got on well: she used to look after her. (Ib was very shy at being half-naked.) It's got a happy atmosphere I think." Ib remembered more the discomfort of lying on bare floorboards, resenting being hauled away from home all day, particularly on Sundays. The painting breathes vexation. Sulkily bored, with nothing to look at but the big plant pot inches from her nose, Ib lies doggo, a shock-headed urchin out of Struwwelpeter, inclined to tantrums. She has to keep still, but the room is hot and smelly. Bright leafage, a proliferation of escaping thoughts, press against the opaque window above and beyond her. She could be a foundling under a gooseberry bush, a surprise under a Christmas tree. Her mother was pregnant as the painting began; by the time it was finished she had another sister.

Freud regarded the house plant as a green memory. "I've always liked *Zimmerlinden*; my father used to grow them: he used them in winter gardens. The stems were held up by the windowpane. If I moved it, it would collapse. This one had huge leaves and so it took on a life against the light." The jacket hung on the shutter and catching the light was a torn and rumpled presence somehow. (He had used such a jacket before, in the stable at Benton End and in the room

across the street in *Hotel Bedroom*.) "Hang your hat up, your coat up: a sign of possession."

Did he intend a slight incongruity?

"I never put anything anywhere odd (except obviously I used the zebras as if they were more native to the room than they were). But the coat: no. It's a plant (that is to say, I planted it) insofar as it's not where it lived."

The Goncourts in 1871, witnessing the siege of Paris and Commune: "I was forgetting a dramatic detail: in front of the closed doors of a carriage entrance, a woman was lying flat on the ground, holding a peaked cap in one hand."[12]

While *Large Interior* was the main day picture, *Night Interior* (1969–70), a reverse set-up at the other end of the room ("You see right through from the studio to the bathroom"), had Penelope sprawled on the chair beneath the distracting reflection of a naked light bulb in the window. Set between bathtub and cupboard (door half open, revealing the ubiquitous jacket) she was, all unconsciously, positioned as Edvard Munch had been in the cramped purgatory of his 1940 *Between the Clock and the Bed*. Harry Diamond was similarly placed for *Paddington Interior, Harry Diamond* (1970) immediately afterwards. "I sat him in this doorway. It was done at night, in this case because he finds it so hard to get up in the morning. He tries and tries to get up and he can't. He sort of misses the day. A tenacious sponger." The cupboard behind him was now bare and with his fists clenched he appeared ready to spring to his feet the moment he was told that this stint was over. "It was somewhat exhausting," he said. "Afterwards one felt depleted, but also invigorated, because he has a stimulating personality." For Harry Diamond any stimulus was provocation.

Freud couldn't but be stimulated by Diamond's style of conversation. He came out with astounding remarks. "At one time there were a lot of whores murdered in Portobello Road, four or five of them, and Harry said, 'I don't want to embarrass you, but those whores: did you do that?'

" 'I never have anything to do with whores,' I said. What else could I say?"

Twenty years had now elapsed since *Interior in Paddington* and Diamond had developed a captivating new interest. "He took up pho-

tography. Like someone finds Jesus. He was desperate before then when I painted him. Long after that, I arranged for him to show at d'Offay and d'Offay paid him to photograph painters and gave him addresses, Coldstream and so on, but then he went and sold the photographs to the National Portrait Gallery. Anthony [d'Offay] was very upset and angry, Harry said he'd smash up the gallery and I felt rather responsible. I once said, 'I'm disappointed, I thought you were going to do a *comédie humaine*: better than Deakin,' and he was furious. He knew I was well disposed but I thought he really would glass me." Harry was one for immediate reactions. One evening in the French Pub he took offence when a man came up and said something to a girl he had his eye on, followed him outside and hit him on the head with a hammer.

Diamond photographed Freud, perched on a stool in front of closed shutters, wincing at the exposure. One of the photographs was used as the frontispiece for the catalogue of Freud's first exhibition at the d'Offay Gallery, a couple of years later; another was among "Some London People" in the *London Magazine* in June 1973: Freud in smirched chef's trousers, as anonymous as any Mayhew character, the first in a suite of toff, busker, undertaker, dustmen. "It's so odd: the character of the photographer enters into things. I think you'd find Harry had more scope than Deakin. He walked four or five hours a day from district to district. He does weddings now."

By this time Freud was out of touch with all but one or two of his former Delamere neighbours. Once Charlie Lumley had married he no longer figured. A photograph of him, a labourer standing against a brick wall, turned up in the plan chest in Freud's studio: part of the debris of his past. "After he was married it was sort of drifting apart. He did building jobs, plumbing jobs, drove a bus. Someone in Paddington said, 'He used to be our hero.' He was a good driver, but he wasn't gang league. No longer a force to be reckoned with. He got these children: parents always want to know what children want to be, and when the eldest son, Doug, was a boy of five he said he wanted to be a witch." Freud saw nothing of Charlie and heard from him only once. "I know his wife Audrey moved out and took in cats. He wrote, 'I'm in trouble, Lu. Light and gas cut off: this isn't a con.' Never had any money. I heard that he decided to destroy his car

and get the insurance. Everyone knew this dodge. He set it alight all right—rather badly—just outside his house. The police were alerted and then it turned out that he'd forgotten to insure it."

Another Charlie, Charlie Thomas, was now around. Freud had known him by sight since the fifties when he used to see him at Billy Hill's. "Charlie would be at the games, standing with huge boxes of money. I knew him quite a number of years. He wanted a friend. He was very nice-looking. Broken nose. We went betting. Charlie loved ligging about, going to Wheeler's, and Muriel quite liked him." A painting of Charlie Thomas' sister, the unfinished *Head of a Woman* (1970), has an affronted look. "Married to a car salesman. She was hard, Charlie wasn't: not at all pushy, hated fighting. He came round every morning and said, 'Anything you want done?' Charlie loved his nephews and nieces and had very nice manners. I took him up to Glenartney; he taught Ali billiards there.

"Charlie helped me rather than the other way. He sold a few pictures of mine to a man in the City, a picture of him, and the Glenartney picture of George Dyer. Charlie only knew about pictures from the saleroom; he bought what he called 'speccy' pictures from Sotheby's and Christie's, took them in vans to Herefordshire and places, and clever people came down and paid more for them there."

Charlie Thomas had been married to the wife of Claude Bornoff, an antique dealer in Westbourne Grove. "Then there were incidents to do with a girl, Alex Mayall. When he took up with her, he took my father's house in Walberswick, as my father had a heart attack and wanted to sell it. Charlie and Alex lasted a while. Then he got terribly keen on girls and couldn't do anything with them: some form of impotence. He had to have terrific encouragement. But he was marvellous at picking up people. He'd go to Victoria station and see someone. 'What you waiting for?' he would say. 'Wish I was waiting for you.' (I've never tried to pick anyone up because I wouldn't want to start like that, remembering I'd said anything banal like that.) He'd sometimes ring me up and say, 'I've got this marvellous girl.' I got clap once or twice."

In the summer of 1968 Charlie Thomas met Alice Weldon, a young American recently arrived in London from California, escaping from family and intending to paint perhaps or work with children. ("She wanted to get a job with my Aunt Anna, as she had looked after

children.") To start with she decided to find her way around town on foot. "I'd walk as far as I could and take a taxi back. At the end of the day I got to Hyde Park—Speaker's Corner—and there was a man there, dodgy, arty, interesting, who started to chat me up and asked me out to dinner. He said, 'Guess who I had dinner with last night: Francis Bacon. I'll show you my flat in Ebury Street.' He was a crook, a small-time picture restorer. Had a good eye and many art books including one on Francis, which was open at *The Wrestlers*, which, he said, belonged to Lucian Freud. I'd only heard of Sigmund Freud of course and I'd come to London with an ambition to work with Aunt Anna! Lucian? Marvellous name. I was with Charlie for weeks only. He punched me. Hit me."

Freud soon took up with her. "Aunt Anna wanted her to sign a piece of paper vowing eternal loyalty. She didn't want to sign." (In fact she only had an interview with Anna Freud's friend Dorothy Burlingham.) "She drew and painted and worked a bit. Once I went with her to Walberswick to see my father; he said, 'Your friend has an amazingly good figure.' I was amazed." Beautiful, American, confident enough, with just enough money to have her independence, she was the sort of girl he could take to see his parents, unlike most of the others, what with their babies or other complicating circumstances.

Annie Freud too was impressed with Alice. "She was very Jamesian: an American in London, an autodidact, and conducted her own artistic, culinary and literary education on her own, copied out vast passages of great poetry in her beautiful handwriting in order to acquire culture. And she went to cookery school. Being American, Alice had fantastic knowledge about male and female sexuality. She told me what the idea of Fred Astaire and Ginger Rogers was about: she saw the top hat was the cock and the sequinned gown was the wet cunt. The real allure is that, unconsciously, what you are watching is unbelievably sexy." To Annie there was danger for Alice in becoming too involved. "Alice had to find a life not with him [Lucian] because she did a lot of looking after our family; at one stage, when Annabel was still very ill, after she'd been to Leeds University, Dad arranged for her to live with Alice." This was to have been for six weeks but "following the anorexic years," as Alice put it, Annabel's behaviour became frightening and uncontrollable. "She was sixteen when I met her, beautiful like an Eastern princess. She was a talented painter." For

Alice, who too was drawing promisingly, much as Freud had begun, there was his degree of concentration to aim for. "If Lucian hadn't valued my work I wouldn't have pursued it," she admitted. However he said to her, tacitly holding himself up in comparison to her: "I think you're selfish but not selfish enough."[13] By "selfish," needless to say, he meant ruthless.

He liked taking her around with him. "Lucian would say, 'Let's see the Killer,' who lived quite close, in Westbourne Grove." That is, 16 Westbourne Park Villas where Thomas Hardy wrote the poem "1967," ending with: "new woes to weep, new joys to prize." The Killer, Eddie Power, had started picture dealing and wanted Charlie Thomas to buy expensive things for him. "There was a terrible accident outside his house," Alice Weldon remembered. "And the police came and knocked on the door not to enquire but to ask if he'd seen anything: there was blood around and the Killer was really upset by the blood." She was told that this quiet little man, "who seemed so trustworthy, like a civil servant," would go to see a cheater, shoot him in the kneecaps and weep when he had done with him. Among his associates were Freddy Whitney ("a respected burglar") and Charles de Silva who had a non-existent fishing fleet.

In 1974 Charlie Thomas left the scene. "Charlie said he would die young, and he did." Caffeine and purple hearts did for him, Freud said. "He'd take some downers and uppers and go to the Greek café in Charlotte Street and have coffees. He said to me, 'Me mind's gone, me body's gone.' I think he knew he was going to die soon. I gave him one or two things and he gave them away, desperate not to be left with anything. When Charlie died—choked on his vomit—I had to go and see him dead on a slab. I and his sister, and Penelope, went to the morgue and the attendants were pulling him about, seeing his body didn't fall off the slab, trying to cheer things up. And his sister said, 'Lu, why can't you bring my Charlie back to life?' I didn't want him brought back to life. I've never seen her since.

"I didn't go to the funeral—don't ever want to go to them—but people were very upset, especially Penny." She rang June Andrews up and said: "He's so fucking selfish." Freud shrugged at that. "When they are dead they are dead." He told Alice Weldon that when he went back to the studio he wept. He said that he had known Charlie wouldn't last long as he had talked about killing himself.

"There was a terribly nice girl Charlie was with, sort of county girl. I went out with her once or twice, took her to Camden Road when Charlie died, or just not. I said, 'I don't really understand what I'm taking you out for.' 'Trying to rub my unhappiness off on you,' she said."

In 1969 Freud visited a mental hospital where Sonia Orwell's brother, a doctor, worked and gave a talk. This was by way of a thank-you to Sonia's brother for being helpful with Annabel. "Art therapy isn't art," he told the staff, who assumed otherwise. Introduced to a hulking great patient who painted, he asked him why he did so. "To deal with pernicious women," he growled.

"Lucian always had a struggle," Anne Dunn said. "Everything has to be found, discovered, worked for. I know very few painters who can sustain concentration for so long."[14] He remembered her former husband, the easygoing Rodrigo Moynihan, saying to him once, "You can try *too* hard, you know."

In 1970 Anne Dunn bought from Cyril Connolly *Portrait of a Girl*, Freud's indelibly intimate painting of her from 1950. "I always feel mixed up, with the great attraction or affection or whatever it is," she said many years later. "He gets one because, though I don't see him, he has always remained very important in my life. He takes one's life over in a way that one can never quite expunge."

Her marriage was none of his business. Rodrigo Moynihan, to him, was someone who liked bankers, he said. "I was always on formal terms with him. He looked after Anne's money and Anne had these terrific affairs, chiefly in New York. She told me, 'He doesn't put his foot down, he only puts them up.' She had complicated tastes to do with third parties and a lot of forgiveness and making it up. There was Mrs. Skirting Board the cleaner. Rodrigo had been having an affair with her for years: they could have been married. 'Mrs. Teacosy.' Anne had rows with her children for them not telling her about it: she could have had such fun." He took up with her again. "He asked to be in the magazine I and Rodrigo (and Sonia Orwell, for a while) edited: *Art and Literature*. John Rothenstein wrote a bit, not a good article, but Lucian was very insistent that something should be written. We had another interlude. It was when he was with Penelope Cuthbertson,

so we saw each other quite a lot for a bit. It wasn't very serious, I felt there was a lot left to be resolved but it never was. Sometimes, instead of counting sheep, I count Lucian's children."[15] She sat for him and was sporadically involved with him well into the 1970s.

"Lucian's justice and morality was present throughout his life really and he never, *never*, made any sort of moralising remark," Frank Auerbach stressed. "He never moralised, he never suggested that there was a code, he just behaved well. Well, he had his own code of behaviour. There were certain rules, which he told me, which were news to me. He said that if you went to bed with somebody, the thing to do the next day was to take them out to lunch so that they wouldn't feel badly about it. As I didn't have as sophisticated a life as Lucian I didn't know that that was the form. I was focused on sloshing around, doing the paint."[16]

One day Freud mentioned to the doctor that he would be going to the hospital to see Annabel, "if work permits." The doctor was shocked and Freud—as he himself told Auerbach—was only belatedly aware that it was the wrong thing to say; but he said it anyway because it was the thought—the priority—that prompted him. He had no idea of the correct thing to say in such circumstances. "Lucian asked him how he would recommend him to kill himself. 'What's the best way?' The doctor told him the best way was to inject air into a vein. That way he, the doctor, couldn't be culpable of, for example, supplying drugs."[17] It wasn't a serious question, more a matter of him wanting to control things.

A play was staged and Freud drew Annie aged twenty for the flyer: *Encarnation in the Square*, never performed: just rehearsed. But he attended some of her rehearsals, with advice. He told her off once about smoking outside. "Only prostitutes smoke in the street,"[18] and told her she'd be one if she did.

"Lucian told me that he often had girls who had had 'trouble' with their fathers," Alice Weldon said.

> *If a mistress has acquired a veneer of breeding, art or literature, and tries to talk to us on an equal footing about our thoughts and our feeling for beauty; if she wants to be a companion and partner*

in the cultivation of our tastes or the writing of our books, then she becomes for us as unbearable as a piano out of tune—and very soon an object of dislike.[19]

The supremely condescending way the Goncourt brothers talked about their relationships with the opposite sex tickled Freud. It wasn't so much their attitude, more the shamelessness. His own approaches to women were apt to be abrupt not for lack of manners or self-possession but from an inability to be relaxed about getting to the point. "I can't do courting. It makes me so nervous. I want an immediate intimate situation with a stranger I do like, but the fact that it involves sex, obviously that's where the intimate part comes in . . . With someone you are already intimate with, you go on making things more intimate."

Incorrigibility was part of his tenacity: his stubborn pursuit of a course of action without recourse to advice from anyone. Painting could only be fully accomplished by an investment of effort amounting to a siege assault. Eventually, with any luck, the place would be taken, the object accomplished, the need satisfied.

Such painting, so assertive, so ardently demanding, was now plainly within his capacity and grasp; so much so that he came to regard it as more the stuff of life than anything else that affected him, stimulant or fancy. Nearing his fifties, he found himself of an age to be increasingly conscious of time dwindling and painting therefore being all the more his most intimate concern.

"In Paddington there was a Jewish butcher and the chickens were terribly old and blue and a friend saw talcum powder on them."

NOTES

PROLOGUE

1. Nanos Valaoritis, "Problems of an Empire," *Botteghe Oscure*, no. 20, 1957, pp. 435–6.

I · "I LOVE GERMAN POETRY BUT I LOATHE THE GERMAN LANGUAGE"

1. Magnus Linklater, "Throwing a pot of paint at the artist," *The Times*, 22 August 1995.
2. David Sylvester, "Recanting, No way, Brian," *Guardian*, 25 August 1995.
3. Geoffrey Holme (ed.), *The Studio Year Book: Decorative Art 1934* (London: Studio, 1934).
4. Frank Auerbach, conversation with the author, 14 September 2012.
5. Gabriele Ullstein, conversation with the author, 6 October 1998.
6. Clement Freud, *Freud Ego* (London: BBC Books, 2001), p. 12.
7. Sigmund Freud, *Moses and Monotheism* (London: Hogarth Press, 1939), p. 134.
8. Annie Freud, conversation with the author, 29 May 2012.
9. Michael Molnar (ed.), *The Diary of Sigmund Freud, 1929–39* (London: Hogarth Press, 1992), p. 114.
10. Richard "Wolf" Mosse, interview with the author, 27 November 1998.
11. Freud Museum Archives, London.
12. Michael Hamburger, conversation with the author, 11 December 2000.
13. Bertrand Russell, "Why Are Alien Groups Hated?," *Everyman*, 6 October 1933.
14. F. Yeats-Brown, editorial, *Everyman*, 31 January 1933. *Everyman* was known as the "First Fascist Organ" from January 1933 to its closure in August of that year. "Germany is pre-War" refers to the years of confidence before 1914.

2 · "VERY MUCH A SLIGHTLY ARTISTIC PLACE"

1. Freud Museum Archives.
2. Ibid.
3. Ibid.
4. Clement Freud, *Freud Ego* (London: BBC Books, 2001), p. 16.
5. Glenys Roberts, "The Forgotten Freud," *Daily Mail*, 23 April 2009.
6. Quoted in Michael Molnar, *Looking through Freud's Photos* (London: Karnac Books, 2015), p. 116.
7. Poem "Blythburgh 1910" by Humphrey Jennings, 1943, quoted in Marylou Jennings, Introduction, *Humphrey Jennings: Film-maker, Painter, Poet* (London: BFI, 1982), p. 6.
8. Nikolaus Pevsner, *Buildings of England: London North* (Harmondsworth: Penguin, 1952), p. 198.
9. Jack Baer, letter to the author, 21 October 1998.
10. This fund was formally set up in November 1937.
11. Adrian Heath, letter to the author, 18 October 2012.
12. Richard Dorment, "Master of the Art of Dealing," *Daily Telegraph*, 30 July 2001.
13. W. H. Auden and John Garrett, *The Poet's Tongue* (London: George Bell, 1935), p. vii.

3 · "MY MOTHER STARTED WORSHIPPING IT SO I SMASHED IT"

1. Sigmund Freud, *Moses and Monotheism* (London: Hogarth Press, 1939), p. 93.

4 · "TO CUT A TERRIFIC DASH"

1. Lawrence Gowing, *Lucian Freud* (London: Thames & Hudson, 1982), p. 8.
2. Peter Noble, *Reflected Glory* (London: Jarrolds, 1958).
3. Frank Auerbach, conversation with the author.
4. Also "Everything that you can imagine is real."
5. Felicity Hellaby, phone conversation with the author, 19 February 2012.
6. T. W. Earp, Introduction, *Flower and Still Life Painting*, ed. Geoffrey Holme (London: Studio, 1928), p. 19.

7. John Bensusan-Butt, "Baronet with Palette," *Essex County Standard*, 16 October 1959, quoted in Richard Morphet, *Cedric Morris* (London: Tate Gallery, 1984), p. 93.

8. Sigmund Freud, letter to Marie Bonaparte, August 1939, cited in Mark Edmundson, *The Death of Sigmund Freud* (London: Bloomsbury, 2010).

5 · "A PRIVATE LANGUAGE"

1. LF (Lucian Freud) letter to Cedric Morris, n.d., Cedric Morris papers, Tate Archive, London.

2. David Kentish, letter to Joan Warburton, n.d., Joan Warburton papers, Tate Archive.

3. LF letter to Cedric Morris, n.d., Cedric Morris papers, Tate Archive.

4. LF letter to Arthur Lett-Haines, n.d., Tate Archive.

5. LF recollection of conversation with William Coldstream, n.d.

6. Stephen Spender, letter to Mary Elliott [1940], Stephen Spender papers, Watkinson Library, Trinity College, Hartford, Connecticut (previously in Sotheby's sale July 2015).

7. David Plante, *Becoming a Londoner* (London: Bloomsbury, 2013), p. 308.

8. David Kentish, letter to Joan Warburton, January 1940, Warburton papers, Tate Archive.

9. Ibid.

10. Ibid.

11. Ibid.

12. Ibid.

13. W. H. Auden, Poem XXX, *Look, Stranger!* (London: Faber & Faber, 1936).

14. Ludwig Goldscheider, *El Greco* (London: Phaidon, 1938).

15. Stephen Spender, "Exiles from This Land," *The Still Centre* (London: Faber & Faber, 1939).

16. LF letter to Joan Warburton, January 1940, Tate Archive.

17. David Kentish, letter to Joan Warburton, 25 January 1940, Tate Archive.

18. David Kentish, letter to Joan Warburton, 28 January 1940, Tate Archive.

19. Stephen Spender, letter to Joan Warburton, n.d., Tate Archive.

20. LF from memory.

6 · "BORN NAUGHTY"

1. Charles Baudelaire, "The Painter of Modern Life" (1863), in *Baudelaire: Selected Writings on Art and Artists* (London: Penguin Books, 1972 [1951]), pp. 399–400.
2. John Russell, Introduction to Hayward catalogue, *Lucian Freud 1974* (London: Arts Council, 1974), p. 7.
3. Geoffrey Grigson, *Recollections* (London: Chatto & Windus/Hogarth Press, 1984), p. 44.
4. Ruthven Todd, letter to the author, 4 February 1972.
5. Stephen Spender, "The Room above the Square," *The Still Centre* (London: Faber & Faber, 1939).
6. Ibid.
7. Michael Wishart, *High Diver* (London: Blond & Briggs, 1977), p. 27.
8. Ernst Freud, letter to Arthur Lett-Haines, 1940, Tate Archive.
9. Ibid.
10. LF letter to Stephen Spender, n.d., Stephen Spender papers, Tate Archive.
11. LF quoting Cedric Morris.
12. W. H. Auden, "The Capital" (1939).
13. LF letter to Stephen Spender [1940], Sotheby's sale, 2 July 2015.
14. The Comte de Lautréamont [Isidore Ducasse], *The Lay of Maldoror*, trans. John Rodker (London: Casanova Society, 1924).
15. Ibid.
16. David Gascoyne, *Short Survey of Surrealism* (London: Frank Cass, 1935), p. 10.

7 · "I USED TO ALWAYS PUT SECRETS IN. I STILL DO."

1. *British Restaurants: An Inquiry Made by the National Council of Social Services* (London: Oxford University Press, 1946), p. 3.
2. Peter Noble, *Reflected Glory* (London: Jarrolds, 1958).
3. Stephen Spender, *New Selected Journals, 1939–1995*, ed. Lara Feigel and John Sutherland with Natasha Spender (London: Faber & Faber, 2012).
4. George Millar, *Isabel and the Sea* (London: William Heinemann, 1948), p. 364.
5. Official Log-Book: Foreign-Going or a Home-Trade Ship, Ship 132840. Time Stamped 18 August 1941. Marine Safety Agency, Cardiff.

6. George Millar, *Isabel and the Sea* (London: William Heinemann, 1948), p. 364.

7. The Essential Work (Merchant Navy) Order made it compulsory for anyone leaving a ship to be retained in the Merchant Navy Reserve Pool.

8. Ian Collins, *John Craxton* (Farnham: Lund Humphries, 2011), p. 44.

8 · "SLIGHTLY NOTORIOUS"

1. *Manpower* (London: Ministry of Information, 1944), p. 47.

2. Felicity Hellaby, phone conversation with the author, 19 February 2012.

3. In 1983, two years after she died, Mary Keene's novel *Mrs. Donald,* written in the early 1950s, was published, belatedly vindicating her claims. *Mrs. Donald,* ed. Alice Thomas Ellis, with an epilogue by Keene's daughter Alice (London: Chatto & Windus, 1983).

4. LF recollection.

5. One of eleven letters from LF to Felicity Hellaby sold by Sotheby's London, 13 February 2014, now in a private collection.

6. Ibid.

7. Felicity Hellaby, phone conversation with the author, 19 February 2012.

8. Winston Churchill broadcast, BBC, 15 February 1942.

9. Natasha Spender, conversation with the author, 14 October 2008.

10. LF letter to Felicity Hellaby (private collection).

11. Ibid.

12. Felicity Hellaby, phone conversation with the author, 19 February 2012.

9 · "SLIGHT *DREIGROSCHENOPER*"

1. Simon Martin interview, "John Craxton: A Romantic Spirit," *Pallant House Gallery Magazine,* Chichester, 11 March 2007, p. 26.

2. Marriott Edgar, "The Lion and Albert" (1930), www.youtube.com/watch?v=gIdbxTGxTM.

3. Ian Collins, *John Craxton* (Farnham: Lund Humphries, 2011), p. 45.

4. Ibid., p. 55.

5. LF's recollection.

6. Kenneth Clark, *Listener,* 22 February 1940.

7. Kenneth Clark, *New Statesman,* 30 January 1943.

8. Catherine Porteous, letter to the author, 1999.

9. LF letter to Felicity Hellaby (private collection).

10. Ibid.

11. Dan Davin, *Closing Times* (Oxford: Oxford University Press, 1975), p. 103.

12. LF letter to Felicity Hellaby (private collection).

13. Ibid.

14. Ibid.

15. Kenneth Clark, "Ornament in Modern Architecture," *Architectural Review*, December 1943, p. 150.

16. LF letter to Felicity Hellaby (private collection).

17. David Gascoyne, *Journal* (London: Enitharmon, 1991), p. 57.

18. Robert Fraser, *Night Thoughts: The Surreal Life of the Poet David Gascoyne* (Oxford: Oxford University Press, 2012), p. 197.

19. Ibid.

20. LF letter to Felicity Hellaby (private collection).

21. Ibid.

22. Vivienne Light, *Circles and Tangents: Art in the Shadow of Cranborne Chase* (Morcombelake: Canterton Press, 2011), p. 181.

23. Simon Martin interview, "John Craxton: A Romantic Spirit."

24. Geoffrey Grigson, extended caption in *Lilliput*, vol. 22, no. 8, June 1948, p. 42.

25. *Horizon*, April 1942.

26. The Comte de Lautréamont [Isidore Ducasse], *The Lay of Maldoror*, trans. John Rodker (London: Casanova Society, 1924).

27. Light, *Circles and Tangents*, p. 179.

28. Lautréamont, *The Lay of Maldoror*, Sixth Book, part 7.

29. John Craxton, conversation with the author, 25 March 1999.

30. Simon Martin interview, "John Craxton: A Romantic Spirit," p. 28.

31. Peter Watson, letter to LF, n.d., private collection.

10 · "A QUESTION OF FOCUS"

1. Quoted in Cressida Connolly, *The Rare and the Beautiful: The Lives of the Garmans* (London: Fourth Estate, 2004), p. 136.

2. Laurie Lee, "Good Morning," *Penguin New Writing*, 16, January–March 1943, p. 11.

3. Valerie Grove, *Laurie Lee: The Well-Loved Stranger* (London: Viking, 1999/Robson Press, 2014), p. 178.

4. Ibid., p. 179.

5. Ibid., p. 173.

6. The fictional characteristics of Laurie Lee's reportage in *A Moment of War* (London: Viking, 1991) were widely remarked on at the time of publication.

7. From "Song in the Morning," Laurie Lee, *The Sun My Monument* (London: Hogarth Press, 1944).

8. Grove, *Laurie Lee*, p. 174.

9. Michael Wishart, *High Diver* (London: Blond & Briggs, 1977), p. 6.

10. Grove, *Laurie Lee*, p. 174.

11. Connolly, *The Rare and the Beautiful*, p. 176.

12. Grove, *Laurie Lee*, p. 173.

13. Connolly, *The Rare and the Beautiful*, p. 174.

14. LF letter to Felicity Hellaby (private collection).

15. Saki (H. H. Munro), "The She-Wolf," in *Beasts and Super-Beasts* (New York: The Viking Press, 1914).

16. Bruce Bernard, "Four Painters," essay commissioned by British Council, MSS p. 1, private collection.

17. Ibid., p. 2.

18. John Craxton, letter to Elsie Queen Nicholson (EQ), Tate Archive, reproduced in Ian Collins, *John Craxton* (Farnham: Lund Humphries, 2011), p. 62.

19. LF letter to Felicity Hellaby (private collection).

20. Charles Wrey Gardiner, Introduction to M. Lindsey, *Sailing Tomorrow's Seas* (London: Fortune, 1944), p. 5.

21. Tambimuttu had employed Moore briefly as his assistant.

22. Stephen Spender, *Horizon*, December 1944.

23. A Ratepayer, "Plea for the Appointment of an Architect for Paddington's New Housing Scheme," *Architect's Journal*, 28 April 1938.

24. Stephen Spender, *Air Raids*, War Pictures by British Artists series (London: Oxford University Press, 1943), p. 8.

25. W. H. Auden, "To a Writer on His Birthday," Poem XXX, *Look, Stranger!* (London: Faber & Faber, 1936).

26. Charles Wrey Gardiner, *The Dark Thorn* (London: Grey Walls Press, 1946), p. 138.

11 · "LIVING IN A DUMP AND GOING OUT TO SOMEWHERE PALATIAL"

1. Marie Paneth, *Branch Street* (London: Allen & Unwin, 1944), p. 34.

2. Charlie Lumley interviewed by Michael Macaulay for Sotheby's catalogue, 13 October 2011, p. 76.

3. Ibid.

4. Julian Trevelyan, *Indigo Days* (London: MacGibbon & Kee, 1957), p. 183.

5. *Evening Standard*, 23 November 1944.

6. Michael Ayrton, *Spectator*, 1 December 1944.

7. Ibid.

8. Ian Collins, *John Craxton* (Farnham: Lund Humphries, 2011), p. 59.

9. Herbert Read, Introduction, *Kurt Schwitters* (London: Modern Art Gallery, December 1944).

10. Ibid.

11. The *Times Literary Supplement*, 17 March 1945, remarked that Moore "talks volubly in verse."

12. Charles Wrey Gardiner, *The Dark Thorn* (London: Grey Walls Press, 1946), p. 104.

13. Ibid., p. 35.

14. Ibid., pp. 39, 104.

15. Ibid., p. 25.

16. Ibid., p. 11.

17. Ibid., p. 107.

18. Michael Luke, *David Tennant and the Gargoyle Years* (London: Weidenfeld & Nicolson, 1991), p. 169.

19. Ernst Freud quoted by LF.

20. Michael Hamburger, conversation with the author, 11 December 2000.

21. Gabriele Ullstein, conversation with the author, 6 October 1998.

22. Dick "Wolf" Mosse, conversation with the author, 27 November 1998.

23. John Lehmann, *I Am My Brother: Autobiography*, vol. 2 (London: Longmans, 1962), pp. 313–14. See also Alan Pryce-Jones, *The Bonus of Laughter* (London: Hamish Hamilton, 1987), pp. 161–2: Ernst Freud "was well liked by the Marylebone authorities." He served as Pryce-Jones' house-restoration architect, yet "when the law descended . . . Freud told the authorities that he was only a colour consultant and that I had acted illegally quite on my own."

24. Valerie Grove, *Laurie Lee: The Well-Loved Stranger* (London: Viking, 1999), ch. 11 passim.

25. Luke, *David Tennant and the Gargoyle Years*, p. 171.

26. Norman Bentwich, *I Understand the Risks* (London: Victor Gollancz, 1950), pp. 111–12, 135–6.

27. Cyril Connolly, "Comment," *Horizon*, September 1945, p. 152.

28. *Times Literary Supplement*, 28 March 1975, p. 827.

29. John Sutherland, *Stephen Spender: The Authorized Biography* (London: Viking, 2004), p. 303.
30. Gardiner, *The Dark Thorn*, p. 75.
31. Anne Ridler, "Islands of Scilly" ("a clutch of islands, every one distinct"), *Collected Poems* (London: Faber & Faber, 1972).
32. John Craxton, conversation with the author, 25 March 1999.
33. Joan Wyndham, *Anything Once* (London: Sinclair-Stevenson, 1993), p. 8.
34. Ibid.
35. Ibid.
36. Maurice Collis, *Observer*, February 1946.
37. Michael Ayrton, "Some Young British Contemporary Painters," *Orion III* (London: Nicholson & Watson, 1946), pp. 84–7.

12 · "FRENCH MALEVOLENCE"

1. LF letter to his mother [August 1946], Freud Archives, National Portrait Gallery, London.
2. Christian Morgenstern, "Das Hemmed," *Galgenlieder* (Berlin: Bruno Cassirer, 1905).
3. Herbert Read, "Art in Paris Now," *Listener*, 16 August 1945.
4. Herbert Read, "British Children's Art in Paris," *Athene*, vol. III, no. 3, Winter 1945, p. 112.
5. Jean-Pierre Lacloche, *Olivier Larronde: Oeuvres poétiques complètes* (Paris: Le Promeneur, 2002), p. 27.
6. Stephen Spender, *Horizon*, July 1945, p. 9.
7. Alexander Watt, "The Art World of Paris," part 1, *Studio*, December 1946, p. 172.
8. Albert Camus, *The Outsider*, trans. Joseph Laredo (London: Penguin Books, 1983).
9. Jean-Paul Sartre, "The Childhood of a Leader," *The Wall* (Paris: Gallimard, 1939).
10. Michael Wishart, *High Diver* (London: Blond & Briggs, 1977), p. 27.
11. Anne Dunn, letter to the author, 9 January 2013.
12. Ibid.
13. Wishart, *High Diver*, p. 37.
14. John Margetson, letter to the author, 18 September 2002.
15. Marie Bonaparte, *Myths of War* (London: Imago, 1947), p. 132.
16. Diane Deriaz, trapeze artiste from the Pinder Circus.
17. Jean Dubuffet, *Notes pour les fins-lettrés* (Paris: Gallimard, 1946).

13 · "THE WORLD OF OVID"

1. John Craxton, letter to Elsie Queen Nicholson (EQ), n.d. [1946], Tate Archive.
2. Norman Dodds MP, Stanley Tiffany MP and Leslie Soley MP, *Tragedy in Greece: An Eye-witness Report* (London: Progress Publishing/League for Democracy in Greece, 1946), p. 62.
3. Henry Miller, *The Colossus of Maroussi* (San Francisco: Colt Press, 1941).
4. Geoffrey Grigson, *John Craxton: Paintings and Drawings*, unpaginated monograph (London: Horizon, 1948).
5. John Craxton, conversation with the author, 25 March 1999.
6. Nanos Valaoritis, letter to the author, 13 May 1999, citing *Botteghe Oscure*, no. 20, 1957, pp. 435–6.
7. LF letter to his mother Lucie, n.d. [1947].
8. George Millar, *Isabel and the Sea* (London: William Heinemann, 1948), p. 356.
9. Ibid., pp. 357–8.
10. Ibid., p. 359.
11. Ibid., p. 358.
12. George Millar, Preface, *Horned Pigeon* (London: William Heinemann, 1949).
13. Millar, *Isabel and the Sea*, p. 359.
14. Ibid., p. 363.
15. John Craxton, letter to EQ, n.d. [1946], Tate Archive.
16. John Craxton, letter to EQ, n.d., Tate Archive.
17. Millar, *Isabel and the Sea*, p. 359.
18. Michael Ayrton on Freud and Minton, "Some Young British Contemporary Painters," *Orion III* (London: Nicholson & Watson, 1946), p. 87. "Whilst not British in origin, he [Freud] may be said to be of the 'School of London.'"
19. *Independent*, 7 September 1994.
20. Millar, *Isabel and the Sea*, p. 379.
21. Ibid., p. 381.
22. Ibid., p. 364.
23. Nanos Valaoritis, "Modern Greek Poetry," *Horizon*, March 1946.
24. Millar, *Isabel and the Sea*, p. 371.
25. Ibid., pp. 393–4.
26. LF letter to Felicity Hellaby (private collection).
27. Grigson, *John Craxton: Paintings and Drawings*.

14 · "FREE SPIRITS LIKE ME"

1. Cressida Connolly, *The Rare and the Beautiful: The Lives of the Garmans* (London: Fourth Estate, 2004), p. 216.
2. W. H. Auden, "Death's Echo" (1936).
3. Kenneth Tynan, *Diaries*, ed. John Lahr (London: Bloomsbury, 2002), 12 April 1971, p. 40.
4. Annie Freud, conversation with the author, 29 May 2012.
5. Kenneth Clark in *Epstein Centenary* catalogue, Ben Uri Gallery, London, p. 3.
6. Kenneth Clark, *Henry Moore Drawings* (London: Thames & Hudson, 1974), p. 114.
7. Jacob Epstein, letter to LF, n.d. [1949], private collection.
8. Dilys Powell, review of *The Blue Lamp*, *Sunday Times*, January 1950, reprinted in *Shots in the Dark* (London: Allan Wingate, 1951), p. 127.
9. Waldemar Hansen, letter to John Myers, 4 May 1947, private collection.
10. Michael Hamburger, letter to the author, 5 December 2000.
11. June Rose, *Time*, 26 May 1947.
12. Bernard Denvir, "Wilfred Evill," *Studio*, February 1949, p. 44.
13. Kitty Garman, letter to Kathleen (Epstein), July 1947, Walsall Art Gallery Archives.
14. Ibid.
15. LF letter to Meraud Guinness, Tate Archive.
16. LF letter to Meraud Guinness, Tate Archive.
17. LF letter to Meraud Guinness, Tate Archive.
18. Herbert Read, Introduction, *Exposition de la Jeune Peinture en Grande Bretagne*, British Council/La Galerie René Drouin, 23 January–21 February 1948.
19. Robin Ironside, *Painting since 1939* (London: British Council, 1947), p. 36.
20. *Studio*, December 1947.
21. Bernard Denvir, *Tribune*, November 1947.
22. Maurice Collis, *Time & Tide*, November 1947.
23. Frank Auerbach, conversation with the author, 2013.
24. Kitty Garman, conversation with the author, 17 February 2000.
25. Nanos Valaoritis, "Problems of an Empire," *Botteghe Oscure*, no. 20, 1957, pp. 435–6.

15 · "ME WITH HORNS"

1. LF to Felicity Hellaby, n.d. [1947] (private collection).
2. Felicity Hellaby, conversation with the author, 19 February 2012.
3. Richard Buckle, *The Adventures of a Ballet Critic* (London: Cresset Press, 1953), p. 133.
4. A. L. Lloyd, "An Artist Makes a Living," *Picture Post*, 21 December 1946, pp. 22–4.
5. Collotypes of *Girl in a White Dress* and *Chicken on a Table* were published in Oliver Simon's *Signature* 10 (London: Curwen Press, 1950).
6. William Sansom, *Equilibriad* (London: Hogarth Press, 1948), p. 17.
7. Kitty Epstein (Godley), conversation with the author, 2000.

16 · "FED SWEETS BY NUNS ON THE COACH TO GALWAY"

1. Cited in Roger Berthoud, *Graham Sutherland: A Biography* (London: Faber & Faber, 1982), p. 247.
2. Douglas Cooper, conversation with the author, BBC Radio 3, 6 July 1983.
3. Graham Sutherland, letter to Robert Melville, November 1948, Robert Melville papers, Tate Archive.
4. Cecil Beaton on Bérard, from *Ballet* magazine, quoted in *Christian Bérard*, exhibition brochure (London: Arts Council, 1950).
5. *Lucian Freud: Portraits* (2004), film directed by Jake Auerbach, produced by Jake Auerbach and William Feaver.
6. Anne Dunn, conversation with the author, 16 April 2000.
7. Anne Dunn, letter to LF, n.d., from Zetland Hotel Galway, private collection.
8. Anne Dunn, conversation with the author, 16 April 2000.
9. Ibid.
10. Ibid.
11. Ibid.
12. Ibid.
13. Samuel Beckett, "Homage to Jack Yeats" (1954), reprinted in *Disjecta* (London: John Calder, 1983), p. 148. "Strangeness so entire as even to withstand the stock assimilations to holy patrimony."
14. Later collected in *After the Wake*, "twenty-one prose works including previously unpublished material" (Dublin: O'Brien Press, 1981).
15. William Townsend, *Journals: An Artist's Record of His Times, 1928–51*, ed. Andrew Forge (London: Tate Publishing, 1976), p. 82.
16. Ibid., p. 88.

17. Anne Dunn, conversation with the author, 16 April 2000.
18. Beaton, quoted in *Christian Bérard*.
19. Christian Bérard, reported by LF.
20. Anne Dunn, conversation with the author, 16 April 2000.
21. Ibid.
22. Ibid. Derek Jackson, 1906–82: one-time chairman of the *News of the World*, six marriages, two of which were to the femme fatale Barbara Skelton and Janetta Woolley.
23. Ibid.
24. Ibid.
25. Ibid.
26. Frank Auerbach, conversation with the author, April 2010.
27. Ibid.

17 · "MY *LARGE* ROOM IN PADDINGTON!"

1. Balthus, quoted in Jean Clair, *Balthus* (London: Thames & Hudson, 2001), p. 131.
2. Balthus, interview by David Bowie, *Modern Painters*, vol. 7, no. 3, 1994, p. 194.
3. Cyril Connolly, "Comment," *Horizon*, November 1947, p. 227.
4. Robin Ironside, "Balthus," *Horizon*, April 1948, p. 266.
5. Lawrence Gowing, Introduction to *William Coldstream* catalogue (London: Arts Council, 1962), p. 12.
6. Geoffrey Grigson, "Remarks on Painting and Mr. Auden," *New Verse*, January 1939, p. 19.
7. LF comment.
8. William Coldstream, interview by Rodrigo Moynihan, "A Nonconformist," *Art and Literature*, 4, 1965, p. 208.
9. BBC Third Programme, reprinted in the *Listener*, 5 February 1947.
10. Nicholas Garland, letter to the author, 17 March 2000.
11. George Orwell, *The English People* (London: Collins, 1947), p. 8.
12. Bill Brandt, *Camera in London* (London: Focal Press, 1948), p. 14.
13. Stephen Spender, editorial, *Horizon*, July 1945.
14. William Plomer, "Voyage autour de W2," in John Sutro (ed.), *Diversion: 22 Authors on the Lively Arts* (London: Max Parrish, 1950), p. 211.
15. Oscar Wilde, *The Picture of Dorian Gray* (1890), ch. 19.
16. Anne Dunn, letter to the author, 9 March 2012.
17. Frank Auerbach, conversation with the author.
18. Colin MacInnes in Mark Haworth-Booth (ed.), *The Street Photographs of Roger Mayne* (London: Victoria & Albert Museum, 1986), p. 73.

19. Cyril Connolly, "Comment," *Horizon*, November 1948, p. 299.
20. Michael Hamburger, conversation with the author, 11 December 2000.
21. Anne Dunn, conversation with the author, 16 April 2000.
22. Ibid.

18 · "MY NIGHT'S ENTERTAINMENT"

1. Percy Wyndham Lewis, *Listener*, 14 July 1949.
2. Patrick Heron, *New Statesman*, 25 March and 29 April 1950.
3. Wyndham Lewis, *Listener*, 17 November 1949, p. 860.
4. The Comte de Lautréamont [Isidore Ducasse], "Midway" Chant 6, *The Lay of Maldoror*, trans. John Rodker (London: Casanova Society, 1924).
5. Frances Spalding, *Dance till the Stars Come Down: A Biography of John Minton* (London: Hodder & Stoughton, 1991), p. 149.
6. Anne Dunn, conversation with the author, 16 April 2000.
7. Heron, *New Statesman*, 29 April 1950.
8. Spalding, *Dance till the Stars Come Down*, p. 149.
9. William Townsend, *The Townsend Journals: An Artist's Record of His Times, 1928–51*, ed. Andrew Forge (London: Tate Publishing, 1976), p. 88.
10. Heron, *New Statesman*, 29 April 1950.
11. "Freud the Younger," *Flair*, February 1952, pp. 32–3.
12. Lincoln Kirstein, autobiographical notes, *Quarry* (privately printed, 1986), p. 107.
13. Lincoln Kirstein letter [1953], British Council Archives.
14. Anne Dunn, conversation with the author, 16 April 2000.
15. LF quoting Cyril Connolly.
16. Anne Dunn, conversation with the author, 16 April 2000.
17. Ibid.

19 · "BEING ABLE TO SEE UNDER THE CARPET"

1. Charlie Lumley, letter to LF, n.d. [1950], private collection.
2. Harry Diamond, conversation with the author, April 2003.
3. Ibid.
4. Albert Camus, "Absurd Creation," *The Myth of Sisyphus* (1942) (London: Penguin, 1975), p. 87.
5. George Orwell, *Nineteen Eighty-Four* (London: Penguin reissue, 1954), p. 176.

6. Harry Diamond, conversation with the author, April 2003.
7. Graham Sutherland, "Some Thoughts on Painting," *Listener*, 6 September 1951.
8. Albert Camus, *The Outsider*, trans. Joseph Laredo (London: Hamish Hamilton, 1946), part 2, ch. 2.
9. David Sylvester, *Burlington Magazine*, October 1951, p. 329.
10. Ibid.
11. The Comte de Lautréamont [Isidore Ducasse], *The Lay of Maldoror*, trans. John Rodker (London: Casanova Society, 1924).
12. Harry Diamond, conversation with the author, April 2003.
13. LF Archives, NPG (National Portrait Gallery).
14. Alice Keene, *The Two Mr. Smiths: The Life and Work of Sir Matthew Smith* (London: Lund Humphries/Corporation of London 1995).
15. William Blake, "Miscellaneous Epigrams," XIV, *The Poetry and Prose of William Blake* (London: Nonesuch Press, 1948), p. 107.
16. Annie Freud, conversation with the author, 29 May 2012.

20 · "TRUE TO ME"

1. Richard Hamilton, letter to the author, 12 January 1999.
2. Ibid.
3. Ibid.
4. Ibid.
5. Herbert Read, *Art and Industry* (London: Faber & Faber, 1934), Introduction.
6. Richard Hamilton, letter to the author, 12 January 1999.
7. Herbert Read, *Contemporary British Art* (London: Penguin Books, 1951), p. 25.
8. Ibid., p. 35.
9. Ernst Gombrich, *Meditations on a Hobby Horse* (London: Phaidon, 1963), part 2.
10. Ibid., part 9.
11. Francis Bacon, conversation with LF.
12. Charlie Lumley, "I'm the Boy in Freud Painting," by Louise Jury, *Evening Standard*, 1 September 2011.
13. Letter from John Minton to Michael Wishart, quoted in Frances Spalding, *Dance till the Stars Come Down: A Biography of John Minton* (London: Hodder & Stoughton, 1991), p. 14.
14. H. L. Hunter with Cecil Whiley, *Leaves of Gold* (London: George M. Whiley, 1951); this was a company history commissioned by George M. Whiley Ltd, goldbeaters of Covent Garden.

15. Augustus John, "Fragment of an Autobiography," *Horizon*, December 1945.

16. Graham Sutherland, BBC Third Programme, reprinted in the *Listener*, 4 December 1951.

17. Anne Dunn, conversation with the author, 16 April 2000.

18. Ibid.

19. T. S. Eliot, "Sweeney Erect," *Poems* (New York: Alfred A. Knopf, 1920).

20. Robert Melville, "Francis Bacon," *Horizon*, December 1949, p. 421.

21. Frank Auerbach, conversation with the author.

22. Ibid.

23. Richard Hamilton, letter to the author, 12 January 1999.

24. A. J. Ayer, *More of My Life* (London: Collins, 1984), p. 79.

25. Henry Green, *Doting* (London: Hogarth Press, 1952), p. 252.

26. Michael Luke, *David Tennant and the Gargoyle Years* (London: Weidenfeld & Nicolson, 1991), p. 182.

27. Andrée Melly, letter to LF [c. 1993], private archive.

28. Henrietta Moraes, *Henrietta* (London: Hamish Hamilton, 1994), p. 31.

29. Michael Hamburger, conversation with the author, 11 December 2000.

30. William Empson, "This Last Pain" (the last line reads "And learn a style from a despair"), *Collected Poems* (London: Chatto & Windus, 1956).

31. John Berger, *New Statesman*, 5 January 1952.

32. Francis Bacon in *Matthew Smith: Paintings from 1909 to 1952* (London: Tate Gallery, 1953), p. 12.

33. Ibid.

34. David Sylvester, *Listener*, 8 May 1952.

35. Michael Middleton, *Spectator*, May 1952.

36. Robert Melville, art column in *Architectural Review*, May 1952.

21 · "LADY DASHWOOD, SORRY TO HAVE KICKED YOU"

1. Bruce Bernard and Derek Birdsall, *Lucian Freud* (London: Jonathan Cape, 1996), p. 13.

2. Michael Middleton, *John Minton* catalogue (London: Arts Council, 1958), p. 7.

3. Ibid.

4. Peter Quennell (ed.), *A Lonely Business: A Self-Portrait of James Pope-Hennessy* (London: Weidenfeld & Nicolson, 1981), p. 88.

5. Ann Fleming, *The Letters of Ann Fleming*, ed. Mark Amory (London: Collins, 1985), p. 123.

6. Barbara Skelton, *Tears Before Bedtime* (London: Hamish Hamilton, 1987), p. 164.

7. Ivana Lowell, "Lucian Freud—His Scandalous Private Life," *Newsweek*, 8 July 2011.

8. Anne Dunn, conversation with the author, 16 April 2000.

9. Kitty Garman, postcard to LF, n.d. [1952].

10. Lucie Freud, letter to Ernst Freud, Freud Museum Archive.

11. Annie Freud, conversation with the author, 29 May 2012.

12. Ibid.

13. Jacob Epstein, letter to Peggy-Jean, his daughter, 17 January 1955, Tate Archive.

22 · "A MARVELLOUS CHASE FEELING"

1. Lucian Freud, letter to Ann Fleming, March 1953, *The Letters of Ann Fleming*, ed. Mark Amory (London: Collins, 1985), p. 125.

2. Caroline Blackwood, letter to LF, private collection.

3. Caroline Blackwood, letter to LF, n.d. [1953], from Ritz Hotel, Madrid, private collection.

4. LF quoting Fleur Cowles.

5. LF commenting.

6. Ann Fleming to Evelyn Waugh, *Letters of Ann Fleming*, p. 129.

7. Lucian Freud, "Some Thoughts on Painting," *Encounter*, July 1954, p. 23.

8. Cyril Connolly, *Journal and Memoir*, ed. David Pryce-Jones (London: Collins, 1983), p. 238.

9. Michael Kimmelman, *New York Times Magazine*, 2 April 1995; see also *Lucian Freud: Early Works* catalogue (New York: Robert Miller Gallery, 1993).

10. Cecil Beaton, *Self-Portrait with Friends: The Selected Diaries of Cecil Beaton, 1926–74*, ed. Richard Buckle (London: Penguin Books, 1982), p. 273.

11. Peter Quennell (ed.), *A Lonely Business: A Self-Portrait of James Pope-Hennessy* (London: Weidenfeld & Nicolson, 1981), 29 September 1953, p. 88.

12. Caroline Blackwood, interview by Janet Watts, "The Man I Knew Is Missing," *Observer*, 1 May 1983.

13. LF letter to Lilian Somerville, 17 July 1953, British Council Archives.

14. Ibid.
15. Ibid.
16. Barbara Skelton, *Tears Before Bedtime* (London: Hamish Hamilton, 1987), p. 135.
17. Cecil Beaton, *The Strenuous Years: Diaries, 1948–55* (London: Weidenfeld & Nicolson, 1973), pp. 133–4.
18. Ibid.
19. Caroline Blackwood, "The Interview," first published in the *London Magazine*, 1972, reprinted in Caroline Blackwood, *For All That I Found There* (London: Duckworth, 1973) as a fictional reminiscence of life with an "oddly honourable" painter, the interview involving "my whole past . . . being thrown back at me all curiously curdled and distorted," p. 62.
20. Tania Stern, letter to Lucie Freud, n.d. [1953], Freud Museum Archives.
21. Evelyn Waugh, letter to Nancy Mitford, *The Letters of Evelyn Waugh*, ed. Mark Amory (London: Weidenfeld & Nicolson, 1980), p. 423.

23 · "MY ARDOUR IN THE LONG PURSUIT"

1. Cyril Connolly, letter to Olga Rudge, 16 November 1970, quoted in Jeremy Lewis, *Cyril Connolly: A Life* (London: Jonathan Cape, 1997), p. 548.
2. Caroline Blackwood, "Portraits by Freud," *New York Review of Books*, 16 December 1993.
3. Anne Dunn, in *Lucian Freud: Portraits* (2004), film directed by Jake Auerbach, produced by Jake Auerbach and William Feaver.
4. LF letter to Lilian Somerville, January 1954, British Council Venice Biennale Archive.
5. LF letter to Lilian Somerville, 18 January 1954, British Council Venice Biennale Archive.
6. Lilian Somerville, letter to Alfred Barr, February 1954, British Council Venice Biennale Archive.
7. Ibid.
8. Lilian Somerville, letter to LF, 26 February 1954, British Council Venice Biennale Archive.
9. LF letter to Lilian Somerville, n.d. [1954], British Council Venice Biennale Archive.
10. Caroline Blackwood, in *Lucian Freud: Early Works* catalogue (New York: Robert Miller Gallery, 1993), p. 14.

11. Lilian Somerville, telegram to LF, April 1954, British Council Venice Biennale Archive.

12. Ibid.

13. MS, private collection.

14. LF letter to Lilian Somerville, April 1954, British Council Venice Biennale Archive.

15. Lilian Somerville, telegram to LF, n.d. [April 1954], British Council Venice Biennale Archive.

16. Herbert Read, Foreword, catalogue for British Pavilion, *Nicholson Bacon Freud*, Venice Biennale, 1954.

17. John Rothenstein, catalogue for British Pavilion, Venice Biennale, 1954, pp. 3–4.

18. David Sylvester, catalogue for British Pavilion, Venice Biennale, 1954, p. 3.

19. Alfred Frankfurter, "European Speculations," *Artnews*, September 1954, p. 23.

20. Herbert Read, *Contemporary British Art* (Harmondsworth: Pelican Books, 1st edn, 1951), p. 35.

21. Herbert Read, *Contemporary British Art* (London: Pelican Books, revised edn, 1964), p. 35.

22. Douglas Cooper, *Burlington Magazine*, October 1954.

23. "Ephraim Hardcastle" column, *Sunday Express*, 16 May 1954.

24. Colin Tennant, Christie's catalogue, London sale, 11 December 1997.

25. Ann Fleming, letter to Joan Rayner and Patrick Leigh Fermor, 23 August 1954, in *The Letters of Ann Fleming*, ed. Mark Amory (London: Collins, 1985), p. 141.

26. Vic(tor) Willing, *Selected Writings* (London: Karsten Schubert, 1993), p. 34.

27. Evelyn Waugh, letter to Ann Fleming, 5 May 1954, *The Letters of Evelyn Waugh*, ed. Mark Amory (London: Weidenfeld & Nicolson, 1980), p. 424.

28. David Storey interviewed by Jasper Rees, www.theartsdesk.com, 2 November 2013.

24 · "IDYLLIC, IN A SLIGHTLY MADDENING WAY"

1. Henrietta Moraes had a son by Colin Tennant in 1954, unrecognised until 2009, a decade after her death, when DNA tests were initiated by this son, Joshua Bowler.

2. *Performance* (1970), film directed by Donald Cammell/Nicholas Roeg,

in which James Fox plays a gangster merging personalities with Mick Jagger, cast as a reclusive rock star.

3. David Thomson, *Independent on Sunday*, 19 May 2004.

4. Frank Auerbach, conversation with the author.

5. George Melly, *Owning Up*, trilogy (London: Penguin Books, 2006), p. 490.

6. Keiron Pim, *Jumpin' Jack Flash: David Litvinoff and the Rock 'n' Roll Underworld* (London: Jonathan Cape, 2016), pp. 95–101 and passim.

7. David Litvinoff committed suicide in 1975.

8. Kenneth Clark, *Moments of Vision*, Romanes Lecture 1954 (London: John Murray, 1973).

9. Lawrence Alloway, "London Letter," *Artnews*, November 1954, p. 54.

10. John Minton, "Three Young Contemporaries," *Ark* 13, Spring 1955.

11. David Sylvester, "The Kitchen Sink," *Encounter*, December 1954.

12. Jack Smith, in catalogue *The Forgotten Fifties* (Sheffield: Graves Art Gallery, 1984), p. 49.

13. Frank Auerbach, conversation with the author.

14. Helen Lessore, *Partial Testament* (London: Tate Publishing, 1987).

15. John Berger, *New Statesman*, April 1955.

16. "What is the Secret of This Picture?," *Daily Express*, 20 April 1955, p. 9.

17. Frank Auerbach, conversation with the author.

18. Stephen Spender, *New Selected Journals, 1939–1995*, ed. Lara Feigel and John Sutherland with Natasha Spender (London: Faber & Faber, 2012), p. 164.

19. Ibid., pp. 172–3.

20. Ibid., p. 172.

21. LF, letter to Stephen Spender, 24 October 1982, Sotheby's, London, 2 July 2015.

22. Obliterated by a subsequent owner, once it became known that a Freud mural probably survived under the white paint it was unveiled again some fifty years later.

23. Cecil Beaton, *The Strenuous Years: Diaries 1948–55* (London: Weidenfeld & Nicolson, 1973), April 1955.

24. Charlie Lumley, interview with Michael Macaulay, "Sitting for Lucian Freud," Sotheby's catalogue for 13 October 2011 sale, p. 176.

25. Michael Andrews, letter to the author, 12 August 1985.

26. Annie Freud, conversation with the author, 29 May 2012.

27. Samuel Beckett, *Disjecta* (London: John Calder, 1983), p. 148.

28. LF letter to Clement Freud, *c.* 1954, recited from memory.

29. Clement Freud, *Freud Ego* (London: BBC Books, 2001), p. 120.

25 · "MAD ON HEAT AND RUNNING ROUND, PISSING ALL THE TIME"

1. David Sylvester, *Art News and Review*, 17 June 1955.
2. *The Letters of J. R. Ackerley*, ed. Neville Braybrooke (London: Duckworth, 1975), p. 116.
3. That autumn Eden fell ill and took refuge in Jamaica at Goldeneye.
4. Ann Fleming, letter to Evelyn Waugh, 20 October 1956, quoted in Jeremy Lewis, *Cyril Connolly: A Life* (London: Jonathan Cape, 1997), p. 488.
5. Cyril Connolly, letter to Caroline Blackwood, quoted in Lewis, *Cyril Connolly*, p. 487.
6. Ibid., p. 488.
7. Ibid.
8. Frank Auerbach, conversation with the author.
9. Ibid.
10. Ibid.
11. David Sylvester, *Listener*, 12 January 1956.
12. Frank Auerbach, conversation with the author.
13. Ibid.
14. Stephen Spender, *New Selected Journals, 1939–1995*, ed. Lara Feigel and John Sutherland with Natasha Spender (London: Faber & Faber, 2012), p. 240.
15. Cecil Beaton, *Self-Portrait with Friends: The Selected Diaries of Cecil Beaton, 1926–74*, ed. Richard Buckle (London: Penguin Books, 1982), pp. 304–5.
16. Cecil Beaton, *The Restless Years: Diaries 1955–63* (London: Weidenfeld & Nicolson, 1976), May 1956, pp. 44–5.
17. Spender, *New Selected Journals*, p. 221.
18. Stephen Spender, *New Statesman*, 12 May 1956.
19. Spender, *New Selected Journals*, p. 248.
20. John Minton, reported in the *Daily Express*, 19 May 1956.
21. Andrew Forge, "We Dream of Motor Cars," *Encounter*, January 1956, p. 68.
22. Edward Booth Clibborn, a nephew of Nina Hamnett, remembered seeing Freud in the hospital corridor. Letter to the author, 31 March 2016. Nina Hamnett died in December 1956.

26 · "DO YOU THINK I'M MADE OF WOOD?"

1. John Minton, reported in the *Daily Express*, 19 May 1956.
2. David Wynne-Morgan, "Yesterday There Died a Purple, Melancholy Genius," *Daily Express*, 21 January 1957.
3. Unidentified newspaper cutting.
4. Ivana Lowell [Caroline's daughter by Israel Citkowitz], *Why Not Say What Happened?* (London: Bloomsbury, 2010), p. 23.
5. A. E. Ellis, *The Rack* (London: William Heinemann, 1958). The last woman to be hanged in Britain, Ruth Ellis, had murdered her lover in 1955.
6. Christopher Isherwood, *Diaries*, vol. 1: *1939–60*, ed. Katharine Bucknell (London: Methuen, 1996), February 1959, p. 303.
7. Belinda Rathbone, *Walker Evans* (New York: Houghton Mifflin, 1995), pp. 232–3.
8. Matthew Marks, letter to the author, April 2013.
9. Deborah, Duchess of Devonshire, interviewed by the author in *Lucian Freud: Portraits* (2004), film directed by Jake Auerbach, produced by Jake Auerbach and William Feaver.
10. Fritz Hess, letter to LF, 21 January 1957, private collection.
11. Ernst Freud, letter to Fritz Hess, 1 February 1957.
12. Frank Auerbach, conversation with the author, 2014.
13. Henry Green in *Matthew Smith: Paintings from 1909 to 1952* (London: Tate Gallery/HMSO, 1953), p. 10.
14. Francis Bacon in ibid., p. 12.
15. Frank Auerbach, conversation with the author, 2014.
16. Jane McAdam Freud, conversation with the author, 7 November 2000.
17. Ibid.
18. Stephen Spender, *Journals, 1939–83* (London: Faber & Faber, 1985), p. 175.
19. Anne Dunn, letter to the author, 9 March 2012.
20. "Magistrate Warns Motorist: You ought to see psychiatrist," *The Times*, 10 January 1959, p. 4.
21. Ibid.
22. Ibid.

27 · "BRILLIANT ONES FIZZLED"

1. Deborah, Duchess of Devonshire, letter to Diana, Lady Mosley, 12 August 1957, *The Mitfords: Letters between Six Sisters*, ed. Charlotte Mosley (London: Fourth Estate, 2007), p. 297.

2. Giles Brandreth, "The Duke of Devonshire's A to Z of Englishness," *Daily Mail*, *c.* 2003, reprinted 6 April 2018.

3. Hilaire Belloc, "The Garden Party," in *Cautionary Verses* (London: Duckworth, 1951), p. 131.

4. Evelyn Waugh, letter to Nancy Mitford, 21 June 1960, *The Letters of Evelyn Waugh*, ed. Mark Amory (London: Weidenfeld & Nicolson, 1980), p. 545.

5. Duke of Devonshire reported by LF.

6. Deborah, Duchess of Devonshire, letters to Nancy Mitford, 7 October 1960 and 21 July 1961, *The Mitfords*, pp. 343 and 355.

7. June Keeley (Andrews), conversation with the author, 10 October 1997.

8. Ibid.

9. Colin Clark, *Younger Brother, Younger Son* (London: HarperCollins, 1997).

10. Nick Garland, letter to the author, 17 March 2000.

11. Ibid.

12. Frank Auerbach, conversation with the author, October 2012.

28 · "ACTUALLY IT'S ALL I CAN DO"

1. Don Henderson, letter to the author, 3 May 1992.

2. Bruce Bernard, Introduction, *Lucian Freud* (London: Jonathan Cape, 1996), p. 12.

3. D. H. Lawrence, "Introduction to These Paintings" (1929), in *Selected Critical Writings* (Oxford: Oxford University Press, 1998), p. 248.

4. Anon. (Michael Nelson), *A Room in Chelsea Square* (London: Jonathan Cape, 1958), p. 26.

5. Ibid., p. 71.

6. Ibid., p. 76.

29 · "PEOPLE BEING MONOGAMOUS SEEMS TO ME AN EXTRAORDINARY AND IMAGINATIVE SITUATION"

1. David Beaufort, conversation with the author, 7 November 2012.

2. Quentin Crewe, *Evening Standard*, 17 March 1958.

3. John Berger, "Success and Value," *New Statesman*, 5 April 1958. This appeared three pages on from Paul Johnson on "Sex, Snobbery and Sadism," a review of Ian Fleming's *Dr. No*: "without doubt the nastiest book I have ever read."

4. Ann Fleming, letter to Evelyn Waugh, 29 March 1958, *The Letters of Ann Fleming*, ed. Mark Amory (London: Collins, 1985), p. 215.

5. "James Bond prefers Nature to Art," *Evening Standard*, 1 April 1958.

6. Lawrence Alloway, *Listener*, 10 April 1958.

7. Anon. (David Thompson), *The Times*, 26 March 1958.

8. John Russell, *Sunday Times*, 30 March 1958.

9. Neville Wallis, *Observer*, 30 March 1958.

10. Frank Auerbach, conversation with the author, September 2012.

11. Kenneth Clark, *Listener*, 22 February 1940.

12. John Berger, *New Statesman*, 5 April 1958.

13. John Berger, *New Statesman*, reprinted in his *Permanent Red* (London: Methuen, 1960), p. 43.

14. June Keeley (Andrews), conversation with the author, July 1997.

15. Jeffrey Bernard, "Low Life," *Spectator* [timeless].

16. Andrew Parker-Bowles, conversation with the author, 15 February 2012.

17. Terry Miles, conversation with the author, 18 April 2008.

18. Ann Fleming, letter to Evelyn Waugh, *Letters of Ann Fleming*, p. 219.

19. Cecil Beaton, *Self-Portrait with Friends: The Selected Diaries of Cecil Beaton, 1926–74*, ed. Richard Buckle (London: Weidenfeld & Nicolson, 1979), p. 325.

20. Kitty Garman, letter to LF, 6 February 1959, private collection.

21. Alice Weldon, conversation with the author, 14 January 2014.

22. Michael Andrews, conversation with the author, March 1986.

23. David Wright, writing as James Mahon, "Official Art and the Modern Painter," *X*, vol. 1, no. 1, November 1959, p. 30.

24. Frank Auerbach, "Fragments from a Conversation," *X*, vol. 1, no. 1, November 1959, p. 33.

25. Ibid., p. 34.

26. David Wright, writing as James Mahon, "The Painter in the Press," *X*, vol. 2, no. 4, October 1960, p. 299.

27. Sir Herbert Read, *A Concise History of Modern Painting* (London: Thames & Hudson, 1959), Preface.

28. Herbert Read, "My Favourite Picture," *Books and Art*, January 1958, p. 19.

29. Duchess of Devonshire, letter to Paddy Leigh Fermor, 11 November 1959, *In Tearing Haste: Letters between Deborah Devonshire and Patrick Leigh Fermor*, ed. Charlotte Mosley (London: John Murray, 2008), p. 62.

30. George Millar, *Isabel and the Sea* (London: William Heinemann, 1948), p. 379.

30 · "HE WAS RATHER NICE AND REPULSIVE"

1. Cecil Beaton, *Self-Portrait with Friends: The Selected Diaries of Cecil Beaton, 1926–74*, ed. Richard Buckle (London: Penguin Books, 1982), pp. 324–5.
2. Reggie Kray, *A Way of Life* (London: Sidgwick & Jackson, 2000), p. 235.
3. *X*, vol. 2, no. 4, October 1960.
4. Annie Freud, conversation with the author, 29 May 2012.
5. John Rothenstein, *Time's Thievish Progress* (London: Cassell, 1970), p. 98.
6. *The Times*, 26 May 1967.

31 · "AWFULLY UNEASY"

1. David Sylvester, "Michael Andrews: 'Mysterious Conventionality,'" *Sunday Times* colour magazine, 13 January 1963.
2. John Russell, *Sunday Times*, 10 June 1962.
3. Douglas Cooper, *The Work of Graham Sutherland* (London: Lund Humphries, 1961), Introduction.
4. *Observer*, 21 January 1962.
5. Annie Freud, conversation with the author, 29 May 2012.
6. Ibid.
7. Ibid.
8. Annabel Freud, conversation with the author, 14 February 2013.
9. Ibid.
10. Frank Auerbach, conversation with the author.
11. Tim Behrens, letter to the author, 2002.

32 · "THE ABSOLUTE CHEEK OF MAKING ART"

1. David Sylvester, "Dark Sunlight," *Sunday Times* magazine, 2 June 1963.
2. Joachim Gasquet, *Cézanne: A Memoir with Conversations* (1921) (London: Thames & Hudson, 1991), p. 163.
3. Frank Auerbach, conversation with the author.
4. Jimmy Stern, letter to LF, 2 October 1963, private collection.
5. Eric Newton, *Guardian*, 7 October 1963.
6. David Thompson, *The Times*, 5 October 1963.
7. "Peterborough," *Daily Telegraph*, 7 October 1963.

8. Photographs taken in April 1958.

9. David Sylvester, *Interviews with Francis Bacon* (London: Thames & Hudson, 1975), p. 21.

10. Gasquet, *Cézanne*, p. 158.

11. Lawrence Gowing, *Lucian Freud* (London: Thames & Hudson, 1982), p. 161.

12. Lynda Morris, letter to the author, n.d. [*c.* 2000].

13. Kenneth Clark, *The Nude: A Study of Ideal Form* (London: John Murray, 1957) p. 1.

14. Kenneth Clark quoted in Herbert Read, "My Favourite Picture," *Books and Art*, January 1958, p. 19.

15. LF quoting Kenneth Clark.

16. Edmond L. A. H. de Goncourt and Jules A. H. de Goncourt, *Pages from the Goncourt Journals*, ed. Robert Baldick (Oxford: Oxford University Press, 1978), pp. 53 and 61.

17. Walter Sickert, "The Naked and the Nude," *New Age*, 21 July 1910, p. 277.

33 · "I CAN'T BE PRESSED REALLY"

1. John Russell in Bryan Robertson, John Russell and Lord Snowdon, *Private View* (London: Thomas Nelson, 1965), p. 113.

2. Ibid.

3. Jane McAdam Freud, conversation with the author, 7 November 2000.

4. Ibid.

5. Jane McAdam Freud, letter to the author, 22 November 2000.

6. Paul McAdam Freud, conversation with the author, 4 December 2000.

7. Ibid.

8. Jane McAdam Freud, conversation with the author, 7 November 2000.

9. Jane McAdam Freud, letter to the author, 22 November 2000.

10. Anne Dunn, letter to the author, 7 January 2012.

11. *Francis Bacon: Interviews with David Sylvester*, film directed by Michael Gill, BBC, May 1966.

12. The painting was destroyed in a fire.

13. Charles Baudelaire, "The Salon of 1846," *The Mirror of Art* (London: Phaidon Press, 1955), p. 89.

14. Ibid., p. 70.

15. John Russell, *Lucian Freud* (London: Arts Council, 1974), p. 23.

16. Brian Sayers, letter to the author, February 2012.

34 · "IF WORK PERMITS"

1. Frank Auerbach, conversation with the author.
2. Mark O'Connor, conversation with the author, May 2013.
3. Esther Freud, conversation with the author, 26 February 2016.
4. Ibid.
5. Frank Auerbach, conversation with the author.
6. Esther Freud, conversation with the author, 26 February 2016.
7. Cedric Morris, *Studio*, May 1942, pp. 121–30.
8. Edmond L. A. H. de Goncourt and Jules A. H. de Goncourt, *Pages from the Goncourt Journals*, ed. Robert Baldick (Oxford: Oxford University Press, 1978), 22 May 1865, p. 106.
9. David Somerset, conversation with the author, 7 November 2012.
10. Paul Overy, *Listener*, 2 May 1968.
11. Frank Auerbach, conversation with the author.
12. De Goncourt and de Goncourt, *Pages from the Goncourt Journals*, 23 May 1871, p. 189.
13. Alice Weldon, conversations with the author, 14 January and 15 June 2014.
14. Anne Dunn, conversation with the author.
15. Anne Dunn, letter to the author, January 2013.
16. Frank Auerbach, conversation with the author.
17. Ibid.
18. Annie Freud, conversation with the author, 29 May 2012.
19. De Goncourt and de Goncourt, *Pages from the Goncourt Journals*, 21 May 1857, p. 27.

BIBLIOGRAPHY

Sources relating to the period of Lucian Freud's life
covered by this volume.

PRIMARY SOURCES

Author's recorded interviews and conversations with Freud, 1973 to 2011
Extensive conversations with, among many others, Frank Auerbach, Anne
 Dunn, Annie Freud, Felicity Hellaby, Gabriele Ullstein, Alice Weldon
Lucian Freud, "Some Thoughts on Painting," *Encounter*, vol. 3, no. 1, July
 1954
Lucian Freud, statement in *Modern Art in Britain*, ed. Michael Peppiatt,
 Cambridge Opinion, no. 37, 1964, p. 47
Lucian Freud, statement in *The Artist's Eye* (London: National Gallery,
 1987)

PUBLISHED INTERVIEWS WITH LUCIAN FREUD BY THE AUTHOR

"Lucian Freud: The Analytical Eye," *Sunday Times* magazine, 3 February
 1974
"The Artist out of His Cage," *Observer* Review, 6 December 1992
"The Naked Eye," *Observer* Life, 23 June 1996
Lucian Freud on John Constable: A Conversation with William Feaver (London: British Council, 2003)

SECONDARY SOURCES

Books of particular importance to Freud
J. H. Breasted, *Geschichte Ägyptens* (Vienna: Phaidon, 1936—distributed in
 Britain by George Allen & Unwin)
Lewis Carroll, *The Hunting of the Snark: An Agony in Eight Fits* (London:
 Macmillan, 1876)
Wolf Durian, *Kai aus der Kiste* (Berlin: Franz Schneider Verlag, 1927)
Erich Kästner, *Emil und die Detektive* (Berlin: Williams Verlag, 1928)

Christian Morgenstern, *Galgenlieder* (Berlin: Bruno Cassirer, 1905)

Tom Seidmann-Freud, *ABC: Hurra, Wir Lesen! Hurra, Wir Schreiben!* (Berlin: Herbert Stuffer Verlag, 1930)

Monographs

Bruce Bernard and Derek Birdsall, *Lucian Freud* (London: Jonathan Cape, 1996)

William Feaver, *Lucian Freud* (New York: Rizzoli, 2007)

Lawrence Gowing, *Lucian Freud* (London: Thames & Hudson, 1982)

Craig Hartley, *The Etchings of Lucian Freud, 1946–1995* (London: Marlborough Graphics, 1995)

Film, Television and Radio

Lucian Freud in conversation with William Feaver, *Third Ear*, BBC Radio 3, producer Judith Bumpus, recorded 10 December 1991

Jake Auerbach (producer), *Omnibus: Lucian Freud*, BBC1, 1988.

Jake Auerbach, *Lucian Freud Portraits*, Jake Auerbach Films Ltd, London, 2004 (interviews, conducted by the author as co-producer, with many of Freud's sitters)

Randall Wright (producer), *Lucian Freud: A Painted Life*, BBC2, 2012

Articles

William Feaver, "Stranded Dinosaurs," *London Magazine*, July–August 1970

John Gruen, "The relentlessly personal vision of Lucian Freud," *Artnews*, April 1977, and *The Artist Observed* (New York: A Cappella Books, 1991), pp. 314–24.

Exhibition Catalogues

Richard Calvocoressi, *Lucian Freud Early Works* (Edinburgh: Scottish National Gallery of Modern Art, 1997)

Susan Compton (ed.), *British Art in the 20th Century: The Modern Movement* (London: Royal Academy 1986)

William Feaver, *Lucian Freud* (London: Tate Publishing, 2002)

—, *Lucian Freud* (Venice: Museo Correr, 2005)

—, *Lucian Freud Drawings* (London: Blain Southern, 2012)

Starr Figura, *Lucian Freud: The Painter's Etchings* (New York: Museum of Modern Art, 2007)

Sarah Howgate with Michael Auping and John Richardson, *Lucian Freud Portraits* (London: National Portrait Gallery, 2012)

Robert Hughes, Introduction, *Lucian Freud Paintings* (London: Hirshhorn Museum, Washington DC/British Council, London, 1987)

Catherine Lampert, *Lucian Freud* (Dublin: Irish Museum of Modern Art, 2007)

Catherine Lampert in *Lucian Freud Early Works 1940–58* (London: Hazlitt Holland-Hibbert, 2008)

Nicholas Penny in *Lucian Freud: Works on Paper* (London: South Bank Centre, 1987)

John Russell, Introduction, *Lucian Freud* (London: Arts Council of Great Britain/Hayward Gallery, 1974)

Sebastian Smee, *Lucian Freud: Drawings 1940* (New York: Matthew Marks Gallery, 2003)

—, *The Art of Rivalry* (New York: Random House, 2016)

Sebastian Smee and Richard Calvocoressi, *Lucian Freud on Paper* (London: Jonathan Cape, 2010)

Books

Anon. (Michael Nelson), *A Room in Chelsea Square* (London: Jonathan Cape, 1958)

W. H. Auden and John Garrett (eds), *The Poet's Tongue* (London: George Bell, 1935)

Roger Berthoud, *Graham Sutherland: A Biography* (London: Faber & Faber, 1982)

Ian Collins, *John Craxton* (London: Lund Humphries, 2011)

Cressida Connolly, *The Rare and the Beautiful: The Lives of the Garmans* (London: Fourth Estate, 2004)

Ann Fleming, *The Letters of Ann Fleming*, ed. Mark Amory (London: Collins, 1985)

Robert Fraser, *Night Thoughts: The Surreal Life of David Gascoyne* (Oxford: Oxford University Press, 2012)

Clement Freud, *Freud Ego* (London: BBC Books, 2001)

Martin Freud, *Glory Reflected* (London: Angus & Robertson, 1957)

Martin Gayford, *The Man with a Blue Scarf: On Sitting for a Portrait by Lucian Freud* (London: Thames & Hudson, 2010)

—, *Lucian Freud*, ed. David Dawson and Mark Holborn (London: Phaidon, 2018)

Harry Graham, *More Ruthless Rhymes for Heartless Homes* (London: Edward Arnold, 1930)

Geordie Greig, *Breakfast with Lucian: A Portrait of the Artist* (London: Jonathan Cape, 2013)

Valerie Grove, *Laurie Lee: The Well-Loved Stranger* (London: Viking, 1999/ Robson Press, 2014)

James Hyman, *The Battle for Realism: Figurative Art in Britain during the Cold War* (London: Yale University Press for Paul Mellon Centre for Studies in British Art, 2001)

Jeremy Lewis, *Cyril Connolly: A Life* (London: Jonathan Cape, 1997)

Ivana Lowell, *Why Not Say What Happened?* (London: Bloomsbury, 2010)

George Millar, *Isabel and the Sea* (London: William Heinemann, 1948)

Michael Molnar (ed.), *The Diary of Sigmund Freud, 1929–39* (London: Hogarth Press, 1992)

Henrietta Moraes, *Henrietta* (London: Hamish Hamilton, 1994)

Richard Morphet, *Cedric Morris* (London: Tate Gallery, 1984)

Robin Muir, *Under the Influence: John Deakin, Photography and the Lure of Soho* (London: Art/Books Publishing, 2014)

Michael Peppiatt, *Francis Bacon: Anatomy of an Enigma* (London: Weidenfeld & Nicolson, 1996)

Keiron Pim, *Jumpin' Jack Flash: David Litvinoff and the Rock 'n' Roll Underworld* (London: Jonathan Cape, 2016)

John Richardson, *Sacred Monsters, Sacred Masters* (London: Jonathan Cape, 2001)

Brian Robertson, John Russell and Lord Snowdon, *Private View* (London: Thomas Nelson, 1965)

Alan Ross, *The Forties* (London: Weidenfeld & Nicolson, 1950)

John Rothenstein, *Modern English Painters*, vol. III: *Wood to Hockney* (London: Macdonald, 1974)

Nancy Schoenberger, *Dangerous Muse: The Life of Lady Caroline Blackwood* (Cambridge, Mass.: Da Capo Press, 2002)

Barbara Skelton, *Tears Before Bedtime* (London: Hamish Hamilton, 1987)

Frances Spalding, *Dance till the Stars Come Down: A Biography of John Minton* (London: Hodder & Stoughton, 1991)

Stephen Spender, *New Selected Journals, 1939–1995*, ed. Lara Feigel and John Sutherland with Natasha Spender (London: Faber & Faber, 2012)

John Sutherland, *Stephen Spender: The Authorized Biography* (London: Viking, 2004)

David Sylvester, *Interviews with Francis Bacon* (London: Thames & Hudson, 1975)

Michael Wishart, *High Diver* (London: Blond & Briggs, 1977)

Charles Wrey Gardiner, *The Dark Thorn* (London: Grey Walls Press, 1946)

ACKNOWLEDGEMENTS

Being the subject Lucian Freud had reason to be wary yet he proved so responsive to questioning that before long what was to have been a brief study threatened to become a full-scale biography. When, in December 2000, I showed him a couple of chapters he was perturbed and I agreed to shelve what I'd done, the understanding being that "a novel," as he put it, could well be published after his death. Through the years that followed he continued to reminisce. "How old am I now?" he would often ask when I answered the phone. He even took to referring enquirers to me, telling them that I had come to know more about his life than he could still remember. To him go my prolonged thanks.

Conspicuous among those to whom Lucian was primarily a parent and who provided me with recollections, generous help and insights were Annie Freud, Rose [Boyt] Pearce and Esther Freud. Particular thanks to them, also to his successive dealers, James Kirkman and Bill Acquavella, to his assistant David Dawson and lawyer Diana Rawstron (who together administer the Lucian Freud Archive). Weekly discussions with Frank Auerbach while sitting for him from 2003 onwards proved singularly fruitful. And I'm indebted to Andrew Parker Bowles for the loan of his scrapbook.

Thanks and acknowledgements to:

Judy Adam, Clare Allen, Anne Ambler, June Andrews, Melanie Andrews, Michael Andrews, James Astor, Jake Auerbach, Kate Austin, Jack Baer, Marc Balakjian, Jan Banyard, Oliver Barker, Nicola Bateman, David Batterham, Mary Rose Beaumont, Nicci Bell, Felicity Bellfield (nee Hellaby), Bruce Bernard, Emily Bearn, Edward Booth-Clibborn, Leigh Bowery, Mark Boxer, Ib Boyt, Kai Boyt, Christopher Bramham, Polly Bramham, Dr. Paul Brass, Richard Calvocoressi, Robin Campbell, Henri Cartier-Bresson, Andrew Cavendish, 11th Duke of Devonshire, Deborah Cavendish, Duchess of Devonshire, Robin Cembalest, Susanna Chancellor, Perienne Christian, Sally Clarke, William Coldstream, Cressida Connolly, Robert Coward, John Craxton, Caroline Cuthbert, Robert Dalrymple, William Darby, Hatty Davidson, Erica Davies, Roy Davis, Jim Demetrion, Andrew Dempsey, Stephen Deuchar, Hamish Dewar, Harry Diamond, Pat Docherty, Anne Dunn, Angela Dyer, Freddy Eliot, Jacquetta

Eliot, Tracy Emin, Mark Evans, Tony Eyton, Dan Farson, Alice Feaver, Dorothy Feaver, Emily Feaver, Daniela Ferretti, Starr Figura, Jackie Ford, Charlotte Frank, Annabel Freud, Bella Freud, Jane McAdam Freud, Paul McAdam Freud, Stephen Freud, Stephen Gardiner, Nick Garland, Kitty Garman, Martin Gayford, Patrick George, Riccardo Giaccherini, Catherine Goodman, Dan Gordon, Michael Gormley, Lawrence Gowing, Noame Gottesman, Kim Grusczynski, Lindy Guinness, Penelope (Cuthbertson) Guinness, Kathleen Hale, Maggie Hambling, Michael Hamburger, Richard Hamilton, Adrian Heath, David Hockney, Howard Hodgkin, Richard Hollis, Mary Horlock, Sarah Howgate, John Hubbard, Robert Hughes, Evelyn Joll, Jay Jopling, Danny Katz, Moira Kelly, Rolfe Kentish, Edward King, Jeremy King, RB Kitaj, Fred Lambton, Catherine Lampert, Cecily Langdale, Sophie Lawrence, John Lessore, Joe Lewis, Louise Liddell, Vivienne Light, Magnus Linklater, Tomas Llorens, Barbara Lloyd, Janey Longman, Honey Luard, Sarah Lucas, Matthew Marks, John McCracken, John McEwan, Alfie McLean, John McLean, Paul McLean, Mel Merians, Charles Miers, Terry Danziger Miles, Daniel Miller, Mike Moritz, Richard Morphet, Lynda Morris, Rebecca Morse, Richard Mosse, Tim Nicholson, Charles Noble, Cavan O'Brien, Mark O'Connor, Pilar Ordovas, Sonia Orwell, Francis Outred, Eduardo Paolozzi, Geoffrey Parton, Celia Paul, Susanna Pollen, Tristram Powell, Marcus Price, John Richardson, Eric de Rothschild, Alan Ross, John Russell, Roz Saville, Brian Sayers, Patricia Scanlan, Paul Schimmel, Karsten Schubert, Colin Self, Nicholas Serota, Michael Sheldon, Sebastian Smee, David Somerset, 11th Duke of Beaufort, Graham Southern, Unity Spencer, Natasha Spender, Sophie de Stempl, George Stephenson, Timothy Stevens, Mercedes Stoutzker, Jeremy Strick, Christine Styrnau, David Sylvester, Charlotte Taylor, Ruthven Todd, Vitek Tracz, Euan Uglow, Gabriele Ullstein, Nino Valaoritis, Virginia Verran, Alice Weldon, Rowan Williams, Alexi Williams Wynn, Lady Jane Willoughby, Colin St. John (Sandy) Wilson, John Wonnacott, Randall Wright, Francis Wyndham.

A number of others have expressed a wish to remain anonymous; and the help of many whose involvement and knowledge relate to Freud's life from the seventies onwards will be acknowledged in the second volume.

The following have kindly given me permission to quote from letters and documents: Lucian Freud Archives, [Sigmund] Freud Museum Archives (Michael Molnar), Tate Archives (Adrian Glew) National Portrait Gallery Archives, Marine Safety Agency (Neil Staples), Craxton Estate (Richard Riley).

My heartfelt thanks to my literary agent Deborah Rogers, of Rogers, Coleridge & White, whose vivid guidance and advocacy for this book

extended over decades until her untimely death in 2014, since when Zoë Waldie has been a most excellent guide and minder.

At Bloomsbury Alexandra Pringle's enthusiasm and verve have delighted me, my editor Bill Swainson has been a friendly guide and fastidious amender, as has Peter James (copy editor) and Catherine Best (proofreader) while my in-house editor Angelique Tran Van Sang has conducted matters with patience, skill and aplomb. Many thanks also to Allegra Le Fanu, Francesca Sturiale, David Mann, Douglas Matthews, Emma Bal, Genista Tate-Alexander and Maria Hammershoy.

Shelley Wanger at Knopf in New York has coordinated publication there with super-efficient flair with help from Katherine Hourigan (managing editor), Andy Hughes (director of production), Zachary Lutz (production associate), Soonyoung Kwon (designer), Rita Madrigal (production editor) and Ryan Ouimet (editorial assistant). And special thanks to Carol Carson for her jacket design.

*

To Andrea Rose for her support, endurance, knowledge and telling advice, my ultimate gratitude and love.

*

INDEX

Notes: Page numbers in *italics* refer to illustrations. Works by Lucian Freud (LF) appear directly under title; works by others under artist's/author's name.

Index 669

ILLUSTRATION CREDITS

Lorna Wishart, c. 1930. Private Collection

Lucian Freud with zebra head, photograph by Ian Gibson Smith, reproduced in *Penguin New Writing*, 1943

Lochness from Drumnadrochit, 1943 (pen and ink on paper), Freud, Lucian (1922–2011) / Private Collection / © The Lucian Freud Archive / Bridgeman Images

Portrait of a Young Man, 1944 (black crayon and white chalk on paper), Freud, Lucian (1922–2011) / Private Collection / © The Lucian Freud Archive / Bridgeman Images

Dead Monkey, 1944. Private Collection

Private view invitation, 1944. Private Collection

Rose reproduced in *Horizon*, 1946

Man with a Thistle (Self-Portrait) 1946 (oil on canvas), Freud, Lucian (1922–2011) / Tate, UK / © The Lucian Freud Archive / Bridgeman Images

"*Truant*," George Millar's yacht moored off Poros, 1946. Private Collection

Hercules, 1948 (pen and ink on paper), Freud, Lucian (1922–2011) / Private Collection / © The Lucian Freud Archive / Bridgeman

Startled Man: Self Portrait, 1948 (pencil on paper), Freud, Lucian (1922–2011) / Private Collection / © The Lucian Freud Archive / Bridgeman Images

Christian Berard, 1948 (black and white conte pencil on buff Ingres paper), Freud, Lucian (1922–2011) / Private Collection / © The Lucian Freud Archive / Bridgeman Images

Portrait of Mrs. Ian Fleming, 1950 (oil on canvas), Freud, Lucian (1922–2011) / Private Collection / © The Lucian Freud Archive / © The Lucian Freud Archive / Bridgeman Images

Lucian Freud and Brendan Behan in Dublin, 1953. © Getty

Francis Bacon, 1952. © The Lucian Freud Archive

Francis Bacon, 1951 (pencil on paper), Freud, Lucian (1922–2011) / Private Collection / © The Lucian Freud Archive / Bridgeman Images

Lucian Freud painting bananas at Goldeneye, Jamaica, 1953. Private Collection

Coronation Decorations, Clarendon Crescent, Paddington, 1953 (ink, graphite and pencil on paper laid down on board), Freud, Lucian (1922–2011) / Private Collection / Photograph © Christie's Images / Bridgeman Images

Lucian Freud with Caroline Blackwood and assembled wine glasses, Madrid, 1953. Private Collection

Portrait of a Man ('Napper' Dean Paul), 1954 (oil on canvas), Freud, Lucian (1922–2011) / Private Collection / © The Lucian Freud Archive / Bridgeman Images

Man in a Headscarf, 1954 (oil on canvas), Freud, Lucian (1922–2011) / Private Collection / © The Lucian Freud Archive / Bridgeman Images

Lucian Freud at Coombe Priory, Dorset c.1957. Photograph Michael Wishart

Lucian Freud book jacket for Nigel Dennis' *Cards of Identity*, 1958

Lucian Freud and Bernardine in the South of France. Private Collection

Wheelers Lunch, March 1963 (b/w photo; L to R: Tim Behrens, Lucian Freud, Francis Bacon, Frank Auerbach, Michael Andrews), Deakin, John (1912–1972) / The John Deakin Archive / Bridgeman Images

Red Haired Man on a Chair, 1962–63 (oil on canvas), Freud, Lucian (1922–2011) / Private Collection / © The Lucian Freud Archive / Bridgeman Images

Interior with Hand Mirror (Self Portrait), 1967 (oil on canvas), Freud, Lucian (1922–2011) / Private Collection / © The Lucian Freud Archive / Bridgeman Images

Drawing, c. 1958.

COLOUR PLATE SECTIONS

First plate section

Landscape with Birds, 1940 (oil on panel), Freud, Lucian (1922–2011) / Private Collection / © The Lucian Freud Archive / Bridgeman Images

Girl on the Quay, 1941 (oil on canvas), Freud, Lucian (1922–2011) / Private Collection / © The Lucian Freud Archive / Bridgeman Images

Man with a Feather (Self-Portrait), 1943 (oil on canvas), Freud, Lucian (1922–2011) / Private Collection / © The Lucian Freud Archive / Bridgeman Images

The Painter's Room, 1944 (oil on canvas), Freud, Lucian (1922–2011) / Private Collection / © The Lucian Freud Archive / Bridgeman Images

Woman with a Daffodil, 1945 (oil on canvas), Freud, Lucian (1922–2011) / Museum of Modern Art, New York, USA / © The Lucian Freud Archive / Bridgeman Images

Girl with a Kitten, 1947 (oil on canvas), Freud, Lucian (1922–2011) / Tate, UK / © The Lucian Freud Archive / Bridgeman Images

Father and Daughter, 1949 (oil on canvas), Freud, Lucian (1922–2011) / Private Collection / © The Lucian Freud Archive / Bridgeman Images

Girl with a White Dog, 1950–51, Lucian Freud (1922–2011). Tate, London, 2019. © Tate

John Minton, 1952 (oil on canvas), Freud, Lucian (1922–2011) / Royal College of Art, London, UK / © The Lucian Freud Archive / Bridgeman Images

Interior at Paddington, 1951 (oil on canvas), Freud, Lucian (1922–2011) / Walker Art Gallery, National Museums Liverpool / © The Lucian Freud Archive / Bridgeman Images

Hotel Bedroom, 1954 (oil on canvas), Freud, Lucian (1922–2011) / Beaverbrook Art Gallery, Fredericton, N.B., Canada / © The Lucian Freud Archive / Bridgeman Images

Woman Smiling, 1958–59 (oil on canvas), Freud, Lucian (1922–2011) / Private Collection / © The Lucian Freud Archive / Bridgeman Images

Pregnant Girl, 1960–61 (oil on canvas), Freud, Lucian (1922–2011) / Private Collection / © The Lucian Freud Archive / Bridgeman Images

Baby on a Green Sofa, 1961 (oil on canvas), Freud, Lucian (1922–2011) / Collection of the Duke of Devonshire, Chatsworth House, UK / © The Lucian Freud Archive / Reproduced by permission of Chatsworth Settlement Trustees / Bridgeman Images

Second plate section

Head, 1962 (oil on canvas), Freud, Lucian (1922–2011) / Private Collection / © The Lucian Freud Archive / Bridgeman Images

John Deakin, 1963–64 (oil on canvas), Freud, Lucian (1922–2011) / Private Collection / © The Lucian Freud Archive / Bridgeman Images

A Man and His Daughter, 1963–64 (oil on canvas), Freud, Lucian (1922–2011) / Private Collection / © The Lucian Freud Archive / Bridgeman Images

Naked Child Laughing, 1963 (oil on canvas), Freud, Lucian (1922–2011) / Private Collection / © The Lucian Freud Archive / Bridgeman Images

Man in a Blue Shirt, 1965 (oil on canvas), Freud, Lucian (1922–2011) / Private Collection / © The Lucian Freud Archive / Bridgeman Images

Michael Andrews and June, 1965–66 (oil on canvas), Freud, Lucian (1922–2011) / Private Collection / © The Lucian Freud Archive / Bridgeman Images

Girl on a Turkish Sofa, 1966 (oil on canvas), Freud, Lucian (1922–2011) / Private Collection / © The Lucian Freud Archive / Bridgeman Images

Naked Girl, 1966 (oil on canvas), Freud, Lucian (1922–2011) / Collection of Steve Martin / © The Lucian Freud Archive / Bridgeman Images

Woman in a Fur Coat, 1967–68 (oil on canvas), Freud, Lucian (1922–2011) / Private Collection / © The Lucian Freud Archive / Bridgeman Images

Buttercups, 1968 (oil on canvas), Freud, Lucian (1922–2011) / Private Collection / © The Lucian Freud Archive / Bridgeman Images

Small Interior, c. 1968–72 (oil on canvas), Freud, Lucian (1922–2011) / Private Collection / © The Lucian Freud Archive / Bridgeman Images

Reflection with Two Children (Self-Portrait), 1965 (oil on canvas), Freud, Lucian (1922–2011) / Thyssen-Bornemisza Collection, Madrid, Spain / © The Lucian Freud Archive / Bridgeman Images

Annabel, 1967 (oil on canvas), Freud, Lucian (1922–2011) / Private Collection / © The Lucian Freud Archive / Bridgeman Images

Interior with Plant, Reflection Listening (Self-Portrait), 1967–68 (oil on canvas), Freud, Lucian (1922–2011) / Private Collection / © The Lucian Freud Archive / Bridgeman Images

Large Interior, Paddington, 1968–69 (oil on canvas), Freud, Lucian (1922–2011) / Museo Thyssen-Bornemisza, Madrid, Spain / © The Lucian Freud Archive / Bridgeman Images

William Feaver is an art critic and a curator. He was the chief art critic for *The Observer* from 1975 to 1998 and is the author of *Frank Auerbach* (Rizzoli, 2009). He has also co-produced with Jake Auerbach *Lucian Freud Portraits* and *The Last Art Film*. He curated Lucian Freud's retrospective at Tate Britain in 2002, the 2012 exhibition of Freud's drawings in London and New York, and the John Constable exhibition at the Grand Palais in 2002 with Freud. He lives in London.

A NOTE ON THE TYPE

This book was set in Janson, a typeface long thought to have been made by the Dutchman Anton Janson, who was a practicing type-founder in Leipzig during the years 1668–1687. However, it has been conclusively demonstrated that these types are actually the work of Nicholas Kis (1650–1702), a Hungarian, who most probably learned his trade from the master Dutch typefounder Dirk Voskens. The type is an excellent example of the influential and sturdy Dutch types that prevailed in England up to the time William Caslon (1692–1766) developed his own incomparable designs from them.

Composed by North Market Street Graphics,
Lancaster, Pennsylvania

Printed and bound by LSC Communications,
Harrisonburg, Virginia

Designed by Soonyoung Kwon